Timor mortis conturbat me
The fear of death disturbs me

William Dunbar, "Lament for the Makers"

BOOK OF THE DEAD
THE COMPLETE HISTORY OF ZOMBIE CINEMA

This third pressing published by FAB Press, March 2007
(First published by FAB Press, October 2005. Second pressing published by FAB Press, February 2006)

FAB Press
7 Farleigh
Ramsden Road
Godalming
Surrey
GU7 1QE
England, U.K.

www.fabpress.com

Text copyright © 2005 Jamie Russell.
The moral rights of the author have been asserted.

Edited and Designed by Harvey Fenton,
with thanks to Francis Brewster for production assistance.

This Volume copyright © FAB Press 2007.

World Rights Reserved.

No part of this book may be reproduced or transmitted in any form or by any means, electronic or mechanical, including photocopying, recording, or by any information storage and retrieval system, without the prior written permission of the Publisher.

Copyright of illustrations reproduced in these pages is the property of the production or distribution companies concerned. These illustrations are reproduced here in the spirit of publicity, and whilst every effort has been made to trace the copyright owners, the author and publishers apologise for any omissions and will undertake to make any appropriate changes in future editions of this book if necessary. Acknowledgements are due to the following companies:
20:20 Vision, ADN Associates Ltd., Alfa Films, American Films Inc., American International Pictures, Amicus, Ancla Century Films, Andros Films, Arista Films Inc., Astor Pictures, Atlas International, Avco Embassy Pictures Corp., Beatrice Films, Belen Films S.A., Camp Video, CBS/Fox, Clover Productions, Cinema International Corporation, Cinemavault Releasing, Columbia Pictures, Constantin Film Produktion GMBH, Continental Motion Pictures, Coyote Home Video, Dawn Associates Inc., Dead Films Inc., Dialchi Film s.r.l., Dias Film, Distant Horizon, DMV Distribuzione, Étoile Distribution, Eurociné, Fairway International, FARSA Producciones, Fever Dreams LLC, FIDA Cinematografica S.p.A., Films Dara, Flora Film, Fox Searchlight Pictures, Frontline Films, Fulvia Film S.R.L., Fusion International Sales, Gaumont, Geneni Film Distributing Co., General Video, Gico Cinematografica, Glass Eye Pix, Gold Gems Ltd., Golden Era Film Distributors, Governor Films, Hammer, Hemdale Home Video Inc., Hofmann & Voges Entertainment GMBH, Hooligan Pictures, Interfilme P.C., Intervision, Izaro Films, J F Films, Laurel, Lions Gate Films, LMG, Lotus Films Internacional S.A., Lucky Charm Studios, Manson International, Media Blasters, Media Releasing Distributors Ltd., Medusa Home Video, Midnite Movies, Midnight Pictures Ltd., Miracle Films, Monogram Pictures, Motion Picture Corporation of America, Mundial Film S.A., New World International, New World Video, Nu Image, Nueva Films S.A., Paramount Pictures, Plata Films, Profilmes SA, Rebel Filmwurx Inc., René Chateau Distribution, Rennaisance Pictures, RKO Pictures, Rogue Pictures, Rush Distribution, Samourai Films, Scotia, Shaw Brothers, Skouras Pictures, SouthEast Records, Spierigfilm, Star Film, Strike Entertainment Inc., Sub Rosa Studios LLC, Sunseri Studios, Synapse Films, Taurus Entertainment, Terror Home Video Entertainment, Tigon, Tot Media, Towa, Trans-Bay Pictures Inc., Tri-Star Pictures, Trunk Records, Turner Broadcasting System Inc., Twentieth Century Fox, United Film Distribution Company, Universal Studios, Variety Film SrL, Vestron Video International, Video Collection International Ltd., VIPCO, VTC, Warner Bros., Wild Street Pictures, Worldwide Entertainment Corporation, X-Rated.

Front cover illustration
Adapted from the Italian poster created for the promotion of Lucio Fulci's **City of the Living Dead**.

Back cover illustration
Adapted from the Italian poster created for the promotion of Andrea Bianchi's **The Nights of Terror**.

Frontispiece illustration
Adapted from the Spanish press book created for the promotion of Amando de Ossorio's **Tombs of the Blind Dead**.

Title page and acknowledgements page illustrations:
Iconic zombie movie images from George A. Romero's **Dawn of the Dead**.

A CIP catalogue record for this book is available from the British Library.

ISBN 1 903254 33 7

The Complete History of Zombie Cinema

Jamie Russell

Acknowledgements

Exhaustive projects like this are always hard work, but I have been fortunate enough to have been given the help, advice and encouragement of many friends, colleagues and family. I'm deeply indebted to Nigel Burrell, Brian Holmes, Nev Pierce and David Whittaker who generously agreed to look over the manuscript and offered a host of insightful comments from very different perspectives. I'd also like to thank Francis Brewster and Ling Eileen Teo for their eagle-eyed proofreading skills, as well as Jamie Graham at *Total Film* (a true horror fan after my own heart) and Daniel Etherington at *Channel 4 Film.com* ("zombies you gotta love 'em") for their generous interest and helpful suggestions.

Marc Morris and David Oakes were invaluable in helping me track down cobwebbed zombie movies that have slid into obscurity. Julian Grainger was kind enough to look over the filmography and offer invaluable advice and corrections. Paul Brown, Ingo Ebeling, Adele Hartley, Sam McKinlay and Alan Simpson provided some wonderful zombie images. Meanwhile, the legendary Alan Jones was generous in offering me an advance look at his interviews with George Romero for *Shivers* magazine. Overseeing the whole project, Harvey Fenton of FAB Press proved to be the kind of editor that most authors only ever dream of finding - knowledgeable, enthusiastic and always ready to offer much needed encouragement (not to mention obscure VHS tapes).

Many thanks to the staff of the British Film Institute and the British Library, who remained eternally professional - and managed to keep a straight face - while fielding my questions about zombie-related holdings. I'm also deeply indebted to Peter Dendle, whose enthusiasm for zombies was a great inspiration: my copy of his excellent tome *The Zombie Movie Encyclopedia* is now very well thumbed and annotated. A word too for all those editors who've helped keep me freelance while writing this book: Adrian Hennigan, Martin Glanville and Rachel Simpson at *BBC Movies*, Paul Morgan and Scott Henderson at *DVD Review*, Matthew Bingham at *FHM*, Rachel Holdsworth and Jim Healy at *What's On*, Paul Dale at *The List*, Steve O'Brien at *SFX*, Andrea Toal and Edward Lawrenson at *Sight & Sound* and everyone at *Total Film*.

Finally, I'd like to thank Jonathan Crocker, Tom Dawson, Ged Glover, Julian Groombridge, William Groombridge, Jon and Helen Macmillan (who've always hated zombies), Stella Papamichael, Scott Russon and Ceri Thomas for all their help, advice and polite interest. As always, John and Anna Maria Groombridge and Colin and Doreen Whitehouse were some of my most enthusiastic supporters; hopefully they'll see that all those years spent watching "weird" films did eventually pay off.

More thanks than I can express go to Mum and Gran - especially for buying me my very own VCR at the ripe old age of fifteen and letting me loose in the horror section of SE26's video stores! And finally, this book would never have seen the light of day without my wife Louise, who showed me so much love while I was up to my eyeballs in all the horror.

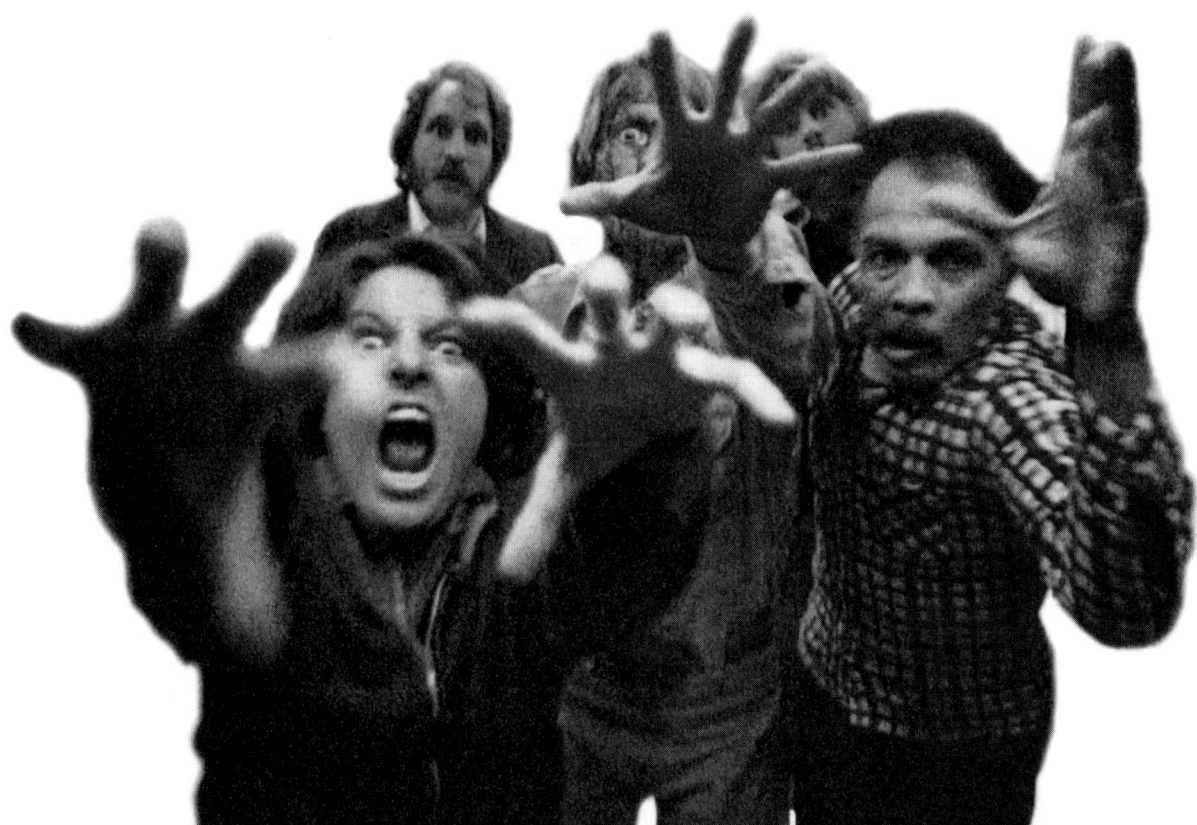

Contents

Introduction: Dead Men Walking ... 7

Chapter One: Caribbean Terrors ... 9
 Tracking the Walking Dead ... 9
 The Origins of the Zombie ... 11
 The Zombie in the West ... 15

Chapter Two: The Zombie Goes to Hollywood ... 19
 Horror Hits the Stage ... 19
 Cultural Anxieties: Haiti, the Depression and Race ... 20
 The Zombies Are Revolting ... 27

Chapter Three: Down and Out on Poverty Row ... 33
 Horror Comedy on Black Island ... 33
 The Poverty Row Years ... 34
 Val Lewton: A Touch of Class ... 41

Chapter Four: Atomic Interlude ... 47
 Sci-Fi Horrors ... 47
 Voodoo's Last Gasps ... 48
 The Mass Destruction of Men's Minds ... 51

Chapter Five: Bringing It All Back Home ... 55
 Keeping It in the Family ... 55
 Stiff Upper Lips and the Walking Dead ... 56
 South of the Border ... 60
 Back on American Soil: Night of the Living Dead ... 64

Chapter Six: Dawn of the Dead ... 71
 Romero's Children ... 71
 The Ghouls Can't Help It ... 76
 Destructive Tendencies ... 81
 Sex, Death and Amando de Ossorio's Templars ... 86
 By the Dawn's Early Light ... 91

Chapter Seven: Splatter Horror ... 129
 The Italians Are Coming! ... 129
 The Apocalypse of Narrative: Fulci's Zombie Trilogy ... 137
 The Return to the Caribbean ... 142
 Splatter House of Horrors ... 151

Chapter Eight: Twilight of the Dead ... 161
 Night of the Living Dead Redux ... 161
 Poverty Row for the MTV Generation (Or, Children Shouldn't Play with Camcorders) ... 164
 Of Death, Of Love: An Interlude ... 169
 The Resident Evil Effect ... 171
 Big-Budget Ghouls ... 175
 Rebirth of the Dead ... 178

*Afterword: **Something To Do With Death*** ... *225*
Notes and References ... *226*

Chapter Nine: Zombie Filmography ... 233

Bibliography ... *310*
Index ... *313*

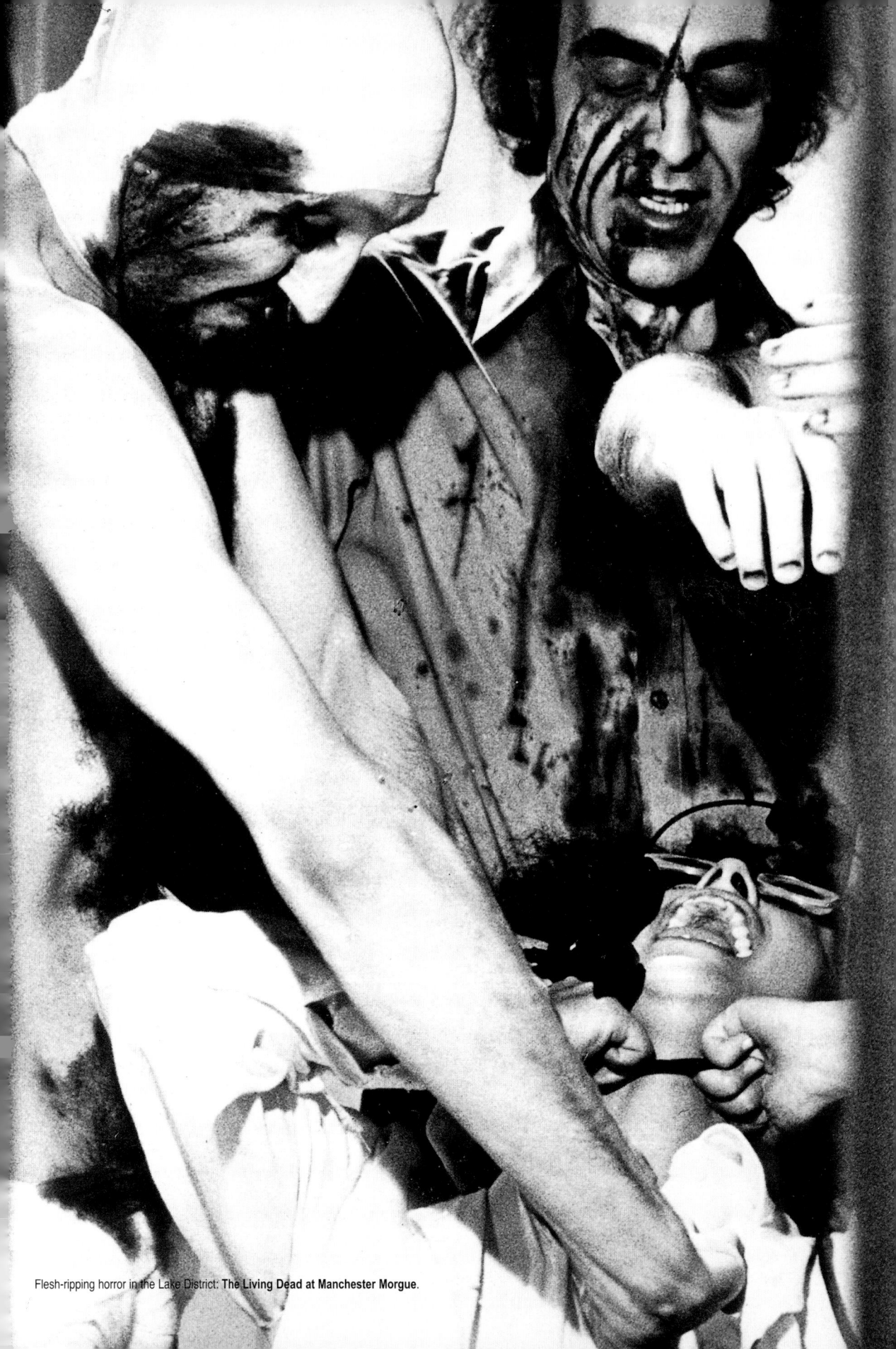
Flesh-ripping horror in the Lake District: **The Living Dead at Manchester Morgue**.

introduction

Dead Men Walking

In his wide-ranging study of the Western world's fascination with horror, James B. Twitchell is strangely dismissive of the living dead:

> The zombie myth seems flawed by its lack of complexity. The zombie is really a mummy in street clothes with no love life and a big appetite. Both are automatons; neither is cunning nor heroic. They simply lumber about (Karloff called it "my little walk"), shuffling their feet like dateless high school students before the prom. As opposed to the vampire, who is crafty, circumspect and erotic, these two cousins are subhuman slugs [...]
>
> The zombie is an utter cretin, a vampire with a lobotomy, and this is what has tended to make [all the films following *I Walked with a Zombie* (1943)] little more than vehicles of graphic violence, full of people (usually men) poking each other and then occasionally eating them. The zombie is so shallow [...] even Abbott and Costello refused to meet with him.[1]

Few horror movie monsters are as maligned as the zombie. While vampires, werewolves and even serial killers command respect, the zombie is never treated as anything other than a buffoon who stumbles around on the margins of horror cinema messily decaying. There are no aristocrats, blue bloods or celebrities among zombies, no big name stars or instantly recognisable faces, just low-rent, anonymous monsters who usually can't talk, can barely walk and spend most of their energy trying to hold their decomposing bodies together.

Zombies are the great unwashed of horror cinema, soulless creatures that wander around without personality or purpose - a grotesque parody of the end that awaits us all. For all their lack of finesse or style, though, the living dead have been a constant presence in horror films since the 1930s with a filmography that includes many critically-acclaimed and popular films: *White Zombie* (1932), *I Walked with a Zombie* (1943), *Invasion of the Body Snatchers* (1956), *Night of the Living Dead* (1968), *Dawn of the Dead* (1978), *The Beyond*, (orig. *L'aldilà*, 1981), *Dellamorte Dellamore* (1993), *28 Days Later* (2002) and *Shaun of the Dead* (2004).

So why hasn't the zombie ever been treated seriously? Partly it's because the living dead lack an established literary heritage. Dracula, Frankenstein's monster, Dr. Jekyll and Mr. Hyde and even the Wolf Man can boast a lineage that stretches back to Gothic fiction, European folklore and ancient legends. In contrast, the zombie is the most modern of monsters, a twentieth-century interloper whose first fully-fledged appearance in the English-speaking world dates back to the publication of *The Magic Island*, William Seabrook's groundbreaking study of Haiti, in 1929.

Without the force of history behind it the zombie has become a forlorn figure, cast aside by most movie fans as a second rate villain with none of the instantly-recognisable legitimacy - or celebrity - of Count Dracula or Frankenstein's monster. It's no wonder, then, that zombies have never made the cover of *Empire* magazine, are rarely seen at the Oscars and don't get invited onto many talk shows. Boris Karloff may have become famous for his self-styled "little walk" as Frankenstein's monster, but no one has ever become famous playing one of the living dead. Even Bela Lugosi, a horror actor not known for being choosy about his roles, always played the zombie master and never one of the walking corpses.

Given the lowly status of its monstrous stars, it's not surprising that the zombie movie has remained on the cultural margins. Rejected by the academy - scholarly studies of horror movies generally prefer to discuss vampires, werewolves and even serial killers before the living dead - these films have been consigned to the graveyard of popular culture, and the zombie itself has become *persona non grata* with everyone except those horror fans who like their movies raw and bloody.

What has always troubled critics and mainstream audiences about the zombie is its frequent appearance in such terrible films. There's simply no way of getting around the fact that the zombie, more than any other horror star, has an appalling track record in terms of quality control. Whether starring in Poverty Row era trash, Italian rip-offs or homemade shot-on-video shockers, the living dead are always found lurking in movies that are low on stars, short on cash and often hurried into the cinematic equivalent of a shotgun wedding.

Yet just because some of these outings fall far below the standard set by mainstream A-list Hollywood doesn't mean that they're not worthy of serious attention. Indeed, it is often the very marginality of these zombie movies that makes them so fascinating. The aim of this book is to chart the history of the zombie in the West and, in particular, its development as a horror

movie icon. Up until now, almost all of the books written about living dead cinema have been panoramic filmographies. I hope to trace the historical and cultural shifts that brought the zombie out of Africa and into the horror film industries of America and Europe via the Caribbean.[2] Why did the zombie first come to the attention of the American public in the late 1920s? Why has it had a constant screen presence ever since? And what does our fascination with - and frequent hatred of - the zombie tell us about ourselves?

The monsters that dominate any particular culture or period offer an unusual insight into the specific fears and anxieties that characterise that historical moment. As horror theorist Judith Halberstam argues, "monsters are meaning machines" whose existence gives us insight into the anxieties of the culture that produced them.[3] After all, the very word "monster" has etymological roots that can be traced back to the Latin *monstrare*, meaning to show, to display, to de*monstrate*.[4]

Since it's such a recent addition to the Western world's pantheon of bogeymen, the zombie is a monster whose cultural significance isn't shrouded by centuries of over-familiarity. Entering American - and then European - popular culture in the late 1920s at the height of the United States' geopolitical interest in Haiti, the zombie was appropriated from Afro-Caribbean culture for a wide variety of different ends.

Ultimately, the zombie is a symbol of mankind's most primitive anxiety: the fear of death. Full of a morbid sense of the body's limitations and frailties, the zombie myth is closely bound to our troubled relationship with our own bodies. That's enough to make it significantly different from the vampire legend and from those stories of the dead returning to life as ghastly apparitions or demons, which is why films about the "resurrected" - such as *City of the Dead* (aka *Horror Hotel*, 1960) and *Baron Blood* (1972) - are absent from this book's filmography. Put simply, the zombie is a corpse reanimated through some form of magic or mad science that returns to "life" without regaining any of its former personality.

In the many ways it has been deployed in Western popular culture, however, the zombie has slowly been transformed. It has come to signify something much more complex than just the fear of death. Growing out of a wide range of cultural anxieties - from American imperialism to domestic racial tensions, Depression era fears about unemployment, Cold War paranoia about brainwashing, post-1960s political disenfranchisement and AIDS era body horror - the zombie has become, as we will see, a potent symbol of the apocalypse. It's a monster whose appearance always threatens to challenge mankind's faith in the order of the universe.

Forever poised in the space between the traditional Western understandings of white/black, civilised/savage, life/death, the zombie is a harbinger of doom. Its very existence hints at the possibility of a world that cannot be contained within the limits of human understanding, a world in which these binary oppositions no longer stand fixed. Trampling over our cherished certain certainties, the zombie is, above all else, a symbol of our ordered universe turned upside down as death becomes life and life becomes death. In the chapters that follow, this book hopes to explain the allure of such a catastrophic occurrence, placing the development of the zombie in its socio-historical context in an attempt to understand why it is that, after all these years, we are still so fascinated with the dead that walk.

chapter one
Caribbean Terrors

I. Tracking the Walking Dead

It was in 1889 in the pages of *Harper's Magazine* that the zombie made its debut appearance in the English-speaking world in a short article by journalist and amateur anthropologist Lafcadio Hearn entitled "The Country of the Comers-Back". Although the term "zombie" was first recorded in *The Oxford English Dictionary* in 1819, and was frequently heard mentioned by slaves in America's Deep South in the latter part of the eighteenth-century, it was Hearn's article that became the first widely circulated report of the existence of the living dead.[5]

A Greek by birth Hearn emigrated to the United States in 1869. He travelled out to the island of Martinique in 1887 to study the local customs and folklore for a series of popular articles on life in the Caribbean. Among the many stories and legends he came across on his travels around the island there was one in particular that fascinated him: the story of the *corps cadavres* or "walking dead". Wherever he went, the islanders talked in hushed tones about the disaster that would befall anyone unlucky enough to encounter one of the horrific beings known as zombies. Whenever Hearn asked them to explain what these creatures were and where they came from, his questions were greeted with tightly sealed lips. No one, it seemed, was willing to enlighten him about the *corps cadavres* and he could only speculate about the link between these mysterious monsters and the island's nickname of *Le pays des revenants* (The Country of the Comers-Back).

Even when Hearn did find people who were willing to speak to him about the *corps cadavres*, the contradictory anecdotes, vague stories and superstitious mumblings he encountered proved more confusing than illuminating. His journey through the mountainous region near Calebasse was typical of his experience. Spending the night in the home of a local family, Hearn decided to question them about island superstition. As supper was being cleared away, the traveller asked his host's eldest daughter to tell him what she knew of the zombie. Replying in French - the language stamped on the island's populace by years of colonial rule - the young girl gave him an answer that was as vague as it was intriguing: "*Zombi? Mais ça fais dèsodè lanuitt, zombi!*" ("Zombie? It is something that causes disorder in the night!").

Perplexed, Hearn tried asking the girl's mother for her views on the subject. The old woman gave him a longer, though no more illuminating, explanation: "When you pass along the high road at night, and you see a great fire, and the more you walk to get to it the more it moves away, it is the zombie that makes that… Or if a horse with three legs passes you: that is a zombie." Warming to the topic, her daughter chimed in with some additional information: "Or again, if I were to see a dog that high [she held her hand about five feet above the floor] coming into our house at night, I would scream: *Mi Zombi!*"[6]

Unable to get to the bottom of the mystery surrounding the *corps cadavres*, Hearn returned to America with little to offer *Harper's Magazine* other than a colourful account of his travels. Even though his mention of the zombie was enough to ensure that he would go down as one of the first white westerners to popularise the notion of the walking dead, it would be left to a very different writer to bring the zombie to the world's attention.

In 1928 the American adventurer William Seabrook arrived in Haiti, the so-called "voodoo capital" of the Caribbean. Like Martinique, St Croix and most of the Lesser Antilles, Haiti was dominated by zombie legends and so it wasn't long before Seabrook's curiosity was piqued by stories of the walking dead. However, unlike Hearn, Seabrook wasn't the kind of man to be fobbed off with tales of three-legged horses. Researching Haiti's superstitions for a full-length book on the island's voodoo culture, he was determined to get to the bottom of the mystery of the zombie.

Born in Westminster, Maryland on 22 February 1887 - coincidentally, the same year that Hearn first visited Martinique - Seabrook studied at the University of Geneva before graduating into a career as a journalist, foreign correspondent and daring adventurer. A veteran of the First World War (he was gassed at Verdun in 1916 and cited for the *Croix de Guerre*), he went on to become a peripheral member of the "Lost Generation" of American writers and artists who congregated in 1920s Paris - a group which included such luminaries as Gertrude Stein, William Faulkner and Ernest Hemingway.

Seabrook's literary reputation rested on his non-fiction work. His first book, the wonderfully titled *Adventures in Arabia: Among the Bedouins, Druses, Whirling Dervishes & Yezidee Devil Worshippers*, was published to great acclaim in 1928. Seabrook's crisp

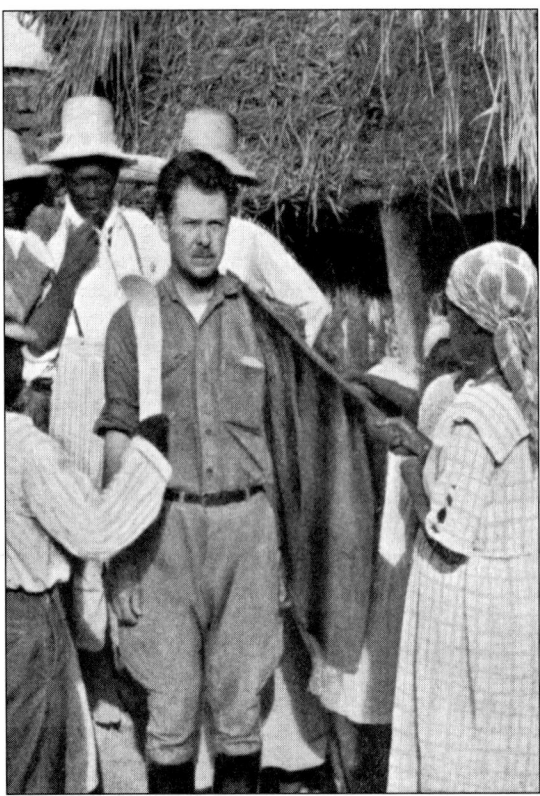

William Seabrook in Haiti.

prose, coupled with his unquenchable desire to sample every unusual aspect of the cultures that he visited, paved the way for a series of autobiographical travelogues about his adventures in Haiti (*The Magic Island*, 1929) and Africa (*Jungle Ways*, 1931; *The White Monk of Timbuktu*, 1934), as well as a candid account of his treatment for alcoholism (*Asylum*, 1935) and a book on the occult (*Witchcraft, Its Power in the World Today*, 1940).

His willingness to throw himself into his research in the hope of finding material that would entertain, shock and horrify his readers was one of the more distinctive features of his work. It was also the source of his reputation as a daring - and rather unusual - adventurer. At first sight, no one would have ever guessed that this short and unimposing man was anything out of the ordinary. Arriving in Haiti's bustling capital of Port-au-Prince in 1928, Seabrook was hardly conspicuous, even as a white man. Haiti had fallen under American rule in 1915 and the island was awash with white soldiers, bankers, clerks and businessmen. With his well-groomed moustache, cleft chin and narrow, intense blue eyes, Seabrook looked like just another white-collar American drawn to the so-called "Black Republic" of Haiti in the hope of combining exotic adventure with financial reward.[7] A rare photograph of the author in *The Magic Island* shows a stern yet vaguely comical figure;

khaki shirt sleeves rolled up to the elbow to let his pale arms catch the glare of the Caribbean sun, gallopers and riding boots recalling the stereotype of the 1920s white explorer. All that is missing, perhaps somewhere off camera, is a pith helmet.

In reality, though, Seabrook was anything but ordinary. From his friendship with the notorious occultist Aleister Crowley to his penchant for bizarre sexual encounters, he cultivated a reputation that owed more to the ideals of artistic bohemianism than adventuring. His sexual peccadilloes were the stuff of legend. According to one infamous rumour he travelled everywhere - whether through the jungles of Africa or the deserts of Arabia - with a suitcase full of whips and chains. It was a story that was given added credence after one of his bohemian circle, the photographer Man Ray, recounted how Seabrook had asked him to watch over his apartment one afternoon. Man Ray arrived to find a young girl "nude except for a soiled loincloth, with her hands behind her back chained to the post [of the staircase] with a padlock".[8] The astonished photographer was given specific instructions not to untie her since she was being paid handsomely for her services.

Such enthusiasm for the bizarre spilled over into Seabrook's writing. This was an author who was ready to gamble life and limb to bring back sensational stories of exotic native cultures that his readers would be unlikely to ever see for themselves. His thirst for the unusual - and his belief in writing only about what he'd experienced first-hand - led him into a series of hair-raising adventures in Arabia, Haiti and Africa. Indeed, he was so scrupulous about the necessity of subjective experience that he refused to write about cannibalism for his book *Jungle Ways* until he'd actually tasted human flesh. Having missed the chance to sup with cannibals while in the heart of Africa, Seabrook paid a Paris hospital orderly to secure him a pound of flesh from the body of a workman killed in a traffic accident. With his prize neatly tucked away in a surgical napkin, he rushed over to a friend's apartment and convinced his cook to roast, broil and stew pieces of the meat, telling her that it was a "kind of wild goat that no one had ever eaten before". Then, as he sampled the human dish, he made notes. It tasted, he later said, like pork, except that it needed more seasoning.[9]

Quite how much truth there was in these fantastic stories, only Seabrook knew. But whatever the extent of their veracity, they proved one thing: he was someone who knew how to transform the ordinary into the sensational. It was a talent that would inform his work on Haitian voodoo and, in particular, the zombie. Attracted to the occult, the unusual and the just plain weird, Seabrook proved to be the perfect person to uncover the realities of Haiti's voodoo lore. Not for him a vague article in the pages of *Harper's Magazine*; his work would reach a far more receptive audience eager to know the truth about the walking dead.

II. The Origins of the Zombie

As Seabrook tells the story in his book *The Magic Island*, it was a Haitian farmer called Polynice who first introduced him to some real-life zombies. During the course of his research into the island's voodoo superstitions, Seabrook had already established far more about the *corps cadavres* than Hearn had ever dreamt of. Travelling the length and breadth of Haiti, interviewing as many islanders as possible, taking part in voodoo rites and hoarding as much information about the mysteries of the island's superstitions as he could lay his hands on, Seabrook had become quite an expert on voodoo lore by the time he encountered Polynice.

For the Haitians who Seabrook talked to, the zombie was a powerful symbol of fear, misery and doom. It was also an integral part of the religious beliefs that dominated the island. The origins of Caribbean *voudoun* can be traced to the moment when the first slaves were transported from Africa into the West Indies. Within fifty years of arriving on the island that would later become known as Haiti, the first European settlers had wiped out the indigenous population through a combination of brutal violence and deadly disease. In an attempt to bolster the declining number of natives - and keep the lucrative production of sugar cane running smoothly - hundreds of thousands of slaves were shipped across the ocean from West Africa. As a result of this interference in the island's population, Haiti's indigenous culture was irrevocably altered as the native Indians were systematically replaced by a population of around 70,000 whites and mulattoes who dominated a slave force of half a million Africans.

In the close cultural confines of the island, the slaves' religious beliefs gradually transformed into a complex hybrid of African animism and Roman Catholicism that eventually became known to Westerners as "voodoo". Despite various attempts to outlaw these heathen practices during the French rule of Haiti, voodoo flourished and strengthened in the face of adversity.

One of the central concepts in most voodoo ceremonies is the idea of possession by the gods. During these ceremonies, music and dance are used to encourage a trance-like state that will enable a god to descend and take control of one of the assembled worshippers. In order for a person to be possessed in this way, their essential soul has to be removed from their body. According to the tenets of the voodoo faith, a person is comprised of two souls, the *gros-bon-ange* (literally, the big good angel) and the *ti-bon-ange* (the little good angel). The first of these is an individual's life force, the second is everything that defines them as *them*. For a god to take possession of a worshipper, the second of these two souls has to be cast out of the body. The spirit of the god then takes over the empty shell of flesh. Later, when the god departs, the person's *ti-bon-ange* returns to the body. In voodoo, much as in Christianity, the soul and the body are considered separate entities and thus one can exist without the other.

The very real danger - and it is here that the concept of the zombie begins - is that if a person's soul can be separated from their body during a voodoo rite, an unscrupulous sorcerer might make this kind of separation occur outside of these closely managed ceremonies. According to zombie legend, such necromancy usually occurred after the sorcerer brought about the victim's "death" through a combination of magic and potions. After the unlucky victim had mysteriously fallen ill and apparently died, the sorcerer captured their essential soul and, on the eve of the burial, opened up their grave and removed the body. The sorcerer could then bring this corpse back to "life" as an obedient, mindless slave that could be put to work on some distant part of the island where it was unlikely to be recognised.

Since the existence of zombies was considered common knowledge in Haiti, the families of the newly dead did their best to prevent the bodies of loved ones from being reanimated. If they were wealthy, they'd bury the body in a proper tomb that was solid enough to deter intruders; if they were poor, the corpse was interned beneath heavy masonry. Often the family would post a guard at the graveside to watch over the site until the body had had time to decompose. Alternatively, the corpse might be buried near a busy street or crossroads. In more extreme circumstances, the corpse was "killed" again - shot through the head or injected with poison - to prevent the body being of any use to grave robbers.

If such precautions weren't followed, there was no doubting the potential horror of what could happen: the body of the dead loved one might rise from the grave as a zombie. As the origins of the word indicate, it was a horrifying prospect. Linguists have claimed that the etymological root of "zombi" might be derived from any (or all) of the following: the French *ombres* (shadows); the West Indian *jumbie* (ghost); the African Bonda *zumbi* and Kongo *nzambi* (dead spirit). It may also have derived from the word *zemis*, a term used by Haiti's indigenous Arawak Indians to describe the soul of a dead person.

For most Haitians, the predominant fear was not of being attacked by zombies, but of *becoming* one. The best horror stories have always been those that tap into their audience's daily fears. The success of the Caribbean zombie as a figure of superstition was because it did exactly that. For a population whose ancestors had been captured, shackled and shipped out of Africa to the far-off islands of the Caribbean, dominated by vicious slave masters and forced to work for nothing more than the bare minimum of food to keep them strong enough to live another day, the zombie symbolised the ultimate horror. Instead of an escape into paradise, death might

just be the beginning of an eternity of work under a different master, the voodoo sorcerer. Nothing, for a nation that had been born into slavery and had only just succeeded in throwing off the imperial shackles of its European oppressors, could be more terrifying. As biologist and anthropologist Wade Davis writes:

> Zombis [sic] do not speak, cannot fend for themselves, do not even know their names. Their fate is enslavement. Yet given the availability of cheap labour, there would seem to be no economic incentive to create a force of indentured service. Rather, given the colonial history, the concept of enslavement implies that the peasant fears, and the zombi [sic] suffers, a fate that is literally worse than death - the loss of physical liberty that is slavery, and the sacrifice of personal autonomy implied by the loss of identity.[10]

Seabrook already had a fair sense of most of this when he sat down to talk to Polynice, since his research into the island's voodoo culture had been exhaustive to say the least. As he later wrote in *The Magic Island*, he knew that the zombie was supposed to be "a soulless human corpse, still dead, but taken from the grave and endowed by sorcery with a mechanical semblance of life - it is a dead body which is made to walk and act and move as if it were alive".[11] Yet he had no idea of quite how seriously the islanders took these stories of the walking dead.

During the course of his conversation with the farmer, Seabrook quizzed him about all manner of mythical creatures, from vampires to werewolves to ghosts. Polynice scoffed loudly at each of these monsters, claiming that they were nothing more than old wives' tales. But when Seabrook enquired about the legend of the zombie, the farmer's tone changed and he became deeply serious, warning his new-found friend that the zombie was more than just a legend. "They exist to an extent you whites do not dream of," he told Seabrook in hushed tones.[12] "At this very moment in the moonlight, there are *zombies* working on this island, less than two hours ride from my own habitation... If you will ride with me tomorrow night, yes, I will show you dead men working in the canefields."[13] Before he fulfilled this promise, this farmer recounted to Seabrook what would become the first proper zombie story to be published in the West.

In 1918 the Haitian sugar cane crop was larger than usual. Concerned that this bumper harvest would be too much for the regular workforce to cope with the Haitian-American Sugar Company (HASCO) offered bonuses to farmers to help them bring in the crop. Desperate for the money that was being offered, poverty-stricken Haitians of all ages streamed into the HASCO plantations. One man, who some of the farmers knew as Ti Joseph of Colombier, arrived with a ragged-looking group of men and women. The other farmers realised immediately that these blank-faced creatures were zombies yet the white bosses of HASCO didn't care who or what they were, as long as they were good workers.

Camping out on the edge of the plantation, Ti Joseph and his wife Croyance kept the zombies away from the rest of the workforce, partly because the creatures were terrified of the noise of the sugar factory but also out of fear that someone might recognise them as dead friends or relatives. Even at mealtimes the zombies were kept apart as Croyance fed them a special *bouillie* (stew) that she carefully prepared without seasoning since salt was the one thing that could free a zombie from the sorcerer's control.

The living dead workforce toiled in the sun-baked fields for several weeks until the annual *Fête Dieu* holiday when HASCO granted its employees a short break so that they could attend the island's many celebrations. Ti Joseph decided to keep the zombies billeted in the cane fields to avoid any suspicious questioning, but since he was eager not to miss out on the festivities he told his wife to watch over them while he travelled into Port-au-Prince to join the carnival. Angry at being left to baby-sit the living dead slaves, Croyance decided to ignore her husband's instructions and took the zombies into a nearby town to watch the local processions.

Feeling sorry for her forlorn-looking charges, Croyance bought them some candy from a roadside stall little realising that it had been made with salted nuts. As soon as the group tasted the candy they began to awaken, slowly becoming aware of their surroundings as the salt broke Ti Joseph's magical hold over them. Moving off with a single purpose, they shuffled towards their home village in the nearby mountains, ignoring Croyance's frantic attempts to stop them.

As the zombies returned home, their terrified relatives came out of their houses to watch in appalled silence as these former loved ones limped through the village towards the cemetery where they had been buried. Collapsing onto their empty graves, the zombies fell still as death took hold of them again. The next day, the outraged relatives hired a band of assassins to waylay the unsuspecting Ti Joseph as he travelled back to the cane fields from Port-au-Prince. The sorcerer was beheaded and his body was left to rot by the roadside.

After listening to this lurid story, Seabrook realised that he had found the perfect centrepiece for his book on Haitian voodoo. Eager to replicate his previous work on Arabia and Africa, the author was convinced that the occult practices of the island - with their enticing mix of sex, living death and witchcraft - would be the blueprint for an immediate bestseller. Excited, he asked Polynice to show him the dead men working in the cane fields.

A few days later Polynice led the white adventurer deep inland. It was mid-afternoon when they reached their destination. The glare of the sun made the fields shimmer in a heat haze as Polynice pointed out four distant figures working in the middle of a plantation. After riding on ahead to ask the man in charge of the zombies if he would consent to letting a white traveller see them, Polynice eventually beckoned his friend over to take a look. Ever curious, Seabrook went up to each of the three zombie workers and stared deep into their eyes. It was, according to his account in *The Magic Island*, a truly shocking encounter:

> My first impression of the three supposed *zombies*, who continued dumbly at work, was that there was something about them unnatural and strange. They were plodding like brutes, like automatons […] The eyes were the worst. It was not my imagination. They were in truth like the eyes of a dead man, not blind, but staring, unfocused, unseeing. The whole face, for that matter, was bad enough. It was vacant, as if there was nothing behind it. It seemed not only expressionless, but incapable of expression. I had seen so much previously in Haiti that was outside ordinary normal experience that for the flash of a second I had a sickening almost panicky lapse in

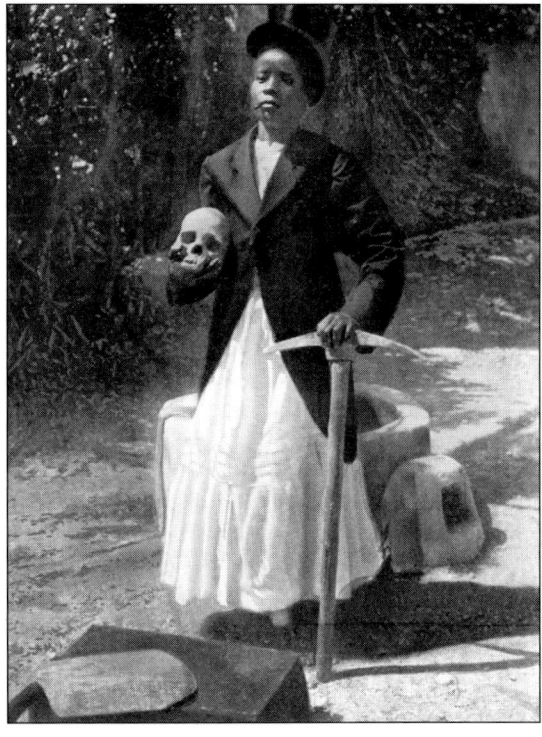

above and below: Voodoo sorcerers.

panicky lapse". What he had just seen was an affront to science, religion and common sense.

Yet, for all his professions of fear and surprise Seabrook was quick to explain this encounter with the living dead in scientifically acceptable terms. Staring into the blank eyes of the zombies, the adventurer decided that these weren't the dead brought back to life, but simply members of Haiti's underclass - mentally challenged unfortunates who were being exploited under the guise of some ancient superstition. They were nothing more than "poor, ordinary human beings, idiots, forced to toil in the fields".[15] Their blank expressions weren't proof of some black magic but just their dumb misery and confusion as they were exploited as cheap labour.

Continuing his research in the months that followed this historic confrontation, Seabrook realised that there might also be another explanation for the ubiquitous zombie legends that dominated Haiti and much of the rest of the Caribbean. Consulting various medical experts on the island, the adventurer uncovered an explanation for the living dead phenomenon that, he believed, might stand up to the scrutiny of medical science. Discussing the zombie with a Haitian doctor in Port-au-Prince, Seabrook realised that these living dead corpses might be nothing more than drugged sleepwalkers whose appearance of "death" had been manufactured through the use of some kind of toxic substances.

The official Haitian *Code Pénal* hinted at exactly this, with a specific paragraph (article 249) referring to dubious practices that might be used to make the living appear dead:

which I thought, or rather felt, "Great God, maybe this stuff is really true and, if it is true, it is rather awful, for it upsets everything." By "everything" I meant the natural fixed laws and processes on which all modern human thought and actions are based.[14]

As the first documented meeting between a white man and a zombie, Seabrook's description is an important starting point in any attempt to understand the West's fascination with the living dead. Explicitly describing the zombie as an affront to both science and reason, Seabrook claims they upset all of mankind's certain certainties. Brought back from beyond the grave to perform some servile labour, the zombie appears to be an automaton whose existence challenges not only "all modern human thought" but also the "natural fixed laws and processes on which all modern human thought and actions are based". Defying Western science's understanding of the realities of life and death, the zombie was - for Seabrook at least - a powerful symbol of a world turned upside down. If the zombie was more than just a legend, then perhaps death might not be the end after all. One can understand why Seabrook described his first response as "a sickening almost

> Also shall be qualified as attempted murder the employment which may be made against any person of substances which, without causing actual death, produce a lethargic coma more or less prolonged. If, after the administering of such substances, the person had been buried, the act shall be considered murder no matter what result follows.[16]

"No matter *what result* follows". Even - Seabrook guessed - if the body of the alleged murder victim was later found harvesting sugar cane crops in a distant plantation.

It wouldn't be until the 1980s that such suspicions would be fully investigated by Western scientists (something discussed in chapter seven). Perhaps if the riddle of the living dead had been solved sooner, the zombie would never have taken root in the imagination of the Western world. Without offering a full and proper explanation of the mystery surrounding the living dead, Seabrook's *The Magic Island* unleashed the *corps cadavres* on an audience that was all too eager to believe that the dead could really walk.

III. The Zombie in the West

On its publication in America in 1929, *The Magic Island* was warmly received, quickly becoming the best-selling travel book of the year. It was instantly hailed by the critics with the *New York Evening Post* calling it "the most thrilling book of exploration that we have ever read".[17] It once again proved Seabrook's knack for writing popular and accessible travelogues that combined personal recollections with amateur anthropology. Much of the book's success was the result of fortuitous timing. It hit the shelves just as the American public's interest in Haiti reached a considerable peak. In order to understand the reasons why Haiti, Seabrook and, ultimately, the zombie had such an impact on American popular culture, it's necessary to outline the history of America's fraught involvement with the Caribbean island itself.

By the early 1800s, Haiti had forcibly freed itself from the yoke of French colonial rule and become an independent state. The island's chequered colonial past and its unusual independent status gave it a powerful hold over the imagination of the white world. As Seabrook explained in his introduction to *The Magic Island*, Haiti shared many histories, from the "wrecked mansions of sixteenth-century French colonials who had imported slaves from Africa and made Haiti the richest colony in the Western Hemisphere," to the scenes of the "white massacres when the blacks rose with fire and sword."[18] But the greatest lure of all, for both the author and his readership, was the natives' inherent savagery: "Only the jungle mountains remained, dark and mysterious; and, from their slopes came presently far out across the water the steady boom of Voodoo drums."[19]

After a series of bloody slave revolts led by François Dominique Toussaint Louverture and Jean-Jacques Dessalines at the end of the eighteenth-century, Haiti became the second black nation in the Western hemisphere to gain independence from its white rulers. The slaves successfully fought off a 40,000 strong invasion force dispatched by Napoleon Bonaparte to retake the island and formally declared their independence in 1804. As Dessalines's angry inaugural speech proved, it was a hard won victory that none of the former slaves were likely to forget: "We will write this Act of Independence using a white man's skull as an inkwell, his skin as parchment and a bayonet as a pen".[20]

Victory came at a price, though. The country was left in ruins, the economy was on the verge of bankruptcy and, as the following decades would painfully prove, the revolutionaries had little idea of how to run the island. Having thrown off its colonial oppressors, this "Black Republic" was effectively

isolated by the international community, particularly by those states that had vested interests in the Caribbean. Fearing that Haiti might set an example that other colonies would eagerly follow, the European powers did their best to hamper the new black nation's development.

By the end of the nineteenth-century, the situation had progressed from bad to worse. The island began to feel pressurised by America's growing interest in securing its Caribbean "backyard" in order to keep careful control of the Panama Canal. After the Spanish-American war of 1898, in which US-funded Cuban revolutionaries led an uprising against Spanish rule, America's presence in the Caribbean grew exponentially with at least thirty military interventions in the region from 1900 to 1930.

As the internal stability of Haiti worsened, with seven different regimes rising and quickly falling during the years from 1908 to 1915, America's interest in the island's internal politics grew increasingly ominous. Spurred on by concerns about maintaining stability in the region - and using the fact that Haiti had defaulted on a $21 million debt it owed America's banks as a none-too-subtle pretext - US military intervention became a foregone conclusion.

In July 1915, America became directly involved in the island's affairs when Admiral Caperton of the gunboat *U.S.S. Washington* arrived in the harbour of Port-au-Prince. Already aware of the wave of domestic unrest that was plaguing the newly instated government of President Guillaume Sam, the United States had sent the *Washington* to observe the situation. As Admiral Caperton would later testify to a Senate inquiry into the reasons for the gunboat's intervention, the crew of the *Washington* "observed" more than they'd bargained for:

> I was about a mile off and I saw much confusion, people in the streets, and apparently there was a procession, as if they were dragging something through the city, and I afterwards found out, from officers whom I sent ashore that this was the body of President Guillaume Sam, which had been mutilated, the arms cut off, the head cut off, and stuck on poles, and the torso drawn with ropes through the city.[21]

Under the guise of protecting American and European interests on the island, Admiral Caperton ordered a Marine taskforce ashore to secure Port-au-Prince and then sent an anxious cable to Washington requesting reinforcements. It was an action that would drastically alter American foreign policy in the region. In previous years, America's intervention in Haiti's turbulent politics had been restricted to diplomatic wrangling, but as the first Marines landed on the island two decades of American military occupation began.[22]

Officially the American intervention was supposed to be limited to protecting American, British and French holdings on the island as well as, in the words of ex-Secretary of State Robert Lansing, "terminat[ing] the appalling conditions prevalent in Haiti for decades".[23] However, there were other - less altruistic - reasons for America's interest in the island's affairs. In Washington, the predominant concern was that a foreign power might take advantage of the political unrest in Haiti and intervene with a military taskforce. To prevent a nation like Germany from turning Haiti into a military base strategically placed on the United States' doorstep, President Wilson committed additional troops to Caperton's taskforce in an attempt to quell the rebels and restore order.

For ordinary Haitians, the American occupation was not only an insult to their country's sovereignty but also an attack on their individual freedom. The American-Haitian treaty, signed shortly after the Marines took control of Port-au-Prince, promised to improve the island's basic amenities such as sanitation, roads and schooling. In reality, these philanthropic aims were thwarted by the suspicious relationship that existed between the two nations. Outbreaks of revolutionary violence and banditry throughout 1918-1919 reminded the occupying forces that their presence was far from welcome, while American attempts to improve the island's infrastructure relied on forced labour policies which antagonised local Haitians. Ruthlessly upheld by the local police, such infringements of the islanders' civil liberties led many press-ganged Haitians to wonder if the arrival of the Americans was really nothing more than a return to the days of colonial rule.

From the moment the first American troops landed, tensions ran high. As reports of atrocities carried out by American Marines began to circulate, popular opinion on the island began to turn against the occupation. The all-white Marine taskforce had little time for the natives or the Caribbean. As one American Marine put it:

> It hurt. It stunk. Fairyland had turned into a pigsty. More than that we were not welcome. We could feel it as distinctly as we could smell the rot along the gutters… In the streets were piles of evil-smelling offal. The stench hung over everything. Piles of mango seeds were heaped in the middle of the highway, sour smelling. It was not merely that these, mingled with banana peels and other garbage, were rotting - the whole prospect was filthy.[24]

The troops' hatred of the islanders extended to Haiti's light-skinned, racially-mixed elite despite the fact that they were generally better educated than their black brothers: "No matter how much veneer and polish a Haitian may have," wrote one American officer, "he is absolutely savage under the skin and under strain reverts to type."[25] It was an explicitly racist attitude that bred only fear and resentment among Haiti's social and political leaders. "The Americans have taught us many things," explained Ernest Chauvet, owner of the island's *Le Nouvelliste* newspaper, to Seabrook. "Among other things they have taught us is that we are niggers. You see, we really didn't know that before. We thought we were Negroes".[26]

As long as the occupation continued, the tension between the islanders and the Americans increased. The streets of Port-au-Prince were awash with drunken off-duty soldiers; prostitutes began to openly ply their trade; saloons and dance halls sprang up everywhere; the Americans began to introduce Jim Crow laws, making provisions for segregated residential areas, hotels and even Catholic masses. "In as many ways as they could manage, the Americans were remaking Haiti in their own image," explains historian Elizabeth Abbott.[27]

Published at the height of America's involvement in Haiti, Seabrook's book tapped into the American public's thirst for information about the exotic island that had unexpectedly fallen under their control. "To Americans in particular, Haiti was like having a little bit of Africa next door," says Wade Davis. "Something dark, and

foreboding, sensual and terribly naughty."*28* And it wasn't just Seabrook who set the cash-tills ringing. After the success of *The Magic Island*, publishers began falling over themselves to commission increasingly lurid accounts of the island's voodoo culture.

Although *The Magic Island* was relatively restrained in its sensationalism, other books were less so. The titles of John Huston Craige's books *Black Bagdad: The Arabian Nights Adventures of a Marine Captain in Haiti* (sic, 1933) and *Cannibal Cousins* (1934) tell their own story about the racial prejudice underpinning such projects. As well as books, several films also followed: *Voodoo Land* (1932), a short about Haitian superstition and *Voodo* (sic, 1933) a documentary about a Marine sergeant who claimed to have spent three years as a local native king.

This interest in Haiti's exotic voodoo rites - and the allegations of cannibalism and savagery that accompanied it - was more than just a sensational marketing ploy. It was also a rather crude attempt to attempt to justify the American occupation of the island since, as Davis reflects, "any country where such abominations took place could find its salvation only through military occupation".*29* Sensationalism and propaganda went hand in hand. The zombie played an important role in this, since it was a monster whose alleged existence could be cited as proof of Haitian savagery, occultism and perhaps even Satanism.

The first sign of Seabrook's influence and the zombie's arrival in American popular culture was to be found in 1930s horror fiction. Before *The Magic Island*, the zombie had never appeared in any literary works in either Europe or America, for while tales of the dead returning to life were not unheard of (Edgar Allan Poe's stories gave enough examples of this alone), the Caribbean zombie - the dead body that doesn't simply return to "life", but is reanimated into living death - was something altogether new and different.

By the early 1930s, the situation had radically altered as the success of *The Magic Island* turned the zombie into a recognisable horror monster. Henry S. Whitehead, Archdeacon to the Virgin Islands from 1921 to 1929, was one of the first writers to tackle the subject of the zombie in his short story, "Jumbee" (1930) about undead goings on in St. Croix. The following year, Garnett Weston published "Salt Is Not for Slaves" in the August issue of *Ghost Stories* magazine (under the pseudonym G.W. Hutter). More short stories followed, including August Derleth's "The House in the Magnolias," in the July issue of *Strange Tales* magazine in 1932. Derleth, who would later become a pivotal figure in the history of horror publishing after founding the legendary Arkham House, was sufficiently in touch with the shifts in the contemporary horror scene to realise that the zombie was ready to leave its Caribbean homeland. Setting his story in New Orleans, he brought the walking dead firmly onto American soil, highlighting the close cultural ties between the Caribbean and the voodoo superstitions to be found among the black population in the American South.

The growing popularity of the zombie was enough to suggest that its cultural usefulness extended beyond the crude propaganda of the occupation. This ancient symbol of Haitian fears about slavery, work and the resurrection of the body after death had clearly tapped into some deep-seated American anxiety. The military occupation of Haiti and Seabrook's voodoo research brought the living dead into American culture in the guise of popular travelogues and pulp fiction horror stories. Yet it would be a very different medium that would firmly ensconce the zombie in the West. As the craze for stories about Haiti and voodoo superstitions reached a crescendo, it was Hollywood - the nation's dream factory - that turned the zombie into an American nightmare.

The illustration above, along with those on pages 14 and 15, are from the original edition of William Seabrook's **The Magic Island**. Alexander King's line drawings perfectly capture the mystery and atmosphere of Haitian voodoo.

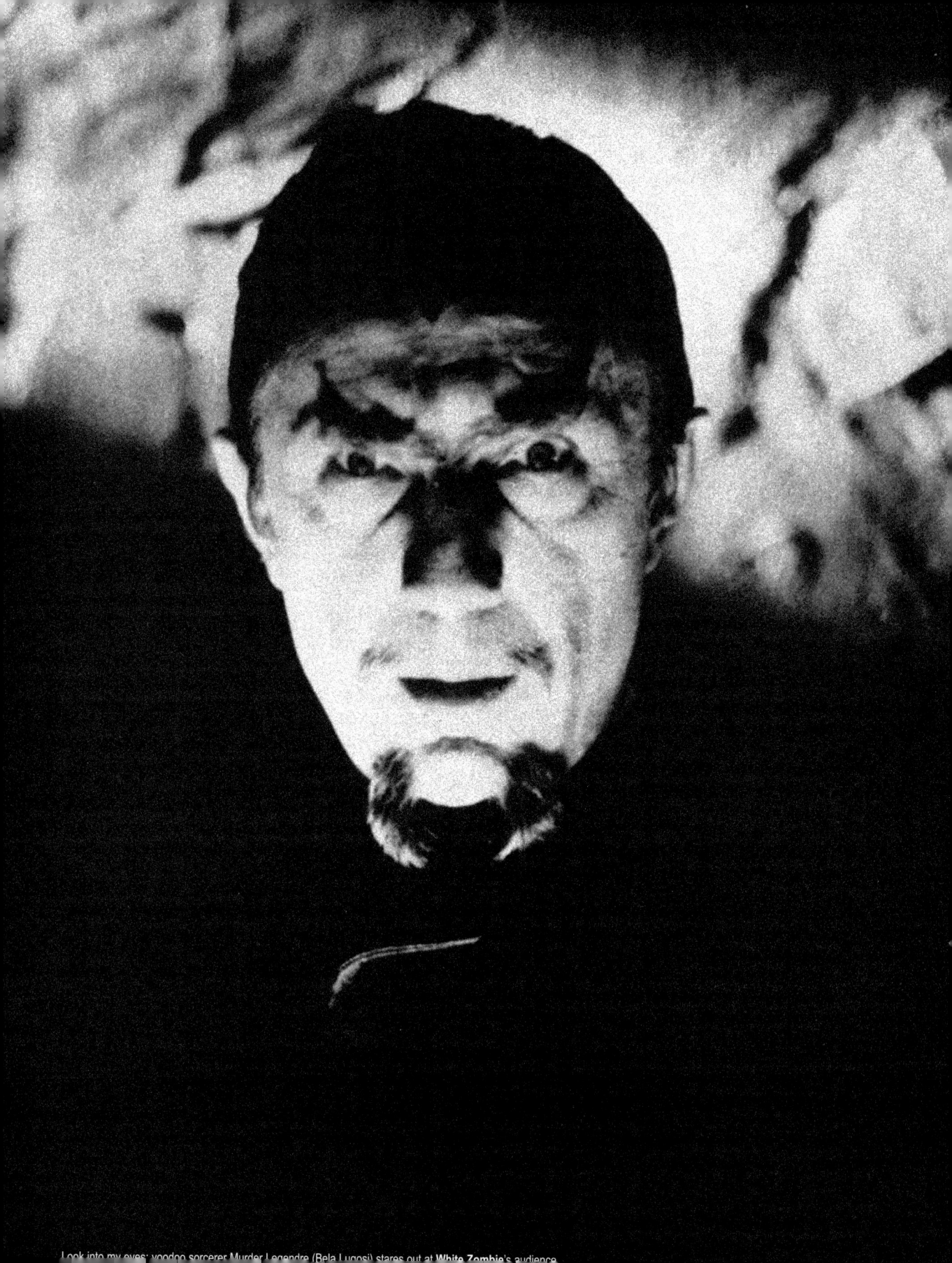

Look into my eyes: voodoo sorcerer Murder Legendre (Bela Lugosi) stares out at *White Zombie*'s audience.

chapter two

The Zombie Goes to Hollywood

I. Horror Hits the Stage

From the well-trodden boards of The Strand to the bright lights of Broadway, horror dominated the theatre stage on both sides of the Atlantic in the 1920s. The trend began in earnest in the aftermath of the First World War with productions like *The Bat* (1920), *The Monster* (1920) and the hugely influential *The Cat and the Canary* (1922), before reaching its apotheosis in Horace Liveright's box office juggernaut *Dracula* (1927). Liveright's stage production - with its staggering $2 million gross - proved what canny theatre producers had known for several years: the public had an insatiable appetite for chills, thrills and buckets of blood.

Whether this horror lust was simply a passing fad or some cultural pressure valve releasing the pent up anxieties of the war and its aftermath - the on-stage death and destruction safely repackaging the all-too-real horrors of the European trenches in a manageable form - wasn't certain. But it didn't pass unnoticed that in Weimar Germany, the war-scarred nation's home-grown cinema had begun to harness the still-new medium of film to produce some terrifying visions: *Das Cabinet des Dr. Caligari* (*The Cabinet of Dr. Caligari*, 1919), *Der Golem, Wie er in die Welt Kam* (*The Golem*, 1920) and *Nosferatu - eine Symphonie des Grauens* (*Nosferatu*, 1922).

The success of Liveright's *Dracula* play and the popularity of German horror films in American cinemas encouraged a new generation of movie producers to try and cash in on the horror trend with their own frightfests. In films like *The Phantom of the Opera* (1925) and *London After Midnight* (1927), Hollywood studios began to toy with the idea of making pictures that would utterly terrify their audiences. As the decade closed, two film properties emerged that would set the standard for American horror: Tod Browning's *Dracula* (1931) and James Whale's *Frankenstein* (1931).

It was into this world that Seabrook's *The Magic Island* was released. The author would no doubt have seen little relation between his voodoo research and the horror stage-plays, but America's entertainment industry was far more imaginative in recognising the potential of his work. By the time *Dracula* and *Frankenstein* had been produced in both the theatre and the cinema, the amount of sure-fire material available to scriptwriters was rapidly dwindling and it was clear that, in order to capitalise on the trend for horror pictures, some new property was needed.

Given such circumstances the announcement of *Zombie*, a new stage production for 1932, probably shouldn't have been surprising. For Kenneth Webb, a theatre writer and producer, the zombie was everything he needed. Not only was it a fresh concept that would scare jaded audiences, but it also didn't require lengthy copyright negotiations. Liveright had been forced to barter with the Stoker estate for several years to secure permission for his stage production of *Dracula*, but Webb gleefully realised that he could filch Seabrook's zombie chapter and dramatise it without paying a single cent since it was reputedly based on fact.

Webb, whose previous experience as a playwright included such throwaway productions as *One of the Family* (1925) and the revue *Who Cares?* (1930), kept the concept as simple and accessible as possible with a three-act story about a pair of American plantation owners, Jack and Sylvia Clayton, and their adventures on Haiti. After Jack dies from a mysterious illness the plantation's Haitian overseer, Pedro, reanimates his corpse in a cunning attempt to take control of the estate. Confronted by this walking corpse Sylvia enlists the help of two brainiac Americans - Dr. Paul Thurlow and Professor Wallace - to solve the mystery surrounding his death.

Despite its novelty value, *Zombie* was a pretty meagre production. With all three acts set in "The Living Room of a Bungalow in the Mountains of Haiti" and some supporting roles for a couple of "Haitian Labourers" (played first by white actors in blackface and then, in an attempt to gain some extra publicity, a pair of Haitian immigrants) it was obvious that this was one horror play that lacked the necessary fright factor. Although Jack ended up - in the words of one reviewer - "stalking about the place and scaring the daylights out of everybody" and a later scene cooked up a whole army of living dead extras, *Zombie* didn't come close to replicating the success of Liveright's *Dracula*.[30] Not even the surprise ending in which the real zombie master turns out to be Professor Wallace could make up for the play's dreary lack of imagination and faintly ludicrous feel.

Unsurprisingly, this self-proclaimed "Play of the Tropics" received generally poor notices. The suspicion among most reviewers was that it was more likely to elicit hilarity rather than horror and the press gleefully recounted reports of audiences sniggering in the aisles. The *Herald Tribune*'s scathing review was indicative of the disdainful reaction: "Happily, Mr. Webb hasn't even the skill to make himself be taken seriously by ingenuous judges of book-of-the-month-clubs."[31]

Opening in New York's Biltmore theatre on the 10th of February 1932, *Zombie* closed after just twenty performances. Webb relocated to Chicago, opening the play at the Adelphi Theatre on the 13th of March 1932. It remained there for two months, moved to a couple of smaller theatres in the city, then suddenly closed for good.

However disastrous this production was, *Zombie* secured a place in the history books by helping to pave the way for the film that would make the living dead truly famous, Victor and Edward Halperin's *White Zombie* (1932). Intrigued by Webb's stage-play - and fully aware that its failure owed more to the playwright's lack of dramatic flair than the public's distaste for tales of the walking dead - the Halperins decided there might well be money to be made from bringing the dead back to life.

II. Cultural Anxieties: Haiti, the Depression and Race

Publication of *The Magic Island* may have brought the walking dead into American popular culture, but its impact was rather limited. For those who hadn't read Seabrook's book or seen Webb's short-lived play the zombie was still *persona non grata*. Dracula, Frankenstein, the Hunchback of Notre Dame and the double act of Jekyll and Hyde had a cultural cachet that meant they were instantly recognisable to millions of cinemagoers, but the zombie was something of a cultural upstart, an interloper from the Caribbean that no one really knew anything about.

When Kenneth Webb realised that *Zombie* wasn't going to be the runaway stage hit he'd hoped for, the news that Hollywood might be interested in putting the walking dead into the movies seemed like a godsend. In reality, the beleaguered theatre producer had little to be excited about. Since the zombie wasn't under copyright to either Seabrook or Webb, no one in Hollywood was about to pay either man for the privilege of using the monster in a film. As a result, Webb's stage-play didn't generate much interest in Tinsel Town other than as a jumping off point for a movie treatment. He gradually came to the bitter realisation that Hollywood was interested in zombies, not *Zombie*.

Director and producer team Victor and Edward Halperin had already decided as much by the time they commissioned scriptwriter Garnett Weston to write a treatment for what would become the zombie's big screen debut. Weston was the perfect choice. The author of one of the first Seabrook-influenced short stories about the living dead, "Salt Is Not for Slaves", he fully understood what made the walking dead tick and quickly bashed out a script for his new employers.

For Webb, the disappointment of being passed over by Hollywood proved too much to bear. Already despondent at his play's unfortunate run, he vented his anger by taking the Halperins to court for breach of copyright. It was a move that had little hope of success and the judge quickly realised that the legal suit was simply a case of sour grapes. Webb's claims were thrown out and the court ruled that the film couldn't constitute unfair competition since the play had already closed. More importantly, the zombie wasn't an original concept and so Webb's rights couldn't have been infringed.

The Halperins took such incidents in their stride. As an independent production put together without the clout or protection of a big name studio, *White Zombie* was always destined to be a risky venture, which was why the brothers decided to try and find a recognisable star to ensure some degree of box office return on their investment. Fortunately, they were in luck. Bela Lugosi, straight from the set of *Dracula*, agreed to take the role of zombie master Murder Legendre. Best of all, Lugosi wasn't just interested, he was desperate for the part - although, in truth, it was an enthusiasm that had more to do with his precarious financial situation than his love of the material.

Despite his considerable talent, Lugosi was down on his luck by the time the Halperins approached him in 1932. The Hungarian-born actor had arrived in New York in 1920 when he was 46 years old. He'd taken a series of forgettable dramatic parts before landing the title role in Horace Liveright's *Dracula* stage-play in 1927. It should have been his breakthrough performance, and in many ways it was, but it didn't do much to rescue his ailing finances. While Liveright raked in the dollars, Lugosi found that his slice of the box office takings were considerably less than the star of a smash hit stage production might have hoped. The contract had been weighted against him and in his rush to sign he hadn't negotiated a particularly good deal.

When Universal began to cast their cinematic production of the same story, Lugosi was convinced that his problems were finally over. The Count was, after all, a role he'd made his own. Who else would be able to portray the Transylvanian aristocrat better than himself? Universal weren't convinced, though. Decidedly lukewarm about hiring this Hungarian thespian, they invited him in for an audition and were pleasantly surprised. In the negotiations that ensued, the actor badly tipped his hand, letting Universal see just how desperate he was for the part. Safe in the knowledge that his back was against the wall, they hired him for $500 a week for seven weeks' work.

After *Dracula* set the box office alight, Universal began to wonder if Lugosi's mesmerising acting style and inimitable Hungarian accent might be the traits of a new star player. Deciding to groom him into the new Lon Chaney, the studio offered Lugosi a role in the upcoming film adaptation of Mary Shelley's novel *Frankenstein*. First he was asked to play the eponymous mad scientist and then, in keeping with Chaney's reputation as the

the zombie goes to hollywood

man of a thousand faces, the role of the monster itself. Lugosi got as far as having the test make-up applied before declining the part, famously claiming: "I'm an actor, not a scarecrow!" It was a disastrous decision. In his place, Universal hired a young unknown British actor named Boris Karloff to play the monster. The rest is horror movie history.

When the Halperins approached Lugosi, he was ready to accept whatever acting work he could find. *White Zombie* didn't do much to improve his contract rates. The Halperins hired him for around $800 a week for just 11 days work. It might have been a step up from his *Dracula* salary, but Lugosi obviously hadn't learnt from his earlier mistakes. He was taken to the Beverly Hills cleaners once again as *White Zombie* grossed an unexpected $8 million at the box office. It was a staggering amount for an independently produced movie - with an original budget of just $62,500 - to recoup.

Regardless of this terrible salary, Lugosi was definitely the star of the picture. None of the other actors, with the possible exception of the heroine Madge Bellamy, were well-known performers. Bellamy had been a successful actress back in the silent era, but she had been struggling to reassert herself in the brave new world of the "talkies" (and judging by her childlike voice, it was obvious why). *White Zombie* helped keep her career alive for a few more years - perhaps because her role was largely a non-speaking one - until she was arrested for shooting her two-timing millionaire boyfriend in 1943. Christened "Pistol Packing Madge" by the papers, who were eager to play up this tale of violence and pre-marital sex, it proved to be her last great role. She put a brave face on the whole story, later claiming: "I only winged him, which was all I meant to do. Believe me, I'm a crack shot."[32] In retrospect, it seems significant that this fiery young woman would be cinema's first victim of zombification.

Taking *The Magic Island* as its starting point, Weston's screenplay for *White Zombie* was a cleverly packaged piece of sensationalism, sex and the living dead. It begins with a scene set at a dark Haitian crossroads that could have been lifted straight out of Seabrook. An American couple, Neil (John Harron) and Madeleine (Bellamy), arrive in a horse-drawn carriage and discover a voodoo ceremony in full sway. Asking their black driver to explain what's happening, the terrified couple learn that they're witnessing a special burial designed to deter those "who steal dead bodies".

A little further down the track, the Americans receive their second fright of the evening as the driver pulls up to ask directions from a caped figure standing by the roadside. Ignoring the driver's questions, the ominous stranger stares at Madeleine, seemingly transfixed by her. Suddenly, the driver spies several figures shuffling down the hillside towards them. "Zombies!" he cries, whipping the horses onwards in a terrified frenzy. As the carriage plunges forwards, the stranger clutches Madeleine's scarf, almost strangling her until she frees it from around her neck.

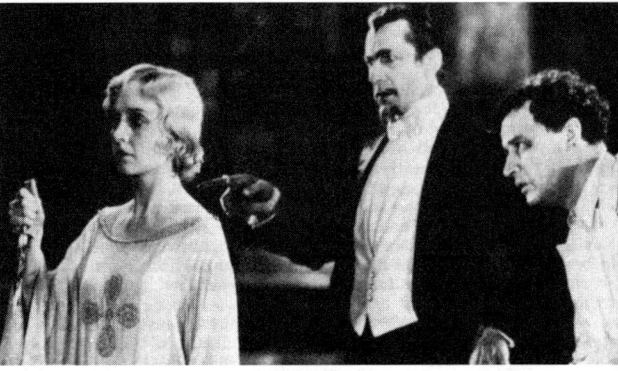

"He brought her back to life... and made her his slave."
Legendre (Lugosi) commands the zombified Madeleine (Madge Bellamy) as Beaumont (Robert Frazer) looks on in **White Zombie**.

After this creepy opening, things spiral out of control. Neil and Madeleine discover that their Haitian benefactor, a fellow American named Beaumont (Robert Frazer), is not as altruistic as he appears. Desperately in love with Madeleine, Beaumont is determined to have her for himself and when she refuses his advances, he hires the help of Murder Legendre (Lugosi), the man from the crossroads. A European plantation owner who has discovered the secrets of voodoo, Legendre is employed to zombify Madeleine on her wedding night.

At Neil and Madeleine's wedding, Beaumont's plan goes into action. Armed with a secret potion from Legendre, Beaumont poisons the new bride. Later that night, Legendre and his zombies steal her body from the crypt and spirit her away to the sorcerer's cliff-top retreat (known locally as "The Land of the Living Dead") where she's reanimated as a zombie. But Beaumont quickly becomes bored with how unresponsive his zombie bride is and tries to convince Legendre to return her to normal. Already peeved by Beaumont's snobbish attitude towards him, Legendre spikes his employer's drink with poison and terminates their business agreement once and for all.

His victory is short-lived, though, as Neil and a local Christian missionary named Dr. Bruner (Joseph Cawthorn) storm his castle to do battle with his zombie slaves. In the ensuing fight, Legendre orders Madeleine to kill her husband, but she resists his command and tries to throw herself off the cliffs instead. After battling the zombies - who prove impervious to bullets - the heroes manage to save the day. Dr. Bruner knocks Legendre unconscious, severing his control over the zombies, who careen off the cliff-top like lemmings. Then, as Legendre comes round, Beaumont staggers out of the castle. He grapples with his poisoner and the two men fall over the precipice onto the rocks below. Neil and Dr. Bruner tend to Madeleine who, it transpires, was only drugged and never actually dead.

Sex and (living) death in **White Zombie**.

For most cinemagoers in 1932, this shocking story of love and necrophilia was their first encounter with the living dead. Taking the bare bones of Seabrook's research - the Haitian setting, the sugar cane fields and voodoo trappings - as its starting point, Weston's screenplay ushered the zombie into cinema history. It didn't matter that the critics hated the film; audiences loved the dark and moody setting, Lugosi's voodoo sorcerer and, of course, the zombies.[33]

Keenly aware that few cinemagoers had read *The Magic Island*, the publicity department at distributors United Artists blitzed America with an aggressive marketing campaign. Not only did they play up the veracity of the events depicted in the film - "The story of *White Zombie* is based upon personal observation in Haiti by American writers and research workers and, fantastic as it sounds, its entire substance is based on fact"[34] - but they also arranged a sensational series of promotional events. By the time the film opened on 29 July 1932, the living dead had finally arrived as a twentieth-century monster. The following extract from *The 1933 Film Daily Year Book of Motion Pictures* gives some idea of the scale of the film's PR campaign:

> When *White Zombie* was ushered into the Rivoli Theater in New York, all Broadway was startled by the sudden appearance of nine zombies on a boardwalk erected above the marquee of the theatre. Thousands packed the sidewalks and gasped with amazement as the nine figures, faithfully garbed and made-up to simulate actual members of the *White Zombie* cast, went through a series of thrilling dramatic sequences [...] The doll-like figures of the girls were dressed in white flowing robes and the men looked as if they had been dug up from the ground with wooden splints on their legs and battered facial expressions [...] crowds gathered all day, lured there not only by the drama enacted above the theater but by the *White Zombie* sound effects records which included the screeching of vultures, the grinding of the sugar mill and the beating of the tom toms and other nerve wracking sounds.[35]

The monsters of *White Zombie* truly deserved the name walking dead. Madeleine may have been simply drugged into zombification but the rest of the ghouls were the real deal: ghastly corpses reanimated without souls. With make-up by Carl Axcelle and Jack Pierce from Universal (the latter had been responsible for transforming Boris Karloff into Frankenstein's monster the previous year), the zombies were memorable creations. Shuffling slowly but purposefully through the shadowed scenery, they even managed to survive being upstaged by Lugosi's hammy villain. But what really ensured their success was the way in which they tapped into fears that resonated well beyond the walls of the movie theatres.

The American horror boom of the 1930s was, as so many film historians have pointed out, intimately tied to the economic bust of 29 October 1929 when the Wall Street crash wiped millions of dollars off US share prices in the space of just a few hours. If the international effects of the dollar's sudden collapse were spectacular, the domestic upheaval it produced was devastating. Millions of ordinary Americans found themselves unemployed and queuing in the breadlines as their savings and investments were wiped out overnight. The Roaring Twenties had roared themselves hoarse and the economic hangover that followed would bring nothing but misery and destitution.

Drawing a link between the economic downturn and the sudden dominance of horror pictures hardly requires a great leap of the imagination. By 1929 horror was on the nation's streets as well as its screens. As the *Washington Post*'s critic Nelson B. Bell presciently noted in February 1932, just five months before *White Zombie* took the country by storm:

Many are without employment, many are employed only by virtue of having accepted drastic curtailment of income, many lead their lives in a state of constant dread of the disaster that may overtake them at any minute. This is a state of mind that creates a vast receptivity for misfortunes more poignant than our own... The end of horror pictures is not yet.[36]

That the zombie should burst into American popular culture at this moment hardly seems surprising. In Haiti, the zombie had encapsulated fears of enslavement and the terrifying loss of individual freedom that the slave trade had imposed on generations of displaced Africans. In 1930s America, the zombie and the stock market crash segued neatly together, expressing the powerlessness that so many felt as they suffered under an unstable economy that reduced princes to paupers, bank managers to bums and whole families to beggars. The zombie - a dead worker resurrected as a slave into a hellish afterlife of endless toil - was the perfect monster for the age.

White Zombie capitalised on exactly this, its vision of a living dead workforce neatly tapping into the American public's fears. The scene in Legendre's sugar mill, where all the workers are mindless zombies, must have seemed like a startlingly grim vision of hell and an ironic inversion of every American's hopes of employment through the Depression. At a time when the greatest fear was losing one's job - unemployment had reached almost 25% - here was a film that transformed work itself into horror.

The zombies who operate the sugar mill are human beings who have become expendable automatons. Even when one of their number plummets into the mill they continue working, crunching his body in the machinery (one can only imagine the impact that the startling sound of his death must have had on audiences who were still getting used to the aural effects of the "talkies"). It's a pivotal moment that highlights the film's wider resonance: for Americans who had seen the crushing forces of capitalism at work, the scene must have seemed particularly poignant. "They work faithfully and they're not afraid of long hours," Legendre says menacingly, offering Beaumont some worker zombies for his own plantation. Here was the dark side of capitalist economics - which so many had seen from the breadline - laid bare.

From this perspective, it's easy to see why *White Zombie* became such a commercial success. The zombie's arrival was perfectly timed. It wasn't just Madge Bellamy who had to suffer the indignity of being zombified. Everyone faced the awful possibility of joining the shuffling, blank-faced down-and-outs waiting in line for bread and soup, an economic zombification of terrifying proportions. "Millions already knew they were no longer in control of their lives; the economic strings

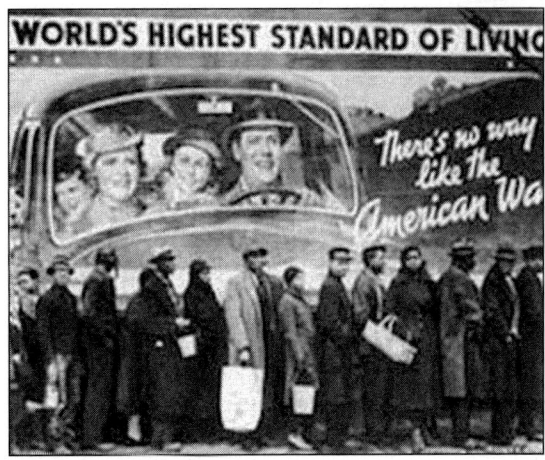

The misery of the breadline.

were being pulled by faceless, frightening forces," explains film historian David J. Skal. "If the force had a face, it was likely to be that of zombie-master Bela Lugosi, commanding you mesmerically."[37]

Whether or not the Halperins were aware of the film's intimate relation to America's economic collapse isn't certain. They were clearly savvy enough to recognise the movie's other appeals, though. "A weird love story, the strangest in 2,000 years. A zombie bride whose soul and heart were dead, performing every wish of he who had her by his magic," exclaimed the lurid lobby posters. As if such necrophiliac sensationalism wasn't enough to get the punters through the door, other posters had Lugosi's eyes focussing on a nude woman with the tagline "He brought her back to life... and made her his slave". The hints of morbid sexual perversity in both the publicity material and the movie itself are quite blatant, suggesting that at least one of the film's pleasures lay in the way its erotically charged script played with the taboos surrounding sex and death.

Trapped between her husband, her kidnapper and the zombie master who controls her, Madeleine is compromised three times over. As Weston's screenplay turns her into the stereotypical male fantasy - a completely compliant and subservient woman - *White Zombie* addresses some very contemporary fears about women's independence, fears that were surfacing in a wide range of 1930s films, from *Svengali* (1931) to *Mad Love* (1935) and even *Bride of Frankenstein* (1935). In each of these films, heroines find their autonomy compromised by evil male villains. The answer to *White Zombie*'s tagline - "What does a man want in a woman, is it her body or her soul?" - was readily apparent in Legendre's wanton willingness to keep Madeleine zombified and take his pleasure. Unlike Beaumont - who loses his nerve too soon crying, "I thought that beauty alone would satisfy me. But the soul is gone. I can't bear

those empty staring eyes" - Legendre is far beyond such worries. As Lugosi's magnificently evil smirk testifies, he's the kind of man who doesn't need the object of his affections to be anything more than that, an object.

It's no accident that the dreamlike quality of *White Zombie*'s evocative cinematography and its long stretches of eerie silence are punctuated by what is probably the film's most famous image, the close-up of Lugosi's eyes. Zombification - whether it's turning men into slaves or women into sex objects - is closely linked with themes of powerlessness and the loss of personal autonomy. Lugosi's eyes, first seen hovering above the road like doom-laden twin moons, are not only a symbol of Legendre's voodoo power, but also his ability to bend others to his will. When Lugosi stares straight into the camera lens - breaking the first rule of cinematic realism which states that the actors must never acknowledge the camera's existence - Legendre's gaze suggests that he even has the power to hypnotise the audience itself. At one point, shortly after Madeleine's "death", he emphasises his power over the filmic medium by walking straight towards us as if he were about to come out of the screen. The result is spectacularly unsettling. We are transformed from passive spectators into potential victims as the security of the darkened auditorium is threatened by his looming figure. In a film that bases its horror on the collapse of boundaries (specifically those between life and death, work and slavery), this tampering with the cinema's own boundary line is extremely effective.

As a comment on America's relationship with Haiti, *White Zombie* is equally intriguing. By the time of the film's release in 1932, the occupation of the island was entering its final stages but the American public's interest in the island was at its height. Popular books about Haiti's heady mix of exoticism and the supernatural were joined by a sudden rash of Hollywood films which took voodoo as their starting point: *Drums O' Voodoo* (1934), *Chloe: Love Is Calling You* (1934), *Ouanga* (1934) and *The Devil's Daughter* (1939). Without Seabrook's research or the box office success of *White Zombie*, it's unlikely that any of these pictures would have ever seen the light of day.

On the most basic level, the story of a white American woman kidnapped by natives appealed to the popular belief that the Caribbean was ruled by primitive desires. By ignoring the reality of Haiti's former independence prior to the American occupation of 1915 to 1934, the film argues that the island's culture is only a few steps removed from outright savagery. When Neil suggests that they contact the local police about Madeleine's missing corpse, Dr. Bruner carefully spells out his lack of faith in the island's indigenous law enforcement: "Neil my boy, you don't know these islands. The native authorities are afraid to meddle." How much more strongly could the filmmakers have expressed their support for American intervention on an island where, as Bruner claims, "we may encounter sins that even the devil himself would be ashamed of"?

The American occupation of Haiti is never mentioned during the proceedings however, making it the film's silent subtext. While tracking down Madeleine, Bruner and Neil rely on their own resources

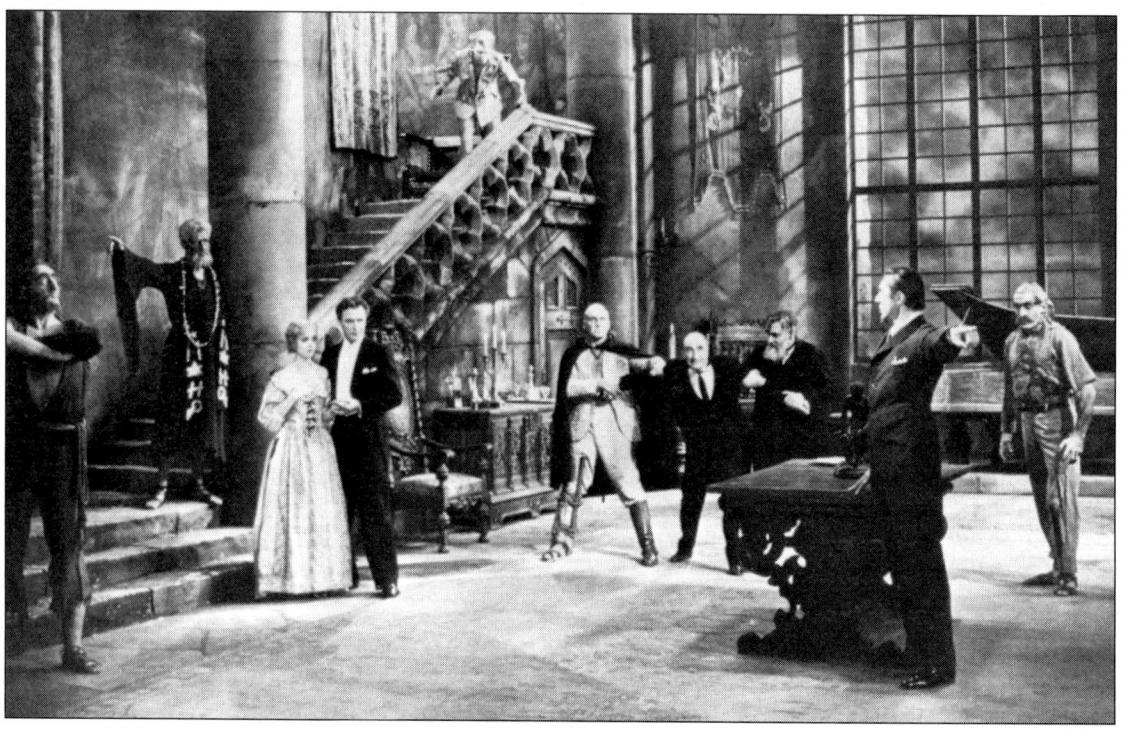

A full house at Murder Legendre's mansion in **White Zombie** as ghouls converge on Madeleine and Neil (Madge Bellamy and John Harron, both centre-left).

and there is no suggestion of enlisting the help of any American authorities. True enough, contemporary audiences wouldn't have needed to be told why an American boy like Neil was working in the Port-au-Prince bank - yet there's no denying the fact that the film is spectacularly coy about the realities of the American presence. Acknowledging the occupation would have prevented the filmmakers from presenting Haiti as an island in the grip of voodoo anarchy.

Neil is a fairly representative member of the various American clerks and personnel who travelled out to the island to oversee Haiti's bureaucratic and economic infrastructure and his view of the Caribbean is in keeping with America's imperialism; he describes the region to Madeleine as "*our* West Indies". In contrast, Beaumont is rather more complex. A flamboyant entrepreneur, the plantation owner may hold an American passport, but he's quite obviously a European at heart. His impressive mansion, expensive clothes and ostentatious manners mark him out as something of a dandy, as does his pusillanimous failure to see his scheme through to its dastardly conclusion.

What the interplay between Neil, Beaumont and Legendre sets up is a neat parallel of Haiti's contested status, with Madeleine standing in for the island itself as she's torn between these three men. Beaumont's European manners and apparent willingness to go native by enlisting voodoo to ensnare the object of his affections are clearly not meant to win our sympathy. Yet, it's Legendre himself who is the film's real European and hence its real villain. His licentious habits, evil smirk and slightly camp mannerisms signal that he's the most dangerous threat to both Madeleine *and* the stability of the island itself.

The film's plot revolves around a conflict over Madeleine/Haiti in which the American hero Neil, aligned with the forces of Christian moral rectitude (Dr. Bruner, the missionary), must fight off the dangerous solicitations of Beaumont and Legendre, the representatives of European colonialism that once dominated the Caribbean. Building on American fears that Haiti might fall back under European influence - the occupation had, after all, begun in response to fears that Germany might invade the island - *White Zombie* dramatises the conflict between America and Europe over Haiti's independent status.

But where do the zombies fit into all of this? It's no accident that the film's six main zombies comprise a cross-section of Haitian society. As the evil European, Legendre has zombified the island's key representatives. The scene in which he boasts about his conquest to Beaumont is wonderfully staged, with Lugosi capturing Legendre's self-congratulatory flamboyance with a characteristic flourish: "In their lifetimes, they were my enemies: Ledot, the witchdoctor, once my master; his secrets I tortured out of him. Von Gelder, the swine, swollen with riches. He fought against my spells right to the last; he even yet tries to struggle and fight. Ricard, once Minister of the Interior; Scalpiere, Brigand Chief; Marque; and this is Chauvin, the high executioner. He almost executed me. I took them, just as we will take this one [Madeleine]". Clearly disturbed by this carnival of lost souls, Beaumont asks what will happen if they ever regain their independence. Legendre's answer suggests both his own coming doom and American fears of releasing its grip over the Caribbean: "They will tear me to pieces".

Similarly, the scene in Legendre's sugar mill emphasises his association with Europe's colonial past. His zombie workers are segregated in exactly the same way as they would have been during the French rule of Haiti, with the Negroes performing the manual labour and the mulattoes acting as supervisors. If Legendre is supposed to represent the decadent Europeans who enslaved the Haitian population, then Neil is obviously a symbol of America's guardianship of the island (no wonder he's clad in a brilliant white suit). Teaming up with Bruner, Neil's heroic pursuit of Legendre promises to restore order to the island through the civilising influence of a combination of American might and Christian guidance. Bruner's desire to have "every witchdoctor in Haiti shaking in his sandals" makes this apparent enough. Civilising the natives - and eradicating the subversive influence of Europe - is a definite priority.

The American and British press books for the film played up this racial dimension in a series of startlingly crass ways. One suggestion was to "hire several negroes to sit in front of your theatre and beat a steady tattoo on tom-toms. Attire them in tropical garments and every once in while have them cut loose with a couple of blood-curdling yells."[38] Even more indicative of the racial tension that worked its way through the film was the following suggestion:

> Here's a ballyhoo that will actually bring pounds into your box office. Arrange for a parade of zombies through the main streets of your city, the men following a girl in white. The faces should be stolid, staring, gaping with empty eyes. They should walk with a mechanical, deathlike precision, looking neither to the left nor the right and not returning the gazes of the interested onlookers. The men to be dressed in sombre black. Their backs should bear cards reading "I'm a Zombie". Then in large letters on the back of the woman is imprinted "White Zombie" with emphasis on the word White. The girl to be dressed in flowing robes similar to the heroine in the picture [...] Tip off newspaper offices that "Black Magic" is being practised on the streets of your city.[39]

Three years after *White Zombie*, such racial themes resurfaced in George Terwilliger's *Ouanga* (1934), a lurid tale of Caribbean voodoo and zombies that's slipped into obscurity since its low-key release. Fredi Washington stars as Clelie, a mulatto plantation owner on the Haiti-esque Paradise Island who falls in love with her American neighbour Adam (Philip Brandon). Furious at being rebuffed by him, Clelie flies into a terrifying rage crying "Don't draw away from me as though I were a black wench in your fields!" Adam, though, is resolute; they can never be anything more than friends: "The barrier of blood that's between us can't be over come... You belong with your kind". Angry at Adam's brusque treatment and jealous of his obvious interest in New York party girl Eve (Marie Paxton), Clelie uses her voodoo powers to get even. She sends Eve a death charm - the ouanga of the title - then dispatches a pair of burly black zombies to abduct her rival when she falls into a coma.

Clelie intends to sacrifice Eve to the voodoo gods but is stopped by her black servant LeStrange (confusingly played by white actor Sheldon Leonard). Desperately in love with Clelie himself, LeStrange is convinced that her refusal to acknowledge his affection is simply a result of her confused racial identity. He's determined to make her see the error of her ways in pursuing a white man - "Your white skin doesn't change what's inside you! You're black! You belong to us. To me!" - but she loathes everything that he represents: "I hate you, you black scum!".

Exaggerating the sensational treatment of voodoo in *White Zombie*, *Ouanga* plays up the supposed savagery of the Caribbean. Styling the light-skinned Clelie as a black sorceress intent on breaking up the relationship between this white Adam and Eve, *Ouanga* presents its racially confused heroine as the satanic snake in the Caribbean paradise. Her desire for a white man is, the film argues, totally unacceptable.

As a reaction to America's imperialist adventures in the Caribbean, *Ouanga* is fascinating. Clelie not only represents white fears about miscegenation (her light skin allows her to "pass" in white society), but also about the state of Haiti itself. Imagining the island as a hotbed of native superstition, savagery and occultism, *Ouanga* suggests that the black population's belief that they can govern themselves is dangerously mistaken. The scenes of dozens of native extras entranced by the power of Clelie's voodoo ceremony and swaying in unison like brainwashed automatons makes the film's unsubtle subtext quite clear: Paradise Island/Haiti needs white American rule to bring it back from the brink of social, political and spiritual disaster.

Even the film's well-documented production history seems to have been cooked up to bolster exactly this assessment. Much was made of the run of bad luck that reportedly hampered the film. According to film historian Bryan Senn, the cast and crew suffered a series of accidents after an over-eager prop master decided to steal various voodoo paraphernalia from a market in Port-au-Prince. On the first day of the shoot, cast and crewmembers were attacked by a swarm of hornets. A few days later, a barracuda attacked a key-grip while he was standing in the surf; he died in hospital from massive blood loss. Then a make-up man succumbed to yellow fever and an assistant soundman broke his neck in a fall. Finally, actor Sheldon Leonard had the extremely painful experience of falling into a patch of barbed cactus quills that had to be cut, one by one, out of his backside. Regardless of whether they were true or false, such stories had an important role in bolstering American discourses about Haitian savagery and occultism.[40]

The transparent pro-American ideological politics of *Ouanga* and *White Zombie* did little to save these cheap outings from a critical mauling. The sarcastic review of *White Zombie* in the *New York Times* was typical of that film's dismissive notices:

> Necromancers waved their sinister hands from the screen of the Rivoli yesterday and tried to hypnotise blondes into killing their boy friends. A legion of individuals, with deceased minds but alert bodies, threw butlers into subterranean streams. Eagles screamed and vultures carried on a terrific caterwauling all around a mountainous castle. And half way through the picture that inspired all these things an actor wistfully remarked: "The whole thing has me confused; I just can't understand it." That was, as briefly as can be expressed, the legend for posterity of "White Zombie." Charity - still the greatest of the trilogy - suggests that the sentence be allowed to stand as comment. To go on would lead only to a description of why the eagle screamed, and that would prove very little, indeed, in the orderly scheme of life. There was, in short no great reason. Nor was there, to be candid, much reason for "White Zombie." The screen shuddering slightly can go on; it can forget, it can be a zombie, too [...]
>
> Of the cast, Bela Lugosi plays the chief part - that of the lad who has the power to turn corpses into automatons. Madge Bellamy is the blonde, John Harron the young man in the affair and Robert Frazer, a sort of semi-tropical villain. All the actors have strange lines to say, but appear to enjoy saying them. Those given to Mr. Harron seem, on retrospection, to be the most fantastic - if a superlative of any sort is allowable in a discussion of "White Zombie."
>
> "Not that," he says at one point. "Better death than that."
>
> Yes indeed, much better.[41]

Dead, but not for long: a funeral procession leads the sarcophagus of Professor Morlant (Boris Karloff) in **The Ghoul**.

Audiences didn't seem to care what the critics said. Although the torturous distribution history of *Ouanga* meant that most American cinemagoers didn't see the film until the 1940s, *White Zombie* became an instant box office success.[42] Whether it was Lugosi's central performance, the evocative cinematography, or the topical subtext that made *White Zombie* such an overnight sensation is difficult to say for certain. One thing is clear, though: the history books may show that the Americans occupied Haiti between 1915 and 1934, but in the year of 1932 the island's zombie-culture invaded the American imagination.

III. The Zombies Are Revolting

Although the success of *White Zombie* was undeniable, few of the major studios were interested in pursuing the living dead. Widely regarded as little more than a box office fluke, *White Zombie* didn't encourage any established filmmakers to turn their hand to movies about the walking corpses or the Caribbean. Most of the Hollywood establishment regarded the zombie as little more than a ragged upstart, a one-hit wonder that was vaguely downmarket. Unconvinced that there was money to be made from seeing the dead walk, the big studios turned their backs on the zombie and the monster's long-running association with low-budget, critically dismissed films began in earnest.

Since the zombie lacked a well-established literary base those screenwriters who did decide to tackle the living dead frequently took liberties with the legend, displaying an irreverence that would have been unthinkable towards respected contemporary properties such as *Dracula* or *Frankenstein*. Forced to play the part of the eternal poor relation (and with no copyrights and few vested interests to protect it), the zombie was pushed from pillar to post by writers who had little idea what to do with it.

Hot on the heels of Lugosi's *White Zombie*, his chief rival Boris Karloff appeared in three zombie-styled chillers during the decade, all of which dropped the Caribbean focus of the Halperins' outing. In British horror movie *The Ghoul* (1933), Karloff played an Egyptologist whose knowledge of ancient burial rights allows him to return from the dead. Sadly, his doubting manservant hasn't carried out his instructions properly leaving Karloff to return as a half-dead, half-alive ghoul in what was little more than an echo of his star turn in *The Mummy* (1932). In *The Walking Dead* (1936) Karloff played a man wrongly executed for a crime he didn't commit and then brought back to "life" as a shuffling zombie who takes revenge on the gangsters who framed him. Meanwhile in *The Man They Could Not Hang* (1939), he starred as a crazed scientist experimenting with artificial hearts, who's hanged for murder after the accidental death of one of his test subjects. Needless to say, he doesn't stay dead for long.

Produced under the respective banners of Gaumont, Warner Bros. and Columbia, *The Ghoul, The Walking*

Dead and *The Man They Could Not Hang* illustrate the extent to which the major studios were only interested in the zombie when it was completely stripped of its Caribbean heritage.[43] Uninterested in the racial anxieties inherent within films like *White Zombie*, Karloff's movies turned the living dead into just another bogeyman. It was something that other films were more than willing to do as well. Britain's *The Scotland Yard Mystery* (1934, reissued in the US as *The Living Dead* in 1936) revolved around a story about a drug that puts people into a death-like trance. The American tagline suggested just how far from the Caribbean zombie the filmmakers had strayed: "Not a ghost! Not a Vampire! Not a Zombie! What are *The Living Dead*?"

As interest in Haiti and the Caribbean waned and the first rumblings of war in Europe began to be heard, the focus of the United States' foreign policy moved further afield. It's not surprising then that the next film to feature the zombie - and use the word in its title - would have little to do with Karloff's insipid outings. Released in 1936, *Revolt of the Zombies* was conceived as an unofficial sequel to *White Zombie*. Produced and directed by the Halperin brothers in a vain attempt to cash in on that earlier movie's success, *Revolt* may have completely divorced itself from the Caribbean, yet it succeeded in linking the zombie with a very different kind of American foreign policy.

Breaking their collaboration with Bela Lugosi and screenwriter Garnett Weston, the Halperins brought in a cast of fresh faces along with two new scriptwriters, Howard Higgin and Rollo Lloyd. The results of these changes were rather disappointing. As Weston went off to a lucrative career scripting Bulldog Drummond adventures, the new writers struggled to come up with a plausible reworking of the genre. Lacking Weston's intimate knowledge of both the zombie myth and Seabrook's voodoo research, Higgin and Lloyd's script rehashed many of the elements of *White Zombie*, while failing to match the earlier film's powerful impact. At times, the similarities between the two properties bordered on the ludicrous with a love-triangle plot that explicitly echoed that between Neil, Madeleine and Beaumont in the earlier film. Adding to the feeling of déjà vu, the Halperins also recycled the distinctive footage of Lugosi's mesmerising eyes. Originality, it seems, was difficult to come by.

The plot broke with Seabrook and *White Zombie* by relocating the action from the Caribbean to the Far East. During the height of the First World War, Armand Louque (Dean Jagger) discovers that Cambodian priests are in possession of a devastating mind-control technique that allows them to turn ordinary soldiers into zombie warriors completely impervious to pain, bullets and the bitter misery of the trenches. Believing that these "tireless, fearless human machines" could turn the tide of the war in the Allies' favour, Armand approaches General Duval (George Cleveland) who is unimpressed by his findings until he sees the Cambodian zombies in action. They storm a German trench under the telepathic control of a priest, slaughtering everyone who gets in their way and shrugging off enemy fire.

Terrified that this power should reside in Cambodian hands - and explicitly concerned that it might bring about the "destruction of the *white* race" - General Duval imprisons the priest then sets out with Armand and various Allied officers to Angkor where they plan to destroy all trace of this super-weapon. But one of the group, the distinctly Russian looking Colonel Mazovia (Roy D'Arcy), has other plans. He wants to use this telepathic power for his own ends. Killing the priest and stealing the map that shows where the secret of the mind-control technique is hidden, Mazovia travels out to Cambodia with a very different agenda.

During their adventures in the jungle, Armand falls in love with General Duval's daughter Claire (Dorothy Stone), but after a brief engagement she dumps him for his friend Grayson (Robert Noland). Furious at being slighted, Armand feels powerless to intervene until he unexpectedly discovers the secret of the zombie mind-control technique himself. Killing Mazovia to prevent any

unwelcome interference in his plan, Armand then binds the whole of Cambodia to his will and turns its citizens into his own private zombie army.

Still desperately in love with Claire, Armand blackmails her into seeing him. She sweet-talks him into proving his love by releasing the Cambodian populace from his grip. The film ends with Armand being killed by his former slaves who are - quite understandably - rather annoyed about having been zombified. The Cambodians storm Armand's palatial mansion and take their revenge, while the rest of the cast bemoan the dangers of one man having too much power.

In comparison with *White Zombie*, *Revolt* is strictly second-rate. Where the first film built up both atmosphere and mood to create a nightmarish mix of death and desire, *Revolt* is more likely to send audiences to sleep with its hackneyed acting and languorous pace: one ten minute chase sequence follows Armand as he silently pursues a Cambodian monk through a back-projected jungle swamp, with both actors doing their best to "wade" through the non-existent water.

above: Professor Morlant (Boris Karloff, right) teaches his manservant Laing (Ernest Thesiger) that revenge is a dish best served dead in **The Ghoul**.
below: Karloff does a Lugosi in **The Walking Dead**.

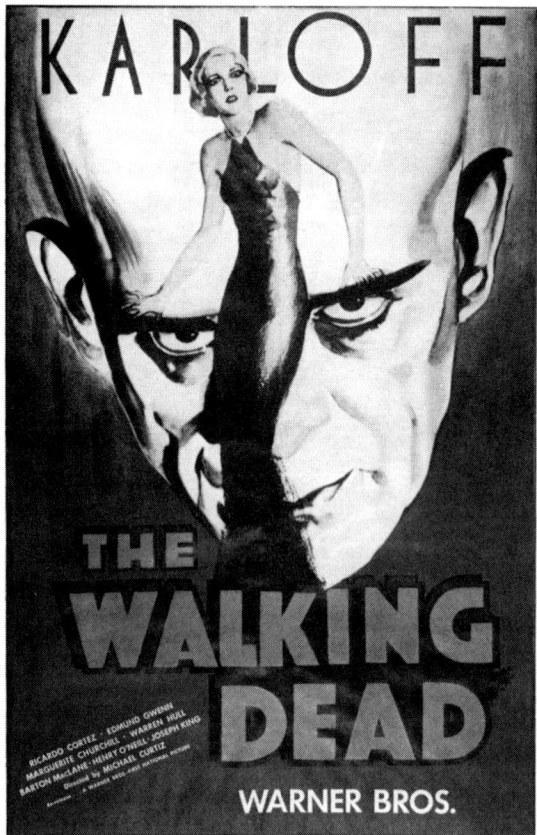

victims of Armand's telepathic control. Instead of reanimated corpses, these Cambodian super-soldiers are living subjects whose zombification is mental rather than physical. For contemporary critics, this off-hand reworking of zombie lore was simply too much. Writing in the *New York Times*, critic Frank S. Nugent reprimanded the Halperins for their misguided attempts to change the central tenets of the zombie myth:

> The zombies, the revolting zombies, are revolting at the Rialto this week and we don't blame them. Even a zombie has his rights and we loyal necrophiles will fight to the last mandrake root to protect them. Under any code of fair practice, a zombie is entitled to be authentically dead but revived horrendously by some sorcerer to do his evil bidding [...] To suggest, as "Revolt of the Zombies" does, that our blank-faced, glazed-eyed heroes are merely under the hypnotic spell of a handsome chap who found a synthetic zombie formula in a Cambodian temple is to discredit an honourable profession. And to hint that they are not really zombies at all, but sleepwalkers or something, is to imperil the very foundations of a grand spook legend. No wonder the zombies revolted, turned on their love-forlorn master and shot him down: he was their conjur' man and he done them wrong.[44]

Originally, the Halperins had planned to open the film in the year 839 A.D. with a sequence showing the Cambodian city of Angkor being built by zombie slaves. In the end, budgetary restrictions scuppered the plan and hampered the rest of the project itself. Combining truly awful back-projection of Cambodian temples with unconvincing attempts to show a whole nation under the sway of one man's mental power, *Revolt* never escapes the dreary limitations of its cheap and slapdash roots. The original posters boasted that the film contained 500,000 zombies, but the true number in the finished film is probably about fifteen.

Yet for all its explicit cribbing from its predecessor, the film remains an important milestone in the development of the genre. In contrast to the small-scale terrors of *White Zombie*, *Revolt* was the first film to appreciate the fact that one potential avenue for the living dead's development was in linking the image of the zombie to the masses. With its cast of "Cambodian" extras and a flawed but ambitious attempt to depict a whole nation of zombies, *Revolt* established what in later years would become a genre staple: the zombie apocalypse in which the living are terrorised not by one or two walking dead, but a whole army of them.

One reason why *Revolt*'s influence took so long to take effect was undoubtedly because of the film's central red herring of making its "zombies" into brainwashed It wasn't just the reviewers who were unhappy with the Halperins' attempts to style these "robot soldiers" as zombies. Amusement Securities Corporation, the company who'd purchased the redistribution rights for *White Zombie*, took the filmmakers to court protesting that a second Halperin film with the word "zombie" in the title constituted unfair competition. The Halperins, well used to such legal wrangling, agreed to rename it *Revolt of the Demons* until an appeal hearing later overturned the case and the film reverted to its original title.

If nothing else, such incidents prove just how firmly established in American popular culture the zombie was by the mid-1930s. But they also obscure the film's chief innovation, for by tampering with the voodoo basis of the zombie mythology, *Revolt* opened up the genre's scope in quite unexpected ways that, in time, would have a significant impact on the zombie movie.

Although *White Zombie* and *Ouanga* played with American anxieties surrounding the Depression and the occupation of Haiti, *Revolt* confronts a very different set of concerns. It's no accident that the film's "robot soldiers" owe a considerable debt to the sleepwalking murderer of Robert Wiene's classic of German Expressionism *Das Cabinet des Dr. Caligari* (*The Cabinet of Dr. Caligari*, 1919). In that earlier film, the sleepwalking Cesare (Conrad Veidt) became a suggestive symbol of the way in which Germany's

populace had been brainwashed into the bloody madness of the First World War. In *Revolt*, the image of the sleepwalking (zombified) mass is closely bound to similar concerns, including the growing re-emergence of German military aggression.

With its First World War setting, *Revolt* seems determined to force a link between the zombie army and the tensions of the world stage in the mid-1930s. As National Socialism restructured German society for its own world-conquering ends, the similarities between *Revolt*'s vision of a whole nation held under the hypnotic spell of a single dictator and events in Europe were readily apparent. Given this, Armand's vocal attempts to justify his actions by using the sub-Nietzschean chatter of his friend Grayson seem particularly pointed. Grayson's off-hand talk about taking what one wants could have been lifted verbatim from *Mein Kampf*: "If you want anything, ride roughshod over everything... Be ruthless, forget all sentiment. Get to your objective, take it and hold it."

Significantly, *Revolt of the Zombies* wasn't the only film from the period to draw links between the zombie and the impending war. In France, a very different kind of film was toying with zombie iconography in a similar attempt to underscore the relationship between the living dead and the bloody insanity of twentieth-century conflict. While placing Abel Gance's arty anti-war film *J'accuse* (1937) beside *Revolt of the Zombies* may seem like an affront to the terrible beauty of Gance's vision, there are undeniable similarities between the two films in terms of their use of the zombie to mirror fears about the looming European hostilities.

A remake of his silent 1919 film of the same name, Gance's 1937 version of *J'accuse* is an indictment of the twentieth-century's ongoing war-lust in which shell-shocked First World War soldier and poet Jean Diaz (Victor Francen) tries to warn the world not to repeat the mistakes of 1914 to 1918. The only survivor of a platoon that is massacred in the trenches, Diaz becomes a pacifist and invents a form of unbreakable "steel" glass that he hopes might put an end to war. The military want to use this invention as a weapon and so, in a delirious reaction to their pigheaded stupidity, Diaz orders the dead of the First World War from their graves to march across the country and remind the living of their past folly. It's a startling sequence that owes a great debt to the traditions of the horror genre. Gance's controversial decision to use real members of the *Union de Gueules Cassées*, who get to display their horrific wounds alongside made-up extras, gives it an added resonance. Released to a Europe on the brink of another round of slaughter, *J'accuse* stands as one of history's most poignant productions - a cinematic warning cry that no one heeded.

"Tireless, fearless, human machines": Cambodian zombie soldiers in **Revolt of the Zombies**.

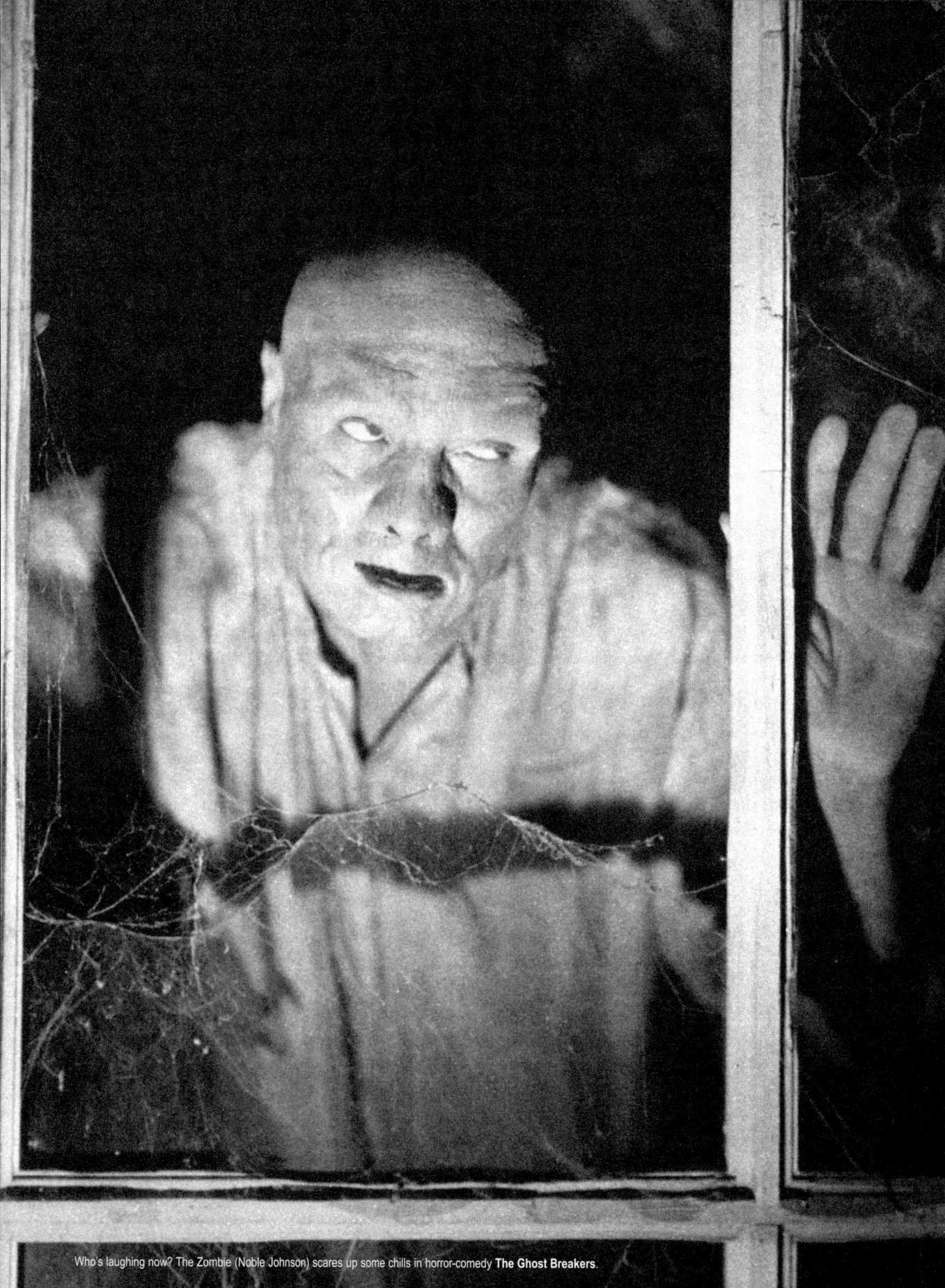
Who's laughing now? The Zombie (Noble Johnson) scares up some chills in horror-comedy **The Ghost Breakers**.

chapter three

Down and Out on Poverty Row

I. Horror Comedy on Black Island

Throughout the 1930s, the predominant characteristic of zombie movies was their low-budget origins. Lacking the sponsorship of the major horror-producing studios, the living dead never achieved the same status as the other critically and popularly acclaimed monster movies of the period.[45] This marginal position remained part of the genre's limitation during the 1940s as well, for as the 1930s horror boom came to an end, the living dead slipped out of the limelight into the slums of Hollywood's Poverty Row studios.

Before being eased out of the mainstream, the zombie did have its first and (for many, many years) last shot at the big time as Paramount released the horror farce *The Ghost Breakers* (1940) with a cast that included Bob Hope, Paulette Goddard and Anthony Quinn. Envisioned as a sequel to the successful comic partnership of Hope and Goddard in the previous year's horror-comedy *The Cat and the Canary*, *The Ghost Breakers* transported the voodoo-zombie thematics of *White Zombie* and other 1930s Caribbean pictures to Havana, where American beauty Mary Carter (Goddard) inherits a reputedly haunted Cuban castle on Black Island.

Although she doesn't know it, Carter's castle stands over a lucrative silver vein. Various bad guys are planning on snaffling the mine out from under her nose by playing up the castle's reputation as a haunted house in order to scare her off. Fortunately she has the help of radio celebrity Larry Lawrence (Hope) and his black valet (Willie Best), two cowardly lions who solve the riddle of the castle while fending off the unwelcome attentions of the island's chief residents: Mother Zombie (Virginia Brissac) and her living dead son, The Zombie (Noble Johnson).

As a comedy horror, *The Ghost Breakers* succeeds because of the sublime comic partnership of Hope and Willie Best. Competing over who can be the most cowardly, this well-matched duo play up the movie's chills with their hammy comic mugging. Stumbling over one another to get out of harm's way, tripping over each other's feet and generally jumping at the sight of their own shadows, their wide-eyed expressions of terror are hilariously funny. As they creep around the haunted castle, the sparklingly polished gags shine through, with Hope getting all the best lines: "If a couple of fellas come running down the stairs in a few minutes, let the first one go - that'll be me".

As far as the film's horror content goes, it's Johnson's zombie who steals the show. A shuffling, ragged monster with a misshapen head and wrinkled, decomposing skin, the zombie is far scarier than the rest of the film's alleged shocks - rubber bats on strings, cobwebbed skeletons, hidden passageways and gun-toting bad guys - put together. Johnson (who once played the African chief in *King Kong*) transforms the zombie into *The Ghost Breakers*'s real threat. The scene in which he chases the terrified Goddard through the spooky house is quite possibly the only unsettling moment in the film.

The Ghost Breakers is significant because its monster is the first cinematic member of the walking dead who actually looks *dead*. During the 1930s, American horror movies simply dressed their zombies in rags and slapped on some cadaverously pale make-up. In comparison, the zombie in *The Ghost Breakers* appears to have spent the last few decades decomposing in the castle grounds.

Repeatedly upstaging Johnson's monster with humour, though, the film walks a thin line between comic effectiveness and horror bankruptcy. As Hope arrives in the Caribbean, he's given the requisite lesson in living dead mythology. "A zombie has no will of its own. You see them sometimes walking around blindly, following orders, not knowing what they do, not caring," someone explains. To which Hope deadpans: "You mean like Democrats?" Later, with a blatant disregard for all living dead conventions, the zombie dresses up in a suit of armour and tries to bump off our blundering heroes with a spiked mace. It's an unlikely proposition which not even Hope's "quick get the can-opener" quip can paper over.

Such comedy may have taken the bite out of the film's chills, yet it did little to disguise *The Ghost Breakers*'s reactionary racial politics. Poised between the first and second cycle of zombie films, the picture marked the beginning of a trend that would thread its way throughout the period. Pitting a white hero and his black manservant against the forces of the living dead, *The Ghost Breakers* signalled a shift away from the Haiti-dominated voodoo films of the 1930s by setting its action in Cuba, a land far less foreign to the United States than Haiti. Yet like those earlier films, *The Ghost Breakers* is obsessed with issues of race. It certainly seems significant that the castle is located on *Black* Island, was built by "Cuba's greatest slave trader" and is haunted by "those lost souls who were starved and murdered in the castle dungeons". Nor does it come as any surprise to learn that the zombie and his mother are black.

II. The Poverty Row Years

Never trust a voodoo Nazi scientist:
Mac (Dick Purcell, centre) falls under the spell of the **King of the Zombies**.

The Ghost Breakers marked the end of the big studios' obsession with the horror film. The boom that had begun in the early 1930s ground to an abrupt halt as America and the rest of the world found itself coming to terms with the realities of war once again. While horror movie production never stopped - with its European backdrop Universal's *Wolf Man* series proved unexpectedly popular during the Second World War - there was a significant shift within the industry as the genre was slowly marginalised, eventually taking up residence in Hollywood's Poverty Row studios.

Unlike Universal or MGM, the studios grouped together under the Poverty Row banner were small independent companies. They coexisted in the gaps between the "A" and "B" picture productions of the major studios on the one hand and the twilight world of "exploitation" films, with their sensationalist warnings about sex hygiene, crime and drugs, on the other.[46] Founded during the Depression, Poverty Row companies like Republic, Grand National, Mascot, PRC and Monogram managed to survive in the over-crowded movie marketplace by churning out exceedingly cheap productions. Specialising in one-horse Westerns, action films (usually involving lots of inexpensive fist-fights and foot chases) and horror movies, these were hand-to-mouth operations interested only in making enough profit to keep them in business for another week.

Monogram was one of the first of these independent studios, founded shortly after the 1929 stock market crash by mid-Westerner W. Ray Johnston. Using second-rate talent on both sides of the camera, there was little room for art, originality or risks. In the early 1940s, the average Monogram picture made a profit of just $1,932 and twelve cents in change. As Tom Weaver points out in his excellent history of Poverty Row horror, it was a "minuscule dividend that left little room for tinkering and fine tuning".[47]

The success of the big studio horror pictures of the 1930s convinced the Poverty Row players to try their hand at the chiller market. Picking up where Universal left off - though without a fraction of the budget of films like *Dracula* - the studios produced scores of cheap movies that promised to curdle the blood, but in reality were often only terrifying in terms of how truly awful they were. The years from 1940 to 1946 were a golden age in the world of hackneyed scares and Z-grade schlock horror with casts that frequently included talented but hard-up actors like Lugosi, John Carradine, George Zucco, Glenn Strange and Lionel Atwill.

There are few apologists for the Poverty Row horror films of the period and even the biggest Lugosi fan will admit that these nickel and dime productions did little to enhance his floundering career. Yet, in spite of their very

The equation of the zombie with America's racial Others was something that would become a permanent feature in the zombie films of the 1940s, as issues of race and imperialism intertwined. As the promotional posters for *The Ghost Breakers* made clear, the zombie could serve as a potent symbol of white America's anxieties over its African-American populace. "Step right up Paulette and meet the Spooks," Bob Hope says to a seated Paulette Goddard on one of the original publicity posters. Willie Best stands behind her, while above them hover the spectral figures of two misshapen black zombies. The link between "spooks" and African-Americans becomes transparent as Goddard is invited to meet both the African-American Best and the non-Caucasian zombies. That "spook" was a slang term of racial abuse in 1940s America simply adds grist to the dubious pun. Given this, the fact that *The Ghost Breakers* was the first American zombie movie to employ a black actor to play its monster seems more than coincidental.

In the films that followed *The Ghost Breakers* - particularly *King of the Zombies* (1941) and *Revenge of the Zombies* (1943) - the relationship between the comic antics of the black servant and the films' zombies became a recurrent theme. The black servant was made to mimic, mirror or even replace the living dead as the films' chief source of anxiety. This racial dynamic eventually reached its zenith in Jacques Tourneur's *I Walked with a Zombie* (1943), a gothic horror tale set in the Caribbean. Exaggerating white anxiety over racial difference to hysterical proportions, *I Walked with a Zombie* equated the living dead not only with the primitive but also with the total collapse of truth, reason and meaning.

obvious failings, Monogram's pictures always found an audience because, as Tom Weaver explains, they usually had at least a hint of a good idea behind them:

> The unfortunate part about the Monogram horror films is that in some ways, a number of them came awfully close to being halfway decent; all they needed was a bit more production and a good writer to fiddle with the scripts and the dialogue. Monogram's horror scripts were notoriously bad, but somewhere in them - buried in incoherent dialogue and goofy plot twists - were often ideas that had a good bit of unrealised potential.[48]

With such tiny profits at stake, however, there was little inclination to "fiddle" with the niceties of plot, dialogue or character.

The horror pictures of this period range from PRC's *The Devil Bat* (1941) and *The Mad Monster* (1942) to Republic's *The Lady and the Monster* (1944) and *The Vampire's Ghost* (1945). Unlike its rivals, Monogram's chiller movies were usually horror-lite affairs in which Bela Lugosi would wade through a supposedly scary, but actually rather mediocre, script. Trading on Lugosi's reputation as the master of horror, Monogram's scriptwriters did their best to ensure that there was actually very little scary content (and therefore little expense) other than the presence of the man who had once played Dracula. Crippled by budget restrictions often even worse than many of its equally cash-starved competitors, Monogram's films rarely even stretched to a half-decent monster.

A quick comparison of the PRC and Republic titles listed above with those of Monogram's catalogue is telling. Movies such as *Invisible Ghost* (1941), *The Corpse Vanishes* (1942), *Ghosts on the Loose* (1943) and *Spook Busters* (1946) reveal the extent of the studio's budgetary constraints. While the other Poverty Row studios may have been cheap, they could usually scrounge together a few dollars to invest in a monster of some description. Monogram, however, relied on invisible ghosts and vanished corpses - budget-saving devices around which Lugosi had to conjure up some semblance of horror.

One monster that Monogram could always afford was the zombie. All the living dead films that came out of the Poverty Row studios bore the Monogram stamp: *King of the Zombies* (1941), *Bowery At Midnight* (1942), *Revenge of the Zombies* (1943) and *Voodoo Man* (1944).[49] They were all, without exception, dreadful.

Monogram's filmmakers repeatedly returned to the zombie because the living dead required little in the way of special effects. A hard-pressed director could churn out a relatively effective zombie film without having to spend more than a handful of dollars on make-up and wardrobe; the casting director wouldn't have to search out skilled

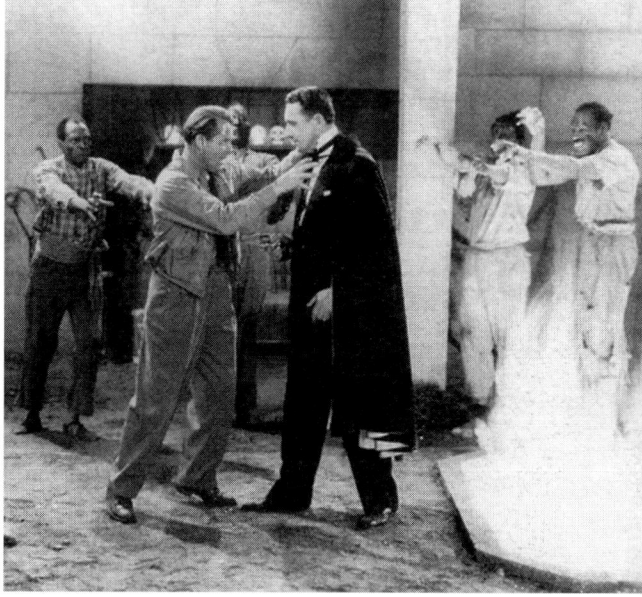

Dr. Sangre (Henry Victor) feels the wrath of the living dead in the final moments of **King of the Zombies**.

professionals to play the film's living dead roles; and the zombie actors' fees would be negligible since, as horror movie historian Denis Gifford points out, the union-scale payment for non-speaking parts was considerably lower.[50]

Unfortunately for the genre, Monogram's involvement with the zombie merely confirmed the suspicions of the Hollywood mainstream. The major studios became convinced that the zombie was a cheap, low-rent monster that was more of an embarrassment than a worthy successor to the chills of *Dracula* or *Frankenstein*. It was a prejudice that would shape the genre's development over the next two decades.

The first Poverty Row production to employ the zombie was an unabashed cash in on the success of *The Ghost Breakers* entitled *King of the Zombies*, which ripped-off the white hero/black valet pairing of Hope and Best. Directed by Jean Yarbrough, *King of the Zombies* was originally conceived as one of Monogram's many Lugosi vehicles, but after he dropped out - and an ambitious attempt to sign up Peter Lorre fell flat - the role of the mad scientist went to Henry Victor. Victor had played the strongman in Tod Browning's *Freaks* a decade before and by the 1940s his German upbringing and distinctive accent kept him typecast in Nazi roles.

King of the Zombies begins as Bill (John Archer), his black valet Jeff (Mantan Moreland) and their pilot Mac (Dick Purcell) crash land their plane on a mysterious Caribbean island during the Second World War. Discovering a nearby mansion owned by Austrian scientist Dr. Sangre (Henry Victor), the trio gradually realise that all is not well on the island. Sangre has taken an American admiral captive and is trying to interrogate

book of the dead

him using voodoo magic. Eager to allay his new guests' suspicions, Sangre attempts to hypnotise Jeff and Mac, but his plans fall apart as Jeff blows the whistle on his cellar full of zombies.

It wasn't just the mix of horror and comedy that *King of the Zombies* owed to *The Ghost Breakers*. It also replayed much of the earlier film's racial subtext. In copying the white investigator/black manservant pairing of Hope and Willie Best, though, *King* significantly changed the formula. Hope's cowardice and Willie Best's scared bumbling are combined in the character of Jeff, while white hero Bill is transformed into a brave but bland everyman, whose role is significantly diminished. It was a subtle shift that made the film's racial politics far more transparent. What *King of the Zombies* illustrates, is the manner in which the zombie movie of the 1940s lost interest in the American-Caribbean and became, instead, an oblique commentary on domestic relations between whites and African-Americans.

Significantly, this shift occurred in a period that had become particularly self-conscious about the role of black actors in American cinema. As film historian Donald Bogle suggests in his book *Toms, Coons, Mulattoes,*

top: 'Tis too grave a matter to jest about: Bill (John Archer) and Jeff (Mantan Moreland) horse around in **King of the Zombies**.

Mammies and Bucks: An Interpretative History of Blacks in American Films, the 1930s were "the Age of the Negro Servant" since:

> No other period could boast of more black faces carrying mops and pails or lifting pots and pans than the Depression years. In the movies, as in the streets, it was a time when the only people without job worries were the maids, the butlers, the bootblacks, the bus boys, the elevator men, the cooks and the custodians.[51]

Relishing the visibility that mainstream Hollywood cinema was offering them, black performers made the most of their limited parts, turning their cooks, butlers and maids into larger than life characters who challenged African-American stereotypes, even as they were forced to play up to them.

By the 1940s, however, the situation was changing. Black commentators were becoming increasingly critical of such strategies of visibility, claiming that their oppositional potential was, at best, deeply flawed. Meanwhile, white audiences were becoming bored with the constant stream of dark-skinned comic characters that Hollywood's screenwriters were churning out. One such stereotype - the "coon" - was a staple of the period. Most famously represented by actor Stepin Fetchit (his stage-name was significantly servile - "step and fetch it"), the "coon" was usually a black male servant who was pathologically lazy, greedy and prone to getting ideas above his station. By the 1940s, such representations of black masculinity were on the wane, but it was Willie Best and Mantan Moreland who squeezed the dregs out of the stereotype. It was a role that Moreland made his trademark in the Monogram zombie pictures and elsewhere, as Bogle explains:

> Always cast as the faithful right-hand man [Mantan Moreland] added a perverse twist to the tradition. Generally, Mantan was always there *until* his white friend needed him. Then he took off for the hills. He was a fantastic cowardly lion with an uncanny command of stagecraft. In those films in which he was terr'fied of de ghosts, Moreland displayed an arsenal of gestures and grimaces that actors had traditionally used to steal scenes and develop characters. He was notorious for his perfectly timed double-takes. No other actor could widen his eyes like Moreland. Nor could any other manage his trick of appearing to run without actually moving at all. He always looked as if he were about to trip over his own feet as he tried to make a hasty departure.[52]

Although played for laughs, the role of the "coon" spoke volumes about white America's racial stereotyping. The audience's reaction to him was necessarily double-edged. On one hand his laziness, cowardice and greed were used for comic effect; at the same time, these qualities were generally reviled. The "coon" was thus simultaneously both the comic star and the comic villain, playing a role that invited guffaws and censure in equal measure.

In *King*, Moreland's "coon" act is intimately bound up with the film's zombies. As the lazy black servant who doesn't know his place, Jeff is zombified by Sangre in a manner that suggests that his predicament is more than just the outcome of the necessities of plot. By zombifying Jeff, Sangre puts this bumptious Negro in his place, offering (white) audiences not only a comic adventure in which Jeff joins the "fugitives from the undertaker" but also a blatant piece of wish-fulfilment as the "coon" gets taught the error of his ways. *King* may end with Sangre's plot exposed and Jeff returned to normal, but the (white) audience's enjoyment of his transformation from "coon" to zombie is, without doubt, the film's chief focus.

In the scenes leading up to Jeff's zombification, the antagonism between Jeff and Sangre is spectacularly pointed. We already know that Jeff's behaviour regularly steps outside the normal limits of what a black manservant ought to be able to get away with; Bill and Mac's exasperated expressions tell us that his laziness, cheekiness and outright incompetence is a nuisance to them both. Yet the general sense is that he's tolerated by them in much the same way as a badly behaved puppy dog might be.

Sangre has less patience with the servant's uppity behaviour. As Jeff tries to join the three white men in a glass of brandy (Sangre pointedly pulls the tray out of his reach) and badgers their host about the sleeping arrangements ("Excuse me doctor, but didn't you forget something? What about me?"), it's clear that the Austrian scientist doesn't agree with Bill's indulgent attitude towards his valet. Refusing to let Jeff sleep upstairs because it "might set a bad example for the other servants," Sangre puts Jeff in his place by sending him down to the basement. Jeff's mournful complaints - "The idea of me doing skulduggery in the kitchen; why that ain't no business for a man who's used to resorting with big shots" - suggests just how unused to such treatment he is. In the basement, Jeff meets two of Sangre's servants: Samantha the maid (Marguerite Whitten) and Tahama the cook (Madame Sul-Te-Wan). He also encounters the household zombies: a ragged group of ghouls brought back from the dead to work as slaves. When Jeff tries to tell his boss what's lurking downstairs, the idea is ridiculed and Sangre claims these supposed "zombies" are actually just his servants.

Eager to take his revenge on the ever-troublesome Jeff, Sangre then hypnotises him into thinking he's a zombie, pointedly commanding: "Get over there where you belong." It's a sequence that's shot through with humour: "Move over boys, I'm one of the gang now,"

Moreland wisecracks as he joins the ranks of the undead. By the next scene, Jeff has fulfilled the promise of the film's title, becoming (quite literally) the king of the zombies and drilling his undead cohorts as if on parade: "Company! Halt!"

For all the supposed comedy of these scenes, there's an underlying seriousness to the horseplay. The transformation of Jeff into a "zombie" may appear to be a subplot, but it's actually the main focus (significantly, when Mac is hypnotised into thinking he's a zombie he's shunted to the sidelines until the film's final moments). By turning Jeff into a zombie, Sangre takes his revenge on the character's cheeky arrogance, effectively punishing the "coon" for his wayward behaviour and failure to know his place.

The effect of this is twofold: the audience (both white and black) get to enjoy Jeff's comic misdemeanours, his slighting of authority and his barefaced cheek. Yet his zombification also acts as a punishment that the (white) audience can simultaneously enjoy before the film closes with the defeat of the Nazi scientist and the return of Bill, the white hero, to centre stage. The film has it both ways. It presents the African-American Jeff as dangerously arrogant *and* comically incompetent; as dangerously autonomous *and* as naturally passive (the fact that Sangre's real zombies are presented as lazy, dim-witted and constantly hanging around the kitchen waiting for food obviously has more to do with white-led representations of African-Americans than conventions of zombie lore). In other words, *King* raises the spectre of growing African-American autonomy in 1940s America, only to undercut it by turning its black hero into a zombie and having him serve the needs of his white masters in thwarting their common enemy.

Race not only dominated the film's subtext, but also the publicity material. Describing director Jean Yarbrough as a man of "tact and discretion", the film's press book recounted a story that allegedly occurred during the shoot. Preparing for a scene in which Dick Purcell, Joan Woodbury and Moreland stumble across a zombie, Yarbrough reportedly told his cast, "Now when you see this 'dead man' rise from the coffin, recoil and blanch with fear - you know, turn pale." Moreland, described in the press book as "a gentleman of color from Alabama," is said to have replied: "Mistah Yarbrough, that is a little difficult for me." Yarbrough thought things over and said, "Okay Mantan - you just sort of blanch darkly".[53]

While this story might appear to be nothing more than an innocuous piece of press book trivia, its racial dimension is telling. Not only does it underscore the film's obsession with race, but it also puts Moreland in his place once again as a cheeky "gentleman of color from Alabama" whose disruptive potential (interrupting the white director; trying to make things more difficult than they are) is circumvented by the quick-thinking Yarbrough. It was a joke that someone at Monogram obviously thought was particularly amusing since it also occurs in the film itself when, in a suitably scary moment, Jeff mutters: "If it was in me I sure would be pale now".

By Monogram's standards, *King of the Zombies* was an unexpectedly successful venture. Audiences enjoyed the comedy and - though it's difficult to believe today - some even found the horror elements frightening. The *Monthly Film Bulletin* claimed, "except for those who enjoy an eerie and gruesome film, this is a most unpleasant one of its type, full of voodooism, black magic, graveyards and walking dead".[54] What was even more surprising was the fact that by some strange quirk of showbiz fate, *King of the Zombies* was nominated for an Academy Award for Best Score - the first, and most definitely last, time that a Monogram horror movie made it to the Oscars. Competing against films like *Citizen Kane* and *Dr. Jekyll and Mr. Hyde*, Edward J. Kay's score didn't have much hope of winning. Quite how any soundtrack containing the lyrics "Eddie loves those cocoa beans / Zombies! / I like cocoa, I like cocoa" could ever have been nominated in the first place has yet to be explained. Perhaps if the planned sequence in which the zombies gave a rendition of a musical number called "The Gravedigger's Song" had gone ahead an Oscar might have become a reality. Instead, the award went to Bernard Herrmann's infinitely more deserving score for *The Devil and Daniel Webster*.

With *King of the Zombies* achieving such unexpected success, a sequel was put into production and released in 1943. Co-written by *King* scribe Edmond Kelso, *Revenge of the Zombies* saw the return of Mantan Moreland in a film that was more of a remake than a sequel. Although boasting slightly better production values than its predecessor, *Revenge* proved far less memorable. Its storyline was lifted almost verbatim from *King* and jazzed up for Second World War audiences with an explicitly Nazi villain named Max von Altermann (John Carradine) who clicks his heels, speaks fluent German, and commands a platoon of goose-stepping zombies.

above: A death in the family: Lila von Altermann (Veda Ann Borg, in the coffin) in **Revenge of the Zombies**.

bottom right: Toby (John Carradine) watches over the pretty vacant (and pretty dead) starlets of **Voodoo Man**.

Hiding out in his laboratory, von Altermann is creating a race of zombie super-soldiers to help his beloved Fatherland win the war: "I am prepared to supply my country with a new army, numbering as many thousands as are required," he brags. The chief advantage of these soldiers is that they're already dead and so can't be killed on the battlefield: "Against an army of zombies, no armies could stand. Why, even blown to bits - undaunted by fire and gas - zombies would fight on so long as the brain cells which receive and execute commands still remained intact."

Budgetary constraints meant that audiences never got to see this formidable army in action. Instead, *Revenge* managed to muster a handful of assorted male extras to stumble bare-chested around von Altermann's basement lab. None of these domesticated zombies look capable of taking over the world and, if von Altermann's zombified wife is anything to go by, they don't even seem to be particularly obedient. Playing up the Nazi theme and struggling under a hefty dollop of wartime propaganda, *Revenge* dispenses with the racial subtext of *King*, giving Mantan Moreland far less screen time and focussing instead on some crass Jerry-bashing.

The other zombie-themed Monogram films of the 1940s had little to recommend them either. Two vehicles for Bela Lugosi - *Bowery At Midnight* (1942) and *Voodoo Man* (1944) - put the poverty squarely into Poverty Row, with shockingly terrible scripts and laughable living dead extras. Proving that Monogram's interest in the zombie was only ever the result of financial necessity both *Bowery* and *Voodoo Man* brought the still youthful genre to a new low.

In *Bowery At Midnight*, Monogram attempted to revive the zombie-gangster movie that had begun with Karloff's *The Walking Dead*. Lugosi, whose career slide had led him to embark on a permanent cycle of public appearances as Dracula and quick acting jobs on Poverty Row, played a dual role. By day he's Professor Brenner, an acclaimed psychologist and upstanding member of the community; but by night he's Karl Wagner, a villainous criminal who uses a Manhattan soup kitchen called the Bowery Friendly Mission as a front for his crime syndicate.

For most of its sixty-minute running time, *Bowery* is distinctly lacking in any horror content whatsoever. As the ridiculously intricate plot unfolds, Lugosi switches back and forth between his roles, performing a few cold-blooded (but resolutely bloodless) murders and generally trying to evade arrest. The film's zombies only arrive in the final reel as we discover that the drug-addled Bowery janitor Doc (Lew Kelly) has been reviving the dead bodies of Wagner/Brenner's victims and keeping them locked away in a secret room in the basement. As Wagner tries to hide from the police in the soup kitchen, Doc decides he's had enough of his double-crossing employer and so unleashes the zombies. Eager for revenge, the living dead tear Wagner to pieces. Bloodlessly and off-screen of course.

Implicitly expanding on the link made between the living dead and the unemployed during the Depression, *Bowery*'s down-at-heel setting is the perfect location for the American zombie. Putting the living dead in a soup kitchen populated by New York's bums and petty thieves, the film belatedly proves the monsters' symbolic ties to the poor, dispossessed and unemployed. No wonder the Poverty Row studios loved the zombie so much - here was a monster that summed up their own feelings of being low-rent, mass-produced and only one step away from complete destitution.

"Reduced to utter absurdity": Nicholas (George Zucco) and Dr. Marlowe (Bela Lugosi) serve up some ham in **Voodoo Man**.

Lugosi's next zombie outing for the Monogram stable proved little better. *Voodoo Man* caught the luckless actor just as he finished a stage-production of *Arsenic and Old Lace* and teamed him up with George Zucco and John Carradine in a witless story that was even more ridiculous than *Bowery*. Anyone who had the misfortune of seeing director William Beaudine's earlier film *The Living Ghost* (1942) - another cheap and flatly boring Monogram production about a banker who's turned into a catatonic killer - knew pretty much what to expect. Everyone else was caught off guard by the truly terrible plotting.

Mad old Dr. Marlowe (Lugosi) kidnaps lone female motorists with the help of gas station attendant Nicholas (Zucco) and moronic handyman Toby (Carradine). He's hoping to use voodoo magic to transfer their minds into the body of his zombified wife Evelyn (Ellen Hall) who's been dead for the last twenty years. A succession of failures has left Marlowe's rickety old house full of former abductees who've been turned into zombies - and rather pretty ones at that. Since none of these girls' temperaments match that of his wife, the experiments keep failing adding yet more lasses to the collection of zombies in the basement. Keeping an eye over the braindead ladies is Carradine's half-wit handyman, who spends most of his time gawping at them: "Gosh - you've got pretty hair".

The triple bill of Poverty Row horror stalwarts Lugosi, Carradine and Zucco didn't offer three times the chills as hoped, just three times the ridiculousness. Of the trio, Lugosi just about escaped with what was remained of his dignity, while Carradine made a complete fool of himself by pulling stupid faces from underneath a silly haircut. Zucco fared the worst of the three as he was forced to don a "voodoo" costume comprised of a feather

headdress, a bone necklace and star-spangled cape and intone solemn prayers to the god Ramboona.

"It has been obvious for some time that if Bela 'The Mad Doctor' Lugosi, John 'The Mad Scientist' Carradine and George 'The Mad Man' Zucco kept it up long enough they would be reduced to utter absurdity," wrote the *New York Post*'s reviewer. "Now the obvious has come to pass. They kept it up."[55] Worse still, it was patently obvious that the zombie plot was actually little more than an excuse for Monogram to parade a selection of its starlets for the gratification of the (male) audience. As Peter Dendle succinctly puts it, "Marlowe's experiments amount to a veritable machine for female objectification, with women going in one end and women's bodies coming out the other."[56]

Voodoo Man signalled the beginning of the end for Monogram's horror output. Although there were rumours of another Mantan Moreland movie - *When Zombies Walked* - nobody's heart was in it anymore. The reviewer at the *New York Daily News*, got it right when he summed up *Voodoo Man* by commenting that the film wasn't merely content "to portray zombies; it gives the impression of having been made by them."[57] Harsh words, but in respect of so many of Monogram's living dead films, it was unquestionably true.

III. Val Lewton: A Touch of Class

RKO Pictures may have been in a totally different league than the cheapskates at Monogram but in the 1940s the studio was plagued by financial difficulties. Still feeling the balance sheet pinch after young buck Orson Welles crippled the studio with his expensive commercial flops *Citizen Kane* and *The Magnificent Ambersons*, RKO was in desperate need of new ideas to rescue it from its growing stream of creditors. So, the RKO horror unit was set up in 1942 with just one aim in mind: profits.

The horror unit's remit was to make sensational chillers on a tight $150,000 budget per film. In comparison with the Poverty Row studios, this was blockbuster funding, although in mainstream Hollywood terms it amounted to little more than small change. The only artistic input the studio heads had over the productions was the list of titles - *The Leopard Man*, *The Body Snatcher*, *Bedlam* - that they issued in expectation of some suitably exploitative pictures. Heading the unit was producer Val Lewton, poached from MGM.

According to Lewton's own self-deprecating (and probably apocryphal) account, he'd been headhunted by RKO because someone had told them that he was the author of several "horrible novels". Mishearing their informant, the RKO executive thought Lewton was a horror novelist and offered him the job. For Lewton, a well-educated, impeccably mannered Russian immigrant, horror films were the last things he wanted to be involved with. Completely uninterested in the genre, he even dismissed the monsters of Universal's classic horror movies as a collection of "mask-like faces, hardly human, with gnashing teeth and hair standing on end".[58]

Despite his qualms, Lewton was smart enough to realise that heading up the horror unit might be his best chance to show Hollywood what he could do. Giving up his job as David O. Selznick's story editor at MGM, he accepted RKO's offer and set about twisting the unit's remit so that it suited his own agenda. "They may think I'm going to do the usual chiller stuff which will make a quick profit, be laughed at and forgotten," he told his friends. "But I'm going to make the kind of suspense movies I like."[59]

Over the next four years, Lewton produced nine low-budget films at RKO: *Cat People* (1942), *I Walked with a Zombie* (1943), *The Seventh Victim* (1943), *The Leopard Man* (1943), *The Ghost Ship* (1943), *The Curse of the Cat People* (1944), *Isle of the Dead* (1945), *The*

Body Snatcher (1945), and *Bedlam* (1946). All of them were invariably *not* what the RKO studio executives had expected. Instead of Universal-style creature features, Lewton delivered remarkably restrained, hauntingly poetic movies. It was highbrow horror, not bargain basement shocks.

The RKO executives realised that they were getting far less than they'd bargained for as soon as the unit's first production *Cat People* was unveiled in 1942. The studio wanted a schlock horror tale about subhuman cat creatures. What they got was an understated psychological thriller about a woman who believes she'll turn into a leopard if she has sex. Replacing sensationalism with a set of low-key chills, *Cat People* should have spelt the premature end of Lewton's career as a producer. Except that audiences flocked to see the picture, making it a huge success.

In *I Walked with a Zombie*, Lewton tried to replicate much the same blend of psychological horror, hysteria and eerie atmosphere. Teaming up with director Jacques Tourneur, the producer returned to the zombie's Haitian roots. Lyrical, creepy and thoroughly unsettling, *I Walked with a Zombie* single-handedly thrust the living dead into the canon of critically acclaimed cinema. By exploring the thematic and symbolic potential of the zombie, Lewton rescued the living dead from the purgatory of Poverty Row once and for all.

The RKO executives had taken the title "I Walked with a Zombie" from an *American Weekly* article by Inez Wallace. Although it was an uninspired piece of journalism, Wallace's article was significant - at least in terms of the zombie's cultural standing - because it returned to the voodoo-fixated anthropology of Seabrook's work. Cribbing almost all of his material from *The Magic Island*, Wallace shamelessly recycled that earlier book's catalogue of voodoo history, anecdotes about the living dead, references to Article 249 of the Haitian penal code and descriptions of zombies as (rather inevitably), "dead men working in the cane fields". Passing itself off as a first-person confession about walking with zombies, Wallace's article was little more than a blatantly sensational piece of pulp anthropology that owed as much to movies like *Ouanga* or *White Zombie* as it did to serious research. To anyone familiar with Seabrook's book it was obvious that Wallace had never even set eyes on a zombie, let alone walked with one.

The article inadvertently ended up establishing a rather strange opposition between its attempts to convince the reader that the zombie was a reality and Wallace's own ignorance and lack of first-hand knowledge of the subject he was writing about. While it's clear that this oscillation between fact and fiction, truth and ignorance, the real and the imagined is an unfortunate (and unplanned) result of Wallace's limitations as a writer, the article actually ends without having kept the promise implied in its title. The author doesn't walk with zombies. What's more, he fails to offer any evidence of their existence other than a collection of second-hand stories which we're asked to believe are true because they come from "the lips of white men and women whose word I can not doubt".[60] For all its claims to offer first-hand reportage about the existence of the living dead, Wallace's article ends without having proved (or disproved) anything. The zombie remains a completely unknowable figure.

As far as the moneymen at RKO were concerned it was the perfect title for the kind of gutsy, lurid horror movie they were after. What Lewton took from Wallace was more than just the article's title, though. The finished film mimics Wallace's uncertainty and hesitation, absorbing the inherent paradoxes between the clash of knowledge and ignorance found in the article. Taking this as its starting point, *I Walked with a Zombie* interrogates the limits of truth and, in a spectacularly breathtaking move, elevates the zombie into an image of entropy, confusion and empirical impotence. It gave the living dead a seriousness that few cinemagoers of the period - jaded by Monogram's inane efforts - were expecting.

During pre-production for *I Walked with a Zombie*, Lewton told his staff to gather as much information about voodoo as possible. "We were all plunged into research of Haitian voodoo, every book on the subject Val could find," recalls Ardel Wray, one of the younger members of the horror unit.[61] It was a period of study that left Lewton immensely dissatisfied with the script that had been turned in by Universal scribe Curt Siodmak. The nervous studio executives had foisted the screenwriter on him in the hope that some of Siodmak's pulp style - his previous projects included *The Wolf Man* (1941) - might rub off on Lewton. It didn't. Over the following weeks, the producer and his team put the original draft through multiple rewrites, transforming the story into a Caribbean-set version of *Jane Eyre* and completely changing its focus.

The filmed script opens with a long shot of two figures walking along a deserted beach as the voice-over narration from Betsy (Frances Dee) starts: "I walked with a zombie [laughs]. It does seem an odd thing to say. If anyone had said that to me a year ago I'm not sure I'd have known what a zombie was. I might have had some notion that it was strange or frightening, even a little funny. It all began in such an ordinary way…"

Initially, this opening appears to be the first half of a fairly conventional framing narrative. The couple on-screen don't mean anything to us - the figures are too far away for us to make out who they are - and the rather silly confessional tone, complete with its embarrassed attempt to dismiss the word "zombie," punctures any expectations we might have had about the title's promise. The first audience to see the film at a special preview in the Hawaii Theatre in Hollywood in 1943 reportedly "tittered" at this opening line though by the end of the film they were "much impressed".[62] Perhaps they would have laughed

Cinema's most majestic zombie: Betsy (Frances Dee) confronts Carrefour (Darby Jones) in a classic scene from **I Walked with a Zombie**.

even louder if they had noticed that the wording of the traditional disclaimer had been altered: "The characters and events depicted in this photoplay are fictional. Any similarity to actual persons living, dead or *possessed* is purely co-incidental".

This opening sets up certain expectations that are deliberately left unfulfilled. First of all, the framing narrative doesn't actually "frame" since the story ends without a return to Betsy's voice-over (an unspecified narrator delivers the film's sombre concluding lines). By the time the credits roll, we realise that the couple walking along the beach at the beginning are in fact Betsy and the main zombie, Carrefour. However, nothing in the film explains when, where or how such a stroll along the sand could have come about. What's more, the film never answers the question of what a zombie actually is - nor what it means to walk with one. Few cinematic openings promise so much and yet deliver so little.

The story of *I Walked with a Zombie* focuses on Betsy, a young nurse who travels out to the island of San Sebastian to take care of Jessica (Christine Gordon), the invalid wife of American plantation owner Paul Holland (Tom Conway). When she arrives on the island, Betsy slowly learns the story of Jessica's illness. According to the locals, Jessica has been turned into a zombie, but the Holland family doctor claims this is nonsense and that she

is simply suffering from the irreversible effects of a rare tropical fever that burnt out portions of her spinal cord and left her "a sleepwalker who can never be awakened".

As Betsy settles into her new job, she begins to fall in love with Jessica's husband, Paul. She's also courted by Paul's half brother, Wesley Rand (James Ellison). The more she enquires into the circumstances of Jessica's illness, the more she learns about the Holland family, including the local rumour - turned into a calypso song - that Wesley and Jessica had an affair and were planning to run away together before she fell ill.

Desperate to help Jessica, even though she's actually deeply in love with the invalid's husband, Betsy asks the doctor to try an experimental treatment she's heard about. It doesn't work and so, in an act of desperation, Betsy leads Jessica out to the island's houmfort (voodoo church), where she hopes to find some alternative cure for her condition. Taking Jessica through the cane fields and surviving an encounter with Carrefour, the local zombie, Betsy is shocked to learn that the houmfort is run by Mrs. Rand (Edith Barrett), the mother of Wesley and Paul. It transpires that she's been dabbling in voodoo in order to win the islanders' trust and give them access to Western medicine.

Jessica's appearance at the houmfort causes a commotion among the islanders who - for reasons that are never explained - want to keep this white zombie for themselves. After Betsy takes Jessica back home to Fort Holland, one of the local voodoo sorcerers sends Carrefour to abduct her. When that fails, he casts a spell over Wesley. Later, when Wesley hears that Jessica is to be sent to an asylum on the mainland in the hope of calming the locals, he decides to take matters into his own hands. He leads the sleepwalking Jessica down to the beach and kills her and then himself. Was he bewitched or simply wracked with guilt and desperation?

Released in 1943, *I Walked with a Zombie* was quite unlike any other film that had previously featured the living dead. Abandoning the more straightforward horror aims of films like *White Zombie* and contemporary Poverty Row chillers, Lewton's picture returned to the zombie's voodoo origins. Completely ignoring every living dead film that had gone before it, Lewton built up a heady mix: repressed sexuality, a philosophical meditation on the limits of knowledge, and a visual style that bordered on the poetic in its beautiful play of light and shadow.

The two zombies in Lewton's film - Jessica and Carrefour - mark a break with previous cinematic interpretations of the walking dead in that they are resolutely passive figures. Although they never attack anyone, they're still terrifying creations. Trading visceral shocks for a more cerebral set of terrors, *I Walked with a Zombie* succeeds by challenging our cherished certainties about the world we live in and our place in it. Wallace's article was unable to prove or disprove the

existence of the zombie; Lewton's film turns such uncertainty into the stuff of nightmares.

The predominant theme of the film is mis-seeing. Drawing on the Gothic literary tradition, *I Walked with a Zombie*'s heroine is a naïve nurse who is, as Paul Holland points out, so "afraid of the dark" that she mistakes everything she sees for something else. Nothing in the film is what it seems: a puff pastry brioche looks like a huge meal but is just a thin shell of pastry full of air; the island's jungle drums sound threatening, but are actually nothing more than "San Sebastian's version of the factory whistle". As Paul Holland gruffly tells Betsy during the sea crossing to the island, "everything seems beautiful because you don't understand".

It's not only Betsy who proves to be an unreliable judge of appearances, though. No one is fully able to explain Jessica's condition: the doctor thinks it's the result of a tropical fever, Paul thinks he may have driven her mad and Mrs. Rand thinks that she unconsciously placed a voodoo curse on her. The myriad explanations for both Jessica's illness and the island's voodoo rites eventually end up cancelling each other out.

The impossibility of any of these characters (or us) ever finding the truth about the mysteries that surround them is repeatedly worked into the film's visual framework. Tourneur shrouds his characters and locations in a darkness that's as impenetrable as the confusion that envelops the film's textual meaning. He sets up a delicate play of light and shadow that obscures as much as it reveals and makes everything appear different from what it actually is.

Betsy's nocturnal explorations in the fort's tower, where she discovers the sleepwalking Jessica, are a prime example of this skilful intersection of form and content. Her confusion (has she really heard a woman crying?) is matched by the camera's slow, disorientating glide up the spiral stone staircase and by the subtle lighting, which ensures that each frame is filled with more darkness than light. Every aspect of the film is pervaded by "uncertainty, ambiguity, [and] the reversal of expectations," according to film historian Robin Wood.

The film's shadowy, haunting atmosphere is actually an expression of its moral and spiritual world - one in which nothing is fixed or certain, nothing is what it seems. It's a realm subtly dominated by the subconscious, a world of shadows in which we can do no more than cautiously and hesitantly grope.[63]

By employing a variety of distancing devices, the filmmakers underline the manner in which the questions raised by the action of *I Walked with a Zombie* cannot be reduced to simple yes/no, real/unreal answers. The gaps in the film's narrative (including the inexplicable opening shot of Betsy and Carrefour walking together), the lack of a conventional musical soundtrack and the film's steadfast refusal to explain the central conundrum of whether the zombie is real or not, leave us completely at a loss to account for what we have witnessed. Are these events supernatural in origin, or are they perfectly explicable in rational terms? Sidestepping such questions, the film ultimately reaches a point where it gives up the struggle to explain, and surrenders instead to what Chris Fujiwara calls, "a mute acceptance of the inexplicable".[64] Like Betsy's investigations, our own detective work fails to deliver any answers since the world of the film refuses to fit itself into any pattern we can recognise.

As many critics have pointed out, *I Walked with a Zombie*'s hesitation over issues of truth and knowledge owes more to the literary genre of the fantastic than the conventions of the Hollywood horror movie. In the seminal theory of the fantastic advanced by Bulgarian literary critic Tzvetan Todorov, this particular mode is said to be characterised by a hesitation about whether the story's phantoms or apparitions are real or imagined, a hesitation that reduces the reader's sense of certainty in the veracity of events described. As Todorov argues, in the fantastic the worlds of the real and the imagined are so closely intertwined that they're impossible to separate - and so they co-exist together.[65]

In *I Walked with a Zombie*, it's the living dead who embody this sense of hesitation and the attack on the forces of reason, certainty and knowledge that it brings about. Picking up on the unique position of the zombie as a monster that is always caught in a liminal state somewhere between life and death, science and magic,

above: Tourneur's Expressionist shadow play styles the arrival of Carrefour (Darby Jones) as a terrifying waking nightmare in **I Walked with a Zombie**.

opposite bottom: Betsy (Frances Dee) leads zombified invalid Jessica (Christine Gordon) towards the houmfort in search of a cure in **I Walked with a Zombie**.

reason and unreason, *I Walked with a Zombie* builds on the ambiguity that lies at the heart of Wallace's article and transforms its two zombies into powerful symbols of uncertainty, disorder and chaos. Because it refuses to offer an explanation of the events it depicts, *I Walked with a Zombie* demands to be read as an unsettling text - one that challenges our assumptions about the world as an ordered and knowable realm. As such, the film raises surprisingly philosophical questions about the limits of knowledge and employs the figure of the zombie - a monster that cannot be satisfactorily explained in terms of either magic or science - as the central image of this uncertainty.

The first meeting between Betsy and the island's native zombie, Carrefour (Darby Jones) emphasises exactly this hesitation. The filmmakers present the encounter between nurse and peasant, white woman and black man, as the first step on a journey into the realm of the unknowable. Leading Jessica through the dark canefields, armed only with a flashlight, Betsy comes face to face with Carrefour, a gigantic, bare-chested zombie who guards the path to the voodoo houmfort. Illuminating his lithe, towering body with her flashlight, Betsy stares into his cold dead eyes - but finds no answers, only more questions.

It's a meeting that reverses our expectations. Betsy has been warned that she'll only be able to pass this guardian of the crossroads if she carries a voodoo charm. Since she loses the charm on her journey through the canefields, we expect Carrefour to attack her, but he remains resolutely passive. So who is this silent figure? Is he alive or dead? A zombie? Or just a native who's trying to scare her? Nothing in the film answers these questions. When Carrefour later invades Fort Holland - the family's home and the island's last bastion of white authority - we expect violence. But he grinds to a halt like a naughty child as soon as Mrs. Rand calls his name. Later, when Wesley kills Jessica on the beach, Carrefour follows him to the water's edge, but doesn't intervene. In the final scene he helps the fishermen carry the couple's dead bodies - and none of the islanders seem the least bit perturbed by his presence. Without any explanation of who or what he is, Carrefour remains completely unknowable.

Like the voodoo films of the 1930s and the Mantan Moreland zombie movies at Monogram, *I Walked with a Zombie* centres on a clash between the world of white American colonialism and native superstition. Yet unlike those other films, *I Walked with a Zombie* elevates this cultural clash to a central position in the narrative. In doing so, Lewton and Tourneur's film skilfully plays with the zombie's status as a monster that's caught between the opposing states of life and death, body and soul, science and magic. The film deconstructs these opposites, turning the living dead into a metaphor of the limits of (white, western) knowledge.

Whereas earlier zombie films had explicitly used the living dead to suggest the primitive Otherness of the Caribbean and its black populace, *I Walked with a Zombie* turns the focus back on the white world itself. The zombies in Lewton's film are terrifying not because they're the symbols of some primitive culture, but because their existence can't be explained. If First World science can't explain Third World superstition then perhaps white Westerners' belief in their superiority is simply self-delusion. Offering questions but no answers, the empirical puzzle of *I Walked with a Zombie* proved that the living dead had a career far beyond the skids of Poverty Row, for here was a monster that had a rich, yet relatively untapped, symbolic potential.[66]

It was a potential that would remain untapped for years to come. In response to the success of Lewton's *I Walked with a Zombie*, RKO produced an unofficial comedy sequel, *Zombies on Broadway* (1945). Having absolutely nothing to do with Lewton and Tourneur's sublime masterpiece except for the use of the word zombie in its title, this riotous (read risible) outing starred the studio's answer to Abbott and Costello, Wally Brown and Alan Carney. Poaching actors Darby Jones and Sir Lancelot from *I Walked with a Zombie*, the story centres on the attempts of incompetent press agents Jerry and Mike (Brown and Carney), who have to come up with a suitable promotion for the newly opened "Zombie Hut" nightclub or face a painful dressing down from the ex-con manager Ace (Sheldon Leonard, once seen in *Ouanga*). Escaping to the Caribbean, the boys encounter fruity scientist Dr. Renault (Bela Lugosi) and return to the States with a zombification formula that unleashes all manner of allegedly entertaining chaos.

Even by Abbott and Costello's uninspired standards, Carney and Brown were a painfully unfunny comic partnership. As a result, this horror-comedy survives only on the "scary" moments, which director Gordon Douglas sets-up reasonably well. Lugosi's brief appearance leaves most of the chills in the capable hands of Darby Jones who once again proves himself the black and white era's most majestic and terrifying zombie. But for the most part, *Zombies on Broadway* proves two things: firstly, that the zombie concept had become so familiar by 1945 that it could effortlessly provide the basis for such mainstream entertainment and secondly, that the major studios were still finding it impossible to do anything interesting with this particular monster.

By the time the inaccurately titled *Valley of the Zombies* was released in 1946, there seemed little doubt that the potential of the zombie was still eluding filmmakers. This voodoo chiller about an undertaker (Ian Keith) who discovers the secret of immortality in the eponymous valley of the zombies had less to do with the living dead than bloodsucking vampires.[67] It seemed that the zombie was destined to spend many more years on the margins.

chapter four

Atomic Interlude

I. Sci-Fi Horrors

As the shadow of the mushroom cloud fell across the globe, the American horror movie experienced a sudden and unexpected period of change. In a world where scientific progress had given man the power to split the atom and destroy the planet several times over, the terrors of yesterday no longer seemed frightening. Vampires, werewolves, ghosts and zombies were now out-dated; superstition was replaced with science and a new kind of monster was born: it was a modern, nuclear-powered breed against which the old mumbo jumbo of crucifixes, silver bullets and holy water wouldn't be much use.

In *The Beast from 20,000 Fathoms* (1953), *Attack of the 50 Foot Woman* (1958), *The Monster that Challenged the World* (1957) and many, many other titles horror and science fiction began to merge. The Cold War interplay of anti-Communism, nuclear anxiety and fears about extra-terrestrial invasion mutated both genres into something more suited to the period. As a result, horror became science-fictional and science-fiction became horrific, producing a new pantheon of monsters engineered for the specific concerns of the atomic age. Giant ants, spiders, crabs, or dinosaurs suggested the disastrous possibilities of tampering with Nature; alien invaders became inextricably linked with America's anti-Communist anxieties; and apocalyptic sci-fi captured the all-too real possibility of a nuclear holocaust. It was no accident that Universal's original 1930s creature features were sold to the newly emerging television market during the period; they were old-fashioned monsters, small screen terrors from a more innocent age.

According to cultural theorist Mark Jancovich, one of the key shifts that occurred in 1950s sci-fi/horror was a change of emphasis "away from a reliance on Gothic horror and towards a preoccupation with the modern world."[68] As a result of this seismic upheaval in the realm of film nightmares, the "threats which distinguish 1950s horror do not come from the past or even from the action of a lone individual, but are associated with the processes of social development and modernisation."[69]

Part of the reason for this radical change was the momentous array of cultural upheavals that was shaping the West in the wake of the Cold War standoff. But it was also brought about by the huge advances in mass capitalism that were set into motion by the post-war consumer boom - especially the transformation of the social and economic realm through Fordist practices of labour regulation. As America entered a new age of atomic energy, consumerist plenty and Cold War paranoia, Hollywood's sci-fi/horror genre promised to sweep aside the old traditions and deliver monsters that were terrifyingly modern.

This shift threatened to return the zombie to the cultural graveyard once and for all. Indeed, the 1950s proved to be the worst decade for the production of films about the living dead with only a handful of - often not particularly memorable - zombie films being produced during these years: *Scared Stiff* (1952), *Creature with the Atom Brain* (1955), *Invasion of the Body Snatchers* (1956), *Teenage Zombies* (1957) *Voodoo Island* (1957), *Womaneater* (1957), *Zombies of Mora Tau* (1957), *Quatermass 2* (1957), *Plan 9 from Outer Space* (1958) and *Invisible Invaders* (1959).

Hindsight is a wonderful thing, though. Looking back, it's clear that the 1950s proved to be a transitional period in the zombie movie's history. While many of the decade's living dead outings were shoddy, trite or just plain boring, they marked a decisive change in the genre's dynamics. It's in these films that the issues of voodoo, race and colonial anxiety were supplanted by fears of invasion, of brainwashing and mass apocalypse. Taking the living dead out of the Caribbean and placing them firmly in the realm of atomic America, this handful of films initiated the dawn of the dead and paved the way for George Romero's landmark *Night of the Living Dead* (1968).

Back from Davy Jones's Locker: some nautical ghouls in **Zombies of Mora Tau**.

II. Voodoo's Last Gasps

Such exciting changes didn't happen overnight. Still haunted by the spectre of *Zombies on Broadway*, one of the first films of the 1950s to return to the living dead was little more than a rather blatant - and painfully unfunny - remake of *The Ghost Breakers*, which replaced Bob Hope and Willie Best's interracial partnership with the whitebread comedy of Dean Martin and Jerry Lewis (the latter taking Best's role).

Abbott and Costello may have had enough sense not to joke around with anyone other than Dracula, Frankenstein or the Wolf Man, but in the search for quick gags, the screenwriters of *Scared Stiff* (the title itself is a dreadful pun) weren't so prudent. Stealing the director, the plot and the Cuban setting wholesale from *The Ghost Breakers*, *Scared Stiff* may have been one of the biggest grossing movies of 1953 but it didn't have the imagination to come up with a frightening villain (the zombie barely gets a look in), making its title spectacularly redundant.

In terms of redundant titles, however, few films could compete with Fred C. Brannon's *Zombies of the Stratosphere* (1952), a story about a group of evil Martians conspiring to knock the Earth out of its orbit so that their home planet can take its place. Conceived as a twelve-part serial sequel to the director's *Radar Men from the Moon* - released earlier that same year - *Zombies of the Stratosphere* is notable for starring a young Leonard "Mr. Spock" Nimoy but little else.

Featuring lots of jetpack footage lifted from Brannon's earlier *King of the Rocket Men* (1949), several laughable spaceships, robots that looked like hand-me-downs from the previous decade, and absolutely no zombies whatsoever, Brannon's film should have been sued for misleading advertising. The extra-terrestrials are only once referred to as "zombies," though for no discernible reason other than to make an already incomprehensible plot even more confusing. Chopped down into a seventy-minute feature film in 1958, and released under the equally inappropriate title of *Satan's Satellites*, the *Zombies of the Stratosphere* serial suggested that the living dead would have to adapt quickly to the decade's obsession with science fiction if they wanted to survive in any recognisable shape or form.

Not every horror filmmaker was far-sighted enough to realise the necessity of such changes. The year 1957 proved a bumper one for voodoo-themed zombie films: *Voodoo Island*, *Womaneater* and *Zombies of Mora Tau*. These three low-budget efforts offered audiences an uninspired and largely unwelcome alternative to the sci-fi trappings of standard B-movie fare. They had a spectacularly short screen life, going up against Universal's creature feature *The Deadly Mantis,* Roger Corman's extra-terrestrial *Not Of This Earth*, and the atomic-anxieties of *The 27th Day* (all 1957).

These films' stale reliance on voodoo and the supernatural was evident to everyone involved in them. For Aubrey Schenck, producer of the Boris Karloff vehicle *Voodoo Island*, the film proved to be an obvious flop: "I only have memories of *good* pictures," he told an interviewer when asked about the project in 1996. "That [film] was a lost cause. But, hell, you take a chance. With Karloff's name we thought we had a good chance, but it didn't work out. I'm not proud of that picture."[70] If horror fans couldn't be suckered into a picture that had Karloff as top billing, the writing was clearly on the wall for the supernatural scares of yesteryear.

Shot on location on the Pacific island of Kauai, *Voodoo Island* has little to recommend it other than its exotic locale. Investigator Phillip Knight (Karloff) is sent by the owner of an American hotel chain to an island in the South Pacific that is reportedly cursed. A crew of engineers and architects who were on the island drawing up plans for a new hotel complex have disappeared. The only surviving member of the group has returned home to America as a zombie and is unable to do anything except stare straight ahead with wide, bulging eyes.

At first, Knight and his research assistant Sarah Adams (Beverly Tyler) believe it's all nothing more than a canny publicity stunt to promote the island's new hotel. On setting out to the tropical paradise they begin to think differently, though, as the expedition runs into a series of mishaps all of which appear to be directly linked to the voodoo death charm that's discovered on the deck of their boat. After man-eating plants, voodoo-dolls and a group of natives who have been chased out of their homes by the ever-encroaching world of white industrialisation have taken their toll on the expedition, Knight concedes that there might be some truth in the zombie myth after all.

The clash between white, Western science and native superstition is the focus of *Voodoo Island*'s narrative, suggesting that its terrors are closely bound to

Would you buy a hotel from this man?
Dr. Knight (Boris Karloff) examines one of the zombies of **Voodoo Island**.

colonial anxieties. However, screenwriter Richard Landau, who had earlier co-written the first *Quatermass* adaptation for Hammer, also links these fears into the film's sexual politics. It is Adams, Knight's pretty young assistant, who bears the brunt of much of this. Described by rakish ship's captain Gunn (Rhodes Reason) as a "push button control system," who is only one step away from becoming a "machine," Adams is explicitly styled as the film's second zombie: "[Are you] something so crammed full of facts and figures, names, dates and places, reports, typing up Knight's lectures that you've no room left inside to be like a woman?" Gunn demands of her with characteristic tact.

Gunn has clearly fallen for the secretary, but he's perturbed by her apparent lack of emotion and her overtly scientific outlook on life. He's already reeling from the fact that Winter (Jean Engstrom), the group's other female member, rejected his advances. An older, more sexually confident woman, Winter is no stranger to the pleasures of the flesh - stripping off to bathe in a jungle pool and generally vamping her way across the island. Armed with all the frostiness that her name suggests, she's seemingly immune to Gunn's charms, leading him to suspect that she may be a lesbian with the hots for Adams.

Both of these women prove more threatening to Gunn than anything on the island, even the zombies. Adams is a woman who wants to possess the cold calculating mind of a man; Winter is a woman who refuses heterosexuality. One can understand then why Gunn - with his phallic, masculine name - feels under siege. He prevails of course, conquering the island and the women with aplomb. Adams is turned into a "real" woman, swapping the masculine world of facts and figures in favour of a life of settled domesticity. Meanwhile Winter proves to be beyond salvation and is eaten by the jungle's carnivorous plants, flora that look like botanical versions of the *vagina dentata*. Clearly it is only by containing the feminine that the threat of the island - and its inhabitants' ability to turn white men into passive, feminised zombies - can be overcome.

At least the presence of a major star guaranteed *Voodoo Island* some slight box office return. Other projects were less fortunate. In the British production *Womaneater*, director Charles Saunders didn't have a single star name to bolster his ailing picture - a real handicap since *Womaneater* was desperately in need of something (in fact, anything) to compensate for its utter lack of the one essential ingredient any zombie movie needs: a halfway decent zombie. The story of a scientist (George Coulouris) who resurrects his dead maid with the help of some dubious botanical chemistry that he's picked up from an Amazon shaman, *Womaneater* featured some strange scenes of women being fed to a carnivorous plant (clearly a trend had been set) but not much to satisfy horror fans' appetites.

Mona (Allison Hayes, centre) leads the **Zombies of Mora Tau** onto dry land.

On the basis of these two flops it was clear to even the most enthusiastic producers that horror in general and the zombie movie in particular had out-grown the voodoo-focused films of the 1930s and 1940s. If it wasn't atomic and didn't glow in the dark, it wasn't going to sell. Even the most imaginative voodoo thriller of 1957 - *Zombies of Mora Tau*, released in the UK as *The Dead That Walk* - couldn't overcome the fact that audiences weren't interested in any expeditions that didn't involve rocket ships or nuclear power.

Set in West Africa, *Zombies of Mora Tau* marked not only a return to the zombie's voodoo roots, but also a clever relocation of voodoo itself, tracing the religion back from the Caribbean to its West African origins. The screenplay's inventiveness didn't stop there: with underwater ghouls and a radical reworking of the basic zombie myth, Edward L. Cahn's film promised so much. More in fact than it could actually deliver. *Zombies of Mora Tau* may have been better than producer Sam Katzman's first zombie film - the lamentable *Voodoo Man* (1944) - but not by a very wide margin. It was hampered by being set in an unspecified African locale that is strangely devoid of any Africans, crippled by strained acting, atrocious dialogue and cursed with a perfunctory script.

Young colonial girl Jan Peters (Autumn Russell) returns to her great-grandmother's house on the coast of Africa after finishing her schooling abroad. She's not the only arrival in the tiny coastal village: a team of treasure hunters have dropped anchor in the hope of finding the wreck of the nineteenth-century ship the Susan B.

According to legend, the Susan B sank in 1894 after its European crew stole a collection of diamonds from the local native tribe. The treasure, it is rumoured, is somewhere at the bottom of the ocean.

"They're dead I tell you. They have no morality, no free will. They'll kill anyone who comes for the diamonds," warns Granny Peters (Marjorie Eaton) as she regales the treasure hunters with tales about the zombies who guard the wreck. She claims that the tribe's witchdoctor turned the Susan B's crew into living dead slaves who've been forced to spend eternity guarding the diamonds from greedy treasure hunters.

Naturally, the American expedition led by Captain Harrison (Joel Ashley), his floozy wife Mona (Allison Hayes) and young buck diver Jeff (Gregg Palmer) don't believe a word of it. Not even Granny Peters's talk of the Spanish, Portuguese and British treasure hunters who previously went to their doom can sway them - nor can the old woman's claim that her husband is among the ship's zombified crew. When Jeff's first dive to the wreck unleashes aquatic zombies he begins to have second thoughts about the expedition. However, Harrison is too greedy to care and it's only after his wife is infected by the ghouls that his resolve begins to waver. Even then, his desire for the diamonds is difficult to dampen and Jeff has to save the day by casting the troublesome gems back into the ocean. As they sink without trace, the zombies crumble to dust.

Zombies of Mora Tau was a modest genre entry, but its influence on future productions was more significant than might have been predicted. The film's walking (and swimming) dead are fairly unconvincing: dressed in assorted nautical costumes and draped with the odd strand of seaweed, they lumber after the principal characters, strangling anyone they can get their hands on. Still, they're decidedly creepy, prefiguring the mass zombie apocalypse that would later become a genre staple. Unlike their predecessors, these living dead attack *en masse*; towards the end of the film they storm the treasure hunters' ship and pound on the doors of the barricaded cabin. They're the first cinematic ghouls to be capable of turning their victims into zombies as well, which makes Cahn's film an important milestone in the zombie's on-screen evolution.

At the heart of *Zombies of Mora Tau* is a story about colonial anxiety as the pillaging of West Africa by white Europeans leads to a reversal of the colonial mission. Here it's the natives who subdue and enslave the colonial invaders using voodoo witchcraft. Revolving around issues of contamination, *Zombies of Mora Tau*'s chief horror stems from the fact that the characters are unable to contain the zombie threat. Just as the white crew of the Susan B were unable to dominate the natives, so the new adventurers find themselves at the mercy of zombies who constantly cross the boundaries of life and death, land and sea, inside and outside.

Given such fears, it's no surprise that Mona, the film's blatantly "bad" woman, should be zombified, nor that her male counterparts should imprison her within a perimeter of burning candles (logically, these watery zombies are afraid of fire). In this vision of the world, the failure to keep a tight reign over the Other - whether it be racial or sexual - has disastrous consequences. It is only when the diamonds are cast into the sea that the repressed can be contained as the sign of white, colonial guilt is dispersed into the cleansing waters once and for all.

III. The Mass Destruction of Men's Minds

In his book *An Illustrated History of the Horror Film*, critic and historian Carlos Clarens casts his eye over the films of the 1950s and offers the following argument:

> The ultimate horror in science fiction is neither death nor destruction but dehumanisation, a state in which emotional life is suspended, in which the individual is deprived of judgment. That the most successful SF films seem to be concerned with dehumanisation simply underlines the fact that this type of fiction hits the most exposed nerve of contemporary society: collective anxieties about the loss of individual identity, subliminal mind-bending, or downright scientific/political brainwashing (not by accident the trend began to manifest itself after the Korean War and the well publicised reports coming out of it of brainwashing techniques) [...] The automatoned slaves of modern times look perfectly efficient in their new painless state. From this aspect they are like the zombies of old - only we never bothered to wonder if zombies were happy in their trance. Zombies, like vampires, seemed so incontrovertibly different; the human counterfeits of [...] *Invasion of the Body Snatchers* are those we love, our family and friends. The zombies are now among us, and we cannot tell them and the girl next door apart any more.[71]

While many sci-fi/horror films of the 1950s were dominated by anxieties about the Bomb, there was also another equally fraught Cold War discourse threading its way through the films of the period. Fears about Communist subversion, stoked by the mass hysteria surrounding the witch-hunts led by Senator Joseph McCarthy and the House Un-American Activities Committee (HUAC), were a recurrent theme and in the sci-fi/horror films being produced by the Hollywood studios, invasion narratives proliferated. Martians were a particularly useful metaphor for Communist infiltration and invasion: where else would the Reds come from but the "red planet"?

Not all invasions were military in origin, though. Films like *Invaders from Mars* (1953), *It Came from Outer Space* (1953) and *I Married a Monster from Outer Space* (1958) suggested that the alien threat might be less visible, and therefore more dangerous, than the arrival of conspicuous flying saucers. If it was possible for aliens to take over family, friends and loved ones without them appearing significantly different, then we would have to be eternally vigilant. Like those fifth columnist "Reds under the bed" that Senator McCarthy had whipped America into a paranoid frenzy over, the aliens might already be here among us, subverting the course of democracy and capitalism from the inside.

While reactionary commentators were concerned that America was going to be overrun by Commies determined to enslave the populace, left-wing voices warned that conservative consumer culture was threatening to enslave ordinary citizens in a very different way. As Mark Jancovich claims, the 1950s were equally characterised by "deep-seated anxiety about social, political, economic and cultural developments which led many to argue that America was becoming an increasingly homogenous, conformist and totalitarian society; that the basis of individuality was being eroded and that the possibility of resistance was disappearing."[72] Sociologist William Whyte summed up such fears in his warnings about the rise of the Organisation Man, a living dead worker whose place in the economy was guaranteed "only in exchange for his soul". It seemed that, for many, capitalism was just as capable of producing zombified slaves as extra-terrestrial Communism.[73] Ditching the supernatural, voodoo-related connotations of the walking dead, several films deployed the image of the zombie slave as a metaphor for these Cold War fears about co-option and the loss of individuality.

Concerns about thought control reached hysterical proportions during the decade. Journalist Edward Hunter first coined the word "brainwashing" in a *Miami Daily News* article in 1950. A literal translation of the Chinese "*hsi-nao*" ("to wash the mind"), the concept of brainwashing came to have a special resonance for the American public after the Korean War, when it was alleged that the Communists had coerced American POWs into signing statements denouncing the conflict and America's involvement in it. Dubbed "Manchurian Candidates" after the publication of Richard Condon's 1959 novel, these POWs had apparently been brainwashed by sophisticated psychological techniques involving solitary confinement, sleep deprivation and coercive interrogation techniques.

For the American authorities, and the CIA in particular, the news that the Reds were employing such new-fangled tactics was a major concern. The CIA had been researching their own mind-control techniques, with little success, since the end of the Second World War in top secret projects BLUEBIRD, ARTICHOKE and, later, MK-ULTRA. Eager to answer the question of whether or not it was possible to, in the words of one classified brief, "get control of an individual to the point where he will do our bidding against his will and even such fundamental laws of nature as self-preservation," the CIA commissioned research into special interrogation techniques and the use of psychoactive drugs as varied as magic mushrooms, nitrous oxide, and LSD25.[74]

Some commentators have suggested that the CIA may have played up this alleged brainwashing to increase funding for their often-questionable research into mind-

control techniques: Edward Hunter, the journalist who first brought "brainwashing" to the American public's attention, was a CIA operative; more suspiciously, no British or Turkish POWs were reported to have suffered the same treatment in Korea as American servicemen. Whatever the truth, there's no doubting the impact that the *idea* of brainwashing had on the American public. Stories about mind-control and mental slavery cropped up everywhere, mirroring the public's paranoid fears.

The zombie was the perfect monster to encapsulate such anxieties about the loss of individuality, political subversion and brainwashing. Several films - including *Creature with the Atom Brain* (1955), *Invasion of the Body Snatchers* (1956), *Teenage Zombies* (1957), *Quatermass 2* (1957), *Plan 9 From Outer Space* (1958), and *Invisible Invaders* (1959) - presented a modern version of the zombie myth, sweeping aside the racial concerns of earlier films in favour of updating the living dead to Cold War America.

In Jerry Warren's schlock drive-in movie *Teenage Zombies*, the links between zombies, insidious mental control and Communism are so clearly delineated that even the most inattentive audience could grasp them. When a bunch of Beatnik kids find a secret laboratory on a deserted island, they uncover a Communist plot to take over the United States by contaminating the nation's water supply with a chemical agent designed to turn the American public into mindless zombie slaves. According to vampy Russian scientist Dr. Myra (Katherine Victor), it's a more effective and less destructive strategy than dropping the Bomb. "With half the people on Earth in this condition we'd have the epitome of civilisation," she smirks as she introduces the kids to her zombie henchman (who's named, rather too appropriately, Ivan). Suddenly Communist science, not voodoo, was capable of creating zombies.

In Don Siegel's *Invasion of the Body Snatchers*, the links between zombification and Communist subversion proved less obvious but far more effective. Based on Jack Finney's best-selling novel of the same name, *Invasion of the Body Snatchers* posits the invasion of the Earth by extra-terrestrial seedpods that are able to grow into exact replicas of any humans they come into contact with. It begins in a small American town where the seedpods replace the local inhabitants with replicas, killing the originals while they sleep. Since the alien replicas look, talk, walk and act like us, it's almost impossible to tell the copies from the original. The only thing that identifies the invaders is their zombie-like lack of emotion.

In *Invasion of the Body Snatchers*, zombification isn't even remotely linked to ideas of the supernatural, voodoo or magic. This is a crisis of individual autonomy that is perfectly suited to Cold War fears of co-option: "Tomorrow you'll be one of us," threaten the invaders as they capture Miles (Kevin McCarthy) and Becky (Dana Wynter). They're promising a new order, a society without pain and misery. Apparently it's nirvana, but for our hero, it's nothing short of the end of the world, the end of mankind and the end of all vestiges of difference.

This is an apocalypse in which zombification occurs on a massive scale. The threat posed by the Body Snatchers isn't confined to just one or two individuals. It's one that's gone beyond individuals, beyond families, beyond the small-town where it starts. It's threatening to engulf the whole of America and perhaps even the world. For the first time since *Revolt of the Zombies* (1936), the idea of the zombie was linked to a global apocalypse. Hardly surprising, then, that the film's most famous sequence occurs when Miles and Becky realise that they're the only two humans left in town. Chased through the streets by a mob of body-snatched townsfolk, they're among the first cinematic characters to experience the terror of being pursued by a zombie horde.

Such fears were clearly not just American in origin. In the UK, the Hammer studio also tapped into this fascination with body snatching and zombification. Reworking popular British radio and television serials for the screen, Hammer's first horror picture was an adaptation of Nigel Kneale's 1953 BBC serial *The Quatermass Experiment*. Playing up its status as the first British film to be awarded the newly created "X" certificate, Hammer's big screen adaptation was entitled *The Quatermass Xperiment* (1955). It became an instant hit in the UK as its horrific tale of an astronaut returning to Earth as a monster caught the public's imagination. The studio was canny enough to realise that a sequel was needed and released *Quatermass 2* in 1957, with American actor Brian Donlevy reprising his role as the eponymous professor.

White-collar zombies want more than a salary rise in **Invisible Invaders**.

Reworking the central theme of *Invasion of the Body Snatchers*, *Quatermass 2* toyed with the same fears of mass brainwashing and zombification in a story about the invasion of the Earth by tiny meteorites that carry an alien parasite. As the meteorites land they crack open, releasing a gas that turns any nearby humans into slaves compelled to work on the invaders' behalf.

After spotting the arrival of this stream of meteorites, Quatermass eventually discovers the aliens' secret facility and realises that they are attempting to recalibrate the Earth's atmosphere to make it suitable for them to breathe. His attempt to blow the whistle on these intergalactic carpetbaggers is hampered by the fact that they've already turned key members of the UK police force, government and military into their slaves.

With its vision of fifth columnists infiltrating Britain's military-industrial complex, *Quatermass 2* voices the same kind of paranoid fears about external influence that were established in *Invasion of the Body Snatchers*. The Cold War tone - emphasised by the coalition of American and British heroes - takes the premise far beyond Siegel's film, further emphasising the underlying links between the invasion and ideas of disease and contagion. The gas released from the meteors leaves plague-like black burns on the skin and allows the alien parasite to take control of the host's body, turning the human victims into creatures that Quatermass explicitly describes as "zombies". In case we're still in any doubt about the dangers or the scope of this infiltration, Quatermass goes on to explain that it produces "an invasion of [the] nervous system. Something is implanted... an instinct, a blind compulsion to act for them." The very real threat is a global apocalypse in which the invaders effect "the mass destruction of men's minds" - robbing us of our individuality and creating a conformist society of mindless slaves.

While *Quatermass 2*, *Invasion of the Body Snatchers* and *Teenage Zombies* used the living dead to work through Cold War fears about subversion, invasion and brainwashing, a small group of other films approached the atomic age from a very different perspective. As we've seen, the movies that link the zombie with brainwashing rarely kept to the zombie's origins as a living corpse, preferring instead to update the idea of "zombification" as a mental rather than physical state. But at least three American movies of the period weren't so shy about making sure that their living dead were actually *dead*. In *Creature with the Atom Brain* (1955), *Plan 9 From Outer Space* (1958) and *Invisible Invaders* (1959), the zombie remained a corpse, albeit an atomic one.

All three of these films are strictly Z-grade fare. Edward L. Cahn's *Creature* and *Invisible Invaders* are vaguely competent low-budget efforts, while Ed Wood Jr.'s *Plan 9* has won the unenviable reputation of being the worst film ever made. However, the way in which they conflate the atomic age with stories of dead men walking is curiously suggestive of the reason why the zombie largely fell out of favour during the 1950s.

Filmed either side of his voodoo movie *Zombies of Mora Tau*, Cahn's *Creature with the Atom Brain* and *Invisible Invaders* diverge remarkably from that old-fashioned voodoo tale, focusing instead on two common Cold War concerns; nuclear energy and extra-terrestrial invasion. Following the adventures of a gangster (Michael Granger) and his scientist sidekick (Gregory Gaye), *Creature with the Atom Brain* stars a gaggle of radioactive zombies that are reanimated as an army of radio-controlled automatons and used to kill their creators' underworld rivals.

Scripted by Curt Siodmak - the screenwriter who produced the first draft of *I Walked with a Zombie* - *Creature* is pure nuclear schlock complete with plenty of sci-fi gizmos: clunking radiation suits, chirruping Geiger counters and a bizarre wind tunnel contraption that the villains have to clamber through before using their radioactive material. For all its high-tech trappings, though, the film is blatantly sceptical of the benefits of atomic power. Its nuclear scientist is an ex-Nazi and it repeatedly emphasises the dangers of radiation sickness and exposure.

Perhaps that explains why the film is so fascinated with the bodies of its zombies. In the final reel showdown between the local police department and the zombie army, Cahn delights in the chaos, letting the bullet-scarred faces of his zombies loom menacingly into the camera lens while other scenes focus on the

Phillip Scheer's distinctive make-up turns the **Invisible Invaders** into radioactive corpses for the atomic age.

corporeality of these radioactive living dead whose foreheads boast nasty looking brain surgery scars.

Meanwhile, in *Creature with the Atom Brain*'s subplot, the crusading Dr. Walker (Richard Denning) takes time out from his pursuit of the nuclear corpses to keep his cute little daughter from discovering the realities of death. He makes up a cock and bull story about why her favourite copper, Captain Harris (S. John Launer), won't be coming to visit her anymore (he's been turned into a zombie). The importance of this silly aside is pretty transparent: this is a movie about the fear of death in the nuclear age.

In Cahn's third zombie film, *Invisible Invaders*, this theme is developed further. Invading extra-terrestrials plan to take over the bodies of the dead and use them as shock troops in the battle to destroy humanity. The invasion is tinged with nuclear anxiety: the extra-terrestrials claim that our new-found atomic ability has become too much of a threat to the rest of the galaxy. Fortunately, a lone band of scientists and military personnel (including Philip Tonge and John Agar) eventually stop them by using high frequency sound waves, but that's not before Cahn conjures up the image of an army of corpses - dressed as white-collar professionals - rising up around the globe to suppress the living. It's an idea that's played out again in *Plan 9 from Outer Space* where the extraterrestrials spend most of their time in a graveyard, recruiting new foot soldiers for their zombie army.

What's so intriguing about these three films is the way in which they link their walking corpses with Cold War concerns about nuclear power and invading aliens. Fixated by the idea of a global apocalypse dominated by a mass of dead bodies, they make explicit, however unwittingly, the realities of a nuclear war: a mountain of corpses. It's something that few other horror/sci-fi movies of the period - with their campy bug-eyed monsters, flying saucers and mutant creatures - were able or willing to confront.

In retrospect, one wonders whether the general disappearance of the zombies during the 1950s - and their later return in the 1960s - was a result of this uncomfortable association between the zombie and death. In a period when death itself was transformed from being personal and individual into an event of global apocalypse, movies about the dead rising up against the living fell out of favour. Facing up to the realities of mass death and destruction - even through the distorted lens of zombie-themed science fiction - was something that few people living in the shadow of the Bomb were willing to do.

Individuality under threat in **Invasion of the Body Snatchers** as Miles (Kevin McCarthy) and Becky (Dana Wynter) run for their lives.

chapter five

Bringing It All Back Home

I. Keeping It in the Family

The landmark horror film of 1960 may not have involved zombies, but it did feature the mummified corpse of a mommy. After all the bug-eyed monsters that had dominated the cinema screens of the 1950s, Alfred Hitchcock's *Psycho* took horror into the heart of the American family with a sadistic audacity that made it an instant success. The film was one of the first expressions of a new kind of horror - a terror which came from "within" rather than from "without," a terror that was already among us, lurking somewhere out on the back roads of America in places as innocuous as the Bates Motel.

While the previous decade's scary movies had taught audiences to watch the skies, *Psycho* warned them to watch their neighbours. If the shy motel clerk turned out to be a schizophrenic transvestite with a penchant for putting mom's kitchen knives to anti-social uses, who could you trust? Your family? Your neighbours? The person sitting next to you in the darkened movie theatre? That Norman Bates seemed so ordinary was what made him so terrifying. He hadn't been turned into a murdering psychopath by alien invaders, Communist infiltrators or atomic explosions, but because of his seemingly ordinary American upbringing. Here was a horror that was internal, that was part of our society, that was part of *us*.

Bringing horror into the home, collapsing the boundaries between the ordinary and the monstrous, and locating the family as the site of terror, the post-*Psycho* horror film frequently challenges our notion of the gulf between the fictional horrors it presents and the everyday world in which we live our lives. "What distinguishes contemporary horror films from a more traditional stage in the genre is that the threat emerges much closer to home," explains film critic Lianne McLarty. "The threat is located in the commonplace and the body is a site/sight of graphic images of invasion and transformation."[75] It is a vision of the horrific in which "the monster is not simply *among* us, but possibly *is* us".[76]

In the previous chapter we saw that this shift from the horror of Them to the horror of Us was something that was already well underway in the zombie-themed movies of the 1950s. Abandoning the racial anxieties of earlier zombie films, these pictures blurred the line between the living and the living dead. As the small-town American setting and doppelgänger scenario of *Invasion of the Body Snatchers* suggested, the monsters might not be readily identifiable as bug-eyed aliens. Much worse - they might look like our friends and neighbours. In many ways, the zombie was perfectly suited to this paranoid fear of the horror within since the living dead looked so ordinary: they looked like us; heck, they once *were* us.

After the string of zombie-themed box office debacles that dominated the 1950s, though, most Hollywood producers wanted nothing more to do with walking corpses. As a result, the early half of the 1960s saw the zombie flourish in various other national cinemas outside America, from Britain to Mexico to Italy. What proved so provocative about these admittedly scrappy international efforts was the way in which they styled the zombie as a symbol of this kind of internal, familial horror.

Steve Parker (Paul Stockman) returns from the dead in **Doctor Blood's Coffin**.

II. Stiff Upper Lips and the Walking Dead

Harold Macmillan in Number Ten, The Beatles singing "I Want To Hold Your Hand", The Profumo Affair hitting the headlines. Britain in the early 1960s seemed like a rather unlikely location for the rebirth of zombie cinema. Yet it was on these shores that three low-budget horror films were shot: *Doctor Blood's Coffin* (1960), *The Earth Dies Screaming* (1964) and *The Plague of the Zombies* (1966). Together they helped bring the moribund genre back from the grave.

Doctor Blood's Coffin dusted off the Frankenstein myth with a grisly story about a young surgeon named, rather appropriately, Doctor Peter Blood (Kieron Moore). After completing his medical studies in Vienna, Blood returns to his home village in Cornwall full of grandiose ideas about reviving the dead through heart transplant surgery. His father, the village doctor, hopes he'll settle down into a career as a general practitioner not realising that Peter has little time for the Hippocratic oath. Systemically murdering the locals after paralyzing them with curare and delving around in their insides, young Doctor Blood continues his harebrained schemes to revive the dead. He's such a cad he even romances Linda Parker (Hazel Court), the pretty young widow who works as a nurse in his father's surgery, while secretly planning to bring her husband back from the dead.

Distributed by United Artists, helmed by Canadian television director Sidney J. Furie and photographed by Stephen Dade (with a young Nicolas Roeg acting as camera operator), *Doctor Blood's Coffin* is very different from the Gothic horror tradition of the Hammer studios. Updating the mad scientist story to the 1960s with impressive efficiency, it's a clinical little movie full of visceral shocks and a lone zombie who sadly only appears well into the film's final reel. It's also an interesting example of the kind of familial horror that was beginning to become fashionable during the period.

Returning to his home village after years abroad, Peter is a classic example of the interloper who disturbs the established order. Upsetting his father's routine and the extended family of the village, he's full of the arrogance of youth. Furie takes pains to ensure that the dangers of his monomaniacal obsession are understood, styling him as a sadistic killer with little sympathy for those he considers beneath his social station. Yet, no matter how evil he is, he's also a part of the community that he's preying on.

The film's zombie is central to this familial dynamic. As Peter reanimates the decomposed body of Linda's dead husband Steve, *Doctor Blood's Coffin* eventually turns into a hysterical psychosexual drama in which Linda is forced to confront the lumbering remains of the man who she once loved: "You haven't brought Steve Parker back to life," she screeches in a blind panic as Blood invites her to meet the decomposed body of his first successful transplant subject, "this is something from hell!". Romancing the widow, Blood has already made her feel guilty about being unfaithful to her dead husband's memory; then he brings the corpse back to life just for good measure. It's hardly surprising that the zombie's reaction isn't to hug his long lost wife but lunge at her in a murderous, inarticulate rage.

Centring on the age-old fear of coming face to face with the dead, *Doctor Blood's Coffin* neatly illustrates the classic Freudian belief that fears about the dead returning to life stem from the living's guilty consciences. In *Totem and Taboo*, Freud claims that the terror of confronting a dead relative is always the result of the "unconscious hostility" that the living project onto the dead, making "the dead man into an enemy".[77] Expanding on this in his essay "The Uncanny," Freud suggests that this fear of the dead is tied to the assumption that "the deceased becomes the enemy of his survivor and wants to carry him off to share his new life with him".[78] As Linda Parker's experience suggests, the return of the dead signifies not only our own fear of death but also our fear of the dead themselves - those who we loved, but were unable to save from the inevitable end. Given such psychological stakes, it makes sense that cinema's zombies are always so bad tempered. Their return to life is always tied up with our guilty assumption that they're here to punish us for our misdemeanours and transgressions.

Such provincial and familial horrors were given a slightly different but equally telling spin in Terence Fisher's *The Earth Dies Screaming* (1964), a sci-fi movie that relocates the premise of *Invasion of the Body Snatchers* and *Invisible Invaders* to the Home Counties using all the production values of an early episode of *Doctor Who*. After an extra-terrestrial gas attack wipes out most of the earth's population, a band of survivors group together in an English country hotel. Robot invaders amble through the streets reactivating the dead to use as "mindless slaves, worse than animals" while the survivors bicker about how to respond to the threat. Unlike *Quatermass 2*, which crisscrossed up and down the country as the aliens began to take over the planet, *The Earth Dies Screaming* limits itself to just a handful of locations. The result of this budgetary penny pinching proves unexpectedly unsettling as the film is forced to focus on the ordinary, the local and the familiar.

The Earth Dies Screaming was actually the first film in a loose thematic trilogy of invasion narratives directed by Terence Fisher and was followed by *Island of Terror* (1966) and *Night of the Big Heat* (1967). While unrelated in terms of plot or character, these three films share the same provincial viewpoint. As critic Peter Hutchings explains, the alien invasion is always "represented on a much smaller scale, often in terms of the domestic and the familial, and played out in isolated settings".[79] Rather than focussing on the attempts of the nation to pull together, each film in Fisher's trilogy centres on a small group of survivors.

The Earth Dies Screaming is more interested in the interpersonal dynamics of the group than the invaders. The scariest moments in the film are the unexpected return of friends and family members such as Violet (Vanda Godsell) and Quinn (Dennis Price) who have been killed and resurrected as zombified slaves. Being invaded by alien robots is one thing, but watching as the dead bodies of husbands, wives and friends are brought back to life is enough to test the stiffness of any English gentleman's upper lip.

While both *Doctor Blood's Coffin* and *The Earth Dies Screaming* were low-budget attempts to cash in on the success of the British horror market that had been revived by Hammer, their appeal was distinctly limited. Rather inevitably, it was an entry from the venerable

above and opposite bottom: "This is something from hell!" Paul Stockman provides some final reel scares in **Doctor Blood's Coffin**.

studio itself that would become the most influential British zombie film of the decade. Director John Gilling's *The Plague of the Zombies* (1966) may not be one of Hammer's best-known films but it's an accomplished piece of living dead cinema nonetheless. Breaking with the zombie's American history it's set in nineteenth-century Cornwall where a country squire is zombifying the local villagers and using them as cheap labour in his tin mine.

Given this distinctly British setting, it's ironic that the production's original treatment owed a fair deal to *The Magic Island*. First announced in 1963 as *The Zombie*, the story was supposed to open in nineteenth-century Haiti with a young English squire playing cards in a disreputable gambling den. After being caught cheating, the squire is chased out into the jungle. Escaping his pursuers, he stumbles across a native voodoo ceremony and learns the secrets of zombification.

On returning to Cornwall, the squire discovers that he has inherited his late father's estate and replaces the staff with Haitian servants from the Caribbean. Not long after this, the village is blighted by a dreadful and unexplained plague that the locals believe - in a plot development ripe for the kind of racial subtext so many American zombie movies of the 1930s and 1940s possessed - is being spread by the Haitian servants. In actual fact, the squire and his servants are killing off the villagers, using their knowledge of voodoo spells and potions to resurrect them as zombie slaves.[80]

Beset by pre-production problems, *The Zombie* fell by the wayside as Hammer concentrated on other projects. In 1965, the treatment was rediscovered, dusted off and given a thorough revision by screenwriter Peter Bryan. It was then shot back-to-back with *The Reptile* (1966) by director John Gilling.

During the course of this redevelopment, the racial focus of the original outline was exchanged for some very different concerns. The filmed version of *The Plague of the Zombies* opens with a voodoo ceremony in which white-robed priests perform some unspecified, but clearly nefarious, ritual. Strangely, the setting isn't the Caribbean but a dank English mineshaft. The film then cuts to London where Sir James Forbes (André Morrell) receives a letter from Dr. Peter Thompson (Brook Williams), a general practitioner in a tiny Cornish village. Thompson's letter is a muddled plea for help; his patients are dying from a mysterious illness and he needs his old teacher's assistance in order to ascertain the cause and outline an effective course of treatment.

Arriving in Cornwall a few days later, Sir James and his daughter Sylvia (Diane Clare) find the village in uproar. The terrified locals believe that the new doctor is responsible for the "plague" that is killing their loved ones. Meanwhile, the thuggish young friends of the village squire terrorise the neighbourhood. Riding through the village streets on horseback during a foxhunt, they carelessly charge through the funeral procession of the plague's latest victim. Sir James and Sylvia look on in horror as the coffin is overturned and a grotesquely contorted corpse is tipped onto the road.

A ragged corpse stretches away his rigor mortis in the brilliant dream sequence of **The Plague of the Zombies**.

After meeting Thompson and his wife Alice (Jacqueline Pearce), Sir James begins to investigate the plague's origins. Ironically, the next victim is Alice, who falls ill with a fever and then wanders out onto the moors where Sylvia sees her attacked by a strange-looking man. Alerting the local police Sir James and Thompson head off to the moors; there they find Alice's body and a drunken mourner from the funeral who takes the blame for her murder. Suspecting far fouler play, Sir James orders the grave of the plague's most recent victim exhumed - and discovers an empty coffin. After Alice's burial, Sir James and Thompson keep watch over the cemetery and see Alice return to life as a zombie. Horrified, Sir James decapitates her with a spade.

Guessing that Squire Hamilton (John Carson) is dabbling in voodoo, Sir James confronts him and realises that the squire has been killing the villagers and resurrecting them as zombie slaves to work in his tin mine. After putting a spell on Sylvia, the squire tries to sacrifice her in a voodoo ceremony but Sir James and Thompson storm the mine to save her. In the fracas, the mine is set on fire, the zombies attack the squire and his henchmen, and our heroes escape as the shaft collapses.

While it would have been exciting to see what Hammer might have made of *The Zombie*'s Haitian setting, Gilling's film is refreshingly original. Abandoning the traditional racial elements of American zombie films and relocating the action to the mannered social hierarchies of nineteenth-century England, the director built on Britain's Gothic heritage: the film borrows liberally from Bram Stoker's *Dracula* and Sir Arthur Conan Doyle's Sherlock Holmes novels, in particular *The Hound of the Baskervilles*.

In keeping with so many of Hammer's films, it's class rather than race that dominates *The Plague of the Zombies*. Uniting Dr. Thompson and Sir James against Squire Hamilton, the film sets its bourgeois heroes against the aristocracy in their bid to save the village proletariat. It's a template that could have been lifted straight from Hammer's many *Dracula* adaptations in which the aristocratic vampire is hunted down and destroyed by a coalition of middle class vampire hunters led by Van Helsing. What's so important about this class theme, however, is the way in which it is intimately tied to the kind of family-based horror that was dominating the films of the period. Squire Hamilton's abuse of his position brings horror into both the extended family of the village and, more importantly, Dr. Thompson's own home.

Revolving around a series of paternal relationships - Sir James and Thompson (mentor/student), Thompson and the villagers (doctor/patients), Squire Hamilton and the villagers (aristocrat/peasants) - *The Plague of the Zombies* focuses on the way in which this Cornish village is ruined by its abusive and manipulative feudal overlord. Instead of caring for those in his charge, the young squire breaks the relationship between the peasantry and the

Haitian voodoo in rural England: **The Plague of the Zombies**.

bourgeoisie, upsetting the hierarchical community of the village and plunging its populace into a state of fear, disease and ruin. Exploiting his charges by turning them into zombie slaves, Squire Hamilton is the bad father whose law is corrupt. His overthrow is an act of social re-organisation that says as much about the post-war Labour government's desire to limit the overreaching power of the aristocracy than anything concerning nineteenth-century Cornwall.

The scene in which Thompson and Sir James encounter the zombified Alice is pivotal to the film's play of familial horror. Coming out of her coffin and walking towards the camera with a slow step and voracious smirk, Alice is transformed from dowdy housewife to lascivious zombie. As Thompson and Sir James recoil from this image of feminine sexual appetite, it's clear that their disgust has more to do with Alice's sexual transformation than her physical reanimation. Much like Lucy's sexualised transformation from virgin to vampire in Stoker's *Dracula*, Alice is an affront to the primacy of male sexual authority and is dealt with accordingly as Sir James - the good father - lops her head off with a spade.

Clearly, the squire's voodoo dabbling has not only wrecked the extended community of the village but also Thompson's own family, forcing him to confront his wife's repressed sexuality. In the film's most memorable moment, a dream sequence in which Thompson watches ragged corpses claw their way out of the ground in the village graveyard, the doctor realises the full extent of the squire's destructive power: this reckless aristocrat has even turned the villagers' ancestral family ties into a site of horror.

Taking the zombie out of the Caribbean and placing it in the provincial world of the British countryside, *Doctor Blood's Coffin*, *The Earth Dies Screaming* and *The Plague of the Zombies* pursue much the same ends. In each, the horror represented by the zombie is local, familial and personal; in each, the chief focus is not on confronting racial difference but the Otherness that lies within the family unit itself. It is a confrontation in which all that was *famil*-iar is transformed into something unrecognisable and horrifying.

above: A mad ghoul makes an incongruous appearance on the moors.
top: Alice (Jacqueline Pearce) loses her head in **The Plague of the Zombies**.

III. South of the Border

Britain wasn't the only country to have recognised the zombie genre's appeal after Hollywood lost interest in the walking dead. A sudden rash of Mexican movies began with *The Curse of the Doll People* (orig. *Muñecos infernales*, 1960) and flourished into a micro-genre of enchilada-flavoured zombie horrors throughout the 1960s. Directed by Benito Alazraki, *The Curse of the Doll People* returned to Haitian soil. Its story followed some unlucky tourists who are cursed by a voodoo priest after they inadvertently witness a secret occult ceremony. They don't realise how much trouble they're in until they're picked off one by one by the "doll people" of the title - murderous animated dolls controlled by the sorcerer's chief zombie, Sabud.

From this inauspicious start, Alazraki tried his hand at more living dead cinema by creating the first in a series of zombie movies starring masked wrestler El Santo (The Saint), who became a popular icon in Mexican cinema during the 1960s. He fought a wide variety of traditional horror personalities - including Dracula and Frankenstein's monster, as well as assorted demons, werewolves and vampires - in a long-running series of comic book adventures that were the mainstay of Mexico's floundering national cinema during the period. In *Invasion of the Zombies* (orig. *El Santo contra los zombies*, 1961), *Santo and Blue Demon Against the Monsters* (orig. *Santo y Blue Demon contra los monstruos*, 1968), *Santo and Blue Demon in the Land of the Dead* (orig. *El mundo de los muertos*; aka *The Land of the Dead*, 1969) and *Santo vs. Black Magic* (orig. *Santo contra la magia negra*, 1972), the masked wrestler faced a veritable army of reanimated corpses. Curiously, the living dead were always ready to rumble.

Other Mexican productions followed Santo's lead. By the far best of the bunch was *Dr. Satan vs. Black Magic* (orig. *El Dr. Satán y la magia negra*, 1967), a high camp horror romp featuring a magician named Dr. Satan (Joaquín Cordero). When he isn't busy battling his archenemy Black Magic (Noe Murayama), Dr. Satan proves he's a real swinger by hanging out with zombie girls dressed in miniskirts and boob-enhancing sweaters. In *Invasion of the Dead* (orig. *La invasión de los muertos*, 1971) Santo's mate Blue Demon battled living dead enemies who were able to drive cars and fly helicopters (it's not half as much fun as it sounds). Finally, in *Isle of the Snake People* (orig. *La muerte viviente*, 1968) an ageing - and seriously ill - Boris Karloff played around with voodoo rites on a South Pacific island. He hoped to create zombies but all he really produced were snores.[81] Given the dubious quality of these later Mexican entries, it's clear that the Santo series was probably the country's biggest contribution to living dead cinema. A sorry state of affairs in anyone's book.

Other international productions took their zombie horrors more seriously. One of the most thoroughly European films of the period was *Dr. Orloff's Monster* (orig. *El secreto del Dr. Orloff*; aka *Brides of Dr. Jekyll*, *Dr. Jekyll's Mistresses,* 1964), a Spanish/French co-production shot by infamous exploitation film director Jesús "Jess" Franco. Franco's on-going services to genre cinema surely require an encyclopaedic reference book of their own. However, the sheer volume of his multifaceted output, together with its questionable quality and slapdash distribution history makes this something that only the most intrepid film historian is likely to undertake.[82] Fusing pretentious artiness, technical incompetence and sleazy exploitation, Franco has become a legend in the history of European horror. His films may be a strange mix of the inept, the ridiculous and the just plain boring, but they're always good fun.

The living dead films of Franco - who was no stranger to the zombie's curious charms - include the surreal family drama *A Virgin Among the Living Dead* (orig. *Une vierge chez les morts vivants*, 1971), a so brief it remains uncredited stint on *Zombie Lake* (orig. *Le lac des morts vivants*, 1980) - during which he vanished during preproduction and was replaced by a bewildered Jean Rollin - and *Oasis of the Zombies* (orig. *La tumba de los muertos vivientes*, 1982).

However, it's Franco's first zombie film *Dr. Orloff's Monster* that's probably his best. It was loosely styled as a sequel to Franco's first major production, *The Awful Dr. Orlof* (orig. *Gritos en la noche*, 1961), which starred Howard Vernon as a scientist terrorising young girls with the help of a blind, bug-eyed zombie-esque automaton called Morpho (Ricardo Valle). In *Dr. Orloff's Monster*, Franco upped the stakes with a similar tale of perversity and Euroschlock that paid far more attention to the existential angst of being dead with a ghoul who was explicitly styled as a zombie.

The film opens with Austrian college student Melissa (Agnès Spaak) travelling out to her aunt and uncle's run-down castle to spend the Christmas holidays. Uncle Conrad (Marcelo Arroita-Jáuregui) is a secretive and quite obviously insane scientist who has inherited some innovative research into "ultrasonics" from one of his late colleagues - the Dr. Orloff of the title. Using this new-fangled technology Conrad - or Dr. Jekyll as he's more infamously known - manages to reanimate the dead. His first test subject is his dead brother, Melissa's father Andros (Hugo Blanco). Jekyll murdered Andros several years earlier, after discovering that Andros was having a torrid affair with his wife. Melissa is totally ignorant of the circumstances surrounding her father's death and his unexpected return to life. She also doesn't know about her uncle's penchant for using his new zombie slave to murder the local good time girls - a foolish indiscretion that eventually leads the police straight to his door.

Kicking off with a surreal montage of shots involving Jekyll, his wife and Andros, *Dr. Orloff's Monster* is chiefly memorable because of Franco's consistent attempts to fashion this cheap zombie film into high art. Employing regular bursts of eye-catching editing and unusual camera angles Franco desperately tries to disguise the fact that this is actually little more than a risqué exploitation movie. The fact that the zombie spends most of his time pursuing strippers and streetwalkers gives the game away, though.

In keeping with Franco's pretentious artiness, Hugo Blanco proves to be one of cinema's most refined ghouls - a black-suited cadaver whose face is horrendously scarred and whose hands are always clad in leather gloves. He actually looks as though he'd be happier sitting in a Parisian Left Bank café sipping espresso and reading Sartre than stuck in this cheap B-movie. A few years later, Franco would return to this chic style for his espionage movie *Attack of the Robots* (orig. *Cartes sur table*, 1966) featuring robotic assassins dressed in similar black suits and turtle-necked jumpers.

When Andros finally escapes Jekyll's control and disappears into the night, the police ask Melissa to help them find him before he kills again. How she'll be able to find him better than anyone else isn't explained, but it does allow Franco to set up some *faux*-pathos as daughter lures zombified father to his doom. He dies with a supposedly poignant "*pourquoi?*" on his lips.

While the international appeal of the zombie during this period was a long way from rivalling the explosion that

occurred in the early 1980s, it was in films like *Dr. Orloff's Monster* that European cinema discovered the living dead's potential, paving the way for the genre's later success in the Italian and French markets. In Italy, the "peplum" boom - named after the tunics that dominated the wardrobes of these sword and sandal epics - was running short on ideas. Giuseppe Vari's magical epic *War of the Zombies* (orig. *Roma contro Roma*, 1964) spiced up its rather conventional storyline with a battalion of living dead soldiers being resurrected by John Drew Barrymore's evil sorcerer.

Determined to force the Roman Empire to its knees, Barrymore sets "Rome against Rome" as the literal translation of the film's Italian title attests. Only briefly toying with the psychological horror of soldiers fighting the reanimated remains of their dead comrades, *War of the Zombies* proved more interested in putting together spectacular battle sequences in which zombie soldiers fought living infantry. It proved the quip that old soldiers never die - they just go to hell to regroup.

Few other Italian productions of the period could offer anything quite as spectacular. Massimo Pupillo's *Terror-Creatures from the Grave* (orig. *Cinque tombe per un medium*, 1965) told the story of a medium who returns to life after being killed by his adulterous wife (Barbara Steele). Despite a number of gruesome set pieces including a wheelchair-bound protagonist rolling himself onto a sword blade and various amputated limbs coming to life, *Terror-Creatures from the Grave* suffered from an abundance of Gothic atmosphere that was all build up and no climax, leaving it distinctly lacking in any "terror".

Perhaps the most important European film of the decade was an Italian-American co-production directed by Ubaldo Ragona and Sidney Salkow called *The Last Man on Earth* (orig. *L'ultimo uomo della terra*, 1964). The film secured a Stateside release thanks to the intercession of American International Pictures (AIP), who were encouraged by the presence of their favourite actor Vincent Price in the lead role. Adapted from American author Richard Matheson's classic vampire apocalypse novel, *I Am Legend* (1954), *The Last Man on Earth* proved far more influential in America than its bilingual production history might have suggested. Although it is ostensibly a vampire movie, its bloodsucking ghouls would have a significant impact on Romero's zombie cinema.

The Last Man of the title is Robert Morgan (Price), a scientist caught up in a global plague that wipes out the entire human race and leaves a mere handful of vampires in its place. Through some strange quirk of fate, Morgan is the only human survivor. Desperate to drink his blood, the half-witted, lumbering vampires congregate around his barricaded house every night moaning, "Come out Robert!" in a vain attempt to entice him to leave his fortified abode.

The face of death: some ghoulishly brilliant make-up in **Terror-Creatures from the Grave**.

Since the vampires can only emerge after sunset, Morgan is free to roam the empty city streets by day, searching for fellow-survivors and supplies while killing as many of the sleeping ghouls as he can before night falls again. Each morning he loads up his car and drives out to the still-burning plague pit that lies on the city's outskirts to dump his most recent kills into the flames. It's a hellish existence and as Price's cracked voice-over threatens to spill over into outright hysteria, we begin to appreciate the horror of Morgan's dreadful loneliness as the only uninfected human being left alive.

With its urban locale (shot in Rome for Los Angeles), deserted streets and mounds of corpses, *The Last Man on Earth* is directly related to the atomic anxieties that dominated the previous decade. Yet, there's more to this tale than simply a presaging of nuclear doom. Morgan's situation is made all the more terrifying because he is forced to confront ghoulish creatures who were once his neighbours. His chief antagonist is Ben (Giacomo Rossi-Stuart) a former friend and colleague who was also the only scientist to guess that the plague was turning its victims into vampires. In a flashback we see that Morgan dismissed Ben's far-fetched - but ultimately accurate - theory out of hand in a moment of arrogance that only helped hasten the apocalypse. As a constant reminder of his own culpability and failure Ben is more than just another ghoul, which is why Morgan projects all his impotent anger onto him: "When I find him, I'll drive a stake though him just like all the others," he promises with grim determination.

Confronting past friends and neighbours is admittedly difficult, but the greatest horror is coming face to face with relatives and loved ones. The scene in which Morgan encounters his dead wife is as unsettling as any in the film. Refusing to believe that his wife would return to harm him, Morgan decides not to incinerate her body in the plague pit and buries her in the backyard instead. No sooner has she been laid to rest than she's back from the grave, eager to drink his blood. He's left with the unenviable responsibility of dispatching her reanimated corpse again with a stake. It's a disturbing sequence that underlines the ways in which the apocalypse of *The Last Man on Earth* is one that's played out in the local community and (quite literally) Morgan's own backyard. In the process, the benign world of American suburbia is turned into a nightmarish realm of abject horror.

What makes *The Last Man on Earth* so important in the development of the zombie genre's obsession with family-based horror is its attempt to challenge the line between Us and Them. While searching the city streets, Morgan discovers that he's not the only person to have survived the plague. In addition to the lumbering, imbecilic vampires, there's also a small section of the populace who have managed to retain their higher mental functions. Forced to spend all day in the shadows, these

I hear you knocking, but you can't come in... Robert Morgan (Vincent Price) fends off the hordes in **The Last Man on Earth**.

infected survivors have set up an alternative post-apocalyptic society, a new order in which Morgan's immunity to the plague is seen as an aberration rather than a stroke of luck.

During his daylight raids on the sleeping vampires - a series of which we see in a short montage sequence where Price bursts into apartments armed with a hammer and stake - Morgan has been inadvertently killing members of this new order, mistaking them for ghouls when they're actually something else: a new breed of humanity. As the film draws to a close, these survivors hunt Morgan down. They're convinced that *he* is the real monster of this post-apocalyptic world.

"You're a legend in this city," explains Ruth (Franca Bettoia) the infected girl sent to assassinate him. "Living by day instead of night, leaving as evidence of your existence bloodless corpses - many of the people you destroyed were still alive." Inverting the vampire dynamic so that it's Morgan who seems abnormal, the film erodes the line between "Them" (the monsters) and "Us" (humanity).

In the final sequence, Morgan is chased into a church by an army of black-uniformed, machinegun carrying vampire soldiers. "Freaks! All of you!" he screams as they open fire, "I'm a man, the last man!" His bullet-strewn body collapses on the church altar with pointed symbolism, yet Morgan's potential role as the messiah is significantly undermined as this version of *The Last Man on Earth* turns him into a scapegoat and he becomes messiah and monster simultaneously. The result is a film that challenges us to reassess where the Self and the Other begin and end.[83]

Whatever the film's faults - and there are many, chief among them being the miscasting of Price, whose

velvety voice and occasional flashes of camp humour leave us waiting for a punch line that never comes - *The Last Man on Earth* is an intelligent slice of apocalyptic sci-fi/horror. In its willingness to envision the end of the world, it overturns all sense of the heroic, the good and the true with a bleak nihilism rarely seen in the films of the period. Significantly, this downbeat attempt to challenge all notions of selfhood, truth and value was something that Romero would shape into the genre's seminal masterpiece, the *Citizen Kane* of zombie cinema, *Night of the Living Dead* (1968).

IV. Back on American Soil: Night of the Living Dead

Shunted out into Europe, Mexico and Great Britain, the living dead were in exile from both the country that had invented them and the land that had turned them into cinematic terrors. In America, the zombie had become a poor relation, ignored by the mainstream and trampled over by the exploitation circuit. For most of the 1960s, American zombie productions struggled to re-establish themselves. Devoid of their Caribbean racial dynamic and cut adrift by the atomic influence of the previous decade, the majority of American zombie films during this period were marginal genre entries that had little to offer anyone except perhaps the most undiscerning horror fans.

Even after three decades of screen history, it seemed that some American filmmakers still didn't know what a zombie was. Playing fast and loose with living dead mythology films like Del Tenney's *The Horror of Party Beach* (1963, released on a double-bill with the director's slightly better mystery thriller *The Curse of the Living Corpse*) or the Ed Wood penned *Orgy of the Dead* (1965) were willing to pass off all manner of creatures as zombies in the hope of turning a quick buck. *The Horror of Party Beach* touted a bunch of radioactive sea monsters as zombies while *Orgy of the Dead* presented its ghouls as damned female souls who spend their time doing stripteases in glorious "Sexicolor".

Needless to say, such dreadful drive-in movies were strange enough to guarantee an audience of curiosity seekers. The most bizarre American film of the decade was surely *The Incredibly Strange Creatures Who Stopped Living and Became Mixed-Up Zombies!!?* (1963). The "creatures" of the title are the unwitting victims of a funfair gypsy fortune-teller (Brett O'Hara) and her sister (Erina Enyo) who douse their punters with acid, brainwash them and keep them locked up in a cage at the back of their tent. Sadly, the zombies play second

fiddle to the film's crazy mixed-up hero Jerry (played by director Ray Dennis Steckler), who is hypnotised into becoming a murderer by the gypsy woman. Not even Steckler's desperate overacting can stop him being upstaged by the film's abundant catalogue of strippers, girlie show dancers and musical revues - all of which are shown in mind-numbing and distinctly unerotic detail in the hope of padding out the flimsy script.

Such silliness was only surpassed in two mad scientist movies: *Monstrosity* (1963) and *The Astro-Zombies* (1967). In the former, director Joseph Mascelli (cameraman on *The Incredibly Strange Creatures*) took audiences on a crazed journey into the heart of atomic medicine with the story of a doctor (Frank Gerstle) who's trying to implant the brain of his ageing employer (Marjorie Eaton, the old grandma from *Zombies of Mora Tau*) into a fresh young body. Seeing as all he's produced to date are a girl with the brain of a cat who now has a taste for mice and a man who thinks he's a dog, things don't look too promising. The added complication is that if the brains are too far deteriorated, the subject becomes a zombie. Whether that is better or worse than being a cat woman is never made clear.

In *The Astro-Zombies*, another mad scientist (John Carradine, natch) attempts to create a Frankenstein-style "Quasi-Man". Rather than the superhuman all-purpose man-machine expected, the fruit of his labour turns out to be a solar-powered zombie with an electrically-driven synthetic heart, a stainless steel mesh stomach, a plastic pancreas and the brain of a psychopath (since that was the only one available at the time!). He quickly goes on the rampage - as any self-respecting psycho-monster would in such dire circumstances. Decked out in a cheap joke store skull mask, this "Astro Zombie" marks the nadir of 1960s ghouls. Still, there's much fun to be had in watching writer-director-producer Ted V. Mikels plumb the depths of stupidity. The zombie's habit of recharging his solar-powered batteries by clamping flashlights against his forehead during nocturnal excursions offers some unintentional hilarity, as does the script's choice collection of atrocious dire-logue: "When a man doesn't know the difference between an experiment on an Air Force officer and a cadaver, I think it's time to drop him from the team".

If trash films like *The Incredibly Strange Creatures Who Stopped Living and Became Mixed-Up Zombies!!?* or *The Astro-Zombies* had continued unchecked, it's quite possible that the zombie genre might have completely disappeared. Fortunately, in deepest Pennsylvania, one low-budget filmmaker was about to change the course of the zombie movie forever by bringing to fruition the themes of family horror, the apocalypse and the living dead that so many movies had touched on yet failed to turn into cinematic gold. The result was a film that pushed the envelope of modern horror in a manner that perhaps no other movie since *Psycho* had done.

When *Night of the Living Dead* was released on 2 October 1968, the response to it was immediate, incensed and utterly hysterical. Typical of the moral outrage that accompanied George A. Romero's debut film was the original, soapbox-clambering review in the pages of *Variety*:

> Until the Supreme Court establishes clear-cut guidelines for the pornography of violence, "Night of the Living Dead" will serve nicely as an outer-limit definition by example. In a mere 90 minutes this horror film (pun intended) casts serious aspersions on the integrity and social responsibility of its Pittsburgh-based makers, distributor Walter Reade, the film industry as a whole and [exhibitors] who book [the picture], as well as raising doubts about the future of the regional cinema movement and about the moral health of filmgoers who cheerfully opt for this unrelieved orgy of sadism [...]
>
> No brutalising stone is left unturned: crowbars gash holes in the heads of the "living dead," people are shot in the head or through the body (blood gushing from their back), bodies are burned, monsters are shown eating entrails [...]
>
> On no level is the unrelieved grossness of "Night of the Living Dead" disguised by a feeble attempt at art or significance.[84]

With provocatively sensational notices like this, it's hardly surprising that Romero's low-budget horror film would become a license to print money. Inspired by such damning reviews, thousands of patrons rushed to the movie's limited showings turning it into an overnight smash hit. Contrary to what *Variety* might have thought, it seemed that there was a large section of the public who would "cheerfully opt for this unrelieved orgy of sadism" if given half a chance.

Although few critics were able to see it at the time, there was far more to *Night of the Living Dead* than just its visceral impact. *Psycho* might have recalibrated the focus of modern horror, but it was Romero who widened its scope. Taking the family-based terror of Hitchcock's masterpiece as his starting point, the Pittsburgh director moulded it into a wide-ranging critique of contemporary America marked by unrelenting nihilism, graphic violence and visceral scenes of a world turned completely upside-down. This was a film that dragged American horror kicking and screaming into the modern age.

It took audiences completely by surprise. Film critic Roger Ebert was so concerned about the disastrous effect *Night of the Living Dead* might have on young minds that he penned a potent warning to parents in the pages of *Reader's Digest*. He was prompted, he explained, by his own experience of sitting through a matinee performance of the film surrounded by wailing

Bringing it all back home: Harry Cooper (Karl Hardman), his wife Helen (Marilyn Eastman) and their daughter Karen (Kyra Schon, lying down) chart the collapse of the nuclear family in **Night of the Living Dead**.

nine-year-olds whose parents had left them at what they'd assumed was just another silly monster movie:

> The kids in the audience were stunned. There was almost complete silence. The movie had long ago stopped being delightfully scary, and had become unexpectedly terrifying. A little girl across the aisle from me, maybe nine years old, was sitting very still in her seat and crying.
>
> I don't think the younger kids really knew what hit them. They'd seen horror movies before, but this was something else. This was ghouls eating people - you could actually see what they were eating. This was little girls killing their mothers. This was being set on fire. Worst of all, nobody got out alive - even the hero got killed.
>
> I felt real terror in the neighbourhood theatre. I saw kids who had no sources they could draw on to protect themselves from the dread and fear they felt.[85]

Nobody was more surprised by the movie's phenomenal success than the filmmakers themselves. Romero and his producers Karl Hardman and Russell Streiner (who both appear in front of the camera playing Cooper and Johnny respectively) had originally wanted to make a non-horror art-house movie. Fortunately for genre fans, they were deterred from this lofty aim and realised that their best chance of seeing some return on the $114,000 budget they'd scraped together would be to make an exploitation movie.

Funding the project out of their own pockets and enlisting the help of local sponsors, the filmmakers decided that their subject matter would have to be dictated by the realities of the financial constraints they faced. With little money for make-up, costumes or special effects, they opted to build the story around the cheapest monster they could come up with - the zombie.

Night of the Living Dead begins on a deserted stretch of highway in the Pennsylvania countryside. It's the late evening and Johnny (Streiner) and his sister Barbara (Judith O'Dea) are driving along the isolated road to a nearby cemetery where the couple are planning on paying their respects at their father's grave. Cranky and irritable, Johnny's angry about having to drive so far and doesn't see the point in this empty ritual of honouring the dead. Bored, he begins to taunt Barbara and, once they reach the cemetery, tries to scare her by pretending that the elderly man they see walking between the gravestones is a ghoul. It's a cruel joke - but it turns out to be unexpectedly true as the approaching stranger attacks Barbara and, in the ensuing scuffle, kills Johnny. So begins *Night of the Living Dead*'s assault on its audience.

Escaping to an isolated farmhouse further down the road Barbara hides until the arrival of Ben (Duane Jones),

who comes into the house to take shelter. After killing a few of the ghouls massing outside, Ben starts to barricade the doors and windows while the terrified girl looks on helplessly. Once the commotion subsides, a group of people emerge from the cellar: two sappy young kids, Tom (Keith Wayne) and Judy (Judith Ridley), an arrogant but cowardly businessman named Harry Cooper (Karl Hardman), his wife Helen (Marilyn Eastman) and their daughter Karen (Kyra Schon), who has fallen sick after being bitten by one of the ghouls.

The fact that they stayed hidden downstairs while he fought for his life doesn't do much to endear them to Ben. Almost immediately, an argument breaks out between Ben and Cooper over who's in charge and whether or not the group ought to hide downstairs in the cellar (Cooper's plan) or fortify the house (Ben's plan). As the characters bicker about the best course of action, the television news reports the outbreak of "murders being committed in the Eastern third of the nation". At first, citizens are advised to stay in their homes; later they're told to make their way to the nearest rescue station where the National Guard will protect them.

After discovering the keys to the petrol pump outside, Ben suggests that they make a run for safety using the truck. In the course of the escape attempt, though, everything goes wrong. The truck catches fire and then explodes, killing Tom and Judy whose barbecued remains are eaten by the ghouls. Cooper tries to lock Ben out of the house, but he manages to get back inside and, in the ensuing struggle, the spineless businessman is shot. Barbara, who's been catatonic for most of the proceedings, pulls herself together and helps Ben fight off the advancing zombies but is eventually dragged out of the front door by her brother Johnny who's come back from the dead.

Down in the cellar, the Coopers' daughter has died from the bite she received and joined the ranks of the living dead. She kills her mother with a garden trowel, then emerges from the cellar and attacks Ben. Realising that he has no other option, Ben barricades himself inside the cellar and shoots Harry and Helen Cooper in the head as they return to life. When morning finally dawns, the zombies have dispersed. A posse of policemen and militia approach the farmhouse and as Ben, the only survivor of the night, emerges from the cellar he's shot in the head by the rednecks. The film closes with a montage of still images showing Ben's body being dragged out of the house on meat hooks and tossed onto a bonfire of zombie corpses.

For the average audience in 1968, the visceral horror of *Night of the Living Dead* packed quite a punch. While blood-soaked special effects had been enlivening drive-in horror movies for a few years before Romero's debut - particularly in the outrageous gore of films like Herschell Gordon Lewis's *Blood Feast* (1963) and *Two Thousand Maniacs!* (1964) - the Pittsburgh director's take on the

Cemetery Man: a ragged ghoul (Bill Hinzman) kicks off the **Night of the Living Dead** by attacking Johnny (Russell Streiner) and Barbara (Judith O'Dea).

"meat" movie was completely different. Lewis and his imitators offered lashings of gore simply for its own sake, with scenes of dismemberment and mutilation framed by plots that were perfunctory at best, incoherent at worst. Romero displayed a far lighter touch, only pushing the boundaries of good taste in a handful of *Night of the Living Dead*'s scenes and, what's more, doing it in black and white cinematography. Intriguingly, this restraint helped increase rather than diminish the film's impact, foregrounding the one thing that's always the inevitable focus of any zombie movie, the human body itself.

Under Romero's direction, the corporeal was made decidedly *real*. From the half-eaten skull of the farmhouse's owner that's discovered on the first floor landing to the numerous scenes in which zombie foreheads are bashed by tire irons and grasping hands are cut down to size by kitchen knives, Romero never lets us forget that this is a film about the body. Or, to be more accurate, the horror of the body. Refusing to skirt the issue of the zombie's physicality - both in its monstrous form as a reanimated corpse and in its newly threatening form as a flesh-eating creature - Romero brought an uncompromising realism to the genre and added a previously unheard of dimension to the zombie myth: cannibalism.

Before *Night of the Living Dead*, zombies had been content to scare, strangle or bludgeon their victims. Romero upped the ante by giving them a taste for warm,

human flesh. As a result, the scene in which the barbecued remains of Tom and Judy are eaten by ghouls became the film's most influential moment. Although the crew jokingly dubbed this sequence "The Last Supper", there was nothing comical about its execution. Romero shipped in real animal entrails from a Pittsburgh butcher in order to achieve the right degree of authenticity, then found extras who were willing to chomp greedily on pig hearts and sheep intestines. It was gory, it was distressing and it was innovative enough to dominate the genre's development forever. From that moment onwards cinematic zombies would almost always be flesh-eaters.

Such uncompromising commitment to realism characterises the film. The grainy cinematography - bolstered by TV footage of anxious news anchormen and bewildered Washington officials - gives the film a *cinéma vérité* look, suggesting that these events aren't part of some *super*natural horror, but something altogether more ordinary. Indeed, even the film's newsreaders find themselves at a loss when trying to describe these "unidentified assassins" since they're so "ordinary looking" that "there is no really authentic way for us to say who or what to look for or guard yourself against". Tellingly, Romero refrains from calling his monsters "zombies" at any point in the film.

This ordinariness is the key to the film's horror. As Gregory Waller has suggested, Romero's ghouls aren't conventional horror movie monsters. Rather *Night of the Living Dead* is a film that sets out to "redefine the monstrous - thereby redefining the role of the hero and the victim as well - and situate horror in the everyday world of America".[86] The zombies of *Night of the Living Dead* are not really monsters at all. Instead, they're "our fellow citizens who, with no leader and no motive beside hunger, have returned to feed on us".[87] They are simply, as Romero is so fond of saying, "the neighbours".[88]

By excising both the supernatural and the magical connotations of the zombie's voodoo origins, *Night of the Living Dead* foregrounds its horror in the real world as it is transformed from safe to horrific by an inexplicable shift in the natural order. Much like Hitchcock's *The Birds* (1963), a film that was an apparent influence on Romero, the action centres on a situation that challenges our understanding of the fundamental dynamics of the universe. As birds group together to attack humans or dead bodies return to feed off the living, the whole basis of civilisation - and man's sense of mastery over his environment - is instantly altered.

What makes Romero's apocalyptic vision so utterly unsettling is the nihilism that informs it. The rising up of the dead against the living is presented as a sustained attack on every truth, value and comfort that civilisation holds dear. It is a revolution, claims Gregory Waller, in which "we are given no secure basis for dealing with the escalating horrors".[89] All objective standards of truth and value are swept aside, trampled beneath the feet of the living dead as they march on the nation's cities. Every vestige of authority, every convention of heroism is overturned by Romero's script.

In many respects, it is the living's failure to co-operate and put aside their petty differences that invites the chaos. Fascinated by how quickly the social order can crumble - a theme he would return to in the next two instalments of his living dead series, *Dawn of the Dead* (1978) and *Day of the Dead* (1985), as well as in his biological warfare thriller *The Crazies* (1973) - Romero shows us that it's the territorial bickering of the living that's the real threat to civilisation. The problem of the dead returning to life actually seems quite containable if only Ben and Cooper - and on a much larger scale the infighting authorities in Washington - could stop arguing for long enough to formulate a plan of action. For Romero, this is the way the world ends: not with a bang, but with a series of whimpering arguments that invite a chaotic collapse of the social order into arguments, fistfights and dispassionate news reports.

As anarchy prevails, even the comforts of conventional horror movie wisdom falter. Authority is one of the first casualties of the upheaval swiftly followed - on a more local level - by the collapse of the American family. The TV news reports show harassed Washington officials rushing between meetings, and Romero himself appears as an exasperated reporter fruitlessly trying to ascertain the facts of the situation from the politicians. It's clear that the government is unable to help those caught in the midst of the crisis. What's more, the implicit suggestion

is that it may well have been the military-industrial complex that caused the catastrophe in the first place. Talk about the dangerously high levels of radiation returning to Earth with a crashed "Venus probe" hint at where the blame may lie.

If the politicians and military can't help us, who should we look to? The answer seems to be no one. The police and militia are little more than trigger-happy rednecks. Even the film's ostensible hero, the resourceful Ben, is rather suspect. His assertion that the cellar is a "death trap" is proved hopelessly wrong and his cold-blooded killing of the cowardly Cooper - however understandable - is hardly admirable, or heroic.

The family fares little better. As Johnny and Barbara's opening argument about their visit to their father's grave illustrates, familial ties have already collapsed, long before the dead start walking. The Coopers' traditional nuclear family can't offer any hope; mother and father both hate each other and their daughter ends up turning on them when she becomes one of the zombies, hacking her mother to death with a garden trowel in a scene that's an eerie but poignant echo of *Psycho*'s shower murder.

The redefinition of the monstrous that Romero undertakes eventually comes to challenge our understanding of the line between Self and Other. "They're us and we're them," claims Barbara in the 1990 remake of *Night of the Living Dead* (written, though not directed, by Romero). It's a throwaway statement that's actually deeply significant in respect of Romero's original 1968 film. By challenging the distinction between the living and the dead, the normal and the monstrous, *Night of the Living Dead* brings terror into the American home, hearth and family. One of the most memorable moments is when the zombified Johnny - who was killed in the film's opening reel - returns from the dead to drag his sister out of the house. It encapsulates the predominant terrors of the post-*Invasion of the Body Snatchers* zombie movie - namely, that the individual may be co-opted into the mass. It also pinpoints the way in which *Night of the Living Dead* locates its terror in the familiar and ordinary rather than the alien and extraordinary.

The visceral scenes of flesh-eating that appalled contemporary commentators are also typical of this thematic clash between the Self and the Other. Making the body into the site of Otherness, *Night of the Living Dead* offers a vision of the world in which our own flesh is made to seem strange, disgusting and gross. The cannibalism that Romero adds to the zombie mythology wasn't simply a spectacular ploy to drum up controversy and boost ticket sales, but central to the film's provocative vision of individuals being consumed/subsumed into the larger group. Romero takes the paranoid fears of *Invasion of the Body Snatchers* - in particular its vision of the mass as a terrifyingly homogenous entity - and multiplies them several times over.

What exactly do the ghouls represent? For critic Linda Badley, the zombie horde is like some "ambulatory mass grave" and thus both a reminder of the inevitability of death and an affront to our belief in its finality.[90] For Robin Wood, Romero's vision of the living dead as a relentless, unswerving group enacts a return of the repressed in which our fear of dead family members - and even the dead of Vietnam - leads us to imagine them taking their revenge on the living. Wood's Freudian reading of the horror film in general suggests that, "the true subject of the horror genre is the struggle for recognition of all that our society *re*presses or *op*presses".[91] Thus for Wood, the monster can be understood as a projection of our secret desires that comes to haunt us in a very literal fashion, returning from the graveyard of the unconscious. From the perspective of this psychoanalytic reading of the horror genre, the reason why the characters of zombie movies spend most of their time barricading themselves away inside houses, cellars and attics is that they're terrified of coming face to face with that which they previously refused to acknowledge.

Vietnam lurks in every frame of Romero's film. Hitting cinemas at the height of the war, as race riots, peace demonstrations and the angry outbursts of a youthful counterculture raged through America, Romero's debut pulled no punches in its representation of a nation falling apart on every level. Echoes of the conflict itself are everywhere in the film: the search and destroy missions are carried out by the local militia under the insistent thud-thud-thud of helicopter rotor blades; the men on the ground tackle the ghouls with gung-ho enthusiasm; the TV news reports are dominated by an anxious discourse of contagion and containment. Explaining the extermination of the enemy in the cold, dehumanised language the sheriff's matter-of-fact response to the return of the dead sounds like an extension of the detached "professionalism" that dominated the official descriptions of the war in Vietnam: "Shoot 'em in the head… beat 'em or burn 'em, they go up pretty easy… they're dead, they're all messed up". The living dead enemy even possesses a linguistic echo of the one in Southeast Asia: "ghoul" is only a few letters removed from "gook". It's hardly surprising, then, that at least one contemporary commentator made the link with the war explicit by suggesting that if Lyndon B. Johnson had seen it he might never "have permitted the napalming of the Vietnamese".[92]

Aligning itself in direct opposition to the dominant American patriarchal order of family, community, police and military, *Night of the Living Dead* suggests that the whole of society is rotten to the core. It's this maggot-ridden, flesh-eating putridity that's crawled back from the grave to jab a decomposing finger of blame at us all, much like the dead of Abel Gance's *J'accuse* (1937). No accident, then, that the film opens with a young couple journey to visit the grave of their dead father - this is a world completely lacking in patriarchal authority.

The extent of Romero's critique of the forces of law, order and authority is underscored in the film's conclusion. As Ben emerges from the cellar, having survived the long, dark night of the living dead, he's shot in the head by the sheriff's posse who believes he's "one of *them*". Have the rednecks made a genuine error and mistaken him for a zombie? Or do they think that as an African-American Ben is simply a different kind of *them*? The film ends without answering the question, but perhaps it doesn't matter. Romero has already convinced us that the world has gone to hell, giving Ben's death all the terrifying, but inevitable, logic of a bad dream. As the film closes, with a series of stills showing his body being tossed onto a bonfire, the parallels with 1960s newsreel footage of everything from Vietnam to the Watts race riots are transparent.

If *Psycho* set the trend for placing horror in the family, Romero develops Hitchcock's strategy through his use of the zombie. In *Night of the Living Dead*, family horror is everywhere. The Coopers are faced with their zombified daughter ("It's Mommy," Helen vainly whispers as her murderous daughter approaches armed with a garden trowel). Barbara has to confront her dead brother. Ben is forced to watch as former members of the farmhouse community return from the dead. More than anything else, *Night of the Living Dead* suggests that the nationwide family of America itself is a site of horror - there's no longer any simple way to tell the monsters from the normal people.

Central to these strategies is the zombie itself. Romero's breathtaking rejuvenation of the genre centres on his total break with the past. Ignoring the voodoo mythology of the living dead that had been thriving since the 1930s, *Night of the Living Dead* takes its energy from films like *Invasion of the Body Snatchers* and *The Last Man on Earth*. These aren't voodoo zombies, but reanimated corpses functioning without emotion or malice. Their only desire is to feed on the living in order to sate their incessant hunger. By forcing audiences to sit up and recognise the zombie for what it really was - a cadaver - Romero challenged our understandings of the monstrous and our long-held beliefs about the finality of death. Turning the death of the body into his film's main focus, the filmmaker asked audiences to confront the horror that lay within them, the Otherness of their own flesh. It was a vision that finally gave the zombie film a credibility it had previously lacked. By collapsing the boundaries between the normal and the monstrous, the living and the dead, Romero signalled a new stage in the zombie's development. Zombie filmmakers no longer had to hide behind half-baked plots and silly special effects. Instead they could instead approach serious issues with a grim, apocalyptic nihilism that was shocking and exhilarating in equal measure.

"The neighbours": **Night of the Living Dead**.

chapter six

Dawn of the Dead

I. Romero's Children

Night of the Living Dead was a watershed movie. It played for years after its initial release, screened at drive-ins, grindhouses, film clubs and even dormitory walls (courtesy of Super 8 projectors).[93] It established the "midnight movie" trend - late-night film screenings which privileged cult, low-budget horror films - and it reminded American filmmakers that exploitation cinema could be socially progressive, radical and even revolutionary. Dragging the horror movie kicking and screaming into the post-1968 world, its subdued, black and white visuals and unrelenting violence left audiences in no doubt that the acid-tinged optimism of the hippie era was coming to an end.

Romero's bleak focus on the destruction of the present order spoke volumes about the cataclysmic shifts in American consciousness that had occurred since the assassination of President Kennedy in 1963. Imagining an apocalyptic catastrophe of such epic proportions that all hope of social regeneration becomes impossible, Romero took his audience on a journey into America's heart of darkness. As the war in Vietnam spiralled out of control and the counterculture's idealistic dreamers awoke to an acid hangover that included the Manson murders, the violence at the Altamont rock concert and the shamefaced truth of the Watergate scandal, Romero's nihilism seemed perfectly in tune with the times.

Perhaps that explains why the films that followed in the wake of *Night of the Living Dead* took the disillusionment and rude awakening of the acid generation as their starting point. For Alan Ormsby and Benjamin "Bob" Clark, *Night of the Living Dead* was certainly an inspiration. After graduating from the University of Miami, the two young budding filmmakers were encouraged by the box office success of Romero's film into making their own foray into the world of low-budget horror with two productions: the horror-comedy *Children Shouldn't Play with Dead Things* (1972) and the far more ambitious *Deathdream* (aka *The Night Andy Came Home*, *Dead of Night*, 1972). What distinguishes both of these movies is their savage satirical bent. *Children Shouldn't Play with Dead Things* begins as a spoof of *Night of the Living Dead*, then proceeds to rip the heart out of the 1960s counterculture as a group of obnoxious hippies unwittingly unleash some zombies.[94]

Deathdream combines the vengeful tongue-in-cheek logic of the E.C. horror comics of the 1950s with a surprisingly powerful anti-Establishment thrust and a story about a Vietnam veteran who returns to America as a flesh-eating ghoul.

Both films turned out to be successful enough to launch Clark and Ormsby's respective film careers. Indeed, *Children Shouldn't Play with Dead Things* proved such a hit on the drive-in circuit that the pair found themselves in the enviable position of being able to convince their financial backers to give them five times that film's budget for *Deathdream*. Following their second collaboration, Clark went on to enjoy a successful career as a director with films like the groundbreaking slasher picture *Black Christmas* (1974) and the phenomenally successful teen comedy *Porky*'s (1981). Meanwhile Ormsby stayed in the horror genre long enough to write and co-direct *Deranged* (1974), based on the Ed Gein case, and script Paul Schrader's *Cat People* remake in 1982.

Filmed over 11 nights in 1972 for the minuscule sum of $50,000 *Children Shouldn't Play with Dead Things* follows a theatre troupe of hippies as they travel out to a Florida burial island for a midnight adventure. Their leader is the self-styled "Uncle Alan" (Ormsby), a bitchy megalomaniac with a nasty tongue and a penchant for loud clothes. The rest of the group are an assorted ragbag of 1960s acid casualties and stoner drama queens who have reluctantly agreed to the trip in order to stay in their employer's good books. Like the kids of *The Texas Chain Saw Massacre* (1974), they're dumb, brash and completely unsympathetic characters.

Alan claims that he's planning to perform a magic ritual that will wake the dead from their graves, but the troupe guess that he's simply trying to scare them senseless. It's a suspicion that's confirmed when the first two "ghouls" to come back from the grave are nothing more than a couple of Alan's friends caked in suitably pallid make-up. Alan's not content with a successful prank, though. He really does want to raise the dead and instructs the group to carry a freshly exhumed corpse (dubbed "Orville") into the house of the island's caretaker. After a series of false starts, the magic incantation actually works and the dead rise from their graves to lay siege to the isolated house.

Structured as a horror-comedy, with the zombies only arriving in the last half hour of the film, *Children* rarely rises above the level of a spoof. Yet at least it's a

71

spoof with bite. Setting their sights squarely on the disillusionment of the early 1970s, Clark and Ormsby's aim is to expose the rotten core of the hippie dream of peace, love and community. Alan and his cohorts are living proof of how and where the counterculture failed to deliver on its idealistic vision of a better society. Dominated by power games, sexism, bitchy backstabbing and sadistic threats, the theatre troupe appears to be as corrupt and unpleasant as the established order it's supposed to be an alternative to. As the group's idle chatter about weird cults and mass murderers suggests, this is a world in which hippie idealism has already turned sour.

Underlying this scathingly satirical take on the bankruptcy of the counterculture is a dark despair that finds its fullest expression in Alan himself. Far from believing in traditional flower power values, the villainous anti-hero espouses a disturbed and disturbing vision of the empty pointlessness of existence: "The dead are losers. If anybody hasn't earned the right for respect, it's the dead... Man is a machine that manufactures manure."

Alan positively revels in his appreciation of a world without truth or value, describing his handsome leading man as "a slab of meat I hired to dress my stage" and praying to Satan with a mock-seriousness that suggests he can't even find enough faith to take the Antichrist seriously. He thrives on making his audience face up to the dreary emptiness not only of life, but also of death. "That's all you are old buddy - clay, mud," he tells the dead Orville in a moment of outright nastiness. Much to the chagrin of his fellow hippies, he then threatens to feed the corpse's rotting flesh to the dogs and use his bones as soup ladles and Christmas decorations.

Glibly riffing on the transitory nature of physical existence, Alan faces up to the realities of a world in which God is absent. After his nihilistic pronouncements, the return of the dead seems to have an inexorable logic. Rather than a sign of some higher power at work the ghouls are styled as machines that have malfunctioned, dead flesh that has forgotten to die and is continuing to move around in a parody of the living's pointless and expendable existence.

That Alan isn't ready to deal with such emptiness on anything other than his own terms is the film's chief source of blackly comic *schadenfreude*. Instead of embracing the ghouls as proof of his solipsistic beliefs, Alan desperately does everything in his power to save his own hunk of flesh, culminating in an outrageous scene that fans of the film fondly remember as typical of its dark pessimism. Chased onto the staircase by the marauding zombies, Alan tries to save himself by pushing death-obsessed hippie chick Anya (Anya Ormsby, the actor's real-life wife) into the path of the pursuing horde. As she tumbles into their grasp the action momentarily pauses as everyone - including the zombies - is stunned by Alan's despicable cowardice. Naturally, Alan eventually gets his just desserts as Orville comes back from the dead and eats him. In this world it's Death, not God or Satan, who will always have the last laugh.

The vengeful tradition of E.C. Comics was also an inspiration in Clark and Ormsby's next film, *Deathdream* (1972). If *Children Shouldn't Play with Dead Things* frequently seems rather reactionary in its gleeful attack on the spirit of the 1960s counterculture, *Deathdream* redresses the balance by using the zombie to take a broad swipe at the Establishment instead. The story of a killed-in-action G.I. who returns home from Vietnam as a blood-slurping zombie, *Deathdream* was remarkably bold. It was one of the first horror films to deal with the subject of the Vietnam War at a time when Hollywood considered the conflict box office poison. Proving that marginal productions can often be unexpectedly radical in ways that the mainstream can never manage, *Deathdream* joined a small band of grindhouse movies - including cheap beat-'em-ups featuring troubled veterans such as *Billy Jack* and *Chrome and Hot Leather* (both 1971) - that were willing to deal with the impact of the war on their own terms.

Deathdream has all the hallmarks of a Vietnam veteran movie. The opening scenes take place in some dark "in country" location, where tracers and explosions light up the sky as a gun battle rages in the jungle. The film then cuts to America, where the family of G.I. Andy Brooks (Richard Backus) are concerned that they haven't heard from him for several weeks. While his father and sister are secretly convinced that he's dead, his mother hysterically refuses to face reality and makes a desperate *Monkey's Paw* style wish for his safe return. And return he does.

There's a slight problem though: Andy's *different*. He doesn't talk much, sits in his room all day in his rocking chair, wears dark glasses even when it's night, and seems to be totally devoid of any human warmth or emotion. It turns out he's blood-drinking zombie who has to chomp on human flesh to keep his rapidly deteriorating body from falling apart. After a series of unexplained murders are reported in the local newspapers, his father begins to suspect that this Andy isn't the same all-American boy who was shipped out to the 'Nam. When Andy strangles the family dog in front of the neighbourhood kids, it's clear that something is very, very wrong.

Unlike the Vietnam-themed horror of the much later *House* (1985) - a jokey tale in which a veteran-turned-novelist is haunted by the zombified remains of a fellow G.I. - *Deathdream* doesn't let the laughs outweigh the potential seriousness of the setup. Taking their cue from Romero's socially-conscious stance in *Night of the Living Dead*, the filmmakers use the zombified return of Andy as a savagely bitter commentary on America's war against Communism, capturing the disillusionment of the period in quite unexpected ways.

Deathdream's effectiveness stems from the simplicity of its central idea. When Andy returns home from the horror of the war in Southeast Asia as a blood-drinking ghoul, his atrocities back on American soil are little different in scope than those he may have committed while acting in the service of his country. Bringing the war back home with him, Andy's murderous impulses prove impossible for anyone around him to comprehend. "Why would a soldier want to do that?" naively asks a local waitress on hearing that the police are looking for a Vietnam veteran in connection with the recent murders. It's a deliciously ironic line matched only by Andy's glib attempts to style his ghoulish needs as commensurable with his community's willingness to ship him off to Vietnam in the first place: "I died for you, Doc. Now why shouldn't you return the favour?"

Such satirical intent makes *Deathdream* a fitting companion piece to *Children Shouldn't Play with Dead Things*. Taken together, these two films comprise a quite remarkable attack on both ends of the political spectrum - the counterculture and the military-industrial complex - of 1970s America. Clearly, *Night of the Living Dead* had done more than just revitalise the zombie as a credible monster. It had also radicalised the low-budget American horror movie, reinstating the marginal genre's potential for putting forward oppositional critiques of the prevailing social order.

Not all of the films that followed *Night of the Living Dead* proved as successful in delineating the disillusionment that followed in the wake of the 1960s. Although several zombie-themed horror movies - including *Let's Scare Jessica To Death* (1971), *Garden of the Dead* (1972), *Messiah of Evil* (1972), Romero's own *The Crazies* (1973), *Shivers* (1975) and *Blue Sunshine* (1977) - tried to imitate Romero's blend of nihilistic despair, political radicalism and bleak cynicism, the results were rarely inspired (the exception to the rule is David Cronenberg's *Shivers*, which proved to be one of the most subversive, misanthropic movies of the decade). What's fascinating about these 1970s films, though, is the way in which they insist on overturning the ideals of the flower power generation. Forming a backlash against the utopian hippie dream, these films toy with fears about the dangers of mind-altering drugs and rampant sexuality, while also displaying a stark mistrust of the strangeness of other people.

In Jeff Lieberman's demented *Blue Sunshine* (1977), ex-hippies are turned into raving homicidal maniacs as a delayed side effect of a batch of bad acid - the Blue Sunshine of the title - that they sampled during the years of turning on, tuning in and dropping out. Having already abandoned their tie-dyed flares to become upstanding members of the community, these bankers, lawyers and doctors suddenly lose all their hair and are turned into psychotic zombie anti-hippies who go on the rampage, murdering everyone they can lay their hands on.

Such chemical anxiety is also to be found in John Hayes's dire romp *Garden of the Dead* (1972) in which hillbilly prisoners get high on formaldehyde fumes. After being shot to bits by the guards during an escape attempt, the stoned convicts are buried in formaldehyde-soaked

shallow graves. Pretty soon they're back on their feet seeking revenge. It was an idea that would later be replayed in *Toxic Zombies* (aka *Bloodeaters*, 1979) in which a field of marijuana is sprayed with experimental herbicides turning the local rednecks into bloodthirsty cannibal maniacs. Meanwhile, in Romero's *The Crazies* (1973), a bio-chemical weapons spill turns ordinary American citizens into demented killers. On the basis of these films, it seems that several horror filmmakers had come to the conclusion that the drugs didn't work.

The most disturbing of this cycle of movies was one of the first, John Hancock's *Let's Scare Jessica To Death* (1971). After possibly taking one too many tabs of LSD, hippie heroine Jessica (Zohra Lampert) loses her marbles and becomes convinced that the spirit of a dead Victorian girl is haunting her. As a muted expression of acid anxiety, *Let's Scare Jessica To Death* is a profoundly creepy and effective little film. Far from embracing the idealism of the previous decade, Hancock exposes the fear and loathing underpinning it by focussing on Jessica's mental disorientation. She's convinced that the local townsfolk are zombies out to get her (they all bear the same strange scar on their faces) and slowly begins to believe that the drifter hippie who's sharing her house is a vampire. Instead of the hippie dream of community, Hancock hints at a world ruled by Jean-Paul Sartre's famous dictum "L'enfer c'est autres" (hell is other people). The sour-faced locals even scratch the word "love" off the side of the hippies' flower power hearse.[95]

In many respects, Sartre's misanthropic disgust is the perfect index of the concerns of the zombie movie after *Night of the Living Dead*. These films are dominated by storylines in which our friends, neighbours and families reveal their threatening Otherness by becoming flesh-eating ghouls whose only aim is to make us become part of their horrific group. In the low-budget, but ambitiously arty, *Messiah of Evil* (aka *Dead People*, 1972), this sentiment is taken to its logical conclusion as the heroine Arletty (Marianna Hill) searches for her missing father. Ending up in a strange town that's one part David Lynch to two parts H.P. Lovecraft, Arletty discovers that the local populace are zombies, who roam the streets late at night looking for fresh victims. While the film's hundred-year-old Satanic plot proves difficult to follow even with extended bursts of voice-over narration, there's no mistaking the point of the surreal episodes in which the living dead prove that they really are - to borrow Romero's term - "the neighbours". The standout scenes are those in which the inhabitants of the deserted town of Point Dune unexpectedly appear in the most banal settings. The ghouls interrupt a late-night trip to the supermarket by feeding themselves from the meat counter and, in the film's most memorable sequence, they slowly occupy the empty seats around an unsuspecting girl (Joy Bang) as she sits engrossed in a movie in the local cinema.

Other filmmakers made even more of the zombie's potential as a metaphor for the collapse of the hippie dream. In David Cronenberg's shocking *Shivers* (1975), hell is not only other people but also the body itself. It takes place in a hi-tech middle-class apartment block besieged by a parasite that unleashes the unbridled sexual desire of anyone infected by it. Pretty soon these phallic/turd-like creatures have turned the uptight bourgeoisie of the building into rapacious sex-maniacs.

Shivers opens like a commercial as still shots of desres apartment block Starliner Towers are overlaid with an estate agent's patter: "All our apartments come fully equipped with the most modern brand-name electrical appliances. And cable TV is standard too". Something's not quite right, though. The pictures of this tower block paradise look bleached and soulless, like a relative of the cavernous shopping mall of Romero's later *Dawn of the Dead* or, better yet, the tower block in J.G. Ballard's novel *High-Rise* published the same year. The soft-spoken sales pitch sounds creepy rather than enticing. You know something's wrong even if you can't quite put your finger on what exactly it is.

What's actually happened is that crazed scientist Dr. Hobbes (Fred Doederlein) has been experimenting with a new form of laboratory-bred parasite using the apartment block's most promiscuous resident as a kind of Typhoid Mary. Ostensibly the creatures have been created to replace damaged organs - introduced into the body, they are supposed to take over the functions of the liver or kidneys. In actual fact, though, their purpose is more sinister: the parasites have an aphrodisiac quality that reduces their hosts to slavering, horny maniacs. Eager to strip away the veneer of civilisation and reveal man's basest desire, Hobbes has sown the seeds of a sexual apocalypse. The resulting zombies don't want to eat you, but bang your brains out.

Shivers is a kinky film - part softcore skin flick, part gloopy horror movie - and it presents plenty of flesh in its quest to keep the grindhouse crowd happy: cute, doe-eyed nurse Lynn Lowry does an impromptu striptease; scream queen Barbara Steele tries some girl-on-girl tonsil tennis with busty co-star Susan Petrie; every woman wears nipple-hugging sweaters; and, for the neglected ladies in the audience, actor Allan Migicovsky bares his hairy medallion man chest as parasites wriggle around inside his stomach. Yet, the titillation serves chiefly to fuel the horror.

Made in the gap between the 1960s love-in and AIDS era fear and loathing, *Shivers* was ahead of its time with zombie-esque ghouls whose existence satirises the Free Love generation's belief in better living through orgasmic pleasure. As the parasites spread through the building, they turn Starliner Towers into a mass orgy which resident doc Roger St. Luc (Paul Hampton) is unable to contain. Bankers, insurance agents and accountants become horny rapists. Fathers cop off with their daughters. Old women drool with desire ("I'm hungry! I'm hungry for love!").

Little girls are turned into knowing Lolitas and the disgusting parasites crawl out of the plughole to enter Barbara Steele as she lies in the bathtub.

"The very purpose was to show the unshowable, to speak the unspeakable," Cronenberg explained years later.[96] This willingness to unleash the forbidden is what gives *Shivers* its raw power. It's a radical, restless piece of agitprop disguised as exploitation - an angry young man's film, consumed by its hatred of the Establishment. Cronenberg made it while living penniless in the real-life apartment building that served as his principal location surrounded by the very white-collar professionals he loathed - a kind of bilious Method directing. The resulting film comes with a subversive, misanthropic edge. It may not, strictly speaking, feature zombies, but it takes Romero's nihilism and runs with it, presenting an ambiguous sexual apocalypse that demands to be read as liberatory (Cronenberg celebrating the zombies' reduction of mankind to its primal instincts) and simultaneously terrified (as Cronenberg's obvious distaste for the flesh shines through). It's one of those remarkable works of art that manages to occupy two contradictory positions at once: a radical/reactionary masterpiece in which the world ends not with a bang, but with a whimpering, moaning, venereal orgasm. Perverse to the last, it closes with the zombies heading into Toronto to start a mindless, polymorphous orgy. Is it the end, or a new beginning? Cronenberg's not telling.

While these varied productions tried to ape Romero's success, the Pittsburgh director was desperately trying to do much the same thing himself after having been knocked back by two total flops. Convinced that he was destined to make arthouse cinema in the tradition of Rohmer or Bergman rather than drive-in horror flicks, Romero followed up the success of *Night of the Living Dead* with a romantic drama *There's Always Vanilla* (1971) that left critics and audiences completely bored. He then decided to play it safe, returning to the genre that loved him. The proto-feminist psychological horror movie *Jack's Wife* (aka *Season of the Witch*, 1972) about a suburban housewife who dabbles in the occult was the result, quickly followed by *The Crazies* (1973). Although neither movie found the same audience as *Night of the Living Dead*, *The Crazies* succeeded in reconfiguring Romero's zombie apocalypse without actually featuring any zombies. It's a significant film, though, since it paved the way for Romero's *Dawn of the Dead* five years later.

After a secret bio-chemical weapon (codenamed Trixie) is accidentally released into the water supply of a small town in Pennsylvania, the local inhabitants turn into homicidal maniacs. The army move in and declare martial law but the town erupts into an orgy of violence as little old ladies attack soldiers with knitting needles, an amorous father almost commits incest with his daughter, and a variety of rednecks (some crazy, some just plain angry) go on the rampage. Building on the hysteria he dissected so expertly in *Night of the Living Dead*, *The Crazies* saw Romero refining his exploitation-cinema-as-social-critique approach. Here the catastrophe is nothing if not proof of the Establishment's boneheaded stupidity and its willingness to sacrifice citizens in order to escape censure.

Romero's satire is startlingly effective. Blurring the line between the trigger-happy soldiers, the homicidal "crazies" and the angry townsfolk, the filmmaker asks us to question who the real crazies are. The fact that nobody at the Pentagon bothered to commission an antidote to "Trixie" before pulling the plug on the project is typical of Romero's cynical take on the military-industrial complex's bureaucratic incompetence. Indeed, the military is so inherently stupid that it allows two opportunities to contain the outbreak - in the shape of a specially designed vaccine and a valuably immune citizen - to be thrown away. If that's sanity, the film seems to be saying, who knows where madness starts.

As the military infringe the civil liberties of the townsfolk by imposing martial law and beating, harassing and pistol whipping anyone who objects, it's clear that Romero has lost none of his anti-Establishment fervour nor his despair at the sheer stupidity of the human race. The film makes veiled, but striking, references to the Vietnam War. A local priest immolates himself in the manner of the Buddhist monks who doused themselves in petrol; the military can't tell the "crazies" (read communist guerrillas) from innocent civilians; and there are implicit parallels between the biochemical weapons spill and the use of Agent Orange on the jungle canopies (and civilian populations) of Southeast Asia. Romero's central point - that the real crazies may be those in charge - makes for sobering viewing.

With such hard-hitting politics, it's unsurprising that *The Crazies* failed to find its audience. Yet much of the reason for its failure at the box office actually had more to do with distributor Lee Hessel than its dark edge. Hessel tried to style this low-budget horror as a big-budget blockbuster, erecting a huge billboard in Times Square and hiring some out of work actors to wander around the New York theatre district in white bio warfare suits. The result was a total bomb. "About four people showed up," recalls Romero.[97]

In a moment eerily reminiscent of similar scenes in **Dawn of the Dead**, infected apartment complex residents go on the rampage at the end of **Shivers**.

II. The Ghouls Can't Help It

Horror fans have always had a cruelly intimate knowledge of the law of diminishing returns. Few genres require the triumph of hope over experience quite as often as horror cinema does: for every brilliant shocker like *The Exorcist* there's an *Exorcist: The Beginning*, for every groundbreaking *Nightmare on Elm Street* there's a cash-in *Freddy Vs. Jason*. Blood may drip, but money talks.

Night of the Living Dead certainly produced more than its fair share of cash-ins, most of which picked up on the revitalised popularity of the zombie with a lack of imagination that threatened to bore the poor creatures back to death. Nazi zombies, kiddie zombies, even zombie mimes all fought to succeed Romero's masterpiece in the years following its release. It made for a bumper crop of movies that have since slid into (mostly) deserved obscurity.

William Castle's *Shanks* (1974) is a case in point. An ingenious attempt to take the zombie into new territory, it fell flat on its face as dodgy production values and ropey acting took their toll. Proving that not all of the decade's films about the living dead were obsessed with the end of the hippie dream, *Shanks* was one of a clutch of zombie productions that was allegedly more interested in entertainment than social commentary.

In his first starring role in a feature film, legendary mime artist Marcel Marceau plays Shanks, a mute puppeteer who takes a job as an assistant to a local scientist (also played by Marceau). The boffin is attempting to reanimate dead animals using electrical currents. Following his employer's unexpected demise, Shanks takes over his work using dead people instead of dead animals. With three corpses under his control he plays puppet master and takes his new family out on shopping sprees before eventually putting them to far less innocent uses. A fairy tale blend of fantasy and horror, *Shanks* used Marceau's mime expertise to choreograph the jerking movements of the zombies as they're charged with electrical current. Uncertain what to do with such an oddity Paramount quickly pulled it from cinemas - then watched in perplexed horror as it went on to pick up an Oscar nomination for Best Score a few months later.

Academy Award nods stayed well away from most of the other American zombie outings of the decade. In 1971, director Del Tenney followed up *The Horror of Party Beach* with *I Eat Your Skin*, a laughable voodoo-esque tale about a playboy novelist (William Joyce) who heads out to the Caribbean to research his latest thriller. Once there he gets mixed up with a scientist who's creating an army of zombies. While it sounds like the kind of production that harks back to the Poverty Row chillers of the 1940s, its pedigree actually dated back to 1964 when it was originally shot under the title *Zombies* then shelved for reasons obvious to anyone who has had the misfortune of sitting through it. Dusted off and re-titled in 1971, it was then released on a double bill with David E. Durston's equally disposable hippie-Satanists-on-LSD thriller *I Drink Your Blood*.

"Meet Sugar Hill and her zombie hit men. Devil woman with voodoo powers to raise the dead, she's supernatural," promised the posters for Paul Maslansky's *Sugar Hill* (1974). Taking the living dead out of Haiti and into the urban sprawl of the American ghetto, *Sugar Hill* cleverly blended badass blaxploitation attitude with plenty of zombies and voodoo trappings made familiar in Bond movie *Live and Let Die* (1973).

After gangsters kill her fiancé, Sugar Hill (Marki Bey) makes a pact with a voodoo god (Don Pedro Colley) to secure her vengeance. Pretty soon, she's terrorising the criminals with a band of zombies: glassy-eyed former slaves, covered in cobwebs and shackled in irons. Despite brilliantly combining the zombie's Caribbean heritage with the blaxploitation boom, *Sugar Hill* failed to do anything particularly interesting with its premise.

At least *Sugar Hill*'s ghouls were more interesting than the dull zombies stalking a crew of horror filmmakers around a stately home in Paul Harrison's irritating *The House of Seven Corpses* (1973). Raised from the grave

above: A porridge-faced zombie searches for a dermatologist in **I Eat Your Skin**.
opposite top: Living dead slaves evoke the zombie's Haitian origins in **Sugar Hill**.

after an actress reads from the Tibetan Book of the Dead, they only manage to get in a few good kills before the credits roll. Meanwhile, the unfriendly reanimated stiff in Ron Honthaner's *The House on Skull Mountain* (1974) was barely on-screen for more than a few minutes before heading back to the graveyard. Resurrected by her voodoo practising butler, Pauline (Mary J. Todd McKenzie) arrives to find her will in dispute and decides to end the arguments by simply killing her scheming servant.

American audiences had it bad, but Britain wasn't doing much better. There were only four notable British zombie productions keeping ghouls in work during the 1970s: Fred Burnley's sombre love story *Neither the Sea Nor the Sand* (1972), Tom Parkinson's forgotten *Disciple of Death* (1972), Amicus's UK/US co-production *Tales from the Crypt* (1972) and Hammer's UK/Hong Kong outing *The Legend of the 7 Golden Vampires* (1973). Burnley's film was little more than a genre oddity: a terribly depressing story about a married woman (Susan Hampshire) whose lover dies during a weekend trip to Scotland then comes back from the grave as a zombie. Played absolutely straight by all concerned it's a drab little British affair that's more interested in its central romance than its lighthouse keeper turned zombified lover (played by Michael Petrovitch), whose return from beyond the grave comes with little horror and little explanation.

In *Disciple of Death*, meanwhile, BBC radio star Mike Raven set out to corner the horror market as the new Christopher Lee with a "blood-curdling" tale of Satanic worship and virgin sacrifices in eighteenth-century Cornwall. After Hammer lost interest in the script (co-written by Raven under a pseudonym), the ambitious thesp stumped up some of his own cash to cover the £50,000 budget. Playing a demon brought back from hell by some spilt blood, Raven goes in search of a virgin bride (chief candidate being Marguerite Hardiman) while surrounding himself with pallid female zombies. Christopher Lee had little to fear.

Fortunately British horror studios Hammer and Amicus were on hand to deliver some more conventional pleasures in two living dead movies released around the same time. Styled as Dracula Goes to China, director Roy Ward Baker's *The Legend of the 7 Golden Vampires* updated the bloodsucking legend to the Far East. Teaming Chinese martial artists with Van Helsing (Peter Cushing), his son Leyland (Robin Stewart) and Norwegian pinup

Peter Cushing rises from the grave in **Tales from the Crypt**. The sunken eye-sockets and peeling flesh are courtesy of Roy Ashton.

Julie Ege as the film's token love interest, it was pretty obvious that Hammer wanted to capitalise on the kung fu craze of the early 1970s. That the ageing British studio managed to make the Shaw Brothers' chopsocky antics seem vaguely ridiculous summed up its ailing fortunes. It came as no surprise that this turned out to be Hammer's penultimate horror film.

The film's reputation wasn't much helped by the appearance of John Forbes-Robertson as Count Dracula. Stepping in after Christopher Lee finally said fangs-for-the-memories and decided against another outing as the toothsome aristocrat, Forbes-Robertson delivered a terribly camp performance as the Count. Over-indulging himself in the make-up trailer, he played Dracula as a hammy old queen caked in rouge. In such circumstances, the zombies were probably glad to play only a minor role; much as in the old Santo movies, the film's green-faced fugitives from the undertaker are little more than punchbags rolled out for the extended fight sequences.

The Legend of the 7 Golden Vampires was Cushing's penultimate movie role for Hammer. Although the venerable genre star made his name as vampire hunter Van Helsing in the studio's inimitable Dracula films, he wasn't always the good guy. In Amicus's portmanteau horror collection *Tales from the Crypt*, based on the American E.C. comic book of the same name, he appeared as a zombie in the film's third section, entitled "Poetic Justice".

It told the story of a suburban estate agent (Robin Phillips) who's keen to get rid of down-at-heel neighbour Mr. Grimsdyke (Cushing) because he thinks he's lowering the tone of the street. When the kindly old man refuses to move on voluntarily, he receives a sack-load of poison pen Valentine cards so nasty he hangs himself. One year later, Grimsdyke returns from the dead as an eyeless, decomposed zombie to take his revenge; the startling make-up effects came courtesy of Roy Ashton who had previously worked on Hammer's *The Plague of the Zombies*. The story ends as the estate agent's mutilated body is discovered next to a Valentine's card written in blood: "You were mean and cruel right from the start / Now you really have no…" The letter unfolds to reveal the bully's bloody and still beating heart.[98]

The film's other zombie segment "Wish You Were Here" is a tired variation on *The Monkey's Paw* and rather less original. Still, it's nasty enough in the funnily savage manner of the E.C. Comics tradition to be entertaining. When Enid (Barbara Murray) gets her hands on a Chinese curio that will allegedly grant her three wishes, she thinks

she's solved her crooked husband's cash flow problems once and for all. Her first wish is for lots of money and after her hubby (Richard Greene) dies in a car accident she receives a hefty lump sum from his life insurance. Horrified, she uses her second wish to bring him back to how he was before the crash - only to discover that he died from a heart attack just before the car went off the road. With one wish left, she asks that he be given eternal life. A great idea with just one flaw: the undertaker has already treated her husband's remains. He returns to life screaming in agony as an embalmed corpse. Enid cracks and tries to dispatch him with a sword yet there's one more twist to come: his body stays alive even when it's hacked into itty bitty pieces…

Tales from the Crypt was successful enough to spawn a sequel, *The Vault of Horror* (1973) directed by Roy Ward Baker, which sadly dispensed with the zombie theme in its five stories - but was canny enough to change the principal cast into zombies in the framing story's twist ending. It gave Ashton's cadaverous make-up some welcome screentime, and managed to escape the mauling that the rest of the film received in the editing stages. Zombies notwithstanding, E.C. Comics were unhappy with the finished result and called time on the series.

Peter Cushing was sensible enough not to return for *The Vault of Horror* and later made an appearance in one of the most underrated American films of the decade, *Shock Waves* (1976). Directed by Ken Wiederhorn, who would later go on to helm *Return of the Living Dead Part II* (1988), it single-handedly updates the minor but notable tradition of Nazi zombies for modern audiences, a theme that had first found currency in the 1940s with John Carradine's plans for world domination in *Revenge of the Zombies*. *Shock Waves* follows American holidaymakers led by Brooke Adams, whose trip to the tropics goes disastrously wrong when they land on an island guarded by former Nazi officer Peter Cushing (looking thin and rather ill by this point in his career). He warns them against staying but they ignore his advice (natch) and end up falling victim to a squad of SS zombies.

According to the film's backstory these living dead are the result of a series of macabre experiments that the Nazis conducted on homicidal maniacs during the Second World War. The SS had hoped to engineer a race of super-soldiers who could man U-boats without the usual human requirements of food and oxygen. After the German high command lost control of these deranged aquatic soldiers, Cushing sank their submarine off the coast of the island and has kept watch over them ever since. Surfacing from their watery graves after being awakened by strange atmospheric conditions, the Nazi zombies proceed to pick off the holidaymakers one by one with all the ruthless efficiency one would expect from a corps of genetically engineered SS stormtroopers.

Rich in atmosphere and complete with a cast of corpses dressed in Nazi uniforms - a truly disturbing sight in itself - *Shock Waves* is a moody genre piece with some brilliant shots of the ghouls moving through the murky depths. Unfortunately it never manages to flesh out its distinctive zombie scares with anything solid, hastening its slide into undeserved obscurity.

Jumping ahead of ourselves slightly, *Shock Waves* initiated a short-lived trend for Nazi zombies at the beginning of the 1980s, all of which were of considerably lesser quality: the atrocious American entry *Night of the Zombies* (aka *Gamma 693*, 1981) and two dubious European efforts - Jean Rollin's *Zombie Lake* (orig. *Le lac des morts vivants*, 1980) and Jess Franco's *Oasis of the Zombies* (orig. *La tumba de los muertos vivientes*, 1982).[99]

Night of the Zombies focuses on a Second World War gas dubbed "Gamma 693" that's being tracked by a CIA agent (porno stud Jamie Gillis) who's eager to stop it from falling into the wrong hands. American and German zombie soldiers are protecting the canisters containing the stockpiled gas; they were exposed to it during the war and are now planning to use it to take over the world. A truly awful piece of cinematic trash full of terrible acting, wonky camerawork and ridiculous zombies who appear to be caked in flour, it's the kind of film that's so bad it's achieved a near mythic status among cult movie fans.

On the scale of artistic worthlessness, *Zombie Lake* and *Oasis of the Zombies* only rank a few notches higher but they're both more fun in a perverse kind of fashion. Produced and distributed by legendary purveyors of Z-grade trash cinema, Eurociné, these two European Nazi-zombie movies films are chiefly remembered because of their troubled production histories.

Director Jess Franco disappeared just before shooting started on *Zombie Lake*. Unable to find the legendary hack, Eurociné hired a bemused Jean Rollin to take over the production at the midnight hour. "Well Jess Franco just didn't turn up," recalled Rollin years later.

> It was the day before shooting and nobody knew where he was. No trace of him, nothing. I was about to go on holiday when the phone rang. It was the production company, Eurociné, who asked if I was interested in shooting a film for them. I said: "Why not? When do you need me?" and they replied "You start tomorrow". I didn't read the script, I knew nothing about the film except it was about zombies and the producer explained to me each morning what I was supposed to shoot. I never took this film seriously […] Eurociné is a really weird company. I am not really 100% sure what they are doing. I mean, I believe they think films like *Zombie Lake* are good horror films! They live on another planet![100]

Given the circumstances, Rollin did the best he could with the story about a bunch of German soldiers who're

executed by the French Resistance and dumped in the village lake. Arising to attack nude bathers the zombies cause plenty of havoc, yet Rollin is more interested in following one of the dead soldiers as he clambers out of the lake to visit his daughter. Padded out with lots of naked female flesh, a handful of algae-covered zombies and an off-kilter electronic score, *Zombie Lake* is extremely trashy but occasionally fun.

The same wasn't true of the company's next living dead outing, *Oasis of the Zombies*, which was helmed by Franco, who managed not to disappear during pre-production this time round. The resulting mess turned out to be bad enough to make most horror fans wish that Franco had never returned from his mystery trip. The story was lame: teenagers head into the African desert in search of some lost Nazi gold only to fall foul of the zombified remains of the soldiers who were guarding it. But it was Franco's direction that really sank the proceedings. Over-indulging his customary penchant for pointless zooms, nonsensical editing and crummy shock sequences, Franco rendered the finished product almost completely unwatchable. As a result, the film effectively marked the end of the short-lived Nazi zombie cycle - although the occasional new entry, like Rob Green's atmospheric and ghostly British-made chiller *The Bunker* (2000) has helped to keep the Sieg-Heiling zombie tradition alive.

Other cycles were equally brief, in particular the rather curious trend for kiddie zombie movies that was encouraged by young Karen, the mommy-killing zombie, in *Night of the Living Dead*. The nipper in Robert Voskanian's creepy *The Child* (1976) may not have been a zombie, but she's able to make the dead rise from their graves using her ESP-powers. In the true tradition of the zombie movie, things quickly turn nasty as Rosalie (Rosalie Cole) realises that she can use the ghouls to kill anyone who upsets her.

From *The Child*, things snowballed. A pair of zombie ankle-biters attacked characters in *Dawn of the Dead* (1978) and got hammered by an M16 assault rifle locked on full auto in the process - a taboo-shattering moment that left UK censors feeling rather queasy. Then a whole band of nippers turned to the dark side in Max Kalmanowicz's *The Children* (1980) in which a school bus is exposed to a radioactive leak. Although they survive the accident, the children are turned into atomic zombies with a penchant for murder most foul. Meanwhile, in *The Boneyard* (1989) zombie children are discovered feasting on brains in a rundown mortuary. Grubby little demon-urchins with Neanderthal social skills, they're possibly the screen's most memorable kiddie ghouls. It's just a shame that director James Cummins decided to upstage them by unleashing a giant zombie poodle on the cast… Whatever was he thinking?

French lobby card for Jess Franco's **Oasis of the Zombies**.

III. Destructive Tendencies

Returning to the 1970s, the true successor to Romero's crown wasn't an American, but a European. In 1974, Spanish director Jorge Grau made *The Living Dead at Manchester Morgue* (orig. *No profanor el sueño de los muertos*), a UK-shot living dead outing that followed directly in the footsteps of Romero's masterpiece. Escaping from his native Spain - which was under the influence of General Franco's fascist regime - into the wet and windy countryside of the Lake District, Grau succeeded in producing one of the finest zombie movies of the 1970s. It was a film that bridged the gap between Romero's *Night of the Living Dead* and his later *Dawn of the Dead* (1978), reaffirming the savage nihilism of the first while prefiguring the comic book "splatter" of the latter.

The nightmare of Grau's zombie apocalypse begins in a smog-filled Manchester where antique dealer George (Ray Lovelock) is preparing for a weekend holiday in the Lake District.[101] By all accounts he can't escape soon enough: the city is a dark, grey place where commuters hurry through the streets with makeshift facemasks to protect themselves from the fumes; a bowler-hatted gent surreptitiously swallows a handful of suspect-looking pills; a dead sparrow rots in the gutter; and a busty female streaker - two fingers held aloft in the traditional peace sign - jogs through the traffic jams attracting little attention from the jaded motorists. Clearly, the hippie dream has given way to pollution, ennui and the beginning of the strike-filled, unemployment-soaring 1970s.

Out in the rolling green fields of the Lake District, George meets Edna (Christine Galbo) at a petrol station after she accidentally backs into his motorcycle.[102] Since his bike needs to be repaired, George makes her give him a lift to Windermere. Along the way they stop at a farm to ask for directions and George witnesses a demonstration of an experimental pest-killing device that's being field-tested by Ministry of Agriculture scientists. Using ultrasonic emissions to drive insects into a frenzy in which they attack each other, the machine is already being hailed as an alternative to chemical pesticides. George is unconvinced, arguing that it's simply another tool in man's quest to destroy the natural world.

Heading back to the car, George finds Edna screaming in terror after having been attacked by a strange man (Fernando Hilbeck) who apparently bears an uncanny resemblance to a local tramp who died a few weeks earlier. Confused, George takes his shaken companion to her sister's house but as they arrive, they realise that something strange is afoot. Edna's sister Katie (Jeannine Mestre) has been attacked by the same tramp - who has murdered her husband and then vanished.

all images above: Terror stalks the Lake District in **The Living Dead at Manchester Morgue**.

Another innocent victim of **The Living Dead at Manchester Morgue**. The film's on-screen British release title was changed on its publicity materials to the subtly different **The Living Dead at the Manchester Morgue**. Originally entitled **No profanor el sueño de los muertos**, it had many other English-language titles, including **Don't Open the Window** and **Let Sleeping Corpses Lie**.

When the police arrive on the scene it quickly becomes apparent that they don't believe the story. Bluff copper Sergeant McCormick (Arthur Kennedy) doesn't have much time for all their wild talk of dead people rising from the grave and suspects that the three of them are personally responsible for the murder. Later, when one of his police constables is killed by a group of zombies who chase Edna and George into a church crypt, he still refuses to countenance the possibility that they might be telling the truth and decides instead that they must be Satanists.

On the run from the police, Edna and George try to piece the mystery together and find themselves back in the field where the pesticide machine is still running. "Not even DDT was this effective when it first came out," remarks one of the technicians. However, George has begun to suspect that it may have some unexpected side-effects. Unable to convince the local hospital surgeon to take action against the testing, he vandalises the machine. But it's not enough to save the day since the recently dead have already begun to rise from their graves.

Gruffly dismissing George's hysterical talk of zombies and belittling his hippie appearance - "You're all the same the lot of you with your long hair and faggot clothes, drugs, sex and every sort of filth" - the bigoted sergeant fails to avert the coming apocalypse. At the hospital George rescues Edna from a horde of the living dead who were waiting to be shipped out to the Manchester morgue, then is shot in the head by McCormick who arrives too late to see the proof that the

dead really are walking. "I wish the dead could come back to life you bastard," he tells George's corpse, "because then I could kill you again." In the film's closing scenes, the newly repaired pest machine brings George back from the grave to take an ironic revenge on the fascistic policeman.

With its insistent ecological message ("We are poisoned by a progress which doesn't consider the consequences," explained Grau when asked to account for the film's politics[103]) and its cynical presentation of the authorities as stupid, ineffectual and downright reactionary, *The Living Dead at Manchester Morgue* clearly owes a considerable debt to Romero. Yet, it's a captivating film in its own right, offering an unforgettably bleak vision of entropy and decay. From the opening shots of a polluted, smog-filled Manchester to the rural, grey locations (comprised entirely of gloomy riversides, cluttered farmhouses, ramshackle churches and rundown hospitals), the action takes place in a country - perhaps even a world - that's already half-dead itself.

Of all the characters we meet, only George seems to have any radical passion. The rest of the cast are washed-out automatons desperately grasping at anything they can find - from opiates to fascistic brutality - to numb themselves against the bleak reality that surrounds them. Even the zombies seem listless, as if equally weighed down by this world's sagging lack of energy.

Challenging all conventional values of authority, heroism and religious faith, *The Living Dead at Manchester Morgue* takes place in a world in which humanity has lost its way and has nothing left to believe in. The radio news reports discuss the possibility of an impending environmental catastrophe but the government announces that such "ecological problems are exaggerated". The sign outside the cemetery proclaims "This is God's acre, let nothing defile it" but it's already awash with zombies. Not even the hospital surgeon can help. When George takes him out to see the pest machine, he claims his hands are tied: "You can't get the government to act on much more serious concrete facts these days. Imagine what success we'd have getting anyone to act on a mere hypothesis. I'm afraid they'd laugh at us."

None of the traditional institutions - from the church to the state to the scientific establishment - are able to offer any guidance since their authority has collapsed. It's something Grau makes desperately apparent in his depiction of the Manchester police force in general and Sergeant McCormick in particular. The blinkered, reactionary conservatism of the forces of law and order seems to be the only thing that's propping up the rotten system. McCormick's cantankerous nastiness (wonderfully played by Arthur Kennedy) eventually makes us desire rather than fear the liberatory destruction that the zombies represent.

The first stirrings of this occur in the hospital as George tries to rescue Edna from the zombies who've emerged from the downstairs mortuary. Battling the living dead, George manages to pull Edna out into the corridor. But as he embraces her, he suddenly recoils in horror as he realises that she's already a zombie. Pushing her back into the now burning treatment room he watches the flames engulf her. On paper, this scene sounds fairly uninteresting. Yet, the way it's shot gives it a curious undertow. As Grau cuts to a point of view shot from George's perspective, we watch as Edna goes up in smoke with one hand plaintively outstretched and the soundtrack dominated by her whimpering fear. There's a certain ambiguity here. It's as if Edna were actually still alive and begging George to save her. It's only momentary but its effect is to make us sympathise, for the first time in the film, with the living dead.

In a way this brief scene serves as a prologue for the final shift of allegiance that Grau forces us to undertake as George returns from the dead and kills McCormick. It's a crowd-pleasing moment in which our zombified hero takes revenge on the film's real villain. It's also a scene that once again asks us to align ourselves with the zombies since everyone we've rooted for (George, Edna and Katie) are no longer among the living. The underlying sentiment is that in a world this rotten the retributive force that the zombies represent deserves to be unleashed.

The deliberate destruction of the present social order in favour of apocalyptic chaos is something that the post-*Night of the Living Dead* zombie film is frequently fascinated by. Presenting us with a revolution in which the dead rise up against the living, films like *Night of the Living Dead*, *The Living Dead at Manchester Morgue*, *Deathdream* and *Children Shouldn't Play with Dead Things* flout every cherished value and symbol of authority. They deliver a progressive fantasy about the overthrow of a dominant order that is inherently corrupt and reactionary. Most fascinating of all, however, is the way in which the old order is overturned without *anything* being offered in its place. Calling for the destruction of the present order without advancing any plans for social renewal or regeneration, filmmakers like Romero, Grau and Clark offer a nihilistic howl of destructive rage that cannot be assuaged. These films are progressive without ever progressing to anything in particular - as if the filmmakers are wary of creating an alternative order that's as flawed and corrupt as the one it replaces.

In the eyes of some producers, the public's desire to embrace the apocalypse promised sizeable box office returns. That was certainly what French producer Claude Guedj believed when he hired director Jean Rollin to helm the Gallic zombie apocalypse movie *The Grapes of Death* (*Les raisins de la mort*, aka *Pesticide* (1978)). It was originally planned as a cash-in imitation of the big-budget American disaster movies of the period, but Guedj and Rollin decided to make a horror movie instead, since the towering infernos and sinking cruise liners of Hollywood were well beyond the reach of their limited budget. After watching a range of films - including *The Poseidon Adventure* (1972) and *Earthquake* (1974) - Rollin came to the conclusion that these destructive blockbusters all followed a similar pattern:

> We took *The Poseidon Adventure* and reduced it to a diagram to see how it was built: basically, it was a group of people moving from a place to another and stopped on their way - for various reasons - every four minutes. We took that construction. But as, obviously, we didn't have the money to make a catastrophe film we decided to shift to the fantastic.[104]

Grafting this template onto a *Night of the Living Dead*-style zombie movie was a simple but inspired decision.

For Rollin, the project was a change of pace. Making his reputation in France in the late 1960s with the infamous *Le viol du vampire* (*The Rape of the Vampire*, 1968), the director was more used to dealing with the undead rather than their living dead counterparts. On its first release in France in 1968, *The Rape of the Vampire* caused a sensation. The project had begun life as a short film produced to accompany screenings of PRC's Poverty Row chiller *Dead Men Walk* (1943) in late 1960s Paris. A distributor friend of Rollin's had secured the rights to the old George Zucco vampire picture but at just an hour's running time it was considered too short to play alone. Rollin was hired to shoot additional footage to bolster the black and white production, and the result was a film that became the director's most infamous "Rollinade".

The Rape of the Vampire's deliriously crazed and nonsensical narrative created a public outcry. It broke the conventions of cinematic storytelling in a manner that shocked and dismayed most contemporary cinemagoers. Critics walked out in disgust, audiences splattered the screen with garbage and several of the cast and crew denounced the film, claiming that they had had no idea that the finished project would turn out the way it did.

A decade later, Rollin had established himself as a director obsessed with the undead in a series of films that included *La vampire nue* (*The Naked Vampire*, 1969), *Le frisson des vampires* (*Shiver of the Vampires*, 1970), *Requiem pour un vampire* (*Requiem for a Vampire*, 1971) and several other characteristically bizarre genre entries.

all images above:
Terror stalks the French countryside in **The Grapes of Death**.

When the opportunity arose, he was willing to stray into alternative areas of filmmaking including pornography and the zombie film. His other forays into living dead territory were the rather risible *Zombie Lake* (1980) and *La morte vivante* (*The Living Dead Girl*, 1982), a mournful tale in the tradition of the director's immensely personal vampire efforts in which a young girl (Françoise Blanchard) is resurrected from the dead after toxic chemicals are spilled in the family crypt beneath her château.

In *The Grapes of Death* Rollin offered something very different: a straight-ahead horror movie with little room for his customary bursts of lyricism. Deciding to base this disaster-horror movie on some form of contaminated consumer product, Rollin suggested to his co-screenwriters Christian Meunier and Jean-Pierre Bouyxou that they choose one of two typically French delights: wine or tobacco. In the finished script, a batch of wine contaminated by a defective pesticide is turning vineyard workers in rural France into crazed "zombies". Although not actually dead, those who drink the wine begin to rot from the inside out. It's a condition that leads to increasingly erratic and violent behaviour towards the uninfected.

Elizabeth (Marie-Georges Pascal) is travelling by rail through the French countryside on her way to visit relatives when she first realises that something's amiss. It's October and the out-of-season train is spookily deserted. Suddenly a hideously disfigured man bursts into Elizabeth's carriage and, crazed with bloodlust, kills her travelling companion. He then chases our heroine through the train until she pulls the emergency cord and escapes into the empty, dusky countryside.

What follows is - as Rollin planned - a series of chases and escapes that runs on a continuous cycle of short bursts with only the briefest of lulls in between each set-piece. It's a narrative structure that denies the audience any sense of safety or pause, a juggernaut of events that throws near-hysterical Elizabeth from frying pan to fire and back again with an insistence that borders on the sadistic. Interspersed among these chase sequences are bouts of explosive violence that are rendered all the more shocking because they interrupt the film's hypnotic rhythm. These sudden and often totally unexpected moments range from a young girl's evisceration with a pitchfork, to a crazed local who batters his bloodied, gooey forehead against a car window, and - in the film's most infamous scene - the frenzied decapitation of a blind girl carried out with the aid of a decidedly blunt axe.

Deliberately distancing himself from his most obvious influence, Rollin claimed that his tactics were notably different from Romero's: "In *Night of the Living Dead*, claustrophobia is the dominant element; normal people are locked in and the dead are outside; in my film normal people would constantly move outside."[105] Just because the action takes place outside doesn't dilute the horror. Rather, Rollin's choice of location emphasises the desolate wasteland that accompanies the zombie apocalypse. Here, the wide, open spaces and dank, dark villages form a kind of reverse pastoral; it's a spectral environment that's more like some annexe of hell than any traditional image of the French countryside.

In reality, the location itself proved so inhospitable that the filmmakers ran into production difficulties. Filming in the deserted mountain region of Les Saivennes, Rollin's cast and crew found themselves at the mercy of the elements as temperatures dropped so low that the camera had to be housed in a special shelter to keep it filming at 24 frames per second. The fact that the director's favourite actress, porn star Brigitte Lahaie, managed to strip off for her striking nude scene in such conditions remains an impressive testament to their long-running professional relationship (to say the least). Recalling the difficulties posed by the location, Rollin said: "I remember the scene in which Brigitte had to undress herself. There she was, naked, and supposed to deliver her lines, but when she opened her mouth, she literally couldn't speak because it was so cold."[106]

After a series of narrow escapes from the zombified locals, Elizabeth eventually encounters a pair of grumbling construction workers who have taken it upon themselves to eliminate the infected locals. It's at this point that the film's debt to the angry social commentary of *Night of the Living Dead* becomes clear. Elizabeth's escorts have escaped the infection since they only drink beer (or, at a push, champagne). Their mean-spirited response to the outbreak marks them as villains rather than heroes; they take pot-shots at the crazed locals and treat the situation as an opportunity to do as they please. The Gallic cousins of Romero's rednecks, they're hateful figures who positively revel in the chaos: "Wait till I tell my wife about this!"

Although it lacks the impact of *Night of the Living Dead*, *The Grapes of Death* is one of the best zombie films of the decade - a gloriously off-kilter shocker made by a director who understands (and subverts) the conventions of the genre. In one particularly playful scene, Rollin dupes the audience into expecting a zombie attack as he introduces a supporting character. Focusing first on a close-up of her fumbling, outstretched hands, then on her shuffling feet, Rollin mimics the traditional framing of an attacking zombie before cutting to a medium shot that reveals that this figure is nothing more than a blind girl desperately groping her way through the carnage.

It's an ironic moment that, when coupled with random bursts of the film's creepy electronic score and the disturbing violence, makes this an exceptional entry in the genre. Dogged by the kind of distribution problems that Rollin's films have frequently experienced - according to anecdotal evidence, a bootleg German print of the film even re-titled it *Torture Mill of the Raped Women* (!) - *The Grapes of Death* has never found the audience it deserved.[107] It drifted instead into relative obscurity on the bootleg video market for over twenty years before DVD restored it to its rightful, if still somewhat marginal, glory.

IV. Sex, Death and Amando de Ossorio's Templars

While European films like *The Grapes of Death* and *The Living Dead at Manchester Morgue* carefully toyed with the social criticism of *Night of the Living Dead*, one Spanish director took Romero's nihilism and put it to very different uses. In the early 1970s, Amando de Ossorio began an influential series of films - *Tombs of the Blind Dead* (orig. *La noche del terror ciego*, 1971), *The Return of the Blind Dead* (orig. *El ataque de los muertos sin ojos*, 1973), *Horror of the Zombies* (orig. *El buque maldito*, 1973) and *Night of the Sea Gulls* (orig. *La noche de los gaviotas*, 1975) - that reworked Romero's emphasis on the physicality of the body into a curious blend of sex, violence and death.

For Spanish horror cinema, de Ossorio's quartet of "Blind Dead" movies was something of a breath of fresh air. As the Franco regime gradually crumbled under the weight of the General's ill health and the public's increasingly vocal demands for liberalisation, the horror movie became one of the Spanish cinema industry's most cost-effective productions. The growing international demand for horror, together with the widening domestic market, meant that the genre was the easiest place for eager producers to make some fast cash. As a result, they began to export their homegrown productions around the globe often with additional scenes of sex and violence that had been cut from domestic prints.

The first person to benefit from the booming horror market was Spanish filmmaker Paul Naschy (aka Jacinto Molina) whose prolific career was largely spent recycling Universal and Hammer traditions with roles that included Dracula, Frankenstein and a wolfman called Waldemar Daninsky. During his time on both sides of the camera, Naschy inevitably turned his hand to the zombie movie. In director Carlos Aured's *Horror Rises from the Tomb* (orig. *El espanto surge de la tumba,* 1972) Naschy played a fifteenth-century warlock whose ghost is causing trouble for his unfortunate descendants in 1970s France and resurrecting the dead. In Léon Klimovsky's *Vengeance of the Zombies* (orig. *La rebelión de las muertas*, aka *Rebellion of the Dead Women*, 1972), he starred as an Indian fakir turning the pretty daughters of British ex-colonialists into ghouls. Meanwhile, in José Luis Merino's *Return of the Zombies* (orig. *La orgía de los muertos*, 1972), he played second fiddle to the main zombie plot as a halfwit who keeps a stack of corpses in an underground lair. Bare breasted zombies wandering through the countryside? Loquacious gravediggers? Only in a Naschy movie.

Naschy's films attracted wide distribution in the 1970s and have inexplicably remained cult favourites ever since. Yet his vision of horror was more camp than chilling. Other Spanish films like the American co-production *The Swamp of the Ravens* (orig. *El pantano de los cuervos*, 1973) raised the horror stakes, but it was writer-director Amando de Ossorio who helped Spanish cinema catch up with the times (his Blind Dead films also helped pave the way for Grau's far gorier Spanish/Italian co-production *The*

above: Front of house still from **Vengeance of the Zombies**. *opposite inset:* German Admat for **Return of the Zombies**.

above: John Gilling's **La cruz del diablo** was graced by the distinctive blind dead zombies made famous in Amando de Ossorio's acclaimed series of films.

Living Dead at Manchester Morgue, which didn't receive a release in Spain until late 1975). He escaped Franco's moral watchdogs by filming in Portugal and countered Naschy's eminently unfrightening productions with his own impressively original take on the zombie genre.

The Blind Dead films were based on the writings of nineteenth-century Spanish author Gustavo Adolfo Bécquer, whose work frequently referred to the Knights Templars. The Templars were soldiers who fought in the Crusades during the twelfth and thirteenth centuries and amassed great wealth until King Philip IV of France, who was scared of their autonomy, disbanded the order. In de Ossorio's version of the story, the Templars return from the Crusades having swapped Christianity for the occult. Obsessed with the idea of achieving eternal life they perform a series of blood-drinking rituals involving female virgins that they learned during their sojourn in the Middle East. Excommunicated by their former church and condemned to death, they're rounded up and hanged en masse. As they dangle from the tree branches, crows swoop down and peck out their eyes.[108] However, their occult rituals pay dividends and they're returned to "life" as mummified zombies who emerge from their tombs at regular intervals to drink the blood of unsuspecting victims. Since they are now completely blind, they're forced to track their prey by sound alone.

Although de Ossorio was always rather modest about his contribution to the zombie genre - "I didn't set out to innovate, I just wanted to do something different," he told interviewers[109] - his zombies turned out to be some of the most original living dead since Romero's flesh-eating ghouls. They were popular enough to spawn three sequels as well as making a brief appearance in John Gilling's *La cruz del diablo*, 1974 (lit. *The Cross of the Devil*) and be mooted as possible companions of Naschy's wolfman Waldemar Daninsky in a project entitled "El necronomicon de los templarios" (fortunately, this rather risible plan came to nothing).[110] Naschy went

on to use the idea of blind zombies in *The People Who Own the Dark* (orig. *Último deseo*, 1976) a post-apocalyptic tale about a bunch of cynical survivors trapped in a country château by sightless peasants whose eyes have been burnt out by a nuclear blast.

What's so striking about the Blind Dead is the way in which they underline the zombie's role as an image of mortality. With their skeletal frames, mildewed cowls, tufts of beard and eyeless faces, de Ossorio's zombies look like distant relatives of the four horsemen of the apocalypse, the ferryman of the Styx, or even Death itself. Unsurprisingly, though, it was the scenes in which they emerge from their tombs and ride through the countryside on ghostly horses - as the soundtrack crescendos in a barrage of beating drums and chanting monks - that would become de Ossorio's instantly recognisable trademark. Still, there's more to the Blind Dead quartet than just a clever reworking of the zombie's appearance. These four films also try, with varying degrees of success, to build up a thematic link between the zombies and the sex-obsessed narratives in which they appear.

During the 1970s, European horror cinema was deeply affected by the decade's booming pornography industry. As sex films entered the mainstream, with titles like *Deep Throat* (1972) and *Emmanuelle* (1974) playing to packed houses, the horror genre underwent an important transformation that blurred of the line between horror and pornography. One seminal influence on this shift was the French *fantastique*. The *fantastique* is a mode that, as horror movie critics Cathal Tohill and Pete Tombs explain, is dominated by sex:

> [In the *fantastique*] linear narrative and logic are always ignored [and] the pictorial, the excessive are the privileged factors [...] With logic and rationality out of the way, the repressed takes the centre stage, and it's hardly surprising that the other guiding factor inside the *fantastique* film is its predilection towards the erotic.[111]

Since many of the filmmakers involved in the sexploitation boom were writers and directors who were "renegades from the fantasy and horror cinema," it was only a matter of time before a crossover between the worlds of sexploitation and horror occurred.[112] Paving the way for such cross-genre fertilisation were films like Walerian Borowczyk's *The Beast* (orig. *La bête*, 1975), Rollin's vampire fantasies and Jess Franco's experiments with "horrotica" and "sexpressionism". By the late 1970s and early 1980s, directors like Franco, Rollin, Aristide Massaccesi and Andrea Bianchi frequently flitted between the worlds of hardcore pornography and "hard-gore" horror.

Although not the most sexually graphic zombie productions (as the next chapter will amply demonstrate), de Ossorio's Blind Dead films repeatedly foreground the issue of sexuality with an insistence that borders on the obsessive. In the first film of the series, *Tombs of the Blind Dead*, the opening sequence takes place at an outdoor

above and top:
Literal embodiments of death: Amando de Ossorio's blind zombie monks.

swimming pool where old school friends Betty (Lone Fleming) and Virginia (María Elena Arpón) unexpectedly run into each other. Between the scantily clad leads and nubile extras wandering around in the background, the scene's undercurrent of eroticism is clear. The building sexual *frisson* is only complicated by the arrival of Virginia's flirtatious boyfriend Roger (César Burner), who eagerly invites Betty to join himself and Virginia on a weekend camping trip. The glint in his eye suggests he's interested in erecting more than just tent poles.

For contemporary Spanish audiences, this must have seemed like a utopian glimpse of exactly the kind of sexually liberated, consumer/leisure paradise that Franco's repressive regime was denying them access to. As if to underline the truth of that, foreign prints of the film contain an additional soft-focus flashback sequence in which Betty recalls having a lesbian fumble with Virginia while they were both schoolgirls.

As the trio embark on their ill-fated camping trip, things quickly get out of hand. Jealous of Roger's flirtations with Betty, Virginia jumps off the train in the middle of the countryside, little realising that her friend is a lesbian who has no interest in Roger's macho advances. Deciding to camp overnight in a ruined monastery, Virginia pitches her tent and strips down to her underwear, at which point the gathering sexual tension reaches its climax.

In a different kind of horror film, the sight of this half-naked heroine might alert us to the impending arrival of a serial killer or rapist. Here, however, her scantily clad presence tempts the Templars out of their tombs. Their protracted abuse of Virginia as they blindly chase her around the monastery and the orgy of blood drinking (shot off-screen) that follows is styled as a symbolic rape. In case we miss the significance of her name (*Virgin*-ia) or the way in which she is killed, the morgue attendants in the following scene make de Ossorio's point quite clear, complaining: "Young girls show too much these days".

Conflating sex and horror, de Ossorio seems intent on challenging our understanding of where the link between the two lies. In the uncut prints of the later Blind Dead films, he takes this even further. Flashback sequences detail the Templars' medieval revels in which young women are chained, whipped, stripped then forced to watch as their bare breasts are mutilated. Significantly, *Tombs of the Blind Dead* also includes a literal rape, as swarthy smuggler Pedro (José Thelman) tries to convert Betty to heterosexuality by force. In the later films in the series, rape becomes a narrative prerequisite with at least one of de Ossorio's pretty young hot pants- or bikini-clad heroines being subjected to a sexual assault at some point in the story.

Although it would be easy to dismiss such moments of misogynist violence as nothing more than a questionable attempt to keep the attention of the film's (male) audiences, this catalogue of sexual abuse actually

Ravished by death: mortality and eroticism elegantly combine in **The Night of the Sea Gulls**.

plays an integral role in the series' thematics. Made under the repressive dictates of the Franco regime, the Blind Dead films make sex the site of a clash between two very different generations: hard-line fascists and youngsters who just want to have fun. As Nigel J. Burrell points out, *Tombs of the Blind Dead* can be read as an analogy of "the rising up of Old Spain against the permissive generation, the repressive fascism of the Franco regime [...] versus the youth of the day".[113]

While this reading is insightful, it's important to note that de Ossorio's sexual vision doesn't really present death as a punishment for the joy of sex. Ultimately, there is no sexual pleasure in de Ossorio's universe, only violence, rape and thwarted desire. Unlike the teen horror movies of the 1980s, the Blind Dead films never present sex as a transgressive experience that needs to be punished. Rather, it's a violent business in which men bully and brutalise young women.

What the Blind Dead films offer is a replay of the dark nihilism of so many of the other zombie films of the period. Instead of concentrating on the corrupt social order of the present (something far too dangerous to do in Franco's Spain), the series shifts its nihilism towards the presentation of the sexually active body. It's a pessimistic vision in which youth and beauty are always destroyed.

De Ossorio's decision to pit his heroines against the desiccated remains of the Templars is more than just a throwaway whim. In each of the four films - but especially in *Tombs of the Blind Dead* and *Horror of the Zombies* - the women outnumber the men. They're invariably young, pretty and shown in various states of undress. They are also the primary focus of the films' horror as the zombies chase and attack them. *Horror of the Zombies*, for instance, begins with an arresting display of female flesh during a bikini photo shoot. The rest of the

The Templars prepare to take the train in the final moments of **Tombs of the Blind Dead**.

story takes place on a mysterious sixteenth-century galleon where the Templars emerge from below decks and attack the assembled cast who've foolishly strayed aboard. Amid the mayhem, the girls are captured by the Blind Dead and dragged below as the grasping, skeletal hands of the Templars tear off their skimpy clothing. While Romero's ghouls were distinctly oral monsters who bit and chomped their victims' flesh, the Blind Dead are tactile. Each attack is styled as a prelude to some living dead gang rape as hands grope female flesh and sex becomes nothing more than a prelude, a "little death" that brings us ever closer to the final end.[114]

By concentrating on the nubile bodies of his female cast as they confront these cowled representations of Death himself, de Ossorio suggests that the flesh is simply a reminder of our own mortality. The younger and prettier it is, the more poignant the realisation of its eventual death, decay and destruction. As the Templars shuffle blindly and (incredibly) slowly towards their victims, it's impossible not to see them as the literal embodiment of death's relentless and completely implacable approach. The fact that these lumbering blind ghouls always manage to catch their victims says less about the stupidity of the living than the inevitability of the end.

The rigorous demands of the Spanish censors meant that de Ossorio was unable to mimic the gory set pieces of films like *The Living Dead at Manchester Morgue* or *The Grapes of Death*. Still, his quartet manages to demonstrate the body's inevitable fragmentation and destruction in quite novel ways. In *Tombs of the Blind Dead* Betty's mannequin workshop is a metaphor for the kind of physical trauma that de Ossorio can't explicitly show on-screen. The sequence begins with a close-up of what appears to be a real (and troublingly empty) eye socket. At first it we think it must be one of the Blind Dead but then, in a startling moment, an eyeball appears swivelling wildly around the socket. At this point the camera pulls back to reveal that this potentially hideous image is actually nothing more than one of Betty's assistants assembling the head of a shop window dummy. The rest of the sequence frames Betty and Roger in the workshop where they are surrounded by half-assembled mannequins, plastic arms, legs, torsos and heads. The flickering light of a red neon sign outside the window bathes the whole scene in hellish hues. It's a prescient image of the dismemberment that awaits our heroes.

In a knowing homage to Romero, *Tombs of the Blind Dead* ends as the ghouls head into a nearby city on a train. Upon arrival at a station, the film's action dissolves into a montage of grainy stills similar to those that close *Night of the Living Dead*. Screams rise to a crescendo on the soundtrack and the film ends with a sick little joke: a title card bearing the legend "Fin" appears on-screen and the skeletal hand of one of the Templars drops across it.

It's a thrillingly bleak conclusion that turns the train into an apt image of the inevitability of death. Hurtling ever onwards, the living characters of de Ossorio's films are trapped on a fast track to doom. There's no turn off, no reverse gear: death is the final destination. Instead of the savage satirical critiques offered by Romero, Grau and Rollin, de Ossorio gives us a quartet of films that ask us to acknowledge the inevitable *Fin* that awaits us all.

"Each attack is styled as a prelude to some living dead gang rape" - **Tombs of the Blind Dead**.

Sale of the century: zombie consumers shop till they drop in **Dawn of the Dead**.

V. By the Dawn's Early Light

"It's everywhere," mutters one of the characters in the opening half hour of *Dawn of the Dead* (1978). Spreading across America, the zombie plague of *Night of the Living Dead* has not stopped. At the end of that 1968 film, the authorities appeared to be in control of the situation as martial law was put into effect and "search and destroy" squads worked their way through the countryside. As *Dawn of the Dead* opens, it's apparent that the balance of power has radically changed.

Shot ten years after *Night of the Living Dead*, Romero's return to the genre that made his name was as exciting as it was expected. Unable to rediscover the success of his debut in films like *There's Always Vanilla*, *Jack's Wife* and *The Crazies*, the decision to return to the zombie had as much to do with economics as artistry. The result was *Dawn of the Dead*, a film that would have an irrevocable impact on the zombie's cinematic status. Indeed, it's almost impossible to overestimate the film's importance - particularly on the European horror market of the late 1970s and early 1980s. Rather than simply replaying the zombie apocalypse of *Night of the Living Dead* with a bigger budget and colour film stock, *Dawn of the Dead* took the concept in unexpected directions, reviving the zombie genre with comic panache just as it was threatening to become moribund.

The origins of the story can be traced back to the mid-1970s, when Romero was given a tour of a sprawling shopping mall in Monroeville, Pennsylvania by a business associate who had offices in the gigantic complex. Overawed by this cavernous temple to American consumerism, the filmmaker began to wonder what it would be like if the survivors of his apocalyptic scenario found themselves taking shelter there. "It centred around this couple - a guy and a pregnant woman - who were living up in this crawl space. He was like the hunter/gatherer, going down into the mall for supplies and food. They were really like cave people; they were naked all the time. I was really going out there, very heavy. It was too dark. It was really ugly."[115]

Convinced that this idea was simply too much for the sequel to handle - in terms of both tone and chronology - Romero decided to take a step back and come at the material from a different angle. He was eager not to play all his aces at once, realising that if *Dawn* began with the complete destruction of civilisation, there would be little chance of continuing the story in a third film. To compensate, Romero moved the action of *Dawn of the Dead* back to the catastrophe itself, focussing instead on the collapse of the social order that had only been hinted at obliquely in *Night of the Living Dead*. Although ten years had passed between the original movie and its sequel, Romero presented the action as if was occurring the morning after *Night of the Living Dead*. Despite the change in fashions and technology that had occurred in the intervening decade, this bold move worked surprisingly well and the join between the two films feels completely seamless.

The news that Romero was writing a new zombie script attracted lots of attention, some of it from rather exciting quarters. In Italy, producer Alfredo Cuomo received an incomplete draft of the sequel script in the hope that he might be willing to find European support for the film's projected $1.5 million budget, which was more

Stills from **Dawn of the Dead**.
above: Roger (Scott H. Reiniger) gets a close-up view of zombie dental hygiene. *below:* "Shoot 'em in the head!" - a ghoul benefits from some poor marksmanship.
opposite top: Tom Savini's make-up was inspired by his experiences in Vietnam. *opposite bottom:* Zombie extras wander the Monroeville mall.

than a thirteen-fold increase on *Night of the Living Dead*'s $114,000 cost. Much to the delighted surprise of Romero, Cuomo passed on an Italian translation of the script to his friend Dario Argento, a legendary horror director whose films *Deep Red* (1975) and *Suspiria* (1977) Romero greatly admired. It was to prove a marriage made in heaven (or perhaps, given their respective interests, hell). Full of mutual respect for one another, Romero and Argento brokered a distribution deal that would allow Romero to pursue his ideas without interference from pusillanimous financial backers.

Selling Argento the foreign rights to the film in all non-English speaking territories except South America, Romero and his partners secured $750,000 of the film's budget upfront. Argento, who had come on board with his brother Claudio and producer Cuomo, had no input in the project apart from giving his blessing to the shoot. Once the editing process began Argento then cut his own European version of the film. It was eight minutes shorter than Romero's edit, a little lighter on the humour and bolstered by an extended score from Argento's favourite musicians Goblin.[116]

Dawn of the Dead starts with Fran (Gaylen Ross) jolting out of a bad dream into the waking nightmare of the zombie reality. The living dead have won the upper hand and the fabric of society is crumbling, not least of all in the chaotic Pittsburgh television station where Fran works. "We're blowing it ourselves," she whispers as ratings-hungry producers try to air a list of rescue stations that they know is already out of date in order to keep the viewers from switching channels. Fran's right: it's not the dead that are the problem, but the living.

Outside the television station, martial law prevails. In a nearby ghetto, National Guardsmen, police and SWAT teams storm a tenement building where the occupants are hiding the (living) corpses of their dead relatives. Chaos reigns supreme and in the ensuing gun

battle, scores of Latinos and African-Americans are killed as the police attack with tear gas, shotguns and automatic weapons. One officer goes "ape-shit," indiscriminately blowing off heads while ranting about "niggers". The wrong door is opened and a horde of zombies pours out. A woman rushes into the arms of her dead husband, only for him to take a deep bite out of her shoulder. SWAT officers Peter (Ken Foree) and Roger (Scott H. Reiniger) make their way down into the cellar where the dead are being kept. In a gruesome sequence, the heroes shoot scores of the living corpses as they writhe about on the floor.

The constant refrain of *Dawn of the Dead* is "shoot 'em in the head!" and in the unmitigated chaos of the film's opening scenes, it's a mantra that seems terrifyingly perverse. The headshot may be the only way to "kill" the zombies once and for all, but it also symbolises everything that's wrong with the authorities' response to the crisis. "Shoot 'em in the head" is the policy of a world gone mad. It's also a policy that's doomed to failure since giving up the head (reason, logic, the intellect) can only encourage the body (emotion, desire, the flesh) to gain ascendancy. Judging by all the mindless corpses milling around, that's something that's already happening of its own accord.

Only the scientists seem to have kept their heads, but their cold rationality is too much for the rest of the populace to bear. "We must not be lulled by the concept that these are our family members or our friends," explains one. "They are *not*! They will *not* respond to such emotion." His demand that the ghouls be "exterminated on sight," only provokes anger and his suggestion that the living ought to start feeding the zombies is met with horror. The failure to face up to the grim reality of this changed world becomes more of a threat to the living's survival than the ghouls themselves.

This apocalypse of reason dominates the film. As Peter, Roger, Fran and her boyfriend Stephen (David Emge) escape Pittsburgh in a stolen helicopter, Romero paints this world as increasingly "headless": law and order has vanished; the television and radio signals have been switched off; no one is in control anymore. Landing at an abandoned out-of-town mall, the group secure the building by blocking the doors, then settle into a life of quiet domesticity as the world goes to hell. This supposedly idyllic existence quickly gives way to boredom, though. Their ennui is only broken by the arrival of a band of looters who break into the mall and open it up to the zombies once again. In the ensuing three-way battle between bikers, zombies and mall occupants only Peter and Fran survive. As the mall is completely overrun they fly off in the helicopter to face an uncertain future and potential oblivion.

The irrationality of this "headless" world is mirrored in the increasingly foolish antics of the living. Losing one's head becomes a recurring theme. Roger's whooping macho antics as the group secures the mall leads to his death as he compromises his SWAT team professionalism by getting off on the adrenalin rush of fighting the zombies. Bitten in the arm because of his carelessness, he's the group's first victim. Later Stephen follows his example: he fights the bikers in a ridiculously venal attempt to save the array of useless consumer goods that the mall houses ("This is ours, we took it"). Had Stephen restrained himself, the group could have survived. The upstairs hideaway would have kept them hidden from both zombies and bikers and, it is possible to suppose, they might well have been able to resecure the mall again once the bikers departed. By trying to defend his "property" Stephen wrecks everything they've worked for and inadvertently leads the zombies to the upstairs den after he becomes one of the living dead.

While the social critique of *Night of the Living Dead* was largely implicit, its sequel is somewhat heavy-handed in its satirical impact. "Just because I'm dealing with gross graphic violence doesn't mean I have to shy away from making the film fun," explained Romero before linking this sentiment with his anti-Establishment position: "The age of the 'splatter cinema' coincides with the age in the USA where people were refusing to go to war. It is criticism for overstatement. It's overkill and obviously so. It carries things to such an absurd degree that we know it is absurd. Nothing I do will have a causative effect. No one

is going to come out of [*Dawn of the Dead*] and eat anyone."[117] So, while "*Night* reflected the time in which it was made and the anger around that time, the late 1960s. The aim [in *Dawn of the Dead*] was to reflect the 1970s a bit more."[118] The finished film certainly captures the empty materialism of the "Me-generation" decade as consumer goods and gadgets have started to replace human relationships and community. As Stephen King suggests, the film's apocalyptic vision also captures the sense of decay and entropy that was working its way through American culture at the time of its production:

> As the oil runs out, as the Three Mile Island nuclear plant sprays radiation into the atmosphere like an atomic teakettle that someone forgot to take off the burner and as the dollar gradually becomes more and more transparent, Romero invites us into a crazed bedlam where zombies stagger up and down escalators, stare with dulled fascination at department store dummies wearing fur coats and try to eat perfume bottles. The movie's four protagonists at first segregate themselves from this world, and then, unknowingly become part of it. The only difference is that they're not dead. At least not yet...[119]

Romero's decision to turn his zombies into mindless consumers is the perfect illustration of *Dawn of the Dead*'s cartoon satire. As the zombies roam the mall, drag themselves around the ice rink and trundle through the empty shopping aisles to the sound of a Muzak-style polka called "The Gonk," Romero leavens the apocalypse with slapstick buffoonery. He even stages a one-sided custard-pie throwing and soda-siphon squirting battle between the rampaging bikers and the living dead.[120]

Such comedy keeps *Dawn of the Dead* far lighter than its predecessor, but it doesn't blunt the edge of Romero's critique. While some viewers have complained that Romero's central conceit - the zombies are simply a different kind of late-capitalist consumer - is rather too obvious, that is arguably the whole point of the movie's underlying irony. Romero doesn't have a vision of how to save capitalist society; he's only interested in destroying the whole rotten structure itself. The mordant humour barely conceals the film's disgust at the shallow, zombified wasteland that is 1970s America.

Reading through and beyond the comedy, Barry Keith Grant has claimed that the serious intent of Romero's project means that for the filmmaker, "the zombie becomes as crucial a metaphor of social relations as the prostitute for Godard" as well as a tool for challenging "macho masculinism and conspicuous consumption".[121] Pointedly lampooning the faux utopian logic behind the consumerist boom of the 1970s, the middle section of *Dawn of the Dead* places its four protagonists inside the zombie-free, empty enclosure of the mall, gives them all they could ask for (cash, food, sports facilities, gadgets and unlimited leisure time) and then quietly watches as they descend into abject misery and self-loathing. Apparently, the zombies aren't the only ones who've lost their souls.

Yet the target of Romero's satire is more than just consumerism; it's the whole fabric of postmodern capitalist culture itself. As Robin Wood suggests, "the premise of *Dawn of the Dead* is that the social order (regarded in all Romero's films as obsolete and discredited) *can't* be restored".[122] In other words, what *Dawn of the Dead*'s narrative trajectory encompasses is a nihilism similar to that found in *Night of the Living Dead*, *The Living Dead at Manchester Morgue* and *The Grapes of Death*. The zombie apocalypse is one in which everything our heroes had believed in crumbles into nothingness. As actress Gaylen Ross explains:

> [The consumer goods in the mall] are only *symbols*. A pound of coffee from a store is not just a pound of coffee; it represents a way of being. In *Dawn of the Dead*, the symbols have lost their meaning. The film's characters have given it value only to realise that none it *is* valuable anymore, because there's no longer any context for it.[123]

In this world the only thing that still seems certain is the vulnerability of the flesh. Hacking at the bodies of his characters and monsters with gleeful aplomb, Romero offers us a glimpse of a universe in which all spiritual

values have been replaced by our awareness of the material realities of the corporeal and consumerism.

The film's special effects and make-up were created by Tom Savini, a former Vietnam combat photographer. His work on *Dawn of the Dead* catapulted him to instant genre fame as one of the industry's leading special effects artists. It was a reputation that he went on to cement by working on *Friday the 13th* (1980), *Maniac* (1980) and Romero's *Day of the Dead* (1985). Employing Savini's talent with fake blood and latex - not to mention his first-hand experience of battlefield carnage - Romero shows us the body fragmented: heads are exploded by shotgun blasts, brains are scrambled by screwdrivers, chunks of flesh are bitten off the bone and helicopter rotor blades slice open the head of an advancing zombie. It's a vision that, in the true spirit of the grotesque, comes with as much humour as horror. In one particularly memorable moment, a foolish biker is pulled to pieces by zombies while he sits in a blood pressure reading machine. As the ghouls drag him away, his dismembered arm is left in the machine's strap and the reading goes off the scale as his blood pressure plummets.

The comedy of such horrific scenes does little to reduce the impact of their gross violence. In fact, the comedy exaggerates the horror by making us even more aware of just how ridiculously vulnerable the flesh is. If Romero's aim really is to make us lose all faith in bodily integrity, then it's the comic impact of the gory special effects (what Romero dubbed the "splatter") that hammers the point home. The human body isn't just a hunk of flesh - it's a *ludicrous* hunk of flesh.[124]

It was this grimly comic willingness to expose the body's object status that caused the film to fall foul of the American censors. *Dawn of the Dead* was released in Italy in September 1978 under the alternative title *Zombi* in a 119-minute cut credited to Argento, who excised most of the humour giving the action a harder edge. It proved an immediate success. In America, it was another eight months before the film reached cinemas as a pitched battle with the Motion Picture Association of America (MPAA) began. The censors decreed that unless significant cuts were made to Romero's 127-minute edit of the film they would be forced to give it an X rating. This would be the commercial kiss of death since it would deny the film any possible chance of respectability, consigning it to the level of a hardcore porn movie (despite the fact that there wasn't a single sex scene in it) and imposing strict rules on how it could be advertised.

In the months that followed, Romero and his producers decided to take a chance and release the film unrated. This was something that they were legally entitled to do, although received industry wisdom suggested that it might also be commercial suicide. In the end, the decision proved unbelievably lucrative. Released in New York in April 1979, this $1.5 million film became a sensation, taking over $900,000 in the city alone in just its first week of release.[125] It was a sign of things to come, as the film eventually took $55 million worldwide. Romero's return to the monster that had made his name was a staggering financial coup.

Best of all, the critics were upbeat, with a string of glowing reviews hailing the sequel as a masterpiece. Even Roger Ebert - who had been so worried by the original film's impact on the young - was impressed by Romero's vision of the end of the world, declaring it "The ultimate horror film!" and claiming it was "Brilliantly crafted, funny, droll, disgusting […] a savagely satanic vision of America […] How can I defend this depraved trash? I do not defend it. I praise it. Nobody said art had to be tasteful".[126] Naturally, there were dissenters: *Variety* dismissed the enterprise much as it had the original as "banal when not incoherent" and claimed "Romero professes no pretension to 'art' on his film's behalf".[127] *New York Times* reviewer Janet Maslin apparently left the preview theatre after just fifteen minutes, peevishly remarking that in the years since *Night of the Living Dead* Romero had "discovered colour. Perhaps horror movie buffs will see this as an improvement".[128] She clearly did not.

Using the horror genre to critique American culture, capitalism and the political status quo, *Dawn of the Dead* was distressing for more reasons than its gory scenes of bodily trauma. The assault on the body politic is equally - if not more - shocking. Perhaps this explains why the MPAA couldn't be mollified. One can only imagine what the puritanical censors made of the film's

broad swipes at religious authority. Refusing to offer a cohesive theological explanation for the apocalypse, *Dawn of the Dead* only gives us two tantalisingly brief religious discussions as an alternative to the pragmatic nihilism of the scientists.

The first of these comes from the lips of the one-legged Hispanic priest who rebukes Peter and Roger as they catch their breath after the tenement building slaughter that opens the film. "When the dead walk señores, we must stop the killing or lose the war," he warns them, subtly harking back to the zombie's Caribbean heritage and implicitly suggesting that Judgement Day may well be at hand. Later as our heroes watch the zombies clamouring outside the mall, Peter recalls the superstitious mutterings of his Caribbean grandfather: "There's no more room in hell," he whispers, adding, "Something my granddaddy used to tell us. You know Macumba? Voodoo. Grandaddy used to be a priest in Trinidad. Used to tell us: 'When there's no more room in hell, the dead will walk the earth.'"

Romero is careful to ensure that the suggestion that the zombie apocalypse might be a divine punishment is left unresolved. In a world where neither science nor capitalism have answers, it's telling that religion doesn't fare any better, offering no hope to these beleaguered characters as they struggle to make sense of a world turned upside down.

If that weren't enough of an affront to the censors, then the memorably bleak finale probably did little to endear the film to them either. With Roger and Stephen dead, the mall half-destroyed and the zombies everywhere again, Peter and Fran head up to the roof. Despairing, Peter contemplates suicide as Fran climbs into the helicopter. Then, in a sudden change of heart, he turns his single-shot pistol on an advancing zombie and karate-chops his way out to the helicopter. As zombies stumble over the roof, the surviving pair fly off into the horizon in a chopper that's low on fuel. Will it get them to safety? Is there any safety left? Resigned to their fate Fran and Peter share a wry smile, then the credits roll.

In many respects, it's an ambiguous conclusion. Will they survive? We don't know for certain. But if they do live long enough to reach another safe haven, Romero seems to be hinting at the possibility of a progressive new beginning for the human race as black man and (pregnant) white woman head off in hope of a fresh start. Perhaps they might even found some radical interracial utopia. As the only two characters who have managed to keep their heads throughout the proceeding action, it seems fair to say that Fran and Peter represent mankind's last, best hope.

For Robin Wood, writing shortly after the film's American release in 1979, *Dawn of the Dead* offers proof that the horror film is "currently the most important of all American genres [because it is] progressive, even in its overt nihilism".[129] Claiming that such horror films offer "the possibility of radical change and rebuilding," Wood cites *Dawn of the Dead* rather than *Night of the Living Dead* as a film whose characters are absolved from the value-structures of the past.[130]

Intriguingly, Romero claims that such a positive outcome wasn't his original intention. In the shooting script, the action ends with a spectacular double suicide. Escaping into the upper levels of the mall, Peter and Fran separate. Too exhausted and despairing to carry on, Peter puts a gun to his head while Fran starts the helicopter. Hearing the gunshot, though, she loses all interest in carrying on alone and steps up into the whirling rotor blades, decapitating herself. As the summation of the film's thematic obsession with losing one's head, this shocking sequence would have made a staggeringly evocative finale. According to Romero it was replaced with the alternative, and more ambiguous, ending because the special effects sequence created for Fran's decapitation wasn't up to the standard that he wanted.[131] Eager not to end the movie with a piece of bad splatter, Romero instead decided to let his hero and heroine fly off towards a tenuous future. It may not possess the pessimism or shock that the planned conclusion would have delivered, but it carries its own grim logic all the same.

RENÉ CHATEAU présente

"Quand il n'y a plus de place en enfer les morts reviennent sur terre"

ZOMBIE

UN FILM DE GEORGE A. ROMERO

Promo artwork for some of the earliest zombie features. All are American films from the 1940s, except for **Revolt of the Zombies**, which was made in 1936.

Zombie movies developed through the 1940s and 1950s, until the 1960s ushered in a new breed of violent feature films such as **The Astro-Zombies** (1967, above). Then **Night of the Living Dead** (1968) changed the face of the genre forever.

above: French poster for George A. Romero's **Night of the Living Dead**.
left: A typically original Spanish poster design for **Night of the Living Dead**.
opposite: Spanish poster for **Tombs of the Blind Dead** under its original title.
below: Amando de Ossorio's terrifying zombie monks as seen in **Tombs of the Blind Dead**.

above: Greek video cover for José Luis Merino's **Return of the Zombies**.
opposite: Spanish poster for Merino's film under its original title.
right: Italian locandina poster for **Tombs of the Blind Dead**.
below: Templar monks prove a highway hazard for Fernando Sancho in **Return of the Blind Dead**.

German poster for **The Return of the Blind Dead**.

Spanish poster for **The Return of the Blind Dead**.

MARIA PERSCHY — JACK TAYLOR
CARLOS LEMOS — BARBARA REY
MANUEL DE BLAS — BLANCA ESTRADA

EASTMANCOLOR

EL BUQUE MALDITO

director: AMANDO DE OSSORIO UNA PRODUCCION ANCLA CENTURY FILMS PARA BELEN FILMS

above: The cowardly town mayor (Fernando Sancho) gets his just desserts in **Return of the Blind Dead**.
right: Italian locandina poster for **Return of the Blind Dead**.
opposite: Spanish poster for **Horror of the Zombies**.
below: The Blind Dead leave their boat behind and head onto land at the climax of **Horror of the Zombies**.

this page and opposite: German lobby stills for **Horror of the Zombies**.

Das Geisterschiff der schwimmenden Leichen

top: German lobby card for **Vengeance of the Zombies**.
above: Spanish press book for **Zombie Lake**.
left: German video cover for **A Virgin Among the Living Dead**.
opposite top: Mexican lobby card for **The Night of the Sea Gulls**.
opposite bottom: Spanish front of house still for **La cruz del diablo**.

this page top: Italian make-up maestro Gianetto De Rossi set a new benchmark for zombie realism in his work on **The Living Dead at Manchester Morgue**. Note the impressive abdominal stitching on the morgue ghoul.

opposite: the exquisite original Spanish poster for **The Swamp of the Ravens** promises more horror than the film itself actually delivers.

EL PANTANO DE LOS CUERVOS

CON RAMIRO OLIVEROS · MARCELLE BICHETTI · FERNANDO SANCHO · MARCOS MOLINA
ANTONIA MAS · BILL HARRISON · CESAR CARMIGNIANI
DIRIGIDA POR **MANUEL CAÑO** GUION: LARRY EVANS MUSICA: JOAQUIN TORRES
COPRODUCTION MUNDIAL FILM, S.A. OF MADRID – AMERICAN FILMS INC. OF MIAMI
TECHNISCOPE – TECHNICOLOR

top: Two suitably scary stills from **Living Dead at Manchester Morgue**.
above: The Dutch video cover for **Oasis of the Zombies** is characteristically upfront about the film's pleasures.
right: More sexploitation horror in the Spanish press book for the same film.
opposite: Blaxploitation meets zombie horror in **Sugar Hill**.

above: The key art for **Shock Waves**, as seen on this French poster, seems to have taken its inspiration from (non-zombie) star Peter Cushing's ageing features. *opposite:* A ravishing poster for **Devil's Kiss**, a little-seen Spanish movie from director Georges Gigó.

left and above: The infamous exploding head and spectacular blood-squib effects by make-up maestro Tom Savini defined the era's most influential zombie movie, **Dawn of the Dead**.

below: French lobby card for **Dawn of the Dead**.

opposite: Japanese poster for **Dawn of the Dead**.

RENÉ CHATEAU présente

ZOMBIE

UNE SÉLECTION DE
DARIO ARGENTO

MISE EN SCÈNE DE
GEORGE A. ROMERO

ZOMBIE
DAWN OF THE DEAD
ゾンビ

■製作/特殊効果
〈サスペリア〉のダリオ・アルジェント
■監督/ジョージ・A・ロメロ
■音楽/ゴブリン

デビッド・エンゲ/ケン・フォーレ
スコット・H・ラインガー/ゲイラン・ロス
〈カラー作品〉イタリア映画
4chステレオ・サウンド
日本ヘラルド映画

Herald

地獄の底から這い出して、ゾンビが食う、人間を食う！
残酷映画史を真紅の血のりで塗り替えた驚異のスーパー残酷！

above: British quad poster for **Dawn of the Dead**.

left: Belgian poster for **Dawn of the Dead**.

opposite: Actor David Emge perfected a unique zombie shuffle for his after-death scenes as "Flyboy" (note his in-turned feet).

below: Make-up man Tom Savini puts his handiwork to good use, playing marauding biker Blades in **Dawn of the Dead**.

Claude GUEDJ

Rush Distribution
PRESENTE

LES RAISINS DE LA MORT

(Pesticide)

above: Catherine (Françoise Blanchard) feasts on an unlucky victim in Jean Rollin's **The Living Dead Girl**.
right: French poster for **The Living Dead Girl**.
opposite: An explicit scene graces the cover of the French press book for Rollin's **The Grapes of Death**.
below: Wine turns to blood in **The Grapes of Death** as Rollin panders - wonderfully - to the gore crowd.

above: French poster for **Devil Story**, one of the most obscure films in the entire book.
opposite top and bottom: Lucio Fulci's "walking flowerpots" earn their keep in **Zombi 2** (aka **Zombie Flesh-Eaters**); "homeless itinerants or hopeless winos" were hired to play the ghouls.

Belgian poster for **Zombi 2** (aka **Zombie Flesh-Eaters**).

chapter seven

Splatter Horror

I. The Italians Are Coming!

The world wasn't prepared for Lucio Fulci's *Zombi 2*. Released in 1979 as a strictly unofficial sequel to Romero's *Dawn of the Dead* - which had been distributed throughout Continental Europe under the title *Zombi* - Fulci's gorefest took audiences completely by surprise. At first glance, it looked like just another "spaghetti" rip-off, but in reality it was something more: a bravura piece of exploitation filmmaking that was so successful it was rumoured to have out-grossed the very film it was unabashedly imitating.

By the 1980s, the Italian film industry had developed something of a reputation for shamelessly replicating other countries' films. Churning out cheap remakes, pastiches and even outright copies of any picture that achieved a healthy box office, unscrupulous Italian producers cared little about charges of plagiarism. The bigger the film, the more likely a rehash, which is why *Star Wars*, *Jaws* and *The Deer Hunter* were all reinvented spaghetti style.

Much of the credit for *Zombi 2*'s success belonged to make-up artist Giannetto De Rossi, who brought Fulci's gory vision to the screen with graphic chutzpah. His portfolio of torn jugulars, skewered eyeballs and clay-faced zombies ushered in a new kind of realism, nastier and more brutal than Tom Savini's blue-skinned living dead with their custard pie slapstick gore. It made what could have been a pale imitation of *Dawn of the Dead* into a visceral orgy of - as the UK release title called them - *Zombie Flesh-Eaters*.

Flesh-eating was nothing new for Italian audiences. Ever since the cannibal cycle of the 1970s, Italian cinema had been awash with scenes of evisceration and entrail-munching as the success of Umberto Lenzi's *Deep River Savages* (orig. *Il paese del sesso selvaggio*, 1972) launched a wave of anthropophagous outings. Showcasing bodily trauma in graphic detail, these films had a huge influence on *Zombi 2* and its many Italian imitators, not least of all because so many of the industry's make-up artists cut their teeth (so to speak) on them. Giannetto De Rossi, for example, went from *Zombi 2* to *Cannibal Apocalypse* (orig. *Apocalypse domani*, 1980) then back to Fulci's later zombie movies *The Beyond* (orig. *L'aldilà*, 1981) and *The House by the Cemetery* (aka *Quella villa accanto al cimitero*, 1981).

Following the example of these notorious cannibal films, Fulci set out to give gorehounds exactly what they wanted: scene after scene of outrageous special effects in which bodies are ripped to shreds. *Zombi 2* was a rollercoaster ride of graphic nastiness in which each new gore shot had to top the last in terms of visceral impact and inventiveness. The film's prologue is a perfect example of this desire to deliver more blood, more gore and more flesh trauma than had ever been seen on-screen before: on the fictional Caribbean island of Matul, white doctor David Menard (Richard Johnson) stands watch over a corpse wrapped in a sheet and tied up with rope. As the body inevitably starts to twitch, he shoots it in the head, spattering the sheet with bright red blood. Fulci then cuts to New York's harbour district, where an unidentified yacht sails towards the docks. A police launch intercepts the vessel, but as the officers board it, an overweight zombie bursts out of the downstairs cabin and goes on a bloody rampage. In the fight that ensues, one of the policemen has his jugular ripped open in a graphic close-up, sending spurts of claret flying in all directions. The other cop opens fire, repeatedly shooting the ghoul in its blubbery belly until it falls overboard into the water. All this is before the film has even properly started.

As the rest of *Zombi 2* unfolds there's no let up in the violence. Arriving on the Caribbean island heroine Anne (Tisa Farrow, Mia's sister) and reporter Peter West (Ian McCulloch) go in search of Anne's missing father. What they discover instead is an army of indigenous ghouls

above: Lucio Fulci's **Zombi 2** (aka **Zombie Flesh-Eaters**) brought a shocking new level of realism to the violence of the zombie genre.

lurking in the shadows of the palm trees. Giving his characters and audience little time to catch their breath, Fulci unleashes a torrent of gory attacks as clay-faced native zombies chow down on the western interlopers in graphic detail. Eyeballs are skewered, flesh is eaten, brains are battered with blunt instruments and - in an insane moment - an undersea zombie wrestles a bull shark.

We can thank Fulci for *Zombi 2*'s brooding atmosphere. Jungle drums beat a steady rhythm on the soundtrack making each sun-drenched location ten times more terrifying than most horror movies' pitch-black corridors or deserted houses. The power of the violence, however, stemmed from De Rossi's skill as a make-up artist and, as he modestly recalls, a little bit of luck:

> Although I'd done the make-up for *The Living Dead at Manchester Morgue*, nobody took any real notice until my work with Fulci. Lucio was a very strange person. Very cultured and artistic on one side, a sleazy bum on the other. *Zombi 2* was made for no money, so not only could I not afford to make latex appliances, but we also never knew what extras would be available to be the living dead as they were all homeless itinerants or hopeless winos. I just smeared clay on whoever's face was in front of me and, by accident, it turned out to be the perfect look for the film.[132]

Fulci, according to horror movie legend, dubbed his living dead extras "walking flowerpots".

In *Zombi 2*, just as in almost all the Italian films that were rushed into production in its wake, the body is always the central focus of the horror. Many critics have been eager to read this as a perverse reflection of Italian Catholicism. Stephen Thrower, for instance, suggests that the Italian zombie movie is closely bound to Christian understandings of the flesh:

> It's hardly surprising that Italy, a country under the desiccated thrall of Catholicism, should have produced the most dedicated and compulsive volume of zombie films. A zombie in Italian cinema carries an iconoclastic connotation. It is

this page and opposite: At the time of the groundbreaking **Zombi 2**'s release, Fulci's "walking flowerpots" were the most corporeal screen zombies ever seen.

explosive; able to fragment realism by inferring the implacable presence of something supernatural yet stubbornly corporeal: and it is philosophical, beyond good and evil; parading the flesh *without* the much-vaunted spirit. For Christians the body is a mere waste product, excreted by the passage of the soul into heaven.[133]

The Catholic fascination with the flesh certainly informs the mechanics behind this kind of philosophical-spiritual-religious questioning, which may well explain why Romero's original zombie films were succeeded by Spanish contributions such as de Ossorio's Blind Dead movies and Grau's *The Living Dead at Manchester Morgue*. Yet what's so interesting about the Italian zombie movie is the way in which it frequently refutes any possibility of spiritual transcendence whatsoever, focusing instead on the collapse of the body, the unravelling of narrative meaning and an extensive revision of the genre's inherent racial politics. This section and the two that follow it will address each of these issues (the body, narrative and race) separately, while the final part of this chapter will look at the ways in which American cinema tried to assimilate the impact of these bloody spaghetti horrors during the latter half of the decade.

The financial success of Fulci's *Zombi 2* was enough to convince ever-eager Italian producers to churn out similar living dead movies. An explosion of zombie films ensued as various pictures competed to dominate this niche market, with distributors often using a numerical suffix in a rather blatant attempt to cash in on the public's eagerness for a sequel to *Zombi 2* (many of these were imposed after the films' release to increase video sales).[134] Unable to replicate *Zombi 2*'s shocking impact, these films were largely hamstrung by poor dubbing, cheap production values and some wild variations in the quality of the acting and direction.

The sheer range of films churned out during this period is staggering. There were vaguely competent but hugely enjoyable films like Umberto Lenzi's *Nightmare City* (orig. *Incubo sulla città contaminata*; aka *City of the Walking Dead*, 1980) and Andrea Bianchi's *The Nights of Terror* (orig. *Le notti del terrore*; aka *Burial Ground, Zombie 3*, 1980). Yet there were also truly atrocious schedule-fillers such as Bruno Mattei's *Zombie Creeping Flesh* (orig. *Virus, Apocalipsis caníbal*; aka *Night of the Zombies*, 1980), Claudio Lattanzi's *Killing Birds* (*Raptors*, 1988), Fulci's own *Zombi 3* (aka *Zombie Flesh-Eaters 2*, 1988), Claudio Fragasso's *Zombie 4: After Death* (orig. *After Death (Oltre la morte)*, 1990) and Frank Agrama's *Dawn of the Mummy* (1981) which, although often thought of as an Italian film, is actually an American production that employed a largely Italian crew.

Undoubtedly, the centrepiece of the Italian zombie cycle is Fulci's loose trilogy: *City of the Living Dead* (orig. *Paura nella città dei morti viventi*; aka *The Gates of Hell*, 1980), *The Beyond* (orig. *L'aldilà*; aka *Seven Doors of Death*, 1981) and *The House by the Cemetery* (orig. *Quella villa accanto al cimitero*, 1981). Going far beyond the simple charm of *Zombi 2*, these films have a dark majesty quite unlike anything else in the genre, which is why they're discussed separately in the following section.

Africa or the Far East - as these movies stage a violent and bloody revolution in which the living dead rise up and threaten a global apocalypse *à la* Romero.

With a few exceptions, for example Pupi Avati's sublimely creepy, but vaguely nonsensical, chiller *Zeder - Voices from the Beyond* (1983) and Lamberto Bava's insipid TV movie *Graveyard Disturbance* (orig. *Una notte nel cimitero*, 1987), most of the Italian zombie movies revolve around scenes of graphic violence. In these films, the body is presented as nothing more than a hunk of flesh, a machine that shows little or no sign of being connected to either the divine or the spiritual. Proving this are graphic scenes that have become infamous landmarks in the history of splatter cinema: the eyeball gouging of *Zombi 2*, the hand inserted so far into a victim's mouth that the eyeballs are pulled out of their sockets from the *inside* in *Zombie Creeping Flesh*, and scenes of breast-ripping in both *Nightmare City* and *The Nights of Terror*. Add to this all manner of zombie bites, bullet-ridden bodies, spilled entrails and Romero-style exploding heads and it's easy to see why these Italian gore fests frequently upset moral guardians and censors in their nihilistic treatment of the flesh as nothing more than a vessel on which to inscribe pain.

The other defining characteristic of these Italian outings is sex. Naturally, as exploitation movies, the necessity of having some bare female flesh on display is pretty obvious. However, rather than serving a purely titillating function, the nudity and sex in many of these films actually adds to their horror. Showing the female body in various states of undress and arousal adds an undeniable *frisson* to the zombie genre's inherent

The other Italian directors working in this genre could only dream of achieving such an effect, offering outrageous splatter and little else. Yet the cumulative impact of this onslaught of spaghetti horror is spectacularly visceral and curiously intriguing. Taking the theme of bodily trauma that had become a genre staple in the hands of Romero, Grau, Rollin and de Ossorio as their starting point, these distinctly marginal exploitation movies offered horror audiences an array of gruesome shock set-pieces. It was definitely a case of the gore the merrier. Existing in the gap between mainstream, non-horror productions and the increasingly comedy-focussed horror output of the major American studios, these refreshingly nasty movies enjoyed a success that was inextricably linked to their willingness to challenge the boundaries of good taste. Unsurprisingly, the more competitive the market became post-*Zombi 2*, the more sensational the driving force behind these films' violence became.

So what do the Italian zombie movies share with one another? The basic pattern of these films usually revolves around some kind of man-made disaster: the nuclear spill of *Nightmare City*, the biochemical viruses of *Zombie Creeping Flesh* and *Zombi 3*, or the experiments of a mad scientist of *Zombi Holocaust* (orig. *La regina dei cannibali*, aka *Doctor Butcher, M.D.* 1980). Occasionally the cause is supernatural in origin, as in the Etruscan magic of *The Nights of Terror* or the voodoo of *Erotic Nights of the Living Dead* (orig. *Le notti erotiche dei morti viventi*, 1980) and *Porno Holocaust*, 1980). Whatever triggers these films' zombie outbreaks, the majority of the action usually takes place in some Third World locale - frequently the Caribbean, but sometimes

Eroticism and body trauma: zombie ghouls chow down in **Dawn of the Mummy**.

anxieties about the messy corporeality of the flesh. Creating a disturbing link between physical pleasure and physical pain these films frequently link sex with bodily trauma.

Bianchi's *The Nights of Terror* (1980) is a forthright example of this intersection of sex and death. It opens with bourgeois holidaymakers arriving at a lavish country mansion where they're due to spend the weekend. Modern cousins of the decadent revellers of Edgar Allen Poe's *The Masque of the Red Death*, they disappear into their rooms to indulge in some heavy petting as soon as they arrive. However, their naughty pleasures are constantly interrupted: first by the creepy young son of one of the couples, who insists on walking into their rooms while they're *in flagrante*; then later by a group of Etruscan zombies who have been accidentally brought to life by a local archaeology professor.

As the zombies attack the castle - rising up from their graves and arming themselves with pitchforks, scythes and a makeshift battering ram - the story's political undertone becomes clear enough. This is a revenge of the dead against the living in which the ragged, plebeian zombies overthrow the decadent, libertine bourgeoisie. What's more insistent than the issues of class warfare, however, is the sexual undercurrent.

Like so many of the directors of the Italian zombie cycle, Bianchi had had first-hand experience as a pornographer. Here though he seems intent on making a porno-horror movie in which the scenes of sex and violence are played simultaneously rather than separately. The opening zombie attack takes place as two lovers enjoy a quick fumble in the château's grounds - "You look like just a whore. But I like that in a girl!" whispers the randy lothario as he pulls his young lass onto the grass - and it sets the tone for all that follows. As events unfold, Bianchi frequently cuts between sexual clinches and scenes of the zombies milling around. As in de Ossorio's Blind Dead films, there's no sexual pleasure in this world, chiefly because the interloping zombies always interrupt it. Sex again becomes a prelude to death.

The link between sex and death is exemplified in the infamous scene in *The Nights of Terror* where a slutty mother (Mariangela Giordano) attempts to suckle her son (Peter Bark) in the midst of the zombie apocalypse. This clumsy Oedipal moment is bizarre not simply because of its incestuous undercurrent (the boy is supposed to be a pre-teen and so is far too old to be breastfed), but also because of the strange presence of Bark, a strikingly odd looking actor who looks more like a midget version of horror director Dario Argento than a young child. As the zombified boy sinks his teeth into his mother's breast, he rips a huge chunk out of her bosom thereby linking sex and maternal nourishment with pain and death.

In other films, the collision between sex and death is even more remarkable. After the success of *Zombi 2*, Fulci's producer Fabrizio De Angelis went on to script and

all images above:
The Nights of Terror.

produce *Zombi Holocaust* with many of *Zombi 2*'s cast and crew. Lacking much in the way of technical or artistic competence, *Zombi Holocaust* (1980) is a mishmash of the cannibal and zombie cycles, but it's notable for its astounding catalogue of gore shots. With a new title sequence using three minutes of footage from an unfinished project by Roy Frumkes called "Tales That Will Tear Your Heart Out", the US release was renamed *Doctor Butcher, M.D.*, which perfectly captures this movie's near-clinical obsession with sex and the flesh (the M.D. stands for "Medical Deviate" (sic)).

The plot is pretty perfunctory. A New York policeman played by *Zombi 2*'s Ian McCulloch investigates a spate of corpse mutilations and ends up in the jungles of Southeast Asia. With the help of busty heroine Alexandra Delli Colli he discovers a cannibal-zombie cult presided over by a mad scientist (Donald O'Brien) intent on prolonging lifespan. All that really matters is the film's parade of sex and gore. If *Hustler* magazine merged with *Mortuary Management Monthly*, this might be the result. Lead actress Alexandra Delli Colli bares her breasts at inappropriate moments, while hospital cadavers are dissected for the benefit of the camera; McCulloch uses a boat's outboard motor to blend an attacking zombie's face to mush; various poor souls are impaled in bamboo traps, eaten alive and generally cut into shreds for the benefit of the audience. Getting off on the corporeality of the body, *Zombi Holocaust* features shots of hands delving into eviscerated bodies and reaching through incisions and gaping wounds in a desperate attempt to see what lies inside. By the end of the film's interminable running time, it seems as if bloody wounds and sexual orifices are on the verge of becoming interchangeable.

In the movies of Aristide Massaccesi (better known in the English-speaking world as Joe D'Amato) the sleaze became integral to the splatter as zombie sex went far beyond the bounds of good taste. In *Erotic Nights of the Living Dead* (1980) and its companion piece *Porno Holocaust* (1980) Massaccesi created bizarre syntheses of pornography and horror. *Erotic Nights* allows bloodletting and orgasms to run together as white holidaymakers find themselves on a Caribbean island where zombies roam the jungle and the beaches. Featuring lots of scenes of fellatio and cunnilingus - and in the film's most bizarre sequence a woman whose party trick involves opening a bottle of champagne with her vagina - *Erotic Nights* plays like a dated porno flick cut with bouts of zombie violence. With its grainy cinematography and drab Dominican Republic locations, the film proves a suitably depressing cinematic experience, possessing little eroticism but plenty of misanthropic - and corporeal - loathing.

What's so troubling about *Erotic Nights* is the way in which the sex and the horror merge. In one sequence Massaccesi cuts from a man enjoying the oral attentions of two young ladies to an external scene in which an

unrelated character has his throat ripped open by a ragged zombie. Later startling jump-cuts take the viewer from sexual encounters to close-ups of diseased and maggot-ridden zombie flesh, gouged-out eyeballs and decapitated bodies. In the film's most wince-inducing sequence our hero (George Eastman, aka Luigi Montefiori) lets the beautiful, naked native woman who's apparently controlling the zombies go down on him then watches in horror as she sinks her teeth into his penis and bites it clean off. It's the closest that this strand of "erotic" horror ever gets to a traditional money shot.

In Massaccesi's follow-up, the wonderfully titled *Porno Holocaust* - a riff on Ruggero Deodato's seminal Italian flesh-eating movie *Cannibal Holocaust* (1980) - things follow much the same course, only this time with more explicit hardcore sequences and a zombie who isn't afraid of taking an active role in the sexual couplings. Wandering around his Caribbean island killing off white holidaymakers, *Porno Holocaust*'s dark-skinned zombie brings the collision between sex and horror to an inevitably silly and undeniably racist conclusion as he rapes the female members of the group with his monstrous phallus. One young lady is forced to perform fellatio until she chokes to death while others are ripped apart by his huge girth.[135]

Sex and zombies have a curiously fertile history in exploitation cinema. The granddaddy of the "gore-nography" trend is undoubtedly Claude Pierson's little-seen *Naked Lovers* (orig. *La fille à la fourrure*, 1977) in which aliens possess the bodies of the recently dead to experiment with sex with earthlings. Released in a hardcore print (under the upfront English language title *Porno Zombies*) and a trimmed softcore print that usually circulated under the *Naked Lovers* title, it was a forerunner of Massaccesi's films.

After Massaccesi's explicit outings, the sex zombie really had nowhere left to go. Director Mario Siciliano did his best to set a new porno benchmark in *Erotic Orgasm* (orig. *Orgasmo esotico*, 1982), which again made the zombies active participants in the bedroom-Olympics on display. This time however they proved more interested in getting off than eating anyone as lesbian sex, threesomes, dildos and a zombified woman going down on her male partner padded out an incomprehensible plot about a black witch who turns horny lovers at an isolated villa into crazed sex fiends. Since that mind-boggling outing, zombie sex has fallen by the wayside. The occasional title still appears intent on linking corpses and orgasms. Recent examples include French softcore gore outing *The Revenge of the Living Dead Girls* (orig. *La revanche des mortes vivantes*, 1987) in which a batch of milk tainted by toxic waste turns girls into zombies, Vidkid Timo's gay porno-horror movie *At Twilight Come the Flesh-Eaters* (1998), a hardcore sex flick that's also a very funny spoof of *Night of the Living Dead* (best line: "He's eating me while he fucks me!"); and Kelly Hughes's *La Cage Aux Zombies* (1995), a gender-bending, cross-dressing spoof of cult gay French classic *La cage aux folles* (1978).

There's also a rather minor trend for softcore titillation that encompasses zombies and prostitutes. Spanish filmmaker Ignasi P. Ferré gave us the relatively bloodless *Morbus* (1982) in which a group of zombies start their killing spree by attacking a pair of prostitutes; Jon Valentine's *Night of the Living Babes* (1987) and Hugh Gallagher's *Gore Whore* (1994) feature prostitutes who are actually zombies. The nadir of this rather outré cycle is Jeff Centauri's deplorably misogynist *Zombie Ninja Gangbangers* (1998) in which actress Stephanie Beaton is raped not once, but twice, by vomiting zombies. Ugh.[136]

The link between pornography and horror isn't as odd as it might at first seem. Both genres deal in the forbidden and the fleshy and both are "body genres" that try to produce a physical reaction in their audiences (pleasurable arousal and/or pleasurable fear). What's more, both genres also deal with extreme images of the body, the kind of images that are usually kept hidden behind the locked doors of the bedroom or the morgue.

What makes the films of the Italian cycle so distinct from other sex zombie efforts is their insistence

This German poster for **Erotic Nights of the Living Dead** *(above)* and the Italian **Zombi Holocaust** fotobusta *(opposite)* show the era's fixation with flesh.

above: Zombie monks devour the glistening innards of a victim in **The Nights of Terror**. *opposite:* Denizens of a hospital morgue come to life in **The Beyond**.

on creating a different kind of pornography in which the body's surface is ruptured, exposing its inner mechanics to the audience's gaze. It's a frightening confrontation with the body's materiality and its status as an object. While conventional hardcore pornography revels in this object status and finds pleasure in exposing the body's traditionally hidden zones (the genitals) to view, these zombie movies offer us something more horrific: a vision of the body's essential emptiness. Opening up the body for the camera, these Italian splatter movies try to show us what lies beneath the skin and significantly, they discover nothing but a bloody mess of tubes and piping in which there is no indication of the divine. As a result, gore becomes a poor substitute for God.

While *Dawn of the Dead* took this splattery nihilism as the basis of a grim comedy of terrors in which the body's materiality made it a ludicrous hunk of meat, the Italian cycle finds nothing funny in it at all. Dark, depressingly grim and relentlessly nasty, these films seek to remind us that sex and death aren't laughing matters but are, instead, proof of our status as little more than meat. As characters hop from the bed to the grave with dismaying speed, this simple point becomes ever more transparent.

The curious thing about these Italian sex-splatter efforts is just how empty the films themselves are. As the initial rush of the transgressive pleasure offered by *Zombi Holocaust*, *The Nights of Terror*, *Erotic Nights of the Living Dead*, *Porno Holocaust* and *Erotic Orgasm* palls, boredom quickly sets in. These are one-note movies, resounding with the mournful but monotonous toll of the death-knell. But that, arguably, is their entire point. Making us recognise the gore that lies underneath our flesh, these films ask us to confront the great unspoken truth of our existence: that we are, in material terms, nothing more than a collection of organs, blood and messy slop.

For feminist theorist Julia Kristeva, the fear of the body's internal reality - what she terms "abjection" - is closely tied to our understandings of ourselves as independent subjects.[137] For Kristeva, the sight of the bodily fluids and excrement are disturbing because they remind us of our own inevitable deaths and shatter our belief in the stability of our egos. We try to hide or deny these horrid secretions because they are proof of our status as machines that will, one day, stop working:

> A wound with blood and pus, or the sickly, acrid smell of sweat, of decay, does not *signify* death. In the presence of signified death - a flat encephalograph, for instance - I would understand, react, or accept. No, as in true theatre, without make-up or masks, refuse and corpses *show me* what I permanently thrust aside in order to live. These body fluids, this defilement, this shit are what life withstands, hardly and with difficulty, on the part of death. There, I am at the border of my condition as a living being.[138]

The most terrifying image in this respect, she goes on to argue, is the corpse:

> The corpse, seen without God and outside of science, is the utmost of abjection. It is death infecting life. [...] If dung signifies the other side of the border, the place where I am not and which permits me to be, the corpse, the most sickening of wastes is a border that has encroached upon everything. It is no longer I who expel. "I" is expelled.[139]

With this in mind, it's no wonder that censors, mainstream moviegoers and film critics hated the Italian cycle. Shattering all the taboos about bodies and death, these films deliberately break the protective psychological barrier that our skin offers us and delve deep into the body. Their horror is both physical and psychological: a dizzyingly nihilistic refusal to find anything meaningful within us apart from the truth of our death.

Emerging at a moment in our history when the flesh was already under threat from the HIV/AIDS pandemic, the films of this period revolve around a desire to provoke their audiences by turning the body itself into a site of horror. Denying all our attempts to delude ourselves that the body is the sign of either our personal autonomy or of God's existence, these films drag us into a confrontation with the strangeness that lies within and the emptiness that lies without.

II. The Apocalypse of Narrative: Fulci's Zombie Trilogy

"I am the Italian cinema's last zombie!" proclaimed Lucio Fulci before his death in 1996. As the man responsible for launching a whole cycle of spaghetti living dead movies, it's a claim few would argue with. However, Fulci's reputation is based on much more than just his impressive rip-off of Romero. In his Gothic trilogy of *City of the Living Dead* (1980), *The Beyond* (1981) and *The House by the Cemetery* (1981) the director produced not only the finest work of his career but also three distinctive additions to the genre. Eschewing Romero's influence, these films strike a different path, combining the occult mythos of H.P. Lovecraft with the portentous tone of the biblical Book of Revelation. It was a brilliant change of focus, offering an alternative to the Italian cycle's obsession with the flesh and concentrating instead on fragmented storylines that challenge our understanding of the conventions of linear narrative.

Teaming up with his favourite screenwriter, Dardano Sacchetti, Fulci set out to create three radical, avant-garde gore movies. Infused with the skewered, irrational logic of a nightmare, each instalment in this unholy troika constitutes a quite remarkable viewing experience. As Thrower explains, "Fulci's Gothic films [...] all use the supernatural as a means to subvert cause and effect, leading to situations where the very structures of the films seem to be under attack from the stories' otherworldly agents".[140] It was something that Fulci himself was explicit about. Speaking to an interviewer about *The Beyond*, he explained:

> My idea was to make an *absolute* film, with all the horrors of our world. It's a plotless film: a house, people, and dead men coming from The Beyond. There's no logic to it, just a succession of images [...] We tried in Italy to make films based on pure themes, without a plot, and *The Beyond* like [Dario Argento's] *Inferno*, refuses conventional and traditional structures.[141]

Such refusal is startlingly obvious to anyone who watches any of the three films. *City of the Living Dead* begins with Father Thomas (Fabrizio Jovine), a priest in the small American town of Dunwich, committing suicide by hanging himself from a tree in his church's graveyard. This act of despair triggers an apocalyptic rift in the spiritual world, opening one of the seven gateways to hell. Unless the gateway is shut before All Saint's Day, the dead will flood back into the world and evil will triumph. As this drama unfolds, Mary (Catriona MacColl), a young

woman attending a New York séance has a vision of the priest's suicide and apparently dies from shock. Investigating her death is reporter Peter Bell (Christopher George), who rescues the (actually catatonic) Mary from being buried alive. With the help of psychiatrist Gerry (Carlo De Mejo), Mary and Peter prepare to battle the strange forces are gathering in the town of Dunwich.

In synopsis, this opening sounds perfectly straightforward. The experience of watching it, however, is anything but. The first thirty minutes of *City of the Living Dead* are completely disorienting. Cutting back and forth between events in Dunwich and New York, Fulci casts us adrift in a story that's packed full of incident but little coherence. Moving from the priest's suicide to the dead returning to life, to a scene involving a young man, a dead baby and a blow-up sex doll, to the office of a Dunwich psychiatrist, to the New York séance, to spooky goings on in a Dunwich bar, to the reporter's investigations, Fulci bombards us with characters, plot lines and information. We're left bewildered and confused. There are so many conflicting narrative threads that we don't know which one to follow. Who is the hero of this film? The reporter, the psychiatrist, the young boy, Mary, or one of the bar patrons?

Even when the film's storyline begins to take on some semblance of shape - albeit with five major characters and two main story arcs - Fulci resists the temptation to appease the audience. Instead, he flits between exposition-heavy scenes and moments of outrageous violence as the zombified priest and his living dead hordes attack the residents of Dunwich. What Fulci gives us is a collage of images, some of which fit into the film's story arc, while others simply add to the overall atmosphere of apocalyptic doom. So, a shower of maggots appears out of nowhere, a boy's head comes into contact with an industrial drill and a woman vomits up her intestines.

This willingness to privilege special effects set-pieces over and above narrative conventions reaches a dizzying extreme in the second film in the trilogy, *The Beyond*. A startlingly bold attempt to make what Fulci calls "an absolute film" devoid of plot, *The Beyond* is probably the finest film of the director's career. Fusing a Lovecraftian sense of a world dominated by forces that are beyond our ken with a Gothic *mis en scène* and lots of apocalyptic chaos, *The Beyond*'s fractured story follows New Yorker Liza (MacColl again) as she inherits a rundown hotel in New Orleans.

Back in 1927, the hotel was the scene of a gruesome outbreak of mob violence when locals dragged one of the residents into the basement and crucified him for being a warlock. Liza doesn't know anything about this, though, and so she is baffled when a series of strange occurrences dog the renovation of the hotel. A zombie attacks and kills the plumber (Giovanni De Nava) who goes down into the cellar to fix a leaky pipe; a local architect (Michele Mirabella) is attacked by tarantulas in the town library; the housekeeper (Veronica Lazar) has her head impaled on a rusty nail, forcing one of her eyeballs out of its socket; acid is poured over the face of the plumber's wife (Laura De Marchi) when she visits his body in the local morgue.

While the film clearly has a plot - our heroes must defeat the zombies and close the portal to the Beyond - Fulci is distinctly uninterested in playing out this story in any conventional manner. As the apocalypse draws closer, the film fragments and distorts as narrative logic is sacrificed to its brooding, Gothic atmosphere and outbreaks of violence. None of the pieces of the narrative jigsaw puzzle put together by Liza and hospital doctor John (David Warbeck) make much sense and, as the story progresses, the border between this world and "The Beyond" begins to blur, disrupting the conventions of cause and effect and all spatial and temporal logic. Zombies randomly appear and then vanish, various supernatural events occur without explanation and, in the film's demented conclusion, geographical space itself collapses.

The final reel is simple yet startling. Trapped in the hospital morgue by reanimated zombies, Liza and John eventually escape into the confines of the hospital's basement. When they get there, they find that they have been inexplicably transported back into the basement of the hotel, several miles away. Struggling to comprehend how this could have happened, they face yet another shock as the hotel basement morphs into "The Beyond", a formless, white realm that stretches infinitely in all directions and is littered with corpses. Is this hell? We don't know. But as John and Liza turn to face the camera, we see that their eyes have become blank and milky

white like those of the film's zombies. "And you will face the Sea of Darkness," growls a portentous but resolutely nonsensical voice-over, "and all therein that may be explored". As the credits roll, all our questions about the nature of The Beyond and the fate of our two heroes and the rest of the world are left unanswered. Have we just witnessed the apocalypse? Maybe.

In *The House by the Cemetery*, Fulci turns his hand to a more intimate family horror story. It's the most conventional of the three films, but even its simple set up is dominated by great jumps of narrative logic as university researcher Norman (Paolo Malco), his wife Lucy (MacColl, on her Fulci hat trick) and their son Bob (Giovanni Frezza) move into an isolated country house in Boston, New England. As in *The Beyond*, the house proves cursed. It once belonged to the Freudstein family and unbeknown to our heroes, the zombified remains of Dr. Freudstein - a nineteenth-century scientist rumoured to have dabbled in several unethical practices - are lurking in the basement. He's somehow keeping himself alive by dismembering the bodies of the living and feasting on their flesh.

As the name Freudstein - with its unsubtle conflation of Freud and Frankenstein suggests - *The House by the Cemetery* is a monster movie psychodrama in which the evil zombie's influence upsets the balance of the family and the house. Apart from the sheer ridiculousness involved in keeping a zombie hidden in a small basement for almost ninety minutes, *The House by the Cemetery* makes other demands on the logic of cinematic realism. What are we to make, for instance, of the scene in which the neck of a decapitated shop-window mannequin gushes blood? Or the fact that when Lucy finds her babysitter mopping up a huge bloodstain in the kitchen she doesn't think to ask her where it's come from? These scenes apparently make no sense at all leaving us to either condemn the script as amazingly incompetent or wonder if Fulci is trying to make us question our faith in the tenets of realism itself.

Perhaps a clue is to be found in the film's logic-defying conclusion. Having seen both his parents brutally killed by the monstrous Dr. Freudstein, Bob escapes from the house's basement. Except, paradoxically, he doesn't really escape at all. The basement leads into a house, the very same house that he was in a moment ago, but populated by turn of the century characters. We suddenly realise that he's been transported through a time warp back to the days when the Freudsteins' owned the house. It simultaneously makes perfect sense and absolutely no sense at all.

The House by the Cemetery and *The Beyond* both end leaving their protagonists trapped in a circular logic puzzle that offers them no escape. In comparison, *City of the Living Dead* does something rather different while offering what may well be the perfect image of Fulci's desire to fracture narrative structure. Emerging from the crypt where they've successfully battled the living dead and closed the gateway to hell, our heroes stand blinking in the sunlight. A child rushes towards them ostensibly to hug them. As he approaches, though, they recoil in fear and their faces contort in horror. Fulci doesn't show us what they've seen. Instead he simply freezes the picture on the running child in mid-dash and as this still image hangs on-screen, it slowly cracks apart like a shattered pane of glass and falls to pieces, leaving nothing but an empty void in its place.

It's a deliberately unsatisfactory ending, leaving us uncertain what has happened, yet it's a fitting conclusion to the first film in a trilogy that will create texts in which, as Thrower explains, the "overall dynamic is discontinuous, not progressive, fragmentary instead of explicatory".*[142]* Is Fulci acknowledging his desire to rupture and fragment the conventions of storytelling, and thereby letting us in on his little secret? Quite possibly.

above: A moody shot of the **House by the Cemetery**. *opposite top:* Scenes from **City of the Living Dead**. *this page top:* Scenes from **The Beyond**.

Typically, though, the director refused to explain it in such terms, claiming it was simply an accident - and adding an additional layer of confusion to the matter in the process:

> Originally, the child ran towards the camera, and we cut to the two adults smiling to themselves. That was it, a happy ending. One day, I was in the editing room [with editor Vincenzo Tomassi], and we watched the footage of the adults who were arguing in the shot - they didn't get along. So we cut to the little boy running and cut back to the footage of them arguing. But in that shot, there was an aberration on the film where it looked like the image started to break up. Well, Tomassi said, "Why don't we use that?" So we did and now it's not so happy. Reviewers have written volumes on this ending, which was just basically a mistake saved by an ingenious idea. That's Tomassi.[143]

There's something rather perverse in Fulci's mockery of reviewers for interpreting this ending in so many ways; after all, it's the trilogy's refusal to offer an absolute, coherent textual meaning that encourages such interpretation in the first place!

This remarkable scene isn't the only point at which Fulci hints at his artistic aim in the trilogy. One of the persistent images in these films is that of the ruptured eyeball. It becomes an apt metaphor for the violence Fulci directs towards the conventions of cinematic storytelling (his desire to assault his audience's eyes). In both the trilogy and *Zombi 2*, Fulci proves fascinated with the eyeball, frequently zooming into his actors' eyes and shooting them in close-ups reminiscent of those trademark sequences in Sergio Leone's stylised spaghetti westerns. However, unlike Leone, Fulci takes this ocular fascination to gruesome extremes and regularly places the eyeballs of his characters in distress.

Recalling the razorblade slicing of an eyeball in Buñuel's classic surrealist tale *Un chien andalou* (1928), Fulci's zombie films pierce, split and skewer the eye with sadistic glee. In *Zombi 2*, a protracted - and regularly censored scene - shows actress Olga Karlatos having her eyeball impaled on a splinter of wood as a zombie pulls her head through a broken doorframe. In painstakingly graphic detail, Fulci shows us what happens when the soft globular tissue of the eyeball is pierced by sharp wood. A totally disgusting and deeply disturbing attack on one of the body's most vulnerable zones, it's become an infamous landmark in horror movie history. Such ocular trauma is replayed again and again in the trilogy: in *City of the Living Dead*, the zombie priest has the power to make his victims' eye sockets gush with blood; in *The Beyond*, various characters have their eyeballs attacked as the housekeeper's head is impaled on a nail (this drives one of her eyeballs out of its socket) and an architect is attacked by tarantulas that bite into his corneas.[144]

This eyeball horror is always closely linked to the trilogy's attack on narrative, as our own cinematic gaze is ruptured by Fulci's refusal to adhere to conventional storytelling. Violence against the eye becomes a metaphor for the loss of meaning that the zombie apocalypses of these films embody. Picking up on the nihilism of the post-*Night of the Living Dead* zombie movie, Fulci's trilogy offers a very different approach to the same theme. Here the apocalypse involves more than just the destruction of the flesh or social institutions to encompass the destruction of the body of the text itself.

Fulci's discussion of the trilogy in general and *The Beyond* in particular, emphasises his belief that the apocalypse is absolute and complete. This is not simply some variation of Judgement Day - an apocalyptic moment that reaffirms God's existence as the world we live in ends and we're ushered into paradise (or, perhaps, hell) - but a spiritual vacuum that offers us no truth, no value, no hope.[145] Fulci has claimed that his aim in *The Beyond* was to create "a film without borders", a limitless text with an explicitly avant-garde agenda.[146]

> What I wanted to get across with that film [*The Beyond*] was the idea that all of life is often really a terrible nightmare and that our only refuge is to remain in this world, but outside time. In the end, the two protagonists' eyes turn completely white and they find themselves in a desert where there's no light, no shade, no wind... *no nothing*. I believe, despite my being a Catholic, that they reached what many people

imagine to be the Afterworld [...] I'd like to emphasise that I wanted to make a completely Artaudian film out of an almost non-existent script by Sacchetti [my emphasis].[147]

As the reference to French theatre director and poet Antonin Artaud makes clear, Fulci viewed his trilogy as more than just a collection of cheap horror thrills. While all three films are undeniably motivated by the demands of exploitation cinema, they simultaneously offer something more ambitious. Leavening the zombie movie's grindhouse credentials with the kind of philosophical concerns more often found in the arthouse, Fulci offers us three thrilling and innovative films that want to do more than just make us jump. They want to question our faith in the ordered universe we've built up around ourselves. Hence what the trilogy most resembles in zombie movie history isn't Romero's satiric splatterfests, but the haunting world of *I Walked with a Zombie* with its probing questioning of the limits of knowledge.

It is a project that Artaud would doubtlessly have found some merit in. Obsessed with the possibility of uncovering the tyrannical forces working within the universe - those forces that stretch far beyond the bounds of rational understanding - Artaud's Theatre of Cruelty sought to shock spectators out of their stupor by employing every facet of stage production and design. Using sounds and images, Artaud wanted to capture the terrifying limitlessness of the universe and induce a sense of horrified wonder in the spectator:

> [This cruelty isn't that which] we can exercise upon each other by hacking at each other's bodies, carving up our personal anatomies, or, like Assyrian emperors, sending parcels of human ears, noses, or neatly detached nostrils through the mail, but the much more terrible and necessary cruelty which things can exercise against us. We are not free. And the sky can still fall on our heads. And the theatre has been created to teach us that first of all.[148]

This was a horror that reached beyond the everyday and the corporal limits of "detached nostrils" towards a level where rational sense collapses and the Self is brought into contact with all those irrational and unconscious forces which act against it and mock its belief in its own integrity.

Such philosophical nihilism leads Fulci - somewhat daringly, considering Italy's staunch Catholicism - towards a vision of the world in which God is apparently absent. Negating the Christian belief in the divine as the guarantor of Truth and Value, the trilogy foregrounds religious iconography (several of the gory set pieces in *City of the Living Dead* and *The Beyond* reference the

above: Catriona MacColl fending off a zombie in **The Beyond**.

above: German poster for **City of the Living Dead**.

above: Freudstein's lair in **The House by the Cemetery**.
opposite top: Scenes from **The House by the Cemetery**.

crucifixion and the stigmata) in the service of plots that explicitly subvert Christian certainty. In Fulci's vision, the afterlife is an empty void populated by the living dead. There is no hope of paradise, only the *nothingness* of the Beyond.[149] In the unlikely event that God does exist, He can only lie somewhere beyond the Beyond.[150] It's a startlingly nihilistic viewpoint for an Italian catholic to adopt, an irony that Fulci himself was more than aware of:

> I think each man chooses his own inner hell, corresponding to his hidden vices. So I am not afraid of hell, since hell is already in us. Curiously enough, I can't imagine a Paradise exists, though I am a Catholic - but perhaps God has left me? - yet I have often envisaged hell, since we live in a society where hell can be perceived. Finally, I realise that Paradise is indescribable. Imagination is much stronger when it is pressed by the terrors of hell.[151]

Significantly, Fulci has also suggested that the trilogy is intimately connected to his own problems of faith:

> This may seem strange, but I am happier than somebody like Buñuel who says he is looking for God. I have found Him in others' misery, and my torment is greater [...] for I have realised that God is a God of suffering. I envy atheists, they don't have all these difficulties.[152]

Faced with such questions, Fulci's characters find no answers, since the world they move through is apparently without transcendent meaning. The trilogy's figures of (patriarchal) authority - the psychiatrist and the journalist of *City of the Living Dead*, the academic of *The House by the Cemetery*, the doctor of *The Beyond* - are pathetic and useless in the face of the gathering apocalypse. Given the fact that it is Father Thomas who triggers the zombie disaster at the beginning of *City of the Living Dead*, it's apparent that religion won't be able to help us either. As the trilogy assaults us with writhing maggots, bloodthirsty bats and the emptiness of the Beyond, we lose all faith in our ability to find meaning and order.

Unlike Romero, who was interested in charting the destruction of American society, Fulci's trilogy offers us something different - a world in which meaning has collapsed, the dead walk and there is nothing beyond this plane other than a limitless void. No wonder then that John and Liza are turned blind at the end of *The Beyond* for, as Fulci explains, "their sight has no *raison d'être* any more in this lifeless world."[153] It's a bleak vision of the empty meaninglessness of existence that recalls the words of philosophy's greatest nihilist Friedrich Nietzsche: "He who fights with monsters should look to it that he himself does not become a monster. And when you gaze long into an abyss the abyss also gazes into you."[154]

III. The Return to the Caribbean

Interviewed by *Fangoria* magazine at the time of *Zombi 2*'s release, Lucio Fulci explained what made his vision of the reanimated dead so different from that of his contemporaries:

> I wanted to recapture the moody atmosphere of witchcraft and paganism that must have been prevalent when Europeans first settled in the Caribbean during the 1700s. That's when the concept of zombies - human slaves brought back from the dead - first became known to Western civilisation… Fright films such as *I Walked with a Zombie*, *Voodoo Island* and *The Walking Dead* were in the back of my mind as I made this picture.[155]

While it's obvious that Fulci had much to gain from distancing himself from *Zombi 2*'s most obvious influence - Romero's *Dawn of the Dead* - the Italian director did have a good case for arguing his originality. While *Dawn* is largely uninterested in its ghouls' cultural heritage, *Zombi 2* is fascinated by the Caribbean origins of the monster. As his zombies shuffle through sandy coastal villages flanked by palm trees and the crashing surf of the Caribbean Ocean, Fulci recreates a "moody atmosphere" that harks back to the supernatural chills of the films of the 1930s and 1940s. It was something that the director apparently felt insanely passionate about, even penning an angry letter to Dario Argento accusing him of trying to obscure the monster's cultural heritage:

> When Argento wrote that *Dawn of the Dead* was his creation, I wrote him a letter listing twelve films which demonstrated that zombies were around even before Tourneur's day, before *I Walked with a Zombie*. Zombies belong to Haiti and Cuba, not to Dario Argento.[156]

splatter horror

Foregrounding the Caribbean, *Zombi 2* returns to issues of racial anxiety and imperialism that the previous three decades had largely ignored or reworked beyond all recognition. In many respects, Fulci's interest in the Caribbean needs to be understood in terms of the Italian cycle's European sensibilities. In *Zombi 2*, for instance, the corpses of maggot-eaten Spanish conquistadors claw their way out of the makeshift graves where they were buried centuries before. It serves as a powerful reminder of European colonial guilt, a guilt that the unexplained apocalypse of the movie seems to be some kind of punishment for. As ragged black zombies stumble out of the jungle to attack the white heroes, *Zombi 2* sets up an a series of oppositions between white and black, science and voodoo, civilisation and savagery, that's more than familiar from the zombie films of the 1930s and 1940s.

Fulci wasn't the first Italian to use the horror film to address such racial issues. The cannibal cycle of the 1970s frequently depicted the clash between the First and Third Worlds, perhaps nowhere more strikingly than in Ruggero Deodato's *Cannibal Holocaust* (1980), in which white filmmakers goad a native South American tribe into committing the holocaust of the title and find themselves on the dinner menu as a result. Focussing on the epitome of savagery - man eating man - the cannibal films may have predominantly relied on flesh-eating for sensational splatter, but they weren't blind to the ironic potential of dispossessed natives from the Third World eating invading white westerners.

The zombie films that took their inspiration from the cannibal cycle, including *Zombi 2*, frequently relied on much the same pattern of inversion by imagining an apocalypse in which the Third World's dead rise up against white, western civilisation in bloody revenge for centuries of imperial conquest. It's an idea that's not just confined to the Caribbean; in *Zombi Holocaust* the setting is Southeast Asia, in *Zombi 3* it's the Philippines. In the Italian-Spanish co-production *Zombie Creeping Flesh*, the setting is New Guinea, where an experimental plan to reduce global overpopulation turns the locals into zombies. The latter film wears its crude politics on its sleeve, featuring a laughably silly meeting at the United Nations (actually just a room with couple of desks), where a spokesman for the Third World berates the developed nations: "You have murdered my people. You have treated them like a crowd of human larvae, like insects, savage beasts, prehistoric animals! They are running from their children, their parents, their brothers, transformed into vile creatures that feast on human flesh!" It's risible stuff, but the overriding point becomes pretty clear as the virus makes the population of the Third World eat themselves in a kind of auto-anthropophagous genocide (!).

Such plotting gives some indication of the ludicrous over-simplicity of these films' treatment of race. At times, it borders on the purely offensive. The ghouls of *Zombi Holocaust*, *Zombie 4: After Death*, *Zombi 3* and Jess Franco's *Devil Hunter* (orig. *Sexo canibal*, 1980) are styled as expendable fodder as much because of their skin colour as the fact that they're already dead. Aristide Massaccesi's zombie films are even cruder. The misshapen native zombie of *Porno Holocaust*, for instance, rapes and kills the film's white females with his monstrously huge phallus, suggesting that he's really little more than a demeaning stereotype of black virility run amok.

Rather interestingly, the Italian cycle's interest in race prefigured a much wider return to the Caribbean that occurred during the 1980s. During this period, American zombie films also began to highlight the Caribbean origins of the monster once again, though for very different reasons than their Italian cousins. The most significant of these American returns was to be found, unsurprisingly, in Romero's *Day of the Dead* (1985), the director's third instalment in his living dead series.

Day of the Dead begins where *Dawn* left off, with the living dead hordes having taken over the whole planet, wiping out every last vestige of the civilised world. As the film opens, a civilian-military team left over from the final days of the old order land their helicopter in a deserted Florida street in the vain hope of finding survivors.[157] They're greeted by living dead ghouls who spill out of shops and apartment complexes, hungry for food.

opposite: A conquistador returns from the grave in **Zombi 2**. *above:* A ghoul from **Zombie Creeping Flesh**. *this page top:* The shambolic walking corpses of **Zombi 3**.

143

Years on from *Dawn*, time has taken its toll on the zombies who are now more gruesome monsters - dirty, decomposing and played less for laughs. The development of the special effects industry allows Savini to really push the gore to the limit, giving the film a bleak nastiness that's suitably chilling. The first zombie we see has had its lower jaw ripped off and its tongue flicks around wildly; later a zombie with its abdomen cut open sits up, spilling its internal organs onto the floor in a bloody heap; the film's chief villain is pulled apart by a band of ghouls who rip his limbs and head from his torso in a quite spectacular fashion. Despite the occasional flash of humour - like the swivelling eyes in a decapitated zombie head - the tone is darker, edgier and far more depressing than before.

Back at the team's base, an old mine shaft previously converted into a missile silo and government records depository, the divisions among the group quickly become apparent. Even with a corral full of zombie test subjects Sarah (Lori Cardille) and her fellow scientists Dr. Logan (Richard Liberty) and Ted Fisher (John Amplas) haven't been able to work out what's causing the bodies of the dead to come back to life. The situation is slowly getting out of hand as Logan spirals into some cracked variation of the mad scientist routine - chopping up body after body in his search for an answer while trying to socialise his subjects into good behaviour. His star pupil in this respect is a zombie called Bub (Howard Sherman) who is beginning to display vague traces of humanity and memory.

Meanwhile, the military arm of the group is fed up of waiting for results, prompting Captain Rhodes (Joseph Pilato) to become increasingly dictatorial in running the facility. The only thing that's keeping Rhodes and his men from deserting the compound and the scientists is the fact that they're unable to fly the helicopter. The group's pilot is civilian contractor John (Terry Alexander) who - along with communications expert McDermott (Jarlath Conroy) - apparently has no interest in either the group's scientific mission or in helping the fascist bully boys led by Rhodes.

Having established this community of characters, *Day* proceeds to pull them apart as they bicker their way to oblivion. The film ends as the compound is overrun by the living dead who have been let into the camp by Sarah's boyfriend Miguel (Antone DiLeo), driven insane after being bitten in the arm by a ghoul. As in *Night* and *Dawn*, it is the stupidity of the living that is the greatest

Stills from **Day of the Dead**.
above: Bub the zombie (Howard Sherman) offers a homage to **I Walked with a Zombie**. *top left:* No guts no glory: advances in special effects allowed Savini to push the splatter to the limit. *opposite top:* Graduates, soldiers and bikers: the zombies are united. *opposite bottom:* The opening scene features this chinless wonder.

threat, with the zombies simply capitalising on the petty squabbles. *Day* proves once and for all that the real horror in this world isn't the returning dead, but the inhumanity of the living and the inherent rottenness of contemporary society. While Logan socialises Bub into "good" behaviour, Rhodes and his soldiers slowly regress into barbarism. The apocalypse has destroyed the necessity for civilised behaviour and primitive anarchy beckons.

The only character who recognises and understands this is John, who has no interest in the scientific search for an answer to the zombie apocalypse. Cutting themselves off from the rest of the community, John and McDermott live deep within the mineshaft tunnels in a converted Winnebago they call "The Ritz". In John, Romero revives the series's dormant racial subtext. The third black hero in this set of films, John is linked not only to Ben in *Night* and Peter in *Dawn*, but also to the Caribbean heritage of the zombie since he is explicitly West Indian.

John represents a significant change of direction for Romero. In *Night of the Living Dead*, the filmmaker deliberately avoided mentioning voodoo, arbitrarily blaming the zombie apocalypse on radiation from space (though keeping the racial dimension of the 1940s alive in the character of black hero Ben). In *Dawn*, the return of the dead is largely taken for granted by the main characters, who are more interested in working out how to survive than discovering what has caused the end of the world. The nearest we get to an explanation in that film are the vague remarks of the Puerto Rican priest in the tenement building and Peter's throwaway reference to voodoo in the "No more room in hell" speech. In *Day of the Dead*, however, Romero returns to the zombie's cultural heritage establishing John as a link to the Caribbean and also as the chief explicator of the apocalypse - something that his biblical christian name hints at.

While the early films in the zombie genre - from *White Zombie* to *King of the Zombies* and *I Walked with a Zombie* - relied on a racist understanding of the black male Other as a symbol of horror (the zombie), *Day* transforms this Caribbean black male hero into a saviour who *guarantees* meaning rather than brings about its collapse. The contrast with *I Walked with a Zombie* and other films of the 1930s and 1940s is starkly apparent. These films styled the Caribbean as a terrifying land that contained the seeds of the white world's destruction; in *Day of the Dead* Romero turns it into a place of utopian

potential, a region that might offer mankind one last chance for survival. It's a progressive political undercurrent that tries to turn the tide of the genre's racial anxieties by displacing them with a narrative that deliberately sets out to create a positive black role model whose wit, intelligence and humanity far exceeds that of any of his (white) comrades.

Standing at the centre of this change of emphasis is John's impassioned monologue. Surveying the silo and its stacks of government records, John lectures Sarah about the rottenness of pre-zombie America and the importance of the chance they've been given to start again afresh. After the nihilistic outlook of *Night* and *Dawn*, such an upbeat tone is rather surprising. However, Romero plays it straight, building this lengthy speech into the most poignant commentary in the entire series. It's worth quoting in full:

Miguel (Antone DiLeo) commits suicide by zombie in **Day of the Dead**.

JOHN
We don't believe in what you're doing, Sarah... You know what all they keep down here in this cave? Man, they've got the books and the records of the top five hundred companies, they got the defence budget here and they got the negatives of all your favourite movies, they got microfilm with tax returns and newspaper stories, they got immigration records and census reports and they've got official accounts of all the wars and plane crashes and volcanic eruptions and earthquakes and fires and floods and all the other disasters that interrupted the flow of things in the good old USA. Now, what does it matter Sarah darling? All this filing and record keeping? Are we ever going to get a chance to see it all? This is a great big fourteen mile tombstone with an epitaph on it that nobody's gonna bother to read. And here you come with a whole new set of charts and graphs and records. What you gonna do? Bury them down here with all the other relics of what once was? *And I'll tell you what else, you ain't never gonna figure it out. Just as they never figured out why the stars are where they are. It ain't mankind's job to figure that stuff out... So what you're doing is a waste of time, Sarah... and time is all we got left you know.*

SARAH
I'm doing the only thing that's left to do.

A Caribbean-style calypso plays on the soundtrack.

JOHN
There's plenty to do, plenty to do. S'long as there's you and me and maybe some other people we could start over, start fresh. Get some babies... and teach them never to come over here and dig these records out.

A ghoul's moan interrupts the Caribbean calypso. The music switches to something electronic and darker.

JOHN
You want to put some kinda explanation down here before you leave? Here's one as good as any you're likely to find - we've been punished by the creator. He visited a curse on us so we might get a look at what hell was like. Maybe He didn't want to see us blow ourselves up, put a big hole in His sky. Maybe He just wanted to show us He was still the boss man. Maybe He figured we was getting too big for our britches trying to figure his shit out.

If *Night* and *Dawn* exposed the rotten underbelly of twentieth-century America, *Day of the Dead* fantasises the possibility of an alternative, one that's born out of the destruction of the established order. Taken as a whole, the series's story is one in which, as Sue Ellen Case points out, "the dead have eliminated the family unit, claimed commodity reification for their own in the shopping mall and defeated the military-industrial complex".*158* All that's left is the possibility of beginning again by ditching the signs and symbols of the old order and starting over from scratch. As critic Paul R. Gagne explains, "If the Monroeville shopping mall is a temple to the consumer society Romero pokes fun at in *Dawn*, then [the missile silo cave of *Day*] is its tomb".*159*

The film ends with an upbeat scene that shows Sarah, John and McDermott safely ensconced on a (presumably) zombie-free island in the Caribbean. In Romero's hands, the zombie movie has come full circle, inverting its origins so that the Caribbean becomes a place of safety and civilisation while the American mainland is the site of primitive ghoulish cannibalism. Civilisation and savagery have exchanged places and the implicit suggestion is that what we once considered civilised was never actually civilised at all.

However, what John's speech also makes clear is the extent to which Romero has oversimplified the racial theme in his rush to perform this stunning *volte-face* of the genre's internal dynamics. With his thick patois, laid-back manner and decision not to concern himself with issues that are beyond his understanding, John could be read as a facile racial stereotype of black masculinity. Even his speech, which Romero gives such an important place in the narrative, is affected by this as his talk of knowing one's place ("It ain't mankind's job to figure that stuff out") and transparent allusion to slavery ("Maybe He just wanted to show us He was still the bossman [...] We was getting too big for our britches") reinstates a hierarchical view of the world at precisely the same time as it is apparently trying to overturn it.

There's no doubt that Romero wants us to take this black man as the film's chief hero. Sarah may be *Day*'s main protagonist but she's too misguided to be completely heroic. Unfortunately, both the script and Terry Alexander's performance make John into little more than a rehash of a creaky old racial stereotype, a distant cousin of Mantan Moreland's obstinate "coon" who's happier fishing than fighting and has no interest in filling his head with things that are beyond his ken.

While Romero's treatment of John constantly suffers from such paradoxical confusion, his desire to attack the white patriarchal dominant seems clear enough. In asking the audience to join him in turning against the Establishment, Romero uses his living dead to elicit our sympathy for the cause. Depicting the zombies as slaves (an echo of the monster's Caribbean origins), Romero highlights the way in which the living are mistreating them. Logan tries to socialise his zombie captives by offering them meaty treats for good behaviour and claiming, "They are *us*, they are extensions of us. They are the same animal simply functioning less perfectly". Yet even his actions seem like those of a benevolent slave-master or white missionary doing his best to educate the savages. His angry shouts when the zombies don't conform to the patterns of behaviour he desires are the demented ravings of a mad man.

In Bub, the zombie with a soul, Romero extends his zombie mythology into new territory. Bub becomes part of Romero's project to transform the zombies into the film's most sympathetic characters. Incarcerated by Rhodes, teased and insulted by the enlisted men and hacked up in grotesque Frankenstein experiments by Logan, the zombies are used and abused by the film's humans. Chained and bound and herded around like cattle, they're little more than slaves and, since Romero is keen to present the living as more dangerous than the living dead, we come to have a strange sympathy with their plight.*160*

For some reason, Bub can remember bits and pieces of his past life including how to salute, how to fire a gun and even how to read a Stephen King novel. Sherman's fantastic performance gives him a heart and - dare one say it? - soul that no other screen zombie has ever possessed. Listen closely to his apparently inarticulate grunts and various sentences can be heard, including a whisper of "I... ain't... finished..." when Logan turns off Bub's Walkman in mid-symphony. Like the ghouls drawn to the shopping mall in *Dawn of the Dead*, Bub's blessed with faint stirrings of memory and, as a result, humanity. Could it be that the zombies are more than just dead bodies stumbling around without purpose or meaning?

Zombie maestro George A. Romero surrounded by hordes of extras wearing Tom Savini's revered living dead make-up during the filming of **Day of the Dead**.

Romero wasn't the only American filmmaker interested in returning to the Caribbean in the 1980s, as directors as diverse as Wes Craven and Steven Fierberg all headed south. In retrospect, it's tempting to wonder how much this had to do with the island's internal troubles during the period. By the mid-1980s, Haiti had become the poorest country in Latin America. The stagnating economy triggered widespread food riots and sporadic instances of political unrest that were brutally suppressed by the military and the secret police. The country that had once been the jewel in France's colonial crown - with an annual output that far exceeded any of its other colonies - was on the verge of economic and political bankruptcy because of the greed of its tyrannical rulers.

Chief among these was Françoise Duvalier, commonly known as "Papa Doc", who dominated the island's troubled history from the late 1950s until his death in 1971. The Duvalier regime was characterised by human rights abuses, widespread poverty and a culture of fear and intimidation fuelled by Papa Doc's secret police force, the infamous Ton Ton Macoute. His legacy was the slow destruction of the country and by 1970, over a million Haitians had fled the island to take up residence in other parts of the Caribbean, America and Europe. After Papa Doc's death in 1971, his son Jean-Claude Duvalier ("Baby Doc") took over. He proceeded to run the island's already troubled economy completely into the ground.

America watched the rapid deterioration of its neighbour with a combination of fascination and contempt. In the early 1980s, Haiti had been explicitly blamed for the rise of AIDS, with some leading America health officials drawing links between the island and the spread of the disease in the US. According to these commentators, Haiti was the geographical facilitator for the spread of this so-called "African" disease from the Third to the First World - allegedly because of its alleged encouragement of sexual tourism among American homosexuals. Although the Centers for Disease Control (CDC) eventually overturned this erroneous - as well as racist and homophobic - accusation about the virus's origins in 1985, it was too late to save Haiti's devastated tourist industry, putting further economic strain on the country.

As historian Brenda Gale Plummer argues, "the damage done to Haiti's reputation recapitulated the old repulsion and horror that the West had felt for the 'Black Republic', and it was expressed in similar metaphors of isolation and quarantine".[161] Once again Haiti had become, in American eyes at least, a site of terror and savagery. Just as in previous decades, the US responded to the threat in no uncertain terms employing a range of measures to ensure such "isolation and quarantine".

In the years of negotiation, diplomatic pressure and threatened military action that accompanied Haiti's decline under Baby Doc Duvalier, America played the role of international policeman. The United Nations initiated economic sanctions; American aid packages to the island were reduced or cancelled and by 1986 the failing Duvalier regime was overthrown. Baby Doc fled to Europe aboard an American military plane and took the corpse of his father with him to prevent the looting mobs from molesting - or reanimating - it.

As the Duvalier regime fell, America became increasingly concerned about the growing refugee crisis that accompanied the island's political unrest. The American authorities were determined to stem the rising flood of immigrants. By the early 1990s, President Clinton's government was making explicit reference to the problems of immigration, human rights abuses on the island and Haiti's alleged role as a shipment point for cocaine bound for the US. Convincing the reluctant American electorate that military intervention was necessary - something that few people were keen to risk after the disastrous intervention in Somalia - Clinton forced Haiti's warring factions to stand down. In 1993 a UN-sanctioned American force occupied the island for six weeks during which time a democratic electoral process was reinstated.

If history seemed to be repeating itself, so too were America's cultural products. As Haiti increasingly found itself the focus of American foreign policy during the Reagan, Bush and Clinton years, one book popularised a specific vision of voodoo and zombies. Written by Canadian ethnobiologist Wade Davis, *The Serpent and the Rainbow* (published in 1986) wasn't a Caribbean travelogue but a serious account of Davis's experiences on the island while researching the so-called "zombie powder" used by the voodooists to turn their victims into the living dead.

A factual, though occasionally sensational, description of the author's adventures as a researcher in Haiti during the early 1980s, *The Serpent and the Rainbow* charted Davis's growing interest in the island's culture. The scientist had been despatched to the Caribbean by an American biochemical firm in the hope that he might be able to uncover the mysteries of zombification. The practical applications of such a process if it really existed were clear enough; many hoped that the zombification formula might be used either as an anaesthetic or to develop a form of suspended animation for NASA astronauts undertaking long trips through space.

Desperately trying to gain access to the closed and suspicious world of Haitian voodoo, the white explorer attended religious ceremonies and sorcerers' rites in an attempt to separate the biochemical realities of zombification from its mythical voodoo trappings. Beginning his adventure as a sceptical non-believer, Davis returned home with a newfound appreciation of voodoo's place in Haitian society. He surmised that zombification did exist and was actually a form of capital punishment inflicted on the island's rural peasantry at the whim of the leaders of Haiti's many secret societies.

As a scientific study aimed at the lay reader, *The Serpent and the Rainbow* frequently merges factual reportage with adventure story elements. A comparison with Davis's more academic tome *Passage of Darkness: The Ethnobiology of the Haitian Zombie* (1988), illustrates the extent to which *The Serpent and the Rainbow* glosses over some rich scientific, historical and anthropological issues in the hope of keeping the story cracking along at a lively pace. This wasn't some academic lab experiment but a dangerous piece of fieldwork that blended anthropology and biochemistry with a significant degree of macho bravado. Mixing science with acts of daring, and social history with descriptions of moonlit visits to graveyards, *The Serpent and the Rainbow* was aimed squarely at the bestseller lists.

During the course of his research into Haiti's voodoo culture, Davis came to the conclusion that the active ingredient in the zombification potion used by the voodoo sorcerers wasn't magic, but a poison known to the western world as "tetrodotoxin". Taken from the puffer fish, the poison is capable of inducing a form of paralysis that resembled death. As Davis explains, tetrodotoxin is powerful enough to induce:

> ...a state of profound paralysis, marked by complete immobility during which time the border between life and death is not at all certain, even to trained physicians. It became clear that the tetrodotoxin was capable of pharmacologically inducing a physical state that might actually allow an individual to be buried alive.[162]

In Japan anecdotal evidence suggested that gourmet diners who ate badly prepared puffer fish often experienced similar symptoms. Yet they never for a moment believed they'd been turned into zombies. Why was it, Davis wondered, that so many Haitians who had been drugged in this way thought they'd joined the ranks of the living dead? The answer seemed to lie in the island's voodoo culture. Poor education, lots of superstition and a lifetime's worth of socialisation into voodooism meant that the majority of the islanders wholeheartedly believed that zombification was possible. The effects of the drug merely compounded this, leading Davis to conclude that "in the phantasmagoric cultural landscape of Haiti [the victim] had his own cultural expectation that he carried with him literally into and out of the grave".[163]

If *The Serpent and the Rainbow* was *The Magic Island* for the 1980s, Wes Craven's movie adaptation of the book was the decade's answer to *White Zombie*. Released in 1987, at the height of America's interest in the Haitian crisis, the film starred Bill Pullman in the lead role of Dr. Dennis Alan (a fictional substitute for Davis). Replacing any hint of scientific investigation with all-out adventure and a liberal dash of horror, Craven's film works brilliantly as a scary movie, but rather less so as an

Dr. Alan (Bill Pullman) finds himself at the mercy of zombies with *very* long arms in **The Serpent and the Rainbow**.

Death becomes her: **The Serpent and the Rainbow**.

adaptation of a non-fiction book. Taking liberties with the source material and exaggerating the more sensational aspects of the text, this version of *The Serpent and the Rainbow* played directly into American fears about Haiti's political unrest. Davis's story of scientific study was married to a facile political drama set against the backdrop of the crumbling Duvalier regime.

Craven had previously forayed into the zombie genre in *Deadly Friend* (1986), a lacklustre tale about a teenage science prodigy who uses his expert knowledge of artificial intelligence to bring his girlfriend back from the dead by implanting a microchip in her brain. Ignored by most audiences, *Deadly Friend* turned out to be one of the few turkeys of Craven's high-profile transformation from disreputable director of grindhouse shockers like *The Last House on the Left* (1972) to major Hollywood player.

In *The Serpent and the Rainbow*, Craven set his sights on the mainstream, adapting Davis's book by adding a political context that would explicitly relate the story to contemporary American anxieties and even including archive footage of the fall and escape of Baby Doc Duvalier:

> In the book, Davis was pretty much left alone to do his work, even though the country itself was going through one of its revolutionary periods... We created an antagonist for the Davis character [...] to go up against. The villain [secret police chief and voodoo sorcerer Peytraud] is the symbol for all the terrorism going on in the country, and Alan takes it upon himself to get rid of him.[164]

Bringing his own sensibility to the project, Craven beefs up the novel's implicit terrors with some artistic license, presenting Peytraud (Zakes Mokae) as a supernatural villain who - much like Craven's seminal slasher Freddy Krueger in *A Nightmare on Elm Street* (1984) and its sequels - possesses the disturbing ability to enter Dr. Alan's dreams. Collapsing reality and hallucination, the film's terror focuses on the eruption of the supernatural into the everyday. One of the film's best horror sequences involves a Stateside dinner party where Alan is beset by a phantom image of a hand emerging from his soup bowl. His prim and proper hostess then throws herself across the table to try and stab him with a steak knife. Unsurprisingly, Craven also makes the most of the book's zombie-emphasis with several scenes involving the living dead and a terrifying sequence in which Alan is drugged, paralyzed and buried alive in a coffin with only a tarantula for company.

However, in trying to deal with the political upheaval of mid-1980s Haiti that Davis had deliberately sidestepped in the book, Craven comes unstuck. The script's reliance on the confrontation between the forces of white America (Alan) and black Haiti (Peytraud) is so simplistic that it verges on parody. Craven ends up doing little more than playing up to reactionary American discourses about Haitian "backwardness".

The film's most astute political statement ends up issuing from the mouth of its chief villain, robbing it of its apparent insight into the torturous relationship between America and Haiti. As Peytraud prepares to kill the captured Alan, he explains his view of American foreign policy: "This country lives on the edge, Dr. Alan. One weakness in the wrong place and over it goes into slavery again. Just like with the French. The United States would like anarchy here, I'm sure. Well this isn't Grenada Dr. Alan. I'm here now".

Presenting his dictatorial brutality as a means of maintaining Haiti's independence from foreign interference, Peytraud has a canny grasp of the importance of this tiny island to the world's greatest superpower. Yet the effect of the sequence is to undermine the inherent truth of his speech. As a voodoo torture master with a comic-book villain's flair for overkill, we're unlikely to take his words with anything but a pinch of salt. Of course, that could be Craven's conservative intention and in light of the director's choice of words in the above quotation - "Alan takes it on himself to get rid of him [Peytraud]" - one wonders whether he was consciously trying to justify American intervention in the island's affairs or just naively blind to the reactionary undertone of Richard Maxwell and Adam Rodman's screenplay.

Styling America's interest in the region as pro-democracy and pro-Haitian independence, Craven's film ends up offering little more than naïve political pandering to Washington's propaganda machine. The upshot is that *The Serpent and the Rainbow* ignores the vested self-interest that spurred American foreign policy in the Caribbean in favour of presenting a desperately inaccurate image of America as a disinterested guardian of world democracy. Indeed, Alan becomes a cipher for America's involvement in the island's internal politics, symbolically overthrowing an evil despot who tortures the populace and turns them into zombies.

Released at the height of Haiti's internal turmoil, *The Serpent and the Rainbow* was just one of a series of voodoo-themed films that took advantage of the renewed interest in the region. Horror films like *Angel Heart* (1987) and *Voodoo Dolls* (1990) marked the return of Caribbean magic to cinema screens, while living dead movies like John N. Carter's *Zombie Island Massacre* (1984) and Steven Fierberg's *Voodoo Dawn* (1989) - managed to find a place for the zombie among their stories of black magic.

Putting a characteristically negative spin on the Caribbean, *Zombie Island Massacre* and *Voodoo Dawn* played up to America's willingness to delude itself about its interest in Haiti's political strife in troublingly simplistic ways. In *Zombie Island Massacre* American tourists in the Caribbean are murdered by what everyone assumes to be a zombie, but actually turns out to be warring drug dealers. In *Voodoo Dawn* an ex-Ton Ton Macoute torturer (played by future *Candyman* Tony Todd) flees Haiti and arrives in America's Deep South, where he starts butchering the African-American locals in the hope of creating a patchwork zombie from their body parts. Both movies served much the same ideological role as *White Zombie* and *Ouanga* did decades before, suggesting that the Caribbean needed the guiding hand of Messrs. Reagan, Bush and Clinton to steer it from anarchy to democracy.

IV. Splatter House of Horrors

During the 1980s, more American zombie films went into production than at any time in the genre's history. In terms of quality, however, many of these efforts dragged the already beleaguered genre to new lows. While the Italian cycle produced films that succeeded in discovering flashes of brilliance amidst their stretches of technical and artistic incompetence, the American renaissance of zombie movies in the 1980s signalled a return to the Poverty Row standards of the 1940s. Lured by the promise of quick profits and low overheads, a host of fly-by-night independent companies and straight-to-video merchants churned out a succession of cheesy horror comedies, exploitation flicks and Z-grade schlock. It was a blatant attempt to cash in on the ever-increasing demands of the VCR-dominated marketplace that almost single-handedly scuppered the genre's credibility.

Naturally, it wasn't just zombie movies that were susceptible to this shoddy treatment. However, with the exception of the ubiquitous post-*Halloween* serial killer, the zombie appeared in far more of these cheap scare-fests than any other monster. As a result, the vast majority of the zombie's American appearances during the decade have entered the history books as some of the worst examples of modern horror cinema. Mixing ultra-cheap production values with teen-orientated comedy and occasional dashes of sexploitation films such as *The Alien Dead* (1980), *One Dark Night* (1982), *Bloodsuckers from Outer Space* (1984), *The Gore-Met Zombie Chef From Hell* (1986), *Neon Maniacs* (1986), *Redneck Zombies* (1987), *Zombie High* (1987), *Ghost Town* (1988), *Night Life* (1989) *Dead Men Don't Die* (1991) and *Space Zombie Bingo* (1993) ripped the guts out of the Italian cycle's subversive potential, replacing the spaghetti movies' extreme gore with lame comedy-horror, inept scares, scantily clad babes and unconvincing special effects. And sometimes all of the above.

There were, of course exceptions to the rule. Two American outings that followed hot on the heels of *Dawn of the Dead* were John Carpenter's ghostly *The Fog* (1979) and Gary Sherman's less-famous, but perhaps more deserving, *Dead & Buried* (1981).

Carpenter's film reworked the classic return of the repressed setup with a slick and stylish production and a host of nautical corpses strangely reminiscent of *Zombies of Mora Tau*. In *The Fog*, Carpenter focuses on Californian settlement Antonio Bay, where preparations for the town's hundredth anniversary reach a grisly end as a thick fog sweeps in off the sea and various residents are killed in a series of nasty ways. As local radio presenter Stevie (Adrienne Barbeau) eventually realises, the fog is hiding an army of zombies who've risen from their watery graves to take revenge on the town on the

anniversary of their deaths. A hundred years previously, a ship of lepers was wrecked off the coast after the town's founding fathers refused to let it dock so that they could steal its cargo of gold. Now the lepers are back - armed with cutlasses, hooks and other nautical equipment - to kill everyone in sight and recover what was rightfully theirs. Implicitly arguing that America is a land that was built upon great crimes (Native American genocide, slavery, piracy), Carpenter extends the social message of Romero's work in novel ways.

The Fog gears up for a *Night of the Living Dead*-style climax in which a band of survivors lock themselves inside a hilltop church for safety, only to discover that it hides the treasure that was stolen from the mariners a century before. It's at this point that Carpenter's deft touch begins to falter and one can't help feeling that amidst all the dry ice and electronic synthesizer music, these zombies are rather vague phantoms whose impact suffers from them getting less screen time than they deserve.

As Carpenter falls back on yet another of his trademark siege setups - recalling the barricaded group dynamics of *Rio Bravo*, *The Birds* and *Night of the Living Dead* - *The Fog* squanders much of its originality. Indeed, all of Carpenter's zombie movies follow much the same siege pattern, from the scientists trapped in a church by ghouls led by rocker Alice Cooper in *Prince of Darkness* (1987) to space cops fending off zombie colonists on the surface of Mars in sci-fi outing *Ghosts of Mars* (2001).

In comparison Gary Sherman's *Dead & Buried* (1981) is a somewhat neglected genre piece. A small-town horror thriller set in coastal community Potter's Bluff, where the sheriff investigates a perplexing spate of murdered tourists. Employing some grisly special effects make-up from the soon-to-be legendary Stan Winston, Sherman's film also boasts an early role from Robert "Freddy Krueger" Englund and a script credit for Dan O'Bannon. The result was one of those little-known efforts that horror fans often become passionate about, much like the director's previous film *Death Line* (1972) with its grisly tale of cannibals stalking commuters on the London Underground.

Although Sherman had originally planned to make a rather black comedy, the timing of the film's release into the gore-hungry video market of the early 1980s meant that his financial backers were keen to play up the nastier elements of Winston's make-up effects - even ordering reshoots of the villain's acid-in-the-face demise to appeal to hardcore gore fans. Perhaps the most troubling sequence, though, involves the bandaged body of a badly burnt photographer who is attacked by the zombie townsfolk in the film's opening scene. Laid up in a hospital bed with his lips burnt off and his skin charred beyond all recognition, he receives a fatal hypodermic syringe to his one remaining eyeball during a visit from a sadistic zombie nurse. Ouch.

As the college-educated sheriff struggling to explain the sudden peak in the sleepy town's murder rate, James Farentino holds the film together right until its cheating ending where we realise just how much wool has been pulled over our eyes. Predating David Lynch's obsession with small-town values twisted into perversity, *Dead & Buried*'s ghoulish scares recall *Messiah of Evil* and *Deathdream*. It also creates a memorably freakish villain in the guise of the town's myopic mortician G. William Dobbs (Jack Albertson). Dobbs's passionate interest in restoring dead bodies to lifelike beauty leads him to dabble in some questionable professional ethics. A lap-dissolve sequence in which he demolishes and then rebuilds a dead woman's skull in preparation for her open casket takes the film's obsession with dead flesh into disturbing territory, not least of all because its gory horrors are accompanied by the bubbly, upbeat strains of Glenn Miller's "Serenade in Blue". It's enough to ensure that, while the film's ending is something of a swizz, *Dead & Buried* is a memorable little chiller.

Most of the American movies that followed in its wake were best forgotten. The Italian zombie movies frequently pushed the boundaries of what constituted acceptable violence, provoking repressive measures like the UK's Video Recordings Act along the way. In contrast the trashy American movies that dominated the 1980s rarely upset the censor at all in their desire to appeal to the teen market.

One sure sign that the zombie had gone from censors' nightmare to mainstream icon was its appearance in Michael Jackson's smash hit music video *Thriller* (1983). Poverty Row segued into quick-cutting MTV visuals as Jackson's horror spoof video - directed by John Landis - riffed on vampires, werewolves and the living dead. Although the video's horror content was initially controversial, triggering complaints from parents concerned about its influence on the young, the singer's song-and-dance routine effectively defused much of the criticism. The sight of Jackson sharing screen time with a motley collection of walking and *dancing* corpses helped make the zombie into a living room-friendly ghoul.

Relying on comedy rather than horror to ensure a bigger slice of box office returns, many of the films that followed in the wake of *Thriller*'s revival of the zombie's appeal were safe and silly productions, enlivened only by occasional coups of cult casting. Jack Bravman's tiresome *Zombie Nightmare* (1987) starred an ageing Adam West from the original *Batman* TV show. Meanwhile, the execrable *Revenge of the Living Zombies* (1989) was produced, directed and bolstered by a central performance from Bill Hinzman, whose dubious claim to fame was that he'd starred as the first ghoul in Romero's *Night of the Living Dead* some twenty years earlier. Perhaps so, but that really didn't give him a license to dump this pile of steaming celluloid crud in our laps.

Armand Mastroianni's *The Supernaturals* (1986) featured a platoon of modern-day squaddies led by Nichelle Nichols (better known as *Star Trek*'s Lieutenant Uhura) who are attacked by zombie corpses from the Civil War. More Rebel zombies turned up to whistle Dixie in the cannily titled but dirt cheap *Curse of the Cannibal Confederates* (1982), in which hunters are set upon by zombies left over from the conflict. Then there was *Ghost Brigade* (aka *The Lost Brigade*, *The Killing Box*, 1992), a classier outing starring a host of famous and soon-to-be-famous faces: Martin Sheen, Ray Wise, Billy Bob Thornton and Matt LeBlanc (the film is not to be confused with Australia's 1988 *Zombie Brigade*, about dead Vietnam veterans who return to life after an unscrupulous property developer bulldozes their memorial). The most recent addition to the Civil War zombie cycle is the execrable *Bloody Bill* (2004) about a zombified Southerner who inhabits a ghostly ghost town.

A few filmmakers tried to separate themselves from this morass of cinematic detritus by creating novel genre combinations. Director Samuel M. Sherman showed a great deal of chutzpah but little talent in *Raiders of the Living Dead* (1985), the title of which promised an ingenious combination of zombies and an Indiana Jones-style adventure but actually delivered a bloodless and boring tale. The buddy-cop cycle got a taste of zombie action in 1988's *Dead Heat* penned by Terry Black - the brother of *Lethal Weapon* scribe Shane Black - and directed by Mark Goldblatt. Meanwhile, in Hal Barwood's *Warning Sign* (1985) the tense laboratory setting of *The Andromeda Strain* (1971) was invaded by the living dead as a biochemical research station is quarantined and its staff are turned into pissed-off ghouls. Considering the quality of the movie they were in, who could blame them for being annoyed?

Other combinations were even less subtle. Krishna Shah's *Hard Rock Zombies* (1984) billed itself as a horror-musical featuring Nazi gags, "hard rock" music and dismembered hands. It took bargain basement cinema to new lows with a cameo from Adolf Hitler. Less controversial but equally pointless was the short-lived

opposite top: **The Fog**. *above:* **Dead & Buried**. *top right:* **Zombie Brigade**.

cycle of 1950s-style parodies that tried to pass off their second-rate scripts as ironic reworkings of the Cold War era's cheesy movies. Chief suspects included Marius Penczner's *I Was a Zombie for the F.B.I.* (1984), John Elias Michalakis's rock 'n' roll *I Was a Teenage Zombie* (1986) and Fred Dekker's sci-fi *Night of the Creeps* (1986). It was a genre sleight of hand that few audiences were gullible enough to fall for.

Some producers even seemed to be deliberately *aspiring* to the level of the 1940s Poverty Row productions. The half-baked plot of Jon Mostow's *Beverly Hills Bodysnatchers* (1989) is reminiscent of dire Monogram efforts like *Bowery At Midnight*: proof indeed that the bottom of the cinematic barrel was being noisily scraped. It was a suspicion that was confirmed with the release of two lazy compilation movies - Ken Dixon's *Zombiethon* (1986) and Kenneth J. Hall's *Linnea Quigley's Horror Workout* (1989) - featuring bits and pieces of footage trimmed from a variety of living dead films.

However awful they were, these various productions indicated that the zombie had finally begun to achieve a degree of widespread acceptance. Decades earlier such a range of mass-marketed zombie movies would have been impossible to imagine, but by the mid-1980s producers clearly believed that the majority of cinemagoers (or videocassette renters) were familiar enough with the premise to make the living dead a safe gamble. The period even saw the release of two zombie-themed TV movies: *The Midnight Hour* (1985) and *From*

the Dead of Night (1989). Sadly, neither made very much of the living dead concept - although the skateboarding zombie of *From the Dead of Night* probably deserves a special, dishonourable mention for sheer stupidity.

The epitome of this new mainstream mass appeal was Dan O'Bannon's hugely successful *The Return of the Living Dead* (1985). A comedy-horror that emerged from the shadow of Romero's legacy, it effectively trashed *Day of the Dead*'s box office receipts when it went head to head with that more serious zombie outing. Faced with the prospect of Romero's dark and gloomy horror-drama or the all-out craziness of *The Return of the Living Dead*, American audiences chose the latter and lapped up its gross gags, gross nudity (actress Linnea Quigley became a cult star on the basis of her performance as a punk who strips off in a graveyard for a quick dance) and fast-moving, fast-talking zombies.

The film was conceived by *Night of the Living Dead*'s co-screenwriter John Russo, who was forced to put the project on hold as it became entangled in extensive legal wrangling with Romero's lawyers over the rights to the "Living Dead" title. It was originally supposed to be a straightforward horror picture in the vein of Romero's own work directed by Tobe Hooper (it was based on Russo's novelised sequel to *Night of the Living Dead*). However, by the time it got out of the courts and into production in 1984 things had changed: Russo was no longer attached, Hooper had dropped out, and screenwriter Dan O'Bannon had reworked the script and stepped up to direct.

O'Bannon's rewrite turned the story into a horror-comedy that placed the emphasis squarely on splattery laughs (allegedly this was because he was aware of how much the material owed to Romero and didn't want to step on the master's toes). As O'Bannon told *Cinefantastique* magazine at the time of the film's release: "I just couldn't visualise a straight horror movie at this juncture in history."[165]

For the movie-going public, the arrival of two zombie films together was more than a little confusing. Released alongside Romero's *Day of the Dead*, *The Return of the Living Dead* was frequently ascribed to the Pittsburgh director by critics and mainstream movie fans - even though he had nothing to do with the project.[166] In retrospect it's difficult to imagine two more different movies: *Day* is intelligent, sophisticated splatter that aspires to be more than just a gore movie. *Return* is a breathless horror cartoon that aspires simply to make jaws drop to the floor through its sheer exuberant excess.

O'Bannon was at least respectful of his source. There are few movies that acknowledge their influences as bare-facedly as *The Return of the Living Dead* does. Within the opening minutes Frank (James Karen) and Freddy (Thom Mathews) - employees at the Uneeda Medical Supplies Company ("You need it, we've got it") - are chatting about the movie *Night of the Living Dead*.

According to know-it-all Frank, the film was based on a real incident. Apparently, the dead really did return to life in Pittsburgh in the mid-1960s after an industrial chemical designed by the military for spraying on marijuana crops turned out to have an unusual effect on dead bodies. Hushed up by the government and the US Army, the incident became the inspiration for Romero's horror masterpiece.

Decades later, sealed drums containing desiccated zombie corpses and a copious amount of the reanimating chemical in question are still at large and one particularly leaky barrel has ended up at this Louisville medical supplies warehouse after a bureaucratic cock-up. Eager to impress his young protégé Frank shows him where the deadly reanimating fluid is stored and accidentally releases a brains-hungry corpse in the process.

Unfortunately, the 1968 movie wasn't an accurate version of the truth: once unleashed, these ghouls can't be killed with a shot to the head. In fact, they're almost completely unstoppable. In no time at all Frank and Freddy have been virtually zombified (aching muscles giving the first indication of rigor mortis), acid rain contaminated with the reanimating agent has swept across the city, and a new batch of walking corpses have gatecrashed a graveyard party and turned the revellers into zombie chow.

Incredibly popular, *The Return of the Living Dead*'s madcap spirit was a million miles removed from the dark pessimism of Romero's *Day of the Dead*. No philosophical musing here, just buckets and buckets of gore and a post-punk aesthetic in which anything goes (from nude punkettes to split-in-half dogs). The gags fly thick and fast, but they can't keep up with the adrenaline-charged ghouls themselves - who tear around the screen at a breakneck pace while chattering away ("Send more paramedics" demands one zombie into a walkie-talkie after feasting on an unlucky ambulance crew).

At the heart of *The Return of the Living Dead* is a savage kind of comedy, a nihilistic punk mentality that treats nothing as sacred. Featuring a band of grubby punks led by "Trash" (Quigley) and "Suicide" (Mark Venturini), the film is hardly coy about its attempt to appeal to the youthful, alienated teen audiences of mid-1980s shopping mall culture - it even has a soundtrack that features The Damned, The Cramps and The Flesheaters. In keeping with its attempt to be both hip, humorous and horrific, the end of the world is greeted with open arms by the filmmakers, who positively revel in the destruction of Kentucky.

Every attempt to deal with the crisis, from firing up the local morgue's incinerator to the military's decision to drop a nuke on the city simply makes the whole sorry mess much, much worse. The end result is the horror equivalent of *MAD Magazine* - a brash rejection of anything at all serious, that invites us to giggle while the world goes up in smoke. It's an entertaining ride featuring some truly stunning special effects - not least of which is the infamous "Tarman" zombie, a dripping mass of putrid flesh. But although it remains a firm fan favourite, *The Return of the Living Dead* ultimately has very little to say. Perhaps if someone had listened to the zombies' repeated demands for "Brains!" its legacy and influence might have matched its impressive box office returns.

Regardless of such caveats, *The Return of the Living Dead*'s blend of punk nihilism and sick humour was successful enough to spawn two sequels. Sadly, Ken Wiederhorn's unimaginatively titled *Return of the Living Dead Part II* (1988) did little except lamely retread the same material without a single glimmer of originality - actors James Karen and Thom Mathews were forced to reprise much the same roles and go through the lengthy process of being turned into zombies all over again. A few years later Brian Yuzna's *Return of the Living Dead 3* (1993) tried to revive the franchise with a more leftfield approach, introducing a Romeo and Juliet love affair between hero Curt (J. Trevor Edmond) and his zombified girlfriend Julie (Mindy Clark). It's perhaps best remembered for the scene in which reanimated Julie pierces her dead flesh with nipple rings, chains and various body modification accoutrements in an attempt to stem her hunger for her boyfriend's brains.

book of the dead

At the time of writing two more films in the series - *Return of the Living Dead 4: Necropolis* and *Return of the Living Dead 5: Rave to the Grave* - have just been completed. Although originally planned for Tobe Hooper, they were eventually helmed by director Ellory *Eight Legged Freaks* Elkayem - Hooper's name was then linked with *Zombies* instead, which at the time of writing has still not been completed. Shot back-to-back in Romania and on location at the remains of the nuclear power plant at Chernobyl in the Ukraine, the fourth and fifth living dead films promise to revive this long-dead franchise just in time for the millennium zombie boom - although whether they will restore the series's battered reputation remains to be seen.

By playing up the comedy as well as the gore, *The Return of the Living Dead* successfully broke out of the zombie ghetto and became a mainstream hit. Significantly, the necessity of matching horror with laughs during the conservative climate of the 1980s was something that many filmmakers were becoming increasingly aware of.[167] Sam Raimi's experience with *The Evil Dead* (1982) serves as an illuminating case in point in this respect. Though not strictly a zombie movie - its ghouls are dead bodies possessed by demons rather than walking corpses - Raimi's splatterfest follows Ash (Bruce

top: Who left the fog machine on? **Return of the Living Dead Part II**.
above: Punk aesthetics: Julie (Mindy Clark) in **Return of the Living Dead 3**.

Campbell), a hapless twenty-something who finds himself forced to confront demons from another dimension when a vacation in a log cabin goes horribly wrong. After his friends unleash the evil power of the Necronomicon, Ash has to fend off a seemingly never-ending array of demons, zombies and ghouls. Since none of these evil creatures can be "killed," he has to obliterate them, cutting up the dead bodies of his friends so that the evil spirits can't use them against him.

A groundbreaking example of what a budding filmmaker can do with a few bucks, a homemade Steadicam and some ingenuity in the special effects department, *The Evil Dead* was full of barf bag laughs, all of which were a result of Raimi's sheer unwillingness to compromise on its scares. Exaggerating the gore of the conventional horror film to epic proportions, the film reached levels of over-the-top outrageousness that few people with an understanding of the genre could fail to take with anything other than a pinch of salt.

When it was released in the UK the censors failed to see the humour, though. Chased through the British courts at the height of the video nasties hysteria, *The Evil Dead* became - along with *The Texas Chain Saw Massacre* - one of the most controversial films in cinema history. Its infamy extended to it being included on the DPP's list of video titles for prosecution under the Obscene Publications Act. Raimi, who'd set out to make an outrageous scary movie rather than rip apart the social fabric of mid-1980s Great Britain, was understandably upset - particularly when the UK press and courts declared both the film and its American makers morally corrupt.

Raimi's response was to change his focus, practically remaking *The Evil Dead* two years later as the sequel *Evil Dead II*. Mixing the splatter of *The Evil Dead* with Three Stooges-style slapstick, Raimi effectively pulled the rug out from under the censors' feet. If it was explicitly funny as well as violent, was it possible to brand it morally corrupt? The answer was obvious as the sequel received a much easier ride from Britain and America's moral guardians.

By the time of the third *Evil Dead* film, *Army of Darkness* (1992), the balance had tipped so far that the horror was virtually non-existent. Here Ash is cast back into the Middle Ages to battle yet more demons with his chainsaw and "boom-stick". Despite the bigger budget and Campbell's enthusiastic performance, the splatter took a back seat. Still, that didn't stop the square-jawed actor becoming deified by zombie fans for his effortless ability to dispatch hordes of zombie demons with a shotgun blast and a cry of "Groovy! Hail to the king, baby!" It's an enduring legacy that has spawned rumours of an impending remake of the original *Evil Dead* with a new cast and Campbell and Raimi acting as producers.

The blend of gory horror and gross humour that *The Return of the Living Dead* and the first two *Evil Dead* movies precipitated harked back to the comic book splatter of Romero's *Dawn of the Dead* without trying to match its socio-political commentary. The aim was, as Raimi made clear, a kind of physical comedy that owed much to the work of slapstick classic comedians like Buster Keaton and Laurel and Hardy - something which led to it being dubbed "*splat*stick".

> The Three Stooges were a great influence on [*The Evil Dead*]... When the light bulb fills up with blood and the blood comes out of the sockets, there's a Stooges episode called "A Plumbing We Will Go" [where] they hook up all the pipes and it fills the light bulbs with water and they hook up the water supply to the electrical system. The gas ring pours water and out of the television pours water, so I just took that idea and entirely changed it to horror - they're so close anyway. The Stooges are *so* violent.[168]

Although "splatstick" had a keen awareness of the horror of the body, it invited audiences to laugh or barf. In these movies, the human body becomes an object of ridicule rather than abjection, a faulty machine that doesn't seem to realise quite how ludicrously gross its mass of internal fluids and red matter actually is. As blood and pus replace soda siphons and custard pies, the audience laughs and screams (and possibly vomits) simultaneously. Naturally, almost every "splatstick" movie featured zombies - what other monster could better express our revulsion towards the physical realm than a walking corpse?

Cheryl, the 'cellar witch' in **The Evil Dead**.

Unlike the unrelenting nihilism of the Italian cycle, these films confront the abject with a buoyant sense of playfulness. Certainly there is horror and disgust in their visions of bodily trauma and secretions, but it's repeatedly neutered by the desire to play everything for yucky yuk-yuk-yuks. Indeed, these movies are at their best when highlighting the way in which this Otherness suggests an absurd universe that may be godless but appears to have its own internal comic logic. Physical existence is tinged with comic ignominy. Just as Oliver Hardy was resigned to a life that was a never-ending series of blows and pratfalls, so the "splatstick" protagonist recognises their body as an awkward - ludicrous - hunk of flesh.

The scenes in *Evil Dead II* where Ash is forced to amputate his hand (which then scampers off and continues to taunt him by very literally flipping him the finger) are typical of the comic absurdity that dominates this world-view. Like the recalcitrant objects that hampered slapstick characters decades previously, body parts in "splatstick" horror are turned into alien, annoyingly independent entities that refuse to act as they should.

The cycle was brief-lived yet hugely influential - and staggeringly popular. One of the finest films in this micro-genre was *Re-Animator* (1985). Released a couple of months after the first *Return of the Living Dead*, it was a gory comic book homage to writer H.P. Lovecraft, whose six-part short story series "Herbert West - Reanimator" was the film's loose source. Much like *The Return of the Living Dead* it marked itself out by its irreverent, anything-goes mentality, presided over this time by director Stuart Gordon and producer Brian Yuzna.

Piling on the gags without losing sight of the gore or the scares, *Re-Animator* proved a brilliant blend of humour and horror. To his eternal credit, Gordon kept his tongue wedged in a very bloody cheek at all times working from a screenplay that turns zombiedom into the ultimate cosmic joke. As fanatical science student Herbert West (Jeffrey Combs) tries to invent a serum that can return the dead to life, Gordon unleashes all manner of

chaos including reanimated cats, snake-like intestines writhing around and a variety of living dead morgue inhabitants running amok.

West's chief antagonist is Dr. Hill (David Gale), a faculty member at the Miskatonic University who discovers the wild-eyed student's experiments and plans to steal the serum for himself. In the ensuing chaos, Hill is knocked off and returns as a decapitated zombie. While Hill's cantankerous head plans world domination, his lack of a body proves to be a real stumbling block (quite literally as the headless cadaver careens about the morgue knocking into doors and walls).

Shot in just eighteen days on a skimpy budget *Re-Animator* is, as one intrepid *Fangoria* correspondent later argued, a punk rock horror movie: "[Like a Ramones song] it calls to mind the primal power, the focussed ferocity and the gleeful sense of all-out fun found in all the best rock 'n' roll tracks. *Re-Animator* shares a common bond with the best kick-ass rock around too - a simple formula for success known by all True Believers: 'Three chords and the truth'".[169]

The punk rock analogy is an inspired way of understanding the appeal of *The Return of the Living Dead*, *Re-Animator* and other similar splatter comedies. These are stripped-down, rollicking movies whose only aim is to push against the conventional, the stuffy and the boring. Convinced that enough comedy can let you get away with almost anything, these films push the boundaries of violence and gore with a nod, a wink and a ghoulish grin. Scaling the heights of bad taste, "splatstick" possesses a degree of outrageousness that few other horror movies can match (consider, for instance, the infamous scene of a disembodied zombie head giving head in *Re-Animator*).

The laugh or barf humour doesn't always defuse the horror behind such envelope-pushing assaults on the sanctity of the flesh, though. *Re-Animator* certainly courted its fair share of controversy and fell foul of the MPAA, who objected to the extent of its gore. "They told us we would have to cut everything after the second reel," claimed Gordon. "Too much blood; this has to go, that has to go... if we'd done everything they 'suggested' we'd have ended up without about a half hour of film left".[170] In keeping with its punk mentality, the film was eventually released unrated to well-deserved acclaim. It spawned two sequels: *Bride of Re-Animator* (1990), which followed much the same pattern as the original while lampooning *Bride of Frankenstein*, and *Beyond Re-Animator* (2003), which sent West to prison for his crimes against the dead. Neither film quite matched its predecessor, leaving the series currently hanging in limbo.

Undoubtedly the most influential "splatstick" filmmaker was New Zealand's Peter Jackson, whose love of the living dead gave the world two of the yuckiest zombie movies ever made. Shot over four years on a scraped-together budget ("Mum & Dad" are pointedly credited as special assistants to the producer), *Bad Taste*

opposite top left: Slithering intestines take H.P. Lovecraft's universe to new heights in **Re-Animator**. *opposite bottom:* Kathleen Kinmont gets to the bloody heart of the matter in **Bride of Re-Animator**. *above:* Zombies find themselves serving a life (and death) sentence in **Beyond Re-Animator**.

(1987) is a perfect example of the cycle's lo-fi, lowbrow, DIY punk aesthetic. It comes with enough gleeful energy to sustain its shoddy production values and a cascade of gore that's relentless enough to paper over the film's various technical flaws.

Originally centred around a character called Giles, the film was vastly reworked during shooting after actor Craig Smith got married and could no longer commit his weekends to filming this gore opus - as a result his character was sidelined, resulting in some atrociously bad dubbing to rejig the plot. At the same time, the film mutated from a short entitled *Roast of the Day* through *Giles' Big Day* to *Bad Taste* after Jackson scored some development money from the New Zealand Film Commission (his mentor at the Commission, Jim Booth, advised him not to show the bureaucrats the rushes since "they wouldn't understand". He was right; when they finally saw it they were outraged).

The production's on-the-hoof ingenuity accounts for much of *Bad Taste*'s appeal. Its story of aliens turning the population of a small New Zealand town into blue denim-wearing zombies becomes a jumping-off point for a series of gross gags involving characters supping from bowls of vomit and a rebirth by chainsaw climax. The title's promise is completely fulfilled, not least of all in the verbal gag that sees our alien-bashing heroes announce themselves as members of the Astro Investigation and Defence Service ("I wish they'd do something about those initials!") and the various scenes of zombies being eviscerated by chainsaws and lobotomised with sledgehammers. It is, as Kim Newman perfectly described it in the pages of the *Monthly Film Bulletin*, "some kind of triumph in its horror-comic verve, settling into the genre next to the excesses of *Dawn of the Dead*, *Street Trash* and *The Evil Dead*".[171]

Jackson's next zombie outing, *Braindead* (1992) was the apotheosis of the "splatstick" cycle, a catalogue of viscera that builds to a double climax: one featuring a

giant mother monster, the other featuring a thirty-five minute stretch of mayhem in which a house full of zombies and partygoers are reduced to mush by each other - and a lawnmower. Ambitiously set in 1950s New Zealand, *Braindead* proved to be the most technically accomplished film of Jackson's budding career, featuring a fully-fledged storyline, a remarkable series of special effects and a finely honed comic sensibility.

The film's hero is Lionel (Timothy Balme), a twenty-five-year-old mummy's boy whose domineering widowed matriarch Vera (Elizabeth Moody) keeps him on a tight leash. After local shopkeeper's daughter Pacquita (Diana Peñalver) asks Lionel out on an illicit date to the zoo, Vera follows her son but is bitten by a rare (and incredibly vicious) rat monkey. The monkey is infected with a deadly disease that turns anyone bitten into a zombie. After Lionel's increasingly ill mum scoffs a pet dog, she's declared dead by the district nurse but returns as a ghoul, who quickly disposes of the nurse (who then also comes back as a zombie). Forced to cover up his mother's zombification from prying Teddy Boy Uncle Les (Ian Watkin), Lionel's life gets a whole lot more complicated as the zombie scourge begins to spread out of his basement. Crippled by his sense of social embarrassment, Lionel does his best to keep the lid on his ever-growing family of ghouls but they eventually break out to run riot in Kiwi suburbia.

With a comparatively big budget, Jackson expanded on *Bad Taste* to take "splatstick" to its hilariously yucky - and inevitable - conclusion. It's a truly outrageous film: zombies are cut up with lawnmowers, meat cleavers and kitchen appliances, a zombie baby in a romper suit goes on the rampage and entrails slither around with a murderous will of their own (while the attached anus farts from the exertion). What's more, the outrageousness extends far beyond the special effects sequences into the film's ambitious take on the repressive climate of 1950s New Zealand - a place where *The Archers* plays on the radio and the Queen's photograph hangs on sitting room walls.

The sheer scope of Jackson's film is impressive. Not content with just being a gory zombie movie about the ignominy of the body, *Braindead* turns its climax into a cheeky re-working of psychoanalytic film criticism. In an echo of the alien-gutting finale of *Bad Taste*, Lionel's mother mutates into a giant, pus-dripping monster who tries to suck him back into her cavernous womb. Literally embodying Freudian and Lacanian theories of the Oedipus Complex and the Monstrous Feminine, it's a rousing parody of horror conventions.

Jackson's take on the monstrous matriarchy underpinning the Commonwealth is just as pointed. It ensures that the protracted, crowd-pleasing sequences of zombie mayhem - in which Uncle Les and his mates are turned into ghouls and kung fu vicars "kick ass for the Lord" - are topped off by a pro-republican subtext in which the terrors of being zombified become a metaphor for New Zealand's experience of being ruled by the declining post-war British Empire. Unlike *Bad Taste*, *Braindead* is a film that resolutely refuses to live up to its title.

The gore the merrier: Lionel goes on a zombie killing rampage in **Braindead**.

chapter eight

Twilight of the Dead

I. Night of the Living Dead Redux

The 1990s began with an announcement that caused equal parts elation and despair among George Romero's loyal fans: *Night of the Living Dead* was to be updated for the new decade in a colour remake. Reactions were mixed. The news that Tom Savini was signed up to direct from a script by Romero was encouraging, but the fact that it was being backed by a big Hollywood studio (Columbia Pictures) and tailored for an "R-Restricted" rating sounded less than promising. Common sense suggested that Savini's reputation as a gorehound special effects wizard meant he was far from suited to a production aiming for the mainstream horror market (the "R" certificate would allow anyone under the age of 17 to be admitted as long as they were accompanied by an adult). Worse still, Romero seemed convinced that the main impetus behind the remake was economic rather than artistic. As the director bluntly told a reporter from *The Wall Street Journal*: "From my standpoint, this [remake] is purely financial".[172]

While such comments made the project seem alarmingly mercenary, those familiar with the disastrous distribution history of the original film could only sympathise with the director's motivation. Although the black and white drive-in classic had made millions of dollars following its release in 1968, none of the original filmmakers had seen anything like their fair share of the profits. Between questionable distribution practices, bankruptcy filings and the embarrassing fact that the copyright line had accidentally been left off the original print's title (thereby allowing bootleggers to pirate the film without fear of legal repercussions), *Night of the Living Dead* was a victim of its own success. A colourised version of the film had been released on video in the 1980s in a vague attempt to create some extra dollars in belated revenue, yet it did little to redress the balance. The 1990 remake was designed to maximise the franchise's profitability with a big-budget publicity campaign.

The chief hurdle Savini faced in remaking the film was the over-familiarity of the living dead:

> I had to try and make zombies scary again. After Joe Piscopo's beer commercial [a television advert for Miller Lite beer that parodied *Night of the Living Dead*] and Michael Jackson's *Thriller*, zombies weren't scary any more [...] I had to reiterate that these are dead people walking around [and I wanted] to reiterate in the audience's mind: death, dead, these are poor dead people.[173]

With Savini in the director's chair instead of the props room, it was left to make-up artists John Vulich and Everett Burrell to come up with a suitably scary collection of ghouls.

> Because it's been done to death (pun intended) the image of the zombies as these horrendous, bloody, torn apart creatures just wasn't scary enough anymore, but we wanted to make our zombies scary by injecting a strong sense of realism into their appearance. By going with a slightly emaciated look we wanted the audience to believe that they are their next door neighbours, accident victims, victims of disease and corpses which had long been laying in their graves and returned to life.[174]

Graveyard of horror: Barbara (Patricia Tallman, foreground) and Johnnie (Bill Moseley, rear) fight for their lives in the **Night of the Living Dead** remake.

The artists attended autopsies and studied concentration camp photos to help discover the right degree of realism - an admission that stirred up some controversy at the time of the film's release.

Despite the good intentions of the filmmakers, things didn't turn out quite as planned. The shoot was fraught with tension and backbiting as Savini fell out with certain members of the crew and became tied up in messy divorce proceedings at home. As a result, the finished film was only a shadow of what he had hoped to make: "It's forty percent - maybe forty percent - of what I'd intended to do," he explained years later. He claimed that the troubled production was further hindered by the unwillingness of many of his crew to let him pursue his vision.[175]

Part of the problem stemmed from the fact that Romero was largely absent from the set after he turned in his script. As a novice director who hadn't actually been involved in the original movie, Savini felt increasingly isolated and frustrated as certain factions within the crew turned on him: "There were people involved in the original version [of *Night*] who really resented the fact that George chose me to direct this movie. Some of them are directors themselves. They resented me".[176]

In spite of such troubling circumstances, the remake turned out to be a welcome addition to Romero's living dead universe. Returning to the original with a fresh eye, Romero and Savini crafted a thoroughly ironic pastiche that wasn't afraid to break with audiences' expectations. Typical of the script's iconoclasm is the opening graveyard scene, which deliberately wrong-foots anyone familiar with the 1968 film. Most fans thought they knew what to expect as Johnnie (Bill Moseley) and Barbara (Patricia Tallman) arrive at their father's grave, but Romero and Savini have plenty of tricks up their sleeve. The man who lumbers towards them turns out to be the cemetery's caretaker, not the zombie we expect. It's a cheeky reworking of one of the seminal moments in horror history, eliciting a giggle of laughter from audience that quickly turns to shock as a real zombie suddenly rushes into the frame and attacks Johnnie. We're left deliriously off-balance.

The most fundamental change in the new screenplay is its feminism. Focusing his attention on issues of gender rather than race, Romero plays down the role of black hero Ben (Tony Todd) in favour of transforming the character of Barbara. No longer the passive, near-catatonic victim of the 1968 film, she is now a proactive, gun-toting heroine. An apparent descendant of Sigourney Weaver's ass-kicking character in the *Alien* series, Barbara becomes the only member of the group capable of recognising the zombie threat for what it really is and responding to it in an effective manner. While the men argue over issues of territoriality (Who should have the gun? Who's in charge? Which is safer, the cellar or the ground floor?), Barbara is willing to face up to the return of the repressed that the zombies represent. Instead of barricading herself *inside* the house, she pursues a strategy of confrontation and goes outside among the slow-moving zombies. In psychoanalytic terms, she's the only character who doesn't retreat into the compromised safety of the unconscious (the cellar, the attic) to try and escape the horror. Instead, she faces it head on.

For critic Barry Keith Grant, the transformation of Barbara suggests that "Romero has returned to his original zombie narrative and fashioned a more politically progressive view than in the original, particularly in terms of the feminist issues raised by the first *Night of the Living Dead*'s influence on the subsequent development of the genre".[177] Race may have receded into the background, but as Grant argues, "the new *Night of the Living Dead* encapsulates the series's depiction of patriarchy [since at the beginning of the film] the zombies are the monstrous threat, but at the end it is hysterical masculinity that is horrifying".[178]

Romero's living dead trilogy has always been interested in subverting the conventions of gender roles. While the original character of Barbara may have been a terrified catatonic - prompting *Variety*'s reviewer to describe her as a "blathering idiot" - the heroines of *Dawn of the Dead* and *Day of the Dead* are strong, independent and resourceful women. Contrasting these heroines with the (macho, active) heroes and the (passive, feminised) zombies, Romero offers an understated critique of contemporary culture. It's not just consumerism that turns us into soulless, shuffling zombies. Patriarchal culture does much the same thing - encouraging men to play violent war games that are equally braindead and driven only by instinct. As all-male SWAT teams and groups of rednecks run wild, Romero argues that the only response to the crisis is to reconsider traditional gender roles. Caught between soulless passivity and whooping machismo, Romero's heroines chart a third way as dynamic, independent yet rational and sympathetic protagonists.

Of the three films in the original trilogy, *Dawn of the Dead* made the most of these gender issues. As Fran revokes her maternal, feminine status ("I'm not going to play den mother for you guys"), she initially seems determined to match the boys at their own game, tooling up with all the symbols of patriarchal power from pistols to shotguns to helicopters. Playing both ends of the gender spectrum she becomes a freakish symbol of extreme femininity and extreme masculinity combined: the scene in which she idly sits in one of the mall's beauty salons, caked in make-up, brandishing a revolver and admiring her reflection in the mirror makes her look like an Old West saloon girl and gunslinger rolled into one. It's a telling image of a woman being pulled in opposing directions.

By the time the bikers attack, Fran has realised just how dangerous this identity is. While Stephen is desperate to prove his shooting prowess and masculinity by battling the rampaging bikers, Fran embodies something different

- a professionalism that allows her to be tough and sexy, masculine and feminine simultaneously. It's an identity that Peter seems to share, resorting to violence only when it's necessary and taking no pleasure in it. The insistent point of *Dawn of the Dead* and, indeed, the rest of the series is that machismo is dangerous and patriarchal culture is the real monster.

The Savini-Romero remake of *Night of the Living Dead* makes this critique of patriarchal culture explicit. Like Fran, Barbara offers an alternative to machismo. She's a resolute professional whose response to the crisis is rational and yet still empathetic. In short, she's a survivalist who's willing to do whatever it takes to get through the living dead apocalypse without resorting to hysteria, vindictiveness or cruelty. While the men strut around the house "playing rooster," Barbara is the only person who manages to keep her head - something that, as we've already seen, always has great significance in Romero's universe.

The pivotal scene in this regard comes as Barbara tries to make the rest of the group understand that the hordes of ghouls outside aren't some strange breed of supernatural monster, but simply reanimated corpses. She realises that if they can be killed they can be defeated, which is why she objects to the hysterical reaction that everyone else has to the ghouls. To prove her point, she repeatedly shoots an approaching zombie in the chest while the rest of the group look on in shocked silence. "Is he dead? Is he dead?" she yells at them as the zombie continues its relentless advance. She then calmly puts a single bullet through the ghoul's forehead.

While it momentarily seems as though Barbara has slipped into hysteria, Romero's point is quite clear: Barbara is the only member of the group who hasn't lost her head. She's able to comprehend the facts of their situation and is capable of taking appropriate, effective action. The zombie threat isn't that dangerous at all - they can be stopped with a single bullet. All that one requires is a level head and plenty of ammunition. Thus, the difference between Barbara and her bickering male counterparts - Ben and Harry Cooper (Tom Towles) - is quite apparent even without her barbed jibe at them: "You can talk to me about losing it when you stop screaming at each other like a bunch of two-year-olds".

The extent to which Romero expects us to identify with Barbara's rationalism is apparent in the script's deft reversal of Cooper's death. In the original film, the cowardly businessman died after being shot by Ben in a moment of distinctly unheroic revenge. In the remake, Ben and Cooper have an extended - and utterly pointless - gunfight with each other while the zombies overrun the farmhouse. Their selfish and completely irrational actions destroy the group's chances of surviving the zombie attack. As a result, only Barbara escapes, washing her hands of these pigheaded and cowardly characters and venturing out into the zombie-infested countryside alone.

Look behind you! Patricia Tallman arms herself with a poker but misses the porker creeping up behind her in the **Night of the Living Dead** remake.

Night of the Living Dead make-up artists John Vulich and Everett Burrell controversially based their emaciated ghouls on concentration camp victims.

When she returns to the farmhouse the next morning, Barbara discovers that Ben has become a zombie and that Cooper has survived the night by hiding in the attic. Emotionless, she shoots him in the head and then tells the posse of rednecks who are with her that he was a zombie. It's a crowd-pleasing moment, in which Barbara takes revenge on the film's chief villain. But it's also a brilliant indication of Barbara's detached professionalism. Unlike the blind rage that leads Ben to kill Cooper in the original film, Barbara's violence is presented as an act of retribution rather than personal revenge. Barbara executes Cooper because his behaviour represents everything that is wrong with the dominant patriarchal order. People have died because of his arrogant, self-centred cowardice. Had Ben survived the night, we're left in no doubt that Barbara would have done the same to him since, in this version of the story, both men are as dangerous to those around them as one another.

The remake ends with Barbara surrounded by rednecks who cheerfully herd up the remaining living dead while taunting and torturing them. She looks on in disgust, muttering: "They're us and we're them". She may have the cold rationalism of a killer but she can empathise with the zombies. By failing to recognise the fact that the zombies were once human, the living risk becoming as dehumanised as the living dead. The film's conclusion suggests that while the zombie apocalypse may be contained, the patriarchal apocalypse in which rampant militarism, racism and sexism rule is only just beginning. The mask has finally slipped from the face of the civilised world and it seems that nothing can stop the new barbarism.

II. Poverty Row for the MTV Generation (Or, Children Shouldn't Play with Camcorders)

Savini's remake of *Night of the Living Dead* proved to be a modest critical and commercial success prompting Romero to give serious consideration to adding a fourth film to his original trilogy. Disappointed that the budgetary limitations of *Day of the Dead* had prevented him from bringing the story to a suitably grand conclusion, the filmmaker hoped that Savini's success might have a knock-on effect on his own plans. It was an idea that Romero repeatedly mentioned in interviews:

> I'd love to do a 1990s [instalment] that reflects the attitudes of this decade. It would be further on from the zombie rising, so there'd be fewer people but fewer zombies too, as they'd all have rotted away. And the zombies would just wander around us like the homeless or AIDS victims. They'd be kind of unwanted and annoying to have about, but you'd be used to them - you'd just step over them on the way to the shops. But there are so many fingers in the financial pie over the previous three films that I can't see it ever happening.[179]

> For a long time I had this idea that I'd do one *Dead* film in each of the last four decades. And I jokingly said that maybe the last one should be called *Twilight of the Dead*, or, better yet, *Brunch of the Dead*, because I figured that the 1990s were all about ignoring problems anyway.[180]

Romero's legions of loyal fans were certainly excited, but their hopes came to nothing. The filmmaker knew better than anyone that the logistics of such a post-apocalyptic conclusion to the series would require a budget of the kind of size he'd be unlikely to raise for an independent feature. Working within the Hollywood mainstream might be a possibility but it would bring its own compromises, particularly the need to tone down his trademark splatter in order to secure the inevitable R-rating. It was a double bind that effectively brought plans for a fourth film nominally titled *Dead Reckoning* to an abrupt halt.

As the decade continued, the chances of Romero finding anyone in Hollywood willing to back him looked increasingly unlikely. American horror cinema was moving further into the mainstream. With franchises and personalities being prized over innovative storylines, zombie movies were distinctly out of favour again. The biggest-grossing horror stars of the decade were slashers like Freddy Krueger, Jason Voorhees and Michael Myers, or the suave, intelligent cannibal Hannibal Lecter. Plans for a television series

based on Romero's living dead trilogy were briefly mooted then quietly shelved. It seemed that the walking dead's time had been and gone.[181]

Although a few low-budget features went into production around the turn of the decade, they simply confirmed the bad news. Films as diverse as *The Laughing Dead* (1989), *The Dead Pit* (1989), *The Vineyard* (1989), *Nudist Colony of the Dead* (1991) and *My Boyfriend's Back* (1993) seemed destined to take the genre to new lows. S.P. Somtow's *The Laughing Dead* had a busload of kids travelling to Mexico under the watchful eye of a Catholic priest. Once there, they become the victims of all kinds of Aztec shenanigans including a rather bizarre game of basketball between the living and the living dead. Then there was the asylum-set story of Brett Leonard's *The Dead Pit*, which featured ghouls released from their eponymous pit by a ghostly doctor to stalk the corridors of the hospital where he used to torture his patients. In *The Vineyard*, James Hong's Chinese sorcerer tries to keep his youthful looks by killing pretty teens and burying them in his vineyard (the wine their decomposing bodies help produce is apparently a very good vintage). Of course, they eventually crawl back from the grave to get their revenge. Meanwhile, in Bob Balaban's tongue-in-cheek zombie love story *My Boyfriend's Back*, a high school student returns from the grave after being shot in a store robbery to woo his prom queen girlfriend while trying not to eat her (literally, that is). The less said about *Nudist Colony of the Dead*, in which director Mark Pirro delivers a tiresome blend of musical numbers, naked performers and zombies at a nudist camp, the better. The title song's lyrics speak for themselves: "You'll be shaking in your boots / by corpses in their birthday suits / The horror mounts, the terror grows / these monsters have no use for clothes".

Without the interest of the studios to save the genre from such ignominy, the halcyon days of the 1970s and 1980s appeared to have vanished for good. One group of fans were determined not to let the matter rest, though. In the absence of anyone making the kind of horror movies they wanted to watch, they decided to make their own instead. Inspired by the low-budget splatter tradition of the Italian cycle, these "Camcorder Coppolas" as they joking referred to themselves used the cheap availability of home video technology to produce their own independent features.

In much the same way as the Poverty Row studios of the 1940s had relied on the living dead to provide cheap horror scares, these directors took the living dead into the realm of energetic but decidedly amateur filmmaking. Dominated by a punk aesthetic in which technical ability was considered far less important than sheer enthusiasm, the shot-on-video (SOV) revolution was led by fans who were essentially teaching themselves the mechanics of filmmaking from the ground up - often while they were in the process of shooting. The results

Death mask: evil lurks at the bottom of Brett Leonard's **The Dead Pit**.

were spectacularly bad as eager directors - with little or no formal training - roped in friends and family and forced them to fumble through semi-coherent scripts in productions plagued by horrendously incompetent sound, lighting, editing and camerawork. Amazingly, many of these truly amateurish productions were picked up for home video release by small, independent labels that recognised that these films were offering hardcore horror fans something that no one else was.

The film that was largely responsible for initiating the SOV trend was J.R. Bookwalter's *The Dead Next Door* (1989). A true horror fan - and one time zombie extra on *Day of the Dead* - Bookwalter was fortunate enough to secure the championing and financial assistance of director Sam Raimi while the latter was working on *Evil Dead II*. Armed with a couple of thousand dollars of Raimi's money, Bookwalter put together enough additional cash to get his zombie opus off the ground and filmed and edited the production over the next four years.

Shot entirely on 8mm for a budget of around $125,000 (rumour has it that it is the most expensive film ever made in the format), the finished film is really little more than a home video feature marred by obvious budgetary constraints, technical ineptitude and bad acting. Its moments of blackly comic hilarity were enough to make it into something of an underground horror hit, though, launching Bookwalter's career as a marginal filmmaker.

Set in a post-apocalyptic world where the dead are inexplicably returning to life to feed off the living, *The Dead Next Door* is an uneven little film that cribs rather shamelessly from Romero. Rarely able to convince us

that it's anything more than an enthusiastic fan film, it's let down by ketchup bottle gore effects, a cast who aren't always able to keep a straight face and threadbare production design that regularly verges on the unintentionally ludicrous (the cages that hold the captured zombies, for instance, are so flimsy they appear to have been made out of cardboard). It's only Bookwalter's occasional moments of ingenuity that propel the film forwards. These need to be patiently sought out, but are often worth the wait: a disembodied zombie head biting the fingers off a policeman's hand, only for the undigested digits to emerge from its bloody neck a few seconds later; a zombie armed with an electronic voice box whose cries of "Feed me, I'm hungry!" are eventually followed by a comical rendition of The Star Spangled Banner.

Despite its obvious shortcomings, the film was successful enough to trigger the SOV revolution, with backyard filmmakers all over America turning to the zombie in the hope of aping Bookwalter's underground hit. The director was keen to distance himself from his many imitators simply because so many of the productions that clung to the coat tails of *The Dead Next Door* were irredeemably bad:

> Right now I'm lumped in with every other loser with a camcorder, and it bothers me. A lot of people watch my movies and they see a big difference between what I'm doing and what the average Camcorder Coppola is doing, but the mentality is still there that I'm not making "real" movies. So, I aspire to move up the next rung on the ladder.[182]

While it is easy to sympathise with Bookwalter's desire to put some distance between himself and the rest of the SOV crowd, the fact remained that *The Dead Next Door* was shoddy by mainstream standards. His follow-up, a sixty-minute feature entitled *Zombie Cop* (1991), added little to the zombie-with-a-badge theme that William Lustig's infinitely superior *Maniac Cop* (1988) had started and simply confirmed that he was unlikely to ever evolve into anything other than an amateur auteur.

At least Bookwalter was in good company. The roll-call of SOV filmmakers who emerged between the 1990s and the present is endless. Sadly for cinema fans, the list of crud they've produced is equally endless and terribly depressing. Vaguely notable entries in the SOV cycle include *Working Stiffs* (1989), *Ghoul School* (1990), *The Zombie Army* (1991), *Living a Zombie Dream* (1996), *Sex, Chocolate & Zombie Republicans* (1998), *Meat Market* (2000), *Biohazardous* (2000), *Flesh Freaks* (2001), *Zombie Chronicles* (2001), *Daddy* (2002), *Lord of the Dead* (2002), *Zombie Campout* (2002), *Maplewoods* (2002), *Necropolis Awakened* (2003), *Come Get Some!* (2003), *Hallow's End* (2003), *Blood of the Beast* (2003), *Dead Life* (2004), *The Legend of Diablo* (2004) and *The Stink of Flesh* (2004).

It wasn't a phenomenon limited to North America either: the poisonous *Zombie Toxin* (1998) was shot in England and a clutch of Irish fans produced the Emerald Isle's first zombie movie *Zombie Genocide* in 1993 (since Irish SOV filmmakers were rather less enthusiastic than their American counterparts, another decade passed before zombies continued their assault in *Dead Meat* (2003)). Meanwhile, on the international film circuit, Germany became one of the most prolific producers of low-budget zombie horror with directors like Andreas Schnaas, Timo Rose and Olaf Ittenbach taking the living dead concept to the depths of the bargain basement. The list of dishonourable Teutonic cinema (some SOV, some a little classier) is a lengthy one that includes predominantly worthless trash like: *Zombie 90: Extreme Pestilence* (1990), *Urban Scumbags Vs. Countryside Zombies* (1992), *Premutos: Lord of the Living Dead* (orig. *Premutos: Der Gefallene Engel*, 1997), *Zombie: The Resurrection* (1997), *Das Komabrutale Duell* (1999), *Mutation* (1999), *Legion of the Dead* (2000), *Midnight's Calling* (2001) and *Demonium* (2001 - shot in Italy in English but helmed by prolific German zombie director Andreas Schnaas). In other countries, SOV zombies proved equally popular. Argentina delivered *Plaga Zombie* (1997), Brazil stepped into the fray with *Zombio* (1999) and even France mustered a cheap *Re-Animator* rip off called *Trepanator* (1991) with Jean Rollin propping up the cast list as a mad doctor.

The undisputed king of the SOV era, however, was Kansas filmmaker Todd Sheets whose prolific output included *Zombie Rampage* (1991) *Zombie Bloodbath* (1993), *Zombie Bloodbath II: Rage of the Undead* (1994),

Zombie Bloodbath 3: Armageddon (2000) and many, many more. Sheets's one-man assault on the horror genre produced a stream of films that even he admitted were "unwatchable pieces of trashola". Looking through his *oeuvre*, it's difficult to find anything to counter that undeniably accurate assessment.[183] The movies of Sheets - who lacked the technical skill of Bookwater - are tedious exercises in zombie mayhem with little understanding of the bare essentials of cinematic storytelling. Watching these Kansas backyard epics is rather like sitting through someone else's child's high school play; without any vested interest in the actors, you're left wincing at every mangled line of dialogue and stilted performance.

So what was the appeal of these no-budget, Z-grade efforts? Influenced by the extreme imagery of the Italian cycle of the 1980s and by the obsession with blood 'n' guts to be found in magazines like *Fangoria* and its many imitators, the backyard epics sprayed gore around the screen with wild abandon often spending little or no time establishing niceties such as plot or character. The bastard offspring of spaghetti horrors like *Zombie Creeping Flesh* and *Zombi Holocaust* crossed with the Poverty Row films of the 1940s, the SOV productions flourished due to an obvious gap in the market. As mainstream American horror movies became increasingly homogenous, teen-focussed and unwilling to challenge the censors at the MPAA, fans felt they were getting a bum deal. The spectacle of violent bodily trauma offered by SOV films wasn't to be found in mainstream productions like *Scream*, which were only interested in appealing to the widest audience demographic possible. It was a state of affairs that Sheets and his fellow filmmakers were keenly aware of:

> Today it's all about what hot teen "babe" is in the movie, or how many pop-hit bands are on the soundtrack, or how many endorsements and product tie-ins like Nike, Pepsi, etc. are in it, or how much it makes and costs to make. Who gives a shit?!? These twits, like the girl stars of *Scream* for instance, hate horror movies for the most part! The girls in *The Craft* were on TV interviews acting like they were embarrassed to be in a "horror" movie... They all kept claiming that it wasn't fair to classify it as a horror-picture.[184]

Unlike the glossy, relatively high-budget productions that dominated 1990s studio horror - in particular the endless procession of serial killer movies targeted at the teenage demographic - the SOV market offered gore for gore's sake. Many of these films didn't bother to approach the MPAA for ratings, thereby circumventing the censors. Even if they did apply for certification, it didn't matter if they received an NC-17 rating: such censor-baiting was a badge of honour and a sign that they hadn't sold out or skimped on the horror. While the results of their labours may not have been any good, these films did prove that there was an alternative to the dominant Hollywood hegemony and a whole breed of horror fans who didn't feel their tastes were being satisfied elsewhere.

opposite top: **The Dead Next Door, Meat Market 2, Plaga Zombie: Zona Mutante.** *this page top*: Three shots from Scooter McCrae's **Shatter Dead**.

"The most relentlessly depressing film ever":
Andrew Parkinson's **I, Zombie: A Chronicle of Pain**.

Among the prevailing dross of the 1990s underground horror circuit, the odd gem did appear. The best example is Scooter McCrae's *Shatter Dead* (1993), an uneven but memorable SOV feature that offers a decidedly surreal take on the zombie apocalypse. Significantly, McCrae claimed that his inspiration for the film was his realisation that the Hollywood studios were no longer catering to the interests of horror fans like himself:

> I think that the major studios are incapable of producing what we used to know as the "horror movie," but they are certainly capable of producing what I would call a "horror spectacle," or what critics used to denigrate Dario Argento's films as being by calling them nothing more than "scare machines"... Missing all the subtext of course. By that they meant a film that was calculated to make the audience jump every few minutes with some kind of set piece scare or horrible death; and we all know how difficult that is, right...?[185]

Eager to produce something radically different, McCrae wrote, directed and produced *Shatter Dead*. Combining the gauche pretentiousness of a film school project with occasional flashes of genre-bending brilliance, the film is set in a future world in which there is no more death. With the difference between life and death severely skewed, the living have taken to killing themselves young in order to keep their bodies youthful in living death. Once dead, these zombies can't be killed; the typical bullet to the brain does no more than mess up their faces.

The reason for this drastic change in life and death is apparently linked to the arrival of the Angel of Death, who comes to Earth in the guise of a woman and impregnates a mortal woman using a strap-on dildo (none of this actually makes much sense within the film, but is heavily glossed in the video sleeve notes). "There's no more room in heaven, either" proclaims the tagline and with *Shatter Dead*'s decidedly leftfield sensibility thus established, the film proceeds to create a haphazard universe full of religious overtones and angst-ridden characters. Dismissing the empty gore shots of most SOV productions, this charts its own path and owes little more than a curt nod to Romero or any other zombie filmmaker.

In McCrae's film the dead coexist with the living, begging for food and spare change on the streets of this post-apocalyptic world and forming a new social underclass. "When death ends, life changes," argues the film and the implicit suggestion is that God has abandoned his creation, leaving the dead to wander without hope of redemption. Acting exactly like their living counterparts (they walk, talk and eat) these zombies aren't much of a threat but their presence has had a disastrous effect on the global economy. Through this chaotic world wanders Susan (Stark Raven), a feisty, gun-toting heroine (albeit with a tendency to take her clothes off as often as possible) who vehemently hates the dead and is suspicious of the reconciliatory aims of the mysterious Preacher Man (Robert Wells).

Privileging grim surrealism over conventional horror, McCrae presents us with an upside down world which defies explanation. *Shatter Dead*'s catalogue of the sick, the perverse and the bizarre makes for memorable viewing: a gang of raiders attack the house where the woman carrying the Angel of Death's baby is hiding and shoot her with a shotgun, blasting the unborn foetus out of her belly; Susan's boyfriend slits his writs, remarking "My sin is quite literally on my sleeve for eternity"; the zombies decide to hasten the deaths of the living by killing them themselves. A strange, frequently amateurish, but still quite ingenious film *Shatter Dead* is a true genre oddity and a refreshing change from the rest of the decade's SOV zombie movies.

On the other side of the Atlantic, British director Andrew Parkinson's debut feature *I, Zombie: A Chronicle of Pain* (1998) may have been shot on 16mm but it owed much to the successes of the American SOV market. A curious blend of extreme gore and existential angst, it tells the story of Mark (Giles Aspen), a young Ph.D. student who is bitten by a ghoul and slowly transforms into a zombie in a dank, West London bedsit. Isolated from his friends and family, and desperately in need of fresh flesh to survive, Mark preys on tramps and prostitutes to satisfy his bloodlust.

Described by its distributors as "an attempt to make the most relentlessly depressing film ever [...] a film with no jokes, no light relief, no MTV visuals, just an unrelenting downward spiral [into living death]", Parkinson's movie plays like a kitchen sink zombie drama as it casts an unflinching gaze over its hero's messy physical deterioration.[186] A stunning counterpoint to the teen horror that dominated the 1990s, this is a film with the courage not to pander to its audience, delivering instead a depressing and shocking onslaught of angst and gore.

Meticulously presenting the daily misery of Mark's condition in graphic detail, Parkinson uses voice-over to great effect: "Had another blackout this morning, woke up on the bathroom floor covered in puke. What a fucking mess." As Mark's physical state worsens, so too does his mental stability, turning *I, Zombie* into the diary of a man in despair. Reminiscent of the body horror of David Cronenberg, it certainly chronicles a great deal of pain, with some gruelling moments of self-inflicted violence. Patching his dead body together using a power drill and rusty metal sheeting, Mark is ultimately unable to save his decaying flesh. In the film's most wince-inducing moment the hapless zombie accidentally pulls off his penis while masturbating. As much to do with the social and bodily alienation fostered by the AIDS crisis as zombies, Parkinson's grim nightmare is a disturbing example of a truly alternative horror cinema.

Parkinson moved up to 35mm for his next feature film, demonstrating his ambition to strike out as an independent filmmaker. Replacing the story of Mark's solitary suffering with that of a group of female zombies who live and feed together, *Dead Creatures* (2001) saw the director expanding his range. The film follows female zombies who pose as prostitutes to lure men back to their flat, and the pursuing zombie hunter who's determined to wipe out the scourge.

Parkinson's zombie apocalypse is a slow-burning event that unfolds at a steady pace. Groups of the infected hole up among the living, gradually spreading the disease as they feed. Where it will all end isn't certain (Parkinson has often hinted that there may be a third film in the series), but it's a fascinating glimpse of an underground zombie community that gradually transforms the social order. It's also as far from the mainstream as one could image. As Parkinson told *Fangoria* magazine (who released both films on their own in-house video label): "I don't think the audience for these films is massive but there are enough people out there who are tired of horror comedies and clever postmodern horror".[187]

Interestingly, *I, Zombie*, *Dead Creatures* and *Shatter Dead* fulfil Romero's aims for the 1990s zombie movie by tentatively approaching two of the issues that the Pittsburgh director had earmarked for his planned fourth film: homelessness and the impact of AIDS. In presenting their zombies as social outcasts rather than monsters, these films play up the 1990s concern with urban alienation and marginalisation and try - with varying degrees of success - to question our faith in social progress. From *I, Zombie*'s existential drama (in which Mark worries as much about paying his next gas bill as his deteriorating condition) to *Shatter Dead*'s panhandling zombies (one carries a sign reading, "Help. Dead. Sold arm for medical experiments. What next?"), the living dead become symbols of the forgotten underclass dispossessed during the Reagan/Thatcher era.

III. Of Death, Of Love: An Interlude

I don't know how the epidemic started. All I know is that some people on the seventh night after their death come back to life… I call them "Returners" but frankly I can't understand why they're so anxious to return. The only way to get rid of them once and for all is to split their heads open - a spade'll do it or a dumdum bullet is best […] Is this the beginning of an invasion? Does it happen in all cemeteries or is [mine] the only one? Who knows? And in the end who cares? I'm just doing my job. (Francesco Dellamorte [Rupert Everett] in *Dellamorte Dellamore*).

If the SOV phenomenon suggested that the zombie movie had moved beyond the world of Italian exploitation cinema into a cultural hinterland of fan productions, one 1990s movie redressed the balance. Michele Soavi's *Dellamorte Dellamore* (aka *Cemetery Man*, 1993) starred Rupert Everett - possibly the most unlikely actor to ever appear in a modern zombie film - as a cemetery groundskeeper whose clients keep coming back to life. It became a perfect, if somewhat belated, swansong for the Italian cycle.

Loosely adapted from a popular mid-1980s Italian "*fumetti*" (an adult-focussed graphic novel) by Tiziano Sclavi entitled *Dylan Dog*, *Dellamorte Dellamore* follows Francesco on a blackly comic confrontation with death (and life). For reasons that are never explained the dead bodies that are buried in the cemetery of the Italian town of Buffalora have a tendency to come back to life on the seventh night after their death. More concerned with keeping his job than in trying to explain the ins and outs of the matter to his bureaucratic superiors, Francesco simply deals with the zombies himself, quietly killing these "Returners" each night with the help of his retarded assistant Gnaghi (François Hadji-Lazaro) and an armoury full of hollow point bullets.

Francesco (Rupert Everett) and Gnaghi (François Hadji-Lazaro) are about to become zombie Boy Scout fodder in **Dellamorte Dellamore**.

Francesco has been doing this for so long that it's become a matter of course. But after an erotic encounter with a woman known only as "She" (Anna Falchi), the widow of the town's most recently deceased, things start to go horribly wrong. Returning from his grave to find his wife and Francesco making the beast with two backs, the dead man is understandably annoyed and bites her in a fit of pique. Francesco is left with no choice but to live up to the Italian title's literal translation ("Of Death, Of Love") and shoot the woman he adores before she becomes a ghoul.

Except there's worse to come: Francesco later realises that She wasn't actually dead when he pulled the trigger. Driven insane by guilt and despair, he begins to lose his grip on the difference between the worlds of the living and the dead. Taking matters into his own hands, he starts killing the townsfolk *before* they're actually dead in order to save himself the trouble of dealing with them later. This prompts Death himself to pay him a rather peeved visit and demand that he leave the dead and the living alone. Meanwhile, Francesco keeps running into women who look exactly like She and who seem to have the same amount of life expectancy.

According to Soavi, *Dellamorte Dellamore* "is not about the fear of dying; its concern is the fear of living".[188] Francesco's fear of life is all-too-apparent. Locking himself away behind the high walls of the cemetery grounds, he has effectively annexed himself from the land of the living. Francesco, a figurehead of 1990s apathy turned sour, inhabits a world in which ignorance - and death - is bliss. At one particularly telling point in the story Gnaghi's television set broadcasts an important newsflash about the Gulf War, yet no one notices since they're too preoccupied killing the Returners.

Dellamorte Dellamore's nihilistic, fairy-tale tone stays faithful to Sclavi's original comic book but, as the filmmakers themselves admit, it has been considerably watered down. Screenwriter Gianni Romoli claims that the original comic was "Too bitter, too negative and without any hope whatsoever […] Audiences would have slit their wrists watching a literal version of the book. I wrote five drafts of the script altogether, making the story less and less nihilistic, necrophiliac and pessimistic each time".[189]

As it stands, *Dellamorte Dellamore* is resoundingly bleak, although its moody tone is enlivened by some wonderfully sardonic humour. There are several deliciously perverse moments, from the reanimated severed head of the mayor's daughter that Gnaghi keeps inside a burnt-out TV set (they plan to get married) to the whole troupe of Boy Scouts who are killed in a traffic accident and then return en masse. Matching the script's dark wit, Soavi delivers an endless array of inventive camera angles and bold stylistic flourishes. One surreal shot is taken from *inside* the mouth of a disembodied head as it flies through the air while the film's concluding sequence makes an audacious reference to *Citizen Kane*.

Then there's the unlikely prospect of the film's star. More accustomed to costume dramas than blood and guts, Rupert Everett is an actor with a self confessed hatred of the horror genre. No wonder he was so surprised to be eagerly courted by Soavi for the role of Francesco. The director handpicked him for the part because, somewhat bizarrely, the original comic book's zombie hunter was explicitly based on Everett's classical features (without the actor's knowledge). Soavi was determined to remain true to Sclavi's vision by casting Everett. According to one industry rumour, he even turned down a lucrative American offer to finance the film because the backers wanted him to cast Matt Dillon in the lead. Everett was flattered by such attention into agreeing to make his horror debut despite his initial trepidation. In the end, the actor was impressed by the film's power: "Death here means emotional death, pop-arted into a mad, psychedelic fantasy […] Sclavi's story is how he sees contemporary life in Italy: the people, the government, the mafia scandals, the bleak future. The living dead/Returners are us in effect, because we've all become so boring, so cauterised, so politically correct."[190]

Soavi claims that he set out to make "a black fable about today's Blank Generation".[191] It's wickedly funny, sharply barbed filmmaking that is brimming over with dark intelligence. Trapped by his gloomy outlook and complete rejection of the world around him, Everett's cemetery slacker is significantly more zombified than any of the corpses that return from the dead. A fitting symbol of Blank Generation apathy and disengagement, Francesco is completely unable to find the energy to embrace life. As a result, he's only too eager to follow his charges to the grave: "Everything's shit. The only thing that's not shitty is sleep […] I'd give my life to be dead". The joke is that in this cruel world there's not much chance of death being a very restful experience.

A lone ghoul makes unlikely use of a random tree branch in Michele Soavi's sublime black comedy **Dellamorte Dellamore**.

IV. The Resident Evil Effect

As Romero battled to get his fourth zombie film off the ground, Bookwalter and Sheets played about in their backyards and Soavi brought the Italian cycle to a rousing climax, one intrepid member of the global entertainment industry was preparing to rescue the zombie from the margins. Determined to repackage the zombie as a mainstream monster and an icon of cool, this man was hell-bent on making a fortune out of the living dead. His credentials however, were rather unusual. He wasn't a director or screenwriter but a producer. He didn't work in Hollywood but Tokyo. And he wasn't in the movie industry but the Japanese videogame market.

When Shinji Mikami was first given the brief for the project that would become one of the biggest selling videogames of the 1990s, he was thoroughly unimpressed. Summoned by the Head of Consumer Research and Development at Japanese videogame giant Capcom Inc. one fateful day in 1996, Mikami was instructed to develop a new horror adventure game for the emerging PlayStation console. His boss wanted him to emulate the model of *Sweet Home*, a best-selling haunted house game adapted from Kiyoshi Kurosawa's film of the same name. That title had been a huge success on the rival Nintendo console in Asia and Capcom wanted to release something similar for the PlayStation.[192]

What surprised Mikami was how underdeveloped the brief was: all his boss wanted was a horror game that would garner a cult reputation among gamers in the lucrative PlayStation market. He wasn't concerned with what type of game it might be and he didn't have a long list of criteria that it had to adhere to. As Mikami recalls: "The director said, 'We don't have to sell a large number of games. Our goal is to create a game that is worth owning. It is enough if a total of 300,000 units for both Sony PlayStation and Sega Saturn can be sold."[193] What they wanted was a prestige title that would help consolidate Capcom's reputation among owners of the new Sony console. What they got was *Biohazard* - released in Europe and America as *Resident Evil*. Premiering on the PlayStation in 1996, it became an overnight sensation. Over the next five years, it spawned five different versions and was so successful that it began to compete with the phenomenally successful *Tomb Raider* franchise in terms of multi-million dollar sales and brand name recognition.

"The main attraction of *Resident Evil* is FEAR," explains Mikami. "I really wanted to make it as scary a game as possible."[194] To that end, he instructed his design team to focus on one particular horror monster, the walking dead. "I may have been inspired by the zombies from Romero's *Night of the Living Dead*, which I used to watch when I was in junior high,"[195] recalls the producer, adding:

[But] my main inspiration was *Zombi* [sic], a famous Italian horror movie. When I saw the movie I was dissatisfied with some of the plot twists and action sequences. I thought, "If I was making this movie, I'd do this or that differently". I thought it would be cool to make my own horror movie, but we went one better by making a videogame that captures the same sense of terror. I want *Resident Evil* to give the player the feeling that he's the main character in a horror movie.[196]

The game's set-up is deceptively simple as STARS (Special Tactics And Rescue Squad) officers are sent to the fictional Midwest American town of Raccoon City to investigate a series of strange murders. Unbeknown to the team, an experimental virus has escaped from the secret laboratory of the shadowy Umbrella Corporation and is turning the citizens of Raccoon City into flesh-eating zombies. When contact is lost with the first team, a second STARS group is sent to Raccoon and the player controls two of its members - Jill and Chris - as they search the eerie mansion where the outbreak is rumoured to have started.

Taking the films of Romero and Fulci as its starting point, *Resident Evil* single-handedly established the template for a new genre of videogame quickly dubbed "survival horror" by industry commentators. Armed with a single gun and a limited amount of ammunition players of *Resident Evil* are plunged into a game in which simple survival takes precedence over conventional ideas of winning. Since there are often too many zombies to be killed with the available weapons, survival depends on keeping your head. Correctly guessing when to expend those ever-so precious bullets and when to simply run away from the advancing zombies is of vital importance, as is the ability to be able to rationally solve a set of basic puzzles. Perhaps that explains why the *Resident Evil* games were some of the first to star resourceful women as their player characters instead of the usual pixelated Rambo clones. As in Romero's films, macho heroics are of little use in the game's unforgiving universe.

Moving through each level, players are confronted with a range of atmospheric locations that use carefully-chosen sound effects such as dripping water, breaking glass and the moans of off-screen zombies to heighten the tension. Much like a conventional horror movie, the game makes use of a creepy score interspersed with long sections of disturbing silence to help set up its scripted "shock" moments: zombies smashing through the windows of a deserted hallway as the player's avatar walks along it; a pack of living dead dogs that suddenly leap into the playing area from somewhere off-screen; a zombie unexpectedly lurching out of the shadows.

Forging similarities between the games themselves and the horror movies that inspired them seems to have been something of a deliberate ploy. The survival horror

genre that *Resident Evil* helped to create - which includes games such as *Silent Hill*, *Fear Effect*, *Dino Crisis*, *Forbidden Siren* and many more - frequently draws on horror movies for inspiration and, more importantly, atmosphere. As videogame commentator Steven Poole explains:

> Tense wandering in dark environments is interrupted with shocks, sudden appearances of blood-curdling monsters. Silence is interrupted by grating noise, making you jump and increasing your nervousness. The same sort of atmospheric virtue is present in the *Resident Evil* series of zombie videogames, which [...] lift wholesale the camera angles and action sequences from Romero's own classic zombie flicks such as *Dawn of the Dead*.
>
> Why is it particularly the horror genre, and to a lesser extent science fiction, that largely provides the aesthetic compost for supposedly "filmlike" videogames? [...] The answer is that the horror genre can easily do away with character and plot; it is the detail of the monsters, the rhythm of the tension and shocks that matter.[197]

Intriguingly, the relationship between zombie movies and these videogames proved strangely reciprocal. Just as *Resident Evil* took the failing zombie genre and breathed new life into it by transferring the archetypal apocalyptic storylines of Romero et al. from the cinema to the living room, so the zombie movie itself discovered a new lease of life. Pixelated success bred a resurgence of interest in cinematic tales of the walking dead.

The first territory to register the effect of the games was, perhaps unsurprisingly, the place of their genesis. Before the *Resident Evil* series, Asia's contribution to the zombie movie had been strictly limited. There were a handful of martial arts films that employed the living dead among their chopsocky action sequences, from creaky Shaw Brothers outings like *The Legend of the 7 Golden Vampires* (1973) and *Revenge of the Zombies* (aka *Black Magic II*, 1976) to low-budget but equally manic fight flicks like Hwa I. Hung's *Kung Fu Zombie* (1981) and Godfrey Ho's *Zombie Vs. Ninja* (1987) among others. Meanwhile, Asian cinema's penchant for supernatural stories made the appearance of living dead ghouls in classic Hong Kong films like *A Chinese Ghost Story* (*Sinnui yauwan*, 1987) inevitable.

Over in Japan, the kung fu fighting ghouls of the Hong Kong cycle were replaced by the apocalyptic tradition of the West with cheap, end of the world movies like *The Living Dead in Tokyo Bay* (orig. *Batoru garu*, 1992) following the standard pattern of Romero's living dead outbreaks. Endearingly shoddy in the manner of the country's interminable *Godzilla* series, *The Living Dead in Tokyo Bay* has radioactivity from a crashed meteorite bringing the dead back to life to run riot through the capital while a perky manga-style heroine battles to save the day. It was distinctly undistinguished.

By the late 1990s, the Asian zombie movie found itself in the midst of an unexpected resurgence as a string of new releases featuring the living dead proved domestically successful and also had international appeal. Judging by films as diverse as *Junk* (orig. *Shiryô-gari*, 1999), *Wild Zero* (1999), *Versus* (2000), *Stacy* (2001), *Battlefield Baseball* (orig. *Jigoku kôshien*, 2003) and the slapstick comedy of Hong Kong's *Bio-Zombie* (orig. *Sang dut sau shut*, 1998; the title literally translates as "Petrified Fortune Corpse") it seemed that the Asian market was undergoing something of a renaissance.

"Where the hell are all these new Japanese zombie movies coming from?" was the question being asked in *Fangoria* magazine after this slew of late 1990s releases made Asia in general and Japan in particular into the world centre of zombie productions.[198] With the benefit of hindsight, it's obvious that the prevailing influence was the unexpected success of *Resident Evil* among a whole generation of Asian gamers. If zombies were suddenly cool again, it was thanks to the binary ghouls of Shinji Mikami's survival horror console game.

Perhaps it was because they were so aware of their tenuous cultural heritage that this new wave of zombie films refused to take themselves too seriously. As the self-reflexive title of Atsushi Muroga's *Junk* hints, these films felt no shame in delivering swift, effective but predominantly throwaway bouts of zombie action. *Junk* itself is as forgettable a film as one could ask for, a quick-paced no-brainer in which a couple of petty thieves are caught between the yakuza, the American military and flesh-eating ghouls after the usual army experiment goes balls-up. Chock full of big guns, martial arts moves and entrail-ripping violence it's loud, it's brash and it amounts to very little. As far as the director is concerned, that's the whole point: "I kept the Japanese expression '*shitsu yori ryou*' in my mind at all times. This means 'less quality, more quantity.' I was geared to make the most extreme zombie film I could."[199]

Tetsuro Takeuchi's defiantly punkish *Wild Zero* is a similarly disposable trashfest that plays more like an ingenious promo video for its stars - riotous Japanese punk band Guitar Wolf - than a fully-fledged horror film. Barefacedly acknowledging his lack of interest in cinema, the debut director has made no secret of his belief that *Wild Zero* was meant as nothing more than a joke, claiming "It's probably not a good idea for me to express this, but I'm not a person inspired by movies, someone who grew up with this school of ideas about movies being the best thing. I actually really hate that ideology".[200]

Ripping cinematic form to shreds, *Wild Zero*'s kinetic style and deliberate lack of interest in conventions of "good" moviemaking is perfectly suited to the band's

thrash rock meets full-on punk ethos. Roping in the living dead as shorthand for the nihilism that underpins Guitar Wolf's destructive performances on-stage and off, the film apes the low-budget style of America's notorious Troma Studios. Chucking zombies, UFOs, aliens and manic teenagers into a fast-food blender of cross-cultural reference points, it proves to be just as much of an example of throwaway moviemaking as the junk of *Junk* (although it's considerably wittier and much more fun).

Deliberately embracing the zombie's abject status, *Wild Zero* plays up the genre's link with "bad" filmmaking just for the sheer perversity of it with terrible song lyrics ("Blood Blood Baby Exploding Blood, Exploding Blood, Roaring Blood!") a camp villain decked out in hot pants and a ginger wig, and a trio of Elvis look-alikes who spend more time greasing back their impeccable coiffures than actually dealing with the ghouls. It was an aesthetic that production house Gaga Communications tried to take to new levels of silliness with their next living dead outing - Naoyuki Tomomatsu's *Stacy*, a cheeky zombie schoolgirl tale full of ghouls, eviscerations and Japanese teenagers dressed in bunny outfits selling chainsaws named "Bruce Campbell's Right Hand".

Of these post-*Resident Evil* zombie outings, it's Ryuhei Kitamura's *Versus* that's the most visually impressive, the most accomplished and the most indebted to the impact of the videogames themselves. No less trashy than *Junk*, *Wild Zero* or *Stacy*, this deliriously fast-paced film builds upon the kinetic visual style of über-cool Western movies *The Matrix* and *El Mariachi*, to create a live action manga fantasy. Indeed, *Versus* lifts much of its aesthetic from the videogame and comic book markets. Frantic, bloody and completely relentless, it pits its leather trench coat-clad hero (played by Tak Sakaguchi - an actor who looks rather disconcertingly like an Asian Johnny Depp) against an army of vengeful yakuza foot soldiers and zombies in an insane storyline about inter-dimensional portals and samurai sword showdowns.

"Hong Kong and Korean movies are really powerful these days but Japanese films are not," explained director Ryuhei Kitamura when asked what inspired his distinctive visual style. "A director like John Woo has not appeared in Japan yet. I decided I would do it; I will direct great Japanese entertainment movies and show the samurai soul to the world."[201] The director's immodesty aside, there's an undeniable genius to *Versus*'s effortless ability to commit the frantic, multi-angle mayhem of a videogaming session onto celluloid.

Pilfering bits and pieces of a dizzying array of American cultural products from *Highlander* to *Reservoir Dogs* and referencing every kinetic Asian movie of the last decade or so - including the director's previous film *Down to Hell* (1996) - *Versus* offers breathtaking visual virtuosity and some decidedly bloody moments that are guaranteed to have horror fans cheering. In one sequence, the super-powered villain punches a hole through the

head of a zombie creating a bloody tunnel between the front and the back of the ghoul's skull that the camera perilously zooms through. The following shot shows the gruesome aftermath of this exaggerated violence with hilarious irreverence: the zombie's eyeballs have been glued to the villain's hand by the sheer force of the blow.

Such audacity continued in *Battlefield Baseball*, a bizarre zombie/baseball movie hybrid about a game to the death (and beyond) between two league teams. It starred *Versus*'s hero Tak Sakaguchi as an expert player called on to help a high school team defeat their ghoulish adversaries. Directed by Yudai Yamiguchi - the writer of *Versus* - *Battlefield Baseball*'s outrageous horror-comedy cannily combined two of Japanese pop culture's great loves: the living dead and baseball. In terms of genre blending, though, *Battlefield Baseball* couldn't even start to compete with the wackiness of Takashi Miike's *The Happiness of the Katakuris* (*Katakuri-ke no kôfuku*, 2000). Hailed by critics as a cross between *Night of the Living Dead* and *The Sound of Music*, Miike's film was a high camp combination of thriller, family melodrama, horror movie and karaoke musical with a (sadly brief) scene in which zombies return from the grave for an impromptu song and dance number.

While Japanese cinema frequently used the success of the *Resident Evil* games as a jumping off point for unrelated zombie action, one Hong Kong movie was far more inventive. In *Bio-Zombie*, Hong Kong director Wilson Yip produced a witty homage to Romero and a forthright parody of the influence of videogames. Set in a suburban shopping mall, *Bio-Zombie* stars two loudmouthed VCD pirates, Woody Invincible (Jordan Chan) and Crazy Bee (Sam Lee), who get mixed up with an Iraqi biological weapon stored inside a Lucozade bottle. After the virus is accidentally unleashed, various members of the shopping mall community are transformed into zombies. Trapped inside this neon-lit prison of consumer goods, noodle bars and bootleg movie stores by the ghouls, Bee and Invincible join forces with the local beauty salon girls (Angela Tong and Tara Jayne) in a desperate escape attempt.

Making explicit references to the link between the living dead and videogames, *Bio-Zombie* includes a scene in which Bee, faced by the zombies, has a sudden flashback to his hours of playing the arcade machine *The House of the Dead* - a popular game that allowed players to blast on-screen zombies with a plastic light-gun. Reliving his past glory in the video arcade, Bee has a flash of inspiration and realises that the best policy is to shoot the marauding ghouls in the head. Such knowing nods to the gaming world crop up again in a later tongue-in-cheek scene which stops the action in mid-flow as the principal characters' attributes, statistics and fighting abilities are flashed up on-screen as if they were no more real than the virtual stars of a videogame adventure. Such witty insouciance even extends to the film's loving Romero references, which encompass everything from the mall setting to Bee's blink-and-you'll-miss-it imitation of Scott H. Reiniger's escalator slide in *Dawn of the Dead*.

Lampooning the genre and its digital offspring, *Bio-Zombie* is one of the funniest horror comedies of the 1990s, a madcap adventure that blends the slacker ethos of Kevin Smith's indie cult favourite *Clerks* with Romero's apocalyptic vision. Invincible and Bee are an unlikely pair of heroes, who're more interested in watching *Titanic* for the umpteenth time and trying their luck with the salon girls than saving Hong Kong. Their foul-mouthed, cowardly antics in the face of the end of the world take Romero's obsession with bickering characters to a ludicrous extreme. *Bio-Zombie* perfectly fuses the throwaway mentality of Asian zombie movies with the fast-paced action of video arcade games like *The House of the Dead* and the claustrophobic terror of the *Resident Evil* series. An unofficial - and completely unrelated sequel - called *Bio Cops* (orig. *Sheng hua te jing zhi sang shi ren wu*, 2000) followed much the same screwball tradition.

top left and above:
Petrified Fortune Corpse: two scenes from Wilson Yip's slapstick **Bio-Zombie**.

V. Big Budget Ghouls

Since Hollywood likes nothing better than success, the announcement of an adaptation of *Resident Evil* came as no real surprise. The box office bonanza that had followed in the wake of *Lara Croft: Tomb Raider* (2001), starring actress Angelina Jolie as a live action version of digitally over-endowed heroine Lara Croft, meant that the time was ripe for videogame adaptations. *Tomb Raider*'s success had wiped the awful memory of *Super Mario Bros.* (1993) from most industry insiders' minds and challenged the conventional wisdom that movie tie-ins of videogames were the kiss of death. It was hardly surprising, then, that *Resident Evil* became the next videogame cherry-picked for blockbuster treatment, with none other than George Romero signed up to write and direct.

On paper, the Pittsburgh director looked like the perfect choice. There was, after all, a certain karmic value in hiring to Romero, not least of all because the videogames had cribbed so much of their visual style and sense of apocalyptic foreboding from his trilogy. Asking the filmmaker to step up to bat on the *Resident Evil* movie would neatly close the circle on the self-cannibalising flow between the game world and the cinema. It would also give the film a branding that horror fans would instantly recognise.

That, at least, is what the suits at Capcom must have been thinking in 1995 when they approached Romero with a lucrative offer to shoot a $1 million commercial publicising the release of the second game in the *Resident Evil* series. The sense of anticipation among zombie fans was high and as soon as the sixty-second commercial aired on primetime Japanese television, it was widely circulated in bootleg copies. It prompted many to predict that it would pave the way for Romero's rumoured directorial assignment on the movie itself. After years without making a zombie flick, it seemed that the master was about to return to his beloved genre.

In retrospect, such hopes were spectacularly out-of-touch with the reality of the *Resident Evil* phenomenon. While few commentators noticed it at the time, the *Resident Evil* games had succeeded in taking zombies out of the horror margins and into the mainstream. Capcom's $600 million smash hit videogame franchise - more profitable than most zombie movie releases put together - achieved something that nothing else had ever managed: it made Romero's zombies into A-list stars. The living dead might never have had the luck to headline a hugely profitable blockbuster *movie*, but in the increasingly convergent world of videogames they were enjoying the equivalent kind of success.

From Capcom's perspective, giving Romero a $35 million budget and creative control over such a lucrative franchise would have been commercial suicide. Lacking the temperament, vision or willingness to capitulate to the demands of studio-financed, formulaic movie-making, Romero was hardly the most suitable candidate for the job. Here was a director who had never had a *bona fide* mainstream hit, who worked outside of the Hollywood system while vocally complaining about "The McDonaldization of America", and whose radical-leaning films frequently criticised the dominant patriarchal, consumerist order. Worst of all, he didn't even like videogames.[202]

In the beginning, such considerations didn't occur to either Capcom or the German production company, Constantin Films, who were overseeing the project. Attached as writer-director in 1995, Romero turned in his first draft of the script in the early spring of the following year only to be met with complete disapproval. All too predictably, his script was considered far too gory and thus quite unsuitable for the censor-friendly approach that Capcom were aiming for.

In the past, Romero had made a name for himself as a director who was willing to circumvent the MPAA's certification system in order to stay true to his vision (both *Dawn* and *Day of the Dead* had been released "unrated" rather than with an "X" certificate). On *Resident Evil*, the demands of the budget and the studio financiers meant that such a refusal to compromise would be inconceivable. As far as Capcom were concerned, the film had to gain an "R - Restricted" rating for its US release (and an equivalent 15 certificate in the UK) in order to be financial viable. This was territory that Romero was ill suited to and, as a result, his hopes of taking *Resident Evil* from console to cinema were prematurely dashed. Capcom may have been willing to borrow ideas from the master, but the traffic between the margins and the mainstream flowed strictly one way.

News of Romero's departure from the project was met with a howl of protest from hardcore horror fans.[203] As one angry reader claimed on the letters page of *Fangoria* magazine, Romero's experience was symptomatic of a much wider issue, the general decline of American horror since the 1980s:

> It seems that no horror film can be released in this country without being watered down. Another good example would be the *Resident Evil* movie, which began as a potentially kick-ass zombie flick and, after ditching George Romero's script due to its graphic nature, is now destined to be a horrid piece of shit. Studios seem to be making horror films for people who don't usually like horror films. Instead of movies like *Hellraiser* and *Evil Dead*, they are making horror films for teenage girls, like *Valentine*, and "thrillers," a term which is slowly becoming a euphemism for "boring crap," such as *What Lies Beneath*.[204]

Milla Jovovich besieged by zombies in **Resident Evil.**

As "Camcorder Coppolas" like Bookwalter and Sheets had complained years previously, the Hollywood horror movie had moved so far towards the mainstream that it was no longer effectively scary. The slew of jokey, self-reflexive sequel-driven horror movies initiated by Wes Craven's *Scream* (1996) was killing the genre in the eyes of many fans by encouraging the production of watered-down films that were overly formulaic, teen-focussed and frequently more interested in comedy rather than horror.[205] The tradition of low-budget films like *The Texas Chain Saw Massacre*, *The Last House on the Left* and *Dawn of the Dead* had given way to the dominance of ratings-friendly, mainstream-orientated *product* that was almost completely devoid of guts (both literally and metaphorically). Germany-based Constantin Films may not have been a Hollywood company, but they were eager to ape the American industry. The chances of *Resident Evil* being a meaty horror movie looked quite bleak.

Advance word from the set of *Resident Evil* did little to allay such fears. Firstly, George Sluizer - the writer-director of the Dutch thriller *The Vanishing* (orig. *Spoorloos*, 1988) and its Hollywood remake *The Vanishing* (1993) - was hastily hired then almost as hastily fired after his script was deemed well below par. Increasingly anxious about the fate of their multimillion-dollar property, Capcom then turned to British director Paul W.S. Anderson, whose CV boasted the only commercially successful videogame adaptation in cinema history - *Mortal Kombat* (1995). An avid fan of videogames in general, and *Resident Evil* in particular, Anderson seemed to be the perfect candidate for the project. His script was approved and shooting began in Berlin in March 2001.[206]

In an interview a few months later, Anderson explained why his film was designed to sidestep the gore in favour of capturing a wider, more mainstream audience:

> You can't do today what filmmakers were doing twenty-five years ago. Then, extreme splatter movies like *Dawn of the Dead* and Lucio Fulci's *Zombi* [sic] were everywhere, and gore was the *modus operandi* of the times. To be scary, rather than just gross, I knew we had to be radical with our conception of the undead. I watched every zombie film again before starting this and noticed how dated they all looked [...] It's too easy to gross people out on a splatter level and far harder to scare them senseless. I made a deliberate choice in the script to be frightening rather than visceral - showing everything covered in blood or the usual Italian style exploitation and cannibalism is now such a dated and hokey approach. Ensuring things are shadowy and tension-filled is the best way to keep audiences shrieking and their nerves jangling. That's why I decided to direct the film after initially only wanting to write and produce it. I didn't trust anyone else to pull that chill-laden atmosphere off.[207]

Regardless of the director's accomplished PR spin, this was a decision that was clearly motivated by fiscal rather than aesthetic considerations. The gore-lite approach would ensure that the core audience of game playing teenagers (the 13- to 16-year-old demographic) wouldn't be alienated. The fact that the accountants at Capcom were more concerned with balancing the spreadsheet than making a visceral horror movie came as no surprise to anyone - which simply made Anderson's convoluted explanations of his artistic intent rather redundant. In a final ironic twist to the affair, the film was released in the UK with a 15 certificate while the original videogame carried an 18 certificate for its scenes of pixelated gore.[208]

All in all, it was a bizarre situation. The *Resident Evil* movie was the first big-budget, mainstream zombie production in seventy years, but it was apparently ashamed of its heritage and was directed by a filmmaker desperate to distance his work from the splatterfests of Romero, Fulci and others - the very films that the videogame's creator cited as his chief source of inspiration. Unsurprisingly, the resulting film was fairly unthreatening - significantly, it proved more interested in dubious CGI monsters than zombies. With one eye always fixed on the box office, the creators of the *Resident Evil* movie even had the cheek to prime their audience for a sequel before the film's turgid one hundred and one minutes had played themselves out. The genre that had always been derided for being marginal and a little rough around the edges had suddenly been repackaged as big-budget, mainstream entertainment. A great deal was lost in translation.

Rarely straying from the realms of videogame fantasy, the *Resident Evil* movie simply ignores Romero, Fulci and others more often than borrowing from them. Even when Anderson makes his indebtedness explicit, the result is strangely unsatisfying: towards the end of the film a discarded newspaper bears the headline "The Dead Walk!" a cheeky but pointless nod to a similar headline in the Florida opening of Romero's *Day of the Dead*. Such intertextuality does little more than create a hall of mirrors in which the film of the game of the films recedes ever further away from us. To add to the confusion, the *Resident Evil* movie wasn't simply an adaptation of the best-selling videogame but a live action *prequel* to that digital narrative, depicting the events leading up to the transformation of Raccoon City from ordinary American town to living dead necropolis.

Resident Evil begins as Alice (Milla Jovovich) wakes up inside a deserted mansion with no idea of who she is or how she got there. Piecing together her identity, the amnesiac slowly realises that she is an employee of Umbrella, a shadowy multinational corporation that has been researching bio-chemical weapons in an underground laboratory - known as "The Hive" - hidden beneath the mansion. After an accident involving a vial containing a deadly new virus, the complex has been contaminated and the scientists have become rabid, flesh-hungry zombies.

Before Alice can remember her own part in the catastrophic events and her decision to blow the whistle on the corporation's dubious research programme, a military squad charged with re-securing the lab arrives and takes her into custody. As events unfold, the team is trapped in the complex by the facility's computer, The Red Queen (one of a series of redundant *Alice in Wonderland* references). Surrounded on all sides by zombies as the facility enters its self-destruct sequence, the living face an against-the-clock battle to locate the anti-virus serum and escape The Hive before it explodes.

Designed with all the linear logic of the videogame that inspired it, the *Resident Evil* movie is a completely formulaic adventure in which characters progress from level to level by overcoming various obstacles. References to the film's digital inspiration are rife. At several points during the action a map of the facility flashes up on-screen showing our heroes' progress; in other sequences Anderson makes explicit nods to the *Resident Evil* game itself as zombified Doberman Pinschers pursue Milla Jovovich through the labs and the spectacular finale features The Licker, a mutant CGI zombie monster, in an echo of the traditional videogame "Boss Battle". Other nods prove more esoteric, such as the conversation about "The Nemesis Project" between the scientists who rescue the survivors from the lab (avid gamers will recall that Nemesis is an intelligent super zombie mutated from the original viral strain).

Judging by the prevalence of references to the film's digital forbearer, it seems that the aim is to appeal to videogamers first, moviegoers second. That at least explains why *Resident Evil* fails so spectacularly as a horror movie. Unable to combine its videogame plotting with the requisite sense of menace needed to make its setup scary, Anderson's film lacks even the shock value of its pixelated counterpart. Predominantly skimping on the gore, the film delivers only a handful of tense set pieces. The best of these is a scene where The Red Queen locks the military team in a corridor as she unleashes a series of laser beams that slice 'n' dice them to bloody bits. It's typical of the writer-director's magpie-like approach that this sequence is lifted straight from Vincenzo Natali's sci-fi horror *Cube* (1997). Ultimately however, it's the amount of attention given to The Licker that makes Anderson's intentions clear. More interested in this CGI creation than any of the lo-fi zombies dotted around the lab, Anderson manages to make *Resident Evil* a zombie movie purely by dint of its heritage, not its action.

Part of the reason why *Resident Evil* seems to be such a blatantly mechanical piece of franchise-focussed filmmaking is because of its transparent obsession with demographics. Firmly setting its sights on a core audience of teenage gamers, the film is indicative of the blockbuster mentality that sacrifices innovation for familiarity. The movie plays like a giant prequel to the games themselves (or perhaps, it could be described as an extended videogame "cut scene" in which the player passively watches story exposition before being launched into the interactive action). Had Anderson wanted to make a true horror movie, he might have done better to start the story where the film ends, with Alice waking up in Raccoon City to find that the zombies are loose and the dawn of the dead has begun. Given all this, it appears that the most incisive critical commentary on the film is to be found in Milla Jovovich's throwaway comments to *Total Film* magazine: "We've got really infantile mentalities on this movie. We're like: 'It's gross - cool! It's disgusting - print it!' You have to think like a fifteen-year-old. Wet dress. Zombies. Guns. Cool!"[209] After seventy years of languishing on the horror margins, the zombie had finally been dragged into the mainstream by a blockbuster movie that was as soulless as a walking corpse.

By the time the critically derided sequel *Resident Evil: Apocalypse* (2004) arrived, it was obvious just how far Anderson (now serving as writer-producer) and neophyte director Alexander Witt had strayed from the basic zombie mythology outlined in Romero's trilogy. Only interested in satisfying the most primitive demands of its teen audience demographic, *Apocalypse* relegates its zombies to a strictly secondary position in the storyline as they're turned into little more than cannon fodder.

Taking place immediately after the events of the original film, *Apocalypse* is pitched at audiences who have more than a passing knowledge of the videogame mythology. It employs several of the game's more distinctive characters including heroine Jill Valentine

VI. Rebirth of the Dead

Whatever criticism one might want to level against the first *Resident Evil* movie, it had an undeniably positive effect on the zombie's fortunes. Dragged into the mainstream by the videogame franchise and Anderson's blockbuster adaptation, the living dead suddenly achieved a degree of respectability they'd never had before. It was as if, after seventy odd years of being ignored, they'd finally received their invite to the Hollywood party.

Within mere weeks of *Resident Evil*'s opening came a series of press releases and announcements suggesting that the zombie had finally broken free of its marginal roots: a remake of *Dawn of the Dead* had received the green-light, a big screen adaptation of arcade game *The House of the Dead* was going into production; and, perhaps most exciting of all, George Romero announced at *Fangoria*'s Weekend of Horrors Convention in August 2002 that he was in serious talks with Twentieth Century Fox to complete the fourth and final instalment of his "trilogy" - provisionally dubbed "Land of the Dead" - with a $10 million budget and a planned R-rated release.

The most cheering sign of the zombie's return to cinematic health was actually something far more concrete than Romero's oft-announced plans for a new instalment in the series; it was the gradual - indeed almost imperceptible - invasion of the living dead that was occurring. Zombies were everywhere, from UK television adverts for the new Mini Cooper car to multimillion-dollar American studio pictures. Gore Verbinski's *Pirates of the Caribbean: The Curse of the Black Pearl* (2003) starred a ragbag collection of ghostly zombie buccaneers led by Geoffrey Rush who were clearly indebted to the aquatic ghouls of *Zombies of Mora Tau* and *The Fog*. In the equally mainstream *The Haunted Mansion* (2003), Eddie Murphy proved that the spirit of Mantan Moreland lived on, facing a group of fugitives from the undertaker with some cowardly comic mugging and only a quick-witted wisecrack for defence: "Get back in your beds man".

Perhaps the greatest proof of the zombie's newfound acceptability was their appearance in the biggest blockbuster of the new millennium. In *The Return of the King* (2003), the final film in the *Lord of the Rings* series, the heroes raise a zombie army from The Paths of the Dead and lead them into battle against the forces of Mordor. Credit may have been due to J.R.R. Tolkien's original novels, but it was fitting that director Peter Jackson got the chance to return to his living dead roots even in the midst of making a $300 million blockbuster trilogy.

All in all, it seemed that there was no keeping a good corpse down. This suspicion was reinforced by the appearance of a crossover hit that managed to achieve mainstream success without compromising the genre's chief concerns, Danny Boyle's *28 Days Later* (2002). While the ghostly corpses of *Pirates of the Caribbean* and

(played in the flesh by Sienna Guillory) and the mutant zombie Nemesis (played by a stunt man in a Herman Munster rubber suit). As the Umbrella Corporation evacuates Raccoon City, Valentine and Alice are stranded in the zombie-infested city and are compelled to save the daughter of one of the scientists responsible for the outbreak of the T-Virus in order to gain their freedom.

The videogame credentials are more than just pop culture references; they've become the driving force behind the narrative itself. Mutated by her exposure to the T-Virus, Alice is now a superhuman heroine - much like Ripley in *Alien Resurrection* (1997) - who's able to sprint down the sides of skyscrapers and crash motorbikes through stained glass church windows without incurring a single scratch. Then Nemesis - a hulking oversized brute armed with a shoulder-mounted rocket launcher - appears and the film topples into outright ridiculousness. In the videogame *Resident Evil: Nemesis* this bulky ghoul was an unstoppable boss whose appearance generally resulted in the player either dying or running frantically for their life. On-screen, his unlikely proportions have something of the risible about them - so much so that his appearance is likely to have non-gaming members of the audience hooting with derision even before he growls his throaty "S.T.A.R.S.!" catchphrase.

above: Zombie dogs on the loose in **Resident Evil: Apocalypse**.
top: Fiendish Umbrella scientist (Iain Glen) in **Resident Evil: Apocalypse**.

The Return of the King were far removed from the visceral flesh-eating ghouls of a thousand low-budget pictures, Boyle's film was the real deal. As the first British zombie movie in years (albeit one that was eased into life with the help of American finance), the critical and commercial success of *28 Days Later* signalled that the genre had entered a new phase. Phenomenally popular with audiences on both sides of the Atlantic (though particularly in America, where the addition of an alternative, darker ending helped its kudos among horror fans) it was hailed as the first visceral *and* intelligent zombie movie in recent memory.

Shot cheaply and quickly on digital video, *28 Days Later* was really a guerrilla film masquerading as a studio movie. It was a compromise that not only highlighted the zombie's newfound position as both mainstream and marginal, but also helped Boyle convince the suits at Twentieth Century Fox to push ahead with the film despite its lack of known actors. Needing relatively little box office action to cover its $8 million budget, the film looked like a fairly safe gamble to Fox's accountants.

Curiously, the involvement of a major studio prompted Boyle to be somewhat circumspect about the film's genre lineage. He explicitly distanced himself from horror cinema in general and the z-word in particular. "I suppose my trepidation [about calling it a horror movie] while we were making it was partly to do with how Fox was planning to market it. Are they going to turn this into a mainstream cult film for zombie fans?" the director mused in an interview with *Fangoria* magazine.[210] His fears seemed fair enough, but they did lead to some rather ridiculous comments as he tied himself up in semantic knots in his attempt to disown the film's heritage:

> I don't see *28 Days Later* as part of some zombie lineage. Zombie films are an entertaining part of the horror genre, but they are rooted in nuclear paranoia. Zombie addicts have another theory. They say it has to do with the shooting of Kennedy because you can only kill zombies by shooting them in the head. I don't really buy into that, but I can see the connection with nuclear power and what it will do to us - that whole "living dead" thing. Those fears aren't so relevant anymore, but the idea of a psychological virus is fascinating.[211]

Eager not to associate his monsters with the mixed fortunes of the zombie genre, Boyle instead makes his ghouls reminiscent of the infected civilians of Romero's *The Crazies* or Rollin's *The Grapes of Death*. His raging sub-humans aren't zombies per se, but unfortunate victims of a plague that starts after an over-zealous group of animal rights activists accidentally release a man-made virus from a research laboratory in the pre-credits sequence. Tapping into millennial fears about biological warfare, chemical attacks and viral outbreaks, *28 Days Later* proved the perfect index of the western world's post-9/11 apocalyptic anxieties. The fact that film's release coincided with the SARS panic seemed less like serendipity than proof of how well it had plugged into the zeitgeist.

Twenty-eight days after the virus is unleashed bike courier Jim (Cillian Murphy) wakes from a coma in an empty London hospital. Wandering outside, he discovers that the capital has become a ghost city. Walking through the streets, past overturned buses, looted shops and deserted tourist sites (the digital photography gives the looming spire of Big Ben an eerie presence), Jim eventually runs into a handful of survivors who are doing their best to avoid the "infected" - raging, fast-moving, highly contagious maniacs who have been transformed by the virus into a cross between rabid epileptics and psychotic Ebola carriers. It turns out that the city has become a giant hot zone and, as a snatch of graffiti sprayed onto a wall so eloquently puts it, "THE END IS EXTREMELY FUCKING NIGH". Banding together with fellow survivors Selena (Naomie Harris), cab driver Frank (Brendan Gleeson) and his daughter Hannah (Megan Burns), Jim makes his way north along the empty M1 motorway in search of military protection from the roaming bands of viral victims.

An apocalyptic fantasy in the characteristically British vein of H.G. Wells, John Wyndham or J.G. Ballard, *28 Days Later* is a masterful, sinewy little horror film. Unlike *Resident Evil* it's not ashamed of its zombies, whatever Boyle's personal hang-ups about the z-word itself might suggest. Frantic and furious, the film's infected are terrifying, highly-contagious creatures with a

habit of puking up their tainted blood over the living as the virus causes their internal organs to go into meltdown.

Boldly updating the zombie genre for the new millennium, Boyle and novelist-turned-screenwriter Alex Garland present us with an apocalypse that, they claim, is a reflection of our increasingly stressful social interactions. "It started with road rage and cars, but now every inner-city hospital has to have security guards," explained Boyle. "Air rage, parking rage, trolley rage in the supermarkets. [We thought] what if we could employ *that* as the element that constitutes the zombies?"[212]

Employing the infected as a metaphor for the breakdown of the social structures governing our behaviour towards one another, the film suggests that anger - "rage" itself - has become the defining emotional response in late capitalist societies:

> Some people have a theory that it's democracy that does it - that people are waking up to the fact that democracy tells you all the time, "You have a vote, you are important," but the truth is you're not. Other people say it's actually a direct result of Thatcher. She said, "There's no such thing as society, let's empower the individual," but the truth is we are completely irrelevant. These moments of rage happen when people are not treated properly. I remember seeing this CCTV clip of a woman with parking rage. She was so furious that someone else was going for the same parking space that she repeatedly hammered her car into the other vehicle. The truth is this sort of thing is happening more and more. It's not some abstract monster, the monster is in all of us. We are all capable of flying into a violent rage.[213]

With its murky digital cinematography mimicking the grainy *vérité* of the ubiquitous inner-city CCTV camera, *28 Days Later* questions where we are heading with brutal honesty. Turning the contemporary urban landscape into a vision of hell that owes as much to Hieronymus Bosch as Romero, the film presents us with a stark vision of social breakdown in which the infected are implacable automatons, consumed from within by the destructiveness of their own rage. It makes for a startlingly efficient comment on all that's wrong with contemporary western society. "It's a new kind of intolerance," is how Boyle describes the growing tide of rage. "It's not based on the usual factors that cause violence like race, religion or gender. It's a social rage that doesn't have boundaries defining it."[214]

Even when the survivors think they've found safety with a military squad led by Major West (Christopher Eccleston), they quickly find themselves in more danger than before. The pent up frustration of the all-male group soon explodes into violent rage as the squaddies decide to let off some steam by turning the women into unwilling concubines. Not even Jim, the film's nominal hero, is above such base human emotions. His own regression into savagery in the film's fraught climax suggests that the virus is in some ways already a part of all of us. Appearing before Selena covered in mud and blood after his own inner rage has led him to butcher the squad of soldiers, the film raises the very real (but sadly ignored) possibility that he might be mistaken for "one of them" and struck down by the woman he's just fought so hard to save.

Such a bleak ending would certainly have been preferable - and more in keeping with the film's grim view of the state we're in - to the one that was shown to British audiences. After depicting The End Of The World As We Know It with stark fatalism, the UK version delivered a ludicrously optimistic conclusion in which the survivors discover that the infection never actually spread beyond the British Isles. Retreating to an isolated farmhouse and flagging down a passing airplane with the help of a homemade banner, they eventually get to live happily ever after. It smacked of studio interference.

While *28 Days Later* met with unprecedented success, the tradition of low-budget zombie horror continued apace with early millennial entries across the world. Twins Michael and Peter Spierig's knockabout Raimi-Jackson rip-off *Undead* (2003) featured a story about an Australian town invaded by aliens who turn the inhabitants into zombies. Fighting the hordes is an outback survivalist who's watched one too many John Woo movies (Mungo McKay) and an assorted band of hysterical nobodies who don't get killed off quickly enough. The ending delivers a strange cross between *Night of the Living Dead* and *Close Encounters of the Third Kind*, but it's not enough to save this derivative effort from being just another apocalyptic zombie movie that overplays the stylistic flourishes without offering anything particularly new or interesting.

Dead and loving it: one of the ghouls from Australian entry **Undead** smirks it up.

At least it was a few steps up from Uwe Boll's truly awful *House of the Dead* (2003) - an effort about dumb kids on a haunted island populated by zombies - that succeeded in being even less interesting to watch than the shoot-'em-up arcade game it was based on, and which it relentlessly referenced by lazily inserting in-game footage into the midst of the live action. The script was co-written by Dave Parker, the auteur behind the enjoyably hokey *The Dead Hate the Living!* (1999). He was obviously having an off day.

Meanwhile, in Canada, Elza Kephart was providing a welcome shot in the arm for zombie fans everywhere with the hilariously bizarre *Graveyard Alive* (2003), an irreverent black and white addition to the zombie canon in which ugly nurse Patsy (Anne Day-Jones) finds a new lease of life after being zombified. With newfound sex appeal this walking corpse becomes the ward's new hottie. With the rider "A Zombie Nurse in Love," *Graveyard Alive* mischievously merged the melodrama of TV soap operas with reanimated corpses and lots of off-the-wall humour. The same camp comedy cropped up in *Dead & Breakfast* (2004), a likeable low-budget ghoul outing with an army of redneck zombies and some funny one-liners. Elsewhere, postmodern efforts like Spain's *Una de zombis* (2003) and The Czech Republic's *Choking Hazard* (2004), struck distinctively different paths with stories that don't so much wink at the audience as develop relentless facial tics.

The title of Miguel Ángel Lamata's Spanish comedy-horror effectively translates as "A Film About Zombies", yet that barely scratches the surface of its appeal. If Tarantino ever made a zombie movie the result might be something like this *Pulp Fiction*-esque blend of narrative game playing and ghoulish off-the-wall humour in which a Goth shock jock (co-writer Miguel Ángel Aparicio) ditches his radio station to make the eponymous movie about zombies with the help of a fanboy mate. They end up in all kinds of trouble as the line between script and reality begins to blur and Satanic zombies roam the city at the behest of an underachieving villain whose aim is to conquer the world "a little bit at a time".

Achingly hip and brimming over with inventive energy, it bears some resemblance to cult Spanish director Alex de la Iglesia's films - *Acción Mutante* (1993) or *The Day of the Beast* (1995) - yet possesses a manic glee that's all its own. Memorable moments include a coke-snorting cat, a great gag about "Cannibal Remorse" - an existential sequel to *Cannibal Holocaust* - and various mindbending narrative slips as the story fractures and folds in on itself. It threatens to become tiresome - and to be honest it eventually does - but there's no mistaking its energetic enthusiasm.

The same was true of Czech director Marek Dobes's *Choking Hazard*, an equally ironic and self-reflexive attempt to rejuvenate the tired old zombie formula. Here a bunch of philosophy students retire to an isolated hotel to discover the meaning of life with the help of a blind seminar guru (Jaroslav Dusek). A Jehovah's Witness pornstar gatecrashes the event, quickly followed by a horde of woodsmen zombies (dubbed "woombies") who appear out of nowhere dressed in black overcoats and hats to chomp on the living. There's no explanation for the chaos, just lots of gore, a string of silly jokes (including electrocuted zombies breakdancing in a pool of water) and a bizarre attempt to blend philosophy and the zombie apocalypse. The meaning of life we eventually learn is the balance of reason and instinct - the latter represented by the zombies themselves, of course. Despite running out of steam early on, its insouciance very nearly makes up for its faults.

Strangely enough, though, it was another British production that proved to be the most successful reworking of the living dead. If *28 Days Later* was a British production that played Hollywood at its own game, *Shaun of the Dead* (2004) was a very different kind of zombie film, an unabashedly low-key and overtly comic Brit flick. Billed as "a romantic comedy, with zombies," *Shaun* proved as parochial as *28 Days Later* was ambitious, featuring a host of living dead in-jokes, plenty of riffs on twenty-first century England and a neat awareness of the impact of the *Resident Evil* videogame on the zombie's changing fortunes.

Straight from the twisted imaginations of the slacker geniuses responsible for late 1990s Channel 4 sitcom *Spaced*, *Shaun of the Dead* is a quintessentially British tribute to Romero. Co-written by director Edgar Wright with star Simon Pegg, it's the story of a hapless twenty-nine-year-old shop worker named Shaun (Pegg), whose life is thrown into turmoil when his girlfriend Liz (Kate Ashfield) dumps him. Simultaneously, an American deep space probe unexpectedly crashes to Earth unleashing a wave of radioactivity that turns the population of North London into zombies. It never rains…

Faced with an impending zombie apocalypse, Shaun and his stoner mate Ed (Nick Frost) battle the living dead ghouls, rescue Liz and save Shaun's mum Barbara (Penelope Wilton) - prompting Shaun to shout "We're coming to get you Barbara" in a fanboy nod to *Night of*

Death Actually: no contemporary British movie would be complete without Bill Nighy. Here he gets his hands dirty in **Shaun of the Dead** as Shaun's step-dad Philip.

the Living Dead. Of course, this being merry ol' England, shotguns and shopping malls are in annoyingly short supply which means Shaun and Ed must fend off the zombies by throwing Dire Straits albums and pizza boxes at them, whacking them with spades and cricket bats and eventually taking refuge in the local pub.

The offbeat premise of this "zom-rom-com" was familiar to fans of *Spaced*. Back in 1999, an early episode of the sitcom saw its slacker hero (Pegg) dreaming that he was stuck in a live action version of the *Resident Evil* game after a heavy night of speed snorting and videogaming. In *Shaun*, the ghouls are real rather than just a figment of the hero's frazzled imagination. Blending zombie mythology with British suburban life, Pegg and Wright carefully sketch a twenty-something male slacker lifestyle dominated by PlayStations, spliffs and pints of lager, then set the living dead loose in it.

The chief joke is that everyone's so "spaced" by the dreary dullness of life in Britain that they don't notice the zombies' arrival. Shaun's job as a sales assistant in retailers Foree Electrics (a reference to *Dawn*'s leading man) is so crushingly soul-destroying that he fails to spot the tell-tale signs of the coming apocalypse and mistakes the zombies for listless commuters. In one of the film's funniest sequences, he wanders down to the local newsagents on the morning of the dawn of the dead and is so crippled with a hangover from the previous night's boozing that he's completely oblivious to the chaos around him. "Sorry mate, haven't got any spare change," he mutters to a ghoul he mistakes for a homeless beggar.

"Much of the film is about the way city people conduct their lives and ignore each other and ignore other people," Pegg explains. "In London you can walk past someone who's dying in the street and just step over them - in some respects that's one of the things the zombies represent."[215] For Wright, the movie satirises our attitude towards the rest of the world:

> One of the inspirations for the script was that during the foot and mouth crisis I didn't read a paper for about two weeks and felt utterly stupid when I was watching the TV and saw footage of burning cows. I had to ask somebody what exactly foot and mouth was. A lot of people walk around in their own little bubble of their own problems and don't see wider things going on.[216]

Shuffling, lumbering brutes, the suburban living dead of *Shaun* are the complete opposite of Boyle's raging commuters - something the film half-acknowledges with a gag in which a TV news report dismisses claims that the outbreak is attributed to "Rage infected monkeys". Pegg and Wright were adamant in their decision to stay true to Romero's original trilogy and its painfully slow-moving monsters:

> The zombies [in *Shaun of the Dead*] are very slow and almost inept and shambolic. They're without motive or moral rage. There's something kind of inexorable about it. They are death and they will get you in the end. We could all be in a room now with one and quite happily walk round and round the room and he'd never get you because he'd just be stumbling along. But eventually you'd have to go to sleep and when you did, he'd eat you. There's just something really eerie about that.[217]

Even though they followed in the master's footsteps, Pegg and Wright were still worried that Romero might not approve of their cheeky spoof. After sending an advance copy of the film to the States for his blessing, they waited with baited breath for a response:

> We were given his phone number. We basically called up the man who invented the contemporary movie zombie movie and he really, really enjoyed it! I was waffling on like a fanboy going "I'm sorry that the zombies in our film reanimate straight away while, of course, in your films it takes about half an hour". And he said: "Simon, you know what? I don't mind."[218]

For the actor, who'd spent his twenties watching *Dawn of the Dead* and battling walking corpses in the *Resident Evil* game, Romero's praise was the icing on his ghoulish cake: "It's amazing, because daddy approves! What more do you need? Everything else is just a footnote."[219]

Shaun of the Dead builds to a standoff between the survivors and the zombies in a local pub called The Winchester, which has a still-functioning Winchester rifle hanging over the bar. In a nice little touch, shooting the ghouls evokes memories of Shaun and Ed's videogaming sessions: "Reload!" Top Left! Nice Shot!" While it doesn't have the big-budget gloss of Paul W.S. Anderson's *Resident Evil*, *Shaun* has far more to say about the way in which the PlayStation demographic of twenty-something males has helped revive the zombie as an iconic pop culture figure. Pegg, an avid gamer himself, was adamant in his belief that the 1990s cycle of zombie videogames fuelled the movie boom:

> I'd say *Resident Evil* [the game, not the movie] is directly responsible for the renaissance in zombie films at the moment. It was a Japanese game but somehow they entirely captured the spirit of the Romero movies and they captured the creepiness of those very slow-moving lumbering zombies. People had forgotten the sheer creepy potential of those movie beasts.[220]

"When there's no more room in hell, the dead will walk the Earth," solemnly intoned the tagline of *Dawn of the Dead*. By the spring of 2004 it looked as though it might soon be necessary to add a postscript: "And when there's no more originality in Hollywood, lazy producers will remake anything that moves for a quick buck". As news broke that Romero's seminal classic was being remade by director Zack Snyder, fans everywhere groaned in unison.

An unnecessary rehash of a landmark genre film, the remake of *Dawn of the Dead* was forced into production without Romero's artistic blessing: "I'm not delighted that it's happening," claimed the Pittsburgh filmmaker in an interview with *Rue Morgue* magazine just before the film's release: "I don't have anything against it, I just thought it wasn't a very good idea".[221] Somewhat ironically, it seemed as though Romero's nihilistic vision of a consumer society forced to cannibalise itself in order to satisfy its never-ending greed had finally come full circle. Taking nothing but the basic pitch of the original - an unexplained plague causes the dead to return to life and eat the living, leaving a

handful of survivors to hole up in an empty shopping mall - the remake completely dispensed with the original characters and plot, cynically keeping only the zombies and the dollar-spinning title.

From the very first moment the production was announced, diehard fans raged against the remake and all it stood for. When the film's trailer was screened at *Fangoria*'s January 2004 convention, magazine editor Tony Timpone found himself facing an angry crowd: "They booed. They hissed. They hated it."[222] According to screenwriter James Gunn, feelings among certain fans went to insane extremes: "I got death threats. I had people saying they wanted to shoot me, to kill me. I got long, rambling, schizophrenic letters sent to me through my managers. It was a trip [...] I know that I and a few of my friends loved *Dawn of the Dead*, but I did not know that there was this huge *Dead* underground out there."[223] To borrow the catchphrase from the screenwriter's *Scooby Doo* movies: zoinks!

With such negative audience expectation, the remake's producers were forced to get their PR machine rolling as quickly as possible to justify their apparent "sacrilege" to the fans: "Making a zombie movie in the high $20-million range is a risky proposition," explained producer Eric Newman after he sweet-talked Romero's collaborator Richard P. Rubinstein into signing over the rights. "But as far as the genre goes this is the biggest title."[224] As the release date neared, the filmmakers carefully reasserted their commitment to doing justice to Romero's vision:

> This is a *re-envisioning* of a classic. There was not, is not, a valid reason to "remake" *Dawn of the Dead*. That's not what we set out to do, not what any of us wanted. There are some amazing updates of some great films - I love Kaufman's *Invasion of the Body Snatchers*, Carpenter's *The Thing*, Cronenberg's *The Fly*. They're great movies that add to rather than diminish the original films. We really saw this as a chance to continue the zombie genre for a new audience.[225]

Although there was a certain symmetry to commercials director Zack Snyder stepping into the hot seat (Romero's own career had begun in the advertising industry) it seemed a clear indication to many fans that this project would be nothing more than a souped-up, braindead remake crafted to satisfy the restless "bigger-better-faster" tastes of a generation weaned on MTV.

In many ways, that's exactly what the finished film turned out to be. Except, it was also reverential of its source material, glossily effective and more breathlessly exciting than any American horror movie of the previous decade. In an age where big-budget Hollywood horror was becoming increasingly equated with popcorn fare such as *Ghost Ship* (2002), *Freddy Vs. Jason* (2003) or *Gothika* (2003), the new *Dawn* delivered a degree of edginess and balls-to-the-wall action that was refreshing to say the least.

Engaging the adrenal glands rather than the brain, Gunn's script amped up the splattery action of Romero's original while simultaneously excising its vast chunks of social commentary. We're left with an upgraded, streamlined thrill ride that races through the zombie apocalypse, getting its characters to the mall as quickly as possible. Our heroine is nurse Ana (Sarah Polley) who clocks off work, goes to bed and wakes to the dawn of the dead as a zombified moppet invades her bedroom and bites her husband's neck open. Within seconds, he's bled to death and is up on his feet as one of the film's fast-moving ghouls, a bunch of manic Linford Christies who are less walking than running dead.

As the city is infested by zombies, the social order quickly implodes and anarchy reigns. Joining fellow survivors - including ex-Marine police officer Kenneth (Ving Rhames), electronic salesman Michael (Jake Weber), street-thug turned family man Andre (Mekhi

Phifer) and his pregnant wife (Inna Korobkina) - Ana takes refuge in a suburban Wisconsin shopping mall while waiting for the military to come and rescue them. As the zombie horde grows in size and the televisions fall silent, it's apparent that the end of the world really is nigh.

"America always sorts its shit out," whispers C.J. (Michael Kelly), one of the mall's redneck security guards after watching news footage of army grunts shooting civilians in a desperate bid to contain the infection. It's a tantalising, throwaway line that this equally throwaway adrenaline-fest never makes much of. Lacking the satiric bite that made the original so powerful, Snyder's film shows little interest in the mall location as a comment on American consumerism, reducing the introspective lull in the middle of Romero's film into a brief montage of its inhabitants screwing, playing basketball and sharing a communal dinner - then racing headlong towards the next action sequence.

Although the incredibly yucky moment involving a zombie baby was brilliantly set up (notwithstanding the rather inevitable comparisons with Fulci's *Zombi 3*), it seemed that screenwriter James Gunn hadn't thrown off the influence of his apprenticeship at dumbed-down schlock merchants Troma Studios. Delivering plenty of splatter yet little else, this is Romero-lite. As the action in the final reel trundles towards an escape from the mall (complete with two customised buses that could have come straight out of *The A-Team*), one longs for meat to give the adrenalin bursts more context.

Something more relevant may have been struggling to get out. What are we to make of the title sequence's stock footage of civil unrest being suppressed by riot police around the world? Or the ironic use of Johnny Cash singing "The Man Comes Around" on the soundtrack? The lengthy Reality TV section in which the survivors watch news reports charting the escalating chaos on huge plasma screens in the mall's electrical goods store seems particularly poignant. Yet none of these things build towards anything in particular, just a vague sense of apocalyptic chaos and social breakdown.

As with so many American horror films, it's the tongue-in-cheek irony that eventually defuses the film's build up. When original cast member Tom Savini appears on television as a tough-talking redneck sheriff - "Somebody put another round in that woman over there, she's still twitching!" - the postmodern in-jokes threaten to turn the tension into giggles. It's something that's not helped by the appearance of Scott H. Reiniger as a gruff army general and Ken Foree's solemn televangelist who intones, "How do you think your God will judge you?". Rather than adding anything much to the production, such cameos simply seem *de rigueur* for any remake; the fact that Romero *doesn't* appear says more than the rest of them put together.

Gunn has claimed that his script was supposed to be "about human beings having their lives stripped away,

above: Supermarket Sweep: the new **Dawn of the Dead**'s characters on the run.
opposite: Ana (Sarah Polley) and Kenneth (Ving Rhames) confront the ghouls.

and how they react to that," adding "What would people turn to? How would a person's religious beliefs be affected by the dead returning to life? Would you turn to your faith more? Or would you tend to think it's bullshit?"[226] However, the finished film actually has little interest in such philosophical issues. Despite all the secondary religious waffling - Andre is momentarily concerned about all the bad things he's done in his life and rather self-centredly wonders if the apocalypse is his personal punishment - the film lacks the dark nihilism of Romero's trilogy. These walking dead are really just victims of a virulent plague and since anyone who dies without being bitten by the ghouls doesn't return to life, the hand-me-down "When there's no more room in hell" spiel seems rather redundant. Whatever the filmmakers may want us to believe, this isn't Judgement Day - just another common or garden viral outbreak.

Even without the dark satire, there's much to enjoy in the new *Dawn*. The film's chief pleasure stems from its resplendent goriness in which wooden sticks are stuck through zombie skulls, heads are blasted open with shotguns and special effects make-up designer David LeRoy Anderson unleashes 3,000 ghastly ghouls. A million miles removed from the anodyne, censor-friendly world of *Resident Evil*, this *Dawn* delivers more gore than one can shake an amputated limb at. It also possesses a dark strain of comedy that owes a debt to the E.C. Comics tradition that was such an influence on Romero. The scene in which the survivors play a grim game of sniping - shooting at the massed ghouls with a high-powered rifle and picking out targets on the basis of their similarity to famous people - is chock full of gallows humour: "Jay Leno! [...] Burt Reynolds! No, too easy. Aim for someone harder. Rosie O'Donnell! Tell him to shoot Rosie!"

With *Shaun* and *Dawn* becoming hits on both sides of the Atlantic, 2004 proved a vintage year for zombie fans. Rescued from the shadows, the living dead were finally getting the respect they deserved across a variety of different media. The videogame market delivered slavering ghouls in *Doom 3*, where demonic zombies stalked dark corridors of a Martian space station, as well as a buffed up, redesigned *Resident Evil 4*, which showed the influence of *28 Days Later* by pitching the franchise's influential zombies as "infected" crazies.

Accompanying these new digital developments was a sudden explosion in zombie-themed comic books. Robert Kirkman's understated, monochrome outing *The Walking Dead* began in May 2004 with a dramatic, claustrophobic storyline that privileged character development over gore. Elsewhere Steve Niles's books *Remains* and *Wake the Dead* upped the blood and guts, Simon Pegg contributed a zombie story to long-running British comic *2000 A.D.* and no less than George Romero himself kick-started D.C.'s *Toe Tags* with a story from his own pen. Meanwhile, Max Brooks's affectionately jokey tome *The Zombie Survival Guide: Complete Protection from the Living Dead* became a bookshop favourite with some ingenious, deadpan advice about how to survive a zombie apocalypse.[227]

During 2004 Romero had more than just comic books on his mind, though. A series of announcements throughout the late 1990s and early years of the new century alerted fans that Romero was keen to make another living dead film. The rumours were varied and contradictory: he was going to make a rock musical called *Diamond Dead* with Ridley Scott about a group of musicians brought back from the grave; he was going to make a fourth film in his Living Dead series; he was going to make a videogame called *City of the Dead*; he was struggling to find funding; he was going to work with Twentieth Century Fox; he'd refused to compromise on the gore by working with a studio.

In the spring of 2004, the gossip finally turned into hard facts. Romero was indeed interested in making both a zombie rock musical and a fourth film in his Living Dead series. Plus, after years of battling for funding, he was in the unlikely position of having both bankrolled at once. Understandably, it was the latter project that generated the most excitement and Romero's long-gestating *Land of the Dead* (previously entitled *Brunch of the Dead*, *Twilight of the Dead* and *Dead Reckoning*) was picked up by Universal, the studio that had distributed both the *Dawn* remake and *Shaun of the Dead*. Within twenty-four hours of the announcement, a cast was already locked in that included Dennis Hopper, John Leguizamo and Asia Argento.

Set after the events of *Day of the Dead*, *Land* takes place in a fortified city where the remaining human survivors of the zombie apocalypse are sheltering from the living dead. As the film's title suggests, the zombies have overrun everything. America has become the home of the grave and the land of the dead: a dank wasteland populated by "walkers" or, as some of the less sympathetic characters dub the ambling corpses, "stenches".[228]

What is left of the living living - as opposed to the living dead - can be found in a fortified urban compound (the location of this is never made clear, but in a nicely ironic touch it appears to be Romero's home town of Pittsburgh). It's a community split between the haves and the have-nots, governed by a ruthless, bespoke-tailored CEO called Kaufman (Dennis Hopper).

Kaufman claims to have been the architect of the city's fortifications - a walled compound protected on two sides by water - and he's using the current situation to profit from the misery of the impoverished survivors who're sheltering under his wing. Taking up residence in the plush corridors of Fiddler's Green, a luxury skyscraper apartment complex, Kaufman and his cronies preside over a post-apocalyptic community where the rich are getting richer and the poor are desperately trying not to become zombie chow.

An electric fence keeps most of the ghouls at bay, but also traps the living inside a hellish community where Kaufman's idea of entertaining the masses is to appeal to their baser instincts: "If you can drink it, shoot it up, fuck it or gamble on it, it belongs to him". His most recent idea is to use anyone who upsets him - including ex-hooker Slack (Asia Argento) - as live bait in gladiatorial zombie battles. What was threatened before in Romero's series has finally come to pass: the living are now more like monsters than the living dead.

One man who's realised this is Riley (Simon Baker). He's a burnt-out food forager who's been leading sorties into the nearby zombie-infested towns in a battle truck called Dead Reckoning. As a result of his hard work he's been able to secure the supplies needed to keep Kaufman eating fillet mignon and the impoverished simply eating. Disillusioned with the compound's push towards social collapse, Riley's eager to escape to Canada with his sharpshooter sidekick Charlie (Robert Joy). Even though he hates Kaufman's world of bourgeois comfort, Riley's uninterested in the revolution that's fermenting on the streets beneath Fiddler's Green and simply wants to get out while he still can.

His best laid plans are complicated by two factors: the theft of Dead Reckoning by Cholo (John Leguizamo), who threatens to use it to destroy Fiddler's Green unless he's given a sizeable amount of money, and the evolution of the zombies, who are "learning to be us again" and have suddenly developed the ability to communicate, use tools and work as a group under the command of growling ghoul Big Daddy (Eugene Clark). Enlisted by Kaufman to get Dead Reckoning back, Riley heads out into zombie land with Slack and Charlie, while the zombies head towards Fiddler's Green, swimming across the expanse of water that had previously kept them at bay.

How not to get a-head: Big Daddy (Eugene Clarke) mourns one of his zombie brethren in **Land of the Dead**.

As the first film in Romero's "Dead" series to have the backing of a major studio, be released with an MPAA rating and spawn a slew of official studio merchandise including action figures, *George A. Romero's Land of the Dead* (to give the film its full, if rather grand, title), marks a significant departure for the writer-director.[229] Despite being given a paltry (and near insulting) $15 million budget, Romero managed to stay true to his ambitious vision of social collapse that had been left half-sketched in *Day of the Dead* and that he had long talked about returning to in interviews in the 1990s.

After two decades spent watching other directors derivatively tackle the zombie mythology he had forged himself, *Land of the Dead* was something of a high stakes gamble. In the years since 1985, the living dead had returned to cinematic health: wouldn't it be ironic if Romero, the man who had single-handedly invented the modern zombie, managed to kill it again once and for all with a glossy studio flop?

Fortunately, Romero proved to have lost none of his touch (and, given the variable output of his work during the 1990s, seemed to have rediscovered some of the magic he'd mislaid since the release of *Day of the Dead*). His Faustian pact with Hollywood didn't seem to hamstring his artistic sensibilities either, and the impressive cast he gained as a result gave *Land*'s performances a professionalism that the earlier films in the series had sometimes lacked. Certainly, Romero relished working with a heavyweight like Dennis Hopper ("I want to play Steppenwolf whenever he comes on the set," the filmmaker joked to one reporter) and Asia Argento - daughter of Dario Argento, who'd been instrumental in getting *Dawn of the Dead* financed.[230]

Yet, compromises were inevitably made. Originally planning to shoot in his native Pittsburgh, Romero was reluctantly forced to relocate to Toronto to get the benefit of a couple of million dollars worth of tax rebates and the favourable currency exchange. During production, rumours circulated that Romero was battling the studio over both the budget and his trademark gore shots. More money was eventually found, which enabled him to shoot pick ups: "Universal was willing to pony up a little more dough, [so] we got an extra few days to try and improve on some of the gore things and dance around the MPAA a little bit by doing the shadow thing and smoke thing to indicate what was going on without actually having it in your face."[231]

The result was a movie that could be released with an R rating in the US and, incredibly, a 15 certificate in the UK. Given that the film foregrounds some astonishingly brutal special effects sequences of zombie munching action - intestines being pulled from abdominal cavities, hands being shoved into mouths in search of tongues and, in the most squirm-inducing moment a navel piercing being ripped off - it's surprising that the film received such a lenient ride. Romero seems to have anticipated most of the censors' objections, filming in a dark murky grey that seems to have become *de rigueur* for most American horror movies in recent years, and hiding some of the more gory action behind

foreground figures. Even still, the film's love of splatter is apparent: one of the most ingenious moments features a decapitated zombie who's inexplicably retained some motor function. A quick shake of its shoulders and its obvious why this is so - its head isn't missing, but hanging down its back by a thin piece of spinal cord. Catapulted over its shoulders, the head then proceeds to chomp on one of the unsuspecting living.

The zombies themselves are equally striking creations. Makeup artist Greg Nicotero, who originally assisted Tom Savini on *Day of the Dead*, took that film as his starting point and expanded on its vision of the ghouls as decaying lumps of flesh:

> A lot of what zombies look like in movies has to do with what we did for *Day of the Dead*. The idea then was always to try and make their eyes look deeper set, so we built out the brows and they were a little caveman-ish, and their eyebrows disappeared. The joke was that you became a zombie and your eyebrows are gone. So here, we really wanted to present the facial structures of most of the people. Very rarely have we done brows - we've done enhanced cheekbones and the bridge of the nose and everybody either has custom dentures or we use a mouth rinse to make their teeth look grey. And before every take, we have them rinse their mouths with black mouthwash so their tongues are black, as if there's no living flesh in their mouths.[232]

The detail of the zombie make-up adds much to *Land of the Dead*'s aesthetic, ensuring that even though this is the most action-orientated film in Romero's series, the ghouls dominate the audience's imagination - not even the tongue-in-cheek cameos from Savini (top left), Simon Pegg and Edgar Wright (second still) can detract from that. The scene in which Big Daddy leads his zombie army towards Fiddler's Green - the ghouls silently emerging from the waters that surround the city - has a haunting quality that surpasses anything Romero has achieved before. The film may not be, as the overeager trailers claimed, "Romero's masterpiece", but it has moments of grandeur that makes one wish he hadn't had to wait twenty-plus years to direct a sequel to *Day of the Dead*.

Fortunately, the studio-enforced shenanigans over gore, ratings and money did little to change Romero's vision of where the film was heading politically, as Nicotero explains:

> At this point in the story, the zombies are the majority, and we're taking up where we left off with Bub [from *Day of the Dead*], who was the first ghoul we saw with a hint of intelligence. They've basically taken over, but there are still bands of [surviving] humans, and the story is all

all images above:
Land of the Dead.

about their existence. It's intriguing how George has still been able to inject social relevance to today's culture [...] This one is going to be about greed and selfishness and money, and how that drives everyone. George's movies are always about one part of society consuming another, whether it's consumerism or wealth and power, and we're definitely going to stick with that.[233]

With the apartments of Fiddler's Green a more luxurious take on the shopping mall enclave from *Dawn of the Dead*, it's obvious that Romero has lost none of his anti-consumerist fervour even when taking a major Hollywood studio's dollar. Indeed, it says much about Romero's reputation that it's impossible to imagine any studio could ever have pulled his (socially) critical teeth. Universal obviously realised that a financially successful Romero movie needs to be given some leeway in the subtext department to avoid angering both its director and fans - which leads one to speculate that Romero may have done more to popularise socio-political readings of film among horror fans than any other director living today.

Envisioning a world ruled by a rich cartel of Fiddler's Green residents - all suited and coiffured like a board of fat cat company directors - *Land of the Dead* wins few prizes for subtlety, but Romero does make some well-aimed jabs at the current American establishment. Kaufman and his cronies are, it seems, the zombie apocalypse's answer to Enron, a group of rapacious businessmen interested in fiddling as much green as they can. The name "Fiddler's Green" evokes both corruption and a certain disregard for the situation happening beyond the limits of the skyscraper paradise: "fiddling while Rome burns".[234] It's something that Romero himself is vocal about in explaining his aim for the film:

> It's not so much the zombies. Whatever commentary on consumerism is in *Dawn of the Dead* had nothing to do with the zombies. They're just sort of walkin' through all of this, man. It's really the humans and their attitudes - the same themes of people not communicating, things falling apart internally and people not dealing with it. If everybody just sat down in a room and tried to figure out an approach... But everyone is still working to their own agendas and not willing to give up life as it was. That's the theme that runs through all of this. And *Land*, I believe, has a little bit more of that. The idea of building a society on glass, and not caring about what's going on around you - wearing blinders.[235]

Whatever one makes of Romero's rather disingenuous comment that his consumerist critique in *Dawn* had "nothing to do with the zombies" (what else were they but parodies of soulless consumerism?), this stands as an interesting statement of his intent in *Land*. The sense of a society in meltdown is keenly sketched throughout the film, although at times - as in the ragged revolution being fermented on the streets beneath Fiddler's Green - it's rather clumsy. Still, Romero's point is the same as it has been during the rest of the series, what is the difference between the zombies and us? Or as actor Robert Joy insightfully sums it up: "It makes you ask, 'When is the other really the other and when is the other us?'"[236]

Certainly, the zombies in *Land of the Dead* are more central than in any other of Romero's living dead outings. While the previous three films in the series featured a black hero who was alive, *Land of the Dead* is the first to feature a black hero who is already dead. Big Daddy (Eugene Clark) is a distant cousin not only of Bub, the zombie with a brain from *Day of the Dead*, but also of Ben, Peter and John in the earlier films.

As a zombie who's regained the power of thought and speech - albeit limited - he's jumped several steps up the evolutionary ladder, remembering his former job as a gas station attendant and leading his fellow zombies towards Fiddler's Green in an attempt to save them from extermination by Kaufman's desire to pillage the zombie-infested wastelands beyond the city walls. No longer entranced by the "sky flower" fireworks displays that hold the rest of the zombies transfixed, he's leading his own revolution: a living dead uprising in which the zombies learn to use tools, from meat cleavers to machine guns.

Romero styles this uprising in keeping with the rest of the series's racial undertones. Big Daddy is like a zombified Black Panther, a civil rights revolutionary who leads this living dead underclass on a riot against the Establishment. Clark, who plays the growling, raging zombie with quite remarkable conviction, overtly suggested as much in an interview with *Fangoria*:

> I see Big Daddy as a man, a zombie, an entity who is evolving, and who realises, 'This is wrong!' All right? You come into our territory, we eat you. You don't come into our territory, we don't eat you - we'll leave you alone. You come in, you cause mayhem, and it's wrong. So... civil rights? I don't think there are any civil rights. It's zombie rights. Leave. Us. Alone! [...] There are a lot of atrocities occurring. These events are happening within my world. And when Big Daddy sees people dying, and being slaughtered, it pains him. For me to play this role, there are some really dark places I'm going and it breaks my heart. Those moans and groans come from that place. Any oppressed people around the world, when they're in deep, deep pain, you won't hear words, you hear moaning and groaning.[237]

In Big Daddy, Romero rewires the zombie genre's rich racial history, styling his ghouls as an oppressed minority

above and opposite: Zombies as anti-capitalist rioters in George A. Romero's **Land of the Dead**.

rising up against the fascist dictatorship of Kaufman's Fiddler's Green. It's the first film in the series to explicitly ask us to sympathise with the zombies themselves and it extends Romero's living dead mythology in a way which none of his imitators have ever managed to do.

As Big Daddy leads his mixed band of zombies towards the compound, it's difficult not to read the conflict in racial terms. After all, Kaufman and his cronies have already revealed themselves as racists: Cholo is refused an apartment in the Green because he's the wrong sort of person (i.e., Hispanic); Kaufman employs the services of a black manservant (who, in a moment worthy of Willie Best himself, heads for the hills when the going gets rough). The zombie insurrection may recall the armed proletariat uprisings of both *Nightmare City* and *The Nights of Terror*, but Romero is the first filmmaker to link it with such an explicit racial theme. This could well be the zombie genre's answer to the Watts Riots.

What's striking is the fluidity of Romero's living dead metaphor. Previously styled in the series as the dead of Vietnam, the silent majority of the Nixon era, vapid consumers and now an oppressed (ethnic) underclass, Romero's zombies have a symbolic potential unmatched by any other horror movie monster. His ability to reshape them for each decade has become his filmmaking calling card and *Land of the Dead* proves to be no exception as it bravely tries to tackle the Bush administration, the War on Terror and the post-9/11 world.

Much of this was a result of timing. The original script for the film (written as 'Dead Reckoning') was penned before 9/11 and had to be radically altered after the attacks on the World Trade Center, as certain scenes involving helicopters and skyscrapers suddenly seemed in rather bad taste. As a result, Romero reworked the film in the wake of the tragedy and was able to incorporate the War on Terror into his vision of the zombie apocalypse. As he told a reporter from the *New York Times* during production: "The idea of living with terrorism - I've tried to make it more applicable to the concerns Americans are going through now".[238]

How successful this strategy is depends on how transparent one likes one's subtext. Yet, regardless of the lack of subtlety, *Land of the Dead* is one of the first blockbuster productions to openly criticise Bush's war record (earlier in 2005, *Star Wars: Episode III - Revenge of the Sith* made a similar jab at the White House, but Romero's is arguably the most audacious). Whatever its faults, it deserves to be credited as a very subversive studio movie. Presenting Kaufman as a composite of George W. Bush and Defense Secretary Donald Rumsfeld, Romero makes his criticism of the regime more than transparent. After Cholo steals Dead Reckoning and threatens to destroy Fiddler's Green, Kaufman growls "We don't negotiate with terrorists" in an echo of that now famous presidential line. Cholo's response is equally fraught with real-world analogy: "I'm gonna do a jihad on his ass".

Making Kaufman into a symbol of the corporate interests underpinning the Bush government's desire to continue the War on Terror, *Land of the Dead* homes in on a society whose leaders are willing to profit from a dangerous situation, exacerbating that situation in the process in order to make a profit. The link between this and critics of the White House - who contend that the post-9/11 terrorist threat is being used as an excuse for the occupation of oil-rich Iraq, the expansion of corporate America's coffers and the gradual erosion of American civil liberties - is more than a little obvious. Pointing out the twenty-seven year difference between *Dawn* and *Land*'s social commentary, Romero says: "The financial stakes are a little higher, too. In *Dawn*, it was just about getting a pair of Nikes. But, you know, this is the era of Halliburton."[239] It's unsurprising, then, that Kaufman should meet his end by being doused in petrol and set alight by Big Daddy; Romero has lost none of his darkly humorous touch during his sabbatical from the genre.

As the zombies invade the Fiddler's Green skyscraper, Romero re-stages images of the attacks on the Twin Towers. Zombies pile through the lobby and wreak havoc on the inhabitants. Outside, suited residents of the complex run terrified through the streets, a visual analogue of the footage of commuters in New York fleeing the collapsing World Trade Center. Around them, Kaufman's fascist bullyboys - a different kind of Homeland Security - try to stop the advancing ghouls with little success.

The question Romero poses is: who is the real terrorist? Cholo, who's threatening to destroy the city? The zombies (who, as Riley realises, are just looking for a place to call home)? Or Kaufman and his cronies, who've brought this situation upon themselves as a result of their inhumane treatment of both the living and the ghouls? The correct answer isn't difficult to guess.

Land of the Dead is likely to become the yardstick by which the millennial zombie genre revival is measured. By focusing on the War on Terror, the fourth film in Romero's influential series gives some indication of what has fuelled the re-emergence of the genre in the early years of the

twenty-first century. The obvious answer for this unexpected boom in zombie movies is to trace the trend back to the success of the *Resident Evil* games, which brought the living dead to the attention of a new generation who may have been unfamiliar with Romero's work. That's certainly what Romero's take on the situation is:

> I'm cynical enough that I don't think there's any particular reason or social zeitgeist that brings people to this material. One movie becomes a hit and everyone says let's go make a zombie film. I do think the *Resident Evil* videogames woke everyone up to the undead idea that had been lying dormant a while. Then *28 Days Later* and *Shaun of the Dead* added fuel to the flames. Those plus the *Dawn of the Dead* remake certainly helped the *Land* deal.[240]

Yet perhaps there's more to it than this. Romero's self-confessed cynical take on Hollywood's need to always play follow the leader doesn't explain why audiences have responded so favourably to zombies in recent years.

The spectre of several millennial anxieties, from SARS to terrorism, hangs over many of these films. The fact that the redux version of *Dawn of the Dead* concentrates on a group of heroes led by emergency service workers - a nurse, a policeman, and (at a push) a couple of security guards - seems rather significant in the post-9/11 world, as does most of the recent zombie films' interest in viral outbreaks and diseases. As the West braces itself for another terrorist "spectacular", could the zombie be read as a response to our current anxieties about this increasingly dangerous world? In retrospect it seems strangely appropriate that the title of Anderson's first *Resident Evil* movie was originally *Resident Evil: Ground Zero* (it was hastily changed after the attacks on the Twin Towers).

Whatever the answer, it's apparent that the revival of the genre has coincided with a historical moment that the zombie seems more suited to than vampires, werewolves, serial killers or any of the other usual horror monsters. The genre's traditional use of biochemical warfare and toxic spills as the starting point for its living dead apocalypses have an added impetus today after anthrax scares, concerns about weapons of mass destruction and fears about a "dirty bomb" being released in a major metropolitan centre. It's certainly something that *Shaun of the Dead*'s Simon Pegg seems to think is related to the sudden rash of zombie movies:

> It's fear of each other. It's about fear of other human beings, and fear of ourselves. Weirdly enough, a parallel thing [with *Shaun of the Dead*] is that it's all about not noticing the threat around you. And now here we are in a situation where apparently we could be blown to smithereens at any point because of terrorism and it's a threat that

we have not noticed gather up around us. It's very current, this whole thing: viral paranoia, fear of outsiders coming in, xenophobia, these bogeymen terrorists that are out there.[241]

As if to prove the point, a couple of months after the US release of *Land of the Dead* the world's news channels were suddenly dominated by horrendous images from New Orleans in the wake of Hurricane Katrina. Tuning into CNN, we saw scenes from the devastated city that could have been the backdrop to a Romero movie: bewildered, scared residents wandering through flood-damaged streets; looting and lawlessness; incompetent government agencies. The dead may not have been walking, but it all had an eerily familiar ring.

The fear of natural disasters and terrorist attacks certainly seem to have found a pop culture outlet in the zombie movie. It's something that has led to some unlikely intersections. We live in unsettling, uncertain times where - for whatever reason - our faith in the cohesion of the social order has been profoundly shaken. The zombie myth, which has evolved over the decades to become less about race or magic than about the apocalypse itself, seems to have become the perfect expression of these fears.

At the time of writing, there doesn't seem to be any conceivable end in sight to the genre's upward trend. Indeed, it has never looked stronger, more inventive or exciting at any point in its seventy-odd-year screen history. The sheer range of zombie related cultural outpourings is truly dizzying and quite without precedent. Every popular medium seems to have harnessed the living dead from videogames (*Dead Rising*) to literature (Max Brooks's *World War Z*) and comic books (John Russo's *Escape of the Living Dead*). True, we have yet to see a zombie-themed television series, but that perhaps has more to do with censorship restrictions than anything else.

Zombies have even become ironic postmodern performance art, with zombie-themed flash mobs - groups of strangers who spontaneously meet in a public place - springing up in the US and Canada. Where once such meetings involved nothing more than public pillow fights or mini dance-a-thons, recent years have seen events where participants pretend to be members of the living dead. Wherever you look, the dead are back from the grave, this once marginal monster now turned into an incredibly popular horror icon. It's a cultural phenomenon that will probably need to run out of steam before it can be properly mapped.

Certainly the end of zombie cinema itself is not yet. Going from strength to strength, the genre has become something it's never been before - a consistently viable horror property that mainstream studios are willing to acknowledge and invest in. The sheer range of forthcoming films is staggering. There are sequels like *28 Weeks Later* and *Resident Evil: Extinction*; remakes like *Children Shouldn't Play With Dead Things* and *Day of the Dead*; and completely new material like Joe Dante's anti-Bush satire *Homecoming*.

Romero's success with *Land of the Dead* at the US box office may have paved the way for a sequel, something that the writer-director says he's interested in working on.[242] Before that, though, Romero is following his fervently independent instincts and trying something different in *Diary of the Dead*. It's about a group of filmmakers who find themselves caught up in a zombie outbreak while shooting a horror movie. Unrelated to the four films in his Dead Quartet, it may well offer the filmmaker the opportunity to take the genre he helped spawn in a different direction.

However one looks at it, the zombie's revival in the early years of the twentieth century is a unique cultural phenomenon. Yet it's by no means surprising. The zombie is the perfect monster for these troubled times. From New York to Kabul, Baghdad to Madrid and London, death is all around us. Suspicion, paranoia and fear of other people dominate our everyday lives. The end of the twentieth century may not have brought about the End of Days some expected, but we seem to be experiencing a post-millennial hangover where the threat of a more specific social apocalypse caused by terrorism, climate change or perhaps just our own stupidity seems to be dominating our collective consciousness. As the West wages its War on Terror and makes imperial incursions into the Middle East, the zombie's past use as a metaphor for relations between colonial occupier and native subjects and its more contemporary role as a symbol of the mass destruction of the First World may yet have a place in many, many nightmares.

Break on through to the other side: Big Daddy (Eugene Clark) in **Land of the Dead**. The shot echoes a classic scene from **The Ghost Breakers** (see still on page 32).

top: Promotional artwork for the Spanish release of **City of the Living Dead**. The name on the tombstones suggests a joke at the expense of the zombie extras.
above: Catriona MacColl and Carlo De Mejo appear to have much at stake during the church crypt conclusion of **City of the Living Dead**.
right: Luckless Joe the Plumber (Giovanni De Nava) in **The Beyond** after enduring several hours in Gianetto De Rossi's make-up trailer.
opposite top: Catriona MacColl is attacked by hospital cadavers in **The Beyond**. The British actress gamely appeared in all three instalments of Fulci's trilogy.
opposite bottom: The death of Schweik (Antoine Saint John) at the start of **The Beyond** highlights the Catholic imagery of crucifixion and stigmata running throughout Fulci's trilogy.

this page and opposite: Promotional artwork for Andrea Bianchi's magnificently unapologetic exploitation movie milestone **The Nights of Terror**.

Bianchi's plebeian zombies arm themselves with agricultural tools and offer a veiled comment on the class struggle in **The Nights of Terror**.

DIE RÜCKKEHR DER ZOMBIES (Zombie III)

this page and opposite: Mouldy mayhem in the zombie/cannibal/mad doctor hybrid **Zombi Holocaust**.

Zombies
unter Kannibalen

Darsteller:
JAN McCULLOCH · ALEXANDRA DELLI COLLI
SHERRY BUCHANAN · DONALD O'BRIEN
PETER O'NEAL · JOSEP PERSAUD

Regie:
FRANCESCO MARTINO

Eine Farbfilm-Produktion der Flora-Film S. r. l., Rom
im Alemannia / arabella -Filmverleih

top: The Caribbean ghouls of **Erotic Nights of the Living Dead** go in search of fresh victims (preferably nude, female Euro babes).
left: A curiously OTT Italian poster for Pupi Avati's understated curio **Zeder**.
above: A fantastic French poster for **Revenge of the Living Dead Girls**, a movie that suffered from not having Jean Rollin behind the camera.

above: Umberto Lenzi's gloriously silly **Nightmare City**.
left: Nudity, blood, pert nipples: everything a 1980s zombie movie needs to pull in the gore hounds.
below: Spanish promo material for **Nightmare City**. Interestingly, the atomic ghouls of Lenzi's film pre-empt the militant zombies of Romero's **Land of the Dead**. Lenzi styles their rampage as an urban guerrilla war in which they knock out an entire city's defences. Romero's Big Daddy was obviously paying attention.
opposite: **Dawn of the Mummy**, a movie that should have ditched the bandages and played itself as a straight ghoul flick.

EL DESPERTAR DE LA MOMIA

BRENDA KING - BARRY SATTELS - GEORGE PECK
Música: SHUKY LEVY — Productor ejecutivo: LEWIS HORWITZ
Director: FRANK AGRAMA Technicolor

top: Promotional artwork for Lucio Fulci's **Zombi 3**.
above, left and opposite: Three very different pieces of artwork (and titles!) for Bruno Mattei's **Zombie Creeping Flesh**. The yellow poster shamelessly recycles the artwork from Fulci's **City of the Living Dead** while the poster opposite lures unwary audiences into expecting a cannibal epic.

APOCALIPSIS CANIBAL

(CANNIBAL APOCALYPSY)

PRESENTA UNA PRODUCCION **FILMS DARA**

MARGI EVELYN NEWTON · ROBERT O'NEAL · LOUIS GARFIELD
DIRIGIDA POR **VINCENT DAWN** DIRECTOR DE FOTOGRAFIA **JOHN CABRERA** BSC
UNA PRODUCCION **FILMS DARA** (BARCELONA) **BEATRICE FILMS** (ROMA)

The creators of ALIEN...
...bring a new terror to Earth.

DEAD & BURIED

It will take your breath away...all of it.

RICHARD R. ST. JOHNS PRESENTS
A RONALD SHUSETT PRODUCTION
DEAD & BURIED
STARRING JAMES FARENTINO MELODY ANDERSON AND JACK ALBERTSON
SCREENPLAY BY RONALD SHUSETT AND DAN O'BANNON BASED UPON A STORY BY JEFF MILLAR
AND ALEX STERN PRODUCED BY RONALD SHUSETT AND ROBERT FENTRESS
DIRECTED BY GARY A. SHERMAN EXECUTIVE PRODUCER RICHARD R. ST. JOHNS
MUSIC BY JOE RENZETTI MAKE UP EFFECTS DESIGNED BY STAN WINSTON EXECUTIVE IN CHARGE OF PRODUCTION JOHN W. HYDE

opposite top: Dr. Hill (David Gale) contemplates life without a body in **Re-Animator**.
opposite bottom: Michael Jackson's **Thriller** video became a genre landmark.
opposite inset: The Australian poster for another 1980s classic: **Dead & Buried**.
this page top: The opening scene of **Day of the Dead** (for the safety of the zombie extras, the croc's jaws were taped shut).
right: George Romero surrounded by his creations on the set of **Day of the Dead**.
below: Video sleeve for **Ghost Town**, a unique zombie western.

opposite top: The British quad poster for **Day of the Dead**.

this page and opposite: Frankenstein Unbound: The zombie genre's most revered partnership, George Romero and Tom Savini, take horror into the autopsy room in **Day of the Dead**'s gory parade of cadavers. Despite the realism, the humour still shines through - notice the way in which the soldier's screaming head is being held like a bowling ball in the still above.

GORE-MET ZOMBIE CHEF FROM HELL

Dining out can be a permanent experience!!!

above: This playful video sleeve for **Gore-Met Zombie Chef from Hell** would have any horror fan salivating.
opposite top: To protect and serve: Robert Z'Dar in **Maniac Cop 2**. *opposite bottom:* A bumper crop of zombie close-ups from the underrated **The Video Dead**.

THE VIDEO DEAD

above: Rupert Everett and Anna Falchi make an eye-catching centrepiece in the Japanese poster of **Dellamorte Dellamore**.
opposite: A remake, with bite: Tom Savini's reworking of **Night of the Living Dead** puts two decades of special effects advances to good use.

this page and opposite: **Braindead**.

Welcome to the charnel house: Peter Jackson's **Braindead** ranks as the zenith of zombie splatter with a body count well into triple figures. It set the benchmark for the brief "splatstick" cycle, even topping Sam Raimi's **Evil Dead** films in its special combination of gore, viscera and yuk-yuk-yuks.

left: "More quantity, less quality": the director of **Junk** stays true to his word.
above: If you go down to the woods today: director Ryuhei Kitamura's **Versus**.
below: Is it a film, or is it real? Postmodern tomfoolery in **Una de zombis**.
opposite: Sadomasochist pinup: Mindy Clark finds pleasure in pain in **Return of the Living Dead 3**.

above: The Spanish poster for **Undead**.
opposite: The world's first "rom-zom-com": **Shaun of the Dead**.

SHAUN OF THE DEAD
www.romzom.com

above: Test tube baby: **Return of the Living Dead 4: Necropolis**.
below: Now that's gotta hurt: **Return of the Living Dead 5: Rave to the Grave**.
opposite top: Athletic ghouls in **Dawn of the Dead** (2004).
opposite bottom: Romero's more sedate zombies in **Land of the Dead**.

Finger licking good: a band of ghouls enjoy the zombie answer to fast food in **Land of the Dead**.

Mob rule in the final reel of **Land of the Dead**.

this page: Lock down: zombie ghouls behind bars in **Shadow: Dead Riot**.

汝の愛するものを恐れよ。

BASED ON THE ORIGINAL SCREENPLAY BY
GEORGE . A . ROMERO

ドーン オブ・ザ デッド
DAWN OF THE DEAD

afterword

Something To Do With Death

I can vividly remember when I first fell in love with the zombie. It was one late evening in 1988. I turned on the television set and was greeted with the sight of a ghoul's head being chopped open by a whirling helicopter rotor blade. Fake looking blood spilled out of its brainpan and gushed over its face as it staggered a few steps forward and collapsed. A man dressed in a SWAT uniform looked on with an expression of grim bemusement that matched my own.

The film was the original *Dawn of the Dead* and the programme was Channel 4's *The Incredibly Strange Film Show* hosted by Jonathan Ross. I had no idea what the movie was, but I quickly became engrossed by the story of a bearded Pittsburgh filmmaker called George Romero and his love of zombies. There were clips from *Martin* and *Knightriders*, some black and white footage of zombies milling around outside the farmhouse of *Night of the Living Dead*, lots of scenes from the mall in *Dawn of the Dead* and a clumsy sequence involving a mad make-up man (Tom Savini, I later learnt) who used latex appliances to turn Jonathan Ross into a ghoul.

Watching the footage from *Dawn of the Dead* came with a strange sense of déjà vu. That was mainly because - as I later realised - I'd once played a computer game called *Zombi* (Ubisoft, 1986). It took its entire storyline from Romero's film, turning it into an adventure role-playing game in which you had to guide a band of survivors through a mall where zombies wandered the corridors and randomly attacked you. Compared to today's videogames this Commodore Amiga title was simple stuff, but it was terrifying in its ruthlessness. Every now and then a zombie would pop up out of nowhere to break the eerie quiet of the mall, prompting some frantic hammering of the keyboard and then a long trudge down to the freezer compartment in the basement where the body could be dumped to stop it from reanimating. I never could work out what I was supposed to do to stem the rising tide of the living dead (the whole game was written in French for starters); but when I saw Romero's heroes blockading the mall doors I realised where I'd been going wrong: so that was what the trucks were for!

What had me hooked as I watched the TV show, though, were the zombies. Shuffling, lumbering corpses they were at once ridiculous and yet strangely terrifying. And what scared me more than the ghouls themselves was the foreboding sense of apocalyptic finality that accompanied them. Seeing Fran, Peter, Roger and Stephen hiding out in the shopping mall as the world collapsed sent shivers down my spine. What would I do if the world ended? Where would I go? How long would I survive? That night I had terrifying dreams of being chased by hundreds of ghouls breaking through barricades, grasping through open doorways and windows. Nowhere was safe. I woke up the next morning still terrified, but convinced that I had to watch every single zombie movie there was...

The love of the apocalypse is something shared by every fan of zombie movies. That's because - regardless of whether or not they replay Romero's classic scenario of the living dead taking over the world - zombie movies are always about The End. Full of literal images of death, the genre taunts us with a vision of the permanent full stop that awaits us all as bodies decay and the mind switches off. It's the genre's most enduring quality.

Hopefully this book has succeeded in tracing some of the reasons why the zombie entered western culture in the way it did in the early part of the twentieth-century. Imperialism, racial anxiety and fears about brainwashing have all had their part to play in the zombie's evolution and popularity. Ultimately, though, these walking corpses are always symbols of death, parodies of the supposed finality of the body and the promised everlasting life of the soul. Zombie movies make us confront our fears about death and dying - fears that normally stay hidden in a culture where, to quote Woody Allen, the majority of us aren't afraid of death... we just don't want to be there when it happens.

This Is The End: a cadaverous death mask from **The Nights of Terror**.

Notes and References

[1] James B. Twitchell, *Dreadful Pleasures: An Anatomy of Modern Horror* (Oxford and New York: Oxford University Press, 1985), p.261 and 266.

[2] Problems of availability have meant that I haven't been able to make reference to the large number of African films that feature zombies. The living dead have made frequent appearances in the homegrown video markets of countries like Nigeria, yet getting hold of this material (which is often shot and distributed quickly, cheaply and with little record of production details) has proved difficult. It seems important to recognise their existence, though, if only to highlight the predominant American-European focus of this book. Similarly, the vast literature surrounding the living dead - from E.C. Comic books to pulp novels - and the hundreds of short films featuring zombies are beyond the scope of this study.

[3] Judith Halberstam, *Skin Shows: Gothic Horror and the Technology of Monsters* (Durham, NC: Duke University Press, 1995), p.21.

[4] Ken Gelder, "Introduction to Part Three," in Gelder ed., *The Horror Reader* (London and New York: Routledge, 2000), p.81.

[5] According to *The Oxford English Dictionary*, the first use of the word "zombie" in the English language occurred in 1819 in Robert Southey's *History of Brazil* (London: Longman, 1810-1819). In that book, Southey claims that a "zombie" is synonymous with the Devil. The edition of this book held in the British Library formerly belonged to Samuel Taylor Coleridge - Southey's brother-in-law - who made several pencil annotations in the margins of the text, including one which argues that this definition of the zombie is incorrect. Sadly, the poet doesn't elaborate on why he believes that is so.

[6] Lafcadio Hearn, "The Country of the Comers-Back," *Harper's Magazine*, 1889. Reprinted in Peter Haining ed., *Zombie! Stories of the Walking Dead* (London: W.H.Allen, 1985), pp.54-70.

[7] White Europeans disparagingly dubbed Haiti "The Black Republic" after the island won its independence in the eighteenth-century. It was also the title of a book on the island by Spencer St. John, *Hayti, Or The Black Republic* (London: Elder Smith, 1884).

[8] Man Ray, *Self Portrait* (Boston: Little, Brown and Company, 1963), pp.191-193.

[9] Seabrook's comments about the taste of human flesh can be found in Wambly Bald, *On the Left Bank 1929-1933*, ed. Benjamin Franklin (Athens, Ohio: Ohio University Press, 1987), p.80. For the full story of Seabrook's culinary adventure see Marjorie Worthington, *The Strange World of Willie Seabrook* (New York: Harcourt, Brace & World, 1966), pp.54-57. Worthington was Seabrook's second wife.

[10] Wade Davis, *The Serpent and the Rainbow* (London: Collins, 1986), p.138.

[11] William Seabrook, *The Magic Island* (London: George Harrap and Co., 1929), p.94.

[12] *Ibid.*, p.94.

[13] *Ibid.*, p.95.

[14] *Ibid.*, p.101.

[15] *Ibid.*, p.102.

[16] *Ibid.*, p.103.

[17] F. Van de Water, "Review of *The Magic Island*," *New York Evening Post* (12 January, 1929).

[18] Seabrook, p.7.

[19] *Ibid*, p.7.

[20] Robert Heinl and Nancy Gordon Heinl, *Written in Blood: The Story of the Haitian People 1492-1995* (Lanham, New York and London: University Press of America, 1996), p.41.

[21] Harold Palmer Davis, *Black Democracy: The Story of Haiti* (London: George Allen and Unwin, 1929), p.167.

[22] One of the most fascinating films about the occupation and the history of Haiti's ongoing struggle to free itself from American influence is the documentary *Canne amère* (*Bitter Cane*, 1983), which was clandestinely filmed over the course of six years during the Duvalier regime.

[23] Harold Palmer Davis, p.171.

[24] Elizabeth Abbott, *Haiti: The Duvaliers and Their Legacy* (London: Robert Hale, 1988), p.38.

[25] *Ibid.*, p.39.

[26] *Ibid.*, p.39. Even Seabrook himself was somewhat equivocal about the American occupation of the island. "The presence of the Americans has put an end to revolution, mob violence, and many other deplorable conditions which the entire reasonable world agrees should be put an end to. It has also put an end, or if not an end, a period, to more than a century of national freedom of a peculiar sort, which has existed nowhere else on earth save in Liberia - the freedom of a Negro people to govern or misgovern themselves and to stand forth as human beings like any others without cringing or asking leave of any white man." Seabrook, p.269. Such doubts didn't stop him from playing up the island's "savagery" for the sake of a good read, though.

[27] Abbott, p.40.

[28] Wade Davis, *Passage of Darkness: The Ethnobiology of the Haitian Zombie* (London and Chapel Hill: University of North Carolina Press, 1988), p.73.

[29] *Ibid*, p.73.

[30] The details of *Zombie* are taken from *The Best Plays of 1931-1932 and the Year Book of the Drama in America* ed. Burns Mantle (New York: Dodd, Mead and Co, 1932), p.476.

[31] Cited by Gary D. Rhodes, *White Zombie: Anatomy of a Horror Film* (Jefferson, NC and London: McFarland and Co, 2001), p.85.

[32] Bryan Senn, *Drums of Terror: Voodoo in the Cinema* (Baltimore, MD: Midnight Marquee Press, 1998), p.25.

[33] The critical response to *White Zombie* was predominantly negative, with the *New York Times* claiming that there was "no reason" for the film to exist whatsoever. *Variety* was far more generous, however: "in the main the atmosphere of horror is well sustained and sensitive picture goers will get a full quota of thrills." See reviews in the *New York Times* (31 July, 1932) and *Variety* (2 August, 1932) respectively.

[34] Bryan Senn, *Golden Horrors: An Illustrated Critical Filmography of Terror Cinema 1931-1939* (Jefferson, NC and London: McFarland and Co., 1996), p.88.

[35] Jack Alicoate, *The 1933 Film Daily Year Book of Motion Pictures* (New York: Wid's Films and Film Folk, 1933), p.101.

[36] Nelson B. Bell, "Thoughts on the Horror Era," *Washington Post* (21 February, 1932).

[37] David J. Skal, *The Monster Show: A Cultural History of Horror* (London: Plexus, 1994), p.169.

[38] These selections from the British press book for *White Zombie* are reprinted in Rhodes, p.276.

[39] *Ibid.*, p.276.

[40] Senn, *Drums of Terror*, p.39.

[41] L.N., "Review of *White Zombie*", *New York Times* (29 July, 1932).

notes and references

42 *Ouanga* was originally released by Paramount's British distribution arm in order to sidestep the UK's strict quotas on American film imports. Although the cast and crew were American, the film wasn't actually released in the US until 1942, when it was reissued in a slightly shortened cut as *The Love Wanga*. Given the film's American genesis, it is obviously closely tied to the American interest in the Caribbean, even if the majority of American cinemagoers didn't see it until the occupation was long over. See Senn *Drums of Terror*, p.38.

43 One reason why the Hollywood establishment stopped making films about Haiti during the mid-1930s was because the island's troubled politics had begun to attract the interest of the African-American writers of the Harlem Renaissance. Plays like Eugene O'Neill's *The Emperor Jones* (later made into a film) and the so-called "Voodoo Macbeth" adaptation of Shakespeare's play (which relocated the action to Haiti with an all-black Harlem cast under the direction of a young Orson Welles) alerted Hollywood to the fact that the racial and political stakes of the Haitian occupation had, by this point in time, been raised considerably higher than anyone in white America had ever expected.

44 Frank S. Nugent, "Review of *Revolt of the Zombies*," *New York Times* (5 June, 1936).

45 The nearest Universal ever came to producing a zombie film during the period was the underrated horror movie *The Mad Ghoul* (1943), in which a scientist played by George Zucco discovers an ancient Mayan nerve gas that turns his student into one of the living dead. Significantly, the studio chose "ghoul" rather than "zombie" to describe this state, perhaps because they were unwilling to associate their production with any low-rent zombie movie.

46 In his cultural history of early exploitation films, Eric Schaefer convincingly argues that Poverty Row movies and exploitation films ought to be regarded as distinct from one another. While both kinds of films boasted terribly cheap production values, exploitation films dealt with subjects that were generally considered forbidden (some combination of sex, drugs and the exotic) whereas Poverty Row features aped mainstream Hollywood in everything except quality. Since the 1960s, the label "exploitation" has changed its meaning. During the years between 1919 and 1959, "exploitation" referred to the sensational advertising or promotional techniques that accompanied these films. From the 1960s onwards, "exploitation" was used to describe those films that exploited their subject matter - "sexploitation" or "blaxploitation". The kinds of films each label refers to are very distinct, with the zombie films of the 1960s onwards falling into the latter category as they exploit their audience's desire for violent, gory horror. See Schaefer, *"Bold! Daring! Shocking! True!: A History of Exploitation Films, 1919-1959* (Durham and London: Duke University Press, 1999).

47 Tom Weaver, *Poverty Row Horrors!: Monogram, PRC and Republic Horror Films of the Forties* (Jefferson, NC and London: McFarland and Co, 1993), p.xiii.

48 *Ibid.*, p.xii.

49 Another Monogram zombie contender is *The Face of Marble* (1946). Its status as a zombie movie has always been somewhat in doubt since its ghouls not only act like vampires (drinking blood) but also seem to be ghostly (they can dematerialise and walk through walls). As ever with Monogram's films such inconsistencies seem to be a result of nothing more than bad writing. John Carradine stars as brain surgeon Professor Randolph, who resurrects the corpse of a drowned fisherman using some new-fangled electro-chemical process he's designed with his assistant Dr. David Cochran (Robert Shayne). The corpse returns to life with a "face of marble". To add further confusion to the proceedings, the scientist's Haitian servants are dabbling in some non-zombie related voodoo and the professor's Great Dane is killed and brought back to life as a ghost dog that's terrorising the local livestock! Though the marble-faced zombie make-up is quite distinctive, the film barely qualifies as a tale of the walking dead since its ghouls eventually turn into ghosts.

50 Denis Gifford, *A Pictorial History of Horror Movies* (London: Hamlyn, 1973, revised edition 1983), p.151.

51 Donald Bogle, *Toms, Coons, Mulattoes, Mammies and Bucks: An Interpretative History of Blacks in American Film* (New York and London; Continuum, 1989), p.36.

52 *Ibid.*, p.74.

53 Cited by Weaver, p.36.

54 *Monthly Film Bulletin* Vol. 8, No. 93 (September, 1941).

55 Weaver, p.130.

56 Peter Dendle, *The Zombie Movie Encyclopedia* (Jefferson, NC and London: McFarland and Co.), 2000, p.186.

57 Weaver, p.139.

58 Joseph McBride "Val Lewton, Director's Producer" *Action* 11 (Jan-Feb, 1976), 12.

59 Edmund G. Bansak, *Fearing the Dark: The Val Lewton Career* (Jefferson, NC and London: McFarland and Co., 1995), p.143.

60 Inez Wallace, "I Walked with a Zombie" *American Weekly* (1940). Reprinted in Haining, pp.95-102. My emphasis.

61 Joel E. Siegel, *Val Lewton: The Reality of Terror* (London: Secker and Warburg, 1972), p.41.

62 *Motion Picture Herald,* 150/12 (20 March, 1943).

63 Robin Wood, "The Shadow Worlds of Jacques Tourneur," *Film Comment* 8/2 (1972), 70.

64 Chris Fujiwara, *Jacques Tourneur: The Cinema of Nightfall* (Jefferson, NJ and London: McFarland and Co., 1998), p.86.

65 Tzvetan Todorov, *The Fantastic: A Structural Approach to a Literary Genre,* trans. Richard Howard (Ithaca, NY: Cornell University Press, 1975).

66 Following *I Walked with a Zombie*, Lewton returned again to the land of the living dead, though with far less success. In the Boris Karloff vehicle *Isle of the Dead* (1945), zombies were replaced with a Poe-like story about a woman who is prematurely buried alive. She goes insane and starts stalking and killing a group of tourists stranded on a Greek island during a plague outbreak. Lewton was generally dismissive of the film, claiming: "It started out as a rather poetic and quite beautiful story of how people, fleeing from the battles of the Greek War of 1912, are caught on this island by plague and through their suffering, come to an acceptance of death as being good [...] It ended up as a hodge-podge of horror... This has been a horrible and unfortunate film from the beginning". Lewton also faced interference from his RKO bosses. During pre-production he was warned, "Remember, no messages," to which he politely, but firmly, replied: "I'm sorry but we do have a message and our message is that death is good." Unfortunately, the film was not. See Siegel, p.74 and 71.

67 The plot of *Valley of the Zombies* is rather similar to Vincent Sherman's *The Return of Dr. X* (1939), a film about a mad scientist experimenting with synthetic blood, which starred a young Humphrey Bogart in his debut horror movie appearance. Bogart was sufficiently unimpressed with the low-budget production - which he'd apparently been assigned to as punishment for some unspecified misdemeanour at Warner Bros - that he branded it a "stinking movie" and completely avoided the horror genre for the rest of his career.

68 Mark Jancovich, *Rational Fears: American Horror in the 1950s* (Manchester and New York: Manchester University Press, 1996), p.2.
69 *Ibid.*, p.2.
70 Aubrey Schenck quoted by Tom Weaver in *It Came From Weaver Five: Interviews with 20 Zany, Glib and Earnest Moviemakers in the SF and Horror Traditions of the Thirties, Forties, Fifties and Sixties* (Jefferson, NC and London: McFarland and Co, 1996), p.279.
71 Carlos Clarens, *An Illustrated History of the Horror Film* (London: Secker and Warburg, 1968), p.134.
72 Jancovich, p.22.
73 William Whyte, *The Organization Man* (New York: Simon Schuster, 1956), p.397.
74 Harvey M. Weinstein, *Psychiatry and the CIA: Victims of Mind Control* (London and Washington: American Psychiatric Press, 1990), p.129. For a more detailed history of the American intelligence services' research into mind-control see John Marks, *The Search for the "Manchurian Candidate": The CIA and Mind Control (The Secret History of the Behavioral Sciences)* (New York and London: W.W. Norton, 1979).
75 Lianne McLarty, "'Beyond the Veil of Flesh': Cronenberg and the Disembodiment of Horror," in Barry Keith Grant, ed. *The Dread of Difference: Gender and the Horror Film* (Austin: University of Texas Press, 1996), p.233.
76 *Ibid.*, p.233.
77 Sigmund Freud, *Totem and Taboo: Some Points of Agreement Between the Mental Lives of Savages and Neurotics*, trans. James Strachey (New York: Norton, 1950), pp.63-64. I am indebted to Gregory Waller's insightful discussion of Freud in *The Living and the Undead: From Stoker's Dracula to Romero's Dawn of the Dead* (Urbana and Chicago: University of Illinois Press, 1986), pp.276-77.
78 Freud, "The Uncanny" (1919) in *On Creativity and the Unconscious* (New York: Harper and Row, 1958), p.150.
79 Peter Hutchings, *Terence Fisher* (Manchester and New York: Manchester University Press, 2001), p.127.
80 The full details of this treatment can be found in Peter Bryan, "Zombie! Original Synopsis" *Dark Terrors* 16 (December, 1998), 36-37. Interestingly, the filmed version of the story keeps the Haitian servants but reduces them to incidental characters - it's the squire and his young hooligan friends who act as the voodoo priests, the black servants merely adding some local "colour".
81 This was one of four Mexican horror films that Karloff made just before his death in 1969. Sadly, none of them proved fitting epitaphs for the great actor's horror career. *Isle of the Snake People* delivered a geographically dubious story of Pacific island voodoo zombies cribbed from Karloff's earlier vehicle *Voodoo Island*. According to screenwriter Jack Hill, these productions were never designed to be anything other than ultra-low-budget quickies with Karloff's name employed as an expense that would hopefully dupe distributors and audiences into accepting the shoddy production values. Zombies were used simply to cut costs: "I was required to generate four horror screenplays within the period of only a few months and so a zombie picture was sort of an obvious quick choice". See Senn, *Drums of Terror*, p.156.
82 Sadly, *Obsession: The Films of Jess Franco* ed. Lucas Balbo, Peter Blumenstock (Berlin: Selbstverlag Frank Trebbin, 1993) has been out of print for several years.
83 Given the film's play of difference between Them/Us and Self/Other, it seems significant that a later adaptation of Matheson's novel - director Boris Sagal's *The Omega Man* (1971), starring Charlton Heston in the lead role - turned the scenario into a commentary on American race relations. This adaptation styled its ghouls as a group of albino mutants who clearly owed more to radical 1960s groups like The Black Panthers than the vampires of the novel. In this later film, the ghouls are emphatically not styled as zombies.
84 "Review of *Night of the Living Dead*," *Variety* (16 October, 1968), 6.
85 Roger Ebert, "Just Another Horror Movie - Or Is It?" *Reader's Digest* (June, 1969), 128. This article was an edited version of a piece that appeared in Ebert's film column in the *Chicago Sun-Times* newspaper.
86 Waller, p.289.
87 *Ibid.*, p.275.
88 Dan Yakis, "Mourning Becomes Romero," *Film Comment* 15 (May-June 1979), 62.
89 Waller, p.274.
90 Linda Badley, *Film, Horror and the Body Fantastic* (Westport CT and London: Greenwood Press, 1995), p.74.
91 Robin Wood, "An Introduction to the American Horror Film" in Wood and Richard Lippe eds., *American Nightmare: Essays on the Horror Film* (Toronto: Festival of Festivals, 1979), p.10.
92 Joseph Lewis, "A Bloody Laugh," *The Point* (26 February, 1970), 14.
93 A sign of *Night of the Living Dead*'s success is the number of spoofs it has produced over the years. Two of the weirdest are *Night of the Living Bread* (1990) an eight-minute short in which characters are attacked by slices of white bread and the breathlessly titled *Night of the Day of the Dawn of the Son of the Bride of the Return of the Revenge of the Terror of the Attack of the Evil Mutant Hellbound Flesh-Eating Subhumanoid Living Dead, Part II* (1992), which replays the original movie in full but with a (supposedly) jokey dubbing track.
94 Spoofing *Night of the Living Dead* was an obvious choice, if only because the zombies were cheap monsters. Ormsby's duties included preparing the zombie make-up (credited as Alan Omark). It was something he was also responsible for on *Deathdream*, with a young Tom Savini as his assistant, and on the later *Shock Waves* (1976). Ormsby's stories about the *Children* shoot prove that not even the lowest-budgeted film can always rely on the living dead as a cheap casting option - the extras playing the zombies reportedly went on strike after they discovered that the meatball sandwiches being laid on by their employers were far from fresh (they'd been salvaged from the trash at a local Mr. Meatball restaurant). The shooting schedule was delayed for a couple of days until alternative catering arrangements were made. See Alan Ormsby's interview on the UK Exploited Video release of *Children Shouldn't Play with Dead Things*.
95 Jean-Paul Sartre, *No Exit: A Play in One Act* trans. by Paul Bowles (New York: Samuel French, 1958).
96 Chris Rodley ed., *Cronenberg on Cronenberg* (London: Faber and Faber, 1992), p.43. *Shivers* isn't the only film by Cronenberg to feature monsters similar to zombies. In *Rabid* (1976) porn star Marilyn Chambers heads the cast as a woman whose skin graft operation goes wrong, leaving her with a penile appendage tucked in her armpit and a thirst for blood. Her victims turn into zombified blood drinkers who slowly infect the whole of Canada, prompting the panicking authorities to declare a state of emergency reminiscent of that in Romero's *The Crazies* (here the authorities become as "rabid" as the infected citizens). Judging by these two films, Cronenberg obviously enjoys engaging with the

apocalypse - and shares Romero's distaste for the oppressive, consumerist order dominating the West in the 1970s.

97 Paul Gagne, *The Zombies That Ate Pittsburgh: The Films of George A. Romero* (New York: Dodd, Mead and Company), p.55.

98 Ten years later, Romero put the zombie to similar use in his own portmanteau horror movie, *Creepshow* (1982), which was also conceived as a homage to the E.C. Comics of the 1950s. In the "Father's Day" segment, a mean old patriarch (Jon Lormer) comes back from the grave to kill the daughter who murdered him on Father's Day after his cranky demands for cake became too much for her. When daddy comes back from the grave, he turns her disembodied head into the very cake he'd been denied, complete with icing sugar and candles. In "Something To Tide You Over," Leslie Nielsen buries his cheating wife (Gaylen Ross) and her lover (Ted Danson) up to their necks in sand on the beach and watches as the tide comes in. Later that night, the adulterous pair return as seaweed covered corpses - reminiscent of the living dead in *Zombies of Mora Tau* - and subject him to the same fate. The segment ends with Nielsen dementedly screeching, "I can hold my breath a loooooong time!" It's worth noting that portmanteau horror anthologies often rely on the zombie for some cheap and effective storyline padding - although the results can sometimes be dire. The two walking dead tales in the lamentable collection *Dr. Terror's Gallery of Horrors* (1966) are a suitably egregious example of just that.

99 *Night of the Zombies* (director Joel M. Reed) has several alternative tiles, including *Gamma 693*, *Night of the Wehrmacht Zombies* and even *Night of the Zombies II*. It was released on video in the UK as *The Chilling*, which meant it was often confused with *The Chilling* (directors Jack A. Sunseri and Deland Nuse, 1989). The two films are completely different - the first follows a group of Nazi zombies, the second a group of cryogenically-frozen corpses who are reanimated by a freak lightning bolt - the only thing they have in common is their total dearth of entertainment value or technical skill. Just to complicate matters, it's worth noting that Reed's *Night of the Zombies* shouldn't be mistaken for Bruno Mattei's *Zombie Creeping Flesh* (1980) - which is also sometimes known as *Night of the Zombies*. Such is the confused and confusing world of living dead cinema titles.

100 See Peter Blumenstock, "Jean Rollin Has Risen from the Grave!" *Video Watchdog* 31 (1995), 53. According to Pete Tombs and Cathal Tohill, "even by the low-budget standards of Eurociné the film was ultra cheap. At one point technical problems meant that the camera was running slowly, making the filmed action appear speeded up. There was no possibility of getting it fixed and time was precious, so Rollin had to teach the cast to act in slow motion to compensate". See Pete Tombs and Cathal Tohill, *Immoral Tales: European Sex and Horror Movies 1956-1985* (1994. Reprinted New York: St.Martin's Griffin, 1994), p.155.

101 There seems to be some disagreement over whether or not the opening sequence is set in London or Manchester. In interview, Grau talks about shooting the opening section in Manchester (his original plan was to shoot in Glasgow because it was a city where "everything was black," but this proved too expensive to justify). However, in the English language version of the film, a local farmer comments on George being "up from London" (no doubt because of his over-ripe, dubbed cockney accent!). See Jo Botting, "Catalonian Creeps: An Interview with Jorge Grau," *Shivers* 79 (July, 2000), 25. Bizarrely, for a film that has such a strong sense of place, it was later remade in South Korea as *Goeshi* (aka *Strange Dead Bodies*, 1981); see filmography for more details.

102 Grau claims that Galbo's terrific performance was partly motivated by the death of her husband a few days before shooting started: "In some ways I took advantage of her state of mind and let her express her real horror of death". See Botting, 25.

103 *Ibid.*, 25.

104 See Frederic Levy, "The Rue Morgue: Looking for French Zombies with Jean Rollin," *Starburst* 4/12 (August 1982), 26.

105 *Ibid.*, 26.

106 See Blumenstock, 52.

107 See Tim Lucas, "Versions and Vampires: Jean Rollin on Home Video," *Video Watchdog* 31 (1995), 28-35.

108 During the course of de Ossorio's quartet, the story occasionally changes: angry locals burn out the Templars' eyes in *The Return of the Blind Dead*.

109 Amando de Ossorio, quoted by Mike Hodges in his obituary "Amando de Ossorio: Farewell to Spain's Knight of Horror" *Shivers* 88 (April, 2001), 19.

110 *Ibid*, 20.

111 Tohill and Tombs, p.5.

112 *Ibid.*, p.53.

113 Nigel J. Burrell, *Knights of Terror: The Blind Dead Films of Amando de Ossorio* (Upton, Cambridgeshire: Midnight Media Publishing, 1995), p.5.

114 In Jess Franco's unabashed rip-off of the Blind Dead series, *La mansión de los muertos vivientes* (lit. *Mansion of the Living Dead*, 1982) he indulges in much the same catalogue of sex and death with a plot in which a group of girls discover that the Canary Islands are overrun by the spirits of the Spanish Inquisition. Lesbian interludes, rape and genital mutilation are the outcome.

115 Gagne, p.83.

116 *Ibid.*, p.97.

117 See Alan Jones, "George Romero Interview," *Starburst* 4/12 (August 1982), 36-37.

118 Gagne, p.87.

119 Stephen King "The Horrors of '79" *Rolling Stone* (27 December 1979-10 January 1980), 19.

120 Zombies and bikers make strange, but surprisingly common, bedfellows. The British cult horror movie *Psychomania* first introduced the theme in 1972 with its story of a motorcycle gang aptly called The Living Dead, who are brought back from the grave and go on the rampage in the sleepy English countryside. A worthy successor to this was Antony Balch's dementedly camp movie *Horror Hospital* (1973), which featured homoerotic leather-clad biker boys, a gymnasium full of lobotomised zombies and an unlikely starring role for Robin Askwith. In addition to *Dawn of the Dead*, several other American zombie movies have also mixed bikers and zombies: *Kiss Daddy Goodbye* (aka *Revenge of the Zombie*, 1981), *Chopper Chicks in Zombie Town* (1989), *Zombie Cult Massacre* (1997) *Hot Wax Zombies on Wheels* (1999) and *Biker Zombies from Detroit* (2001).

121 Barry Keith Grant, "Taking Back the *Night of the Living Dead*: George Romero, Feminism, and the Horror Film," in Grant ed., p.202.

122 Robin Wood, "Apocalypse Now: Notes on the Living Dead" in Wood and Richard Lippe eds, *American Nightmare: Essays on the Horror Film* (Toronto: Festival of Festivals, 1979), p.95.

123 Gagne, p.89.

124 Romero is generally credited with coining the term "splatter" to describe the post-*Night of the Living Dead* horror

movie's emphasis on gory special effects which show the human body in various states of decay and rupture. According to horror movie historian John McCarty, splatter movies offer audiences the chance to see the impact of physical violence "in every minute, blood spurting, bony, sinewy, muscle-exposing detail". The aim is not to scare audiences, "but to *mortify* them with scenes of explicit gore". See McCarty, *Splatter Movies: Breaking the Last Taboo of the Screen* (New York: St. Martin's Press, 1984), p.1.

[125] Gagne, p.100.

[126] Roger Ebert, "Review of *Dawn of the Dead*," *Chicago Sun-Times* (20 April, 1979).

[127] "Review of *Dawn of the Dead*," *Variety* (18 April, 1979), 22.

[128] Janet Maslin, "Review of *Dawn of the Dead*," *New York Times* (20 April 1979).

[129] Wood, "An Introduction to the American Horror Film," p.17.

[130] Wood, "Apocalypse Now: Notes on the Living Dead," p.95.

[131] Gagne, p.91.

[132] Alan Jones, "Morti Viventi: Zombies Italian-Style," in Allan Bryce ed. *Zombie* (Liskeard, Cornwall: Stray Cat Publishing, 2000), p.19.

[133] Stephen Thrower, *Beyond Terror: The Films of Lucio Fulci* (Guildford, Surrey: FAB Press, 1999), p.23.

[134] The over-eagerness of various producers to set up their product as sequels to Fulci's own unofficial sequel caused quite a few inconsistencies as various films were touted as "Zombie 3" and "Zombie 4" etc., often with little regard for each other or the niceties of chronological order. The video market's habit of re-titling these low-rent films to maximise their appeal didn't help, producing a stream of "unofficial" sequels. By the time Fulci eventually got around to making his own sequel, *Zombi 3* (1988), the market was already saturated. Worse still, Fulci's long-awaited follow-up was a terrible disappointment, a truly execrable piece of incompetence that combined inept performances, with a ridiculous storyline about a stolen viral agent that turns the infected into zombie-like monsters. The project might have sunk Fulci's already troubled reputation if it were not for rumours that ill health prevented him from actually taking part in much of the shoot - Bruno Mattei allegedly replaced him.

[135] One filmmaker who has managed to take this combination of sex and horror beyond the merely silly is Canada's David Cronenberg, whose films frequently focus on a form of pornography that's borne out of disgust rather than arousal. While Cronenberg is a ferociously intelligent and talented filmmaker whose work bears little resemblance to the technical ineptitude and hopelessly confused narratives that characterise the Italian movies of the period, the thematic similarities between his work and that of Italian horror's interest in sexual horror are readily apparent. Giving oneself up to the body's pleasures is, in Cronenberg's *Shivers*, the same as becoming a zombie (as the body revolts and overthrows the head). As Cronenberg explains with typical insight: "There's a Latin quote that goes '*Timor mortis conturbat me*,' which, roughly translated, means, 'The fear of death disturbs me'. Death is the basis of all horror, and for me death is a very specific thing. It's very physical. That's where I become Cartesian. Descartes was obsessed with the schism between mind and body, and how one relates to the other ... My films are very body-conscious. They're very conscious of physical existence as a living organism." See Rodley ed., p.58.

[136] A quick on-line search proves that zombie porn is far from dead. *Stethoscope* (2001), an arty 16-minute short, features a zombie orgy that converts a handful of living voyeurs into XXX ghouls. Meanwhile, a selection of female "Zombie Pin-ups" can be found at the website <http://www.zombiepinups.com>. Clearly, the strange desire for "gorno" continues unabated.

[137] Kristeva's theory of abjection is the basis of her seminal work *Powers of Horror: An Essay on Abjection*, trans. Leon S. Roudiez (New York: Columbia University Press, 1982).

[138] Ibid., p.3.

[139] Ibid., pp.3-4.

[140] Thrower, p.163.

[141] Robert Schlockoff, "Lucio Fulci" *Starburst* 4/12 (August, 1982), 54.

[142] Thrower, pp.163-64.

[143] See Howard Berger, "The Prince of Italian Terror" *Fangoria* 154 (July, 1996), 65 and Luca M. Palmerini and Gaetano Mistretta, *Spaghetti Nightmares: Italian Fantasy-Horrors as Seen Through the Eyes of Their Protagonists* (Key West, Florida: Fantasma Books, 1996), p.54.

[144] Such eye trauma dominates *City of the Living Dead* and *The Beyond* but is largely absent from *The House by the Cemetery*. However, that film is equally fascinated with ways of *seeing*, foregrounding Bob's child's eye view of this world (and the next). The fact that *House* is a more conventionally structured narrative, of course, suggests one possible reason why eyeball horror isn't so pronounced in its special effects sequences.

[145] Despite the portentous tone of the trilogy, its chief text isn't Biblical scripture but the sub-Lovecraftian *Book of Eibon*, a fictional occult volume penned by *Weird Tales* writer Clark Ashton Smith.

[146] Thrower, p.176.

[147] Thrower, p.60.

[148] Antonin Artaud, *The Theatre and Its Double* trans. Victor Corti (1964. London: Calder, 1993), p.60

[149] Perhaps one indication of Fulci's iconoclastic treatment of the afterlife is to be found in David Warbeck's anecdote about shooting the Sea of Darkness scenes of *The Beyond*. According to the actor, the bodies that populate the Sea of Darkness were local winos who were drafted in from outside the studio in Rome with the lure of alcohol: "the only way to get them to lie down was to give them booze". See Thrower, p.160.

[150] Plans for a follow-up to *The Beyond* were briefly considered after the original film's success and the provisional title of "The Beyond 2 - Beyond the Beyond" was suggested. The story was set to pick up after Liza and John's disappearance into The Beyond, although given the fact that Fulci envisioned that realm as one of infinite nothingness, it's hard to see what anyone could have come up with in the way of a storyline! The idea for a sequel was finally shelved after Fulci and Warbeck's deaths in 1996 and 1997 respectively.

[151] Schlockoff, 54.

[152] Ibid., 54.

[153] Ibid., 54.

[154] Friedrich Nietzsche, *Beyond Good and Evil: Prelude to a Philosophy of the Future* trans. R.J. Hollingdale (1886. London: Penguin, 1990), p.102.

[155] Thrower, p.19.

[156] Palmerini and Mistretta, p.59.

[157] The fact that *Day of the Dead* takes place in Florida seems significant, the proximity between America's Sunshine State and the Caribbean being particularly important.

[158] Sue Ellen Case, "Tracking the Vampire" in Gelder ed., *The Horror Reader* (London and New York: Routledge, 2000), p.209.

notes and references

159 Gagne, p.155.

160 *Day of the Dead* was originally conceived as a much bigger picture (and one that would have required a hefty $16 million budget to be realised on screen - far more than anyone was willing to stump up for a film that was unlikely to receive an MPAA certificate). According to Gagne, the original treatment was to take the zombie revolution "to a point where the living dead have basically replaced humanity and have gained enough of a rudimentary knowledge to be able to perform a few basic tasks. At the same time, an elite, dictatorial politburo of humans has found that the zombies can be *trained*, and are exploiting them as slaves." The close links between such a scenario and the zombie's Caribbean origins are pretty obvious. See Gagne, p.147.

161 Brenda Gale Plummer, *Haiti and the United States: The Psychological Moment* (Athens and London, University of Georgia Press, 1992), p.217.

162 Davis, *The Serpent and the Rainbow*, p.123.

163 *Ibid.*, p.130.

164 Senn, *Drums of Terror*, p.216.

165 Maitland McDonagh, "Sometimes They Come Back... Again: The Making of the *Return of the Living Dead* Trilogy" in Bryce ed., p.59.

166 Gagne, p.167.

167 One less well-known director who attempted this particular balancing act of horror, comedy and zombies was Robert Scott. His debut *The Video Dead* (1987) concerns a group of zombies who emerge from a cursed black and white TV set. The only thing the TV ever plays is a movie called "Zombie Blood Nightmare" and, if watched for long enough, the zombies eventually crawl out of the screen into the world of the living. Generally hated by the majority of horror fans - some of whom have frequently described it as one of the worst films of the 1980s - it may well be one of the most underrated films of the genre. It's a fun little movie with enough invention to take on the whole *Return of the Living Dead* franchise put together. While most zombie movies take place in houses where the characters are sheltering from the zombies outside, *The Video Dead* begins with the zombies already indoors. Domesticating its zombies with hilarious results (they sit around the kitchen table, muck about with the blender and generally get in the way), *The Video Dead* neatly lampoons the genre and includes several very funny sequences amongst the creepy tension - one of which follows the young hero as he chases a zombie bride into the woods, tracking her by the sound of the whirling chainsaw she's carrying. Sadly, this writer seems to be the only horror fan who thinks the movie's any good. Filmmaker Scott hasn't done anything since apart from lots of second unit work on *Beverly Hills 90210*, so clearly there's no accounting for taste.

168 Phil Edwards and Alan Jones, "The Evil Dead Speak: An Interview with Sam Raimi and Robert Tapert" *Starburst* 57 (May, 1983), 29.

169 Balun, Chas, "Re-Animator" *Fangoria* 234 July 2004, 31.

170 Maitland McDonagh, "*Re-Animator* and *Bride of Re-Animator*," in Bryce ed., p.52. Unsurprisingly, the only time the *Return of the Living Dead* franchise ran into serious trouble with the MPAA was when Yuzna took the reins of the third film in the series in 1993.

171 Kim Newman, "Review of *Bad Taste*." *Monthly Film Bulletin* 56/668 (September, 1989), 267-268.

172 Romero's comments to *The Wall Street Journal* are quoted in Michael Frasher, "*Night of the Living Dead*: Remaking George Romero's Horror Classic," *Cinefantastique* 21/3 (Dec, 1990), 17.

173 *Ibid.*, 17.

174 See Simon Bacal "*Night of the Living Dead*: An Interview with John Vulich and Everett Burrell," *Starburst* 19 Monster Special (April, 1994), 64-66.

175 Mike Watt, "*Night of the Living Dead* 1990," *Cinefantastique* 34 3/4 (June, 2002), 116.

176 *Ibid.*, 117.

177 Barry Keith Grant, "Taking Back the *Night of the Living Dead*: George Romero, Feminism, and the Horror Film" in Grant ed., p.202.

178 *Ibid.*, p.208.

179 Neil Fawcett, "Dusk of the Dead" on <http://www.homepageofthedead.com>.

180 Barnes and Noble, "Interview: George A. Romero" on Barnes&Noble.com (8 August 2000). See <http://video.barnesandnoble.com/search/interview.asp?ctr=643332>.

181 One could argue that serial killer Jason Voorhees is a kind of zombie. Inexplicably resurrected from the lake where he drowned as a child at the end of *Friday the 13th* (1980), Jason went on to terrorise teens through various sequels. In the sixth film, *Friday the 13th Part VI: Jason Lives* (1986), he was resurrected from the dead again - this time by a freak lightning bolt. Hovering somewhere between serial killer, zombie and Frankenstein's monster, he's certainly far from human.

182 Richard King "J.R. Bookwalter: A Career in B-Movies and Beyond" *Dark Star* 14/15, reprinted online at <http://www.darkstarorg.demon.co.uk>.

183 Sheets, "The Extreme Entertainment Mission Statement" published online at <http://www.zombiebloodbath.com/mission.html>.

184 *Ibid*.

185 Screen Edge, "Scooter McCrae: The Shatter Boy," published online at <http://www.screenedge.com>.

186 See the sleeve notes to *I, Zombie*'s VHS release on the Screen Edge label.

187 M.J. Simpson, "*Dead Creatures*: Parkinson's Disease," *Fangoria* 206 (September, 2001), 67.

188 Peter Blumenstock, "Michele Soavi: Gravely Speaking," *Fangoria* 149 (January, 1996), 54.

189 Alan Jones, "*Dellamorte Dellamore*," *Cinefantastique* 25/5 (October, 1994), 53.

190 *Ibid.*, 55.

191 *Ibid.*, 55.

192 Kiyoshi Kurosawa's *Suito Homu* (*Sweet Home*, 1989) was a *Poltergeist*-style haunted house movie with special make-up effects by the legendary Dick Smith. Its Nintendo adaptation was a success in Japan, but it was never released internationally. The nearest gaming equivalent was the *Alone in the Dark* series that began in 1993.

193 Shinji Mikami, "Preface" in *Resident Evil: The Book* (Capcom, 1996), p.1. Also online at <http://www.survivhor.com>.

194 *Ibid.*, p.2.

195 *Ibid.*, p.3.

196 Shinji Mikami in a 1996 *GamePro* magazine interview reprinted on *Survivor's Guide Network: Total Coverage of Resident Evil* at <http://www.planetdreamcast.com/residentevil/sec/features/articles/00003.htm>.

197 Steven Poole, *Trigger Happy: The Inner Life of Videogames* (London: Fourth Estate, 2000), p.79.

198 Travis Crawford, "Director *Versus* Everybody," *Fangoria* 213 (June, 2002), 50.

199 Norman England, "Who Made This *Junk*?" *Fangoria* 222 (May, 2003), 40.

200 Travis Crawford, "*Wild Zero*: Brain-Dead and Loving It," *Fangoria* 203 (June, 2001), 44.
201 Crawford, "Director *Versus* Everybody," 50.
202 Romero's distrust of the American studio system is a frequent topic of conversation in interviews. "Economically, you can't make money on a small scale with a movie in this country," he told *Film Criticism* in 1982. "The small distributors have gone belly up; there's just no competition any more. You can't get screens. It's part of the McDonaldization of America, unfortunately." See John Hanners and Harry Kloman, "'The McDonaldization of America': An Interview with George A. Romero" in *Film Criticism* 7/1 (Fall, 1982), 74.
203 By this point, many fans had already read Romero's script themselves after a copy found its way onto the Internet. It did little to convince them that Capcom's suggestion that Romero's writing was not up to scratch was anything more than a bluff. The real problem was obviously the director's maverick approach to the material.
204 Letter from an anonymous reader, *Fangoria* 203 (June, 2001), 6.
205 Incredibly, Romero was offered the opportunity to direct *Scream*. He turned it down, saying that he couldn't understand "whether it was supposed to be funny or scary". See Anthony C. Ferrante, "Return of the Living Dead Director" *Fangoria* 171 (April, 1998), 22. One wonders what might have been.
206 The chronology of *Resident Evil*'s production can be found in Martin Blaney's article "International Production Case Study: *Resident Evil* Ground Zero," *Screen International* (5 October 2001), 18.
207 Paul W.S. Anderson interviewed by Alan Jones in "*Resident Evil*" *Cinefantastique* 34/2 (April, 2002), 11. As if to emphasise the change in temperament from previous zombie outings, lead actress Milla Jovovich claimed that the reason why she was drawn to the film was because of her younger brother: "Me and my little brother played this game, like, *non-stop* last summer, and he thinks I'm God for doing this movie". It was a sure sign that the audience for *Resident Evil* encompassed children and teenagers rather than adult horror fans - and only by keeping the gore to a bare minimum could the film could secure a suitable certificate for such an audience. See Steve Grayson "On-Set Report: *Resident Evil*," *Empire* 145 (July, 2001), 50.
208 In the US *Resident Evil* was trimmed to avoid the much-stigmatised NC-17 rating (no one under 17 allowed) which is generally considered to be commercial suicide. The film was released with an R-Restricted rating, which allows anyone under 17 to attend as long as an adult accompanies them (in reality cinemas rarely enforce this with much severity). In the UK, the film was granted a 15 certificate without further cuts - a sure sign in Britain's current climate of censorship that its "horror" content was relatively mild.
209 Mark Salisbury, "Dead Residents: On the Set of *Resident Evil*," *Total Film* 55 (August, 2001), 8.
210 Mark Salisbury, "To Make the Blood Boyle," *Fangoria* 224 (July, 2003), 21.
211 Danny Boyle, "Soundbite," *SFX* 104 (May, 2003), 85.
212 Alan Morrison, "Rage Against the Machine," *Empire* 161 (November, 2002), 100.
213 Boyle, 85.
214 Andrew Osmond, "In The Hot Zone," *Cinefantastique* 35/3 (Jun/Jul 2003), 39.
215 Simon Pegg, *Shaun of the Dead* Press Conference (London, 29 March 2004).
216 Edgar Wright, *Shaun of the Dead* Press Conference (London, 29 March 2004).
217 Pegg, Press Conference.
218 *Ibid.*
219 *Ibid.*
220 Many thanks to Daniel Etherington at *Channel 4 Film.com* for sharing this unpublished section of his interview transcript of his one-on-one conversations with Pegg and Wright on 29 March 2004. Etherington's entertaining conversation with Pegg and Wright about zombies and videogames can be found online at <http://www.bbc.co.uk/dna/collective/A2499744>.
221 Rod Gudino, "The Dead Walk... Again!: A George A. Romero Retrospective," *Rue Morgue* (July/August, 2003), 16.
222 Tony Timpone, "Elegy: Controversy 'Dawns,'" *Fangoria* 231 (April, 2004).
223 Michael Rowe, "Gunn to the Head," *Fangoria* 231 (April, 2004), 28.
224 Michael Rowe, "New 'Dawn' Rising," *Fangoria* 227 (October, 2003), 45.
225 Entertainment Film Distribution, "UK Publicity Press Notes for *Dawn of the Dead*" (2004).
226 Michael Rowe, "Gunn to the Head," 28.
227 Zombie comics were, of course nothing new. The 1990s had its fair share of titles including several series based on movies like *Night of the Living Dead*, *Re-Animator* and *Army of Darkness*. There were also other titles including *Dead King*, *Dead in the West* and *Zombie World*.
228 *Land of the Dead* is also the first film in Romero's series to refer to its walking corpses as "zombies", the earlier films pointedly avoided any definition of them as such.
229 At the time of writing, SOTA Toys is preparing a line of figures based on the film's characters for release in early 2006.
230 Michael Rowe, "Land of the Dead: Home of the Grave," *Fangoria* 244 (June, 2005), 53.
231 Todd Gilchrist "Land of the Dead on DVD," published online at IGN.com <http://dvd.ign.com/articles/629/629341p1.html>.
232 Rowe, "Land of the Dead: Home of the Grave," 54.
233 Michael Gingold, "This LAND is Gore Land," *Fangoria Website*, published online at <http://www.fangoria.com/fearful_feature.php?id=2675>.
234 Fiddler's Green is also the title of a nineteenth-century sailor's song about a mythical realm where seafarers who die on land are destined to spend eternity. It was said to be a place of unlimited mirth, tobacco and rum.
235 Rowe, "Land of the Dead: Home of the Grave," 51.
236 *Ibid.*, 54.
237 *Ibid.*, 55.
238 Lewis Beale, "The Zombies Brought Him: George Romero Is Back," *New York Times* (3 November, 2004).
239 Scott Foundas, "Dead Man Talking: The Resurrection of Zombie Godfather George A. Romero," *The Village Voice* (28th June, 2005), 12.
240 Alan Jones, "George of the Dead," *Shivers* 121 (June, 2005), 13.
241 Pegg, Press Conference.
242 Romero told one interviewer: "I'd love to continue the story, and if this movie does well, it might be the first time where I'm asked to do another one quickly. Which is what worries me - unless we get nuked in the next six months and then there's something else to talk about." See Foundas, 12.

chapter nine

Zombie Filmography

By Jamie Russell and David A. Oakes

The aim of this extended zombie filmography is two-fold. Firstly, to offer a dip-in/dip-out collection of credits and background information on every title mentioned in the course of this book. Secondly, to give some space to those titles that were deliberately not included in the main text. Since *Book of the Dead* charts the chronological development of the zombie genre in terms of themes, some titles were inevitably left by the wayside as their inclusion would have detracted from each section's overriding focus. No filmography is ever *completely* complete and this one doesn't claim to be definitive. With so many zombie movies floating around (and so many that haven't had the benefit of a theatrical release), it proved impossible to track down every single one. Yet what follows does cover all the most important and/or accessible films at the time of publication.

The most persistent question asked when compiling this filmography was one that really doesn't have an answer: when is a zombie not a zombie? Rather than subscribe to a limited (and limiting) definition of inclusion, I decided instead to take a more relaxed approach. That's why the parameters used for including films in this filmography are governed less by strict rules of classification than this author's desire to chart the scope of an ever-evolving, surprisingly fluid genre.

As a result, creatures that act like, but aren't strictly, living dead zombies are sometimes included here. For instance, the ghouls of *Invasion of the Body Snatchers*, *The Last Man on Earth* and *28 Days Later* have managed to slip into this filmography simply because any attempt to understand the zombie genre without them would be impossible. Despite not featuring traditional zombies, these films (and others) had a huge impact on the development of the zombie genre itself. Likewise, some films that profess to star zombies but actually feature very different villains (like the spacemen 'zombies' of *Zombies from the Stratosphere*) have been included. When discussing such borderline films I have tried to be explicit in pointing out whether or not the ghouls in question are bona fide zombies (dead bodies reanimated by magic or science), complete imposters, or simply distant but influential cousins.

Finally, a note on dates. Actual copyright dates for each film have been included as a matter of course along with technical and cast credits, original and alternative titles, country of origin and a brief piece of commentary. Happy browsing!

THE AFTERMATH

1980, USA
Alternative title: **Zombie Aftermath**
Dir: Steve Barkett. *Prod:* Steve Barkett.
Scr: Steve Barkett
Cast: Steve Barkett, Lynne Margulies, Sid Haig, Christopher Barkett, Alfie Martin, Forrest J. Ackerman, Jim Danforth

The green-faced ghoul on the original video sleeve promises lots of zombie mayhem as two US astronauts return to earth to find the world's population wiped out by a nuclear war. Cities are reduced to rubble and gangs of "mindless battered monsters" roam the streets. It's the perfect post-apocalyptic set up. Except *The Aftermath* only has three mutant ghouls, who appear for a couple of minutes halfway through then vanish again. The rest of the film follows spaceman Steve Barkett as he befriends a cute moppet kid and battles an evil (non-zombie) outlaw played by Sid Haig. Horror legend Forrest J. Ackerman makes a brief appearance as a dying museum curator who lasts just long enough to pass on some vital plot information. "They returned from space expecting a hero's welcome. They were met by something very, very different," proclaims the tagline. If you picked this up expecting zombies, you'll be equally disappointed...

THE ALIEN DEAD

1980, USA
Alternative title: **It Fell from the Sky**
Dir: Fred Olen Ray. *Prod:* Chuck Sumner, Fred Olen Ray. *Scr:* Fred Olen Ray, Martin Alan Nicholas
Cast: Buster Crabbe, Raymond Roberts, Linda Lewis, Mike Bonavia, George Kelsey

The Aftermath

Meteorites turn the living into zombies in this cruddy effort starring an ageing Buster *Flash Gordon* Crabbe as a small-town sheriff responsible for investigating the strange goings on. The zombies spend most of their time hanging out in the Florida swamps, preying on swimmers and occasionally emerging to drag unlucky souls down to their doom. Pretty dismal for all concerned.
See page 151

ARMY OF DARKNESS

1992, USA
Alternative titles: **Army of Darkness: The Medieval Dead, Evil Dead 3**
Dir: Sam Raimi. *Prod:* Robert Tapert, Bruce Campbell. *Scr:* Sam Raimi, Ivan Raimi
Cast: Bruce Campbell, Embeth Davidtz, Marcus Gilbert, Ian Abercrombie, Richard Grove

Poor old Ash finds himself flung back in time to the fifteenth-century to battle yet more demons in the final part of Raimi's *Evil Dead* trilogy. Armed with his trusty chainsaw and shotgun he's out to destroy the pesky Necronomicon once and for all. Not many zombies, although there are plenty of demonic Deadites and an army of skeletons who have a bone to pick with our weary hero. Memorable one-liners ("Well, I've got news for you pal, you ain't leadin' but two things: Jack and shit... and Jack just left town.") and plenty of chainsaw action keep things fresh, but by this point the franchise was beginning to run out of steam.
See page 157, note 227

THE ASTRO-ZOMBIES

1967, USA
Alternative title: **Space Zombies**
Dir: Ted V. Mikels. *Prod:* Ted V. Mikels. *Scr:* Ted Mikels, Wayne Rogers
Cast: Wendell Corey, John Carradine, Tom Pace, Joan Patrick, Tura Satana

Carradine's mad scientist has created a sci-fi Frankenstein's monster out of bits and pieces of body parts. Does it obey orders? Yes, but only when those orders are to go on a killing-spree. A script full of pseudo-scientific twaddle and a monster that's clearly a bloke in a cheap joke store mask make this a lamentable addition to the zombie genre.
See pages 65, 101

AT TWILIGHT COME THE FLESH-EATERS

1998, USA
Dir: Vidkid Timo. *Prod:* Vidkid Timo and Jim Buck. *Scr:* Vidkid Timo
Cast: Jim Buck, Vidkid Timo, Kiki Ann Karrion, Lew R., Chris Sheridan

Zombie cinema's only gay porno zombie outing works as both a skin flick and a cheesy horror spoof thanks to an ingenious movie-within-a-movie setup. A couple of guys plan to spend an evening at home watching a certain video called *Night of the Living Dead*. The rejigged Romero classic opens with Barbara (filmmaker Vidkid Timo in drag) sucking off her brother Johnny on their mother's grave while doing her best to ignore his attempts to scare her ("They're coming to rape you Barbara. They're going to gangbang you Babs!"). Pretty soon sex-crazed zombies are on the loose and Barbara's forced to take refuge in an isolated farmhouse with an assortment of other survivors. Lots of hardcore gay sex punctuates the action and there are funny parodies of *Night of the Living Dead*'s key scenes including a zombie girl who kills her mother with a hairdryer (!). At one point the black hero decides to relieve his pent-up tension by masturbating over the kitchen floor of the besieged farmhouse - which pretty much sums up the iconoclastic nature of this outrageous spoof. Quite what Romero would make of it all is debatable.
See page 135

BACK FROM THE DEAD

2001, New Zealand
Dir: Craig Godfrey. *Prod:* Craig Godfrey. *Scr:* Craig Godfrey
Cast: Tim Aris, Genevieve Morris, John Xintavelonis, Josephine Lee, Chris Baz

This New Zealand film desperately wants to be a kinetic slapstick horror-comedy à la Peter Jackson's *Braindead*. However, it fails miserably. The plot makes no sense whatsoever with a Hitler-esque mad doctor, a cannibal, angry ghosts, a family of invincible zombies and a legion of other things chucked into the mix for good measure. There are no Romero-type zombies here, but the fact that some characters cannot be killed even when they're beheaded just about qualifies it as a zombie movie. However, the utter mess of a plot and the lack of laughs do little to recommend it even to hardened fans of the *corps cadavres* (DAO).

BAD TASTE

1987, New Zealand
Dir: Peter Jackson. *Prod:* Peter Jackson. *Scr:* Peter Jackson, Tony Hiles, Ken Hammon
Cast: Terry Potter, Peter O'Herne, Craig Smith, Mike Minett, Peter Jackson

Intergalactic aliens invade New Zealand in this lo-fi - but delightfully inventive - gross out zombie comedy. A squad from the Astro Investigation Defence Service (AIDS, ahem) are dispatched to battle the intergalactic bullies and end up fighting off zombies, giggling their way

At Twilight Come the Flesh-Eaters

through the ridiculous dialogue and getting mucky as the special effects team try their best to live up to the film's title. The lowest point involves one of our heroes having to sup from a bowl of vomit plus there's a rousing chainsaw/rebirth climax designed to make you larf till you barf. Shot on 16mm over several years while the cast and crew scrimped and saved enough money complete it, *Bad Taste* puts the threadbare filmmakers of the SOV cycle to shame. It may be bargain basement cinema yet it comes with more wit and ingenuity than any of the American backyard epics that followed it. Jackson eventually went on to make *The Lord of the Rings* trilogy - which surely must be one of the most incredible career arcs in the history of modern cinema.
See pages 159-160

BATTLEFIELD BASEBALL

2003, Japan
Original title: **Jigoku kôshien**
Dir: Yudai Yamiguchi. *Prod:* Ryuhei Kitamura. *Scr:* Yudai Yamiguchi
Cast: Tak Sakaguchi, Atsushi Ito, Hideo Sakaki

The team responsible for hyperkinetic Asian zombie outing *Versus* continue their assault on the genre with *Battlefield Baseball*, a manic zombie sports movie in which two high school teams battle it out on the baseball diamond. Reworking the no-holds barred craziness of *Versus*, this simply swaps samurai swords for baseball bats as the human players of Seido High face the notoriously deadly (and completely living dead) team from Gedo High. Fortunately, Seido have a secret weapon: a legendary player not afraid of facing down grey skinned ghouls. Best not to ask why or how, just sit back and enjoy the outrageous, home-run-hitting comedy-horror.
See pages 172, 174

BEVERLY HILLS BODYSNATCHERS

1989, USA
Dir: Jon Mostow. *Prod:* P.K. Simonds Jr., Jon Mostow. *Scr:* P.K. Simonds Jr.
Cast: Vic Tayback, Frank Gorshin, Art Metrano, Rodney Eastman, Warren Selko

There are plenty of strange goings on in the Eternal Palms Mortuary in Jon Mostow's slacker comedy as unemployed kids Vincent and Eddie discover that the mob-connected proprietors are resurrecting the dead. Various complications ensue, until the chief mortician tweaks his formula so that the corpses don't come back as braindead, spaghetti-eating idiots. Neither funny, nor scary, nor entertaining.
See page 154

THE BEYOND

1981, Italy
Original title: **L'aldilà**
Alternative titles: **L'au-delà**, **Die Geisterstadt der Zombies**, **Seven Doors of Death**
Dir: Lucio Fulci. *Prod:* Fabrizio De Angelis. *Scr:* Dardano Sacchetti, Giorgio Mariuzzo, Lucio Fulci
Cast: Katherine [Catriona] MacColl, David Warbeck, Sarah Keller [Cinzia Monreale], Antoine Saint John, Veronica Lazar

The second film in Fulci's loose zombie trilogy finds New York girl Liza moving down to New Orleans to renovate an old hotel. She doesn't realise that the hotel houses the body of a dead painter murdered decades earlier, nor that it's about to become a gateway to hell. A genre classic.
See pages 7, 131, 137-142, 194-195, notes 144, 145, 149, 150

BEYOND RE-ANIMATOR

2003, USA/Spain
Dir: Brian Yuzna. *Prod:* Julio Fernández, Brian Yuzna. *Scr:* José Manuel Gómez, Miguel Tejada-Flores

Cast: Jeffrey Combs, Jason Barry, Elsa Pataky, Simón Andreu, Bárbara Elorrieta

Dr. Herbert West gets banged up in the third film in the Re-Animator series. Fortunately, prison proves to be the perfect place to continue his re-animating experiments and it's not long before the dead start walking all over again. A lifeless corpse of a movie, this disappointing sequel only springs into action for a bonkers scene involving a silhouette fight between a rat and a severed (but reanimated) penis. Cthulhu only knows what H.P. Lovecraft would make of that one.
See page 159

BEYOND TERROR

1980, Spain
Original title: **Más allá del terror**
Alternative title: **Au delà de la terror**
Dir: Tomás Aznar. *Prod:* Francisco Ariza.
Scr: Tomás Aznar
Cast: Francisco Sanchez Grajera, Emilio Siegrist, Alexia Loreto, Andree van de Woestyne, David Forrest

This obscure Spanish film plays like *The Last House on the Left* of zombie cinema. Killers rob a roadside diner, kidnap a wealthy couple then head for the countryside. Along the way, they commit a trail of brutal murders - even bludgeoning an old woman's pet dog to death - before hiding out in a ruined old church. Eventually they get their just desserts: the crypt beneath the church inexplicably spews forth cobwebbed zombies, among whom are the bodies of all their dead victims - including the dog! Solemnly paced and not especially interesting, *Beyond Terror* spends most of its time following its protagonists as they hang out and bicker among themselves. The desiccated zombies owe a nod to the Blind Dead yet the climactic gory death scenes are more *Scanners* than de Ossorio.

BIKER ZOMBIES FROM DETROIT

2001, USA
Dir: Todd Brunswick. *Prod:* Tommy V. Brunswick. *Scr:* John Kerfoot
Cast: Tyrus Woodson, Jillian Buckshaw, Joshua Allen, Jeffrey Michael, Rob Roth

They're bikers, they're zombies and they're from Detroit. Can we leave it at that? No? OK then, this waste of videotape follows a demon recruiting hardened criminals for his zombie army. He sends his minions to kill our hero, who returns as a zombie but refuses to join the Harley-riding ghouls. "Evil never looked so bad" according to the taglines. And neither did backyard cinema...
See note 120

BIO COPS

2000, Hong Kong
Original title: **Sheng hua te jing zhi sang shi ren wu**
Alternative title: **Bio-Crisis Cops**
Dir: Wai-Man Cheng. *Prod:* Wong Jing.
Scr: Chuek-Hon Szeto
Cast: Stephen Fung, Sam Lee, Alice Chan, Wai Ming Chan, Benny Lai

An unofficial sequel to *Bio-Zombie*, this replicates the same kind of Hong Kong comedy with a new cast (Lee is the only familiar face) and a slightly different premise. The result is entertainingly daffy. A CIA funded experiment to create "Painless Warriors" for use in Iraq gets out of control when the project's boss, Harry, is bitten by the first test subject. After turning into a flesh-eating, green-goo-dribbling zombie, Harry takes over a country police station and infects everyone he comes across. Out to stop him are Sam Lee's cowardly triad, copper Stephen Fung and feisty heroine Alice Chan. Lee steals the show by replaying much the same slapstick role as he did in Bio-Zombie and there's a half-arsed subtext about viruses, AIDS and safe sex. The best moments include Lee pretending to be one of the zombies (stumbling

around with his arms outstretched) and an utterly silly gag in which the heroes use gas-filled condoms as weapons against the randy "Zombie New Humans".
See page 174

BIO-ZOMBIE

1998, Hong Kong
Original title: **Sang dut sau shut**
Dir: Wilson Yip Wai Shun. Prod: Joe Ma.
Scr: Matt Chow, Wilson Yip, Siu Man Sing
Cast: Jordan Chan, Sam Lee, Angela Tong, Yiu-Cheung Lai, Emotion Cheung

Hong Kong's New Trend Plaza Mall becomes the site of a zombie outbreak after an Iraqi biological weapon hidden in a Lucozade bottle sets the living dead loose. So that's what happened to those missing weapons of mass destruction...! An unofficial sequel - *Bio Cops* - followed.
See pages 172, 174

BIOHAZARDOUS

2000, USA
Dir: Michael J. Hein. Prod: Howard Hein.
Scr: Michael J. Hein
Cast: Sprague Grayden, David Garver, Al Thompson, Thomas A. Cahill, Will Durham

Here we go again with another variation of a typical zombie plot: Gentech Industries is conducting secret experiments that unleash a horde of living dead ghouls. Two groups - religious extremists and teenage partygoers - have to fight their way through the carnage. The opening features a character called John Romero, by which point it's obvious where this unoriginal little flick is heading (DAO).
See page 166

BLOOD OF GHASTLY HORROR

1971, USA
Alternative titles: **Fiend with the Electronic Brain**, **Man with the Synthetic Brain**, **Psycho a Go-Go**
Dir: Al Adamson. Prod: Al Adamson.
Scr: Dick Poston, Chris Martino
Cast: John Carradine, Kent Taylor, Tommy Kirk, Regina Carrol, Roy Morton

John Carradine's paying the bills again as a mad scientist (is there any other kind?) experimenting on a Vietnam vet and turning him into an electronically controlled killer. Eventually the vet's father (who's also a mad-scientist) decides to take revenge on him for this travesty, using his knowledge of voodoo and mental telepathy learnt in the jungles of Jamaica. The film's re-edited footage reworks *Psycho a Go-Go* (1965) and *The Fiend with the Electronic Brain* (1965), although it's very unlikely you'll actually care.

BLOOD OF THE BEAST

2003, USA
Dir: Georg Koszulinski. Prod: Georg Koszulinski. Scr: Georg Koszulinski
Cast: Derrick Aguis, Josh Briet, Sharon Chudrow, Matt Devine, Georg Koszulinski

Essentially nothing more than a standard SOV zombie flick - featuring campers caught in the Deep South as the living dead run amok - this overcomes the limits of its basic plotting with some innovative visuals and an imaginative backstory. Set in the year 2031, *Blood of the Beast* takes place in a future where the human race has been rendered infertile after a global biochemical war. Genetic engineering has taken over what was once God's work, but now something's amiss and the "first strain" of clones are flipping out and turning into flesh munching ghouls. Director Koszulinski delivers a memorably avant-garde zombie apocalypse using stock World War I footage, an ambient soundtrack and some impressive visual tricks (the last thirty minutes switches to black and white and uses title cards for the dialogue, like an old silent movie). If only all no-budget zombie flicks showed this much imagination.
See page 166

BLOODSUCKERS FROM OUTER SPACE

1984, USA
Dir: Glen Coburn. Prod: Rick Garlington.
Scr: Glen Coburn
Cast: Thom Meyers, Laura Ellis, Dennis Letts, Robert Bradeen, Big John Brigham

The title says it all really. Texas farmers are turned into bloodsucking zombies after an extra-terrestrial wind (!) blows through town. A dull comedy-horror that fails on both counts, it's *Invasion of the Body Snatchers* meets absolute stupidity.
See page 151

BLOODY BILL

2004, USA
Alternative title: **Death Valley: The Revenge of Bloody Bill**
Dir: Byron Werner. Prod: David Michael Latt, David Rimawi, Sherri Strain. Scr: Matthew Yuan, John Yuan
Cast: Chelsea Jean, Jeremy Bouvet, Gregory Bastien, Matt Marraccini, Scott Carson

Bloody Awful would be a better way to describe this boring rehash of *Ghost Town* in which two modern day drug dealers are trapped in a spooky Wild West town along with a vanload of teenagers. It's not long

Bio-Zombie

before everyone realises that the town of Sunset Valley (population 99 and slowly rising) is actually inhabited by ragged, fleet-footed ghouls led by fearsome Confederate warrior William Anderson aka "Bloody Bill". Helmer Byron Werner directs this hunk of junk like an MTV editor on speed, while the talentless cast try their best not too pay too much attention to the ghouls' unlikely looking sub-Leatherface make-up. Scratchy monochrome footage explains Bill's backstory and a blaring thrash rock soundtrack ensures you'll have very few brain cells left by the end of it all. Assuming you last that long.
See page 153

BLUE SUNSHINE

1977, USA
Dir: Jeff Lieberman. *Prod:* George Manasse. *Scr:* Jeff Lieberman
Cast: Zalman King, Deborah Winters, Ray Young, Robert Walden, Mark Goddard

The drugs don't work in Jeff Lieberman's tale of acid anxiety, as a bad batch of LSD called "Blue Sunshine" turns ex-hippies into bald zombie maniacs several years after they first turned on, tuned in and dropped out. When the first of the freaks runs riot, hero Jerry is left carrying the can and hits the road to prove the link between the acid tabs and the killings. Weaving in a conspiracy theory about the man responsible for the original batch now being a powerful politician, and getting great mileage out of the fact that the killers are former hippies who've since reintegrated themselves into polite society as white-collar professionals, this high concept little shocker comes with plenty of social satire.
See page 73

THE BONEYARD

1989, USA
Dir: James Cummins. *Prod:* Richard F. Brophy. *Scr:* James Cummins
Cast: Ed Nelson, Deborah Rose, James Eustermann, Denise Young, Norman Fell

Bring on the zombie poodle! Director James Cummins's naff but undeniably lively tale about zombie kiddies and an ancient Chinese curse ought to be nothing more than a throwaway horror flick - high on the gore and the cheese. Instead, it turns into a cult oddity thanks to some hilariously bad special effects involving animatronic zombie monsters. A pair of cops and an overweight psychic find themselves trapped in the county morgue with the living dead nippers (officially known as "kyoshi" demons) as all hell breaks loose. In the midst of the ensuing chaos, a poodle laps up some gunk and finds itself turned into a seven-foot zombie pooch. Silly, sick and undoubtedly a classic... of sorts.
See page 80

BOWERY AT MIDNIGHT

1942, USA
Dir: Wallace Fox. *Prod:* Sam Katzman, Jack Dietz. *Scr:* Gerald Schnitzer
Cast: Bela Lugosi, Wanda McKay, John Archer, Lew Kelly, Tom Neal

Bela Lugosi plays a dual role as both a philanthropic psychologist and a murderous gangster in this Monogram chiller. The Bowery Mission is a front for his criminal activities, but it also makes the perfect hiding place for the bodies of his victims. Little does he realise that his sidekick is secretly reanimating the dead on the sly. A truly dire Poverty Row schedule filler.
See pages 35, 39, 40, 99, 154

BRAINDEAD

1992, New Zealand
Alternative title: **Dead Alive**
Dir: Peter Jackson. *Prod:* Jim Booth. *Scr:* Stephen Sinclair, Frances Walsh, Peter Jackson
Cast: Timothy Balme, Diana Peñalver, Elizabeth Moody, Ian Watkin, Stuart Devenie

Fondly loved among zombie fans, this amps up the lo-fi gore of Jackson's debut *Bad Taste* with brilliantly yucky results. After a stop-motion rat monkey bites his beloved mother during a trip to the zoo, shy little Lionel watches as she turns into a slavering zombie. Struggling to keep her and her victims under lock and key while romancing local shopkeeper's daughter Paquita, Lionel's sitting on a powder keg of pent up zombie rage. Needless to say, the zombies finally escape and turn a house party into a state of chaos as Jackson and his special effects team take the splatter to the limit. It's a truly astonishing film with scenes involving a garden lawnmower, an oversexed pair of zombies (who produce a living dead baby) and a truly audacious Oedipal climax in which Lionel must face down his hideously mutated, gigantic mother. The zenith of zombie splatter, it's impossible to see how it could ever be topped.
See pages 159-160, 214-215

Braindead

BRIDE OF RE-ANIMATOR

1990, USA
Alternative title: **Re-Animator II**
Dir: Brian Yuzna. *Prod:* Brian Yuzna. *Scr:* Woody Keith, Rick Fry
Cast: Jeffrey Combs, Bruce Abbott, Claude Earl Jones, Fabiana Udenio, David Gale

More goretastic splatter from Lovecraft fanatic Brian Yuzna as Miskatonic University's finest student, Herbert West, resumes his re-animating experiments in this frantic, blood-drenched sequel. Frankenstein references abound as West creates a patchwork corpse - the bride of the title - and dubs her "what no man's mind and no woman's womb ever dreamed of". Dr. Hill returns as a still-severed head (although now with added bat wings) and proceeds to take command of an army of zombies hell-bent on destroying the deranged West once and for all. H.P. Lovecraft was no doubt throwing up in his grave, but chances are he was laughing too.
See pages 158-159

THE BUNKER

2000, UK
Dir: Rob Green. *Prod:* Daniel Figuero.
Scr: Clive Dawson
Cast: Charley Boorman, John Carlise, Jack Davenport, Christopher Fairbank, Nicholas Hamnett

The Bunker is not much of a zombie movie since its corpses are little more than a final reel plot device. However this is worthy of inclusion here on the basis of its heritage, which owes as much to the Nazi zombie cycle as its more obvious influence, Michael Mann's *The Keep*. Trapped in an isolated anti-tank bunker during the final days of 1944, a German platoon begins to crack up as shell-shocked dismay gives way to edgy paranoia. Meanwhile, in the labyrinth of tunnels under the bunker, strange things start happening. Have the Americans infiltrated the complex, or is something evil lurking in the darkness? Building towards a rather ridiculous denouement that may or may not feature the dead returning to life, *The Bunker*'s contribution to the Nazi zombie cycle is stylish yet ultimately unmemorable.
See page 80

BUTTCRACK

1998, USA
Dir: Jim Larsen. *Prod:* Cindy Geary. *Scr:* Jim Larsen
Cast: Doug Ciskowski, Caleb Kreischer, Rob Hayward, Kris Arnold, Mojo Nixon

From the anus it came and to the anus it can return: this is definitely the arse-end of the zombie genre. Troma go for broke with *Buttcrack*, the tale of a man who kills his overweight room-mate only to be shocked when the dead bloater's sister resurrects him with a voodoo spell (sadly, I'm not making this up). He enlists the help of a mad Bible-bashing preacher played by cult rockabilly musician Mojo Nixon and things trundle along until a gore soaked climax. With a title like that, what were you expecting? High art?

LA CAGE AUX ZOMBIES

1995, USA
Dir: Kelly Hughes. *Prod:* Kelly Hughes.
Scr: Kelly Hughes
Cast: Cathy Roubal, Eric Gladsjo, J.R. Clarke, Tony Love, Betty Marshall

Katherine Victor, the evil scientist from *Teenage Zombies*, returns for more ghoulish boredom as aliens infiltrate the US space program by turning good citizens into zombies. Backyard 1960s nonsense from the man behind the execrable *Robot Monster* - thankfully this was his final film.

THE CHILD

1976, USA
Alternative titles: **Kill and Go Hide, Zombie Child**
Dir: Robert Voskanian. *Prod:* Robert Dadashian. *Scr:* Ralph Lucas
Cast: Laurel Barnett, Rosalie Cole, Frank Janson, Richard Hanners, Ruth Ballen

Antisocial little Rosalie may have some behavioural problems, but they're not half as troubling as her supernatural powers, which allow her to raise the dead. The motherless girl uses corpses from a nearby cemetery as playmates until she realises that they can also be effective weapons against anyone she dislikes. It all leads up to a gripping conclusion in which the living dead chase Rosalie's nanny and elder brother into an abandoned lumber mill.
See page 80

Imagine *The Rocky Horror Picture Show* shot on home video and full of zombies. That's what this enthusiastically bad SOV effort wants to be, but never quite manages to become. A wife running away from her drug dealer husband gets mixed up with cross-dressing ghouls after a plane carrying football players crashes and the buff boys come back from the dead. Before long, zombies in jockstraps and trainers are roaming the streets and attacking anyone they can get their well-manicured hands on. With gore effects made out of baked beans and a whole troupe of exquisitely dressed zombie drag queens, this effort is so camp it might as well have come with its own set of tent poles. The title is a riff on the French classic *La cage aux folles* (1978) and there's even a cameo appearance from Russ Meyer favourite Kitten Natividad - who gets her ample (if ageing) jugs out for a pair of zombie boys to suck milk from. Bizarre, but best left to the terminally curious.
See page 135

CAPE CANAVERAL MONSTERS

1960, USA
Dir: Phil Tucker. *Prod:* Richard Greer.
Scr: Phil Tucker
Cast: Katherine Victor, Scott Peters, Linda Connell, Jason Johnson, Billy Greene

CHILDREN OF THE LIVING DEAD

2001, USA
Dir: Tor Ramsey. *Prod:* John A. Russo, Karen Lee Wolf. *Scr:* Karen Lee Wolf
Cast: Tom Savini, Martin Schiff, Damien Luvara, Jamie McCoy, A. Barrett Worland

"Bred from the creators of classic horror *Night of the Living Dead* comes the long-awaited sequel", hypes the DVD tagline, but you'll be struggling to find George Romero's name here. Instead, the people in the dock for this travesty are John A. Russo, Bill Hinzman and Tom Savini. It opens with a zombie outbreak in Pennsylvania (where else?) then fast-forward fourteen years to follow a property developer who disturbs the gravesite of a rubber-faced zombie villain named Abbott Hayes. Hayes raises a zombie army to attack the town in a climax that looks more like a post-pub car park brawl than the end of the world.

CHILDREN SHOULDN'T PLAY WITH DEAD THINGS

1972, USA
Alternative title: **Revenge of the Living Dead**

Children of the Living Dead

Strange things start happening in the sleepy town of Ravensback after a busload of school kids goes missing. It turns out that a leak from the local nuclear power plant has turned the nippers into zombies with pale complexions and black fingernails. Reunited with their parents, the radioactive zombie kids cause havoc. Since they're impervious to bullets, someone comes up with the smart idea of simply chopping the kids' hands off - resulting in lots of mutant moppets holding their spurting limbs in the air. It's a daft as it sounds and the scene in which a radioactive little girl microwaves her mother by hugging her is unintentionally hilarious.
See page 80

THE CHILLING

1989, USA
Dir: Jack A. Sunseri, Deland Nuse. *Prod:* Jack A. Sunseri. *Scr:* Jack A. Sunseri
Cast: Linda Blair, Dan Haggerty, Troy Donahue, Jack A. de Rieux, Ron Vincent

Deep-frozen zombies thaw out after a lightning bolt hits a cryogenic chamber in Jack A. Sunseri's low-budget "chiller". Linda Blair and Dan Haggerty (aka Grizzly Adams) swallow their pride to star as a research assistant and a hirsute security guard at the state of the art laboratory. As hilariously cheesy, green-faced zombie ghouls wrapped up in aluminium shrouds run amok, it's left to Blair and Haggerty to work out why the corpses are returning as killers and how not to wince at lines like "Those frozen TV dinners out there are starting to get to you".
See note 99

A CHINESE GHOST STORY

1987, Hong Kong
Original title: **Sinnui yauwan**
Dir: Ching Siu-Tung. *Prod:* Tsui Hark.
Scr: Kai-Chi Yun
Cast: Leslie Cheung, Joey Wong, Wu Ma, Dawei Hu, Jin Jiang

Stop motion animated zombies are just one of the many surreal things on offer in this memorably bonkers Hong Kong blockbuster. A cowardly debt collector decides to spend a night in a haunted temple on the outskirts of a rural Chinese village. Once there, he falls in love with a beautiful female ghost whose soul he tries to save with the help of a powerful - but somewhat cantankerous - Daoist swordsman. Horror motifs (ghosts, zombies, demons) are pitched alongside knock-about comedy and a heartfelt love story.
See page 172

CHOKING HAZARD

2004, Czech Republic
Dir: Marek Dobes. *Prod:* Marek Dobes, Narek Oganesjan. *Scr:* Stepan Kopriva
Cast: Jaroslav Dusek, Jan Dolansky, Eva Nadazdyova, Anna Fialková, Kamil Svejda

Philosophy students battle living dead zombie woodsman ("woombies") in this frantic Czech comedy-horror. The mashed-up ghouls in black trilbies look like distant cousins of Freddy Krueger but can't compete with the madcap comedy and clever-clever asides on Nietzsche, Jung and John Lilly. "We came here looking for sense and we found nonsense," opines one of the students as zombies trap them in an isolated country hotel. Indeed.
See page 181

CHOPPER CHICKS IN ZOMBIE TOWN

1989, USA
Dir: Dan Hoskins. *Prod:* Maria Snyder.
Scr: Dan Hoskins
Cast: Jamie Rose, Catherine Carlen, Lycia Naff, Vicki Frederick, Kristina Loggia

Dir: Bob Clark. *Prod:* Bob Clark, Gary Coch. *Scr:* Benjamin Clark, Alan Ormsby
Cast: Alan Ormsby, Valerie Mamches, Jeffrey Gillen, Anya Ormsby, Paul Cronin

A theatre troupe of hippies get more than they bargained for when their leader, Alan, takes them out to a burial island for some spooky hi-jinks. Chanting a spell to raise the dead from their graves, Alan gets a shock when they actually do come back. Ghoulish fun.
See pages 71-73, 83, note 94

THE CHILDREN

1980, USA
Alternative title: **The Children of Ravensback**
Dir: Max Kalmanowicz. *Prod:* Max Kalmanowicz. *Scr:* Carlton J. Albright, Edward Terry
Cast: Martin Shakar, Gil Rogers, Gale Garnett, Jessie Abrams, Shannon Bolin

book of the dead

City of the Living Dead

Those trash merchants at Troma Studios strike again. This time they've got a fun premise, though: a posse of leather-clad female bikers ride into the town of Zariah (population: 127) and discover zombies terrorising the living. The ghouls are the creations of the town's mortician, who's implanted the corpses with electronic devices so he can use them as slave labour in a radioactive mine (so far the plot's ripped off *The Plague of the Zombies*, *Dawn of the Dead* and *Dead & Buried*). As usual with Troma this is crude stuff but there's relatively little nudity or gore. Two useless pieces of trivia: eagle-eyed viewers will spot a pre-fame Billy Bob Thornton among the cast; and, according to cult movie lore, the MPAA refused to rate the film under its original title of *Cycle Sluts Vs. the Zombie Ghouls*.
See note 120

CITY OF THE LIVING DEAD

1980, Italy
Original title: **Paura nella città dei morti viventi**
Alternative titles: **La ciudad de los muertos vivientes, The Gates of Hell, Ein Zombie hing am Glockenseil**
Dir: Lucio Fulci. *Prod:* Giovanni Masini. *Scr:* Lucio Fulci, Dardano Sacchetti
Cast: Christopher George, Katherine [Catriona] MacColl, Carlo De Mejo, Antonella Interlenghi, John Morghen [Giovanni Lombardo Radice]

The first film in Fulci's zombie trilogy begins with a priest in New England hanging himself. His suicide opens a gateway to hell and our heroes have until All Saint's Day to close it, otherwise the dead will rise from their graves and take over the world. It would be simple if it weren't for all the zombies, crazed rednecks and plagues of maggots hindering them. A true classic and the inspiration for this tome's cover.
See pages 131, 137-142, 194, notes 144, 145

COME GET SOME!

2003, USA
Dir: Jason Griscom. *Prod:* Jason Griscom, Steven A. Grainger. *Scr:* Jason Griscom, Steven A. Grainger
Cast: Colleen Galeazzi, Steven A. Grainger, Hayley Mattison, Bonnie Moore, Jennifer Strickland

After the notorious zombie outbreak in Pennsylvania in 1969, the government sets up the Human Undead Defense Service (H.U.D.S.) to defend humanity against the living dead. But, after several years without zombies, funding for the agency is about to be cut. What should the people of H.U.D.S do? Justify their existence, of course, by generating a zombie invasion of their own. Unfortunately, things don't go to plan and the town they've chosen as the site of zombie ground zero turns out to have four tough women ready to repulse the ghouls. Although it runs a little long and is saddled with a grating death metal soundtrack, this zombie comedy proves entertaining. Elements of *Dawn of the Dead*, *Day of the Dead* and *The Return of the Living Dead* show up - as does Elvis, who comes back from the dead as a zombie. Uhthangu, Uhthangu verrry much (DAO).
See page 166

CORPSE EATERS

1974, Canada
Dir: Donald R. Passmore. *Prod:* Lawrence Zazelenchuk. *Scr:* Lawrence Zazelenchuk
Cast: Michael Hopkins, Edmond LeBreton, Halina Carson, Michael Krizanc, Terry London

A deservedly obscure Canadian effort, Passmore's film follows four ageing swingers who ought to know better than to venture into a graveyard and summon Lucifer. Old Nick doesn't show up but several flour-covered, cobwebbed zombies rise from their graves to wreak havoc. The heroes end up in hospital, where reality blends with a series of blood-soaked nightmares; meanwhile there are various strange goings on down at the Happy Halo funeral home where the dead are also returning to life. Mercifully, the dull proceedings are over in under an hour.

THE CRAZIES

1973, USA
Alternative title: **Code Name: Trixie**
Dir: George A. Romero. *Prod:* A.C. Croft. *Scr:* George A. Romero, based on an original script by Paul McCollough
Cast: Lane Carroll, W.G. McMillan, Harold Wayne Jones, Lloyd Hollar, Lynn Lowry

A chemical spill turns the inhabitants of a rural American town into homicidal "crazies" in Romero's faux-zombie outing. The military quickly step in to seal off the community, herding the townsfolk around while clad in biochemical warfare suits. Resenting the military's heavy-handed approach some non-infected citizens head out into the countryside to fight a guerrilla war that's curiously reminiscent of America's misadventures in Vietnam.
See pages 68, 73-75, 91, 179, note 96

CREATURE WITH THE ATOM BRAIN

1955, USA
Dir: Edward L. Cahn. *Prod:* Sam Katzman. *Scr:* Curt Siodmak
Cast: Richard Denning, Angela Stevens, Michael Granger, S. John Launer, Gregory Gaye

An ex-con and his scientist partner reactivate the bodies of the dead to take revenge on the gangster who double-crossed them in this no-frills zombie flick from director Edward L. Cahn. Making heavy weather of its radioactive trappings, this pulp tale follows the police's efforts to track down the zombie assassins and their living masters culminating in a pitched battle between cops and ghouls.
See pages 47, 52-54, 101

CREEPSHOW

1982, USA
Dir: George A. Romero. *Prod:* Richard P. Rubinstein. *Scr:* Stephen King
Cast: Stephen King, Hal Holbrook, Adrienne Barbeau, Fritz Weaver, Leslie Nielsen

Scripted by Stephen King, this portmanteau horror collection looks back to the days of the E.C. horror comics of the 1950s with a nostalgic eye. The five

episodes contain two zombie storylines. In "Father's Day", a rich brat watches in horror as her cranky dad returns to life and demands his Father's Day cake, while in "Something To Tide You Over" a cuckolded husband buries his cheating wife and her lover up to their necks in sand on a deserted beach and leaves them at the mercy of the incoming tide. Having drowned, they later come back as salty, seaweed-covered zombies and make him suffer a similar fate.
See note 98

LA CRUZ DEL DIABLO

1974, Spain
Literal title: **The Cross of the Devil**
Dir: John Gilling. *Scr:* Juan José Porto, Jacinto Molina.
Cast: Carmen Sevilla, Adolfo Marsillach, Eduardo Fajardo, Emma Cohen, Ramiro Oliveros

Chiefly notable for starring skeletal zombies filched from the Blind Dead films, this Spanish production by Hammer exile John Gilling has little else to recommend it. A writer travels out to Spain to see his sister, but she's recently carked it and he's suspicious that her death may not have been from natural causes. Paul Naschy was partly responsible for the script under his real name Jacinto Molina, so we can blame him for the resulting slur on the zombie monks.
See pages 87, 113

CURSE OF THE CANNIBAL CONFEDERATES

1982, USA
Alternative title: **Curse of the Screaming Dead**
Dir: Tony Malanowski. *Prod:* Tony Malanowski. *Scr:* Lon Huber
Cast: Steve Sandkuhler, Christopher Gummer, Judy Dixon, Rebecca Bach, Jim Ball

Here's a strong contender for worst zombie movie of all time as campers find themselves pursued by a pack of Confederate zombies. The zombie make-up seems to be little more than cheap masks from the local dime store covered in mayonnaise and the costumes look more blue than grey. Did the zombies switch sides during their stay in the grave? Watch this wretched film at your own risk (DAO).
See page 153

THE CURSE OF THE DOLL PEOPLE

1960, Mexico
Original title: **Muñecos infernales**
Dir: Benito Alazraki. *Prod:* Guillermo Calderón. *Scr:* Alfredo Salazar
Cast: Elvira Quintana, Ramón Gay, Roberto G. Rivera, Quintin Bulnes, Alfonso Arnold

The film that kick-started the enchilada zombie cycle is pretty unremarkable. Four amateur archaeologists stir up trouble for themselves when they pinch a stone deity from an ancient Haitian temple. Ignoring warnings about a curse, they set off home with their booty but before long they are being stalked by the doll creatures - midget actors who kill them one by one. The dolls are controlled by a zombie slave named Sabud who's intent on fulfilling his master's desire to wipe out everyone connected with the desecration.
See page 60

DADDY

2002, USA
Dir: Michael P. DiPaolo. *Prod:* Michael P. DiPaolo. *Scr:* Michael P. DiPaolo, Christopher K. Phillippo
Cast: Celia Hansen, David Shepherd, Aaron Renning, Marc St. Camille, Katherine Petty

A zombie is assaulting and killing young women in a small lakeside town. On the case is Sheriff Sylvia Carlsen who not only has to battle other interfering police agencies and the zombie itself, but also delve into her own past where a dark secret lies. Tackling the horrors of sexual abuse, this thoughtful SOV movie tries to offer a more serious storyline than most yet is let down by the awkwardness that results from combining its well-meaning message with a zombie villain (DAO).

DÄMONENBRUT

2000, Germany
Alternative titles: **Demon Terror**, **Insel der Dämonen II**
Dir: Andreas Bethmann. *Prod:* Andre de Palma. *Scr:* Andreas Bethmann
Cast: Katja Bienert, Thomas Riehn, Anja Gebel, Carsten Ruthmann, Marion Ley

Since the mid-1990s, Germany has replaced Italy as the chief European source of low-budget zombie movies. This particular effort deals with an attempted invasion of our world by supernatural forces and features demonic zombies that spread their contagion through extremely long teeth, drills that perforate men's skulls without warning and tentacles that appear out of nowhere to give viewers some *Evil Dead*-style sex horror. The plot hardly matters since this simply exists to throw lots of blood and gore around the screen. The film can be found in two versions: one cut that's over two hours long, the other that clocks in at around sixty minutes. Pray you pick up the shorter one! (DAO).

DARK ECHOES

1986, Austria/Yugoslavia
Alternative titles: **The Curse of Gohr**, **Deep Echo**
Dir: George Robotham. *Prod:* George Robotham, James Dobson, Fred Tully, John Robotham. *Scr:* George Robotham
Cast: Karin Dor, Joel Fabiani, Wolfgang Brook, James Dobson, Fred Tully, John Robotham, Alex Davion, Hanna Hertelendy

Veteran Hollywood stuntman George Robotham takes his first (and last) stint behind the camera for this aquatic tale of zombie horror which kicks off with a skeleton-faced zombie in a captain's outfit swimming out of a sunken wreck and heading towards the surface. The voice-over tells us that an excursion boat sank on this Austrian lake a hundred years ago, killing Captain Gohr and his eighty passengers. Ever since then, the villagers have been convinced that the

Dark Echoes

book of the dead

above: The new breed of fast-moving ghouls, as seen in the 2004 remake of **Dawn of the Dead**. *opposite top:* Zombies rise from the desert in **Dawn of the Mummy**. *below:* A French lobby card for the original **Dawn of the Dead** (1978). *opposite bottom:* Stylish German poster for the original **Dawn of the Dead** (1978).

ghost of Gohr will return to take his revenge on them - which he eventually does. Set in a Heidi-style Austrian locale, with plenty of underwater scenes (one of Robotham's stunt specialities apparently), this forgotten zombie flick proves better than one might expect with some occasional chills. Gohr himself though is rather ridiculous - and is ultimately defeated once the American clairvoyant called in to solve the mysterious murders realises that the monster's afraid of mirrors!

DAWN OF THE DEAD

1978, USA/Italy
Alternative titles: **Zombie**, **Zombies: Dawn of the Dead**
Dir: George A. Romero. *Prod:* Richard P. Rubinstein. *Scr:* George A. Romero
Cast: David Emge, Ken Foree, Scott H. Reiniger, Gaylen Ross, David Crawford

The sequel to *Night of the Living Dead* has a new set of characters trying to survive the zombie apocalypse by hiding out in a shopping mall. When a rampaging band of bikers attack the mall, though, the zombies stumble back into the neon-lit consumer paradise. More action, more comedy, more social commentary, more gore. Thank you, Mr. Romero.
See pages 3, 7, 68, 74-75, 80-81, 91-97, 120-123, 129, 136, 142-147, 151, 157, 159, 162-163, 172, 174-176, 178, 182-184, 187, 189-190, 225, note 120

DAWN OF THE DEAD

2004, USA
Dir: Zack Snyder. *Prod:* Marc Abraham, Eric Newman, Richard P. Rubinstein. *Scr:* James Gunn, based on George Romero's 1978 screenplay
Cast: Sarah Polley, Ving Rhames, Jake Weber, Mekhi Phifer, Ty Burrel

A full throttle ride into the clammy claustrophobia that made the original so terrifying, this delivers a pared down version of the story and squeezes great mileage out of the setup as a small band of civilians led by Sarah Polley's resourceful nurse and Ving Rhames's police officer wait (hopelessly) in a shopping mall for help to arrive as the living dead mass outside, hungry for their flesh.
See pages 178, 183-186, 192, 221, 224

DAWN OF THE MUMMY

1981, USA
Alternative title: **El despertar de la momia**
Dir: Frank Agrama. *Prod:* Frank Agrama.
Scr: Daria Price, Ronald Dobrin, Frank Agrama
Cast: Brenda King, Barry Sattels, George Peck, John Salvo, Ibrahim Khan

A bunch of insipid fashion models find themselves pursued by a rampaging mummy and his zombie minions in this gory but pointless attempt to blend the zombie and mummy cycles. The mummy is an ancient pharaoh awakened from his tomb; his servants are bald, decomposing ghouls who rise from the desert sand. The gore's the main emphasis (the promise of sex is a red herring) yet nothing here is particularly innovative or even well executed.
See pages 131-132, 203

DAY OF THE DEAD

1985, USA
Alternative title: **Zombie 2**
Dir: George A. Romero. *Prod:* Richard P. Rubinstein. *Scr:* George A. Romero
Cast: Lori Cardille, Terry Alexander, Joseph Pilato, Jarlath Conroy, John Amplas, Richard Liberty

It's the end of the world as we know it. A handful of survivors are desperately trying to discover why the dead won't stay dead. Hiding out in a military missile silo they bicker and fight with one another in a grim vision of apocalyptic dysfunction. The third movie in Romero's on-going series is darker than the rest and considerably gorier, yet it has a remarkably upbeat ending.
See pages 68, 95, 143-147, 154-155, 162, 164-165, 175, 177, 186-189, 207-209, notes 157, 160

DEAD & BREAKFAST

2004, USA
Dir: Matthew Leutwyler. *Prod:* E.J. Heiser, Jun Tan. *Scr:* Matthew Leutwyler
Cast: Ever Carradine, Brent David Fraser, Bianca Lawson, Jeffrey Dean Morgan, Eric Palladino

From the moment the distinctive comic-book titles begin, you know that this teen horror is going to tick more than the usual boxes. And it does, with an outrageously funny "splatstick" vibe that's completely over the top. A group of more-likeable-than-usual teens stop off in a small-town bed & breakfast (hence the terrible titular pun) and end up in all kinds of zombie trouble as a voodoo box and flesh-hungry Texans make their stay a misery. It's off-the-wall stuff with a rockabilly gas station attendant turned narrator who pops up to sing us through the plot developments and more decapitations, amputations and chainsaw action than a Friday night shift in the Miskatonic University morgue. The zombies are redneck Texan ghouls who owe more to *Deliverance* than Romero and have the added benefit of still being able to talk: "Hey David," shouts one of the kids turned living dead mischievously, "did you ever tell Sara that you fucked my cousin?"
See page 181

DEAD & BURIED

1981, USA
Dir: Gary A. Sherman. *Prod:* Ronald Shusett, Robert Fentress. *Scr:* Ronald Shusett, Dan O'Bannon
Cast: James Farentino, Melody Anderson, Jack Albertson, Dennis Redfield, Lisa Blount

top: Bub, the zombie with a "soul": **Day of the Dead**.
above: Your friends and neighbours: **Dead & Buried**.

More North American small-town zombie chaos with local sheriff Dan Gillis investigating a spate of murders in the sleepy coastal community of Potters Bluff. As tourists are killed in strange and particularly brutal ways, Gillis eventually tracks the murders back to the townsfolk themselves and discovers some rather nasty truths about his wife. The chief villain is G. William Dobbs, the town's undertaker; to say any more would spoil all the fun.
See pages 151-153, 206

DEAD CREATURES

2001, UK
Dir: Andrew Parkinson. *Prod:* Andrew Parkinson, Jason Shepherd. *Scr:* Andrew Parkinson
Cast: Beverly Wilson, Antonia Beamish, Brendan Gregory, Anna Swift, Bart Ruspoli

A community of girls infected with the same unexplained virus from Parkinson's earlier film *I, Zombie: A Chronicle of Pain* pretend to be prostitutes in order to lure men into their flat. Once the trick's safely inside, they bludgeon him over the head and carve him up, feasting on the flesh in the hope of stemming their transformation into decomposing ghouls. Significantly complicating the already messy situation is the fact that they're being tracked by a self-styled zombie hunter who wants to eradicate the plague before it spreads even further.
See page 169

THE DEAD DON'T DIE

1975, USA
Dir: Curtis Harrington. *Prod:* Henry Colman. *Scr:* Robert Bloch
Cast: George Hamilton, Ray Milland, Linda Cristal, Ralph Meeker, Joan Blondell

Robert *Psycho* Bloch scripted this zombie TV movie. George Hamilton stars as a man in 1930s Chicago trying to uncover the truth behind his brother's conviction for murder most foul. Lots of shenanigans involving voodoo and reanimated dead bodies ensue and, although the movie never quite lives up to its scriptwriter's pedigree, there's a scary moment in a funeral home where the dead won't die.

DEAD DUDES IN THE HOUSE

1991, USA
Alternative titles: **The Dead Come Home, The House on Tombstone Hill**
Dir: Jim Riffel. *Prod:* Jim Riffel, Melissa Lawes, Marc Bladis. *Scr:* Jim Riffel
Cast: Mark Zobian, Victor Verhaeghe, Doug Gibson, Naomi Kooker, John Cerna, Sarah Newhouse

This Troma-distributed outing features a bunch of hip-hop dudes trying to fix up a dilapidated mansion and turn it into a party venue. They're rather put out when the previous owners return to "re-possess" it. As irredeemably awful and as utterly dated as it sounds.

THE DEAD HATE THE LIVING!

1999, USA
Dir: Dave Parker. *Prod:* Kirk Edward Hanson, Dana Scanlan. *Scr:* Dave Parker
Cast: Eric Clawson, Jamie Donahue, Brett Beardslee, Wendy Speake

Zombie cinema's answer to the self-reflexive humour of *Scream*. Horror filmmakers in an abandoned hospital find themselves besieged by zombies in this mildly diverting effort from the future writer of *House of the Dead*. Lots of postmodern tomfoolery makes the movie-within-a-movie premise quickly annoying as the fictional director decides to use a real corpse in the shoot. Turns out the body is that of Dr. Eibon (grimace away Fulci fans) whose (ab)use opens up a gateway to hell and unleashes the living dead. Gorier and more competent than most of its ilk - although that's not much of a recommendation.
See page 181

DEAD HEAT

1988, USA
Dir: Mark Goldblatt. *Prod:* Michael Meltzer, David Helpern. *Scr:* Terry Black
Cast: Treat Williams, Joe Piscopo, Lindsay Frost, Darren McGavin, Vincent Price

It sounds like '80s video trash, it looks like '80s video trash by God it IS '80s video trash. Starring none other than Treat Williams, an actor who could teach Rutger Hauer a few things or two about bad

Dead Heat

movies, this living dead buddy picture is as painfully atrocious as the generic video sleeve threatens. "These cops are on the biggest murder case of their lives," claims the tagline. "Their own!" After discovering that evil mastermind Vincent Price is planning to resurrect the dead as gnarled zombies, one of the cops dies, returns as a ghoul and has to help his partner solve the case before his body rots away. Apparently that could take anything up to ten hours. Fortunately, for us this is barely eighty minutes long.
See page 153

DEAD LIFE

2004, USA
Dir: William Victor Schotten. *Prod:* Joseph J. Zetts. *Scr:* William Victor Schotten
Cast: Michael Hanton, Joseph J. Zetts, Ashleigh Holeman, Jayson Garity, Bruce Taylor

A deadly outbreak of Necrotising fasciitis erupts, turning people into flesh-devouring zombies. The plot of *Dead Life* won't break any new ground but the make-up and gore effects work very well. The disease has an interesting effect on the zombies as their heads shake violently for a few moments when infected. There's also a humorous scene where a zombie clown and several living dead children go shambling past the camera (DAO).
See page 166

DEAD MEAT

2003, Ireland
Dir: Conor McMahon. *Prod:* Ed King. *Scr:* Conor McMahon
Cast: Marian Araujo, David Muyllaert, Eoin Whelan

Producer Ed King knows a thing or two about scaring people. The founder of Dublin's annual Horrorthon teams up here with writer/director Conor McMahon to bring zombies to the land of Guinness in this micro-budgeted SOV tale about a small group of survivors fending off the living dead with shovels and the help of a sweary hurling coach (who also starred in McMahon's short *Braineater*). Funded by the Irish Film Board, its billed "the first ever Irish horror film" - although it comes ten years after the equally low-budget *Zombie Genocide*.
See page 166

DEAD MEN DON'T DIE

1990, USA
Dir: Malcolm Marmorstein. *Prod:* Wayne Marmorstein. *Scr:* Malcolm Marmorstein
Cast: Elliott Gould, Mark Moses, Philip Bruns, Mabel King, Melissa Anderson

Dead men might not die, but Elliott Gould's career sure does in this abysmal comedy about a TV anchorman who's killed by gangsters. Conveniently, he's brought back to life as a zombie by a black cleaning lady with voodoo powers and goes live on the air without anyone noticing the difference. Ghastly.
See page 151

THE DEAD NEXT DOOR

1989, USA
Dir: J.R. Bookwalter. *Prod:* J.R. Bookwalter. *Scr:* J.R. Bookwalter
Cast: Peter Ferry, Bogdan "Don" Pecic, Michael Grossi, Jolie Jackunas

The Dead Next Door

Ripping off Romero, backyard filmmaker J.R. Bookwalter presents us with a post-apocalyptic America in which zombies have been unleashed by a viral outbreak. Zombie Squads have been despatched to try and stem the tide of the living dead, but they're fighting a losing battle. Meanwhile, scientists are trying to find a cure for the virus and a weird redneck religious cult is planning to put the dead to alternative uses. Gory, cheap and silly.
See page 165-166

THE DEAD ONE

1961, USA
Alternative title: **Blood of the Zombie**
Dir: Barry Mahon. *Prod:* Barry Mahon. *Scr:* Barry Mahon
Cast: John MacKay, Linda Ormond, Monica Davis, Clyde Kelly, Darlene Myrick

Belly dancers, voodoo superstition and a honeymoon on a New Orleans plantation pad out this threadbare and thoroughly stilted early 1960s effort. Newlyweds MacKay and Ormond find their passion thwarted when a jealous cousin raises a ghoul from the dead to kill them. The pallid zombie mistakes a belly dancer for the bride and murders her, alerting the real targets to the danger. If it were not for the jaw-dropping Ed Wood-level thespian efforts, this would be instantly forgettable.

THE DEAD PIT

1989, USA
Dir: Brett Leonard. *Prod:* Gimel Everett. *Scr:* Brett Leonard, Gimel Everett
Cast: Cheryl Lawson, Danny Gochnauer, Steffen Gregory Foster, Jeremy Slate, Joan Bechtel

DEATH WARMED UP

1984, New Zealand
Dir: David Blyth. *Prod:* Murray Newey. *Scr:* David Blyth, Michael Heath
Cast: Michael Hurst, Gary Day, Margaret Umbers, Norelle Scott, William Upjohn

It may be confusing, but there's a memorable nastiness to David Blyth's island-set tale in which a mad neurosurgeon operates on people's brains, turning them into zombie killers. Maybe it's just the Kiwi accents, or maybe it's the wall-to-wall splatter that gives this otherwise silly outing a bit of an edge. Scarily, director Blyth graduated to the *Mighty Morphin' Power Rangers* TV series.

DEATHDREAM

1972, USA/Canada
Alternative titles: **Dead of Night**, **The Night Andy Came Home**
Dir: Bob Clark. *Prod:* Bob Clark. *Scr:* Alan Ormsby
Cast: John Marley, Lynn Carlin, Henderson Forsythe, Richard Backus, Anya Ormsby

The follow-up to *Children Shouldn't Play with Dead Things* is a very different beast. Focussing on the Vietnam experience, Clark and Ormsby follow dead war veteran Andy who's willed back to life by his desperate mother. He returns home as a blood-drinking ghoul and proceeds to leave a trail of death and destruction in his hometown. Throwaway horror-comedy or poignant Vietnam-era satire?
See pages 71-73, 83, 152, note 94

The Dead Pit

A surreal nightmare of a movie, the only thing that's really scary about this is just how bad it is. The spirit of ghastly Dr. Ramzi haunts a creepy insane asylum. He used to perform bizarre experiments on the inmates but now he's after patient Jane Doe (she can't remember her real name) - despite the fact that he's been dead for two decades. He eventually gives up the ghost (so to speak) and brings his long dead victims back to life as zombies to wander through the hallways instead.
See page 165

DEADLY FRIEND

1986, USA
Dir: Wes Craven. *Prod:* Robert M. Sherman. *Scr:* Bruce Joel Rubin, based on a novel by Diana Henstell
Cast: Matthew Laborteaux, Kristy Swanson, Michael Sharrett, Anne Twomey, Anne Ramsey

A bedroom scientist brings his girlfriend back to life as a robot zombie after her nasty dad kills her in a fit of rage. He sticks a microchip in her brain and hey-presto the appliance of science keeps the grave at bay and gives her the opportunity to kill off a few of the enemies she made while alive. Craven was definitely having an off day when he agreed to helm this little chiller filler.
See page 150

DELLAMORTE DELLAMORE

1993, Italy/France
Alternative title: **Cemetery Man**
Dir: Michele Soavi. *Prod:* Tilde Corsi, Gianni Romoli, Michele Soavi. *Scr:* Gianni Romoli, based on a graphic novel by Tiziano Sclavi
Cast: Rupert Everett, François Hadji-Lazaro, Anna Falchi, Mickey Knox, Fabiana Formica

Rupert Everett makes an incongruous lead in this belated - but masterful - addition to the Italian zombie cycle. A caretaker at the Buffalora Cemetery, he faces a regular onslaught of "Returners"

Tending the dead in **Dellamorte Dellamore**.

249

Dellamorte Dellamore

who need to be dispatched with dumdum bullets. Easily one of the best zombie films of the 1990s and the pinnacle of spaghetti zombie outings.
See pages 7, 169-170, 212

DEMONIUM

2001, Italy
Dir: Andreas Schnaas. *Prod:* Andreas Schnaas, Sonja Schnaas. *Scr:* Sonja Schnaas, Ted Geoghegan
Cast: Claudia Abbate, Andrea Bruschi, Emilia Marra, Maurizia Grossi, Giuseppe Oppedisano

In many ways, this movie represents some of Andreas Schnaas's best work (for whatever that's worth). Shot in English and funded with Italian money, it concerns a struggle among the heirs of a wealthy man over their inheritance. Nasty things happen to various people, including the reduction of three of the heirs to zombie-like automatons. Lurking in the background is a zombie killer seeking vengeance for past wrongs. There's the making of a halfway decent movie here, but Schnaas isn't the man to bring it to fruition. Confusion reigns about the exact sequence of events and it requires some effort on the part of the viewer to pull everything together. There's nothing wrong with a complex plot - it just shouldn't be this difficult to understand. Back to the drawing board, Andreas (DAO).
See page 166

DEMONS

1985, Italy
Original title: **Demoni**
Dir: Lamberto Bava. *Prod:* Dario Argento. *Scr:* Dario Argento, Lamberto Bava, Dardano Sacchetti, Franco Ferrini
Cast: Urbano Barberini, Natasha Hovey, Karl Zinny, Fiore Argento, Paola Cozzo

With so much spaghetti talent behind the camera you could be forgiven for expecting more from this disposable gorefest. Aimed squarely at the American teen horror fan it's a wonderfully nasty, but ultimately empty, tale about some ordinary Joes who are given free tickets to a movie premiere. For some unexplained reason, they find themselves trapped in the auditorium as *Evil Dead*-style zombie-demons attack. Sounds silly? Well it is, but the team play it straight, piling on buckets of blood 'n' gore and an eardrum-thrashing soundtrack designed to stop you from questioning the ridiculousness of the action. It was followed by Bava's *Demons 2* (1986), which basically relocated the action to a high-tech tower block and his TV movie *Demons 3: The Ogre* (1988), which had absolutely nothing to do with the first two films except for its cash-in title.

DEMONS 3

1991, Italy
Original title: **Demoni neri**
Alternative titles: **Black Demons**, **Demoni III**
Dir: Umberto Lenzi. *Prod:* Giuseppe Gargiulo. *Scr:* Olga Pehar
Cast: Keith Van Hoven, Joe Balogh, Sonia Curtis, Philip Murray, Juliana Texeira

Demons

Completely unrelated to Lamberto Bava's *Demons* trilogy (see above), this late Italian entry from Umberto Lenzi takes place in Brazil where six black zombies hound some white teenagers as punishment for years of European imperialism. Or maybe just for the hell of it.

DEVIL HUNTER

1980, Spain/Germany/France/Italy
Original titles: **Sexo caníbal, Jungfrau unter Kannibalen, Il cacciatore di uomini**
Alternative titles: **The Man Hunter, Mandingo Manhunter.**
Dir: Clifford Brown [Jesús Franco]. *Prod:* Julian Esteban Gomez. *Scr:* Julius Valery, Clifford Brown [Jesús Franco]
Cast: Al Cliver [Pier Luigi Conti], Ursula Fellner, Robert Foster [Antonio Mayans], Gisela Hahn, Werner Pochath, Claude Boisson

After a famous young actress is kidnapped in an undisclosed Caribbean location, Vietnam vet Al Cliver is dispatched to pay the ransom and get her back. Aside from the kidnappers and a jungle cannibal tribe, Cliver finds himself at the mercy of a towering black zombie who wanders through the undergrowth eating (in every sense) any women he comes across. Franco's on familiar territory with this cannibal-zombie-sex-horror hybrid that's as irredeemably racist as it sounds.
See page 143

DEVIL STORY

1986, France
Original title: **Il était une fois ...le diable**
Dir: Bernard Launois. *Scr:* Bernard Launois
Cast: Véronique Renaud, Marcel Portier, Catherine Day, Nicole Desailly, Christian Paumelle

A zombie, an Egyptian mummy, a spooky galleon and a deformed monster bearing an uncanny (or simply unashamed?) resemblance to the Toxic Avenger are among the pleasures to be searched out in this rare Eurohorror flick. The chief monster is a deformed creature in a Nazi uniform that, armed with a shotgun, is terrorising the French countryside. A sequence in which the mummy raises a dead woman from her grave has little to add to the ramshackle chaos of the plot.
See page 126

DEVIL'S KISS

1973, Spain
Original title: **La perversa caricia de Satán**
Alternative title: **The Wicked Caress of Satan**
Dir: Georges [Jorge] Gigó. *Scr:* Georges [Jorge] Gigó
Cast: Silvia Solar [Genevieve Couzain], Olivier Mathot, José Nieto, Evelyne Scott [Evelyne Deher]

An obscure genre entry, this trashy Eurociné-released Spanish effort involves a medium who raises a zombie to help her take revenge on the people who she blames for causing her husband to commit suicide. Director/bit player Georges Gigó's first and last horror film - for obvious reasons.
See page 119

DIE YOU ZOMBIE BASTARDS!

2005, USA
Dir: Caleb Emerson. *Prod:* Haig Demarjian, Caleb Emerson. *Scr:* Caleb Emerson
Cast: Tim Gerstmar, Pippi Zornoza, Geoff Mosher, Jamie Gillis, Jennifer K. Beal

Die You Zombie Bastards is apparently "The world's first EVER serial killer superhero, Rock 'n' Roll zombie road movie romance". And far be it for this writer to disagree! A trash epic that's willing to throw everything including the kitchen sink into the zombie mix it boasts a supporting role for Jamie Gillis (former porn star turned *Night of the Zombies* thesp) and, according to the publicity, "White hot molten cheese scalding and disfiguring pert young nipples!!!" Draw your own conclusions.

DISCIPLE OF DEATH

1972, UK
Dir: Tom Parkinson. *Prod:* Tom Parkinson, Churton Fairman [Mike Raven]. *Scr:* Churton Fairman [Mike Raven]
Cast: Mike Raven, Ronald Lacey, Stephen Bradley, Marguerite Hardiman, Virginia Weatherell

Eighteenth-century Cornwall is the setting for this pointless British outing. After blood is spilt at an abandoned manor house, demonic lead actor Mike Raven returns from hell and sows the seeds of destruction through the local community by sacrificing the local women to his lord Satan. Lots of sub-*Dracula* moments see Raven trying to pitch himself somewhere

between Bela Lugosi and Christopher Lee, however the film is ultimately little more than a curiosity piece as oo-ar accents, a vampiric dwarf and assorted English Gothic trappings pad out the interminable dullness. The only reason for its inclusion here is that Raven surrounds himself with zombie-like female slaves - although, for all it matters to the movie's plot they could just as well be vampires, demons or shape-shifting aliens from the planet Zartoff. Tellingly, producer/writer Churton Fairman was actually Raven himself working under a pseudonym.
See page 77

DOCTOR BLOOD'S COFFIN

1960, UK
Dir: Sidney J. Furie. *Prod:* George Fowler. *Scr:* Jerry Juran, James Kelly, Peter Miller
Cast: Kieron Moore, Hazel Court, Ian Hunter, Kenneth J. Warren, Paul Stockman

Young Dr. Peter Blood returns home to Cornwall after a spell in Vienna convinced that he can resurrect the dead through the use of heart transplants. Preying on the locals, he paralyzes them with curare then kills them in his botched attempts to prove his hypothesis. Blood finally succeeds and brings the dead husband of his new girlfriend back to life. Neither the zombie nor his widow is particularly impressed. Funny that.
See pages 55-57, 60

DR. ORLOFF'S MONSTER

1964, Spain/France
Original titles: **El secreto del doctor Orloff, Les maîtresses du docteur Jekyll**
Alternative titles: **Brides of Dr. Jekyll, Dr. Jekyll's Mistresses**
Dir: Jesús Franco. *Scr:* Jesús Franco, based on the novel by David Khunne [Franco]
Cast: Hugo Blanco, Agnès Spaak, Marcelo Arroita-Jauregui, José Rubio, Pastor Serrador, Perla Cristal, Marta Reves

After inheriting some groundbreaking research into "ultrasonics" from a dead colleague, Dr. Jekyll is able to resurrect his dead brother-in-law Andros as a zombie. The arrival of Andros's daughter Melissa complicates matters, though. Especially when she catches sight of her reanimated father.
See pages 61-62

DR. SATAN VS. BLACK MAGIC

1967, Mexico
Original title: **El Dr. Satán y la magia negra**
Dir: Rogelio A. González. *Prod:* Sidney T. Bruckner. *Scr:* José María Fernández Unsáin
Cast: Joaquín Cordero, Noe Murayama, Sonia Furio, Luz María Aguilar

A Mexican horror movie sans wrestling, this follows two warring sorcerers (Dr. Satan and "Black Magic") who're out to destroy each other. Various horror conventions buoy up the action, including a pair of rather pert zombie girls.
See page 60

DOWN TO HELL

1996, Japan
Dir: Ryuhei Kitamura. *Prod:* Masami Miyata, Ryuhei Kitamura, Keishiro Shin. *Scr:* Ryuhei Kitamura
Cast: Masami Miyata, Yoshihiro Okamoto, Ryuhei Kitamura, Nobuhiko Morino, Keishiro Shin

Four ruffians kidnap an innocent Japanese salary man and force him to run for his life through a deserted forest. The victim puts up a valiant fight, but he loses the battle and they kill him. Unfortunately for the thugs, they've just happened to pick a forest that has some nasty magic running through its soil. The businessman comes back as a superhuman zombie, making the hunters into the hunted. This is Ryuhei Kitamura's first commercial film and there are several obvious similarities with *Versus*, not least of all the forest setting and amphetamine-amped visual style. It clocks in at just forty-five-minutes (DAO).
See page 173

THE EARTH DIES SCREAMING

1964, UK
Dir: Terence Fisher. *Prod:* Robert Lippert, Jack Parsons. *Scr:* Harry Spalding
Cast: Willard Parker, Virginia Field, Dennis Price, Thorley Walters, Vanda Godsell

After aliens invade the Earth with gas attacks and clunky robots, a handful of British survivors find themselves trapped in a provincial town. They watch in horror as the invaders reanimate the dead and use them as cheap soldiers in the skirmish. In a daring act of bravery our plucky heroes attack the broadcasting antenna that's transmitting the aliens' radio waves and turn the tide of the war.
See pages 56-57, 60

ENTER... ZOMBIE KING

2003, Canada
Alternative title: **Zombie King and the Legion of Doom**
Dir: Stacey Case. *Prod:* Bill Marks. *Scr:* Bill Marks, Sean K. Robb.
Cast: Jules Delmore, Rob "El Fuego" Etchevarria, Jennifer Thom, Raymond Carle, Sean K. Robb.

The spirit of El Santo lives on in this kinetic B-movie wrestling flick. Shot on the cheap in Canada in "minus 40 degree temperatures" during three weeks in 2002, its original title was *Zombie Beach Party*. Internet rumours claimed that it was supposed to star none other than George Romero himself as the villainous "Zombie King" (Big George in a zombie wrestling movie? Oh what might have been...!) Allegedly, Romero fell ill before production and was replaced by one of the film's stuntmen. Still, the finished product has more than enough to recommend it to wrestling/comics/ zombie fans with a plot about masked wrestlers solving a series of zombie-related murders. At the time of writing unconfirmed word from the 2005 Cannes film festival suggests it may have been picked up for a wider distribution deal under the title *Zombie King and the Legion of Doom*.

EROTIC NIGHTS OF THE LIVING DEAD

1980, Italy
Original title: **Le notti erotiche**
Alternative titles: **In der Gewalt der Zombies, Le notti erotiche dei morti viventi, Sexy Nights of the Living Dead**
Dir: Joe D'Amato [Aristide Massaccesi].
Scr: Tom Salina [aka Aristide Massaccesi]
Cast: Laura Gemser, George Eastman [Luigi Montefiori], Dirce [Patrizia] Funari, Mark Shannon [Manlio Cersosimo]

A yachtsman takes a couple of tourists to a distant Caribbean island and runs into a horde of native zombies in this rough and ready effort from Joe D'Amato. As our heroes are torn between making the beast with two backs and fighting off the living dead, things quickly get messy.
See pages 132, 134-136, 201

EROTIC ORGASM

1982, Italy
Original title: **Orgasmo esotico**
Alternative title: **Exotic Orgasm**
Dir: Lee Castle [Mario Siciliano]
Cast: Marina [Frajese] Lotar, Sonia Bennett, Michel Curie, Peter Brown, Joe Mignano [Eugenio Gramignano]

A virtually incomprehensible hardcore sex flick from Mario Siciliano (although it's sometimes also attributed to Joe D'Amato, aka Aristide Massaccesi), *Erotic Orgasm* features lots of explicit orgies and a couple of zombies. There's hardly any dialogue but the plot apparently involves a black witch who uses her supernatural powers to turn the inhabitants of a remote Mediterranean villa into zombie sex slaves. Possessing all the skewered logic of a bad hash dream, it combines endless hardcore porn sequences with a fair few

The Evil Dead

sex toys and a dreadful Eurotrash elevator Muzak score. Given that the zombies are little more than actors caked in pallid make-up and - in the case of a zombie woman who comes back to give her boyfriend head - an overabundance of blue eye shadow, it's never as interesting as it might sound.
See pages 135-136

THE EVIL DEAD

1982, USA
Dir: Sam Raimi. *Prod:* Robert Tapert. *Scr:* Sam Raimi
Cast: Bruce Campbell, Ellen Sandweiss, Hal Delrich, Betsy Baker, Sarah York

Sam Raimi's thundering gorefest is a classic but whether or not it really deserves to be billed as a zombie movie depends on how strict you want to be about your living dead ghouls. It seemed prudent to include it anyway, just because it was such an influence on Peter Jackson's zombie flicks *Bad Taste* and *Braindead*. Ash and his mates head out to a log cabin in the woods for some R&R only to reawaken an ancient evil that turns their trip into a living hell. As the put-upon everyman facing up to demons who have a habit of possessing the bodies of his friends, Bruce Campbell became an overnight horror star. At the time of writing, a remake is under discussion with Raimi acting as producer.
See pages 156-157, 159, 175

EVIL DEAD II

1987, USA
Alternative title: **Evil Dead 2: Dead By Dawn**
Dir: Sam Raimi. *Prod:* Robert Tapert. *Scr:* Sam Raimi, Scott Spiegel
Cast: Bruce Campbell, Sarah Berry, Dan Hicks, Kassie Wesley, Theodore [Ted] Raimi

How do you improve on *The Evil Dead*? Find a bigger budget, tool up with more chainsaws and exaggerate the comedy and the splatter, that's how. Raimi's demented follow-up goes all out for "splatstick" with deliriously funny results as Ash finds himself back in the same log cabin and unleashing the same demons all over again. A dancing zombie girlfriend, a recalcitrant chopped off hand and plenty of Three Stooges pratfalls take horror into uncharted territory. Brilliant.
See pages 157-158, 165

THE FACE OF MARBLE

1946, USA
Dir: William Beaudine. *Prod:* Jeffrey Bernerd. *Scr:* Michel Jacoby
Cast: John Carradine, Claudia Drake, Robert Shayne

John Carradine is up to his old tricks again in this voodoo-themed Monogram outing, resurrecting the dead and a Great Dane dog just for the hell of it. The corpses act more like ghosts than zombies making this just another Poverty Row schedule filler.
See page 100, note 49

FLESH FREAKS

2001, USA
Dir: Conall Pendergast. *Prod:* Conall Pendergast, Ronny Varno. *Scr:* Conall Pendergast
Cast: Eshe Mercer-James, Etan Muskat, Ronny Varno, Erica Goldblatt, Clayton Hayes

This SOV feature turns away from the tired biological/chemical origin of zombies and gives us ghouls spawned by intelligent space worms freed from imprisonment in some Mayan ruins (ahem). Unfortunately, the film's low budget can't match the story's ambitions. The second half of the film supposedly involves a zombie invasion of the outside world, but the limited cast size doesn't convey this effect and although some of the zombie make-up is impressive, the rest of it is all too obviously made from papier-mâché. One wonders what the creators could have done with a larger budget. However, if they use this uneven little movie as their calling card we may never get to find out (DAO).
See page 166

THE FOG

1979, USA
Dir: John Carpenter. *Prod:* Debra Hill. *Scr:* John Carpenter, Debra Hill
Cast: Adrienne Barbeau, Jamie Lee Curtis, Janet Leigh, Tom Atkins, Hal Holbrook, John Houseman

Antonio Bay's celebrating its hundredth birthday when a dark, dank fog rolls in off the ocean. Soon the townsfolk are turning up dead as sea-faring zombies

emerge from the mist to kill off the ancestors of the town's founding fathers who did them wrong. Radio DJ Stevie tries to warn the townsfolk as she broadcasts from the lighthouse but it's too late - the ghouls are everywhere. The survivors eventually decide to barricade themselves in the local church, then realise that that's where the ghouls' stolen gold is buried. Uh-oh.
See pages 151-152, 178

FROM THE DEAD OF NIGHT

1989, USA
Dir: Paul Wendkos. *Prod:* Barbara Black.
Scr: William Bleich, based on the novel by Gary Brander
Cast: Lindsay Wagner, Bruce Boxleitner, Diahann Carroll, Robin Thomas, Robert Prosky

Writer Bill Bleich takes zombies onto the small screen again after *The Midnight Hour* in this equally lame TV movie. Lindsay Wagner stars as Joanna, a woman who's had a near death experience involving a cat and a swimming pool (Don't ask. Or laugh). Now it seems a whole host of strangers are out to kill her, so where better to go for some calm relaxation than Mexico's Day of the Dead festival? It all adds up to a risible plot in which zombie spirits from the afterlife - dubbed "walkers" - try and make Joanna join them. If it saves us having to watch this dross, they're welcome to her.
See page 154

The Fog

GALLERY OF HORROR

1966, USA
Alternative titles: **Alien Massacre, The Blood Suckers, Dr. Terror's Gallery of Horrors, Return from the Past**
Dir: David L. Hewitt. *Prod:* David L. Hewitt, Ray Dorn. *Scr:* David L. Hewitt, Gary Heacock, Russ Jones, David Prentiss
Cast: Lon Chaney Jr., John Carradine, Rochelle Hudson, Roger Gentry, Mitch Evans

John Carradine introduces viewers to five short tales in this anthology film featuring vampires in London, serial killers and bewitched clocks. In the third story "Monster Raid" a rich scientist comes back from the grave as a rotting zombie to avenge himself on his adulterous wife and his traitorous assistant. Meanwhile, in "The Spark of Life" an ageing Lon Chaney plays Frankenstein with a cadaver. No one here seems capable of acting their way out of a wet paper coffin and although the zombie make-up seems to pass muster, we never get a very long look at it, so who knows for certain? Tiresome (DAO).
See note 98

GARDEN OF THE DEAD

1972, USA
Alternative title: **Tomb of the Undead**
Dir: John Hayes. *Prod:* H.A. Milton. *Scr:* Jack Matcha
Cast: Phil Kenneally, Duncan McLeod, John Dullaghan, John Dennis, Marland Proctor, Lee Frost

A group of chain-ganged prisoners in an isolated work camp get high on formaldehyde fumes in this dreadful zombie shocker. After a prison break goes wrong the bodies of dead inmates are slung in shallow graves soaked in formaldehyde and - through some inexplicable chemical

A movie not worth dying for: **Gallery of Horror**.

process - the dead return to life as fast-moving ghouls armed with pick-axes. Lots of boring action sequences pad out the (mercifully) brief running time until the prison guards realise that the best way to keep sexually-pent up zombies quiet is to give them some female company and then catch them with their pants down. Awful.
See page 73

THE GHOST BREAKERS

1940, USA
Dir: George Marshall. *Prod:* Arthur Hornblow Jr. *Scr:* Walter DeLeon, based on a play by Paul Dickey and Charles Goddard
Cast: Bob Hope, Paulette Goddard, Richard Carlson, Paul Lukas, Willie Best

Bob Hope teams up with Willie Best as a radio show host and his valet who end up in a haunted Cuban castle. The castle has been inherited by Paulette Goddard, who's being spooked out of the place by the zombie son of the former housekeeper and a collection of bad guys desperate to get their hands on the silver mine buried beneath the foundations.
See pages 32-36, 48, 98

GHOST BRIGADE

1992, USA
Alternative titles: **Grey Knight**, **The Killing Box**, **The Lost Brigade**
Dir: George Hickenlooper. *Prod:* Brad Krevoy, Steve Stabler. *Scr:* Matt Greenberg
Cast: Corbin Bernsen, Adrian Pasdar, Ray Wise, Rick Schroeder, Cynda Williams, Matt LeBlanc, Martin Sheen, Billy Bob Thornton

Civil War zombie ghouls attract an unlikely cast in this threadbare production. Martin Sheen, Ray Wise, Billy Bob Thornton and Matt LeBlanc are among the famous faces as a band of unkillable Confederate soldiers go on the rampage. Caught somewhere between ghosts and living dead ghouls, these creatures aren't really zombies but a mishmash of horror conventions (they're wounded by silver and can't cross running water). It doesn't add up to anything very much (and rumours of post-production tampering abound) but along with *Ghost Town* it's the nearest anyone's ever come to making a zombie western. Oh, and if the portentous voice-over about the horror of war occasionally sounds as if it's been lifted straight out of *Apocalypse Now* that may be because Hickenlooper also directed the Francis Ford Coppola doc *Hearts of Darkness: A Filmmaker's Apocalypse* (1991).
See page 153

GHOST TOWN

1988, USA
Dir: Richard Governor. *Prod:* Tim Tennant. *Scr:* Duke Sandefur
Cast: Franc Luz, Catherine Hickland, Jimmie F. Skaggs, Penelope Windust, Bruce Glover

A real rarity this, as it's just about the only zombie western ever made. If the filmmakers had any sense, they might have chosen a more suitable title and saved it from obscurity. *A Fistful of Brains*, perhaps? Modern day sheriff's deputy Langley is on the trail of a kidnapped girl when he finds himself stuck in a supernatural ghost town lorded over by a decaying zombie-ghost called Devlin. Can he save the girl and free the town's spirits from their purgatorial existence? Hardly a great movie, but it scores top marks for effort and originality.
See page 151, 207

GHOSTS OF MARS

2001, USA
Dir: John Carpenter. *Prod:* Sandy King. *Scr:* Larry Sulkis, John Carpenter
Cast: Ice Cube, Natasha Henstridge, Jason Statham, Pam Grier, Clea DuVall

John Carpenter takes the zombie movie into space for some laughable shenanigans on Mars in this thrash-rock living dead flick. Vengeful red planet demons possess the bodies of dead colonists and head out to attack cops transporting one of the galaxy's most dangerous criminals, Desolation Williams. Yes, it's *Assault on Precinct 13* (1976) all over again, just set in 2176 A.D. and with zombie ghouls who look like they've escaped from a Slipknot concert.
See page 152

THE GHOUL

1933, UK
Dir: T. Hayes Hunter. *Prod:* Michael Balcon. *Scr:* Roland Pertwee, John Hastings Turner
Cast: Boris Karloff, Ernest Thesiger, Cedric Hardwicke, Dorothy Hyson, Anthony Bushell

Karloff's feted return to Britain after making his name in America isn't a patch on his Universal efforts. Playing a dying Egyptologist who uses an occult amulet to bring him back from his coffin (or rather sarcophagus), the star himself is on fine form. It's just the rest of the movie that's terrible as subplots involving the assembled mourners and thieves who want to steal the trinket take their toll. It doesn't help that the only surviving print is in an awful state. Still, Karloff's hulking, ape-like ghoul is an interesting take on the zombie - a brutal thuggish villain who kicks in windows and bends open bars with his bare hands while sporting a dreadfully decomposed face and thick, bushy eyebrows.
See pages 27, 29

GHOUL SCHOOL

1990, USA
Dir: Timothy O'Rawe. *Scr:* Timothy O'Rawe
Cast: William Friedman, Scott Gordon, Paul Venier, Nancy Sirianni, Ed Burrows

It's the school where the uneducated meet the undead. A SOV production that's almost totally without merit, *Ghoul School* is cursed with a risible plot that's as corny as they come: toxic chemicals leak into the school pool and turn the swim team

The Ghoul

into flesh-hungry zombies. Troma's outing *Class of Nuke 'em High* (1986) is an obvious point of reference for this woeful excuse for a movie.
See page 166

GOESHI

1981, South Korea
Alternative title: **Strange Dead Bodies**
Dir: Kang Beom-gu. *Prod:* Jeong Woong-gi. *Scr:* Ju Dong-woon
Cast: Yu Kwang-ok, Kang Myeong, Park Am, Hwang Ok-hwan, Hong Yun-jeong

This Korean remake of Euro classic *The Living Dead at Manchester Morgue* loses the original film's wonderfully creepy sense of place (the wet and gloomy Lake District) as it relocates the action to Asia. The central premise remains the same - scientists experimenting with a new insecticide accidentally manage to bring the dead back to life to terrorise the living. Although the zombie makeup is limited to white greasepaint, the film's power derives from its spooky scenes of the dead leaving their tombs and - as several reviewers have noted - the veiled (but sadly underdeveloped) allusions to the US's use of Agent Orange during the Vietnam War as three deformed zombie children are spawned by the insecticide.
See note 101

GORE WHORE

1994, USA
Dir: Hugh Gallagher. *Prod:* Hugh Gallagher. *Scr:* Hugh Gallagher
Cast: Audrey Street, Brady Debussey, D'Lana Tunnell, Paul Woodard, Sherry Lynn Garris

No budget, no brains, no taste. Gallagher's z-grade effort has a living dead girl walking the streets as a zombie whore. "With this girl there's no such thing as safe sex," threatens the tagline and with a dedication to penis-slicing woman-spurned Lorena Bobbitt it's pretty obvious why. The less said about the poor girl's method of injecting herself with the reanimating agent needed to keep her alive the better. Was actress Audrey Street really this desperate to see her name on a video sleeve?
See page 135

GORE-MET ZOMBIE CHEF FROM HELL

1986, USA
Dir: Don Swan. *Prod:* Don Swan. *Scr:* Don Swan, Jeff Baughn, William Highsmith
Cast: Theo Depuay, Kelley Kunicki, C.W. Casey, Michael O'Neill, Jeff Baughn

Arguably only remembered because of its distinctive title (which promises too much with the use of the word "zombie"), this effort is so utterly cheap it looks as though it was strung together on a wet afternoon by a bunch of bored teenagers. The zombie chef of the title is Goza, a cursed priest who's forced to spend eternity eating the flesh of humans. That gives filmmaker Swan lots of excuse for some amateur gore, as customers at Goza's restaurant find themselves on the menu. The cannibal cookery deserves three Michelin stars, the rest of the move doesn't.
See pages 151, 210

THE GRAPES OF DEATH

1978, France
Original title: **Les raisins de la mort**
Alternative title: **Pesticide**
Dir: Jean Rollin. *Prod:* Claude Guedj. *Scr:* Jean Rollin, Christian Meunier
Cast: Marie-Georges Pascal, Félix Marten, Serge Marquand, Mirella Rancelot

Wine contaminated by a bad pesticide causes an outbreak of zombification in Jean Rollin's Gallic horror. Heroine Elizabeth finds herself at the mercy of a gang of putrefying locals as the wine's effect devastates rural France. Teaming up with a pair of non-wine drinkers she makes her way to the supposed safety of a mountaintop where a vineyard produces the vino that's actually the cause of the disaster. Rollin's forte is the more austere and elegant genre of the vampire movie. Though his attempt at gore *à l'américaine* may not be one of his most typical films, it's still moody and distinctive stuff.
See pages 84-86, 90, 94, 124-125, 179

GRAVEYARD ALIVE: A ZOMBIE NURSE IN LOVE

2003, Canada
Dir: Elza Kephart. *Prod:* Patricia Gomez, Elza Kephart, Andrea Stark. *Scr:* Elza Kephart
Cast: Anne Day-Jones, Karl Gerhardt, Samantha Slan, Martha Brooke, Barbara Bacci

A feminist zombie picture, *Graveyard Alive* is a welcome riposte to the almost exclusively male dominated movies in the rest of this filmography. Taking the eroticism of the vampire mythology and grafting it onto a living dead soap opera set in a hospital, debut writer-director Elza Kephart delivers a fantastic homage to the low-budget horror movies with some beautiful cinematography (it's shot in black and white in the old Techniscope format) and a very funny line in camp humour. The Zombie Nurse is Patsy, an ugly duckling whose prettier, blonder, sexier peers mercilessly ridicule her for being a plain Jane. Then an encounter with a zombie patient transforms her into a sexy ghoul (complete with all the necessary curves) and she's able to woo the handsome Dr. Dox. Loving, warm and witty, it's a real treat.
See page 181

GRAVEYARD DISTURBANCE

1987, Italy
Original title: **Una notte nel cimitero**
Dir: Lamberto Bava. *Prod:* Massimo Manasse, Marco Grillo Spina. *Scr:* Dardano Sacchetti, Lamberto Bava
Cast: Gregory Lech Thaddeus, Lea Martino, Beatrice Ring, Gianmarco Tognazzi, Karl Zinny

What's more disturbing - this lame TV movie's distinct lack of gore or the realisation that it's directed by Lamberto Bava, scion of Italian horror's greatest dynasty? Thieving teenagers find themselves in trouble when they accept a bet to hide out in some deserted catacombs. Needless to say, they're not as deserted as they thought, which leads to all kinds of encounters with various monsters and a few rotting corpses.
See page 132

HALLOW'S END

2003, USA
Dir: Jon Keeyes. *Prod:* Brandon Baker, Richard T. Carey, Faras Rabadi. *Scr:* Christopher J. Burdick
Cast: Stephen Cloud, Brandy Little, Amy Jo Hearron, Amy Morris, Jim Dunn

This haunted house movie starts out well, but soon falls apart due to a weak script. A group of young people travel to the town of Hallow's End to run a legendary haunted house for charity. They come into the possession of an old book of magic. Naturally, they use it and the haunted house's collection of vampires, zombies, pirates, and other assorted monsters all become real. The script, as unoriginal as it is, might work if we cared about the characters. Yet as it stands, it's all too easy to lose track of who's supposed to be alive and who's supposed to be dead (DAO).
See page 166

THE HAPPINESS OF THE KATAKURIS

2000, Japan
Original title: **Katakuri-ke no kôfuku**
Dir: Takashi Miike. *Prod:* Hirotsugu Yoshida. *Scr:* Kikumi Yamagishi
Cast: Kenji Sawada, Keiko Matsuzaka, Shinji Takeda, Naomi Nishida, Tetsuro Tanba

A demented remake of Korean film *The Quiet Family* (1998), this dispenses with everything apart from the basic premise: a laid-off family leave the big city to open a guesthouse in the mountains. After their first guest commits suicide, the family decide that the best way to keep the tragedy quiet is by burying the body out in the woods. Pretty soon, all of their lodgers end up dead by dawn, creating a pile of corpses that have to be discreetly disposed of. An all-singing, all-dancing karaoke epic, this features a brief scene in which the dead guests return from the grave for a quick dance number.
See page 174

HARD ROCK ZOMBIES

1984, USA
Dir: Krishna Shah. *Prod:* Krishna Shah.
Scr: Krishna Shah, David Ball
Cast: E.J. Curcio, Geno Andrews, Sam Mann, Mick Manz, Jennifer Coe

A rock band is murdered then brought back from the grave in this supposedly outrageous but really rather dull horror-comedy featuring a zombified Adolf Hitler, Eva Braun and lots of rock music. It's brash, it's loud and it's very 1980s. Beavis and Butthead would probably love it. Everyone else is advised to bring earplugs.
See page 153

THE HAUNTED MANSION

2003, USA
Dir: Rob Minkoff. *Prod:* Andrew Gunn, Don Hahn. *Scr:* David Berenbaum
Cast: Eddie Murphy, Jennifer Tilly, Terence Stamp, Nathaniel Parker, Marsha Thomason

Based on a theme park ride, this lacklustre Disney family horror movie follows Eddie Murphy's real estate broker Jim Evers and his family on a trip to a haunted mansion. It throws in every haunted house gimmick imaginable: hidden passageways, vengeful ghosts, spooky butlers, skeletal zombies and suits of armour that have a habit of coming to life. Seems the only things missing are the Scooby Snacks.
See page 178

HELLGATE

1989, South Africa
Dir: William A. Levey. *Prod:* Anant Singh. *Scr:* Michael O'Rourke
Cast: Ron Palillo, Abigail Wolcott, Carel Trichardt, Petrea Curran, Evan Klisser

A town with a secret, a beautiful female zombie, a magical crystal and a campfire ghost story do little to enliven the horrors of *Hellgate* as a girl raped and murdered in the 1950s is brought back to life by her embittered father to wreak revenge on the living. Complete drivel that went straight-to-video for very obvious reasons. In its favour however, the exploding goldfish deserves an honorary (posthumous) mention for services to horror cinema...

HORROR EXPRESS

1972, Spain/UK
Original title: **Pánico en el transiberiano**
Dir: Gene [Eugenio] Martín. *Prod:* Eugenio Martín, Bernard Gordon. *Scr:* Arnaud d'Usseau, Julian Halevy, Eugenio Martín
Cast: Christopher Lee, Peter Cushing, Alberto de Mendoza, Silvia Tortosa, Julio Peña, Telly Savalas

The Trans-Siberian railway is the setting for this alien invasion movie featuring a couple of zombies. The real star of the show is a two-million-year-old alien monster that thaws out in transit and goes wild. The creature has the ability to erase men's minds by turning them into blank-eyed zombies. It's great fun, with Lee and Cushing playing the material for all its worth. "What if one of you is the monster?" demands one of the passengers when they discover that the creature has the ability to jump into people's bodies. "Monster?!" replies an incredulous Cushing, "We're British, you know".

HORROR HOSPITAL

1973, UK
Alternative title: **Computer Killers**
Dir: Antony Balch. *Prod:* Richard Gordon. *Scr:* Antony Balch and Alan Watson
Cast: Michael Gough, Robin Askwith, Vanessa Shaw, Ellen Pollock, Dennis Price

Directed by legendary British distributor and avant-garde filmmaker Antony Balch, several years after he'd collaborated with William Burroughs on *The Cut Ups* and *Towers Open Fire*, this is a quite unique attempt to turn trash horror into something more. It fails dismally, but it's never less than entertaining in a cheesy kind of way. A hippie gets more than he bargains for when a weekend break in a country retreat turns nasty. Brittlehouse Manor is a "health resort" that's definitely bad for your health as experiments on the guests turn them into braindead zombies. Throw in a weird mud creature, leather-clad biker boys, saucy star Robin Askwith and an evil dwarf butler and you have one of the most surreal trash horror movies of the 1970s.
See note 120

THE HORROR OF PARTY BEACH

1963, USA
Dir: Del Tenney. *Prod:* Del Tenney. *Scr:* Richard Hilliard
Cast: John Scott, Alice Lyon, Allan Laurel, Eulabelle Moore, Marilyn Clarke

Director Del Tenney's currency in zombie circles is pretty low even by this variable genre's standards. This ludicrous beach movie come rock 'n' roll horror flick does little to endear him even to the most hardcore of hardcore fans. Partying teenagers are attacked on the sandy beaches by mutant sea monsters after toxic sludge is dumped into the water. The monsters don't have much to do with zombies (other than the fact that dim-witted cast call them that) but look more like The Creature from the Black Lagoon with a hotdog in his mouth. Oh and there's a dance number called "The Zombie Stomp" thrown in for good measure. They should have just had a clam bake...
See pages 64, 76

book of the dead

Death on the ocean waves: a montage of scenes from the press book for **Horror of the Zombies**.

HORROR OF THE ZOMBIES

1973, Spain
Original title: **El buque maldito**
Alternative titles: **The Ghost Galleon, Ghost Ship of the Blind Dead, La noche del buque maldito, Ship of Zombies, Das Geisterschiff der schwimmenden Leichen**
Dir: Amando de Ossorio. *Prod:* J.L. Bermúdez de Castro. *Scr:* Amando de Ossorio
Cast: María Perschy, Jack Taylor, Bárbara Rey, Carlos Lemos, Manuel de Blas

A publicity stunt featuring bikini-clad babes tempt the Templars out of hiding in this nautical take on the *Blind Dead* series. Set out on the ocean wave, it follows a pair of models lost at sea and the attempts of a rescue party to save them. A ghostly galleon containing the Templars unexpectedly interrupts the proceedings by sailing in and out of some vaguely-explained inter-dimensional portal and the protagonists are trapped aboard until the spooky shoreline conclusion. Best not to dwell on the footage of the galleon itself, which looks decidedly like a miniature model floating in a pond.
See pages 86, 88-89, 108-111

HORROR RISES FROM THE TOMB

1972, Spain
Original title: **El espanto surge de la tumba**
Dir: Carlos Aured. *Prod:* Ricardo Muñoz Suay. *Scr:* Jacinto Molina
Cast: Paul Naschy [Jacinto Molina], Emma Cohen, Vic Winner [Victor Alcazar], Helga Liné, Betsabé Ruiz

Paul Naschy stars as an executed fifteenth-century warlock who rises from the tomb to wreak havoc on his descendants with the help of his rapacious wife. Notable chiefly for censor-baiting scenes involving sexual perversity, heart-ripping cannibalism and a handful of zombies.
See page 86

HOT WAX ZOMBIES ON WHEELS

1999, USA
Dir: Michael Roush. *Prod:* Michael Roush, Robert Yesk. *Scr:* Elizabeth Bergholz
Cast: Catherine Brewton, John Riann, Lynne Hatcher, Jill Miller, John Rawling

The House by the Cemetery

Shot in 12 days in sunny California, *Hot Wax Zombies* weighs in with copious amounts of naked flesh as a zombie biker gal opens up a "hot wax" beauty salon in a small town and invites the inhabitants to join her for some fun. Pretty soon sex-crazed, hairless zombies are revving up and down the streets on their motorbikes as the hot wax therapy has unexpected side-effects. With its high camp tone, endless parade of bare breasts, and a bike-riding dominatrix heroine, this follows doggedly in the skid marks of Troma's *Chopper Chicks in Zombie Town* (1989).
See note 120

HOUSE

1985, USA
Dir: Steve Miner. *Prod:* Sean S. Cunningham. *Scr:* Ethan Wiley
Cast: William Katt, George Wendt, Richard Moll, Kay Lenz, Michael Ensign

Friday the 13th's Sean S. Cunningham teamed up with executive producer Roger Corman for this stab at 1980s horror-comedy about a haunted house. William Katt's Vietnam vet turned novelist moves into his dead aunt's spooky home only to find himself haunted by ghosts, flying gardening implements and the zombified remains of "Big Ben", a comrade in arms who he left behind in Southeast Asia. Cheesy horror-comedy at its stinkiest.
See page 73

THE HOUSE BY THE CEMETERY

1981, Italy
Original title: **Quella villa accanto al cimitero**
Dir: Lucio Fulci. *Prod:* Fabrizio De Angelis. *Scr:* Dardano Sacchetti, Giorgio Mariuzzo, Lucio Fulci
Cast: Katherine MacColl [Catriona MacColl], Paolo Malco, Ania Pieroni, Giovanni Frezza, Silvia Collatina

Bob and his parents move into a Victorian house in New England that formerly belonged to a family named Freudstein. Little do they realise that the zombified remains of the evil Dr. Freudstein are still in the basement and that he's attacking anyone who ventures downstairs. A typically surreal addition to Fulci's zombie trilogy, *The House by the Cemetery* doesn't stand up to scrutiny, but give yourself over to its strangeness and it delivers all the primal fear of a Grimm fairy tale.
See pages 129, 131, 137, 139, 140-142, notes 144, 145

THE HOUSE OF SEVEN CORPSES

1973, USA
Dir: Paul Harrison. *Prod:* Paul Lewis, Paul Harrison. *Scr:* Paul Harrison, Thomas J. Kelly
Cast: John Ireland, Faith Domergue, John Carradine, Carole Wells, Jerry Strickler

"Eight graves! Seven bodies! One killer... and he's already dead," enthused the tagline. Shame the movie didn't live up to the hype. In this self-reflexive effort some witless horror filmmakers manage to accidentally raise the dead while shooting a zombie movie in a spooky old mansion where John Carradine works as a caretaker (that should've put most location scouts off for starters). As they're picked off one by one, the production is put on hold which is a shame since the director of the film-within-the-film gets some great lines as he shouts at his truly rubbish cast: "You're supposed to be going into a trance, not having an orgasm!"
See page 76

HOUSE OF THE DEAD

2003, Canada/USA/Germany
Dir: Uwe Boll. *Prod:* Uwe Boll, Wolfgang Herold, Shawn Williamson. *Scr:* Mark A. Altman, Dave Parker
Cast: Jonathan Cherry, Tyron Leitso, Clint Howard, Ona Grauer, Ellie Cornell

The 1998 arcade game gets a pointless big-screen adaptation. Quite how a game that was as simplistic as blasting zombies with a light gun seemed like the perfect movie idea is an enigma. Certainly the finished product doesn't bear much relation to the game with some dumb kids heading out to a deserted island for a rave (sponsored by videogame creators Sega no less) and ending up among the living dead instead. Personally, I'd rather spend ninety minutes watching someone else playing the arcade machine than sit through this lame collection of inept scares, footage culled from the videogame and braindead movie in-jokes. To stave off boredom, keep a look out for a zombie cameo from *Fangoria* editor Tony Timpone.
See page 181

THE HOUSE ON SKULL MOUNTAIN

1974, USA
Dir: Ron Honthaner. *Prod:* Ray Storey. *Scr:* Mildred Pares
Cast: Victor French, Janee Michelle, Jean Durand, Mike Evans, Xernona Clayton

Reading a will proves trickier than it ought to be as the estate of Pauline Christophe is divided up between her relatives. The estate's butler turns out to be a voodoo priest who's planning on keeping the undertaker in business for a while longer by killing off the beneficiaries. It's not greed that's motivating him but some muddled intrigue involving the family's history on Haiti. When Pauline herself comes back from the dead, though, chaos ensues.
See page 77

I EAT YOUR SKIN

1964, USA
Alternative titles: **Voodoo Blood Bath**, **Zombies**
Dir: Del Tenney. *Prod:* Del Tenney. *Scr:* Del Tenney
Cast: William Joyce, Heather Hewitt, Walter Coy, Dan Stapleton, Betty Hyatt Linton

More monochrome monsters from the indefatigable Del Tenney. This time he heads out to the Caribbean with a story about a playboy novelist and his publisher who get caught up in a voodoo conspiracy. The film's zombies are woeful creations that look as if they've been dunked head first in a mud bath. Their eyes are so full of gunk it's a wonder they can see to walk, let alone swing their machetes. Padded out with native voodoo rituals in which bikini-clad ladies gyrate round campfires and a ridiculous scene in which our heroes don a pair of voodoo masks to infiltrate a ceremony, it's pitiful even by Tenney's standards. There's no skin eating and the less said about the crummy lap-dissolve sequence in which we see a man being turned into a zombie, the better for everyone concerned.
See page 76

I WALKED WITH A ZOMBIE

1943, USA
Dir: Jacques Tourneur. *Prod:* Val Lewton. *Scr:* Curt Siodmak, Ardel Wray
Cast: James Ellison, Frances Dee, Tom Conway, Edith Barrett, James Bell

Frances Dee stars as a naïve young nurse sent out to look after the catatonic wife of a plantation owner in the West Indies in this beautiful gothic tale. Uncertain whether or not to believe the local island superstition about voodoo and magic, she becomes embroiled in the family's affairs, encounters a striking native zombie and begins to question her faith in the rational world.
See pages 7, 34, 41-46, 53, 99, 141-142, 145

I WAS A TEENAGE ZOMBIE

1986, USA
Dir: John Elias Michalakis. *Prod:* Richard Hirsh, John Elias Michalakis. *Scr:* James Martin
Cast: Michael Ruben, Steve McCoy, George Seminara, Robert Sabin, Cassie Madden

This throwback to the 1950s starts with a bunch of thirty-year-old high school kids killing a crazed gangster who sells them bad weed. After knocking him off they dump him in the river for good measure, little realising that the water is contaminated with radioactive sludge. He comes back as a green-faced ghoul and kills one of their buddies, Dan. Thinking on their feet, the guys chuck Dan in the water and wait for him to come back too. A rather lame horror-comedy spoof, this stars a pair of green-faced zombies who don't seem particularly dead. Dan's more interested in chatting up cute-but-clumsy Cindy than actually eating anyone. Fortunately, the kindly soda store owner is on hand with some advice about dating the living: "You couldn't expect Cindy to be wanting to raise zombie babies now could you?"
See page 154

I WAS A ZOMBIE FOR THE F.B.I.

1984, USA
Dir: Marius Penczner. *Prod:* Marius Penczner, Nancy Donelson. *Scr:* Marius Penczner, John Gillick
Cast: James Rasberry, Larry Raspberry, Christina Wellford, John Gillick

Any movie that stars two actors called Raspberry (with and without the "p", like the Thompson Twins from *Tintin*) can't be all bad, can it? Well yes and no. This silly monochrome spoof (think *I Was a Communist for the F.B.I.* (1951) with zombies) begins with aliens turning the earth's population into zombies by contaminating our supply of Coca Cola - sorry, Uni-Cola - the globe's favourite drink. Two F.B.I. agents infiltrate the aliens' manufacturing plant to save the day, battling extra-terrestrials, zombies and a stop-motion monster. Made by students at Memphis State University, it's certainly a million miles removed from the backyard epics of the 1990s. Still, its one-joke setup never really delves into the links between Cold War paranoia and the zombie. A missed opportunity.
See page 154

I, ZOMBIE: A CHRONICLE OF PAIN

1998, UK
Dir: Andrew Parkinson. *Prod:* Andrew Parkinson. *Scr:* Andrew Parkinson
Cast: Giles Aspen, Ellen Softley, Dean Sipling, Claire Griffin, Andrew Parkinson

Britain's only zombie auteur, Andrew Parkinson, delivers a thoughtful take on the horrors of joining the ranks of the living dead in this depressingly grim tale in which a Ph.D. student is bitten by a ghoul and endures a lonely and agonising slide into living death in a London bedsit.
See pages 168-169, note 186

THE INCREDIBLY STRANGE CREATURES WHO STOPPED LIVING AND BECAME MIXED-UP ZOMBIES!!?

1963, USA
Alternative title: **Teenage Psycho Meets Bloody Mary**
Dir: Ray Dennis Steckler. *Prod:* Ray Dennis Steckler. *Scr:* Gene Pollock, Robert Silliphant
Cast: Cash Flagg [Ray Dennis Steckler], Brett O'Hara, Atlas King, Sharon Walsh, Madison Clarke, Erina Enyo

After a visit to a funfair fortune-teller called Madame Estrella, mixed-up beatnik kid Jerry is turned into a homicidal zombie maniac. Hypnotised by a psychedelic spinning wheel and sent out to do her dirty work, he proves an effective killer until Madame fears that he's remembering too much about his adventures. She does what any self-respecting evil gypsy hypnotist would do under the circumstances: douses him in acid and throws him in the cage at the back of her tent with all her other zombified victims. It's campy, trashy and not half as much fun as the infamous title promises.
See pages 64-65

INVASION OF THE BODY SNATCHERS

1956, USA
Dir: Don Siegel. *Prod:* Walter Wanger. *Scr:* Geoffrey Homes.
Cast: Kevin McCarthy, Dana Wynter, Larry Gates, King Donovan, Carolyn Jones

The body snatchers might not be zombies yet they had a monumental impact on Romero's *Night of the Living Dead* and so deserve a mention. Alien seedpods land on earth and replicate the living while they sleep, creating perfect copies that take the place of the original humans. As the numbers of these alien doppelgängers increase, a small-town doctor is inundated with people complaining that their loved ones are, well, different. Expertly tapping into America's Cold War fears, the film's central conceit - that the country is being overtaken by people who look like us but aren't us - prefigured Romero's mass zombie apocalypse. Siegel's film was influential enough to be remade twice. In 1978 Philip Kaufman's *Invasion of the Body Snatchers* remake updated the story to contemporary San Francisco and tackled the soullessness of the Me Generation. Then in 1993, Abel Ferrara updated the tale again in *Body Snatchers*, cleverly setting the action on an authoritarian military base that's being taken over by the invaders.
See pages 7, 47, 51-55, 57, 69-70

INVASION OF THE DEAD

1971, Mexico
Original title: **La invasión de los muertos**
Alternative title: **Invasion of Death**
Dir: Rene Cardona Sr. *Prod:* Rene Cardona Jr., Enrique Rosas. *Scr:* Rene Cardona Jr.
Cast: Francisco Javier Chapa del Bosque 'Zovek', Blue Demon, Christa Linder, Raúl Ramírez, Carlos Cardán

Invasion of the Body Snatchers

Mexican wrestler El Santo began his zombie battles in this Mexican quickie about a hooded madman who launches a wave of zombies on the unsuspecting world. The ghouls are all former criminals brought back from the dead and kitted out with high-tech remote control systems that make them virtually unstoppable. Fortunately, Santo is on hand to dispense some rough justice, saving orphaned kids from the rampaging zombies then tracking the ghouls back to their master and whupping the hell out of him.
See page 60

INVISIBLE INVADERS

1959, USA
Dir: Edward L. Cahn. *Prod:* Robert E. Kent. *Scr:* Samuel Newman
Cast: Philip Tonge, John Agar, Jean Byron, Robert Hutton, John Carradine

Invading aliens reanimate the bodies of the dead and use them as shock troops in an attempt to take over the Earth. Scientist Adam Penner and his military assistant Major Bruce Jay retreat to a high-tech government facility to cook up a weapon that will save the day, eventually realising that sound waves will halt the attack. One of director Cahn's better efforts - although that isn't saying much.
See pages 47, 52-54, 57

IO ZOMBO, TU ZOMBI, LEI ZOMBA

1979, Italy
Literal title: **I Zombie, You Zombie, She Zombies**
Dir: Nello Rossati. *Prod:* Elio Di Pietro. *Scr:* Nello Rossati, Roberto Gianviti, Paolo Vidali
Cast: Duilio Del Prete, Renzo Montagnani, Cochi Ponzoni, Gianfranco D'Angelo, Nadia Cassini, Anna Mazzamauro

A long-lost Italian cycle entry, Nello Rossati's zombie comedy was one of those films that many have heard of but few have seen (indeed, this writer could recount several convoluted tales of being told how someone's brother's sister's uncle's second cousin had it on a bootleg tape... once). As luck would have it, a DVD release has been announced just as this book is going to press, which is proof - if nothing else - that the current zombie boom is willing to leave no back

No sign of Santo in this Mexican movie, which skimps on the wrestling in favour of pitting heroes Zovek and Blue Demon against ghouls reanimated by the impact of an extra-terrestrial object on the Earth. Escapologist Zovek died during production, which explains the weird changes in tone between his scenes and those starring Blue Demon. The zombies are distinctive: a horde of living dead who have retained enough of their memory to be able to use cars and helicopters in their attempts to take over the world.
See page 60

INVASION OF THE ZOMBIES

1961, Mexico
Original title: **El Santo contra los zombies**
Alternative title: **Santo Vs. the Zombies**
Dir: Benito Alazraki. *Prod:* Alberto López. *Scr:* Benito Alazraki, Antonio Orellana
Cast: Santo el Enmascarado de Plata, Lorena Velázquez, Armando Silvestre, Jaime Fernández, Dagoberto Rodríguez, Irma Serrano

catalogue stone unturned in its attempt to cash-in on our appetite for the living dead. Unlike the rest of its Italian fellows, this particular zombie movie is actually played for laughs, with a group of ghouls turning themselves into hoteliers and feasting on the living.

ISLE OF THE DEAD

1945, USA
Dir: Mark Robson. *Prod:* Val Lewton. *Scr:* Ardel Wray
Cast: Boris Karloff, Ellen Drew, Marc Cramer, Katherine Emery, Helene Thimig

In the midst of the Balkan War of 1912, a group of Brits, Yanks and Greeks are trapped on an island during an outbreak of the plague. Despite being a firm believer in the certainties of science, Karloff's Greek officer cracks and becomes convinced that one of the civilians is actually a vampire-like creature from Greek superstition. Meanwhile, the British consul's wife is mistakenly buried alive and comes back from the "dead" to stalk the island with a vicious-looking trident. Whilst not one of Lewton's most coherent efforts, it's not without a certain frisson, due to its haunting visuals, which are fashioned after Bocklin's creepy painting of the same name.
See page 41, note 66

ISLE OF THE SNAKE PEOPLE

1968, Mexico/USA
Original title: **La muerte viviente**
Alternative title: **Cult of the Dead**
Dir: Juan Ibáñez. *Prod:* Luis Enrique Vergara. *Scr:* Luis Enrique Vergara, Jack Hill
Cast: Boris Karloff, Tongolele [Yolanda Montes], Julissa, Carlos East, Rafael Bertrand

The legendary Boris Karloff was seriously ill by the time he starred in this dire Mexican horror for Jack (*Spider Baby*, *Foxy Brown*) Hill and it probably hastened the old ghoul's demise. A French military governor arrives on a South Pacific island along with a young temperance worker who quickly attracts unwanted attention of the voodoo variety. A snake cult intend to use her as a human sacrifice while her evil uncle Carl van Molder (Karloff, staying mostly seated) summons legions of living dead ghouls in preparation for the return of voodoo god Baron Samedi.
See page 60, note 81

J'ACCUSE

1937, France
Alternative title: **That They May Live**
Dir: Abel Gance. *Prod:* Abel Gance. *Scr:* Abel Gance, Stève Passeur
Cast: Victor Francen, Line Noro, André Nox, Jean Max, Marcel Delaître

In the fields of Flanders, soldier Jean Diaz agrees to take the place of a father of four on a suicide mission into enemy territory. It turns out to be the final day of the war and although several of the platoon are killed, Diaz survives and returns home a changed man. Back in France, he discovers a new kind of unbreakable "steel" glass that he hopes will put an end to war for good. However, the military pinch his invention and decide to use it for less amenable purposes, prompting Diaz to call the fallen dead of all nations from their graves in order to warn the world about the horror of war.
See pages 31, 69

JUNK

1999, Japan
Original title: **Junk: Shiryô-gari**
Dir: Atsushi Muroga. *Prod:* Tadao Masumizu, Isao Kurosu
Cast: Kaori Shimamura, Yuji Kishimoto, Osamu Ebara, Gouta Tate, Miwa

top and above: Asian girl ghouls in **Junk**.

It looks like junk, it plays like junk, heck it's even called *Junk*. No prizes for guessing that this bottom of the barrel gore effort is as trashy as its title playfully suggests. After a secret US military installation in Japan invents a serum that can bring the dead back to life, a gang of jewel thieves are caught between their yakuza bosses and some hungry ghouls. There's lots of frantic gunplay in the vein of *Versus* - just without the panache.
See pages 172-173, 216

KILLING BIRDS

1988, Italy
Original title: **Killing Birds (Uccelli assassini)**
Alternative titles: **Raptors, Zombie 5: Killing Birds**
Dir: Claude Milliken [Claudio Lattanzi].
Prod: Aristide Massaccesi. *Scr:* Daniel Ross [Daniele Stroppa]
Cast: Lara Wendel, Robert Vaughn, Timothy W. Watts, Leslie Cummins, James Villemaire

Ornithologists and zombies? You've gotta be kidding. If only director Claudio Lattanzi was. Kids in the Louisiana swamps get more than they bargained on while looking for woodpeckers (!) when they encounter Vaughn's blind Vietnam vet. On returning from his tour of duty years earlier, the vet murdered his cheating wife then had his eyes pecked out by swamp birds as punishment. Now he's being harassed by zombies - who take time out from tormenting him to pick off the dumb kids. So, is it a movie about killer birds, killing birds, killer zombie birds, zombie bird killers or something altogether different? Who knows and frankly, given the lack of suspense who really cares? The college student heroes spend most of the movie running around as a couple of mummified zombies give chase, then Vaughn finally pops up in the last two minutes to half-heartedly offer an iffy explanation and face his fate. Maybe director Lattanzi (replaced during shooting by Aristide Massaccesi) was trying to highlight the rarely acknowledged link between *The Birds* and *Night of the Living Dead*... or maybe it's all just a crock.
See page 131

KING OF THE ZOMBIES

1941, USA
Dir: Jean Yarbrough. *Prod:* Lindsley Parsons. *Scr:* Edmund Kelso
Cast: Dick Purcell, Mantan Moreland, John Archer, Joan Woodbury, Henry Victor

Mantan Moreland gets all the best gags in this horror-comedy about three Americans who crash land their plane on a Caribbean island. There they discover a villainous scientist who has a house full of zombies. To make matters worse, the scientist turns out to be a Nazi spy who's using voodoo to interrogate an American officer he's holding prisoner. Poverty Row's best zombie film, which isn't saying much.
See pages 34-39, 98, 145

KISS DADDY GOODBYE

1981, USA
Alternative titles: **Caution, Children At Play, Revenge of the Zombie, Vengeful Dead**
Dir: Patrick Regan. *Prod:* Alain Silver.
Scr: Ronald Abrams, Patrick Regan, Alain Silver, Mary Stewart
Cast: Fabian Forte, Marilyn Burns, Jon Cedar, Marvin Miller, Chester Grimes

After their daddy's killed by nasty bikers, two psychic children manage to bring his corpse back from the grave to wreak revenge. Lame horror notable only for featuring a rare appearance by *Texas Chain Saw Massacre* scream queen Marilyn Burns and for its unusual casting - the kids are the director's real-life children.
See note 120

DAS KOMABRUTALE DUELL

1999, Germany
Dir: Heiko Fipper. *Prod:* Heiko Fipper.
Scr: Heiko Fipper
Cast: Heiko Fipper, Stefan Hoft, Stephan Fipper, Mike Hoffman, Andreio Fiore

Perhaps best described as the zombie answer to videogame *Mortal Kombat*. Guys chop each other up with every weapon available. They cannot be killed. Their friends repair the damage and they're off to fight again until they're little more than shambling corpses. Very repetitive. Utterly worthless. Extremely, extremely violent. (DAO).
See page 166

KUNG FU ZOMBIE

1981, Hong Kong
Original title: **Wu long tian shi zhao ji gui**
Dir: Hwa I Hung. *Prod:* Pal Ming
Cast: Billy Chong, Chan Lau, Chang Tao, Cheng Ka Ying, Kwon Young Moon

What is this obsession with martial arts zombies? At least this fast-paced farce from Hong Kong features some fun ghouls. Kinetic corpses are brought back from the dead for a flurry of chopsocky action after a thief gets a priest to dabble in black magic. A tale of revenge, kung fu fighting and vampire/zombie/corpses, it delivers enough manic laughs to be a memorable favourite among both zombie and martial arts fans. Chong went on to star in horror-comedy *Kung Fu from Beyond the Grave* (1982) opposite vampires, sorcerers and a couple more fugitives from the undertaker.
See page 172

LAND OF THE DEAD

2005, USA
Alternative title: **George A. Romero's Land of the Dead**
Dir: George A. Romero. *Prod:* Mark Canton, Bernie Goldmann, Peter Grunwald. *Scr:* George A. Romero
Cast: Simon Baker, John Leguizamo, Dennis Hopper, Asia Argento, Robert Joy

After a two-decade wait, Romero turns in his fourth and final (?) film in his long-running zombie series. Zombies have taken over the world, trapping a few survivors in a post-apocalyptic version of the gated-community where the line between the haves and have-nots is starkly drawn. Intelligent ghouls, Dennis Hopper's first zombie movie and a veiled allegory on Bush Jr.'s America. God bless you, Mr. R.
See pages 178, 186-190, 192-193, 221-222, notes 228, 229, 234, 242

THE LAST MAN ON EARTH

1964, USA/Italy
Alternative title: **L'ultimo uomo della terra**
Dir: Sidney Salkow (US), Ubaldo Ragona (IT). *Prod:* Robert L. Lippert. *Scr:* Logan Swanson [Richard Matheson], William F. Leicester
Cast: Vincent Price, Franca Bettoia, Emma Danieli, Giacomo Rossi-Stuart, Umberto Rau [Raho]

Land of the Dead -

Vincent Price stars as the eponymous Last Man, the only survivor of a virulent plague that's turned the planet's population into blood hungry ghouls. Barricading himself in his suburban house, Price fights off the creatures while piecing together his own involvement in the apocalypse. A masterful classic - and a huge influence on a certain Pittsburgh filmmaker too.
See pages 62-64, 70

THE LAUGHING DEAD

1989, USA
Dir: S.P. Somtow [Somtow Sucharitkul]. *Prod:* Lex Nakashima. *Scr:* S.P. Somtow [Somtow Sucharitkul]
Cast: Tim Sullivan, Wendy Webb, S.P. Somtow, Premika Eaton, Patrick Roskowick

A Catholic priest takes a bunch of terrible thespians to Mexico on an archaeological dig, only to be confronted with lots of supernatural Aztec shenanigans as they stumble across "The Festival of the Laughing Dead". Unmemorable low-budget horror that's managed to worm its way into the genre history books because of the scene in which the living play blue-tinged zombies at basketball. It's far less zany than it sounds and does little to make up for the wooden acting, poverty-stricken production design or bizarre "Aztec" costumes. In the end, there's little for anyone to laugh about, alive or dead.
See page 165

THE LEGEND OF DIABLO

2004, USA
Dir: Robert Napton. *Prod:* Robert Napton, Neal L. Fredericks. *Scr:* Karl Altstaetter, Robert Napton
Cast: Fred Estrada, Lindsey Lofaso, Mario Soto, Calvi Pabon, Gabriel R. Martinez

Centuries ago, the ancient demon Azar and his army of zombies battled the Aztecs but lost and was imprisoned for his trouble. Fast forward to the present where the sheriff of a small California town, Diablo, discovers the box that holds Azar's prison. Azar takes possession of his body, raises a new army of zombies, and things get worse from there. This digitally shot SOV horror is shoddy at best with an "army" of no more than six zombies and some rather uneven thesping (DAO).
See page 166

THE LEGEND OF THE 7 GOLDEN VAMPIRES

1973, UK/Hong Kong
Alternative titles: **Dracula and the Seven Golden Vampires**, **The 7 Brothers Meet Dracula**
Dir: Roy Ward Baker. *Prod:* Don Houghton, Vee King Shaw. *Scr:* Don Houghton
Cast: Peter Cushing, David Chiang, Julie Ege, Robin Stewart, Shih Szu

Dracula heads East in this uneasy blend of Hammer and the Shaw Brothers. Peter Cushing stars as Van Helsing, tracking the Count through China after discovering that he's teamed up with the seven vampires of the title. With the help of several kung fu fighters, Van Helsing launches an attack on the vampires who're terrorising the local villagers. In the ensuing chaos, the Hong Kong acting contingent get to show off their revered martial arts skills using the vampires and their zombie helpers as chopsocky fodder. Looking decidedly dated even on its release in 1973, this film still has a few moments of power - although the green-faced zombies are seriously underused.
See pages 77-78, 172

LEGION OF THE DEAD

2000, Germany
Dir: Olaf Ittenbach. *Prod:* Michael J. Poettinger, Claudia Quirchmayr. *Scr:* Olaf Ittenbach
Cast: Michael Carr, Russell Friedenberg, Kimberly Liebe, Matthias Hues, Hank Stone

German director Olaf Ittenbach directs his first film entirely in English. Unfortunately, the finished product does not impress. Splatter fans will certainly be satisfied as the red stuff flies all over the place but the acting involves chewing up every inch of scenery available. The biggest problem lies in the plot, which centres on demons - some evil but a few good - involved in an ancient feud. The chief evil demon uses two incompetent zombie hitmen/recruiters to gather fresh flesh for his Legion of the Dead. Ittenbach directs with a lot of energy but the end result is a confusing, barely coherent mess (DAO).
See page 166

The Legend of the 7 Golden Vampires

LET'S SCARE JESSICA TO DEATH

1971, USA
Dir: John Hancock. *Prod:* Charles B. Moss Jr. *Scr:* Ralph Rose, Norman Jonas
Cast: Zohra Lampert, Barton Heyman, Kevin O'Connor, Gretchen Corbett, Alan Manson

The hippie dream turns sour in this lyrical, haunting horror movie. Released from a sanatorium, Jessica heads out to an isolated farmhouse in the Connecticut countryside with her husband Duncan and friend Woody. There they discover a young hippie girl named Emily hiding out in the house and offer to let her stay. As Emily seduces Duncan, Jessica starts to lose her marbles. She's convinced that she's in contact with the spirit of a dead Victorian girl who used to live in the house. She also starts to believe that the girl may be a vampire and that the townsfolk are zombie ghouls intent on making her into one of them. Lacking in sensationalism, director John Hancock's creepy little movie has slipped into obscurity: a shame since it's a fascinating take on the way the LSD-era blurred the line between sanity and madness.
See pages 73-74

Let's Scare Jessica To Death

LINNEA QUIGLEY'S HORROR WORKOUT

1989, USA
Dir: Hal Kennedy [Kenneth J. Hall].
Prod: Fred Kennamer. *Scr:* Hal Kennedy
Cast: Linnea Quigley, B. Jane Holzer, Amy Hunt, Victoria Nesbitt, Kristine Seeley

Quigley is best known for her naked appearance as a punkette in *The Return of the Living Dead*. By 1989 she was famous enough to front this lame collection of clips from her forays into the horror genre. Judging by its salacious treatment of the star, this is aimed squarely at teenage boys. Some zombie relief is on hand when a few ghouls attack Quigley while she jogs through a graveyard. Since they're so unfit, she takes them through a work out routine. Imagine *Thriller* meets an exercise video, then try and come up with one reason why you'd watch this junk. If the words "Linnea Quigley's boobs" spring to mind, this is probably for you.
See page 154

LIVING A ZOMBIE DREAM

1996, USA
Dir: Todd Reynolds. *Prod:* Todd Reynolds. *Scr:* Todd Reynolds
Cast: Amon Elsey, Michelle White, Mike Smith, Frank Alexander, Mike Strain Jr.

A complete and utter waste of celluloid. Just as well, then, that it's shot on video, the modern equivalent of doodling paper for any idiot with a few hundred bucks and a lot of spare time on their hands. A jealous lover finds his brother making out with his girlfriend and so leaves him stranded in the wrong part of town as punishment. Only the cheating brother ends up being murdered... Revenge, zombies and surreal interludes about the angst of being dead follow. What it all adds up to is anyone's guess but if this effort is anything to go by it's pretty clear that talent is thin on the ground in Springfield, Missouri.
See page 166

The Living Dead at Manchester Morgue

THE LIVING DEAD AT MANCHESTER MORGUE

1974, Spain/Italy
Original titles: **No profanor el sueño de los muertos, Non si deve profanare il sonno dei morti**
Alternative titles: **Da dova vieni?, Don't Open the Window, Invasion der Zombies, Let Sleeping Corpses Lie, Le massacre des morts-vivants, Zombi 3**
Dir: Jorge Grau. *Prod:* Manuel Pérez García, Edmondo Amati. *Scr:* Sandro Continenza, Marcello Coscia
Cast: Ray Lovelock, Christine Galbo [Cristina Galbó], Arthur Kennedy, Jeannine Mestre, Fernando Hilbeck

An experimental pest control machine, using high frequency sound waves, reactivates dead bodies in this Spanish-Italian answer to Romero. Shot in the Lake District, it follows antiques dealer George and his unlucky travelling companion Edna as they run into reanimated dead bodies and a disbelieving policeman. Though none of the film takes place in the eponymous Manchester morgue, it'd be churlish to moan too loudly since this proves to be a landmark zombie movie.
See pages 6, 81-83, 86-87, 90, 94, 114, 116, 130-131, notes 101, 102

THE LIVING DEAD GIRL

1982, France
Original title: **La morte vivante**
Dir: Jean Rollin. *Prod:* Sam Selsky. *Scr:* Jean Rollin, Jacques Ralf

269

The Living Dead Girl

Cast: Marina Pierro, Françoise Blanchard, Mike Marshall, Carina Barone, Fanny Magier

Nobody makes films quite like Jean Rollin's. This lyrically tragic necrophiliac tale is like a personal daydream about death. After barrels of toxic waste are accidentally spilled in the crypt of the Valmont chateau, the corpse of young Catherine Valmont is revived from the dead. She begins feeding on anyone who ventures into the catacombs, ripping their throats open with her fingernails then sipping their blood. Catherine's childhood friend Helene eventually realises that she's come back to life and helps her dispose of the bodies while teaching her how to talk again. Blood-drenched eroticism that's completely obsessed with a romantic image of (living) death, this recalls Rollin's vampire movies. Fixated by his two lead actresses, Rollin delivers little story or plot but piles on a few (very) gory deaths to pad out the tedium. If you can give yourself over to its rather adolescent concerns, though, it's a hauntingly mournful tale.
See pages 85, 125

THE LIVING DEAD IN TOKYO BAY

1992, Japan
Original title: **Batoru garu**
Dir: Kazuo "Gaira" Komizu. *Prod:* Kazuo "Gaira" Komizu. *Scr:* Kei Dai
Cast: Cutei Suzuki, Kera, Keiko Hayase, Kenzi Ohtsuki

Self-explanatory title, throwaway movie. A meteor strikes the coast of Japan, unleashing a cloud of DNA-mutating fumes that turn the living into ghouls. Chaos reigns as the army try to prevent the usual band of scientists from finding a cure - they'd rather inject the living with the zombification virus in order to control them. Making her way through the anarchy is Keiko, the "batoru garu" or battle girl of the original Japanese title. Clad in a black leather combat suit and armed to the teeth, she's on a mission to find her father but isn't averse to doing some zombie killing along the way. The destruction of Tokyo is reminiscent of the *Godzilla* cycle and full of the same anti-military posturing. Which is ironic seeing as the filmmakers turn Battle Girl's guns and combat gear into fetish objects.
See page 172

LORD OF THE DEAD

2002, USA
Dir: Greg Parker. *Prod:* Greg Parker. *Scr:* Greg Parker
Cast: Kathy Karle, Richard Greco, Manny Giudice, Barry Ayash, Pete Fuino

Dear God in Heaven, this movie stinks! A nerdy nobody named Steve (writer-director Greg Parker) finds an old book, reads it, and then changes into the son of a demon lord. Anyone he kills becomes a zombie who worships him. With a cast of over- and under-actors that would try the patience of any saints in the audience this is wretched stuff. One demon is clearly little more than a hand puppet and there's a bizarre line in humour ("I like eggs!"), but the most damning thing about it is that Steve himself may well rank as one of the most annoying characters in the annals of zombie cinema. Atrocious (DAO).
See page 166

THE LORD OF THE RINGS: THE RETURN OF THE KING

2003, USA/New Zealand/Germany
Dir: Peter Jackson. *Prod:* Peter Jackson, Fran Walsh, Rick Porras, Jamie Selkirk, Barrie M. Osbourne. *Scr:* Peter Jackson, Frances Walsh, Philippa Boyens, based on the novel by J.R.R. Tolkien
Cast: Elijah Wood, Viggo Mortensen, Sean Astin, Orlando Bloom, Ian McKellen

The final entry in Jackson's epic adaptation of J.R.R. Tolkien's trilogy follows our heroes as they battle the forces of Mordor in an attempt to defeat Sauron. As part of their battle plan, Aragorn raises a ghostly green zombie army from the mythical Path of Dead.
See pages 178-179

THE MAN THEY COULD NOT HANG

1939, USA
Dir: Nick Grindé. *Prod:* Wallace MacDonald. *Scr:* Karl Brown, George Wallace Sayre, Leslie T. White
Cast: Boris Karloff, Adrian Booth, Robert Wilcox, Roger Pryor, Don Beddoe

Karloff's back from the grave again in this 1939 tale of a mad scientist experimenting on reviving the dead who ends up swinging from a noose himself. Not exactly a zombie movie, but part of a brief

series of films Karloff made about men returning from beyond the grave during the period, after his stints on *The Ghoul* and *The Walking Dead*.
See pages 27-28

MANIAC COP

1988, USA
Dir: William Lustig. *Prod:* Larry Cohen.
Scr: Larry Cohen
Cast: Tom Atkins, Bruce Campbell, Laurene Landon, Richard Roundtree, William Smith, Robert Z'dar, Sheree North

"You have the right to remain silent… forever", groans the tagline of this creaky 1980s horror flick penned by B-movie maestro Larry Cohen. When a series of murders featuring a killer in a cop's uniform are reported in New York City, the boys in blue start taking flak for police brutality. Detective McCrae traces the murders back to former NYPD officer Matthew Cordell, jailed for mistreating perps. Funny thing is, though, Cordell's been dead for years. Hands up, the zombie cop back from the grave idea is more than a little ropey. Still, this disposable exploitation effort scores a few points with its unflinchingly downbeat take on the rottenness at the core of the Big Apple. Acting as judge, jury and executioner rolled into one, the cadaverous copper has the whole concept of Zero Tolerance bang to rights. A couple of lesser sequels followed.
See pages 166 (Maniac Cop), 211 (Maniac Cop 2)

LA MANSIÓN DE LOS MUERTOS VIVIENTES

1982, Spain
Literal title: **Mansion of the Living Dead**
Dir: Jesús Franco. *Prod:* Emilio Larraga.
Scr: Jesús Franco
Cast: Candy Coster [Lina Romay], Robert Foster [Antonio Mayans], Mabel Escaño, Eva León, Albino Graziáni

Four oversexed lesbians find their dream holiday in the Mediterranean turning into nightmare in this "sexploitation" effort from prolific purveyor of trash Jess Franco. Taking de Ossorio's Blind Dead films as his starting point Franco cooks up a far-fetched tale about a monastery hiding the spirits of some eighteenth-century monks who prey on passing tourists in a sort of modern day version of the Spanish Inquisition. Lots of rape, torture and general misogyny make this an unpleasant addition to the zombie canon. However, Franco's keen awareness of the sexual sadism running through De Ossorio's films proves an astute commentary on the Blind Dead series.
See note 114

MAPLEWOODS

2002, USA
Dir: David B. Stewart III. *Prod:* Robert Schiller, Joseph DeChristopher Sr, Thomas Reilly. *Scr:* David B. Stewart III
Cast: Thomas Reilly, Elissa Mullen, Christopher Connolly, John Wiedemoyer, John Martineau

In the Romero tradition of socially conscious zombie filmmaking, this little SOV production aspires to great seriousness. During World War II, the Nazis apparently engaged in a biological warfare experiment in an attempt to create an army of undead soldiers. After the war, the US government took that work and tried to perfect it. The commander of a secret base murders 122 people and brings them back as zombies. Of course, they prove to be uncontrollable (obviously no one considered that problem) and an elite team of Special Forces is dispatched to clean it up. Although somewhat hampered by lapses in acting and slow portions of the action, Stewart tries to raise familiar questions about the limits of science and who the greatest enemy may be: zombies or human beings (DAO).
See page 166

MEAT MARKET

2000, Canada
Dir: Brian Clement. *Scr:* Brian Clement
Cast: Paul Pedrosa, Claire Westby, Alison Therriault, Teresa Simon, Chelsey Artensen

Canadian "Camcorder Coppola" Brian Clement takes us on a sub-Romero apocalyptic adventure in his above average SOV gorefest. Wince at the scenes cribbed so shamelessly from *Dawn of the Dead* (including a SWAT team tenement building raid and a suicidal copper blowing his brains out) and focus instead on Clement's occasional bursts of vigour as heavily made-up zombies wander through deserted stretches of British Columbia. Our heroes are enigmatic survivalists who team up with a couple of "vampyros lesbos" armed with laser guns and a masked El Santo-style wrestler named El Diablo. The girls do some heavy petting, there are lots of tattoos and some over-enthusiastic zombie gore. Scariest thing of all, though, is the sex scene involving a bloke in leopard-skin underpants. Now that's grim. *Meat Market 2* (2001) followed.
See pages 166

MESSIAH OF EVIL

1972, USA
Alternative titles: **Dead People**, **Return of the Living Dead**, **Revenge of the Screaming Dead**
Dir: Willard Huyck. *Prod:* Gloria Katz.
Scr: Willard Huyck, Gloria Katz
Cast: Michael Greer, Marianna Hill, Royal Dano, Elisha Cook Jr., Joy Bang, Anitra Ford

This gets an A for effort. Young Arletty goes in search of her father in the spooky Californian town of Point Dune only to discover a horde of zombies masquerading as townsfolk who are apparently the result of some centuries old curse. Lots of atmospheric scenes set in the deserted town give way to some memorable shock sequences and an overly complicated plot that will leave most viewers completely confused. When it works, it's like *Deliverance* meets *Night of the Living Dead* meets *Days of Our Lives*.
See pages 73-74, 152

THE MIDNIGHT HOUR

1985, USA
Dir: Jack Bender. *Prod:* Ervin Zavada. *Scr:* Bill Bleich
Cast: Lee Montgomery, Jonna Lee, Shari Belafonte-Harper, LeVar Burton

Dim-witted high school kids have no one to blame but themselves as zombies walk the streets in this insipid comedy-horror TV movie. After chanting an ancient spell in a graveyard on Halloween, the kids watch in horror as vampires, werewolves and ghouls take over the town. Hero Phil eventually saves the day by undoing the spell and sending them all back to whence they came - if only he'd thought of that sooner we'd have been spared the tedium.
See page 154

MIDNIGHT'S CALLING

2000, Germany
Dir: Timo Rose. *Prod:* Timo Rose. *Scr:* Timo Rose
Cast: Yazid Benfeghoul, Andreas Schnaas, Erich Amerkamp, Ricky Goldberg

Yet another biological/chemical outbreak results in zombies being created as an unexpected side effect. A team of elite soldiers charges in to deal with the problem yet naturally don't meet with much success. Rose's film has everything one expects from a German zombie movie: lots of gut-munching, guns and buckets of claret. It's completely worthless, sub-Todd Sheets stuff. To think that Germany was once the home of *Nosferatu* and *Caligari*… (DAO).
See page 166

MONSTROSITY

1963, USA
Alternative title: **The Atomic Brain**
Dir: Joseph Mascelli. *Prod:* Jack Pollexfen, Dean Dillman Jr. *Scr:* Vy Russell, Sue Dwiggins, Dean Dillman Jr.
Cast: Marjorie Eaton, Frank Gerstle, Frank Fowler, Erika Peters, Judy Bamber

Mad scientist Dr. Frank is trying to transfer the brain of Heddy March, his cranky old employer, into a new body. It's not as easy as it looks though. All the doc's been able to produce so far are various "monstrosities" including a woman with a cat's brain, a man with a dog's brain and a zombified chick whose cerebral matter is no longer firing on all cylinders. Trash cinema although not without perverse enjoyment.
See page 65

MORBUS

1982, Spain
Dir: Ignasi P. Ferré. *Prod:* Carles G. Gatios. *Scr:* Isabel Coixet
Cast: Mon Ferré, Carla Day, Juan Borrás, Victor Israel, Juan-Antoni Crespi

In this little-known Spanish film, a scientist develops a formula for bringing back the dead. It works, but it has the unintended side effect of bringing to life a legion of zombies (what was he expecting, anyway?). The zombies attack a pair of prostitutes then go on the rampage - plus there's also a whole lot of nonsense involving horny nurses, black mass rituals, dream-within-a-dream flashbacks and numerous soft-core sex scenes. Curiously, the writer is Isabel Coixet - who's now the respected filmmaker of critically acclaimed dramas like *My Life Without Me* (DAO).
See page 135

MUTATION

1999, Germany
Dir: Timo Rose, Marc Fehse. *Prod:* Timo Rose. *Scr:* Timo Rose
Cast: Julianne Block, Mark Door, Marc Fehse, Timo Rose, Carsten Fehse

What better McGuffin for a German SOV production than a Nazi zombie serum left over from World War II? Directors Timo Rose and Marc Fehse take the ultra-violent splatter as far as their budget allows as gang leaders tool up with guns and battle the living dead with predictably gory results. Andreas Schnaas is among the cast, which is probably warning enough for most people. Followed by *Mutation 2: Generation Dead* (2001) and *Mutation 3: Century of the Dead* (2002).
See page 166

MY BOYFRIEND'S BACK

1993, USA
Dir: Bob Balaban. *Prod:* Sean S. Cunningham. *Scr:* Dean Lorey
Cast: Andrew Lowery, Traci Lind, Danny Zorn, Edward Herrmann, Matthew Fox

Love is stronger than death in this prom-night high school rom-com. After being shot in a robbery, high school kid Johnny is determined not to stay dead. Crawling out of his newly-dug grave, he goes back to school to find the love of his life, Missy, and take her to the prom. That he died saving her from the gunman's bullet only adds extra saccharine to this silly love story. Still, his attempts not to eat her have a certain nudge-nudge wink-wink undertone.
See page 165

NAKED LOVERS

1977, France
Original title: **La fille à la fourrure**
Alternative title: **Porno Zombies**
Dir: Claude Pierson. *Prod:* Claude Pierson. *Scr:* Élisabeth Leclair
Cast: Ursula White, Alain Saury, Didier Aubriot, Alban Ceray, Barbara Moose

This French porno flick is a real cult oddity, in which a newly remarried widower played by Alain Saury finds himself being haunted by his dead spouse's corpse. She pops up at his bedroom window while he's bedding his new wife and causes all kinds of trouble by turning various horny couples into zombies. Although there's some chatter about the ghouls being aliens, all their make-up actually consists of is some rather bizarre eye shadow. The rest of the movie concentrates on a series of sexual couplings intercut with hardcore close-ups of throbbing genitalia. It builds towards a scene in which zombie couples get naked in a forest and go at it with all the synchronised timing of a Busby Berkeley musical. The tone of Claude Pierson's film is pure Rollin - erotic surrealism on a shoestring budget - but the hardcore goes far beyond the master's customary tits 'n' ass trappings and heads towards the kind of explicitness normally found in Massaccesi's porno zombie films.
See page 135

NECROPOLIS AWAKENED

2003, USA
Dir: Garrett White. *Prod:* Duke White. *Scr:* Garrett White
Cast: Duke White, Brandon White, Brandon Dubisar, Garrett White, Coren Slogowski

Susan Hampshire • Frank Finlay • *Neither the Sea Nor the Sand* (AA)
and introducing **Michael Petrovitch** — Eastman Colour — A Tigon Release

Copious overacting actually proves mildly entertaining in this energetic SOV effort from writer-director Garrett White. In the town of Sky Hook the last human, Bob, must fight the legions of zombies commanded by the undead lord, Nefarious Thorne. A combination of zombie horror with high-octane action, this borrows its jolting camerawork and much of its chutzpah from Sam Raimi's *The Evil Dead*. With only five actors playing all the parts, the make-up and costume departments do an admirable job of papering over the glaringly obvious cracks (DAO).
See page 166

NEITHER THE SEA NOR THE SAND

1972, UK
Alternative title: **The Exorcism of Hugh**
Dir: Fred Burnley. *Prod:* Peter Fetterman, Jack Smith. *Scr:* Gordon Honeycombe
Cast: Susan Hampshire, Michael Petrovitch, Frank Finlay, Michael Craze, Jack Lambert

A supernatural romance featuring a corpse who comes back from the grave, Gordon Honeycombe's adaptation of his own novel is laced with British miserablism. Susan Hampshire plays an unhappily married woman who heads out to Jersey in the bleak midwinter for some peace and quiet. There she falls into bed with lighthouse keeper Petrovtich. Tragedy strikes when he dies while the couple are enjoying a dirty weekend in Scotland. But he's not dead for long and returns from the grave as a taciturn zombie to continue their doomed affair. Despite the breathless scenes of Hampshire and Petrovitch romping, it's a glum little outing - and possibly the nearest zombie cinema has ever come to a Bergman movie.
See page 77

NEON MANIACS

1986, USA
Dir: Joseph Mangine. *Prod:* Steve Mackler, Christopher Arnold. *Scr:* Mark Patrick Carducci
Cast: Allan Hayes, Leilani Sarelle Ferrer, Bo Sabato, Donna Locke, Victor Elliot Brandt

What do you call a movie where the zombies can be killed with squirt guns? Or where the cause of the living dead outbreak is a collection of postcards? Answer: LOUSY! In this dreadful excuse for a horror movie, the eponymous ghouls live in one of the towers of the Golden Gate Bridge and pick off unwary passers-by. A group of kids discover their existence and are slaughtered for their trouble. The only survivor is Natalie, whose wild and crazy story about the "Neon Maniacs" is ridiculed by the local cops. Fortunately, Natalie knows that the zombies can be stopped with water so arms her fellow students with water pistols and prepares to send the ghouls back to hell. Nothing in this movie makes sense - least of all the fact that the zombies are dressed as surgeons, lawyers, soldiers and all kinds of other professionals. Complete and utter garbage (DAO).
See page 151

NIGHT LIFE

1989, USA
Alternative title: **Grave Misdemeanours**
Dir: David Acomba. *Prod:* Charles Lippincott. *Scr:* Keith Critchlow
Cast: Scott Grimes, Cheryl Pollak, Anthony Geary, Alan Blumenfeld, John Astin

A teenage undertaker's assistant thinks he has problems with bullies, unrequited love and all the other woes of adolescence. Then his tormentors die in a car crash and come back from the grave to really make his life hell. Fairly standard 1980s teen horror in the same vein as *The Lost Boys (1987)*, just without the budget.
See page 151

NIGHT OF THE COMET

1984, USA
Dir: Thom Eberhardt. *Prod:* Andrew Lane, Wayne Crawford. *Scr:* Thom Eberhardt
Cast: Robert Beltran, Catherine Mary Stewart, Kelli Maroney, Sharon Farrell, Mary Woronov

Dodgy synthesizer music, yellow legwarmers and big perms: welcome to the 1980s. After Earth celebrates the flyby of a comet unparalleled since the death of the dinosaurs, Regina and her sister Samantha wake up to find the world's population turned to red dust. It seems the comet was more powerful than anyone imagined, leaving the girls stuck in a deserted L.A. with only a few pissed-off zombies for company. There's a breezy energy flowing through the script of this low-budget sci-fi outing, though zombie fans will be disappointed that the ghouls seem to be little more than an afterthought. After our teenage heroines go shopping (to the sound of Madonna's "Girls Just Wanna Have Fun") and tool up with guns ("The Mac-10 submachine gun was practically invented for housewives") writer-director Thom Eberhardt loses his way with a plot about some infected scientists trying to use the girls to produce a serum. Fun, but far from great.

NIGHT OF THE CREEPS

1986, USA
Dir: Fred Dekker. *Prod:* Charles Gordon. *Scr:* Fred Dekker
Cast: Jason Lively, Steve Marshall, Jill Whitlow, Tom Atkins, Allan Kayser

Beginning with aliens who look like naked Teletubbies, this throwback to the days of 1950s sci-fi is supremely ridiculous with a plot involving alien parasites turning whitebread American high school kiddies into slavering zombies. The outbreak is all the fault of Chris and his best mate J.C. who try to steal a corpse from their campus's science labs but end up releasing the parasites instead from cryogenic suspension. With the help of an alcoholic copper and Chris's girlfriend Cynthia, they set out to put things right. Cue lots of zombies on campus, a zombified dog and a coach-load of frat boy zombies going on the rampage in tuxedos. With its retro monster movie feel this is mildly diverting stuff and it's hard not to lap up deadpan lines like "OK girls, there's good news and there's bad news. The good news is your dates are here. The bad news is they're dead."
See page 154

NIGHT OF THE DAY OF THE DAWN OF THE SON OF THE BRIDE OF THE RETURN OF THE REVENGE OF THE TERROR OF THE ATTACK OF THE EVIL MUTANT HELLBOUND FLESH-EATING SUBHUMANOID LIVING DEAD, PART II

1992, USA
Dir: Lowell Mason. *Prod:* Lowell Masson. *Scr:* Lowell Mason
Voices: Lowell Mason

One-man comedy factory Lowell Mason takes Romero's original movie, drops the soundtrack and dubs his own version by voicing all the characters. It's hard to know what's more offensive, the stream of racist, homophobic, sexist wisecracking or the complete lack of respect for the movie itself (it's probably the former). Ben becomes the kind of black stereotype only a Klu Klux Klan supporter would think is funny, while Mason piles on scatological humour and lots of sex talk. If only Romero had kept the copyright line on the original prints, such sacrilege might have been averted.
See note 93

NIGHT OF THE LIVING BABES

1987, USA
Dir: Jon Valentine. *Prod:* Jon Valentine. *Scr:* Anthony R. Lovett
Cast: Michelle Bauer, Connie Woods, Andy Nichols, Cynthia Clegg, Forrest Witt

At the Zombie Ranch brothel, the girls are a little less sprightly than usual. Perhaps that's because they're living dead hookers. Could this be the 1980s' answer to *Orgy of the Dead*? Be afraid, be very afraid.
See page 135

NIGHT OF THE LIVING BREAD

1990, USA
Dir: Kevin S. O'Brien. *Prod:* Kevin S. O'Brien. *Scr:* Kevin S. O'Brien
Cast: Vince Ware, Katie Harris, Robert J. Saunders, Gina Saunders, Wolfgang S. Saunders [Kevin S. O'Brien]

An eight-minute parody of Romero's setup finds Johnny, Barbara and the rest of Romero's characters pursued by slices of white bread. Barricading themselves in the farmhouse, the characters use toasters to fend off the evil, doughy monsters. Mercifully short.
See note 93

NIGHT OF THE LIVING DEAD

1968, USA
Alternative titles: **La noche de los muertos vivientes**, **La nuit des morts vivants**
Dir: George A. Romero. *Prod:* Russell Streiner, Karl Hardman. *Scr:* George A. Romero, John Russo
Cast: Duane Jones, Judith O'Dea, Karl Hardman, Marilyn Eastman, Keith Wayne

The granddaddy of all modern zombie movies, *Night of the Living Dead* sticks its characters in an isolated farmhouse then sets a horde of zombies on them. It's a brilliant, seminal horror movie - and the most influential zombie film ever made.
See pages 7, 47, 64-71, 73-76, 80-81, 83-86, 90-96, 101-102, 135, 140, 144-147, 152-154, 161-162, 171, 174, 180-182, 225, notes 93, 227

above and opposite top:
The original **Night of the Living Dead** (1968).

What better way for the dorks to get the better of the bullies than by becoming zombies? A trio of underachievers at the Friedrich Nietzsche high-school are resurrected from the dead for some fun and games in this German zom-com in which being dead offers all kinds of perks - brains, girlfriends and a body that's impervious to the pranks of the jocks.

THE NIGHT OF THE SEA GULLS

1975, Spain
Original title: **La noche de los gaviotas**
Alternative titles: **Don't Go Out At Night, Night of the Blood Cult, Night of the Death Cult, La playa de los sacrificios, Terror Beach**
Dir: Amando de Ossorio. *Prod:* José Angel Santos. *Scr:* Amando de Ossorio
Cast: Víctor Petit, María Kosti, Sandra Mozarowsky, José Antonio Calvo

NIGHT OF THE LIVING DEAD

1990, USA
Dir: Tom Savini. *Prod:* John A. Russo, Russ Streiner. *Scr:* George A. Romero
Cast: Tony Todd, Patricia Tallman, Tom Towles, McKee Anderson, William Butler

Make-up master Tom Savini stepped into the director's chair for this remake of the original 1968 *Night of the Living Dead* with a script - and a blessing - from George Romero. Although it closely follows the original's plot, there's one very significant change: instead of being hysterical, Barbara now takes charge while Harry Cooper and Ben bicker and everyone else sits around uselessly. Playing with the radical shifts in gender politics that have occurred since 1968, this is a cleverly ironic rehash of Romero's masterpiece.
See pages 69, 161-164, 213

NIGHT OF THE LIVING DORKS

2004, Germany
Original title: **Die Nacht der lebenden Loser**
Alternative title: **Revenge of the Teenage Zombies**
Dir: Matthias Dinter. *Prod:* Philip Voges, Mischa Hofmann. *Scr:* Matthias Dinter
Cast: Tino Mewes, Thomas Schmieder, Manuel Cortéz, Collien Fernandes, Nadine Germann

NIGHT OF THE SORCERERS

1973, Spain
Original title: **La noche de los brujos**
Dir: Amando de Ossorio. *Prod:* José Antonio Pérez Giner, Luis Laso Moreno. *Scr:* Amando de Ossorio
Cast: Simón Andreu, Kali Hansa, María Kosti, Lorena Tower [Loretta Tovar], Joseph Thelman [José Telman]

Shot in the period between *The Return of the Blind Dead* and *Horror of the Zombies*, this mishmash of voodoo, vampires and zombies is, unfortunately, a dreadful stain on de Ossorio's reputation. The opening scenes of voodoo practitioners being slaughtered by white colonials in turn of the century Africa set the scene for a clumsy tale about Europeans getting their just desserts from indigenous peoples. In the present, white scientists conducting a photographic survey of animals on the verge of extinction run into trouble when they encounter a female vampire and her black native zombies. She turns the women in the expedition into scantily-clad vampires in leopard skin furs who leap through the jungle in slow mo. Racist, risible and completely redundant, it's a forgettable effort.

book of the dead

NIGHT OF THE ZOMBIES

1981, USA
Alternative titles: **The Chilling**, **Gamma 693**, **Night of the Wehrmacht Zombies**, **Night of the Zombies II**
Dir: Joel M. Reed. *Prod:* Lorin E. Price. *Scr:* Joel M. Reed
Cast: Jamie Gillis, Ryan Hilliard, Ron Armstrong, Samantha Grey, Juni Kulis

In the snowy hills of Bavaria, German and American soldiers left behind after the end of the Second World War are keeping themselves going by using military chemicals which were originally designed to put wounded soldiers into a state of suspended animation. In order to stop themselves falling apart the zombies need to get a regular quota of Gamma 693 and human flesh, but their survival is threatened by a badass CIA agent who's dead set on thwarting their burgeoning plans for world domination. Atmosphere and scares are thin on the ground, but it's difficult to know what's more laughable - the poverty-stricken production design (check out the Pentagon's sparsely furnished offices), the cruddy sound and visuals, or the lamentably fake skeletons that are left behind when the zombies die.
See page 79, note 99

The final film to feature the Blind Dead (not counting their brief appearance in *The Cross of the Devil*), *The Night of the Sea Gulls* has a deeper resonance than any of the earlier movies in the series. In a small coastal village the inhabitants keep the Templars at bay by handing over women for them to sacrifice to an aquatic god. Shades of H.P. Lovecraft abound, yet what really stands out is the mythology in which the spirits of the girls become seagulls circling the village. Neatly tying into the beach ending of *Horror of the Zombies*, this builds into a fittingly austere climax to the series.
See pages 86, 89, 113

So bad it's good: exploitation "classic" **Nightmare City**.

NIGHTMARE CITY

1980, Italy/Spain
Original titles: **Incubo sulla città contaminata**, **La invasión de los zombies atómicos**
Alternative title: **City of the Walking Dead**
Dir: Umberto Lenzi. *Prod:* Diego Alchimede. *Scr:* Piero Regnoli, Antonio Corti, José Luis Delgado
Cast: Hugo Stiglitz, Laura Trotter, Maria Rosaria Omaggio, Francisco Rabal, Mel Ferrer

Director Lenzi always claimed that his radioactive killers weren't zombies, but there's no disguising the debt *Nightmare City* owes to the rest of the Italian cycle. Most horror fans - prompted by generic conventions and the film's alternative titles - view them as zombies whatever Lenzi's intention. The nightmare begins as an aircraft unleashes the killers on an unnamed city, prompting reporter Dean Miller and his wife Anna to head out into the countryside to take shelter in a deserted theme park(!). There's no forgetting this lamentably bad but hilariously silly exploitation classic, which features fast, smart ghouls who attack the city's key installations with all the strategic planning of a band of heavily armed insurgents. The set-piece TV station sequence sums up the movie: chaotic, ludicrous and full of body-ripping trauma (one poor lass has a breast sliced off in gruesome close-up; fortunately for her, it's clearly made out of latex). As for the cyclical ending, well, that has to rank as one of zombie cinema's most ridiculous moments.
See pages 131-132, 190, 202

THE NIGHTS OF TERROR

1980, Italy
Original title: **Le notti del terrore**
Alternative titles: **Burial Ground**, **Le manoir de la terreur**, **La noche del terror**, **Die Rückkehr der Zombies**, **Het Schrikkasteel der Zombies**, **Zombie 3**, **The Zombie Dead**
Dir: Andrew White [Andrea Bianchi]. *Prod:* Gabriele Crisanti. *Scr:* Piero Regnoli
Cast: Karin Well, Gian Luigi Chirizzi, Simone Mattioli, Antonietta Antinori, Roberto Caporali

This classic Italian *morti viventi* movie finds a handful of bourgeois holidaymakers trapped in a country mansion by marauding zombies. Resurrected from a crypt in the grounds by a hapless professor, the Etruscan zombies lay siege to the mansion, arming themselves with pitchforks, scythes and other farming implements. Despite the best efforts of the living, these slow-moving ghouls quickly overrun the estate, upsetting the sex-obsessed characters' plans for nookie.
See pages 131-133, 136, 190, 196-197, 225

NUDIST COLONY OF THE DEAD

1991, USA
Dir: Mark Pirro. *Prod:* Mark Headley. *Scr:* Mark Pirro
Cast: Deborah Stern, Tony Cicchetti, Rachel Latt, Braddon Mendelson, Jim Bruce

Possibly the worst film in this entire filmography (and that's quite a feat given some of the competition here). Mark Pirro's zombie musical begins with the mass suicide of a group of nudists, who decide to kill themselves after their camp is closed down by puritan officials in order to make way for a religious retreat. Later, the naked folk (who aren't actually naked at all, but dressed in modesty-maintaining body stockings) come back from the grave to terrorise the living and punish them for their narrow-minded ways. The wise would do well to ignore the intriguing title, as this is utterly dreadful. Heck, there's not even any decent nudie cutie corpses. What kind of a cheap trick is that to pull on us?
See page 165

LA NUIT DE LA MORT

1980, France
Dir: Raphaël Delpard. *Prod:* Raphaël Delpard. *Scr:* Raphaël Delpard, Richard Joffo
Cast: Isabelle Goguey, Charlotte de Turkheim, Michel Flavius, Betty Beckers, Michel Debrane

A spooky nursing home is the setting for this obscure French zombie effort, which revolves around the entertaining conceit of the old literally sucking the life out of the living. A young nurse arrives to start work at the chateau but quickly realises that something's up after one of her friends disappears. Her investigations eventually uncover the château's dark secret: the witch-like, piano-playing proprietress and the residents are feasting off the nurses. Plenty of brooding atmosphere and a final reel full of splatter - including severed hands and gouged eyeballs - make up for the slow pacing. *Naked Lovers* helmer Claude Pierson is credited as an executive producer.

OASIS OF THE ZOMBIES

1982, Spain/France
Original titles: **La tumba de los muertos vivientes**, **L'abîme des morts vivants**
Alternative titles: **Der Abgrund der lebenden Toten**, **Bloodsucking Nazi Zombies**, **The Oasis of the Living Dead**, **Le tresór des morts vivants**
Dir: A.M. Frank [Jesús Franco]. *Scr:* A.L. Mariaux [Marius Lesoeur], Jesús Franco
Cast: Manuel Gélin, Eduardo Fajardo, Lina Romay, Antonio Mayans, Javier Maiza, Albino Graziani, Miguel Aristu, Doris Regina

The setup of this Franco atrocity is all-too-simple. Snotty nosed rich kids head out to Africa in search of some lost Nazi gold. They find it. Nazi zombies claw their way out of the sand. There's chaos and lots of bodies. The End. Franco was hardly on top form when he sat behind the camera for this Eurotrash exploitation outing but it did relatively good box office business among curiosity seekers - especially when it was released under the title *Bloodsucking Nazi Zombies*. What self-respecting horror fan could resist a come on like that? As a side note, *Oasis* exists in two alternate edits: a gorier Spanish-only version and a substantially re-worked Euorciné version with alternate footage and music. The latter is the English-dubbed international release and is the most widely available.
See pages 61, 79-80, 116

ONE DARK NIGHT

1982, USA
Alternative titles: **Entity Force**, **A Night in the Crypt**, **Night of Darkness**
Dir: Tom McLoughlin. *Prod:* Michael Schroeder. *Scr:* Tom McLoughlin, Michael Hawes
Cast: Meg Tilly, Melissa Newman, Robin Evans, Leslie Speights, Donald Hotton

A sorority house initiation rite goes badly wrong in this cheap shocker. Spending the night in a mausoleum, Julie's spooked not only by the location but also by the attempts of her so-called friends to freak her out. The high school pranks turn deadly serious, though, when the spirit of a Russian psychic raises zombies to attack the girls. Since the psychic uses telekinesis to move the corpses around, we're greeted to the rather ungainly sight of cadavers floating through the air in pursuit of their victims. Suffice to say it was a silly tweak of zombie mythology that nobody else bothered to imitate.
See page 151

ORGY OF THE DEAD

1965, USA
Alternative title: **Orgy of the Vampires**
Dir: A.C. Stephen [Stephen C. Apostolof].
Prod: A.C. Stephen [Stephen C. Apostolof]. *Scr:* Edward D. Wood Jr.
Cast: Criswell, Fawn Silver, Pat Barringer, William Bates, Mickey Jines

Softcore horror merges with dancing zombie go-go-ghouls in this atrocious and completely un-erotic outing from the pen of Ed Wood. It's essentially comprised of little more than a succession of topless "damned" women dancing on gravestones as the emperor of the dead - played by Wood favourite Criswell - judges them on their ability. Or rather lack of.
See page 64

OUANGA

1934, USA
Alternative titles: **Crime of Voodoo**, **Drums of the Jungle**, **The Love Wanga**
Dir: George Terwilliger. *Prod:* George Terwilliger. *Scr:* George Terwilliger
Cast: Fredi Washington, Philip Brandon, Marie Paxton, Sheldon Leonard

Caribbean plantation owner Adam finds himself trapped by the amorous attentions of neighbour Clelie. Troubled by her confused racial identity (she's black but light-skinned enough to pass as white), Clelie rejects her native foreman's offers of romance in favour of dispatching two zombies to abduct Adam's fiancée. In a striking shot, she raises the zombies out of their coffins and they lumber into line like sleepwalkers. As these black musclemen abduct the screaming Eve, it's obvious what kind of white fears the film is playing on. Still, the zombies are ineffective villains, obeying Adam's commanding voice even though Clelie has ordered them only to listen to her. Perhaps they were swayed by his God-given white authority?
See pages 24, 26-27, 30, 42, 46, 151, note 42

THE PEOPLE WHO OWN THE DARK

1976, Spain
Original title: **Último deseo**
Dir: Léon Klimovsky. *Prod:* Miguel F. Mila. *Scr:* Vicente Aranda, Gabriel Burgos, Joaquin Jorda
Cast: Nadiuska, Alberto de Mendoza, Teresa Gimpera, Paul Naschy [Jacinto Molina], Maria Perschy

Some Marquis de Sade-loving libertines manage to survive a nuclear war while making merry in a castle dungeon in this entertaining slice of post-apocalyptic sci-fi starring Paul Naschy. Meanwhile, the rest of the local populace are turned blind by the flash of the blast (shades of John Wyndham's novel *The Day of the Triffids*). With society on the verge of collapse, the libertines and their whores hole up in the château, but soon find themselves besieged after foolishly angering their blind neighbours. Quite how all of the sightless maniacs managed to find sunglasses to put over their burnt-out eyes remains unexplained yet this little thriller zips along so quickly you probably won't have time to care. For a Naschy movie, it's not bad.
See page 88

PET SEMATARY

1989, USA
Dir: Mary Lambert. *Prod:* Richard P. Rubinstein. *Scr:* Stephen King
Cast: Dale Midkiff, Fred Gwynne, Denise Crosby, Brad Greenquist, Michael Lombard

This Stephen King-scripted shocker (adapted from his own novel) was originally touted by producer Richard Rubinstein as a directorial project for their mutual friend George Romero. Along the way things changed and Mary Lambert took over the reins to deliver a slick but rather ineffective shocker. The title refers to a children's cemetery for dead pets built, it transpires, over an old Indian burial ground that retains magical properties. When Dale Midkiff's three-year-old son is killed by one of the huge trucks that thunders past their far-from-idyllic home, he buries the boy in the cemetery only to see him return as a nasty little zombie armed with an equally nasty scalpel blade. At its best

when dealing with the psychological horror of confronting the dead returned to "life" it never quite manages to fulfil its promise and soon degenerates into a shock-o-rama of hackneyed nastiness. It was followed by franchise-killer *Pet Sematary II* (1992).

PIRATES OF THE CARIBBEAN: THE CURSE OF THE BLACK PEARL

2003, USA
Dir: Gore Verbinski. *Prod:* Jerry Bruckheimer. *Scr:* Ted Elliot, Terry Rossio
Cast: Johnny Depp, Geoffrey Rush, Orlando Bloom, Keira Knightley, Jack Davenport

A rollicking, swashbuckling adventure Gore Verbinski's mammoth box office hit about pirates and lost Aztec treasure gets by on its sparky script and an audacious (over) performance from Depp who bases his character on The Rolling Stones's Keith Richards. It also dips its toes into the zombie genre with a galleon's worth of pirates led by Rush who're actually living dead ghouls (their true form can be seen when they're caught in the moonlight). The pirates are cursed to spend eternity as zombies unless they return every last coin of the plundered loot.
See page 178

PLAGA ZOMBIE

1997, Argentina
Dir: Pablo Parés, Hernán Sáez. *Prod:* Pablo Parés, Berta Muñiz, Hernán Sáez.
Scr: Pablo Parés, Berta Muñiz, Hernán Sáez
Cast: Pablo Parés, Berta Muñiz, Hernán Sáez, Walter Cornás, Diego Parés

This Argentine zombie effort resembles the backyard epics of Todd Sheets yet it's made by people who clearly have some talent. The filmmakers try to be funny, and, unlike many lame zombie comedies, actually succeed in their goal as a band of zombies are unleashed through a television set and aliens run around disguised as humans. There's some pro wrestling; there's kung fu fighting and there's a strutting Crocodile Dundee type thrown in for good measure. It all adds up into a wild ride with enough manic energy to make up for its shortcomings. Followed by *Plaga Zombie: Zona Mutante* (2001) (DAO).
See page 166

THE PLAGUE OF THE ZOMBIES

1966, UK
Dir: John Gilling. *Prod:* Anthony Nelson Keys. *Scr:* Peter Bryan
Cast: André Morell, Diane Clare, John Carson, Alexander Davion, Jacqueline Pearce, Brook Williams

Plan 9 from Outer Space

An English country squire kills off the villagers under his charge and resurrects them as cheap labour for his tin mine in this Hammer picture. London doctor Sir James teams up with the village G.P. to trace the cause of the illness and discovers that the squire has been dabbling in voodoo.
See pages 56, 58-60, 78, note 80

PLAN 9 FROM OUTER SPACE

1958, USA
Dir: Edward D. Wood Jr. *Prod:* Edward D. Wood Jr. *Scr:* Edward D. Wood Jr.
Cast: Gregory Walcott, Mona McKinnon, Duke Moore, Tom Keene, Vampira [Maila Nurmi], Bela Lugosi, Criswell, Tor Johnson

Aliens are resurrecting the bodies of the dead to conquer the Earth in this Golden Turkey winner from Ed Wood Jr., American cinema's most incompetent filmmaker. Apparently eager to save us before we destroy our planet and the rest of the universe by using our nuclear arsenal, the meddling aliens are eventually stopped by a police detective and a navy pilot who don't take kindly to being told that all earthlings are idiots. The film was, rather tragically, to be Bela Lugosi's final role. He died while filming and, in true Wood style, was replaced by a "double" twice his size who kept a cape over his face for the rest of the production.
See pages 47, 52-54

PORNO HOLOCAUST

1980, Italy
Alternative title: **Holocausto porno**
Dir: Joe D'Amato [Aristide Massaccesi].
Prod: Franco Gaudenzi. *Scr:* Tom Salina [Aristide Massaccesi]
Cast: George Eastman [Luigi Montefiori], Dirce Funari, Annj Goren, Mark Shannon [Manlio Cerosimo], Lucia Ramirez

More inimitable sex-zombie action from Joe D'Amato as scientists visit an island inhabited by a radioactive mutant zombie with a huge penis. Scenes of hardcore sex eventually give way to some splatter as the zombie goes on the rampage, killing the men and raping the women. One poor girl is left so battered by his huge John Thomas that she literally bleeds to death. Nasty, indefensible and memorable for all the wrong reasons.
See pages 132, 134-136, 143

PREMUTOS: LORD OF THE LIVING DEAD

1997, Germany
Original title: **Premutos: Der Gefallene Engel**
Dir: Olaf Ittenbach. *Prod:* Andre Stryi, Michael Muller, Olaf Ittenbach. *Scr:* Olaf Ittenbach
Cast: Andre Stryi, Ella Wellman, Christopher Stacey, Anke Fabre, Fidelis Atuma

The first fallen angel, Premutos, has waited for centuries to return to Earth. Fortunately for him, some fool reads a book he shouldn't and gets reborn as the son of Premutos. This eventually leads to an apocalyptic zombie invasion in which people get slaughtered left and right in one of the bloodiest zombie movies ever. Olaf Ittenbach pulls out all the stops as chainsaws carve up zombies and even a tank is brought into play (the zombies don't fare well against heavy artillery!) At the end of the movie, Ittenbach gives viewers a body count and it's well over a hundred. An outrageously gory 16mm effort (DAO).
See page 166

PRINCE OF DARKNESS

1987, USA
Dir: John Carpenter. *Prod:* Larry J. Franco. *Scr:* John Carpenter
Cast: Donald Pleasence, Jameson Parker, Victor Wong, Lisa Blount, Dennis Dun

Carpenter's apocalyptic answer to *The Exorcist* and *The Omen* has nerdy physicists checking out a strange container discovered in the basement of a rundown inner-city church. Inside is the Antichrist, who's about to unleash a reign of terror. Strangely, he begins this grandiose plan by turning a few of the local bums (including rocker Alice Cooper) into zombies.
See page 152

PSYCHOMANIA

1972, UK
Alternative titles: **The Death Wheelers, Death Wheelers Are... Psycho Maniacs**
Dir: Don Sharp. *Prod:* Andrew Donally. *Scr:* Arnaud d'Usseau, Julien Halevy
Cast: George Sanders, Beryl Reid, Nicky Henson, Mary Larkin, Roy Holder

When the leader of a British biker gang known as The Living Dead dies in a road accident, he's buried upright, sitting on his beloved bike! Pretty soon though, there's a revving in the graveyard and he bursts out of the ground with his motor running. The biker has realised that the way to cheat death is to commit suicide whilst having complete faith in the fact that he will return from the dead. He proceeds to convince the rest of his gang to crash and burn so that they can return to join him in a living dead rampage across the Home Counties. Pure 1970s camp.
See note 120

QUATERMASS 2

1957, UK
Alternative title: **Enemy from Space**
Dir: Val Guest. *Prod:* Anthony Hinds. *Scr:* Nigel Kneale, Val Guest
Cast: Brian Donlevy, John Longden, Sidney James, Bryan Forbes, Vera Day

Redoubtable super scientist Professor Quatermass returns in this horror-tinged science fiction offering from Hammer. A wave of meteorites crashes into the Earth, releasing a gaseous alien parasite that is capable of turning the human race into mindless zombie slaves. The aliens plan to colonise the planet by recalibrating the atmosphere; Quatermass discovers exactly what's going on and leads a band of resistance fighters against them.
See pages 47, 52-53, 57

RABID

1976, Canada
Dir: David Cronenberg. *Prod:* John Dunning. *Scr:* David Cronenberg
Cast: Marilyn Chambers, Frank Moore, Joe Silver, Howard Ryshpan, Patricia Gage

After a motorcycle accident, sometime porn star turned regular actress Marilyn Chambers is taken to a plastic surgery clinic and treated with an experimental technique. She ends up with a strange penis-like organ under her armpit and a taste for blood. Everyone she attacks becomes infected with a form of rabies that turns them into homicidal maniacs. Brilliant bio-horror from Cronenberg that owes a considerable debt to the zombie genre.
See note 96

RAIDERS OF THE LIVING DEAD

1985, USA
Dir: Samuel M. Sherman. *Prod:* Dan Q. Kennis. *Scr:* Samuel M. Sherman, Brett Piper
Cast: Scott Schwartz, Robert Deveau, Donna Asali, Bob Allen, Bob Sacchetti, Zita Johann

Nope, not Indiana Jones meets zombies as you might expect, but a curiously pointless tale about a teenager and a reporter who uncover living dead antics at a former prison and destroy the zombies using a DIY laser beam gun. Let this be a warning to all budding zombie filmmakers out there: this is what happens when you try to make a PG-13 zombie movie.
See page 153

RAW FORCE

1981, USA/Philippines
Alternative titles: **Kung Fu Cannibals**, **Shogun Island**
Dir: Edward D. Murphy. *Prod:* Frank E. Johnson
Cast: Cameron Mitchell, Geoffrey Binney, Hope Holiday, Jillian Kesner, John Dresden, Jennifer Holmes

More martial arts zombie mayhem, this time from the Philippines where an island community of cannibal monks are feasting on kidnapped hookers from the mainland. Basting and then spit-roasting the girls, the monks not only get to fill their bellies but also train a zombie army since this "flesh gives them the power to raise the dead". The zombies in question are disgraced martial artists buried on the island and resurrected to battle a group of tourists who have arrived in the monks' territory. Since these tourists have been shipwrecked on their way to a martial arts tournament, the scene is set for some chopsocky action. Chiefly memorable for starring a villain who bears an uncanny resemblance to Hitler (and is eaten by piranhas for his crimes), this is cheap, no-budget cinema that centres on equal parts naked female flesh and some manic zombie fu.

RE-ANIMATOR

1985, USA
Dir: Stuart Gordon. *Prod:* Brian Yuzna. *Scr:* Dennis Paoli, William J. Norris, Stuart Gordon
Cast: Jeffrey Combs, Bruce Abbott, Barbara Crampton, David Gale, Robert Sampson

Mad scientist Herbert West may be taken straight out of the fiction of H.P. Lovecraft yet the rest of this sick little movie is pure Gordon-Yuzna. Reanimating the dead with the help of a glow-in-the-dark serum, West is a precocious student at the Miskatonic

Medical School run by Dr. Hill, who's out to claim the compound as his own. As the experiments get out of control and West struggles to reanimate the dead without them turning into mindless zombies, this blackly comic horror races towards a truly outrageous blood-splattered finale. Spare a thought for West's poor moggy too...
See pages 158-159, 166, 206, note 227

REDNECK ZOMBIES

1987, USA
Dir: Pericles Lewnes. *Prod:* Edward Bishop, George Scott, Pericles Lewnes. *Scr:* Fester Smellman
Cast: Lisa DeHaven, William Benson, James Housely, Anthony Burlington-Smith, Martin Wolfman

The best description of this low-budget-trash comes from the over-egged trailer: "Swilling toxic moonshine they become flesh-eatin', bloodthirsty kinfolk from hell... They become REDNECK ZOMBIES!" A cheap 'n' cheerful effort from the Troma team, this parody of *The Grapes of Death* combines all the usual sick jokes, sexual innuendo and politically incorrect humour you'd expect with some really gory special effects. It's junk, but it's several steps up from the backyard epics of filmmakers like Todd Sheets. It's also promoted with a tagline that claim it makes "*Day of the Dead* look like *Mary Poppins*" - which is proof that Troma's marketing campaigns are always more interesting than the finished product itself.
See page 151

REQUIEM DER TEUFEL

1993, Germany
Dir: Jan Reiff. *Prod:* Andrea Leukel. *Scr:* Jan Reiff
Cast: Andrea Leukel, Jan Reiff, Joachim Schultz, Michael Faulk, Thomas Palmer

One of the better German SOV zombie films, this comes complete with a coherent plot. A husband discovers that his wife is having an affair so he kills her, the lover and an innocent eyewitness. Unfortunately for him, all his victims come back as vengeful zombies. His zombie wife proceeds to ingeniously torture him with her cooking (by putting razor blades in his spaghetti sauce) before he suffers a very nasty fate (DAO).

RESIDENT EVIL

2002, UK/Germany/France/USA
Alternative title: **Resident Evil Genesis**
Dir: Paul W.S. Anderson. *Prod:* Bernd Eichinger, Samuel Hadida, Jeremy Bolt, Paul W.S. Anderson. *Scr:* Paul W.S. Anderson
Cast: Milla Jovovich, Michelle Rodriguez, Eric Mabius, James Purefoy, Martin Crewes

Based on the best-selling videogame, Paul W.S. Anderson's take on the zombie goes for high-concept gloss and videogame references over horror heritage. Milla Jovovich stars as an amnesiac woman caught up in a zombie outbreak at a secret underground laboratory in Raccoon City owned by the Umbrella Corporation.
See pages 175-179, 183, 185, 192, notes 203, 207, 208

RESIDENT EVIL: APOCALYPSE

2004, France/Canada/UK/USA
Dir: Alexander Witt. *Prod:* Jeremy Bolt, Paul W.S. Anderson, Don Carmody. *Scr:* Paul W.S. Anderson
Cast: Milla Jovovich, Sienna Guillory, Oded Fehr, Thomas Kretschmann, Jared Harris

The sequel to Anderson's 2002 smash hit, this picks up where the first movie left off with Jovovich's heroine Alice waking up to find Raccoon City overrun with zombies. Teaming up with a band of plucky survivors, she searches for the missing daughter of one of the Umbrella

scientists responsible for the outbreak and battles Nemesis - a Herman Munster lookalike armed with an RPG. There's the occasional welcome gag - after blasting away one of the Damien Hirst-esque zombie dogs, a character mutters: "Stay!" - but for the most part this is a zombie movie in name only.
See pages 177-178

THE RESURRECTION GAME

2001, USA
Dir: Mike Watt. *Prod:* Amy Lynn Best, Bill Homan and Mike Watt. *Scr:* Mike Watt
Cast: Ray Yeo, Kristin Pfeifer, Francis Veltri, Amy Lynn Best, Bill Homan

Shot in Pittsburgh, the zombie capital of the world, this self-styled 16mm "zombie noir" has been doing the rounds of the horror circuit for several years after a bootleg workprint was circulated among fans by the hard-up filmmakers (in the spirit of full disclosure it's this print that this review is based on). As a result, the film has generated a massive cult fan base since it was first announced in 1998 and despite the drawbacks of watching it under such terrible conditions (a scratched, grainy print with no proper sound) it's obvious why. Set in the future where zombies have become an accepted factor of everyday life, *The Resurrection Game* follows an ex-cop and his buddies as they uncover the damning conspiracy that surrounds the return of the dead. Some noir posturing, a busty dominatrix "exterminator" and the obvious technical talent of the people behind the camera suggest that this has considerable promise. Let's just hope someone eventually gives Watt a decent budget for some proper zombie mayhem.

THE RETURN OF THE BLIND DEAD

1973, Spain
Original title: **El ataque de los muertos sin ojos**
Alternative titles: **The Return of the Evil Dead, Die Rückkehr der reitenden Leichen**
Dir: Amando de Ossorio. *Prod:* Ramón Plana. *Scr:* Amando de Ossorio
Cast: Tony Kendall [Luciano Stella], Fernando Sancho, Esther Ray [Esperanza Roy], Frank Blake [Braña], Lone Fleming

The first sequel to *Tombs of the Blind Dead* apparently bears no relation to that earlier tale in terms of narrative. This time around a rural village's festive celebrations are interrupted when a group of Templars rise from their tombs and cut a bloody swathe through the processions. It turns out that the village idiot has resurrected them in a fit of revenge for his mistreatment, using a kidnapped woman as a blood sacrifice. Several flashbacks flesh out the mythology surrounding these eyeless zombies yet the main focus is on the village's preparations for their festival (which celebrates the five hundred year anniversary of the Templars' deaths). As the dead attack, charging through on horseback, various townsfolk hide inside the cathedral for safety but don't last long against the invading corpses.
See pages 86, 105-107, 109, note 108

THE RETURN OF THE LIVING DEAD

1984, USA
Dir: Dan O'Bannon. *Prod:* Tom Fox. *Scr:* Dan O'Bannon
Cast: Clu Gulager, James Karen, Don Calfa, Thom Mathews, Beverly Randolph

According to Dan O'Bannon's tongue in cheek pastiche of *Night of the Living Dead*, Romero's original movie was based on historical fact. The dead really did return to life in 1968 after the accidental release of a pesticide designed to be sprayed on marijuana crops. Although the incident was hushed up, the corpses of the original zombies were sealed in canisters that, as a result of a bureaucratic cock up, are now sitting in a medical supply company's warehouse in Louisville, Kentucky. Two foolish workers manage to release the gas precipitating a mass

The Return of the Living Dead.

zombie apocalypse in which the country is overrun by brain-munching ghouls. Sadly, Romero's shoot 'em in the head strategy no longer works since these bodies just keep on going, even without any brain tissue: "You mean the movie lied?!"
See pages 154-159, notes 167, 170

RETURN OF THE LIVING DEAD PART II

1988, USA
Dir: Ken Wiederhorn. *Prod:* Tom Fox. *Scr:* Ken Wiederhorn.
Cast: James Karen, Thom Mathews, Dana Ashbrook, Marsha Dietlein, Michael Kenworthy, Suzanne Snyder, Philip Bruns

Just when you thought it was safe to be dead, Dan O'Bannon passes the reins to Ken Wiederhorn for this lame retread of the first film. Another canister is opened, releasing yet more toxic gas and another horde of zombies. Mathews and Karen even reprise much the same roles as before, this time as a gravedigger and his boneheaded assistant. Rehashing old plots isn't the height of postmodern irony, just evidence of a poverty of ideas.
See pages 79, 155-156

left: **Return of the Living Dead 3**'s punkette zombie graces this postcard advertising the soundtrack CD.
below: The spirit of **The Terminator** spices up the action in **Return of the Living Dead 4: Necropolis**.

RETURN OF THE LIVING DEAD 3

1993, USA
Dir: Brian Yuzna. *Prod:* Gary Schmoeller, Brian Yuzna. *Scr:* John Penney
Cast: J. Trevor Edmond, Mindy Clarke, Kent McCord, Basil Wallace

The dead have returned and this time it's love as Brian Yuzna steps into the director's chair and delivers *Romeo and Juliet* for zombies. After his girlfriend Julie is killed in a traffic accident, army brat Curt uses his dad's experiments with the military chemicals of the first two films to bring her back to life as a ghoul. Escaping the army base, they hide out in the sewers with Curt's dad and an angry gang of thugs in pursuit. Julie spends most of her time trying not to chow down on her boyfriend, eventually realising that she can dampen her taste for flesh through self-harming. It all leads to a body modification makeover in which she covers herself in homemade piercings. Ouch.
See pages 155-156, 217

RETURN OF THE LIVING DEAD 4: NECROPOLIS

2005, USA/Romania
Dir: Ellory Elkayem. *Prod:* Anatoly Fradis, Steve Scarduzio. *Scr:* William Butler, Aaron Strongoni
Cast: Aimee-Lynn Chadwick, Cory Hardrict, John Keefe, Jenny Mollen

The fourth entry in the *Return of the Living Dead* series was shot back-to-back with the fifth film and aims to rework the franchise with "a combination of martial arts, anime and horror" according to writer William Butler. Not yet released when this book went to press, it promises to be an irreverent take on an old favourite with a bunch of kids stumbling across a high-tech laboratory where the dead are being brought back to life. The film apparently leads directly into the sequel *Return of the Living Dead 5: Rave to the Grave*, with much the same cast.
See pages 156, 192, 220

RETURN OF THE LIVING DEAD 5: RAVE TO THE GRAVE

2005, USA/Romania
Dir: Ellory Elkayem. *Prod:* Anatoly Fradis, Steve Scarduzio. *Scr:* William Butler, Aaron Strongoni
Cast: Aimee-Lynn Chadwick, Cory Hardrict, John Keefe, Jenny Mollen

Director Elkayem returns for more zombie mayhem in the final film in the franchise (at least to date). Following the events in *Necropolis*, the same band of kids find a barrel of the reanimating zombie agent and mistake it for a new recreational drug. Selling it to their mates in the run-up to Halloween, the scene is set for some living dead chaos as ravers swap their Es for the new drug of choice "Z". The film was still to be released at the time of writing.
See pages 156, 192, 220

RETURN OF THE ZOMBIES

1972, Spain/Italy
Original titles: **La orgía de los muertos, L'orgia dei morti**
Alternative titles: **Die Bestie aus dem Totenreich, Beyond the Living Dead, Bracula - The Terror of the Living Death, The Hanging Woman**
Dir: José Luis Merino. *Prod:* Ramón Plana. *Scr:* José Luis Merino, Enrico Colombo
Cast: Stan Cooper [Stelvio Rosi], Maria Pía Conte, Dianik Zurakowska, Pasquale Basile, Gérard Tichy, Paul Naschy [Jacinto Molina]

Paul Naschy plays a supporting role as a necrophiliac gravedigger in this grim Spanish-Italian offering. While he does his own brand of icky experimentation on the dead, a mad scientist is actually bringing other corpses back to life for some murderous antics. Shades of Jess Franco's classic Spanish horror outing *Dr. Orloff's Monster* abound, although here there's more than one ghoul wandering through the countryside indiscriminately killing people.
See pages 86-87, 104-105

THE REVENGE OF THE LIVING DEAD GIRLS

1987, France
Original title: **La revanche des mortes vivantes**
Dir: Pierre B. Reinhard. *Prod:* Jean-Claude Roy. *Scr:* John King
Cast: Véronique Catanzaro, Kathryn Charly, Sylvie Novak, Anthea Wyler, Laurence Mercier

The Revenge of the Living Dead Girls

Porn director Pierre B. Reinhard takes his cue from Jean Rollin in this tale of three girls turned into zombies when milk is poisoned by some chemical waste. Various combinations of softcore sex and explicit bodily mutilation ensue - including a gruesome scene in which a young lass is run through by a zombie shoving a sword between her legs. But the film well deserves its reputation as one of the most ridiculous attempts to cash in on the sex/gore combination.
See pages 135, 201

REVENGE OF THE LIVING ZOMBIES

1989, USA
Alternative titles: **Flesh Eater: Revenge of the Living Dead, Zombie Nosh**
Dir: Bill Hinzman. *Prod:* Bill Hinzman. *Scr:* Bill Hinzman, Bill Randolph
Cast: Bill Hinzman, John Mowood, Leslie Ann Wick, Kevin Kindlin

Talk about delusions of grandeur. After starring as the opening cemetery ghoul in Romero's 1968 classic, Hinzman took it upon himself to teach zombie cinema a few tricks. The result was this trashola tale in which he stars as a corpse buried for centuries and accidentally dug up by a rural farmer. Cue yet another zombie apocalypse as Hinzman and fellow ghouls gatecrash a Halloween barn party (they get to eat a bloke dressed as Dracula), rip open busty women's blouses and generally make a nuisance of themselves before the rednecks break out the shotgunzzzzzzzzz.
See page 153

REVENGE OF THE ZOMBIES

1976, Hong Kong
Alternative title: **Black Magic II**
Dir: Ho Meng-Hua. *Prod:* Run Run Shaw. *Scr:* I Kuang
Cast: Ti Lung, Tanny [Tien Ni], Lo Lieh, Liu Hui-Ju, Lily Li, Wei-Tu

More Shaw Brothers martial arts mayhem as an evil sorcerer uses black magic to create jumping zombie goons with huge nails stuck in their craniums. Doctors at the local hospital are alerted when a mysterious disease starts killing off their patients in gruesome ways. Could it be the black magic at work? As usual the martial arts are top notch, but purists may be rather dismayed by the gymnastic ghouls.
See page 172

REVENGE OF THE ZOMBIES

1943, USA
Alternative title: **The Corpse Vanished**
Dir: Steve Sekely. *Prod:* Lindsley Parsons. *Scr:* Edmund Kelso, Van Norcross
Cast: John Carradine, Gale Storm, Robert Lowery, Bob Steele, Mantan Moreland

A lame retread of Monogram's earlier *King of the Zombies*, this reprises much the same material with Mantan Moreland and friends falling foul of a Nazi scientist who's trying to create a race of zombie super-soldiers.
See pages 34-35, 38-39, 79

REVOLT OF THE ZOMBIES

1936, USA
Alternative title: **Revolt of the Demons**
Dir: Victor Halperin. *Prod:* Edward Halperin. *Scr:* Howard Higgin, Rollo Lloyd, Victor Halperin
Cast: Dorothy Stone, Dean Jagger, Roy D'Arcy, Robert Noland, George Cleveland

During the First World War, the Allies discover that Cambodian priests are in possession of a mind control technique that can brainwash people into becoming fearless zombie soldiers. A team of scientists is dispatched to the East and one of the group decides to use the power to bind the whole of Cambodia to his will in order to blackmail his girlfriend into marrying him. It must be love.
See pages 28-31, 52, 98, note 44

SANTO AND BLUE DEMON AGAINST THE MONSTERS

1968, Mexico
Original title: **Santo y Blue Demon contra los monstruos**
Dir: Gilberto Martínez Solares. *Prod:* Jesús Sotomayor Martínez. *Scr:* Rafael García Travesí, Jesús Sotomayor Martínez
Cast: Santo el Enmascarado de Plata, Blue Demon, Jorge Radó, Carlos Ancira, Raúl Martínez Solares, Jr., Heidi Blue

Zombies compete for ring space with a host of Universal creatures in this overstocked Mexican wrestling horror (the title's a dead giveaway). Santo's hot on the trail of a mad scientist who's rounding up all the bad guys in Mexico - including a vampire, a werewolf, the Cyclops and Frankenstein's monster - to terrorise the local populace. Among the menagerie of monsters are green-faced zombies who make a pretty poor show of fighting off masked wrestler Santo - but manage to win his tag team partner Blue Demon over to their side.
See page 60

SANTO AND BLUE DEMON IN THE LAND OF THE DEAD

1969, Mexico
Original title: **El mundo de los muertos**
Alternative title: **The Land of the Dead.**
Dir: Gilberto Martínez Solares. *Prod:* Jesús Sotomayor Martínez. *Scr:* Rafael García Travesí, Jesús Sotomayor Martínez
Cast: Santo el Enmascarado de Plata, Blue Demon, Pilar Pellicer, Carlos León, Antonio Raxel

More Mexican wrestling mania sees masked muscleman El Santo taking on a witch and her zombie bullyboys. Not even the flashbacks to the seventeenth-century, a trip to hell, or a small role for an evil Blue Demon (his soul has been captured by the witch) can do much to detract from the poverty-stricken production. The zombies are merely perfunctory additions who jump in and out of Santo's wrestling ring to give him the occasional slap.
See page 60

SCARED STIFF

1952, USA
Dir: George Marshall. *Prod:* Hal B. Wallis. *Scr:* Herbert Baker, Walter DeLeon
Cast: Dean Martin, Jerry Lewis, Lizabeth Scott, Carmen Miranda, George Dolenz

Director George Marshall shamelessly retreads *The Ghost Breakers* for a quick buck. Just as well it was his property to tarnish. Jerry Lewis and Dean Martin replace Willie Best and Bob Hope respectively. Lewis is a bumbling, stumbling waiter, Martin is a suave nightclub singer and together they're roped into helping a damsel in distress as the mob, ghosts and a haunted castle on "Lost Island" prove too much for her to handle. If you're gonna call anyone in a spot like that, Jerry Lewis should not be your first choice. Or second. Or third.
See pages 47-48

THE SCOTLAND YARD MYSTERY

1934, UK
Alternative title: **The Living Dead**
Dir: Thomas Bentley. *Prod:* Walter C. Mycroft. *Scr:* Frank Miller, based on the play by Wallace Geoffrey
Cast: Gerald du Maurier, George Curzon, Belle Chrystall, Grete Natzier, Leslie Perrins

A little-seen British chiller (released in the United States as *The Living Dead*), in which George Curzon's murderer fakes the death of his heavily-insured victims by paralyzing them with a drug that induces a catatonic effect. Once the bodies are in the ground, Curzon cashes-in his victims' policies and pockets the dosh. The victims can be brought back to life using an anti-toxin, making this black and white horror drama quite prescient in its understanding of the toxicology of living death. Despite the film's alternative title, the dead are explicitly not styled as traditional voodoo zombies or, for that matter, any other kind of zombies either.
See page 28

THE SERPENT AND THE RAINBOW

1987, USA
Dir: Wes Craven. *Prod:* David Ladd, Doug Claybourne. *Scr:* Richard Maxwell, A.R. Simoun [Adam Rodman], based on the book by Wade Davis
Cast: Bill Pullman, Cathy Tyson, Zakes Mokae, Paul Winfield, Brent Jennings

Wade Davis's book gets the blockbuster treatment with Wes Craven directing. Dr. Alan is a white American sent to Haiti to uncover the zombification drug for a giant pharmaceutical corporation. Once on the island, though, his presence gains the unwanted attention of one of the corrupt regime's more notorious torturers who also happens to be a voodoo priest. Playing up the psychological dimension of voodoo - "The soul begins and ends with the brain" - this centres on the main thesis of Davis's book that zombification is a mental, drug-induced state used by secret societies to control the island's populace. Significantly, the film's chief zombie Christophe is a former grade school teacher who's been turned into a living dead slave as punishment for his radical political views.
See pages 149-151

SEX, CHOCOLATE & ZOMBIE REPUBLICANS

1998, USA
Dir: Kirk Bowman. *Prod:* Bob Elyea. *Scr:* Kirk Bowman
Cast: Jenna Faustino, Debby Dodds, Linda Etoh Pine, David Tracq, Denise Reiser

The title makes this film sound ridiculously cheesy, and it is. But it's also a fun social satire. When she receives a chain letter, young Jessica unwittingly unleashes a curse that turns seemingly nice and friendly people into zombie Republicans who're ludicrously moralistic, straight-laced morons. The only thing that can stop these rightwing ghouls is a secret herbal cure. Can Jessica and her pals bake enough herbal cookies to free the human race from the nightmare of rabid conservatism? Or will the book-barbecuing Republicans take over the White House and the planet? (DAO).
See page 166

SHADOW: DEAD RIOT

2005, USA
Dir: Derek Wan. *Prod:* Carl Morano, Csaba Bereczky. *Scr:* Michael Gingold, Richard Siegel.
Cast: Tony Todd, Sergio Alarcon, Carla Greene, Cat Miller, Nina Hodoruk

Zombie movies frequently feature claustrophobic scenes where characters barricade themselves inside houses and other fortified buildings, but surprisingly few have ever taken this idea to its logical conclusion and set their action inside a prison. This martial arts horror from the pen of *Fangoria* magazine's managing editor Michael Gingold turns the tide - and takes place in a women's prison for added exploitation value. Tony Todd stars as Death Row inmate Shadow, who returns from beyond the grave twenty years after his death to wreak havoc in the penitentiary. Leading the fight against him is martial arts fighter

Solitaire, who battles zombie prisoners in a series of kinetic fight sequences choreographed by Hong Kong veteran Tony Leung Siu-Hung. The film was unreleased at the time of publication.
See page 223

SHANKS

1974, USA
Dir: William Castle. *Prod:* Steven North.
Scr: Ranald Graham
Cast: Marcel Marceau, Tsilla Chelton, Philippe Clay, Cindy Eilbacher, Helena Kallianiotes

French mime artist Marcel Marceau stars as Malcolm Shanks, a puppeteer who helps out a scientist experimenting on reanimating dead animals using electrical currents. After the scientist and Malcolm's family are killed, Malcolm turns them into puppet zombies and uses them as jerky slaves until an evil biker rampages through the town and prompts Malcolm to use them for less wholesome ends. Director William Castle is better known for his cheapo horror flicks - *House on Haunted Hill* (1959), *Homicidal* (1961) - but this, his last film, is something quite different. A surreal, near-silent fairy tale oddity it's just crying out for a Tim Burton remake.
See page 76

SHATTER DEAD

1993, USA
Dir: Scooter McCrae. *Prod:* Scooter McCrae. *Scr:* Scooter McCrae
Cast: Stark Raven, Flora Fauna, Daniel Johnson, Robert Wells, Marina Del Rey

Touted by many as the finest example of ambitious SOV filmmaking, *Shatter Dead* is crammed full of good ideas - some of which fall by the wayside as the slipshod production takes its toll. Stark Raven plays a young woman who hates zombies - a bit of a problem since the end of death has meant that zombies are now everywhere. As the living die and keep on living, the fabric of society is on the verge of collapse. Director Scooter McCrae's refreshingly leftfield approach to the genre isn't afraid to delve into exploitation territory with lots of gore and plenty of provocative sex: unable to get it up, Raven's dead boyfriend uses her gun as a dildo. Class.
See pages 167-169

SHAUN OF THE DEAD

2004, UK/USA/France
Dir: Edgar Wright. *Prod:* Nira Park. *Scr:* Edgar Wright, Simon Pegg
Cast: Simon Pegg, Kate Ashfield, Lucy Davis, Nick Frost, Dylan Moran, Bill Nighy

The film that single-handedly saved contemporary British horror, *Shaun of the Dead* is billed as a "romantic comedy with zombies" (or a "zom-rom-com"). Shaun, a twenty-nine-year-old shop worker, finds his life thrown into chaos when his girlfriend Liz dumps him and a deep space probe unexpectedly returns to earth and turns the population of North London into zombies.
See pages 7, 181-183, 186, 192, 219, notes 215, 216, 217, 220, 241

SHIVERS

1975, Canada
Alternative title: **The Parasite Murders, They Came from Within**
Dir: David Cronenberg. *Prod:* Ivan Reitman. *Scr:* David Cronenberg
Cast: Paul Hampton, Joe Silver, Lynn Lowry, Allan Migicovsky, Susan Petrie

In a purpose-built apartment block named Starliner Towers, an unhinged medical researcher has been experimenting with strange turd-like parasites that are supposed to take over failed organs but actually turn their victims into sex-crazed maniacs. As the epidemic spreads through the humdrum middle-class world of the complex, the inhabitants' sexual desires are unleashed with murderous results. Can the complex's doctor and his pretty nurse prevent the spread of the infection? Or will they fall victim to the horny grannies and pre-pubescent kids stalking the hallways? The maniacs of Cronenberg's brilliant horror film may not strictly be zombies, but the revolt of the flesh over the brain that they represent owes a considerable debt to Romero.
See pages 73-75, note 96, 135

SHOCK WAVES

1976, USA
Alternative titles: **Almost Human, Le commando des morts vivants, Death Corps**
Dir: Ken Wiederhorn. *Prod:* Reuben Trane. *Scr:* John Harrison, Ken Wiederhorn
Cast: Peter Cushing, Brooke Adams, Fred Buch, Jack Davidson, Luke Halpin, John Carradine

"There is danger here, danger in the water," warns Peter Cushing in this eerily atmospheric chiller featuring Nazi zombies. Genetically engineered during World War II, these super-soldiers were designed to man submarines that would never have to come up to the surface. Foolishly, the test subjects were "cheap hoodlums and thugs and a good number of pathological murderers and sadists". Will mad scientists never learn? Now they're back from the deep, wreaking havoc on some tourists who've been stranded on the island. Emerging from the water in German uniforms and goggles to strangle or drown their victims, they're a striking collection of aquatic ghouls. Sadly the creepy film itself adds up to very little with heroine Brooke Adams eventually driven insane as she watches everyone she knows being picked off one by one.
See pages 79, 118, note 94

SPACE ZOMBIE BINGO

1993, USA
Dir: George Ormond. *Prod:* George Ormond. *Scr:* George Ormond, John Sabotta
Cast: William Darkow, Ramona Provost, Hugh Crawford, Dan Levine, John Sabotta

top: The zombie hordes in **Shaun of the Dead**.
above: A zombie shotgun abortion in **Shatter Dead**.

A quintessentially English zombie movie: **Shaun of the Dead**.

Life's a beach - even in space. The Cold War alien invasion movie gets updated for the 1990s courtesy of those daffy folks at Troma. Earth is under attack from alien invaders from the planet Plankton who are intent on turning us into zombies: thank heavens then for the Zombie Defence Corps, our last best hope. Camp trash with songs, bikini babes and a cute little kitten stuffed into a microwave. Ed Wood would be proud.
See page 151

STACY

2001, Japan
Dir: Naoyuki Tomomatsu. *Prod:* Hiromitsu Suzuki, Naokatsu Ito. *Scr:* Chisato Ogawara, based on the novel by Kenji Otsuki
Cast: Natsuki Kato, Toshinori Omi, Chika Hayashi, Shungiku Uchida, Yasutaka Tsutsui

Sometime in the twenty-first century, teenage girls aged between 15 and 17 start spontaneously dying and returning to life as zombies known as "Stacys". Impossible to stop, short of chopping them up into itty bitty pieces, these zombies prove a threat to civilisation itself which is why the UN has ordered special "Romero Repeat Kill" squads to re-kill the ghoulish girls all over again. Hacking up the bodies with chainsaws, the squads dump the still "live" remains into garbage bags to be burnt. Four interconnected storylines follow a scientist experimenting *Day of the Dead*-style, a puppeteer who falls in love with a teenage girl knowing that she's likely to die soon, some martial arts girls dedicated to killing Stacys and a squad of soldiers who are having trouble coping with the horror of the schoolgirl apocalypse. It's very, very silly but quite unforgettable.
See pages 172-173

THE STINK OF FLESH

2004, USA
Dir: Scott Phillips. *Prod:* Shannon Hale. *Scr:* Scott Phillips
Cast: Diva, Kristin Hansen, Kurly Tlapoyawa, Ross Kelly, William Garberina

Here's a horny little zombie outing: after the dead overrun the world, a wandering zombie slayer gets abducted by a pair of horny swingers looking for some post-apocalyptic between-the-sheets action. Terrible acting and an over-eager profusion of bare flesh and gore can't disguise the dearth of ideas here as characters ponder the state of sexual morality in a world where the dead have returned to life: "The way the world is today, what counts as a crime any more?". The tedium is occasionally broken by asides on the relative merits of living dead sex slaves ("She'd be pretty fucking hot if she weren't decomposing") and a yucky answer to that age old question: do zombies poo?
See page 166

SUGAR HILL

1974, USA
Alternative titles: **Voodoo Girl**, **The Zombies of Sugar Hill**
Dir: Paul Maslansky. *Prod:* Elliot Schick.
Scr: Tim Kelly
Cast: Marki Bey, Robert Quarry, Don Pedro Colley, Betty Anne Rees, Richard Lawson

After heavy-handed thugs beat her fiancé to death, Sugar Hill calls on voodoo God Baron Samedi to help her get revenge. He appears with some cobwebbed black zombies - former slaves who died while being shipped to the New World - and lets Sugar have some fun killing off the men who prevented her from walking down the aisle. The first blaxploitation zombie movie.
See pages 76-77, 117

THE SUPERNATURALS

1986, USA
Dir: Armand Mastroianni. *Prod:* Michael S. Murphy, Joel Soisson. *Scr:* Joel Soisson, Michael S. Murphy
Cast: Maxwell Caulfield, Nichelle Nichols, Talia Balsam, Margaret Shendal, LeVar Burton

This early outing for Civil War zombies (see also *Ghost Brigade*) has modern-day soldiers fighting crusty Confederate ghouls as a training exercise goes tits up. It's a cheap rip-off of Walter Hill's soldiers in the South thriller *Southern Comfort* (1981) with the living dead thrown in to keep the horror crowd interested.
See page 153

Swamp of the Ravens.

THE SWAMP OF THE RAVENS

1973, Spain/USA
Original title: **El pantano de los cuervos**
Dir: Michael Cannon [Manuel Caño].
Prod: Fernando M. Hernandez, Javier Molina. *Scr:* Santiago Moncada
Cast: Raymond Oliver [Ramiro Oliveras], Marcia [Marcelle] Bichette, Fernando Sancho, William Harrison, Mark Mollin [Marcos Molina]

Shot on location somewhere in South America (possibly Ecuador), this atmospheric mad scientist chiller follows Dr. Frosta as he tries to revive the dead. He's not very successful, which is why the swamp behind his isolated shack-come-laboratory is littered with the corpses of his previous victims. In between scenes they occasionally bob up to the surface for added frisson. Kidnapping his ex-girlfriend, Frosta kills her then tries to bring her back to "life" for some necrophiliac loving. Padded out with some dreadful lounge singing, a gratuitous (real?) autopsy scene and a few bare breasts, this never really delivers the zombie goods. The ghouls float about in the eponymous swamp (which is actually inhabited by big black buzzards, not ravens) but don't do much else - although in one scene a disembodied zombie hand strangles a man who tries to blackmail the doc. It's easy to see why this title has slipped into obscurity. Still, it would make a decent double bill with Rollin's *Zombie Lake*.
See pages 86, 115

TALES FROM THE CRYPT

1972, UK
Dir: Freddie Francis. *Prod:* Max J. Rosenberg, Milton Subotsky. *Scr:* Milton Subotksy
Cast: Ralph Richardson, Joan Collins, Ian Hendry, Peter Cushing, Nigel Patrick, Patrick Magee

Living dead fans will need to skip the first, second and fifth tales in this portmanteau collection (though they're actually good fun, especially Joan Collins's nightmare before Christmas) and head along to Cushing's appearance as a bullied neighbour who turns into a ghoul in the third segment. The fourth entry features a man being brought back from the dead over and over again as his wife keeps fluffing her three wishes. Framing the collection is the ghoulish crypt keeper himself, nicely played by Richardson.
See pages 77-79

TEENAGE ZOMBIES

1957, USA
Dir: Jerry Warren. *Prod:* Jerry Warren.
Scr: Jacques Lecotier [Jerry Warren]
Cast: Don Sullivan, Katherine Victor, Steve Conte, J.L.D. Morrison, Bri [Brianne] Murphy

During a waterskiing trip, a gang of fresh-faced American kids stumble across a secret island inhabited by a Russian scientist, who's planning to introduce a biological agent into the United States' water supply that will turn the population into mindless slaves. The kids have to battle the mad doctor and her zombified henchman to save America from the Reds.
See pages 47, 52-53, 100

TERROR-CREATURES FROM THE GRAVE

1965, Italy
Original title: **Cinque tombe per un medium**
Alternative title: **Cemetery of the Living Dead**
Dir: Massimo Pupillo. *Prod:* Frank Merle, Ralph Zucker. *Scr:* Robert Nathan [Roberto Natale], Robin McLorin [Romano Migliorini]
Cast: Barbara Steele, Walter Brandt [Brandi], Marilyn Mitchell [Mirella Maravidi], Alfred Rice [Alfredo Rizzo], Richard Garrett [Riccardo Garrone]

Tales from the Crypt.

Horror favourite Barbara Steele headlines this tale about a dead medium named Jeronimus Hauff who calls plague victims up from their graves beneath his castle in order to avenge himself on his wife. Lots of brooding Italian Gothic atmosphere and some envelope-pushing gore scenes make this a notable but not very exciting genre entry. The terror-creatures themselves are plague-ridden corpses who come to life at the end of the film and take revenge for the dead medium. The film is so cheap that it limits its zombies to outstretched hands shot in shadow inching their way along walls before killing them off with rainwater (!).
See page 62

THEY CAME BACK

2004, France
Original title: **Les revenants**
Dir: Robin Campillo. *Prod:* Caroline Benjo, Carole Scotta. *Scr:* Robin Campillo, Brigitte Tijou
Cast: Géraldine Pailhas, Jonathan Zaccaï, Frédéric Pierrot, Victor Garrivier, Catherine Samie

An arthouse oddity, *Les revenants* begins with the dead returning to life in a French cemetery. Instead of merely wanting to eat the living though, these ghouls are rather different. Director Robin Campillo (who co-wrote Laurent Cantet's masterful drama *Time Out*, about the soullessness of middle-class office life) makes his zombies a metaphor for various social problems. As the dead return home they try to reintegrate into society, but it's not that easy. Relatives react in different ways and the government puts them up in emergency housing, struggling to decide what to do with the sudden return of so many ex-citizens. An intelligently leftfield take on the usual zombie apocalypses, this is an ambitiously probing film about grief, social exclusion and the socio-economics of death.

THRILLER

1983, USA
Dir: John Landis. *Prod:* George Folsey Jr., Michael Jackson, John Landis. *Scr:* John Landis, Michael Jackson
Cast: Michael Jackson, Ola Ray, Michael Peters, John Command, the voice of Vincent Price

A landmark 1980s music video from superstar Jackson, this ropes in horror maestro John Landis to cook up some suitable scares as Jackson and his girlfriend find their smooching disturbed by ghouls. Notable for reviving the zombie's flagging fortunes and for launching a thousand and one dancing zombie skits.
See pages 153, 161, 206

TOMBS OF THE BLIND DEAD

1971, Spain/Portugal
Original titles: **La noche del terror ciego, A noite do terror cego**
Alternative titles: **The Blind Dead, Crypt of the Blind Dead, La noche de la muerta ciega, Le tombe dei resuscitati ciechi, Tombs of the Blind Zombies**
Dir: Amando de Ossorio. *Prod:* José Antonio Pérez Giner. *Scr:* Amando de Ossorio
Cast: Lone Fleming, César Burner, Helen Harp [María Elena Arpón], Joseph Thelman [José Telman], María Silva

The first of de Ossorio's Blind Dead movies set the precedent for all that would follow with skeletal, sightless

zombies pursuing a couple of good-looking lasses and occasionally jumping onto zombie steeds for some operatic slow-mo moments.
See pages 1, 86, 88-90, 102-103, 105

TOXIC ZOMBIES

1979, USA
Alternative titles: **Bloodeaters**, **Forest of Fear**
Dir: Charles McCrann. *Prod:* Charles McCrann. *Scr:* Charles McCrann
Cast: Charles Austin, Beverly Shapiro, Dennis Helfend, Kevin Hanlon, Judy Brown, John Amplas

Marijuana gets sprayed with an experimental pesticide and would-be dope heads are turned into slavering bloodeaters in Charles McCrann's redneck schedule filler. Tom Cole, the forestry department's finest, is stranded in the backwoods with his family as the maniacs stalk the countryside in search of fresh victims. They're not exactly zombies, but the distributors obviously thought that the alternative title - *Bloodeaters* - just wasn't vivid enough.
See page 74

TREPANATOR

1991, France
Dir: N.G. Mount [Norbert Moutier]. *Prod:* Norbert Moutier. *Scr:* N.G. Mount [Norbert Moutier]
Cast: Michel Finas, Jean Rollin, Eva Sinclair, Michael Raynaud, Gilles Bourgarel, William Lustig

This film is the French version of *Re-Animator*. The plot lines are almost identical with a few minor details altered here and there. A young scientist called Herbert East (!) watches his mentor die at the hands of police after conducting sinister experiments involving corpses. Years later Mr. East continues with his mentor's work, eventually resulting in zombie mayhem as the dead return to life. Not a patch on the original's gory goodness, but the presence of Jean Rollin and William Lustig give it some cult appeal (DAO).
See page 166

28 DAYS LATER

2002, UK/USA
Dir: Danny Boyle. *Prod:* Andrew Macdonald. *Scr:* Alex Garland
Cast: Cillian Murphy, Naomie Harris, Megan Burns, Brendan Gleeson, Christopher Eccleston

28 days after the apocalypse, London is deserted and the whole of the UK has been evacuated. Bike courier Jim wakes up in hospital to find that he is one of the few survivors of a viral outbreak that has turned those infected into raging homicidal maniacs. With its stark vision of social collapse, Danny Boyle's digitally-shot sci-fi horror harks back to the Terence Fisher invasion movies of the 1960s and the novels of J.G. Ballard. As of early 2005, negotiations are underway for a sequel, tentatively titled *28 Weeks Later*.
See page 7, 178-181, 186, 192

UNA DE ZOMBIS

2003, Spain
Dir: Miguel Ángel Lamata. *Prod:* Santiago Segura, Javier Valiño. *Scr:* Miguel Ángel Lamata, Miguel Ángel Aijon
Cast: Miguel Ángel Aparicio, Mayte Navales, Miguel Ángel Aijón, Nacho Rubio, Salomé Jiménez

"A Film About Zombies", this delivers plenty of ghouls and possesses a breathless, mordant postmodern wit that takes narrative game-playing into realms that would make Quentin Tarantino proud. The plot folds in on itself so many times it's hard to summarise, but it begins with Goth DJ Caspas and best mate Aijón setting out to make a horror film about (you guessed it) zombies... Then real zombies appear and things turn from crazy to insane.
See pages 181, 216

UNDEAD

2003, Australia
Dir: Michael and Peter Spierig. *Prod:* Michael and Peter Spierig. *Scr:* Michael and Peter Spierig
Cast: Felicity Mason, Mungo McKay, Rob Jenkins, Lisa Cunningham, Emma Randall

Zombie cinema has always had more than its fair share of DIY filmmakers willing to grab a video camera, round up a few mates and slap some flour on their faces. This no-budget effort from Australia follows in the homemade footsteps of *The Evil Dead* and *Bad Taste*

Undead

as twins Peter and Michael Spierig turn an outback town into an alien-infested zombie wasteland. Riding through the chaos is a shotgun-wielding fisherman and the town's former beauty queen. Splatter fans will dig the gut-munching action (which includes a zombie fish!), though sadly this never converts its cult potential into hard currency. Annoyingly hysterical characters, naff CGI reputedly knocked up on an Apple Mac (boy does it show) and relentless steals from other, better movies prove disastrous. You know you're in serious trouble when one of those "better" movies includes (gulp) Stephen King's *Dreamcatcher* (2003).
See pages 180, 218

URBAN SCUMBAGS VS. COUNTRYSIDE ZOMBIES

1992, Germany
Dir: Patrick Hollman, Sebastian Panneck. *Prod:* Patrick Hollman, Sebastian Panneck. *Scr:* Patrick Hollman, Sebastian Panneck
Cast: Kai Dombrowski, Viola Colditz, Alexander Laurisch, Andreas Tretow, Constanze Abraham

Intriguing title, snoozeworthy movie. This German production was one of the first Teutonic zombie outings and it's certainly showing its age. A bunch of kids (the urban scumbags) are sent off to a countryside retreat by their parents who are fed up of their rebellious ways. But instead of being cured by the doctor and the sergeant major-type tough guy who run the centre, they find themselves caught up in a zombie outbreak after two Middle Eastern terrorists drop a barrel of toxic biochemicals. What follows is pretty dull even by low-budget zombie outings with only a few laughing ghouls (apparently the extras are suffering from the giggles), amputation by chainsaw and a zombie pushing his mate about in a supermarket trolley as distractions.
See page 166

VALLEY OF THE ZOMBIES

1946, USA
Dir: Philip Ford. *Prod:* Dorrell and Stuart McGowan. *Scr:* Dorrell and Stuart McGowan
Cast: Robert Livingston, Adrian Booth, Ian Keith, Thomas Jackson, Charles Trowbridge

Disappointingly, this Republic feature doesn't feature a single zombie. Undertaker Ian Keith has discovered a secret voodoo formula that allows him to exist in some halfway state between life and death. Fair enough. Except he needs a steady supply of blood to keep himself going - making this more of a vampire movie than a zombie flick.
See page 46, note 67

THE VAULT OF HORROR

1973, UK
Alternative title: **Further Tales from the Crypt**, **Tales from the Crypt II**
Dir: Roy Ward Baker. *Prod:* Max Rosenberg, Milton Subotsky. *Scr:* Milton Subotsky, based on stories by Al Feldstein, William M. Gaines.
Cast: Tom Baker, Denholm, Elliot, Terry Thomas, Dawn Addams, Michael Craig

This lacklustre outing for UK horror house Amicus fails to capitalise on the joys of *Tales from The Crypt* and marked the death knell of the E.C. Comics adaptations deal that the studio had been hoping to take to a third instalment. The first of the five stories begins as a group of protagonists find themselves trapped in a lift and decide to pass the time by

No, not the zombified cast of **Reservoir Dogs**, but the protagonists of **The Vault of Horror** resurrected as ghouls in the framing story's final moments. Roy Ashton employed much the same make-up technique here as in **Tales from the Crypt**.

telling each other about their dreams. None of the stories involve ghouls, though there's a suitably macabre tale of premature burial. But the framing storyline comes into its own in the final moments of the film as the characters discover that they've got more to worry about than just a broken lift. Cue a memorable scene of zombies shuffling towards oblivion.

VEERANA

1985, India
Alternative titles: **Loneliness**, **The Wilderness**
Dir: Tulsi Ramsay, Shyam Ramsay. *Prod:* Kanta Ramsay, Anjali Ramsay. *Scr:* Shyam Ramsay
Cast: Hemant Birje, Satish Shah, Sahila Chadda, Gulshan Grover, Kamal Roy

Watching Hindi movies can only be described as a unique experience. To those unfamiliar with Bollywood structure, it can be quite mind-boggling to have characters suddenly burst into song and dance. It's even stranger in a horror film. As a movie, *Veerana* is all over the place as its plot about the execution of an evil witch and her attempt to take revenge features demonic possession, evil wizards, a giant zombie, a mind-controlled little girl zombie, stone-like creatures, and a female vampire-zombie-witch-demon. A fascinating addition to Bollywood's horror catalogue and an enjoyably weird ride (DAO).

VENGEANCE OF THE ZOMBIES

1972, Spain
Original title: **La rebelión de las muertas**
Alternative titles: **Rebellion of the Dead Women, Revolt of the Dead Ones, Der Totenchor der Knochenmänner, La vendetta dei morti viventi, Walk of the Dead**

Der Totenchor der Knochenmänner

294

THE VIDEO DEAD

1987, USA
Dir: Robert Scott. *Prod:* Robert Scott. *Scr:* Robert Scott
Cast: Rocky Duvall, Roxanna Augesen, Sam David McClelland, Vickie Bastel, Michael St Michaels

Whatever you do, don't go watching *Zombie Blood Nightmare*. It's one film that's so bad it will kill you (other films in this book might feel like that, but this is the real deal). When a beaten up old TV set arrives on the door step of teenagers Jeff and Zoe's house, they switch it on to discover the aforementioned flick running on a continuous loop. Pretty soon, zombies are clambering out of the screen and getting up to all sorts of nonsense in this black horror-comedy. Wandering through

Dir: Léon Klimovsky. *Prod:* José Antonio Pérez Giner. *Scr:* Jacinto Molina
Cast: Paul Naschy [Jacinto Molina], Rommy, Mirta Miller, Vic Winner [Victor Alcazar], María Kosti

The ubiquitous Naschy plays an Indian fakir turning the daughters of ex-Indian colonials into zombies using voodoo (eh?) in this Spanish pap. The women are naturally all good looking but there's little else to make the heart beat fast as the fakir takes his revenge on the families who previously tried to kill him years before.
See pages 86, 112

VERSUS

2000, Japan
Dir: Ryuhei Kitamura. *Prod:* Shin Keishiro. *Scr:* Ryuhei Kitamura
Cast: Tak Sakaguchi, Hideo Sakaki, Chieko Misaka, Kenji Matsuda, Yuichiro Arai

In essence this could be *Junk* all over again as a couple of escaped convicts meet up with some yakuza types and a kidnapped beauty in a forest just as a horde of living dead are unleashed. That's about as far as the comparison goes, though, as *Versus* spins off to take in inter-dimensional portals, *Highlander*-style swordfights and some outrageously kinetic camera moves. It unspools at a terrific rate with enough verve and style to make it a bona fide cult classic.
See pages 172-174, 216

the neighbourhood, the ghouls make a nuisance of themselves, ransacking homes and messing about with the kitchen appliances while dementedly giggling about nothing in particular. Fortunately they can be scared off with mirrors and leave you alone as long as you pretend not to be afraid of them. An obscure little treat well worth tracking down.
See page 211, note 167

THE VINEYARD

1989, USA
Dir: Bill Rice, James Hong. *Prod:* Harry Mok. *Scr:* James Hong, Douglas Kondo
Cast: James Hong, Karen Witter, Michael Wong, Cheryl Lawson, Cheryl Madsen

Something of a vanity project for star, co-director and co-writer James Hong, this attempt to blend Asian and Hollywood horror falls flat on its face. Hong is Po, an evil sorcerer living on an island off the Californian coast. He's renowned for his award-winning wines yet he harbours a guilty secret: the vineyard is nothing more than a front for his magic dabbling. He's trying to keep his youth by brewing a special wine made from the blood of the beautiful boys and gals that he lures to his hideaway. Suddenly, the zombified remains of his previous victims rise from the vineyard to take their revenge. There's lots of T&A as wrinkly old Hong surrounds himself with nubile flesh half his age. The crappy 1980s feel is only compounded by the zombies themselves - a ragged group of *Thriller* rejects who stumble around a blue-lit vineyard where the mist machines are on permanent overdrive.
See page 165

A VIRGIN AMONG THE LIVING DEAD

1971, Liechenstein/France/Belgium
Original titles: **Christina, princesse de l'érotisme**, **Une vierge chez les morts vivants**
Alternative titles: **Eine Jungfrau in den Krallen von Zombies**, **Testamento diabolico**, **Una virgine fra i morti viventi**, **Zombi 4: A Virgin Among the Living Dead**

Dir: Jess [Jesús] Franco. *Scr:* Jess [Jesús] Franco, Peter Kerut, Henry Brald
Cast: Christina von Blanc, Britt Nichols [Carmen Yazalde], Howard Vernon, Anne Libert, Rose Kienkens, Paul Muller

Is it a dream or is real? Let's hope it's all a dream because this inept shocker really makes no sense whatsoever. Whether that's because it's been butchered somewhere in production or just because director Franco couldn't be bothered to find a decent story to pad out his wonderful collection of titles isn't clear. Either way, anyone looking for zombie action will be disappointed since there's very little indeed. Young Christina visits her uncle's château and slips into a weird state somewhere between the real and unreal, life and afterlife. Various characters pop up, vanish and reappear again and there's lots of emphasis on a pond in the château grounds. Jean Rollin apparently shot the footage in which Christina dreams zombies are after her. His distinctive touch might have been better suited to this morbid yet annoyingly nonsensical outing.
See pages 61, 112

VOODOO DAWN

1989, USA
Dir: Steven Fierberg. *Prod:* Steven Mackler. *Scr:* John Russo, Jeffrey Delman, Thomas Rendon, Evan Dunsky
Cast: Raymond St. Jacques, Theresa Merritt, Tony Todd, Gina Gershon, Kirk Baily

The Walking Dead

Not even four screenwriters (one of them being *Night of the Living Dead* actor/crew member John Russo) can help this voodoo chiller dig itself out of its hole. Nor can the presence of a young, pre-fame Gina Gershon in the cast (bet she's since taken this off her CV). Tony Todd is a voodoo priest terrorising the Deep South by building a zombie out of various body parts as our white American heroes join forces with a wise old herbalist to defeat him before it's too late.
See page 151

VOODOO ISLAND

1957, USA
Alternative title: **Silent Death**
Dir: Reginald Le Borg. *Prod:* Howard W. Koch. *Scr:* Richard Landau
Cast: Boris Karloff, Beverly Tyler, Elisha Cook Jr., Rhodes Reason, Jean Engstrom

Karloff's researcher leads an expedition to a South Pacific island where several American engineers have vanished and the only survivor has been turned into a zombie. Karloff thinks the whole story's just a publicity gimmick for the opening of a new hotel on the island, but he soon realises that the zombies are real and that the natives are using voodoo to deter the white invaders. A disposable schedule filler.
See pages 47-49, 142, note 81

VOODOO MAN

1944, USA
Dir: William Beaudine. *Prod:* Sam Katzman, Jack Dietz. *Scr:* Robert Charles
Cast: Bela Lugosi, John Carradine, George Zucco, Wanda McKay, Louise Currie

Three of Monogram's best-loved horror stars feature in this creaky tale about a mad doctor who abducts starlets off the highway and experiments on them in an attempt to transfer the soul of his zombified wife into their bodies. The experiments never turn out quite right, leaving the doc with a house full of pretty zombie gals to be watched over by his henchmen.
See pages 35, 39-41, 49, 99

THE WALKING DEAD

1936, USA
Dir: Michael Curtiz. *Prod:* Louis F. Edelman. *Scr:* Ewart Adamson, Peter Milne, Robert D. Andrews, Lillie Hayward
Cast: Boris Karloff, Ricardo Cortez, Warren Hull, Edmund Gwenn, Marguerite Churchill, Barton MacLane

Warner Bros. tried to blend their talent for gangster movies with the Universal horror tradition in this interesting take on the zombie. Karloff is the walking dead man of the title, who's framed by evil mobsters and sent to the electric chair before two faint-hearted eyewitnesses find the courage to tell the court that he's actually innocent. Fortunately, they know a scientist who's able to revive him… The results aren't entirely successful and Karloff ends up moping around, playing the piano and killing the men who fitted him up like some lumbering angel of vengeance. According to movie legend, Karloff's casting was a fluke: "The reason I called you in was because I thought you actually were a Russian," explained director Curtiz after the event. "Your name certainly sounded Russian! When you came in you seemed so anxious to get the job that I decided to let you have it!"
See pages 27-30, 39, 142

WAR OF THE ZOMBIES

1964, Italy
Original title: **Roma contro Roma**
Alternative titles: **Night Star - Goddess of Electra**, **Rome Against Rome**
Dir: Giuseppe Vari. *Prod:* Ferruccio De Martino, Massimo De Rita. *Scr:* Piero Picrotti, Marcello Sartarelli
Cast: Suzy Andersen, Ettore Manni, Ida Galli, Mino Doro, John Drew Barrymore

Rome is in revolt as a black magic sorcerer intent on overthrowing the Empire raises an army of dead Roman legionaries to fight his battle for him. Living soldiers are forced to confront their dead comrades-in-arms until a centurion named Gaius attacks the effigy of the sorcerer's god and robs him of his power.
See page 62

WARNING SIGN

1985, USA
Alternative title: **Biohazard**
Dir: Hal Barwood. *Prod:* Jim Bloom. *Scr:* Hal Barwood, Matthew Robbins
Cast: Sam Waterston, Kathleen Quinlan, Yaphet Kotto, Jeffrey DeMunn

A secret biochemical research centre becomes the site of a zombie outbreak after the employees are exposed to a lethal viral agent. The building's sealed off but the dead scientists start coming back to life, faces covered in pustules and eyes wild with rage. They take out a platoon of soldiers in clunky biochemical warfare suits but don't get to do a lot else before this TV movie ties up all the loose ends and finds an antidote. The idea of having the platoon film the attacking ghouls with a live-feed camcorder could well have been an influence on James Cameron's later *Aliens* (1986), but that's about all that makes this notable.
See page 153

WHITE ZOMBIE

1932, USA
Dir: Victor Halperin. *Prod:* Edward Halperin. *Scr:* Garnett Weston
Cast: Bela Lugosi, Madge Bellamy, John Harron, Joseph Cawthorn, Robert Frazer

The original zombie movie still packs some chills. Two young American visitors to Haiti fall foul of Bela Lugosi's evil voodoo sorcerer who bewitches actress Madge Bellamy with a magic potion and turns her into one of his living dead slaves. After her husband storms the sorcerer's castle and battles his gang of thuggish zombies, Bellamy is eventually saved from a fate worse than death.
See pages 7, 18, 20-30, 33, 42, 44, 145, 149, 151, note 33

WILD ZERO

1999, Japan
Dir: Tetsuro Takeuchi. *Prod:* Tetsuro Takeuchi. *Scr:* Satoshi Takagi
Cast: Masashi Endo, Shitichai Kwancharu, Guitar Wolf, Bass Wolf, Drum Wolf

Invading aliens turn the Japanese countryside into a zombie-infested wasteland in Tetsuro Takeuchi's strutting Asian answer to Troma. Three rock 'n' roll heroes from the band Guitar Wolf are on hand to help young rocker Ace as he deals with the living dead and has to come to terms with the realisation that his new girlfriend is a she who's really a he ("Love has no borders, nationalities or genders!" becomes the film's message). What stands out here is the manic couldn't-give-a-damn energy, the primping and preening leather jacket-clad heroes and the general anything goes atmosphere. The zombies are cheap and cheerful creations and everyone has fun blasting their heads off with shotguns. The film ends with Guitar Wolf's front man destroying a UFO as it flies overhead by unsheathing a samurai sword hidden inside his guitar and slicing the spaceship in two. Insane.
See pages 172-173

WITCHDOCTOR OF THE LIVING DEAD

1980s, Nigeria
Dir/Prod/Scr: Charles Abi Enonchong
Cast: Joe Layode 'Garuba', St. Mary Enonchong, Victor Eriabie, Larry Williams

One of the rare sightings of a SOV Nigerian zombie movie (of which anecdotal evidence suggests there are many, but few people actually claim to have seen any), *Witchdoctor of the Living Dead*'s rarity can't make up for its dearth of cinematic entertainment. The witchdoctor of the title is a Ju-Ju man who's terrorising a rural village by turning into a goat and eating their crops. He's also breeding an army of shuffling zombies to do his bidding. Cursed with production values several leagues behind even the worse that Todd Sheets has to offer, this West African effort ambles through a half-baked storyline in which a big city detective arrives to counter the zombie menace. Rubber snakes entering and leaving women's orifices add crassness to the proceedings, while the zombies themselves are laughably dozy (a result of both their sheer ineptitude and the lack of acting ability by the non-RADA cast). Cheap but far from cheerful.

WOMANEATER

1957, UK
Dir: Charles Saunders. *Prod:* Guido Coen. *Scr:* Brandon Fleming
Cast: George Coulouris, Vera Day, Joy Webster, Peter Wayn, Jimmy Vaughan

A mad scientist is toying with carnivorous plant life in the hope of finding a serum that can resurrect the dead. Despite being schooled by an Amazonian witchdoctor, he soon realises that his plan doesn't really work: the body of his dead maid comes back to life as a rather cantankerous zombie.
See pages 47-49

WORKING STIFFS

1989, USA
Dir: Michael Legge. *Prod:* Jay Washburn, David Lowell, Maury Doyle. *Scr:* Michael Legge
Cast: Beverly Epstein, Bruce Harding, Tony Ferreira, Alan Kennedy, Michael McInnis

With its wild overacting and poverty-stricken budget, this film shouldn't be as funny as it is. Yet, somehow, it ranks among the best SOV zombie movies out there. Partly that's because it sets its sights so high and satirises the American workplace like a zombie precursor of *Office Space* (1999). A temp agency decides to make more money by creating the perfect employees, so they kill job applicants and raise them as zombies who are willing to work all day and all night for no pay ("They are dependable. They are dedicated... THEY ARE DEAD!"). The zombies eventually turn on their masters, set up their own agency and force their former boss into a nightmare job in (gulp) telemarketing. A hilarious little movie that proves that "shot-on-video" doesn't always need to be synonymous with totally braindead (DAO).
See page 166

ZEDER (VOICES FROM THE BEYOND)

1983, Italy
Alternative titles: **Revenge of the Dead**, **Zeder**
Dir: Pupi Avati. *Prod:* Gianni Minervini, Antonio Avati. *Scr:* Pupi Avati, Maurizio Costanzo, Antonio Avati
Cast: Gabriele Lavia, Anne Canovas, Paolo Tanziani, Cesare Barbetti, Bob Tonelli

Quite unique among Italian zombie movies, Pupi Avati's sublimely creepy *Zeder* dispenses with the usual sub-Romero gore and living dead invasions in

Zombi 3

favour of a plot that involves folds in the space-time continuum, an ancient typewriter and oblique references to the Holocaust. In 1980s Italy, a writer discovers a bizarre tale imprinted on the ribbon of an old typewriter. Piecing together the words, he learns about "K-Zones" strange locations in which the laws of time and space don't apply and the dead can be brought back to life. The authorities already know about these places and are experimenting with them, which leads to a series of zombie attacks. Deeply mysterious, Avati's chiller eschews everything that defines the Italian cycle in favour of a moody, arthouse atmosphere. Gorehounds will be quite disappointed, but those looking for a very unique take on the zombie mythology will be pleasantly surprised by this occult conspiracy thriller.
See pages 132, 201

ZOMBI 3

1988, Italy
Alternative title: **Zombie Flesh Eaters 2**
Dir: Lucio Fulci. *Prod:* Franco Gaudenzi.
Scr: Claudio Fragasso
Cast: Deran Sarafian, Beatrice Ring, Richard Raymond [Ottaviano Dell' Acqua], Alex McBride [Massimo Vanni], Ulli Reinthaler

Lucio Fulci stepped back into the fray with this "official" sequel to his classic *Zombi 2*. The results are bad enough to make one wish that all concerned had simply given the franchise the last rites instead. Shot in the Philippines, where celluloid is cheap and extras are even cheaper, this kicks off with a biological weapon triggering a zombie outbreak. If you manage to get past the atrocious direction, costumes and acting that assault you in the first ten minutes it only gets much, much worse. Fulci apparently left the production before shooting finished, handing over the reins to the uncredited Bruno Mattei. Who can blame him? It's chiefly memorable for a scene in which a zombie performs a casearean section - from the inside out - on a pregnant woman.
See pages 131-132, 143, 185, 204, note 134

ZOMBIE 4: AFTER DEATH

1988, Italy
Original title: **After Death (Oltre la morte)**
Alternative title: **Return of the Living Dead Part 3**, **Zombie Flesh Eaters 3**
Dir: Claudio Fragasso. *Prod:* Franco Gaudenzi. *Scr:* Rossella Drudi
Cast: Chuck Peyton, Candice Daly, Alex McBride [Massimo Vanni], Don Wilson, Jim Gaines

Zombies run wild on a tropical island in Claudio Fragasso's late entry in the Italian cycle. Adventurers unleash the walking corpses after reading from the Book of the Dead (d'oh). Fending off the zombie hordes with automatic weapons, our heroes work through a turgid movie of tiresome action sequences before the zombies get bored and pick up the guns themselves. Dreadful stuff, only enlivened by the fact that lead actor Chuck Peyton is actually legendary gay porn star Jeff Stryker.
See pages 131, 143

ZOMBIE 90: EXTREME PESTILENCE

1990, Germany
Dir: Andreas Schnaas. *Prod:* Ralf Hess, Matthias Kerl. *Scr:* Andreas Schnaas
Cast: Matthias Kerl, Ralf Hess, Mathias Abbes, Marc Trinkhaus, Christian Biallas

A crashed plane spills an AIDS cure that turns people into zombies in this outing from *Violent Shit* auteur Andreas Schnaas. The film centres on a never-ending stream of micro-budget gore; a baby is pulled from its pram and ripped to pieces (just as well it's only a doll), a man regrets letting a zombie woman go down on him and a chainsaw is wielded with gleeful abandon.
See page 166

ZOMBIE APOCALYPSE

1985, Mexico
Original title: **Cementerio del terror**
Alternative title: **Le cimetière de la terreur**
Dir: Rubén Galindo Jr. *Prod:* Raúl Galindo. *Scr:* Rubén Galindo Jr.
Cast: Hugo Stiglitz, Usi Velasco, José Gómez Parcero, Erika Buenfil

Long after El Santo hung up his mask for the last time, Mexican zombies are still stumbling along. It's a pity the intervening decades don't seem to have done much for their sense of self-esteem. In *Zombie Apocalypse* the ghouls are led by a slasher who's been raised from the dead by some numpty kids on the usual rave to the grave. The slasher gets most of the attention from director Galindo Jr., who seems to be auditioning for the next *Halloween* movie. That gives the slow-moving zombies more than enough time to contemplate the hellishness of starring in a movie this throwaway.

THE ZOMBIE ARMY

1991, USA
Dir: Betty Stapleford. *Prod:* John Kalinowski. *Scr:* Roger Scearce
Cast: Eileen Saddow, John Kalinowski, Steven Roberts, Jody Amato, Patrick Houtman

Two insane asylum inmates attack a platoon of American soldiers in this lame backyard epic. As they kill the soldiers the pair reanimate them using electroshock treatment and set them on anyone else who's still living. Utter corn with a few ketchup bottle gore effects thrown in whenever the interest flags: which is pretty often. The best thing about it is the video box cover art that shows Uncle Sam as a green-faced ghoul in a stars and stripes outfit proclaiming: "I want you for the zombie army" in a parody of all those old wartime recruitment posters. Memo to Betty Stapleford: zombie cinema does NOT want you!
See page 166

ZOMBIE BLOODBATH

1993, USA
Dir: Todd Sheets. *Prod:* Todd Sheets. *Scr:* Todd Sheets, Jerry Angell, Roger Williams
Cast: Chris Harris, Auggi Alvarez, Frank Dunlay, Jerry Angell, Cathy Metz

Sheets and his mates arm themselves with another camcorder for more heavy metal zombie action. It's a carbon copy of the director's other films as a radioactive leak returns the dead to life and they attack the living in a dull Midwest suburban locale. Unbelievably it took three writers to dream up this trash.
See page 166

ZOMBIE BLOODBATH II: RAGE OF THE UNDEAD

1994, USA
Dir: Todd Sheets. *Prod:* Todd Sheets. *Scr:* Todd Sheets, Dwen Daggett
Cast: Dave Miller, Kathleen McSweeney, Gena Fischer, Nick Stodden, Jody Rovick

To misquote the great Oscar Wilde, to make one bad movie is regrettable; to make a whole string of them is absolutely unforgivable. Todd Sheets returns from the SOV graveyard yet again with another zombie rampage. Ever ambitious, Sheets blends a multi-faceted plot about escaped convicts, possessed scarecrows and a bunch of characters trapped in a delicatessen while the zombies queue up outside to chow down on them (oh the irony, stop stop!). Surely someone should have impounded Sheets's camera by now?
See page 166

ZOMBIE BLOODBATH 3: ARMAGEDDON

2000, USA
Dir: Todd Sheets. *Prod:* Todd Sheets. *Scr:* Todd Sheets, Brian Eklund
Cast: Abe Dyer, Curtis Spencer, Blake Washer, Jolene Durrill, Jen Davis

Zombies from the future float through a black hole into the basement of a High School in Nowheresville, USA trapping naughty kids in a *Breakfast Club* meets *Dawn of the Dead* kind of moment. What's so amazing about these backyard movies isn't that Sheets keeps making them, but rather that audiences are willing to keep watching them.
See page 167

ZOMBIE BRIGADE

1988, Australia
Alternative title: **Night Crawl**
Dir: Carmelo Musca, Barrie Pattison.
Prod: Carmelo Musca, Barrie Pattison.
Scr: Carmelo Musca, Barrie Pattison
Cast: John Moore, Khym Lam, Geoff Gibbs, Leslie Wright, Bob Faggetter

Vietnam vampires fight Second World War zombies in this Australian film about an unscrupulous Japanese property developer who destroys a war memorial in order to make way for an amusement park. This gives a legion of vampire veterans left over from the war (shades of *Deathdream*) an excuse to raise hell. Desperate, the town calls upon some World War II zombies to save them and a predictably chaotic battle ensues. How did the Vietnam vets become vampires? We never find out and, quite frankly, don't really care as this offbeat premise degenerates into racist, offensive nonsense (DAO).
See page 153

ZOMBIE CAMPOUT

2002, USA
Dir: Joshua D. Smith. *Prod:* Joshua D. Smith. *Scr:* Joshua D. Smith
Cast: Misty Orman, Tiffany Black, John M. Davis, Jeremy Schwab, Alecia Peterman

Certain things tend to be taboo in Hollywood. But in this twisted and extremely funny little film from Dallas, Texas no such constraints exist: one of the first victims is a child; later, a cute dog becomes zombie chow. Poking fun at the genre's conventions, this is an entertaining SOV outing about a camping trip that's interrupted by a radioactive meteor shower that unleashes hordes of zombies. Along with the outrageous gags, there's a nice line in irony: one young girl tells her friends that zombies are about to get them, only to be told that she can't say the word "zombie" in a zombie movie. The funniest moment occurs when a local sheriff stops and questions the four young heroes. He says there'll be a meteor shower and that it should be harmless... unless, of course, one of the meteors hits the cemetery. But that certainly won't happen... Not in a zombie movie (DAO).
See page 166

ZOMBIE CHRONICLES

2001, USA
Dir: Brad Sykes. *Prod:* David S. Sterling.
Scr: Garrett Clancy
Cast: Garrett Clancy, Emmy Smith, Beverly Lynn, Joseph Haggerty

Billed as being "In the tradition of *Tales from the Crypt* and *Dawn of the Dead*" director Brad Sykes's portmanteau *Zombie Chronicles* is really just another example of SOV filmmakers with too much time - and not enough talent - on their hands. Two ghoulish tales are linked by the wrap-around story of a reporter investigating a series of bizarre rural legends. In the first tale, a Vietnam-era army sergeant is menaced by a recruit he killed in drill practice; in the second, a group of campers are plagued by some Wild West ghouls. Then the reporter discovers that she's also about to become zombie chow... "Being Dead Rots," apparently. But it can't be as bad as watching this.
See page 166

ZOMBIE COP

1991, USA
Dir: J.R. Bookwalter. *Prod:* Scott P. Plummer, J.R. Bookwalter. *Scr:* Matthew Jason Walsh
Cast: Michael Kemper, Ken Jarosz, James R. Black Jr., Bill Morrison, James Black

A policeman is killed on duty by a voodoo priest and manages to shoot the priest just before he carks it. Both cop and priest come back from the dead to continue chasing each other through the streets for another fifty-five minutes before the credits (thankfully) roll. Bookwalter's follow-up to *The Dead Next Door* merely proves what most zombie fans already guessed: his limitless enthusiasm can't disguise his technical incompetence.
See page 166

ZOMBIE CREEPING FLESH

1980, Italy/Spain
Original titles: **Virus**, **Apocalipsis caníbal**
Alternative titles: **De Apocalyps der Levende Doden**, **L'apocalypse des morts vivants**, **Cannibal Apocalypsy**, **Hell of the Living Dead**, **Hell of the Living Death**, **L'inferno dei morti-viventi**, **Night of the Zombies**,
Dir: Vincent Dawn [Bruno Mattei]. *Prod:* Sergio Cortona. *Scr:* Claudio Fragasso, José María Cunilles
Cast: Margit Evelyn Newton, Frank Garfield [Franco Garofalo], Selan Karay [Selahattin Karadag], Robert O'Neil [José Gras], José Luis Fonoll

The First World's plan to make the Third World eat itself doesn't quite succeed in this spaghetti gorefest. Instead of reducing the world's population, Operation Sweet Death produces cannibal zombies willing to eat anything that moves (particularly evil whitey) after an accident at one of its key facilities. Meanwhile, a SWAT team caught up in the New Guinea-set action is joined by a pair of roving reporters who're trying to get to safety. Shamelessly recycling

Zombie Creeping Flesh

archive jungle footage nicked from wildlife documentaries and the instantly recogni-sable *Dawn of the Dead* soundtrack, this is the Italian cycle at its most atrocious. It's a terrible, terrible movie. But that's all part of its... well, charmless charm.
See pages 131-132, 143, 167, 204-205, note 99

ZOMBIE CULT MASSACRE

1997, USA
Dir: Jeff Dunn. *Prod:* Steve Losey, Jeff Dunn. *Scr:* Jeff Dunn
Cast: Bob Elkins, Lonzo Jones, Mike Botouchis, Lani Ford, Randy Rupp

Redneck movie critic Joe Bob Briggs once described this little movie as "George Romero Meets the Branch Davidians in Sturgis, South Dakota". It's as accurate a description as any. Zombies are caught between crazed bikers and Waco style Jesus freaks in this ambitious amateur outing set in a backwater Midwest town. It's a promising set-up and one that Dunn does his best to make the most of throwing everything he can think of at the screen: big-breasted women having their latex cleavages chomped, characters getting mashed on hallucinogenic drugs, bikers zooming around on their crotch rockets and religious zealots muttering about the coming kingdom of Christ. All in all it's an above average redneck trashfest. Pass the moonshine.
See note 120

ZOMBIE FLESH-EATERS

1979, Italy
Original title: **Zombi 2**
Alternative titles: **L'enfer des zombies, The Island of the Living Dead, Sanguelia, Woodoo: Die Schreckensinsel der Zombies, Zombie, Zombie 2**
Dir: Lucio Fulci. *Prod:* Ugo Tucci, Fabrizio De Angelis. *Scr:* Elisa Briganti
Cast: Tisa Farrow, Ian McCulloch, Richard Johnson, Al Cliver [Pier Luigi Conti], Auretta Gay [Gregone]

On the Caribbean island of Matul, white doctor David Menard is trying to stem the tide of cannibal zombies that are returning from the dead. Arriving on the island are Anne and reporter Peter West who're looking for Anne's missing father. Encountering another couple of westerners, the pair soon find themselves under attack from the zombies. They eventually escape in a sailboat - only to discover that the zombie plague has spread across the globe. A genre classic - and cinema's first shark vs. zombie fight...
See pages 127-134, 140, 142-143, 171, 176

Never turn your back on a hungry corpse: a classic shock sequence in Lucio Fulci's **Zombi 2** *(aka* **Zombie Flesh-Eaters***).*

ZOMBIE GENOCIDE

1993, Ireland
Dir: Andrew Harrison. *Prod:* Andrew Harrison. *Scr:* Darryl Sloan
Cast: Andrew Harrison, Khris Carville, Darryl Sloan, Phil Topping

Having the distinction of being Ireland's first homemade zombie movie, Andrew Harrison's backyard epic is an inoffensive but unremarkable trawl through the usual shot-on-video archetypes. This none-too-adventurous effort starts off with Irish kids returning from a camping trip in Portadown to find that zombies have overrun the country. Having missed the evacuation, our heroes are stuck in the suburbs as the army prepares to detonate a nuclear bomb. Anyone hoping for a witty zombie movie take on The Troubles will be sorely disappointed, since what you see is pretty much what you get. Shot over two years with no editing facilities other than the rewind and pause buttons on the filmmakers' video camera, it's a testament to the sheer enthusiasm that zombie cinema seems capable of generating among horror fans (though given the lack of female cast/crew members, it's perhaps also indicative of the extremes that sex-starved geekdom can lead to).
See page 166

ZOMBIE HIGH

1987, USA
Alternative title: **The School That Ate My Brain**
Dir: Ron Link. *Prod:* Aziz Ghazal, Marc Toberoff. *Scr:* Tim Doyle, Aziz Ghazal, Elizabeth Passarelli
Cast: Virginia Madsen, Richard Cox, Kay Kuter, James Wilder, Sherilyn Fenn

School's so boring that the kids are being turned into zombies! Nope, that's sadly not the plot of this po-faced teen horror movie about a school where the vampire teachers turn students into zombie-like automatons so that they can feed off them. The zombies get straight A's in every class, dress in identical suits and ties and always turn up for their lessons on time - which is enough to make new student Andrea smell a rat and start investigating. Disposable filler, but you've gotta love that alternative title.
See page 151

book of the dead

ZOMBIE HOLOCAUST

Not for the faint-hearted...

above: Artwork from the original British video release of **Zombie Holocaust**. *opposite bottom right:* A knife-wielding zombie from **Zombie Holocaust**.

ZOMBIE HONEYMOON

2004, USA
Dir: David Gebroe. *Prod:* David Gebroe, Christina Reilly. *Scr:* David Gebroe
Cast: Tracy Coogan, Graham Sibley, Tonya Cornelisse, David M. Wallace, Neal Jones

A young couple's honeymoon is crudely interrupted when a zombie wanders out of the sea and vomits up some black stuff on the bridegroom, Danny. Before he can say "I don't" Danny's been turned into a walking corpse with a taste for human flesh that very rapidly becomes uncontrollable. Will his new wife Denise accept his sudden transformation into a ghoul? Or will his desire to eat everyone he meets lead to an instant divorce? This leftfield tale goes all out for emotion even while piling on the blood 'n' guts. The basic premise harks back to the scene in the *The Return of the Living Dead* films where Thom Mathews's character tried to convince his girlfriend that if she really loved him, she'd let him eat her brains. Except here the joke is played straight, as Denise tries to decide whether or not "Till death do us part" requires her to stand by her zombie.

ZOMBIE HOLOCAUST

1980, Italy
Original title: **Zombi Holocaust**
Alternative titles: **Doctor Butcher M.D., La terreur des zombies, Zombi holocausto, Zombies unter Kannibalen**
Dir: Frank Martin [Marino Girolami]. *Prod:* Gianfranco Couyoumdjian, Fabrizio De Angelis. *Scr:* Romano Scandariato
Cast: Ian McCulloch, Alexandra Cole [Alexandra Delli Colli], Sherry Buchanan, Peter O'Neal, Donald O'Brien, Dakar

Strange goings on at a New York hospital involving missing body parts prompt police detective Peter Chandler to investigate. Tracking the mystery out to Southeast Asia, Chandler discovers a shocking secret about a mad scientist who's experimenting with brain surgery in the hope of increasing longevity. The experiments aren't going too well, though, which is why the island is awash with mindless zombie corpses who're almost as troubling as the indigenous cannibal savages.
See pages 132-134, 136, 143, 167, 198-200

ZOMBIE ISLAND MASSACRE

1984, USA
Dir: John N. Carter. *Prod:* David Broadnax. *Scr:* William Stoddard, Logan O'Neill
Cast: David Broadnax, Rita Jenrette, Tom Cantrell, Diane Clayre Holub, Ian McMillan

This cheap little effort is dishonest at best as it lures eager audiences into thinking that the reason why unlikeable American tourists are getting stalked 'n' slashed in the Caribbean is because they're being pursued by a zombie. Actually, all they've really falling foul of are some nasty Colombian drug dealers. There's only one zombie in the film, who makes the briefest of appearances in a voodoo ceremony. Pure drivel.
See page 151

ZOMBIE LAKE

1980, Spain/France
Original titles: **El lago de los muertos vivientes, Le lac des morts vivants**
Alternative title: **Zombies Lake**
Dir: J.A. Laser [Julián de Laserna & Jean Rollin]. *Prod:* Daniel Lesoeur. *Scr:* A.L. Mariaux [Marius Lesoeur]
Cast: Howard Vernon, Pierre Escourrou, Robert Foster [Antonio Mayans]

More Nazi zombies in this Eurociné trashfest as a bunch of German soldiers - executed by the resistance and dumped in a lake - come back to life to prey on nude female bathers and the odd Frenchman. Rollin directs this as though it's one of his sensuous vampire tales, trailing off into misty-eyed nonsense as a German zombie officer pays a visit to his daughter in the town. Thankfully the director rallies himself for the finale in which the ghouls are napalmed to a crisp.
See pages 61, 79-80, 85, 112, note 100

Zombie Nightmare

ZOMBIE NIGHTMARE

1987, Canada
Dir: Jack Bravman. *Prod:* Pierre Grisé. *Scr:* David Wellington
Cast: Jon Mikl Thor, Adam West, Tia Carrere, Manuska Rigaud, Shawn Levy

A carload of teenagers run down and kill a high school baseball player, show no remorse to his mother and eventually end up suffering at his zombified hands when a voodoo priestess brings him back from the grave. Jon Mikl Thor, one time front man for the imaginatively monikered heavy metal band Thor, is the stiff who takes revenge while a police captain played by Adam *Batman* West tries to work out what the hell is going on. The scene in which the loudly moaning ghoul chases a scantily-clad blonde through a deserted gymnasium then batters her to death with a baseball bat says it all really - despite the fact that he's so beaten up that his feet don't even point the right way, she's still too dumb to be able to outrun him. Some people are just asking to be killed by zombies.
See page 153

Zombie Lake

zombie filmography

YOUR WORST DREAMS ARE ABOUT TO COME TRUE!

ZOMBIE NIGHTMARE

Featuring the Music of MOTORHEAD GIRLSCHOOL and THOR!

ZOMBIE NINJA GANGBANGERS

1998, USA
Alternative titles: **Bangers**, **Zombie Ninja Bangers**
Dir: Jeff Centauri. *Prod:* Ross Marshall.
Scr: Daryl Carstensen
Cast: Kitten Natividad, Stephanie Beaton, Jeff Centauri, Michael Haboush, Ross Marshall

The first and (one hopes) last zombie rape movie, this disturbingly misogynist film tries to masquerade as cheesy nonsense. The basic premise is that stripper Stephanie Beaton is attacked by randy gangbanging zombies and enlists the help of a friendly bar owner (former Miss Nude Universe Kitten Natividad) and a mad scientist to create a zombie ninja to protect herself. What's so troubling about this film is the gleeful delight that the filmmakers take in its excesses. Bare breasts, gyrating strippers and pole dancers obviously appeal to the usual exploitation market, but the interminable zombie rape scenes in which Beaton is shamelessly abused are completely indefensible. Trash of the highest order, this even manages the unlikely task of making far more explicit Italian sex-zombie movies like *Erotic Orgasm* seem positively innocent. Director Jeff Centauri plays one of the gangbanging zombies himself - which may well explain the main motivation behind this repulsive picture.
See page 135

ZOMBIE RAMPAGE

1991, USA
Dir: Todd Sheets. *Prod:* Louis Garrett.
Scr: Todd Sheets, Erin Kehr
Cast: Dave Byerly, Erin Kehr, Stanna Bippus, Beth Belanti, Ed Dill

Sheets has dubbed many of his movies "unwatchable pieces of trashola". That's certainly a fitting tagline for an interminably atrocious movie. The plot is pointless: a Kansas City gang leader raises the dead from their graves with the help of some voodoo magic and, erm, that's it. Zombies go on the rampage (natch) producing lots of amateur gore shots and very little else. Thoroughly depressing, and a total waste of everyone's time and effort.
See page 166

ZOMBIE TOXIN

1998, UK
Alternative title: **Homebrew**
Dir: Tom J. Moose. *Prod:* Tom J. Moose.
Scr: Tom J. Moose, Adrian Ottiwell, Robert Taylor
Cast: Robert Taylor, Adrian Ottiwell, Tom J. Moose, Lee Simpson

"*Monty Python* meets *Dawn of the Dead*," is the woefully inaccurate promise adorning the sleeve art of this British outing. Talk about being cheated. It's actually nothing more than a stream of scatological gags with zombies thrown in for good measure as some neo-Nazis bottle up the zombie toxin of the title in the hope of turning the local populace into an army of goose-stepping fascists.
See page 166

ZOMBIE VS. NINJA

1987, Hong Kong
Alternative title: **Zombie Revival: Ninja Master**
Dir: Charles Lee [Godfrey Ho Jeung Keung]. *Prod:* Joseph Lai, Betty Chan.
Scr: Benny Ho
Cast: Pierre Kirby, Edowan Bersmea, Dewey Bosworth, Thomas Hartham, Patrick Frzebar

What better way to learn martial arts than to practice against a never-ending stream of zombies? The Mexican wrestling movie meets Eastern kung fu in this laborious tale of an undertaker's assistant who wants to avenge the death of his father at the hands of a gang of thieves. Be warned, whatever the title might imply, there are no scenes of zombies going at it with ninjas. Pah.
See page 172

ZOMBIE: THE RESURRECTION

1997, Germany
Alternative title: **The Resurrection**
Dir: Holger Breiner, Torsten Lakomy. *Scr:* Holger Breiner
Cast: Oliver Van Balen, Tania Reitter, Franz Horn, Sandra Wendt

Those wacky folks in the military have gone and done it again - unleashing a zombie apocalypse with their careless use of biochemical weapons and leaving the civilian population locked in a desperate struggle for survival as the dead rise to walk among the living. This is basically the German equivalent of a Todd Sheets backyard epic. Blood and gore flow in abundance; it's just not very convincing as the make-up looks impressive on some zombies and pathetic on others. Fortunately, this one only lasts fifty-five minutes - though each of those minutes feels like several hours (DAO).
See page 166

ZOMBIEGEDDON

2003, USA
Dir: Chris Watson. *Prod:* Chris Watson, Andrew J. Rausch. *Scr:* Chris Watson
Cast: Brinke Stevens, Tom Savini, William Smith, Edwin Neal, Robert Z'Dar

This self-referential SOV zombie horror features appearances from Tom Savini as Jesus Christ, Troma head honcho Lloyd Kaufman as a homophobic janitor, and a cameo from "Camcorder Coppola" J.R. Bookwalter. Suffice to say that seriousness isn't high on the agenda. A mish-mash of the bad, the terrible and the very, very silly it's designed solely for hardcore fans who'll spot the various references - there's also a controversial sex scene featuring Jesus, which had various Stateside religious groups penning angry letters.

ZOMBIES OF MORA TAU

1957, USA
Alternative title: **The Dead That Walk**
Dir: Edward Cahn. *Prod:* Sam Katzman.
Scr: Raymond T. Marcus [Bernard Gordon]
Cast: Gregg Palmer, Allison Hayes, Autumn Russell, Joel Ashley, Morris Ankrum

Icelandic promo art for **Zombies of Mora Tau**.

An expedition of treasure-hunters head out to West Africa in search of a nineteenth-century ship called the Susan B, which sank off the coast. The ship is rumoured to contain diamonds stolen from the local native tribes. Unfortunately, the zombified remains of the original crew guard the wreck and rise from the depths to attack the American adventurers until the gems are thrown back into the sea.
See pages 47-50, 53, 65, 101, 151, 178, note 98

ZOMBIES OF THE STRATOSPHERE

1952, USA
Alternative title: **Satan's Satellites**
Dir: Fred C. Brannon. *Prod:* Franklin Adreon. *Scr:* Ronald Davidson
Cast: Judd Holdren, Aline Towne, Wilson Wood, Lane Bradford, Stanley Waxman, John Crawford

Don't be fooled by the title: there aren't any zombies in this old Republic serial, which was stitched together into a feature-length movie and redubbed *Satan's Satellites* in 1958. Dastardly Martians are planning to knock the Earth out of its orbit so the red planet can take its place closer to the sun. Can our intrepid heroes - aided by Leonard Nimoy's turncoat alien - defuse the situation in time? You betcha.
See page 48

ZOMBIES ON BROADWAY

1945, USA
Alternative title: **Loonies on Broadway**
Dir: Gordon Douglas. *Prod:* Ben Stoloff. *Scr:* Lawrence Kimble
Cast: Wally Brown, Alan Carney, Bela Lugosi, Anne Jeffreys, Sheldon Leonard

PR agents Wally Brown and Alan Carney are instructed by their gangster boss to find a real walking corpse for his nightclub The Zombie Hut. Taking a trip out to San Sebastian, they encounter Bela Lugosi's mad scientist who has created a zombie serum. Needless to say our heroes get to cause all kinds of mayhem with it. About as funny as cholera.
See pages 46, 48

ZOMBIETHON

1986, USA
Dir/Prod/Scr: Ken Dixon
Cast: K. [Karrene] Janyl Caudle, Tracy Burton, Paula Singleton, Janelle Lewis

When they're not eating people, what kind of movies do the living dead like to watch? Zombie flicks of course! In this lame compilation reel of snippets from other movies, director Ken Dixon shoves a group of ghouls in a cinema and lets them watch scenes from *Zombie Lake*, *The Astro-Zombies* and *Oasis of the Zombies*. You almost feel sorry for the poor creatures.
See page 154

ZOMBIO

1999, Brazil
Dir: Petter Baiestorf. *Prod:* Cesar Souza. *Scr:* Petter Baiestorf
Cast: Cesar Souza, Denise V., Coffin Souza, Rose De Andrade, Claudia De Sord

A witch raises a pack of zombies and sends them after some hapless nincompoops in this Brazilian shot-on-video zombie entry. Despite the South American flava this is barely distinguishable from a hundred and one North American efforts. Some of the make-up and costumes look almost convincing - yet that's undoubtedly damning with faint praise (DAO).
See page 166

Recommended Further Reading

Abbott, Elizabeth. *Haiti: The Duvaliers and Their Legacy*. London: Robert Hale, 1988.

Alicoate, Jack. *The 1933 Film Daily Year Book of Motion Pictures*. New York: Wid's Films and Film Folk, 1933.

Artaud, Antonin. *The Theatre and Its Double*. Trans. Victor Corti. 1964. London: Calder, 1993.

Bacal, Simon. "*Night of the Living Dead*: An Interview with John Vulich and Everett Burrell." *Starburst* 19 Monster Special (April, 1994): 64-66.

Badley, Linda. *Film, Horror and the Body Fantastic*. Westport CT and London: Greenwood Press, 1995.

Balbo, Lucas and Peter Blumenstock, eds. *Obsession: The Films of Jess Franco*. Berlin: Selbstverlag Frank Trebbin, 1993.

Bald, Wambly. *On the Left Bank: 1929-1933*. Edited by Benjamin Franklin. Athens, Ohio: Ohio University Press, 1987.

Balun, Chas. "Re-Animator." *Fangoria* 234 (July, 2004): 31.

Bansak, Edmund G. *Fearing the Dark: The Val Lewton Career*. Jefferson, NC and London: McFarland and Co., 1995.

Barnes and Noble. "Interview: George A. Romero." (8 August, 2000). Published online at <http://video.barnesandnoble.com/search/interview.asp?ctr=643332>.

Beale, Lewis. "The Zombies Brought Him: George Romero Is Back." *New York Times* (3 November 2004).

Bell, Nelson B. "Thoughts on the Horror Era." *The Washington Post* (21 February, 1932).

Berger, Howard. "The Prince of Italian Terror." *Fangoria* 154 (July, 1996): 62-67, 82.

Blaney, Martin. "International Production Case Study: *Resident Evil* Ground Zero." *Screen International* (5 October, 2001): 18.

Blumenstock, Peter. "Jean Rollin Has Risen from the Grave!" *Video Watchdog* 31 (1995): 36-57.

Blumenstock, Peter. "Michele Soavi: Gravely Speaking." *Fangoria* 149 (January, 1996): 52-55, 77.

Bogle, Donald. *Toms, Coons, Mulattoes, Mammies and Bucks: An Interpretative History of Blacks in American Film*. New York and London; Continuum, 1989.

Botting, Jo. "Catalonian Creeps: An Interview with Jorge Grau." *Shivers* 79 (July, 2000): 22-27.

Brooks, Max. *The Zombie Survival Guide: Complete Protection from the Living Dead*. New York: Three Rivers Press, 2003.

Bryan, Peter. "Zombie! Original Synopsis." Reprinted in *Dark Terrors* 16 (December, 1998): 36-37.

Bryce, Allan, ed. *Zombie*. Liskeard, Cornwall: Stray Cat Publishing, 2000.

Burrell, Nigel J. *Knights of Terror: The Blind Dead Films of Amando de Ossorio*. Upton, Cambridgeshire: Midnight Media Publishing, 1995.

Case, Sue Ellen. "Tracking the Vampire." In Gelder, ed. *The Horror Reader*. London and New York: Routledge, 2000, pp.198-209.

Clarens, Carlos. *An Illustrated History of the Horror Film*. London: Secker and Warburg, 1968.

Crawford, Travis. "*Wild Zero*: Brain-Dead and Loving It." *Fangoria* 203 (June, 2001): 44-47.

Crawford, Travis. "Director *Versus* Everybody." *Fangoria* 213 (June, 2002): 50-54.

Davis, Harold Palmer. *Black Democracy: The Story of Haiti*. London: George Allen and Unwin, 1929.

Davis, Wade. *Passage of Darkness: The Ethnobiology of the Haitian Zombie*. London and Chapel Hill: University of North Carolina Press, 1988.

Davis, Wade. *The Serpent and the Rainbow*. London: Collins, 1986.

Dendle, Peter. *The Zombie Movie Encyclopedia*. Jefferson, NC and London: McFarland and Co., 2001.

Dunbar, William. "Lament for the Makers." In John Burrow, ed. *English Verse 1300-1500*. London and New York: Longman, 1977, pp.364-369.

Ebert, Roger. "Just Another Horror Movie - Or Is It?" *Reader's Digest* (June, 1969): 128.

Ebert, Roger. "Review of *Dawn of the Dead*." *Chicago Sun-Times* (20 April, 1979).

Edwards, Phil and Alan Jones. "The Evil Dead Speak: An Interview with Sam Raimi and Robert Tapert." *Starburst* 57 (May, 1983): 24-29.

England, Norman. "Who Made This *Junk*?" *Fangoria* 222 (May, 2003): 40-45.

Entertainment Film Distribution. "UK Publicity Press Notes for *Dawn of the Dead*." (2004).

Fawcett, Neil. "Dusk of the Dead." Published online at <http://www.homepageofthedead.com>.

Ferrante, Anthony C. "Return of the Living Dead Director." *Fangoria* 171 (April, 1998): 20-22.

Foundas, Scott. "Dead Man Talking: The Resurrection of Zombie Godfather George A. Romero." *The Village Voice* (28 June, 2005): 12.

Frasher, Michael. "*Night of the Living Dead*: Remaking George Romero's Horror Classic." *Cinefantastique* 21/3 (December, 1990): 16-17, 19, 20, 22.

Freud, Sigmund. "The 'Uncanny'" (1919). In *On Creativity and the Unconscious* (New York: Harper and Row, 1958), pp.140-155.

Freud, Sigmund. *The Standard Edition of the Complete Psychological Works of Sigmund Freud*. Trans. James Strachey. London: Hogarth Press, 1986.

Freud, Sigmund. *Totem and Taboo: Some Points of Agreement Between the Mental Lives of Savages and Neurotics*. Trans. James Strachey. New York: Norton, 1950.

Fujiwara, Chris. *Jacques Tourneur: The Cinema of Nightfall*. Jefferson, NC and London: McFarland and Co., 1998.

Gagne, Paul. *The Zombies That Ate Pittsburgh: The Films of George A. Romero*. New York: Dodd, Mead and Co., 1987.

Gelder, Ken, ed. *The Horror Reader*. London and New York: Routledge, 2000.

Gelder, Ken. "Introduction to Part Three." In Gelder, ed. pp.81-83.

Gingold, Mike. "This LAND is Gore Land." Published online at <http://www.fangoria.com/fearful_feature.php?id=2675>.

Grant, Barry Keith, ed. *The Dread of Difference: Gender and the Horror Film*. Austin: University of Texas Press, 1996.

Grant, Barry Keith. "Taking Back the *Night of the Living Dead*: George Romero, Feminism, and the Horror Film." In Grant, ed. pp. 200-212.

Grayson, Steve. "On-Set Report: *Resident Evil*." *Empire* 145 (July, 2001): 50.

Gudino, Rod. "The Dead Walk… Again!: A George A. Romero Retrospective." *Rue Morgue* (July/August, 2003): 14-21.

Haining, Peter, ed. *Zombie! Stories of the Walking Dead*. London: W.H. Allen, 1985.

Halberstam, Judith. *Skin Shows: Gothic Horror and the Technology of Monsters*. Durham, NC: Duke University Press, 1995.

Hanners, John and Harry Kloman. "'The McDonaldization of America': An Interview with George A. Romero." *Film Criticism* 7/1 (Fall, 1982): 69-81.

Hearn Lafcadio. "The Country of the Comers-Back." Reprinted in Peter Haining, ed. pp.54-70.

Heinl, Robert and Nancy Gordon Heinl. *Written in Blood: The Story of the Haitian People 1492-1995*. Lanham, New York and London: University Press of America, 1996.

Hodges, Mike. "Amando de Ossorio: Farewell to Spain's Knight of Horror." *Shivers* 88 (April, 2001): 18-21.

Hutchings, Peter. *Terence Fisher*. Manchester and New York: Manchester University Press, 2001.

Jancovich, Mark. *Rational Fears: American Horror in the 1950s*. Manchester and New York: Manchester University Press, 1996.

Jones, Alan. "Dellamorte Dellamore." *Cinefantastique* 25/5 (October, 1994): 52-55.

Jones, Alan. "George of the Dead." *Shivers* 121 (June, 2005): 11-14.

Jones, Alan. "George Romero Interview." *Starburst* 4/12 (August 1982): 34-38.

Jones, Alan. "*Morti Viventi*: Zombies Italian-Style." In Bryce ed., pp.12-27.

Jones, Alan. *Profondo Argento: The Man, the Myths and the Magic*. Guildford, Surrey: FAB Press, 2004.

Jones, Alan. "*Resident Evil.*" *Cinefantastique* 34/2 (April, 2002): 10-13.
King, Richard. "J.R. Bookwalter: A Career in B-Movies and Beyond." *Dark Star* 14/15. Reprinted online at <http://www.darkstarorg.demon.co.uk/intv2.htm >.
King, Stephen. "The Horrors of '79." *Rolling Stone* (27 December 1979-10 January 1980): 17, 19, 20.
Kirkman, Robert. *The Walking Dead: Days Gone By*. Orange, California: Image Comics, 2004.
Kristeva, Julia. *Powers of Horror: An Essay on Abjection*. Trans. Leon S. Roudiez. New York: Columbia University Press, 1982.
L.N., "Review of *White Zombie.*" *New York Times* (29 July, 1932): 18, 2.
Levy, Frederic. "The Rue Morgue: Looking for French Zombies with Jean Rollin." *Starburst* 4/12 (August, 1982): 26.
Lewis, Joseph. "A Bloody Laugh." *The Point* (26 February, 1970): 14.
Lucas, Tim. "Versions and Vampires: Jean Rollin on Home Video." *Video Watchdog* 31 (1995): 28-35.
Mantle, Burns, ed. *The Best Plays of 1931-1932 and the Year Book of Drama in America*. New York: Dodd, Mead and Co., 1932.
Marks, John. *The Search for the "Manchurian Candidate": The CIA and Mind Control, The Secret History of the Behavioural Sciences*. New York and London: W.W. Norton, 1979.
Maslin, Janet. "Review of *Night of the Living Dead.*" *New York Times* (20 April 1979): 5.
McBride, Joseph. "Val Lewton, Director's Producer." *Action* 11 (January-February, 1976): 10-16.
McCarty, John. *Splatter Movies: Breaking the Last Taboo of the Screen*. New York: St. Martin's Press, 1984.
McDonagh, Maitland. "Sometimes They Come Back… Again: The Making of the *Return of the Living Dead* Trilogy." In Bryce, ed. pp.57-63.
McDonagh, Maitland. "The Living Dead at the Miskatonic Morgue: *Re-Animator* and *Bride of Re-Animator.*" In Bryce, ed. pp.49-55.
McLarty, Lianne. "'Beyond the Veil of the Flesh': Cronenberg and the Disembodiment of Horror." In Grant, ed. pp.231-252.
Monthly Film Bulletin. "Review of *King of the Zombies.*" *Monthly Film Bulletin* 8/93 (September, 1941): 116-117.
Morrison, Alan. "Rage Against the Machine." *Empire* 161 (November, 2002): 98-105.
Motion Picture Herald. "Review of *I Walked with a Zombie.*" *Motion Picture Herald*. 150/12 (20 March, 1943): 1214.
Newman, Kim. "Review of *Bad Taste.*" *Monthly Film Bulletin* 56/668 (September, 1989): 267-268.
Newman, Kim. *Nightmare Movies: A Critical History of the Horror Movie From 1968-1988*. London: Bloomsbury, 1988.
Nietzsche, Friedrich. *Beyond Good and Evil: Prelude to a Philosophy of the Future*. Trans. R.J. Hollingdale 1886. London: Penguin, 1990.
Nugent, Frank S. "Review of *Revolt of the Zombies.*" *New York Times* (5 June, 1936).
Palmerini, Luca M. and Gaetano Mistretta. *Spaghetti Nightmares: Italian Fantasy-Horrors as Seen Through the Eyes of Their Protagonists*. Key West, Florida: Fantasma Books, 1996.
Plummer, Brenda Gale. *Haiti and the United States: The Psychological Moment*. Athens and London, University of Georgia Press, 1992.
Poole, Steven. *Trigger Happy: The Inner Life of Videogames*. London: Fourth Estate, 2000.
Ray, Man. *Self Portrait*. Boston: Little, Brown and Company, 1963.
Rhodes, Gary D. *White Zombie: Anatomy of a Horror Movie* Jefferson, NC and London: McFarland and Co, 2001.
Rodley, Chris, ed. *Cronenberg on Cronenberg*, London: Faber and Faber, 1992.
Rowe, Michael. "Gunn to the Head." *Fangoria* 231 (April, 2003): 27-28, 30-31.
Rowe, Michael. "Land of the Dead: Home of the Grave." *Fangoria* 244 (June, 2005): 50-55, 97.
Rowe, Michael. "New 'Dawn' Rising." *Fangoria* 227 (October, 2003): 45.
Salisbury, Mark. "Dead Residents: On the Set of *Resident Evil.*" *Total Film* 55 (August, 2001): 8.
Salisbury, Mark. "To Make the Blood Boyle." *Fangoria* 224 (July, 2003): 20-23, 82.
Sartre, Jean Paul. *No Exit: A Play in One Act* trans. by Paul Bowles. New York: Samuel French, 1958.
Schaefer, Eric. *"Bold! Daring! Shocking! True!: A History of Exploitation Films, 1919-1959*. Durham and London: Duke University Press, 1999.
Schlockoff, Robert. "Lucio Fulci." *Starburst* 4/12 (August, 1982): 51-55.
Screen Edge. "Scooter McCrae: The Shatter Boy." Published online at <http://www.screenedge .com/archive/99/mccrae.htm >.
Seabrook, William. *The Magic Island*. London: George Harrap and Co., 1929.
Senn, Bryan. *Drums of Terror: Voodoo in the Cinema*. Baltimore, MD: Midnight Marquee Press, 1998.
Senn, Bryan. *Golden Horrors: An Illustrated Critical Filmography of Terror Cinema 1931-1939*. Jefferson, NC and London: McFarland and Co., 1996.
SFX Magazine. "Soundbite: Danny Boyle Interview." *SFX* 104 (May, 2003): 85.
Sheets, Todd. "The Extreme Entertainment Mission Statement." Published online at <http://www.zombiebloodbath.com/mission.html>.
Siegel, Joel E. *Val Lewton: The Reality of Terror*. London: Secker and Warburg, 1972.
Simpson, M.J. "*Dead Creatures*: Parkinson's Disease," *Fangoria* 206 (September, 2001): 64-67.
Skal, David J. *The Monster Show: A Cultural History of Horror*. London: Plexus, 1994.
Southey, Robert. *History of Brazil*. London: Longman, 1810-1819.
St.John, Spencer. *Hayti, or The Black Republic*. London: Elder Smith, 1884.
Thrower, Stephen. *Beyond Terror: The Films of Lucio Fulci*. Guildford, Surrey: FAB Press, 1999.
Todorov, Tzvetan. *The Fantastic: A Structural Approach to a Literary Genre*. Trans. Richard Howard. Ithaca, NY: Cornell University Press, 1975.
Tohill, Cathal and Pete Tombs. *Immoral Tales: European Sex and Horror Movies 1956-1985*. 1994. Reprinted New York: St.Martin's Griffin, 1994.
Totaro, Donato. "The Italian Zombie Movie: From Derivation to Reinvention." In Schneider, Steven, ed. *Fear Without Frontiers*. Guildford, Surrey: FAB Press, 2003.
Twitchell, James B. *Dreadful Pleasures: An Anatomy of Modern Horror*. Oxford and New York: Oxford University Press, 1985.
Van de Water, F. "Review of *The Magic Island*," *New York Evening Post* (12 January, 1929).
Variety. "Review of *Dawn of the Dead.*" *Variety* (18 April, 1979): 4
Variety. "Review of *Night of the Living Dead.*" *Variety* (16 October, 1968): 5.
Variety. "Review of *Night of the Living Dead.*" *Variety* (2 August, 1932): 6.
Wallace, Inez. "I Walked with a Zombie." Reprinted in Haining, ed. pp.95-102.
Waller, Gregory. *The Living and the Undead: From Stoker's Dracula to Romero's Dawn of the Dead*. Urbana and Chicago: University of Illinois Press, 1986.
Watt, Mike. "*Night of the Living Dead* '90." *Cinefantastique* 34 3/4 (June, 2002): 116-119.
Weaver, Tom. *It Came From Weaver Five: Interviews with 20 Zany, Glib and Earnest Moviemakers in the SF and Horror Traditions of the Thirties, Forties, Fifties and Sixties*. Jefferson, NC and London: McFarland and Co., 1996.
Weaver, Tom. *Poverty Row Horrors!: Monogram, PRC and Republic Horror Films of the Forties*. Jefferson, NC and London: McFarland and Co, 1993.
Weinstein, Harvey M. *Psychiatry and the CIA: Victims of Mind Control*. London and Washington: American Psychiatric Press, 1990.
Whyte, William. *The Organization Man*. New York: Simon Schuster, 1956.
Wood, Robin and Richard Lippe, eds. *American Nightmare: Essays on the Horror Film*. Toronto: Festival of Festivals, 1979.
Wood, Robin. "Apocalypse Now: Notes on the Living Dead." In Wood and Lippe, eds. pp.91-97.
Wood, Robin. "An Introduction to the American Horror Film." In Wood and Lippe, eds. pp. 7-28.
Wood, Robin. "The Shadow Worlds of Jacques Tourneur." *Film Comment* 8/2 (1972): 64-70.
Worthington, Marjorie. *The Strange World of Willie Seabrook*. New York: Harcourt, Brace & World, 1966.
Yakis, Dan. "Mourning Becomes Romero." *Film Comment* 15 (May-June 1979): 60-65.

index

Page references in **bold** refer exclusively to illustrations, though pages referenced as text entries may also feature relevant illustrations.

1933 Film Daily Year Book of Motion Pictures, The (book) 22, 226
2000 A.D. (comic book) 186
27th Day, The 48
28 Days Later 7, 178-181, 186, 191, 233, 292
28 Weeks Later 192
7 Brothers Meet Dracula, The see *Legend of the 7 Golden Vampires, The*
Abbott, Bud 46, 48
Abbott, Elizabeth 16, 226
Abgrund der lebenden Toten, Der see *Oasis of the Zombies*
abîme des morts vivants, L' see *Oasis of the Zombies*
Acción Mutante 181
Ackerman, Forrest J. 233
Action (magazine) 227
Adams, Brooke 79, 288
Adventures in Arabia: Among the Bedouins, Druses, Whirling Dervishes & Yezidee Devil Worshippers (book) 9
After Death (Oltre la morte) see *Zombie 4: After Death*
Aftermath, The 233
Agar, John 54
Agrama, Frank 131
Aijon, Miguel Ángel 181
Alazraki, Benito 60
Albertson, Jack 152, **153**
aldilà, L' see *Beyond, The*
Alexander, Terry 144, 147
Alice in Wonderland (novel) 177
Alicoate, Jack 226
Alien Dead, The 151, 233-234
Alien Massacre see *Gallery of Horror*
Alien Resurrection 178
Aliens 298
Allen, Woody 225
Almost Human see *Shock Waves*
Alone in the Dark (videogame) 231
American Nightmare: Essays on the Horror Film (book) 228, 229
American Weekly (magazine) 42, 227
Amplas, John 144
Anderson, David LeRoy 185
Anderson, Paul W.S. 176-178, 183, 191, 232, 282
Andromeda Strain, The 153
Angel Heart 151
Apocalipsis canibal see *Zombie Creeping Flesh*
Apocalyps der Levende Doden, De see *Zombie Creeping Flesh*
apocalypse des morts vivants, L' see *Zombie Creeping Flesh*
Apocalypse domani see *Cannibal Apocalypse*
Archer, John 35, **36**
Argento, Asia 186, 187
Argento, Claudio 92
Argento, Dario 92, 95, 133, 137, 142, 168, 187
Army of Darkness 157, 232, 234
Army of Darkness: The Medieval Dead see *Army of Darkness*
Arpón, María Elena 89
Arroita-Jáuregui, Marcelo 61
Arsenic and Old Lace (play) 40
Artaud, Antonin 141, 230
Ashfield, Kate 181, **219**
Ashley, Joel 50
Ashton, Roy 78, 79
Askwith, Robin 229, 259
Aspen, Giles 168
Assault on Precinct 13 256
Astro-Zombies, The 65, **101**, 234, 309

Asylum (book) 10
At Twilight Come the Flesh-Eaters 135, 234-235
ataque de los muertos sin ojos, El see *Return of Blind Dead, The*
Atomic Brain, The see *Monstrosity*
Attack of the 50 Foot Woman 47
Attack of the Robots 61
Atwill, Lionel 34
Aured, Carlos 86
Avati, Pupi 132, 298, 299
Awful Dr. Orlof, The 61
Axcelle, Carl 22
Bacal, Simon 231
Back from the Dead 234
Backus, Richard 72
Bad Taste 159, 160, 234-235, 238, 254, 292
Badley, Linda 69, 228
Baker, Roy Ward 77, 79
Baker, Simon 186
Balaban, Bob 165
Balbo, Lucas 228
Balch, Antony 229, 259
Bald, Wambly 226
Ballard, J.G. 74, 179, 292
Balme, Timothy 160
Balun, Chas 231
Bang, Joy 74
Bangers see *Zombie Ninja Gangbangers*
Bansak, Edmund G. 227
Barbeau, Adrienne 151
Bark, Peter 133
Barkett, Steve 233
Baron Blood 8
Barrett, Edith 44
Barrymore, John Drew 62
Barwood, Hal 153
Bat, The (play) 19
Batman (TV series) 153
Batoru garu see *Living Dead in Tokyo Bay, The*
Battlefield Baseball 172, 174, 235
Bava, Lamberto 132, 250, 251, 258
Beale, Lewis 232
Beast from 20,000 Fathoms, The 47
Beast, The 88
Beaton, Stephanie 135, 308
Beaudine, William 40
Bécquer, Gustavo Adolfo 87
Bedlam 41, 42
Bell, Nelson B. 22, 226
Bellamy, Madge 21, 23, **24**, 26, 298
Berger, Howard 230
Best Plays of 1931-1932 and the Year Book of the Drama in America, The (book) 226
Best, Willie 33-37, 48, **98**, 190, 256, 286
Bestie aus dem Totenreich, Die see *Return of the Zombies*
bête, La see *Beast, The*
Bettoia, Franca 63
Beverly Hills 90210 (TV series) 231
Beverly Hills Bodysnatchers 154, 235
Bey, Marki 76
Beyond Good and Evil: Prelude to a Philosophy of the Future (book) 230
Beyond Re-Animator 159, 235-236
Beyond Terror 236
Beyond Terror: The Films of Lucio Fulci (book) 230
Beyond the Living Dead see *Return of the Zombies*
Beyond, The 7, 129, 131, 137-142,

194, **195**, 230, 235
Bianchi, Andrea 88, 131, 133
Biker Zombies from Detroit 229, 236
Billy Jack 72
Bio Cops 174, 236-237
Bio-Crisis Cops see *Bio Cops*
Biohazard see *Resident Evil (videogame)*
Biohazard see *Warning Sign*
Biohazardous 152, 237
Bio-Zombie 172, 174, 236, 237
Birds, The 68, 152, 266
Black Bagdad: The Arabian Nights Adventures of a Marine Captain in Haiti (book) 17
Black Christmas 71
Black Democracy: The Story of Haiti (book) 226
Black Demons see *Demons 3*
Black Magic II see *Revenge of the Zombies*
Black, Shane 153
Black, Terry 153
Blair, Linda 241
Blanchard, Françoise 85, **125**, **270**
Blanco, Hugo 61
Blaney, Martin 232
Bleich, Bill 255
Blind Dead, The (film series) 86-89, 131, 133, 243, 261, 271, 291
Blind Dead, The see *Tombs of the Blind Dead*
Bloch, Robert 247
Blood Feast 67
Blood of Ghastly Horror 237
Blood of the Beast 166, 237
Blood of the Zombie see *Dead One, The*
Blood Suckers, The see *Gallery of Horror*
Bloodeaters see *Toxic Zombies*
Bloodsuckers from Outer Space 151, 237
Bloodsucking Nazi Zombies see *Oasis of the Zombies*
Bloody Bill 153, 237-238
Blue Sunshine 73, 238
Blumenstock, Peter 228, 229, 231
Blyth, David 249
Bobbitt, Lorena 257
Bocklin, Arnold 265
Body Snatcher, The 41, 42
Body Snatchers 73
Bogart, Humphrey 227
Bogle, Donald 36, 37, 227
Bold! Daring! Shocking! True: A History of Exploitation Films, 1919-1959 (book) 227
Boll, Uwe 181
Bonaparte, Napolean 15
Boneyard, The 80, 238
Bookwalter, J.R. 165-167, 176, 248, 301, 308
Booth, Jim 159
Borg, Veda Ann **39**
Borowczyk, Walerian 88
Bosch, Hieronymus 180
Botting, Jo 229
Bouyxou, Jean-Pierre 85
Bowery At Midnight 35, 39, 40, **99**, 154, 238
Bowles, Paul 228
Boyle, Danny 178-180, 183, 232, 292
Bracula - The Terror of the Living Death see *Return of the Zombies*
Braindead 159, 160, **214**, **215**, 234, 238, 254

Braineater (short film) 248
Brandon, Philip 26
Brannon, Fred C. 48
Bravman, Jack 153
Bride of Frankenstein 23, 159
Bride of Re-Animator **158**, 159, 239
Brides of Dr. Jekyll see *Dr. Orloff's Monster*
Briggs, Joe Bob 302
Brissac, Virginia 33
Brooks, Max 186, 192
Brown, Wally 46, 309
Browning, Tod 19, 35
Bryan, Peter 58, 228
Bryce, Allan 230, 231
Bunker, The 80, 239
Buñuel, Luis 140, 142
buque maldito, El see *Horror of the Zombies*
Burial Ground see *Nights of Terror, The*
Burner, César 89
Burnley, Fred 77
Burns, Marilyn 266
Burns, Megan 179
Burrell, Everett 161
Burrell, Nigel J. 89, 229
Burroughs, William 259
Bush, George 148, 151
Bush, George W. 190, 267
Butler, William 285
Buttcrack 239
Cabinet des Dr. Caligari, Das see *Cabinet of Dr. Caligari, The*
Cabinet of Dr. Caligari, The 19, 30, 272
cacciatore di uomini, Il see *Devil Hunter*
cage aux folles, La 135, 240
Cage Aux Zombies, La 135, 239-240
Cahn, Edward L. 49, 50, 53, 54, 242, 264
Calfa, Don **283**
Cameron, James 298
Campbell, Bruce 157, 254
Campillo, Robin 291
Canne amère 226
Cannibal Apocalypse 129
Cannibal Apocalypsy see *Zombie Creeping Flesh*
Cannibal Cousins (book) 17
Cannibal Holocaust 135, 143, 181
Cantet, Laurent 291
Cape Canaveral Monsters 240
Caperton, William Banks 16
Cardille, Lori 144
Carney, Alan 46, 309
Carpenter, John 151, 152, 184, 256, 280
Carradine, John 34, 38, **39**, 40, 41, 65, 79, **100**, 227, 234, 237, 254, 255, 261
Carson, John 59
Carter, John N. 151
Cartes sur table see *Attack of the Robots*
Case, Sue Ellen 147, 230
Cash, Johnny 185
Castle, William 76, 288
Cat and the Canary, The 33
Cat and the Canary, The (play) 19
Cat People (1942) 41, 42
Cat People (1982) 71
Caution, Children At Play see *Kiss Daddy Goodbye*
cavalcata dei resuscitati ciechi, La see *Return of Blind Dead, The*
Cawthorn, Joseph 21
Cementerio del terror see *Zombie Apocalypse*

313

Cemetery Man see Dellamorte
Dellamore
Cemetery of the Living Dead see
Terror-Creatures from the Grave
Centauri, Jeff 135, 308
Chambers, Marilyn 228, 281
Chan, Alice 236
Chan, Jordan 174
Chaney Jr., Lon 255
Chaney, Lon 20
Chauvet, Ernest 16
Chicago Sun-Times (newspaper) 228, 230
chien andalou, Un 140
Child, The 80, 240
Children of Ravensback, The see
Children, The
Children of the Living Dead 240
Children Shouldn't Play with Dead
Things 71, 73, 83, 228, 240-241, 249
Children Shouldn't Play with Dead
Things (remake) 192
Children, The 80, 241
Chilling, The 229, 246
Chilling, The see Night of the Zombies
Chinese Ghost Story, A 172, 241
Chirizzi, Gianluigi 136
Chloe: Love Is Calling You 24
Choking Hazard 181, 241
Chong, Billy 267
Chopper Chicks in Zombie Town 229, 241-242, 261
Christina, princesse de l'érotisme see
Virgin Among the Living Dead, A
Chrome and Hot Leather 72
cimetière de la terreur, Le see Zombie
Apocalypse
Cinefantastique (magazine) 154, 231, 232
Cinque tombe per un medium see
Terror-Creatures from the Grave
Citizen Kane 38, 41, 170
City of the Dead 8
City of the Dead (videogame) 186
City of the Living Dead 131, 137-142, **194**, 230, 242
City of the Walking Dead see
Nightmare City
ciudad de los muertos vivientes, La
see City of the Living Dead
Clare, Diane 58
Clarens, Carlos 51, 228
Clark, Bob 71, 72, 83, 249
Clark, Eugene 186, **187**, 189, **193**
Clark, Mindy 155, **156**, **217**, **284**
Class of Nuke 'em High 257
Clement, Brian 271
Clerks 174
Cleveland, George 28
Clinton, Bill 148, 151
Cliver, Al 251
Close Encounters of the Third Kind 180
Cohen, Larry 271
Coixet, Isabel 272
Cole, Rosalie 80
Coleridge, Samuel Taylor 226
Colley, Don Pedro 76
Collins, Joan 290
Combs, Jeffrey 158
Come Get Some! 166, 242
commando des morts vivants, Le see
Shock Waves
Computer Killers see Horror Hospital
Condon, Richard 51
Conroy, Jarlath 144
Conway, Tom 43
Cooper, Alice 152, 280
Coppola, Francis Ford 256
Cordero, Joaquín 60
Corman, Roger 48, 261
Corpse Eaters 242

Corpse Vanished, The see Revenge of
the Zombies (1943)
Corpse Vanishes, The 35
Corti, Victor 230
Costello, Lou 46, 48
Coulouris, George 49
Court, Hazel 56
Crabbe, Buster 234
Craft, The 167
Craige, John Huston 17
Cramps, The 155
Craven, Wes 148-150, 176, 249, 287
Crawford, Travis 231, 232
Crazies, The 68, 73-75, 91, 179, 228, 242
Creature with the Atom Brain 47, 52-54, **101**, 242
Creepshow 229, 242-243
Crime of Voodoo see Ouanga
Criswell 278
Cronenberg on Cronenberg (book) 228
Cronenberg, David 73-75, 169, 184, 228, 230, 288
Cross of the Devil, The see cruz del
diablo, La
Crowley, Aleister 10
Croyance (wife of Ti Joseph) 12
cruz del diablo, La 87, **113**, 243, 276
Crypt of the Blind Dead see Tombs of
the Blind Dead
Cube 177
Cult of the Dead see Isle of the Snake
People
Cummins, James 80, 238
Cunningham, Sean S. 261
Cuomo, Alfredo 91, 92
Curse of Gohr, The see Dark Echoes
Curse of the Cannibal Confederates 153, 243
Curse of the Cat People, The 41
Curse of the Doll People, The 60, 243
Curse of the Living Corpse, The 64
Curse of the Screaming Dead see
Curse of the Cannibal Confederates
Curtiz, Michael 297
Curzon, George 287
Cushing, Peter 77-79, 259, 268, 288, 290
Cut Ups, The 259
Da dove vieni? see Living Dead at
Manchester Morgue, The
Daddy 166, 243
Dade, Stephen 56
D'Amato, Joe 88, 134, 135, 143, 253, 266, 272, 280
Damned, The 155
Dämonenbrut 243
Danson, Ted 229
Dante, Joe 192
D'Arcy, Roy 28
Dark Echoes 243, 245
Dark Star (magazine) 231
Dark Terrors (magazine) 228
Davis, Harold Palmer 226
Davis, Lucy **219**
Davis, Wade 12, 16, 17, 148-150, 226, 231, 287
Dawn of the Dead (1978) 3, 7, 68, 74, 75, 80, 81, 91-96, **97**, **120-123**, 129, 136, 142-147, 151, 157, 159, 162, 164, 165, 172, 174-176, 178, 182-184, 187, 189, 190, 225, 229, 242, **244**, 245, 271, 302, 308
Dawn of the Dead (2004) 178, 183-186, 191, **221**, **224**, **244**, 245
Dawn of the Mummy 131, **132**, **203**, 245
Day of the Beast, The 181
Day of the Dead 68, 95, 143-147, 154, 155, 162, 164, 165, 175, 177, 186-189, **207-209**, 230, 242, 246, 282, 289

Day of the Dead (remake) 192
Day of the Triffids, The (novel) 278
Day-Jones, Anne 181
De Angelis, Fabrizio 133
De Marchi, Laura 138
De Mejo, Carlo 138, **194**
De Nava, Giovanni 138, **194**
De Rossi, Giannetto 129, 130
Dead & Breakfast 181, 246
Dead & Buried 151, 152, **153**, **206**, 242, 246-247
Dead Alive see Braindead
Dead Come Home, The see Dead
Dudes in the House
Dead Creatures 169, 247
Dead Don't Die, The 247
Dead Dudes in the House 247
Dead Hate the Living!, The 181, 247
Dead Heat 153, 247
Dead in the West (comic book) 232
Dead King (comic book) 232
Dead Life 166, 247
Dead Meat 166, 247-248
Dead Men Don't Die 151, 248
Dead Men Walk 84
Dead Next Door, The 165, 166, 248, 301
Dead of Night see Deathdream
Dead One, The 248
Dead People see Messiah of Evil
Dead Pit, The 165, 248-249
Dead Rising (video game) 192
Dead That Walk, The see Zombies of
Mora Tau
Deadly Friend 150, 249
Deadly Mantis, The 48
Death Corps see Shock Waves
Death Line 152
Death Valley: The Revenge of Bloody
Bill see Bloody Bill
Death Warmed Up 249
Death Wheelers Are... Psycho
Maniacs see Psychomania
Death Wheelers, The see
Psychomania
Deathdream 71-73, 83, 152, 228, 249, 301
Dee, Francis 42, **43**, **44**, 262
Deep Echo see Dark Echoes
Deep Red 92
Deep River Savages 129
Deep Throat 88
Deer Hunter, The 129
Dekker, Fred 154
Delli Colli, Alexandra 134
Dellamorte Dellamore 7, 169, 170, **212**, 249-250
Demon Terror see Dämonenbrut
Demoni III see Demons 3
Demoni neri see Demons 3
Demoni see Demons
Demonium 166, 250
Demons 250, 251
Demons 2 250
Demons 3 250-251
Demons 3: The Ogre 250
Dendle, Peter 41, 227
Denning, Richard 54
Deodato, Ruggero 135, 143
Depp, Johnny 279
Deranged 71
Derleth, August 17
Descartes, René 230
despertar de la momia, El see Dawn
of the Mummy
Dessalines, Jean-Jacques 15
Devil and Daniel Webster, The 38
Devil Bat, The 35
Devil Hunter 143, 251
Devil Story **126**, 251
Devil's Daughter, The 24
Devil's Kiss **119**, 251
Diamond Dead (unfilmed) 186

Diary of the Dead 192
Die You Zombie Bastards! 251
DiLeo, Antone 144, **146**
Dillon, Matt 170
Dino Crisis (videogame) 172
Disciple of Death 77, 251-252
Dixon, Ken 154, 309
Dobes, Marek 181
Doctor Blood's Coffin **55**, 56, 57, 60, 252
Doctor Butcher, M.D. see Zombie
Holocaust
Doederlein, Fred 74
Donlevy, Brian 52
Don't Go Out At Night see Night of
the Sea Gulls, The
Don't Open the Window see Living
Dead at Manchester Morgue, The
Doom 3 (videogame) 186
Douglas, Gordon 46
Down to Hell 173, 252
Doyle, Sir Arthur Conan 59
Dr. Jekyll and Mr. Hyde 38
Dr. Jekyll's Mistresses see Dr. Orloff's
Monster
Dr. Orloff's Monster 61, 62, 252
Dr. Satan vs. Black Magic 60, 252
Dr. Satán y la magia negra, El see Dr.
Satan vs. Black Magic
Dr. Terror's Gallery of Horrors see
Gallery of Horror
Dracula 19-21, 34
Dracula (novel) 59
Dracula (play) 19, 20
Dracula and the Seven Golden
Vampires see Legend of the 7 Golden
Vampires, The
Dread of Difference: Gender and the
Horror Film, The (book) 228
Dreadful Pleasures: An Anatomy of
Modern Horror (book) 226
Dreamcatcher 293
Drums O' Voodoo 24
Drums of Terror: Voodoo in the
Cinema (book) 226-228, 231
Drums of the Jungle see Ouanga
Dunn, Jeff 302
Durston, David E. 76
Dusek, Jaroslav 181
Duvalier, François ("Papa Doc") 148
Duvalier, Jean-Claude ("Baby Doc") 148, 150, 226
Dylan Dog (comic book) 169
Earth Dies Screaming, The 56, 57, 60, 252
Earthquake 84
Eastman, George 135
Eastman, Marilyn **66**, 67
Eaton, Marjorie 50, 65
Eberhardt, Thom 274
Ebert, Roger 65, 95, 228, 230
Eccleston, Christopher 180
Edmond, J. Trevor 155
Edwards, Phil 231
Ege, Julie 78
Elkayem, Ellory 156, 285
Ellison, James 44
Emge, David 93, **123**
Emmanuelle 88
Emperor Jones, The (play) 227
Empire (magazine) 7, 232
Enemy from Space see Quatermass 2
enfer des zombies, L' see Zombie
Flesh-Eaters
England, Norman 231
Englund, Robert 152
Engstrom, Jean 49
Enter... Zombie King 252-253
Entity Force see One Dark Night
Enyo, Erina 64
Erotic Nights of the Living Dead 132, 134-136, **201**, 253

index

Erotic Orgasm 135, 136, 253-256, 308
espanto surge de la tumba, El see Horror Rises from the Tomb
était une fois le diable, Il see Devil Story
Escape of the Living Dead (comic book) 192
Etherington, Daniel 232
Everett, Rupert 169, 170, **212**, 249
Evil Dead 2: Dead By Dawn see Evil Dead II
Evil Dead 3 see Army of Darkness
Evil Dead II 157, 158, 165, 254
Evil Dead, The 156, 157, 159, 175, 243, 250, 254, 273, 292
Exorcism of Hugh, The see Neither the Sea Nor the Sand
Exorcist, The 76, 280
Exorcist: The Beginning 76
Exotic Orgasm see Erotic Orgasm
Face of Marble, The **100**, 227, 254
Falchi, Anna 170, **212**
Fangoria (magazine) 142, 159, 167, 169, 172, 175, 178, 179, 184, 189, 230-232, 262, 287
Fantastic: A Structural Approach to a Literary Genre, The (book) 227
Farentino, James 152
Farrow, Tisa 129
Father's Day (anthology segment) 229, 243
Faulkner, William 9
Fawcett, Neil 231
Fear Effect (videogame) 172
Fearing the Dark: The Val Lewton Career (book) 227
Fehse, Marc 272
Ferrante, Anthony C. 232
Ferrara, Abel 263
Ferré, Ignasi P. 135
Fetchit, Stepin 37
Fiend with the Electronic Brain see Blood of Ghastly Horror
Fierberg, Steven 148, 151
fille à la fourrure, La see Naked Lovers
Film Comment (magazine) 227, 228
Film Criticism (magazine) 232
Film, Horror and the Body Fantastic (book) 228
Finlay, Frank **273**
Finney, Jack 52
Fisher, Terence 57, 292
Fleming, Lone 89
Flesh Eater: Revenge of the Living Dead see Revenge of the Living Zombies
Flesh Freaks 166, 254
Flesheaters, The 155
Fly, The 184
Fog, The 151, 152, 178, 254-255
Forbes-Robertson, John 78
Forbidden Siren (videogame) 172
Foree, Ken 93, 185
Forest of Fear see Toxic Zombies
Foundas, Scott 232
Fragasso, Claudio 131, 299
Francen, Victor 31
Franco, Francisco 81, 86, 87, 89
Franco, Jess 61, 79, 80, 88, 143, 229, 251, 271, 278, 296
Frankenstein 19
Frankenstein (novel) 20
Franklin, Benjamin 226
Frasher, Michael 231
Frazer, Robert 21, 26
Freaks 35
Freddy Vs. Jason 76, 184
Freud, Sigmund 57, 139, 228
Frezza, Giovanni 139
Friday the 13th 95, 231, 261
Friday the 13th Part VI: Jason Lives 231

frissons des vampires, Le see Shiver of the Vampires
From the Dead of Night 154, 255
Frost, Nick 181, **219**
Frumkes, Roy 134
Fujiwara, Chris 45, 227
Fulci, Lucio 129-131, 133, 137-143, 171, 176, 177, 185, 230, 235, 242, 247, 261, 299
Fung, Stephen 236
Funk, Greg **161**
Furie, Sidney J. 56
Further Tales from the Crypt see Vault of Horror, The
Gagne, Paul R. 147, 229-231
Galbo, Christine 81, **83**, 229
Gale, David 159, **206**
Galindo Jr., Rubén 300
Gallagher, Hugh 135, 257
Gallery of Horror 229, 255
GamePro (magazine) 231
Gamma 693 see Night of the Zombies
Gance, Abel 31, 69
Garden of the Dead 73, 255-256
Garland, Alex 180
Gates of Hell, The see City of the Living Dead
Gaye, Gregory 53
Gein, Ed 71
Geisterschiff der schwimmenden Leichen, Das see Horror of the Zombies
Geisterstadt der Zombies, Die see Beyond, The
Gelder, Ken 226, 230
George A. Romero's Land of the Dead see Land of the Dead
George, Christopher 138
Gershon, Gina 297
Gerstle, Frank 65
Ghost Breakers, The **32**, 33-36, 48, **98**, 256, 286
Ghost Brigade 153, 256, 289
Ghost Galleon, The see Horror of the Zombies
Ghost Ship 184
Ghost Ship of the Blind Dead see Horror of the Zombies
Ghost Ship, The 41
Ghost Stories (magazine) 17
Ghost Town 151, **207**, 237, 256
Ghosts of Mars 152, 256
Ghosts on the Loose 35
Ghoul School 166, 256-257
Ghoul, The 27, **29**, 256, **257**, 271
Gifford, Denis 35, 227
Gigó, Georges 251
Gilchrist, Todd 232
Gilling, John 58, 59, 87, 243
Gillis, Jamie 79, 251
Gingold, Michael 232, 287
Giordano, Mariangela 133, **136**
Gleeson, Brendan 179
Glen, Iain **178**
Goblin 92
Goddard, Paulette 33, 34, **98**, 256
Godsell, Vanda 57
Godzilla (film series) 172, 270
Goeshi 229, 257
Goldblatt, Mark 153
Golden Horrors: An Illustrated Critical Filmography of Terror Cinema 1931-1939 (book) 226
Golem, The 19
Golem, Wie er in die Welt kam, Der see Golem, The
Gordon, Christine 43, **44**
Gordon, Stuart 158, 159, 281
Gore Whore 135, 257
Gore-Met Zombie Chef from Hell 151, **210**, 257
Gothika 184

Gould, Elliott 248
Granger, Michael 53
Grant, Barry Keith 94, 162, 228, 229, 231
Grapes of Death, The 84-86, 90, 94, **124**, **125**, 179, 257, 282
Grau, Jorge 81, 83, 86, 90, 131, 132, 229
Grave Misdemeanours see Night Life
Graveyard Alive: A Zombie Nurse in Love 181, 258
Graveyard Disturbance 132, 258
Grayson, Steve 232
Green, Rob 80
Greene, Carla **287**
Greene, Richard 79
Grey Knight see Ghost Brigade
Gritos en la noche see Awful Dr. Orlof, The
Gudino, Rod 232
Guedj, Claude 84
Guillory, Sienna 178
Guitar Wolf 172, 173, 298
Gunn, James 184, 185
Hadji-Lazaro, François 169
Haggerty, Dan 241
Haig, Sid 233
Haining, Peter 226, 227
Haiti and the United States: The Psychological Moment (book) 231
Haiti: The Duvaliers and Their Legacy (book) 226
Halberstam, Judith 8, 226
Hall, Ellen 40
Hall, Kenneth J. 154
Hallow's End 166, 258
Halperin, Edward 20, 21, 23, 27, 28, 30
Halperin, Victor 20, 21, 23, 27, 28, 30
Hamilton, George 247
Hampshire, Susan 77, 273
Hampton, Paul 74
Hancock, John 74, 268
Hanging Woman, The see Return of the Zombies
Hanners, John 232
Hanthaner, Ron 77
Happiness of the Katakuris, The 174, 258
Hard Rock Zombies 153, 258
Hardiman, Marguerite 77
Hardman, Karl 66, 67
Hardy, Oliver 157, 158
Harper's Magazine (magazine) 9, 226
Harris, Naomie 179
Harrison, Andrew 303
Harrison, Paul 76
Harron, John 21, **24**, 26
Haunted Mansion, The 178, 258
Hayes, Allison **49**, 50
Hayes, John 73
Hayti, Or the Black Republic (book) 226
Hearne, Lafcadio 9, 11, 226
Hearts of Darkness: A Filmmaker's Apocalypse (documentary) 256
Heinl, Nancy Gordon 226
Heinl, Robert 226
Hell of the Living Dead see Zombie Creeping Flesh
Hell of the Living Death see Zombie Creeping Flesh
Hellgate 258-259
Hellraiser 76
Hemingway, Ernest 9
Herald Tribune (newspaper) 19
Herbet West - Reanimator (short story) 158
Herrmann, Bernard 38
Hessel, Lee 75
Heston, Charlton 228

Hickenlooper, George 256
Higgin, Howard 28
Highlander 173, 295
High-Rise (novel) 74
Hilbeck, Fernando 81, **116**
Hill, Jack 228, 265
Hill, Marianna 74
Hill, Walter 289
Hinzman, Bill **67**, 153, 240, **274**, 286
History of Brazil (book) 226
Hitchcock, Alfred 55, 65, 68, 70
Ho, Godfrey 172
Hodges, Mike 229
Hollingdale, R.J. 230
Holocausto porno see Porno Holocaust
Homebrew see Zombie Toxin
Homecoming 192
Homicidal 288
Honeycombe, Gordon 273
Hong, James 165, 296
Hooper, Tobe 154, 156, 192
Hope, Bob 33-36, 48, **98**, 256, 286
Hopper, Dennis 186, 187, 267
Horror Express 259
Horror Hospital 229, 259
Horror Hotel see City of the Dead
Horror of Party Beach, The 64, 76, 259
Horror of the Zombies 86, 89, **108-111**, **260**, 261, 276
Horror Reader, The (book) 226, 230
Horror Rises from the Tomb 86, 261
Hot Wax Zombies on Wheels 229, 261
Hound of the Baskervilles, The (novel) 59
House 73, 261
House by the Cemetery, The 129, 131, 137, 139, **140**, **141**, 142, 230, 261
House in the Magnolias, The (short story) 17
House of Seven Corpses, The 76, 261
House of the Dead 181, 247, 262
House of the Dead, The (arcade game) 174, 178, 181, 262
House on Haunted Hill 288
House on Skull Mountain, The 77, 262
House on Tombstone Hill, The see Dead Dudes in the House
Howard, Richard 227
Hughes, Kelly 135
Hung, Hwa I. 172
Hunter, Edward 51, 52
Hutchings, Peter 57, 228
I Am Legend (novel) 62
I Drink Your Blood 76
I Eat Your Skin 76, 262
I Married a Monster from Outer Space 51
I Walked with a Zombie 7, 34, 41-46, 53, **99**, 141, 142, 145, 227, 262
I Was a Teenage Zombie 154, 262
I Was a Zombie for the F.B.I. 154, 263
I Zombie, You Zombie, She Zombies see Io zombo, tu zombi, lei zomba
I, Zombie: A Chronicle of Pain 168, 169, 231, 247, 263
Iglesia, Alex de la 181
Illustrated History of the Horror Film, An (book) 35, 228
Immoral Tales: European Sex and Horror Movies 1956-1984 (book) 229
In der Gewalt der Zombies see Erotic Nights of the Living Dead
Incredibly Strange Creatures Who Stopped Living and Became Mixed-Up Zombies!!?, The 64, 65, 263
Incredibly Strange Film Show, The (TV series) 225
Incubo sulla città contaminata see Nightmare City

315

Inferno 137
inferno dei morti-viventi, L' see *Zombie Creeping Flesh*
Insel der Dämonen II see *Dämonenbrut*
Invaders from Mars 51
invasión de los muertos, La see *Invasion of the Dead*
invasión de los zombies atómicos, La see *Nightmare City*
Invasion der Zombies see *Living Dead at Manchester Morgue, The*
Invasion of Death see *Invasion of the Dead*
Invasion of the Body Snatchers (1956) 7, 47, 51-53, **54**, 55, 57, 69, 70, 233, 237, 263
Invasion of the Body Snatchers (1978) 184, 263
Invasion of the Dead 60, 263-264
Invasion of the Zombies 60, 264
Invisible Ghost 35
Invisible Invaders 47, 52-54, 57, 264
Io zombo, tu zombi, lei zomba 264-265
Island of Terror 57
Island of the Living Dead, The see *Zombie Flesh-Eaters*
Isle of the Dead 41, 227, 265
Isle of the Snake People 60, 228, 265
It Came from Outer Space 51
It Came from Weaver Five: Interviews with 20 Zany, Glib and Earnest Moviemakers in the SF and Horror Traditions of the Thirties, Forties, Fifties and Sixties (book) 228
It Fell from the Sky see *Alien Dead, The*
Ittenbach, Olaf 166, 268, 280
J'accuse 31, 69, 265
Jack's Wife 75, 91
Jackson, Michael 153, 161, **206**, 291
Jackson, Peter 159, 160, 178, 180, 234, 235, 238, 254, 270
Jacques Tourneur: The Cinema of Nightfall (book) 227
Jagger, Dean 28
Jancovich, Mark 47, 51, 228
Jaws 129
Jayne, Tara 174
Jigoku kōshien see *Battlefield Baseball*
Johnson, Lyndon B. 69
Johnson, Noble **32**, 33
Johnson, Richard 129, **130**
Johnson, Tor **279**
Johnston, W. Ray 34
Jolie, Angelina 175
Jones, Alan 229-232
Jones, Darby **43**, 46
Jones, Duane 67
Joseph, Ti 12
Jovine, Fabrizio 137
Jovovich, Milla **176**, 177, 282
Joy, Robert 186, 189
Joyce, William 175
Jumbee (short story) 17
Jung, Carl 241
Jungfrau in den Krallen von Zombies, Eine see *Virgin Among the Living Dead, A*
Jungfrau unter Kannibalen see *Devil Hunter*
Jungle Ways (book) 10
Junk 172, 173, **216**, 265, 295
Kalmanowicz, Max 80
Karen, James 154, 155, 284
Karlatos, Olga **129**, 140
Karloff, Boris 7, 21, 22, 27, 28, **29**, 39, 48, 60, 77, 227, 228, 256, **257**, 265, 270, 271, 297
Katakuri-ke no kōfuku see *Happiness of the Katakuris, The*
Katt, William 261

Katzman, Sam 49
Kaufman, Lloyd 308
Kaufman, Philip 184, 263
Kay, Edward J. 38
Keaton, Buster 157
Keep, The 239
Keith, Ian 46, 293
Kelly, Lew 39
Kelly, Michael 185
Kelso, Edmond 38
Kennedy, Arthur 82, 83
Kennedy, John F. 71, 179
Kephart, Elza 181, 258
Kill and Go Hide see *Child, The*
Killing Birds 131, 266
Killing Birds (Uccelli assassini) see *Killing Birds*
Killing Box, The see *Ghost Brigade*
King Kong 33
King of the Rocket Men (serial) 48
King of the Zombies 34-39, **98**, 145, 266, 286
King, Ed 248
King, Richard 231
King, Stephen 94, 147, 229, 242, 278, 293
Kinmont, Kathleen **158**
Kirkman, Robert 186
Kiss Daddy Goodbye 229, 266
Kitamura, Ryuhei 173, 252
Klimovsky, León 86
Kloman, Harry 232
Kneale, Nigel 52
Knightriders 225
Knights of Terror: The Blind Dead Films of Amando de Ossorio (booklet) 229
Komabrutale Duell, Das 166, 266
Korobkina, Inna 185
Koszulinski, Georg 237
Kristeva, Julia 136, 230
Kung Fu Cannibals see *Raw Force*
Kung Fu from Beyond the Grave 267
Kung Fu Zombie 172, 267
Kurosawa, Kiyoshi 171, 231
lac des morts vivants, Le see *Zombie Lake*
Lady and the Monster, The 35
lago de los muertos vivientes, El see *Zombie Lake*
Lahaie, Brigitte 85
Lamata, Miguel Ángel 181
Lambert, Mary 278
Lampert, Zohra 74
Lancelot, Sir 46
Land of the Dead 178, 186-192, **193**, **221**, **222**, 232, 267
Land of the Dead, The see *Santo and Blue Demon in the Land of the Dead*
Landau, Richard 49
Landis, John 153, 291
Lansing, Robert 16
Lara Croft: Tomb Raider 175
Last House on the Left, The 150, 176, 236
Last Man on Earth, The 62-64, 70, 233, 267
Lattanzi, Claudio 131, 266
Laughing Dead, The 165, 267
Launer, S. John 54
Laurel, Stan 157
Lazar, Veronica 138
LeBlanc, Matt 153, 256
Lee, Christopher 77, 78, 252, 259
Lee, Sam 174, 232
Legend of Diablo, The 166, 267
Legend of the 7 Golden Vampires, The 77, 78, 172, 268
Legion of the Dead 166, 268
Leguizamo, John 186
Lenzi, Umberto 129, 131, 251, 277
Leonard, Brett 165

Leonard, Sheldon 26, 46
Leone, Sergio 140
Leopard Man, The 41
Let Sleeping Corpses Lie see *Living Dead at Manchester Morgue, The*
Lethal Weapon 153
Let's Scare Jessica To Death 73, 74, 268
Leung Siu-Hung, Tony 288
Levy, Frederic 229
Lewis, Herschell Gordon 67
Lewis, Jerry 48, 286
Lewis, Joseph 228
Lewton, Val 41, 42, 44-46, 227, 265
Liberty, Richard 144
Lieberman, Jeff 73, 238
Lifante, José Ruiz **6**
Lilly, John 241
Linnea Quigley's Horror Workout 154, 269
Lippe, Richard 228, 229
Live and Let Die 76
Liveright, Horace 19, 20
Living a Zombie Dream 166, 269
Living and the Undead: From Stoker's Dracula to Romero's Dawn of the Dead, The (book) 228
Living Dead at Manchester Morgue, The **6**, 81-83, 86, 87, 90, 94, **114**, **116**, 130, 131, 257, 269
Living Dead Girl, The 85, **125**, 269-270
Living Dead in Tokyo Bay, The 172, 270
Living Dead, The see *Scotland Yard Mystery, The*
Living Ghost, The 40
Lloyd, Rollo 28
London After Midnight 19
Loneliness see *Veerana*
Loonies on Broadway see *Zombies on Broadway*
Lord of the Dead 166, 270
Lord of the Rings, The (film series) 178, 235
Lormer, Jon 229
Lorre, Peter 35
Lost Boys, The 274
Lost Brigade, The see *Ghost Brigade*
Louverture, François Dominque Toussaint 15
Love Wanga, The see *Ouanga*
Lovecraft, H.P. 137, 158, 236, 239, 276, 281
Lovelock, Ray 81, **83**
Lowry, Lynn 74
Lucas, Tim 229
Lugosi, Bela 7, **18**, 20-28, 34, 35, 39-41, 46, **99**, 238, 252, 279, 298, 309
Lustig, William 166, 292
Lynch, David 152
MacColl, Catriona 137-139, **141**, **194**, **195**
MacKay, John 248
Mad Ghoul, The 227
Mad Love 23
Mad Monster, The 35
Magic Island, The (book) 7, 10-15, 17, 19-22, 42, 58, 149, 226
Magnificent Ambersons, The 41
maîtresses du docteur Jekyll, Les see *Dr. Orloff's Monster*
Malco, Paolo 139
Man Hunter, The see *Devil Hunter*
Man They Could Not Hang, The 27, 28, 270-271
Man with the Synthetic Brain see *Blood of Ghastly Horror*
Mandingo Manhunter see *Devil Hunter*
Maniac 95
Maniac Cop 166, 271

Maniac Cop 2 **211**
Mann, Michael 239
manoir de la terreur, Le see *Nights of Terror, The*
mansión de los muertos vivientes, La 229, 271
Mansion of the Living Dead see *mansión de los muertos vivientes, La*
Manson, Charles 71
Mantle, Burns 226
Maplewoods 166, 271
Marceau, Marcel 76, 288
Marks, John 228
Marshall, George 286
Martin 225
Martin, Dean 48, 286
Más allá del terror see *Beyond Terror*
Mascelli, Joseph 65
Maslansky, Paul 76
Maslin, Janet 95, 230
Mason, Lowell 274
Masque of the Red Death, The (short story) 133
Massaccesi, Aristide see D'Amato, Joe
massacre des morts-vivants, Le see *Living Dead at Manchester Morgue, The*
Mastroianni, Armand 153
Matheson, Richard 62, 228
Mattei, Bruno 131, 229, 230, 299
Mathews, Thom 154, 155, 284, 305
Maxwell, Richard 150
McBride, Joseph 227
McCarthy, Joseph 51
McCarthy, Kevin 52, **54**, **263**
McCarty, John 230
McCrae, Scooter 168, 288
McCrann, Charles 292
McCulloch, Ian 129, 134
McDonagh, Maitland 231
McKay, Mungo 180
McKenzie, Mary J. Todd 77
McLarty, Lianne 55, 228
McMahon, Conor 248
Meat Market 166, 271
Meat Market 2 **166**, 271
Mein Kampf (book) 31
Merino, José Luis 86
Messiah of Evil 73, 74, 152, 271
Mestre, Jeannine 81
Mestres, Isabel **6**
Meunier, Christian 85
Meyer, Russ 240
Miami Daily News (newspaper) 51
Michalakis, John Elias 154
Midkiff, Dale 278
Midnight Hour, The 154, 255, 272
Midnight's Calling 166, 272
Mighty Morphin' Power Rangers (TV series) 249
Migicovsky, Allan 74
Miike, Takashi 174
Mikami, Shinji 171, 172, 231
Mikels, Ted V. 65
Miller, Glenn 152
Mirabella, Michele 138
Mistretta, Gaetano 230
Mokae, Zakes 150
Molina, Jacinto see Naschy, Paul
Monkey's Paw, The (short story) 72, 78
Monster Show: A Cultural History of Horror, The (book) 226
Monster That Challenged the World, The 47
Monster, The (play) 19
Monstrosity 65, 272
Montefiori, Luigi see Eastman, George
Monthly Film Bulletin (magazine) 38, 159, 227, 231

index

Moody, Elizabeth 160
Moore, Kieron 56
Moran, Dylan **219**
Morbus 135, 272
Moreland, Mantan 35, **36**, 37-39, 41, 46, **98**, 147, 178, 266, 286
Morell, André 58
Morrison, Alan 232
Mortal Kombat 176
Mortal Kombat (videogame) 266
morte vivante, La see Living Dead Girl, The
Moseley, Bill **161**, 162
Mostow, Jon 154, 235
Motion Picture Herald (magazine) 227
muerte viviente, La see Isle of the Snake People
Mummy, The 27
mundo de los muertos, El see Santo and Blue Demon in the Land of the Dead
Muñecos infernales see Curse of the Doll People, The
Murayama, Noe 60
Muroga, Atsushi 172
Murphy, Cillian 179
Murphy, Eddie 178, 258
Murray, Barbara 78
Mutation 166, 272
Mutation 2: Generation Dead 272
Mutation 3: Century of the Dead 272
My Boyfriend's Back 165, 272
My Life Without Me 272
Nacht der lebenden Loser, Die see Night of the Living Dorks
Nacht van de Levende-Doden, De see Night of the Living Dead
Naked Lovers 135, 272, 277
Naked Vampire, The 84
Naschy, Paul 86, 87, 243, 261, 278, 295
Natali, Vincenzo 177
Natividad, Kitten 240, 308
Necropolis Awakened 166, 272-273
Neither the Sea Nor the Sand 77, 273
Neon Maniacs 151, 273
New York Daily News (newspaper) 41
New York Evening Post (newspaper) 15, 226
New York Post (newspaper) 41
New York Times (newspaper) 26, 30, 95, 190, 229, 227, 230, 232
Newman, Eric 184
Newman, Kim 159, 231
Nichols, Nichelle 253
Nicotero, Greg 188
Nielsen, Leslie 229
Nietzsche, Friedrich 142, 230, 241
Night Andy Came Home, The see Deathdream
Night Crawl see Zombie Brigade
Night in the Crypt, A see One Dark Night
Night Life 151, 273
Night of Darkness see One Dark Night
Night of the Big Heat 57
Night of the Blood Cult see Night of the Sea Gulls, The
Night of the Comet 274
Night of the Creeps 154, 274
Night of the Day of the Dawn of the Son of the Bride of the Return of the Revenge of the Terror of the Attack of the Evil Mutant Hellbound Flesh-Eating Subhumanoid Living Dead, Part II 228, 274
Night of the Death Cult see Night of the Sea Gulls, The
Night of the Living Babes 135, 274
Night of the Living Bread 228, 274
Night of the Living Dead (1968) 7, 47, 64-71, 73-76, 80, 81, 83, 85, 86, 90-96, **101**, **102**, 135, 140, 144-147,
152-154, 161, 162, 171, 174, 180, 182, 225, 228, 229, 232, 234, 240, 245, 263, 266, 274, 275, 283, 297
Night of the Living Dead (1990) 69, 161-164, **213**, 275
Night of the Living Dorks 275
Night of the Sea Gulls, The 86, **89**, **113**, 275-276
Night of the Sorcerers 276
Night of the Wehrmacht Zombies see Night of the Zombies
Night of the Zombies 79, 229, 251, 276
Night of the Zombies II see Night of the Zombies
Night of the Zombies see Zombie Creeping Flesh
Night Star - Goddess of Electra see War of the Zombies
Nightmare City 131, 132, 190, **202**, **276**, 277
Nightmare on Elm Street, A 76, 150
Nights of Terror, The 131-133, 136, 190, **196**, **197**, **225**, 277
Nighy, Bill **182**
Niles, Chuck **100**
Niles, Steve 186
Nimoy, Leonard 48, 309
Nixon, Mojo 239
Nixon, Richard 190
No Exit: A Play in One Act (play) 228
No profanar el sueño de los muertos see Living Dead at Manchester Morgue, The
noche de la muerta ciega, La see Tombs of the Blind Dead
noche de los brujos, La see Night of the Sorcerers
noche de los gaviotas, La see Night of the Sea Gulls, The
noche de los muertos vivientes, La see Night of the Living Dead
noche del buque maldito, La see Horror of the Zombies
noche del terror ciego, La see Tombs of the Blind Dead
noche del terror, La see Nights of Terror, The
noite do terror cego, A see Tombs of the Blind Dead
Noland, Robert 28
Non si deve profanare il sonno dei morti see Living Dead at Manchester Morgue, The
Nosferatu 19, 272
Nosferatu, eine Symphonie des Grauens see Nosferatu
Not of This Earth 48
notte nel cimitero, Una see Graveyard Disturbance
notti del terrore, Le see Nights of Terror, The
notti erotiche dei morti viventi, Le see Erotic Nights of the Living Dead
notti erotiche, Le see Erotic Nights of the Living Dead
Nouvelliste, Le (newspaper) 16
Nudist Colony of the Dead 165, 277
Nugent, Frank S. 30, 227
nuit de la mort, La 277
nuit des morts vivants, La see Night of the Living Dead
Núñez Jr., Miguel A. **283**
Nuse, Deland 229
Oasis of the Living Dead, The see Oasis of the Zombies
Oasis of the Zombies 61, 79, 80, **116**, 277-278, 309
O'Bannon, Dan 152, 154, 283, 284
O'Brien, Donald 134
Obsession: The Films of Jess Franco (book) 228
O'Connor, Kevin **268**
O'Dea, Judith 66, **67**
Office Space 298
O'Hara, Brett 64
Omaggio, Maria Rosaria **276**
Omega Man, The 228
Omen, The 280
On Creativity and the Unconscious (book) 228
On the Left Bank (book) 226
One Dark Night 151, 278
One of the Family (play) 19
O'Neill, Eugene 227
Organization Man, The (book) 228
Orgasmo esotico see Erotic Orgasm
orgía de los muertos, La see Return of the Zombies
orgia dei morti, L' see Return of the Zombies
Orgy of the Dead 64, 274, 278
Orgy of the Vampires see Orgy of the Dead
Ormond, Linda 248
Ormsby, Alan 71, 72, 228, 249
Ormsby, Anya 72
Osmond, Andrew 232
Ossorio, Amando de 62, 86-90, 131-133, 229, 236, 271, 276, 291
Ouanga 24, 26, 27, 30, 42, 46, 151, 227, 278
paese del sesso selvaggio, Il see Deep River Savages
Palmer, Gregg 50
Palmerini, Luca M. 230
Pánico en el transiberiano see Horror Express
pantano de los cuervos, El see Swamp of the Ravens, The
Parasite Murders, The see Shivers
Parker, Dave 181
Parker, Greg 270
Parkinson, Andrew 168, 169, 247, 263
Parkinson, Tom 77
Pascal, Marie-Georges 85
Passage of Darkness: The Ethnobiology of the Haitian Zombie (book) 149, 226
Passmore, Donald R. 242
Paura nella città dei morti viventi see City of the Living Dead
Paxton, Marie 26
Pearce, Jacqueline 59, **60**, **279**
Pegg, Simon 181-183, 186, 188, 191, **219**, 232, **289**
Peñalver, Diana 160
Penczner, Marius 154
People Who Own the Dark, The 88, 278
perversa caricia de Satán, La see Devil's Kiss
Pesticide see Grapes of Death, The
Pet Sematary 278-279
Pet Sematary II 279
Petrie, Susan 74
Petrovitch, Michael 77, 273
Peyton, Chuck see Stryker, Jeff
Phantom of the Opera, The 19
Phifer, Mekhi 185
Philip IV 87
Phillips, Robin 78
Pictorial History of Horror Movies, A (book) 227
Pierce, Jack 22
Pierro, Marina **270**
Pierson, Claude 135, 272, 277
Pilato, Joseph 144
Pirates of the Caribbean: The Curse of the Black Pearl 178, 279
Pirro, Mark 165, 277
Piscopo, Joe 161
Plaga Zombie 166, 279
Plaga Zombie: Zona Mutante **166**, 279
Plague of the Zombies, The 56, 58-60, 78, 242, 279
Plan 9 from Outer Space 47, 52-54, 279
playa de los sacrificios, La see Night of the Sea Gulls, The
Plummer, Brenda Gale 148, 231
Poe, Edgar Allan 17, 133
Poetic Justice (anthology segment) 78
Point, The (newspaper) 228
Polley, Sarah 184, **185**, 245
Polynice, Constant 11-13
Poole, Steven 172, 231
Porky's 71
Porno Holocaust 132, 134-136, 143, 280
Porno Zombies see Naked Lovers
Poseidon Adventure, The 84
Poverty Row Horrors!: Monogram, PRC and Republic Horror Films of the Forties (book) 227
Powers of Horror: An Essay on Abjection (book) 230
Premutos: Der Gefallene Engel see Premutos: Lord of the Living Dead
Premutos: Lord of the Living Dead 166, 280
Price, Dennis 57
Price, Vincent 62-64, 247, 267
Prince of Darkness 152, 280
Psychiatry and the CIA: Victims of Mind Control (book) 228
Psycho 55, 65, 69, 70
Psycho a Go-Go see Blood of Ghastly Horror
Psychomania 229, 280
Pullman, Bill 149
Pulp Fiction 181
Pupillo, Massimo 62
Purcell, Dick **34**, 35, 38, **98**
Quatermass 2 47, 52, 53, 57, 280
Quatermass Experiment, The (TV serial) 52
Quatermass Xperiment, The 49, 52
Quella villa accanto al cimitero see House by the Cemetery, The
Quiet Family, The 258
Quigley, Linnea 154, 155, 269
Quinn, Anthony 33
Rabid 228, 281
Radar Men from the Moon (serial) 48
Ragona, Ubaldo 62
Raiders of the Living Dead 153, 281
Raimi, Sam 156, 157, 165, 180, 234, 254, 273
raisins de la mort, Les see Grapes of Death, The
Rancelot, Mirella **84**
Rape of the Vampire, The 84
Raptors see Killing Birds
Rasberry, James 263
Raspberry, Larry 263
Rational Fears: American Horror in the 1950s (book) 228
Raven, Mike 77, 251, 252
Raven, Stark 168, 288
Raw Force 281
Ray, Man 10, 226
Reade, Walter 65
Reader's Digest (magazine) 65, 228
Reagan, Ronald 148, 151, 169
Re-Animator 158, 159, 166, **206**, 232, 281-282, 292
Re-Animator II see Bride of Re-Animator
Reason, Rhodes 49
rebelión de las muertas, La see Vengeance of the Zombies
Rebellion of the Dead Women see Vengeance of the Zombies
Redneck Zombies 151, 282

317

Reed, Joel M. 229
Reinhard, Pierre B. 286
Reiniger, Scott H. **92**, 93, **96**, 174, 185
Remains (comic book) 186
Reptile, The 58
Requiem der Teufel 282
Requiem for a Vampire 84
Requiem pour un vampire see Requiem for a Vampire
Reservoir Dogs 173
Resident Evil 175-179, 183, 185, 191, 232, 282
Resident Evil (videogame) 171-177, 181-183, 191
Resident Evil 4 (videogame) 186
Resident Evil Genesis see Resident Evil
Resident Evil: Apocalypse 177, 178, 282-283
Resident Evil: Extinction 192
Resident Evil: Nemesis (videogame) 178
Resident Evil: The Book (book) 231
Resurrection Game, The 283
Resurrection, The see Zombie: The Resurrection
Return from the Past see Gallery of Horror
Return of Dr. X, The 227
Return of the Blind Dead, The 86, **105-107**, **109**, 229, 276, **282**, 283
Return of the Evil Dead, The see Return of Blind Dead, The
Return of the King, The 178, 179, 270
Return of the Living Dead 3 155, **156**, **217**, 285
Return of the Living Dead 4: Necropolis 156, 192, **220**, **284**, 285
Return of the Living Dead 5: Rave to the Grave 156, 192, **220**, 285
Return of the Living Dead Part 3 see Zombie 4: After Death
Return of the Living Dead Part II 79, 155, **156**, 284
Return of the Living Dead see Messiah of Evil
Return of the Living Dead, The 154-159, 242, 269, 283-284, 305
Return of the Zombies 86, **87**, **104**, **105**, 285
revanche des mortes vivantes, La see Revenge of the Living Dead Girls, The
revenants, Les see They Came Back
Revenge of the Dead see Zeder (Voices from the Beyond)
Revenge of the Living Dead Girls, The 135, **201**, 285-286
Revenge of the Living Dead see Children Shouldn't Play with Dead Things
Revenge of the Living Zombies 153, 286
Revenge of the Screaming Dead see Messiah of Evil
Revenge of the Teenage Zombies see Night of the Living Dorks
Revenge of the Zombie see Kiss Daddy Goodbye
Revenge of the Zombies (1943) 34, 35, 38, 39, 79, 286
Revenge of the Zombies (1976) 172, 286
Revolt of the Dead Ones see Vengeance of the Zombies
Revolt of the Demons see Revolt of the Zombies
Revolt of the Zombies 28-31, 52, **98**, 227, 286
Rhames, Ving 184, 245
Rhodes, Gary D. 226
Richardson, Ralph 290

Ridley, Judith 67
Rio Bravo 152
Robot Monster 240
Robotham, George 243, 245
Rocky Horror Picture Show, The 240
Rodley, Chris 228, 230
Rodman, Adam 150
Roeg, Nicolas 56
Rollin, Jean 61, 79, 80, 84, 85, 88, 90, 132, 166, 179, 229, 257, 270, 272, 286, 290, 292, 296, 306
Rolling Stone (magazine) 229
Roma contro Roma see War of the Zombies
Rome Against Rome see War of the Zombies
Romero, George A. 47, 62, 64-71, 73-76, 81, 83, 85-87, 90-96, 129, 131, 132, 137, 141-143, 145-148, 152-155, 157, 161-165, 168, 169, 171, 172, 174-181, 183-192, **207**, 225, 228, 229, 231, 232, 234, 240, 242, 245, 246, 248, 253, 263, 267, 274, 275, 278, 283, 284, 286, 28
Romoli, Gianni 170
Rose, Timo 166, 272
Ross, Gaylen 92, 94, 229
Ross, Jonathan 225
Rossati, Nello 264
Rossi-Stuart, Giacomo 63
Roudiez, Leon S. 230
Rowe, Michael 232
Rubinstein, Richard P. 184, 278
Rückkehr der reitenden Leichen, Der see Return of Blind Dead, The
Rückkehr der Zombies, Die see Nights of Terror, The
Rue Morgue (magazine) 183, 232
Rumsfeld, Donald 190
Rush, Geoffrey 178, 279
Russell, Autumn 49
Russo, John A. 154, 192, 240, 297
Sacchetti, Dardano 137, 141
Sagal, Boris 228
Saint John, Antoine **195**
Sakaguchi, Tak 173, 174
Salisbury, Mark 232
Salkow, Sidney 62
Salt Is Not for Slaves (short story) 17, 20
Sam, Jean Vilbrun Guillaume 16
Sancho, Fernando **105**, **109**
Sang dut sau shut see Bio-Zombie
Sanguelia see Zombie Flesh-Eaters
Santo and Blue Demon Against the Monsters 60, 286
Santo and Blue Demon in the Land of the Dead 60, 286
Santo contra la magia negra see Santo vs. Black Magic
Santo contra los zombies, El see Invasion of the Zombies
Santo vs. Black Magic 60
Santo vs. the Zombies see Invasion of the Zombies
Santo y Blue Demon contra los monstruos see Santo and Blue Demon Against the Monsters
Sartre, Jean-Paul 74, 228
Satan's Satellites see Zombies of the Stratosphere (serial)
Saunders, Charles 49
Saury, Alain 272
Savini, Tom 95, **122**, 129, 144, 161-164, 185, 188, 225, 228, 240, 275, 308
Scared Stiff 47, 48, 286
Schaefer, Eric 227
Schenck, Aubrey 48, 228
Schlockoff, Robert 230
Schnaas, Andreas 166, 250, 272, 299
Schon, Kyra **66**, 67

School That Ate My Brain, The see Zombie High
Schrader, Paul 71
Schrikkasteel der Zombies, Het see Nights of Terror, The
Sclavi, Tiziano 169, 170
Scotland Yard Mystery, The 28, 287
Scott, Ridley 186
Scott, Robert 231
Scream 167, 176, 232, 247
Screen International (magazine) 232
Seabrook, William 7, 9-17, 19-22, 24, 28, 42, 226
Search for the "Manchurian Candidate": The CIA and Mind Control, The (book) 228
Season of the Witch see Jack's Wife
secreto del Dr. Orloff, El see Dr. Orloff's Monster
Self Portrait (book) 226
Selznick, David O. 41
Senn, Bryan 26, 226-228, 231
Serpent and the Rainbow, The 149-151, 287
Serpent and the Rainbow, The (book) 148-150, 226, 231
Seven Doors of Death see Beyond, The
Seventh Victim, The 41
Sex, Chocalate & Zombie Republicans 166, 287
Sexo caníbal see Devil Hunter
Sexy Nights of the Living Dead see Erotic Nights of the Living Dead
SFX (magazine) 232
Shadow: Dead Riot **223**, 287-288
Shah, Krishna 153
Shakespeare, William 227
Shanks 76, 288
Shatter Dead **167**, 168, 169, 288
Shaun of the Dead 7, 181-183, 186, 191, **219**, 232, 288, **289**
Shaw Brothers, The 78, 172, 268, 286
Shayne, Robert 227
Sheen, Martin 153, 256
Sheets, Todd 166, 167, 176, 231, 279, 282, 298, 300, 301, 308
Shelley, Mary 20
Sheng hua te jing zhi sang shi ren wu see Bio Cops
Sherman, Gary A. 151, 152
Sherman, Howard 144, 147, **209**, **246**
Sherman, Samuel M. 153
Sherman, Vincent 227
Ship of Zombies see Horror of the Zombies
Shiryô-gari see Junk
Shiver of the Vampires 84
Shivers 73-75, 228, 230, 288
Shivers (magazine) 229, 232
Shock Waves 79, **118**, 228, 288
Shogun Island see Raw Force
Sibley, Graham **305**
Siciliano, Mario 135, 253
Siegel, Don 52, 53, 263
Siegel, Joel E. 227
Silent Death see Voodoo Island
Silent Hill (videogame) 172
Silva, Maria **90**
Simpson, M.J. 231
Sinnui yauwan see Chinese Ghost Story, A
Siodmak, Curt 42, 53
Skal, David J. 23, 226
Skin Shows: Gothic Horror and the Technology of Monsters (book) 226
Sluizer, George 176
Smith, Clark Ashton 230
Smith, Craig 159
Smith, Dick 231
Smith, Kevin 174
Snyder, Zack 183-185

Soavi, Michele 169-171
Something To Tide You Over (anthology segment) 229, 243
Somtow, S.P. 165
Southern Comfort 289
Southey, Robert 226
Spaak, Agnès 61
Space Zombie Bingo 151, 288-289
Space Zombies see Astro-Zombies, The
Spaced (TV series) 181, 182, 288
Spaghetti Nightmares: Italian Fantasy-Horrors as Seen Through the Eyes of Their Protagonists (book) 230
Spierig, Michael 180, 293
Spierig, Peter 180, 293
Splatter Movies: Breaking the Last Taboo of the Screen (book) 230
Spook Busters 35
Spoorloos see Vanishing, The
St. John, Spencer 226
Stacy 172, 173, 289
Stapleford, Betty 300
Star Wars 129
Star Wars: Episode III - Revenge of the Sith 190
Starburst (magazine) 229-231
Stavrakis, Taso **209**
Steckler, Ray Dennis 65
Steele, Barbara 62, 74, 75, 291
Stein, Gertrude 9
Stethoscope (short film) 230
Stewart III, David B. 271
Stewart, Robin 77
Stiglitz, Hugo **276**
Stink of Flesh, The 166, 289
Stockman, Paul **55-57**
Stoker, Bram 19, 59
Stone, Dorothy 28
Strachey, James 228
Strange Dead Bodies see Goeshi
Strange Tales (magazine) 17
Strange World of Willie Seabrook, The (book) 226
Strange, Glenn 34
Street Trash 159
Street, Audrey 257
Streiner, Russell 66, **67**
Stryker, Jeff 299
Sugar Hill 76, **77**, **117**, 289
Suito Homu 231
Sul-Te-Wan, Madame 37
Sunseri, Jack A. 229, 241
Super Mario Bros. 175
Supernaturals, The 153, 289
Suspiria 92
Svengali 23
Swamp of the Ravens, The 86, **115**, 290
Swan, Don 257
Sweet Home (videogame) 171
Sykes, Brad 301
Takeuchi, Tetsuro 172, 298
Tales from the Crypt 77-79, 290, 293
Tales from the Crypt II see Vault of Horror, The
Tales That Will Tear Your Heart Out (unfinished) 134
Tallman, Patricia **161**, 162, **163**
Tarantino, Quentin 181, 292
Teenage Psycho Meets Bloody Mary see Incredibly Strange Creatures Who Stopped Living and Became Mixed-Up Zombies!!?, The
Teenage Zombies 47, 52, 53, **100**, 240, 290
Tenney, Del 64, 76, 259, 262
Terence Fisher (book) 228
terreur des zombies, La see Zombie Holocaust
Terror Beach see Night of the Sea Gulls, The
Terror-Creatures from the Grave 62, 290-291

index

Terwilliger, George 26
Testamento diabolico see *Virgin Among the Living Dead, A*
Texas Chain Saw Massacre, The 71, 157, 176, 266
Thatcher, Margaret 169, 180
Theatre and Its Double, The (book) 230
Thelman, José 89
There's Always Vanilla 75, 91
Thesiger, Ernest **29**
They Came Back 291
They Came from Within see *Shivers*
Thing, The 184
Thor, John Mikl 306
Thornton, Billy Bob 153, 242, 256
Three Stooges, The 157
Thriller (music video) 153, 161, **206**, 291
Thrower, Stephen 130, 137, 139, 230
Time Out 291
Timo, Vidkid 135, 234
Timpone, Tony 184, 232, 262
Titanic 174
Tobe Hooper's Zombies (unfilmed) 156, **191**, 192
Todd, Tony 151, 162, 287, 297
Todorov, Tzvetan 45, 227
Toe Tags (comic book) 186
Tohill, Cathal 88, 229
Tolkien, J.R.R. 178, 270
Tomassi, Vincenzo 140
Tomb of the Undead see *Garden of the Dead*
Tomb Raider (videogame) 172
tombe dei resuscitati ciechi, Le see *Tombs of the Blind Dead*
Tombs of the Blind Dead **1**, 86, 88-90, **102**, **103**, 105, 283, 291-292
Tombs of the Blind Zombies see *Tombs of the Blind Dead*
Tombs, Pete 88, 229
Tomomatsu, Naoyuki 173
Toms, Coons, Mulattoes, Mammies, and Bucks: An Interpretive History of Blacks in American Films (book) 37, 227
Tong, Angela 174
Tonge, Philip 54
Total Film (magazine) 177, 232
Totem and Taboo: Some Points of Agreement Between the Mental Lives of Savages and Neurotics (book) 57, 228
Totenchor der Knochenmänner, Der see *Vengeance of the Zombies*
Tourneur, Jacques 34, 42, 45, 46, 142
Towers Open Fire 259
Toxic Zombies 74, 292
Trepanator 166, 292
trésor des morts vivants, Le see *Oasis of the Zombies*
Trigger Happy: The Inner Life of Videogames (book) 231
tumba de los muertos vivientes, La see *Oasis of the Zombies*
Twitchell, James B. 7, 226
Two Thousand Maniacs! 67
Tyler, Beverly 48
Último deseo see *People Who Own the Dark, The*
ultimo uomo della terra, L' see *Last Man on Earth, The*
Una de zombis 181, **216**, 292
Undead 180, **218**, 292-293
Urban Scumbags Vs. Countryside Zombies 166, 293
Val Lewton: The Reality of Terror (book) 227
Valentine 175
Valentine, Jon 135
Valle, Ricardo 61

Valley of the Zombies 46, 227, 293
vampire nue, La see *Naked Vampire, The*
Vampire's Ghost, The 35
Van de Water, F. 226
Vanishing, The (1988) 176
Vanishing, The (1993) 176
Vari, Giuseppe 62
Variety (magazine) 65, 95, 162, 226, 228, 230
Vaughn, Robert 266
Vault of Horror, The 79, 293
Veerana 294
Veidt, Conrad 30
vendetta dei morti viventi, La see *Vengeance of the Zombies*
Vengeance of the Zombies 86, **112**, 294-295
Vengeful Dead see *Kiss Daddy Goodbye*
Venturini, Mark 155
Verbinski, Gore 178, 279
vergine fra I morti viventi, Una see *Virgin Among the Living Dead, A*
Vernon, Howard 61
Versus 172-174, **216**, 235, 252, 265, 295
Victor, Henry 35
Victor, Katherine 52, 240
Video Dead, The **211**, 231, 295-296
Video Watchdog (magazine) 229
vierge chez les morts vivants, Une see *Virgin Among the Living Dead, A*
Village Voice, The (newspaper) 232
Vineyard, The 165, 296
viol du vampire, Le see *Rape of the Vampire, The*
Violent Shit 299
Virgin Among the Living Dead, A 61, **112**, 296
Virus see *Zombie Creeping Flesh*
Voodo 17
Voodoo Blood Bath see *I Eat Your Skin*
Voodoo Dawn 151, 296-297
Voodoo Dolls 151
Voodoo Girl see *Sugar Hill*
Voodoo Island 47-49, 142, 228, 297
Voodoo Land 17
Voodoo Man 35, 39, 40, 41, 49, **99**, 297
Voskanian, Robert 80
Vulich, John 161
Vye, Murvyn **48**
Wagner, Lindsay 255
Wake the Dead (comic book) 186
Walk of the Dead see *Vengeance of the Zombies*
Walking Dead, The 27, 28, **29**, 30, 39, 142, 271, 297
Walking Dead, The (comic book) 186
Wall Street Journal, The (newspaper) 161, 231
Wallace, Inez 42, 44, 46, 227
Waller, Gregory 68, 228
War of the Zombies 62, 297
Warbeck, David 138, 230
Warning Sign 153, 298
Warren, Jerry 52
Washington Post (newspaper) 22, 226
Washington, Fredi 26
Watkin, Ian 160
Watt, Mike 231, 283
Wayne, Keith 67
Weaver, Tom 34, 35, 227, 228
Webb, Kenneth 19, 20
Weber, Jake 184, **185**
Weinstein, Harvey M. 228
Weird Tales (magazine) 230
Well, Karin **136**, **196**
Welles, Orson 41, 227
Wells, H.G. 179

Wells, Robert 168
Werner, Byron 238
West, Adam 153, 306
Weston, Garnett 17, 20-23, 28
Whale, James 19
What Lies Beneath 175
White Monk of Timbuktu, The (book) 10
White Zombie 7, **18**, 20-30, 33, 42, 44, 145, 149, 151, 226, 298
White Zombie: Anatomy of a Horror Film (book) 226
White, Garrett 273
Whitehead, Henry S. 17
Whitten, Marguerite 37
Who Cares? (revue) 19
Whyte, William 51, 228
Wicked Caress of Satan, The see *Devil's Kiss*
Wiederhorn, Ken 79, 155, 284
Wiene, Robert 30
Wild Zero 172, 173, 298
Wilderness, The see *Veerana*
Williams, Brook 58
Williams, Treat 247
Wilson, Woodrow 16
Wilton, Penelope 181, **219**
Winston, Stan 152
Wise, Ray 153, 256
Wish You Were Here (anthology segment) 78
Witchcraft, Its Power in the World Today (book) 10
Witchdoctor of the Living Dead 298
Witt, Alexander 177
Wolf Man, The 42
Womaneater 47-49, 298
Woo, John 173, 180
Wood Jr., Edward D. 53, 64, 248, 278, 279, 289
Wood, Robin 45, 69, 94, 96, 227-230
Woodbury, Joan 38
Woodoo: Die Schreckensinsel der Zombies see *Zombie Flesh-Eaters*
Working Stiffs 166, 298
World War Z 192
Worthington, Marjorie 226
Wray, Ardel 42
Wright, Edgar 181-183, 188, 232
Written in Blood: The Story of the Haitian People (book) 226
Wu long tian shi zhao ji gui see *Kung Fu Zombie*
Wyndham, John 179, 278
Wynter, Dana 52, **54**
Yakis, Dan 228
Yamiguchi, Yudai 174
Yarbrough, Jean 35, 38
Yip, Wilson 174
Yuzna, Brian 155, 158, 231, 239, 281, 285
Z'Dar, Robert **211**
Zeder (Voices from the Beyond) 132, **201**, 298-299
Zombi (computer game) 225
Zombi 2 see *Zombie Flesh-Eaters*
Zombi 3 131, 132, 143, 185, **204**, 230, 299
Zombi 3 see *Living Dead at Manchester Morgue, The*
Zombi Holocaust see *Zombie Holocaust*
Zombi holocausto see *Zombie Holocaust*
Zombi see *Dawn of the Dead* (1978)
Zombie (book) 230
Zombie (play) 19, 20, 226
Zombie 2 see *Day of the Dead*
Zombie 2 see *Zombie Flesh-Eaters*
Zombie 3 see *Nights of Terror*
Zombie 4: A Virgin Among the Living Dead see *Virgin Among the Living Dead, A*

Zombie 4: After Death 131, 143, 299
Zombie 5: Killing Birds see *Killing Birds*
Zombie 90: Extreme Pestilence 166, 299
Zombie Aftermath see *Aftermath, The*
Zombie Apocalypse 300
Zombie Army, The 166, 300
Zombie Bloodbath 166, 300
Zombie Bloodbath II: Rage of the Undead 166, 300
Zombie Bloodbath 3: Armaggedon 167, 301
Zombie Brigade 153, 301
Zombie Campout 166, 301
Zombie Child see *Child, The*
Zombie Chronicles 166, 301
Zombie Cop 166, 301
Zombie Creeping Flesh 131, 132, 143, 167, **204**, **205**, 229, 301-302
Zombie Cult Massacre 229, 302
Zombie Flesh Eaters 2 see *Zombi 3*
Zombie Flesh Eaters 3 see *Zombie 4: After Death*
Zombie Flesh-Eaters **127**, **128**, 129-134, 140, 142, 143, 171, 176, 299, 302, **303**
Zombie Genocide 166, 248, 303
Zombie High 151, 303
Zombie hing am Glockenseil, Ein see *City of the Living dead*
Zombie Holocaust 132, 134, 136, 143, 167, **198-200**, **304**, 305
Zombie Honeymoon 305
Zombie Island Massacre 151, 306
Zombie King and the Legion of Doom see *Enter... Zombie King*
Zombie Lake 61, 79, 80, 85, **112**, 290, 306, 309
Zombie Movie Encyclopedia, The (book) 227
Zombie Nightmare 153, 306, **307**
Zombie Ninja Bangers see *Zombie Ninja Gangbangers*
Zombie Ninja Gangbangers 135, 308
Zombie Nosh see *Revenge of the Living Zombies*
Zombie Rampage 166, 308
Zombie Rampage 2 308
Zombie Revival: Ninja Master see *Zombie Vs. Ninja*
Zombie see *Dawn of the Dead* (1978)
Zombie see *Zombie Flesh-Eaters*
Zombie Survival Guide: Complete Protection from the Living Dead, The (book) 186
Zombie Toxin 166, 308
Zombie Vs. Ninja 172, 308
Zombie World (comic book) 232
Zombie! Stories of the Walking Dead (book) 226
Zombie: The Resurrection 166, 308
Zombiegeddon 308
Zombies Lake see *Zombie Lake*
Zombies of Mora Tau 47-50, 53, 65, **101**, 151, 178, 229, 308-309
Zombies of Sugar Hill, The see *Sugar Hill*
Zombies of the Stratosphere (serial) 48, 233, 309
Zombies on Broadway 46, 48, 309
Zombies see *I Eat Your Skin*
Zombies That Ate Pittsburgh: The Films of George A. Romero, The (book) 229
Zombies unter Kannibalen see *Zombie Holocaust*
Zombies: Dawn of the Dead see *Dawn of the Dead* (1978)
Zombiethon 154, 309
Zombio 166, 309
Zucco, George 34, 40, 41, 84, 227

Quality Books For Cult Connoisseurs from FAB Press

ISBN 0-9529260-6-7

ISBN 1-903254-23-X

ISBN 1-903254-34-5

ISBN 1-903254-46-9

ISBN 1-903254-45-0

ISBN 1-903254-32-9

ISBN 1-903254-36-1

ISBN 1-903254-41-8

ISBN 1-903254-44-2

ISBN 1-903254-39-6

ISBN 1-903254-25-6

ISBN 1-903254-40-X

ISBN 1-903254-42-6

ISBN 1-903254-43-4

ISBN 1-903254-38-8

ISBN 1-903254-31-0

For further information about these books visit our online store, where we also have a fine selection of excellent DVD and soundtrack CD titles from all over the world!

www.fabpress.com